**This book is to be returned on or before
the last date stamped below.**

D1348647

BK05005

DUFY

Dora Perez-Tibi

DUFY

With 379 illustrations, 236 in colour

THAMES AND HUDSON

Translated from the French by Shaun Whiteside
First published in Great Britain in 1989 by Thames and Hudson Ltd, London

Printed and bound in Switzerland

CONTENTS

PREFACE

The range of Raoul Dufy's artistic creation was revealed to the public by a major exhibition devoted to him by the Musée d'Art et d'Histoire, Geneva, in 1952, and by the important retrospective held in Paris at the Musée d'Art Moderne in 1953, a few months after his death. These exhibitions established Dufy's true greatness,[1] and helped to increase his fame, by showing him not as the 'enchanter' or the 'lovable man', but by bringing out his true artistic character.

Dufy's *oeuvre* consists of more than two thousand paintings, as many watercolours and almost one thousand drawings. He illustrated some fifty literary works with wood engravings, lithographs, etchings, watercolours and drawings. He made more than two hundred ceramic pieces. There are almost fifty tapestry cartoons and some five thousand watercolour and gouache fabric designs. Dufy's stage sets, murals and monumental decorations are among the most important of his time.

With the passing years, however, Dufy's works in the field of crafts have lost some of their popularity, to the advantage of his painted work. And, despite the London retrospective at the Hayward Gallery in 1983–1984, which invited us to reconsider Dufy's work as a whole, certain prejudices remain.

Nevertheless, Raoul Dufy's contribution to decorative art is of crucial importance, and one of the major purposes of this study will be to show that he made no hierarchical distinction between 'great art' and the so-called 'minor arts', which he treated with all his natural enthusiasm. He learned the laws and rules of each of these techniques, for he saw that 'between the pleasure of enlivening a silk fabric with beautiful images and the pleasure of painting a canvas', the only distinction is one of 'technique and quality'.[2]

His correspondence and the notes that he kept in his many sketchbooks, as well as his unpublished manuscripts, tend to confirm that although Dufy was not a theorist like Matisse or Lhote, he did constantly question the basis of his art.

Born in 1877, Raoul Dufy, like all the artists of his generation, was confronted with the fundamental problem of the work of art: how can we reconcile the illusion of a representation as it has been handed down to us since the Renaissance, and reality as it is perceived by the artist himself? This question, which he saw as essential, was inherent in problems of colour and light.

The late Impressionism of his earliest works, his adherence to Fauvism, which showed him 'the miracle of imagination in colour', his passing attraction to Cubism, in which he thought he had found a solution to his inquiries, reveal his questing spirit. He referred to the art of both Matisse and Cézanne, without becoming slavishly devoted to them. On the contrary, he refused to be satisfied with the aesthetic precepts of other painters, and adapted their various means of artistic expression to his own temperament, satisfying his passion for colour and his need for order and clarity. Having become apparent early in his work, his originality would assert itself in his travels and encounters.

He did not owe his decorative career only to the precarious financial conditions that often led artists in the first quarter of the twentieth century to practise various different disciplines. Dufy was happy to use craft techniques in his artistic production, thus establishing a dialogue between the various forms of decorative and pictorial creation, constantly in search of the perfect means of expression, which served to enrich his aesthetic vocabulary.

His pictorial work and decorative production are inseparable. Even if they differ in their techniques, they have a common style based on the essence of a representation in which the real mingles with the imaginary. He expresses himself in his treatment of a small set of themes, constantly repeated, recreated, broadened and transfigured.

The spontaneity and inventiveness revealed in his paintings conceal the amount of effort that went into them, an effort that he himself was keen to mask, but which is revealed by the considerable number of his preparatory studies. A combination of his choice of themes and the expression of his art gave his work an apparent simplicity, ease and lightness.

There is a need, therefore, for a new way of looking at his work which will encompass all its various aspects. For Raoul Dufy's art shows a profound sensibility and springs from a joyful meditation, a certain cheerful and poetic humanism reminiscent of the work of Giraudoux. A man of tender rhetoric, his words never refer to the concepts or actions which would legitimate them, but on their own constitute a fairy world modelled according to his fantasy and his humour. He never placed a great deal of stress on reality, preferring to dive into the depths of a fiction where life is good. Dufy, like Giraudoux, has a fear of tragedy, which they both tried to exorcise from their work. Their creations radiate a sense of elation and *joie de vivre*; Dufy's nature was free of sadness, and his eyes 'were made to erase all things ugly'.

The richness of his perpetual inventiveness gives us dreams and constant pleasure. Varying his modes of expression, Raoul Dufy made, like his contemporaries, his own contribution to the integration of art and life. He discovered an infinite richness in daily life, and his creative imagination, his fantasy, his mental energy, combine to produce a poetry that glorifies life in all its manifestations. Like that of Matisse, Raoul Dufy's work is pregnant with the pleasure of painting, the joy of 'creation'; the happiness that comes from being an artist, from being a man.

1. André Chastel, *Le Monde*, 26 June 1953.
2. *Sélection*, Brussels, 1928.

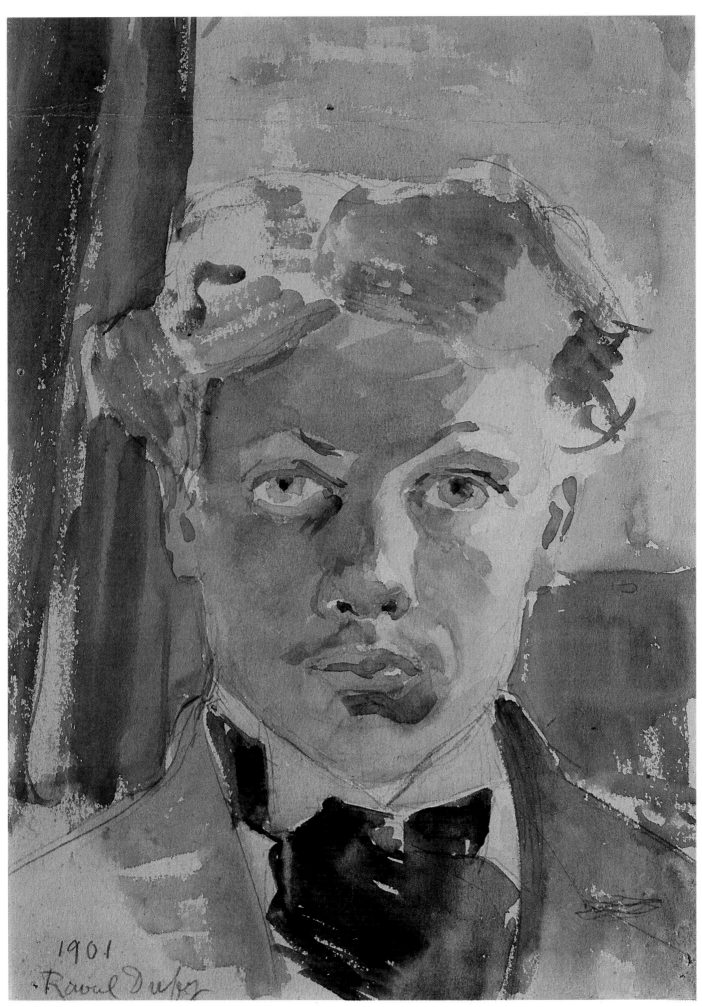

1 *Self-Portrait*. 1901. Watercolour.

I

THE YEARS OF TRAINING

2 *House and Garden at Le Havre*
(detail of ill. 39).

Le Havre (1877–1900)

The Raoul Dufy archives have preserved a number of unpublished sketches which Dufy made in pen and blue ink around 1950, before his final journey to the United States. He had intended them to be part of an autobiography in pictures, but the project remained at the planning stage.[1]

Made in the artist's old age, these drawings amount to the spontaneous introspection of an old man in poor health returning to his roots. They deal primarily with figures and places that influenced the artist's youth, the source of the major themes that recur as leitmotifs throughout his *oeuvre*. 'My youth was cradled by music and the sea,' Dufy said to Pierre Courthion at this time.[2]

The musical atmosphere of his childhood, which nurtured his love of music and the great composers, was provided by his father, Léon Marius Dufy. Dufy's image of his father, which became important to him at the end of his life, is not that of an accountant in a metal-works in Le Havre, but rather that of the organist who conducted the choirs in the churches of Notre-Dame and Saint-Joseph. It is in his role as organist accompanying the choirs that Dufy recalled him in lively pen-and-ink studies.

Marius Dufy communicated his passion for music to all his children; as a boy, Raoul took great pleasure in accompanying his father's choir, sometimes at the organ. But his more talented brother Léon was to make music his profession. A

3 *The Quay on the Bassin du Commerce.*
Around 1950.
Pen-and-ink drawing.

4 *The Le Havre Brass Band.* Around 1950.
Pen-and-ink drawing.

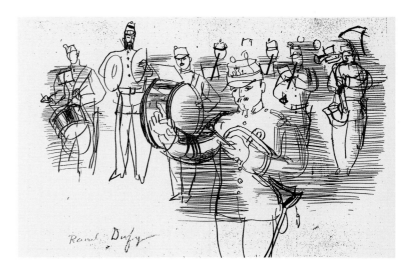

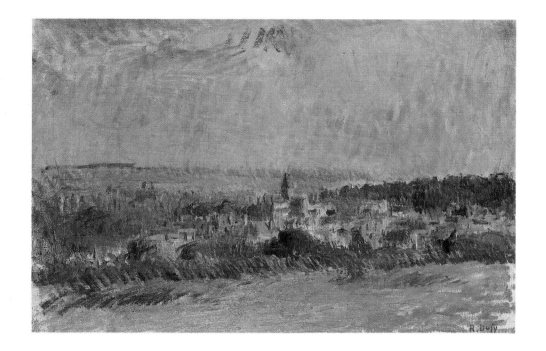

piano teacher, he taught harmony and musical composition to the young people of
Le Havre, one of whom, Armand Salacrou, was later to enjoy fame in the theatre.[3]

Dufy's younger brother, Gaston, was an excellent flute-player, although he
devoted himself to composition. He edited the *Courrier musical* in Paris at the
beginning of the century, a post that allowed him to provide Raoul, then an
impoverished student, with free admission to the concert halls of the capital.

Dufy's mother, *née* Marie Eugénie Ida Lemonnier, devoted all her time to
bringing up her nine children.[4] She is shown in a study by the young painter, sitting
at the family table.[5] Dufy also immortalized the garden of this house on the Rue du
Maréchal-Joffre,[6] with its dense vegetation, full of birdsong that seemed to answer
the musical sounds coming from inside the house. From his earliest childhood, Dufy
showed respect and affection for his parents. An unpublished letter, dated New
Year 1896,[7] reveals a sensitivity which anticipates the human qualities that would
be characteristic of Dufy throughout his life.[8]

The Le Havre Brass Band marching down the street is one of the unpublished
drawings mentioned above; it conveys the musical atmosphere that reigned in Le
Havre and that was so beloved of the city's people. No doubt the general high
standard of musical education was also due in part to the municipal symphony
orchestra. Dufy attended its frequent concerts at the Théâtre du Havre. His 1898
sketches already reveal what was to be a lifelong interest in musicians and musical
instruments.[9]

8 *The Orchestra of the Théâtre du Havre.* 1902.
Oil on canvas.

9 *The Offices of the Luthy & Hauser Company
in Le Havre, 1898.* Around 1950. Raoul Dufy is
seen from behind.
Pen-and-ink drawing.

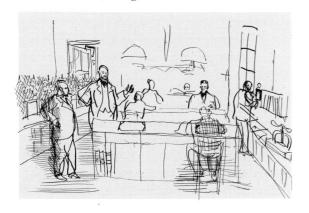

Dufy owed his love of the sea to the city of Le Havre, where he was born in 1877,[10] and where he would spend all of his childhood and his adolescence until the age of twenty-three.

Raoul Dufy was given a sound schooling, based on training in Latin, Greek and German,[11] which was to be of great use to him when, because of family financial difficulties, he was obliged to earn his living from the age of fourteen. In 1891 he became an accountant with a firm of Brazilian coffee importers run by two Swiss businessmen, Luthy and Hauser. At this time the city of Le Havre, which had recently been redeveloped, was enjoying an economic expansion which ensured prosperity in business and trade. During the five years that he spent as an inspector of the produce of the foreign steamers arriving at the Quai du Commerce, Dufy had every opportunity to look out over the view of the port: the dense traffic of ocean-going vessels arriving from the United States or the Bosphorus and setting off once more for foreign shores – a spectacle that lent itself to fantasy and escapism.[12]

A second sketch captures the bustling atmosphere of the Quai, with a paddle-steamer anchored alongside. Black-hulled steamers, yachts with sharp white keels and billowing sails, a forest of upright masts swaying along the quays, drifting on the lapping waves, made constantly changing *tableaux vivants* for the artist. All through Dufy's life, the port of Le Havre and the Bay of Sainte-Adresse would be the references of his principal themes: they would provide the backdrop for his shells with their precisely drawn whorls, they would cradle his *Bathers*, and they would frame his *Regattas*, his *Freighters* and his *Sprat Fishermen*.

In another sketch, Dufy brilliantly evokes the setting of the offices of the Luthy & Hauser Company looking out over the port. The painter himself, shown from behind, is easily recognized by his curly hair. Perched on a tall chair, sitting at a desk, he is busy with his accounting, under the authoritarian eye of an employer whose stature and importance are emphasized by a heavy line.

Dufy's job did not prevent him from taking evening classes, given by the teacher Charles Lhuillier, with a view to perfecting the talents that had been obvious from a very early age. 'Le Père Lhuillier', as he was nicknamed by his pupils, will be remembered by posterity for one reason only. He was the first teacher of three great figures in French painting: Raoul Dufy, Georges Braque and Othon Friesz. Originally from Grandville, Lhuillier was a pupil of Cabanel and later of Picot.

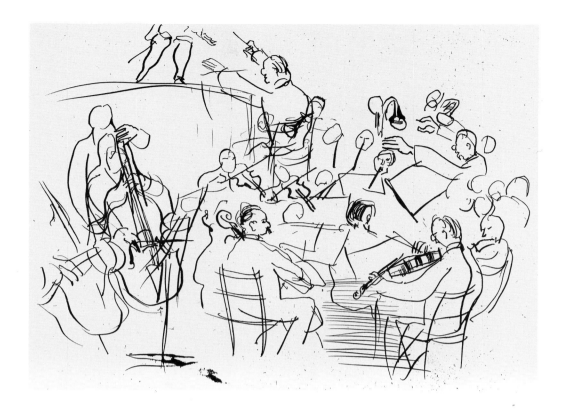

Classically trained and a great admirer of Ingres, he based his teaching on the practice of drawing.

Dufy would always be grateful to Lhuillier for cultivating in him a need for strictness and discipline. Lhuillier was a friend of Jongkind, with whom he sometimes painted from life, but he hated Eugène Boudin, who had beaten him to a scholarship from the city of Le Havre. Lhuillier spent six years as curator at the Musée du Havre before becoming head of the École Municipale des Beaux-Arts in 1871.

Like Gustave Moreau at the École des Beaux-Arts in Paris, the elderly Lhuillier allowed the personalities of his pupils to flourish beneath his benevolent gaze. He encouraged their work and opened his studio to them from six o'clock in the morning. Émile Othon Friesz was a fellow-pupil of Dufy's, and their friendship was to last throughout their lives: 'We would meet in the evening, at "Le Père Lhuillier's"', where, in charcoal and *tortillon* on a sheet of Ingres paper, we would draw Greek and Roman sculpted busts. We held our teacher in high respect and admiration, for he was a true artist, a great classical draughtsman.' This mastery of drawing which Dufy was in the process of acquiring did not prevent him from painting in watercolour and oil outside of his classes, in the company of Friesz, both *en plein air* and in a small maid's-room which he used as a studio.

The young painter's very first works include portraits of his close relations, either on their own or seated around the family table, landscapes of Le Havre and the surrounding area, and numerous self-portraits. Some of them depict the features of a young man with a steady gaze beneath heavy arched eyebrows, and a sardonic mouth; fair hair frames a face modelled in planes of light and shade, highlighted by a white collar and broad black tie. Sometimes he portrays himself wearing a hat cocked at an angle, which gives him the appearance of a young dandy. In all his self-portraits we see 'the young man with his fresh complexion, his head in the air, with his blond curly hair, his protruding sky-blue eyes, dashing, flirtatious and busy', as his friend Fernand Fleuret described him.[13]

Dufy's first landscape works were painted during this period. His watercolours exhibited in 1900 at the Musée des Beaux-Arts du Havre, showing the port and its docks, views of Harfleur and Honfleur, are clearly influenced by Boudin. The young Raoul Dufy sought to portray the world around him, the play of reflections of the

10 *The Orchestra of the Théâtre du Havre.*
Around 1950.
Pen-and-ink drawing.

light on the surface of the water, the steamers and sailboats in the quay, their masts standing out against the sky.

The landscapes of the Normandy countryside are based more on '*peinture en plein air*': the emphasis is on the representation of light, captured in the juxtaposition of long coloured brushstrokes. He and Friesz shared an admiration for Poussin and Delacroix, whose *Justice of Trajan* (Musée de Rouen) was a revelation to Dufy, and certainly made a lifelong impression on him. He returned to see this work during a period of military service in Rouen in 1898.[14]

By this time Othon Friesz had already left Le Havre for Paris, where he had enrolled at the École des Beaux-Arts. Their correspondence shows that their friendship remained strong over two years of separation.[15]

At the end of 1899, Gaston, the youngest of the Dufy family, enlisted before call-up as a flautist in the 119th Infantry Regiment. Since a law prohibited two brothers

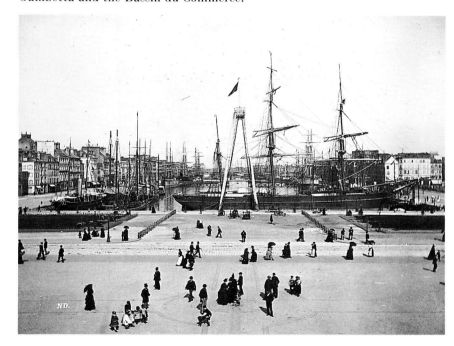

11 *Le Havre, the Docks*. 1898.
Watercolour.

12 Photograph of Le Havre: the Place
Gambetta and the Bassin du Commerce.

from serving in the military at the same time, Raoul was freed of his military
obligations. In 1900, thanks to a recommendation by Lhuillier, he was awarded a
scholarship of 200 francs per month, allocated by the municipality of Le Havre, to
pursue his studies at the École des Beaux-Arts in Paris.

The Paris Years (1901–1905)

When Raoul Dufy arrived in Paris in 1900, the 'Exposition Universelle' was under
way. It is noteworthy that although Picasso came from Barcelona specifically to
attend it, Dufy did not visit the exhibition. The Grand Palais and the Petit Palais,
temples of art built for this occasion, seem not to have attracted him. Nor was his
attention drawn by the craftwork on show to the public in the Petit Palais, where a

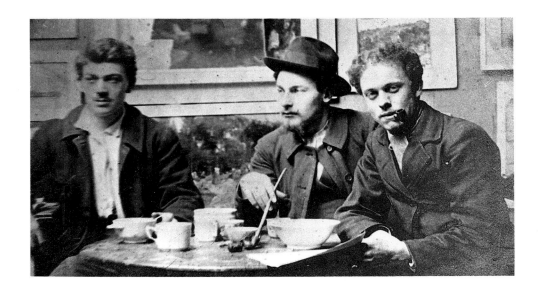

13 Othon Friesz, Raoul Dufy (on the right) and the sculptor Bouchard in Friesz's studio in Paris, 1901.

retrospective presented a panorama of the French arts, from their beginnings until 1880. Neither did the decorative arts on show in the various pavilions of the Exposition consecrating the triumph of Émile Gallé hold any great interest for him.

The Grand Palais was the site of the Centennial exhibition illustrating French artistic creation from 1800 to 1889. The organizer of the exhibition, the critic Roger-Marx, showed, alongside the great figures of Classical, Romantic and Realist art, works by Cézanne, Degas, Gauguin, Manet, Monet, Picasso, Seurat, Sisley, Vallotton and Rodin. Dufy had every opportunity to admire these innovative painters in the galleries on the Rue Laffitte, at Durand-Ruel and Vollard. It was here that he would find the models that his art needed.[16] Although he was impressed by the masterpieces in the Louvre, Dufy seldom went there.[17] The only painter whose works he often went to admire was Claude Lorrain, 'his God', for whom he was to paint a series of *Homages* around 1927.

Dufy studied the works of Manet and the Impressionists, Jongkind, Renoir, Claude Monet and particularly Pissarro. He could not adapt to the academic training given at the École des Beaux-Arts once he had joined his friend Othon Friesz in Bonnat's studio.[18]

For the competition at the École he painted a watercolour from sketches that he had made during his time with 'le Père Lhuillier', *The Square in Falaise*. In this painting, which attempts to draw its stability from the large stone plinth in the foreground, the clumsy representation of the equestrian statue and the awkward perspective indicate Dufy's lack of skill. On the other hand, the schematized notation of the gestures and attitudes of the figures thronging the little square is highly refined, and his treatment of these figures, like his treatment of the sky, is reminiscent of the work of Boudin. Fortunate in having a studio and free models at his disposal, as well as certificates of regular attendance which ensured an income from scholarships provided by the municipality of Le Havre, Dufy spent four years at the École des Beaux-Arts. Although he had difficulty with the academic part of the course, he did acquire, as his teacher predicted,[19] an extreme dexterity as a draughtsman, to the point of forcing himself to use his left hand in order to suppress a facility which had become second nature to him.[20]

During this period Dufy shared a studio with Friesz at 12, Rue Cortot,[21] an old, formerly residential building which housed the writer Léon Bloy, the painter Émile Bernard, Max Jacob, the draughtsman Poulbot, and the actor and director Antoine, prior to his becoming director of the Odéon in 1906. It was the home of Suzanne Valadon, André Utter and Utrillo. Dufy had a calm and reserved appearance, and he frequented concert halls rather than music-halls; he was not at all the typical Montmartre rake. Dorgelès tells us: 'He was never seen untidily dressed, without a collar, slouching about in slippers like all his companions. He loathed bohemianism. His linen was always clean, his shoes well polished, and he bore his poverty with a careless pride.'[22]

18

Unlike Friesz, Dufy did not seek right from the start to 'give art a shake and turn the old principles on their heads'.[23] *Evening in Le Havre*, shown in 1901 at the Salon des Artistes Français, provides an indication of this, with its sober construction and composition and its dark tonalities. The following year, the anarchist painter Maurice Delcourt – Dufy had attracted the attention of the police for sheltering him – introduced him to Berthe Weill, who introduced him in turn to her little shop at 25 Rue Victor-Massé, first by buying a pastel by him and subsequently by involving him in group exhibitions.[24]

In 1903, Dufy decided to show for the first time at the Salon des Indépendants,[25] an avant-garde salon based on the principle, revolutionary at the time, of having neither a jury nor awards. He avoided all academic models and until 1904 painted works that increasingly derived from the art of the Impressionists.

During these years he travelled regularly. The views of Paris and the landscapes of Normandy and the South of France prompted a large number of studies in watercolour or oil. While he conveys a faithful vision of observed reality, his art can be seen to develop from a static figuration towards a lighter and more dynamic depiction of his subject. Thus the landscapes of Falaise, to which he returned during the summer of 1902, show an arrangement of slender and closely woven brushstrokes conveying the structure of the foliage of the trees. This fidelity to his chosen sites is also apparent in the series of *Beaches at Sainte-Adresse*, painted in 1901 and 1902 in the manner of Boudin. Using a fragmented brushstroke, all of these works seek to convey a single moment, a certain silvery vibration of the atmosphere, the movement of the sky, the wind in a flag. However, in one of the versions in the Musée National d'Art Moderne de Paris, painted in 1904, Dufy returns to a less broken line, but one which is still concerned with the drawing of forms in a tightly constructed space, in which the view of the distance comes into focus once more.

During this period of Impressionist influence, Dufy's compositions became more varied. Towards the end of 1902, having become freer and more open, as is revealed by the *Normandy Village*, his style becomes elongated, accentuated, more rhythmical, until in 1903 it conveys the bustle of the carnival crowd in *The Grand Boulevards*, *The Quai de Marseille* (Kunsthaus, Zurich). Although based on the study of atmospheric effects, the spontaneity of the brushstroke does not attempt to break the structure of buildings or forms, but aims at colorific effects with reds, greens and blues, sustained by blacks which organize the composition.

Raoul Dufy remained faithful to this Impressionist vein, despite being aware of the limits of a representation of reality that is essentially plastic and descriptive. It was a revelation to him when he saw Matisse's painting *Luxe, calme et volupté*, which was exhibited at the 1905 Salon des Indépendants. Twenty years later, he modestly and courageously acknowledged his debt to Matisse. *Luxe, calme et volupté* had shown him 'all the new reasons for painting, and Impressionist realism lost all its charm for me, when I contemplated the miracle of the imagination that had penetrated both line and colour. I immediately understood the mechanics of the new painting.' Dufy was already familiar with the technique of divisionism, having visited, in December 1904, the major exhibition devoted to Signac at the Galerie Druet.

Dufy was struck not so much by the method which Matisse used to represent his forms in an imaginary space and an explosion of mosaic colours, as by the very use of such arbitrary brilliance, expressing the inner feeling of a painter for whom Dufy felt a mixture of admiration and reserve. In order to understand the great leap that occurred in Dufy's *oeuvre* in the spring of 1905, we might compare two works on the same subject painted at a year's interval.[26] At the end of 1904, Dufy painted *Yacht Decked out with Flags*. His brushstroke faithfully conveys the movement of the sky, the vibrancy of a natural light and the clarity of the air which makes the flags on the masts flap in the breeze and brings waves to the surface of the water. These characteristic features reveal Dufy's adherence to the Impressionist aesthetic. But they also show his concern with the structure of his painting, in the interplay of vertical and diagonal lines, which he was never to abandon.

In contrast, *Boat Decked out with Flags*, painted in 1905 after the Salon des Indépendants, reveals Dufy's change of direction. He is no longer imitating

14 *The Beach at Saint-Adresse*. 1902.
Oil on canvas.

15 Photograph of the beach at Sainte-Adresse
in 1905.

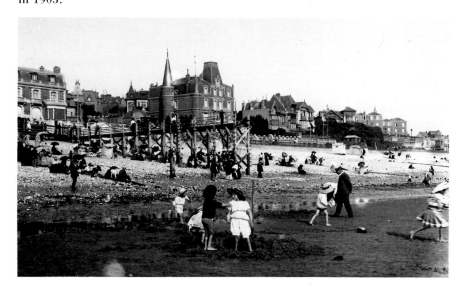

21

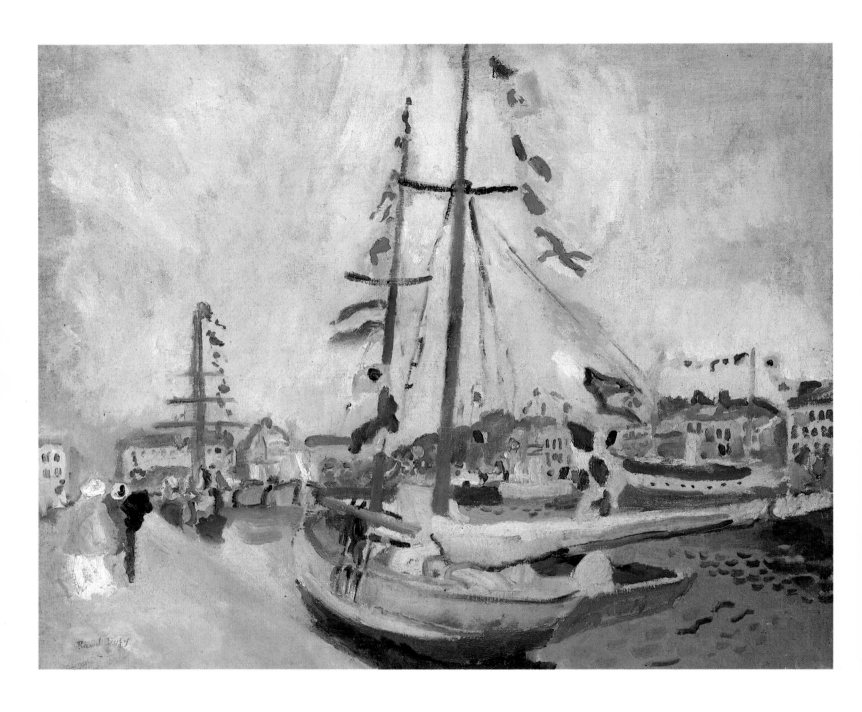

16 *Yacht Decked out with Flags.* 1904.
Oil on canvas.

observed reality, but rather reinventing it. This transposition is effected by means of colours applied in planes and given a plastic role, while forms are simplified and reduced to their pictorial expression.

Back in Le Havre in 1905, Dufy returned to the theme of the *estacade* and the beach of Sainte-Adresse, using arbitrary colours which express the inner feeling that nature awoke in him, a nature which he reinvented according to a subjective vision, conveyed by a technique made up of planes and lines reduced to formal essentials.

Dufy spoke on this subject in his conversations with Pierre Courthion: 'There is one thing against which the painter, like the sculptor, must be on guard: his eye. The painter's eye is his enemy. The painter who trusts only his eye will be deceived,'[27] thus recalling a note from his notebooks: 'Painting means creating an image which is not the image of the appearance of things, but which has the power of their reality.'[28] Later, he relates an experience which explains the logic of his development: 'Around 1905–1906, I was painting on the beach at Sainte-Adresse. I had previously painted beaches in the manner of the Impressionists, and had reached saturation point, realizing that this method of copying nature was leading me off into infinity, with its twists and turns and its most subtle and fleeting details. I myself was standing outside the picture. Having arrived at some beach subject or

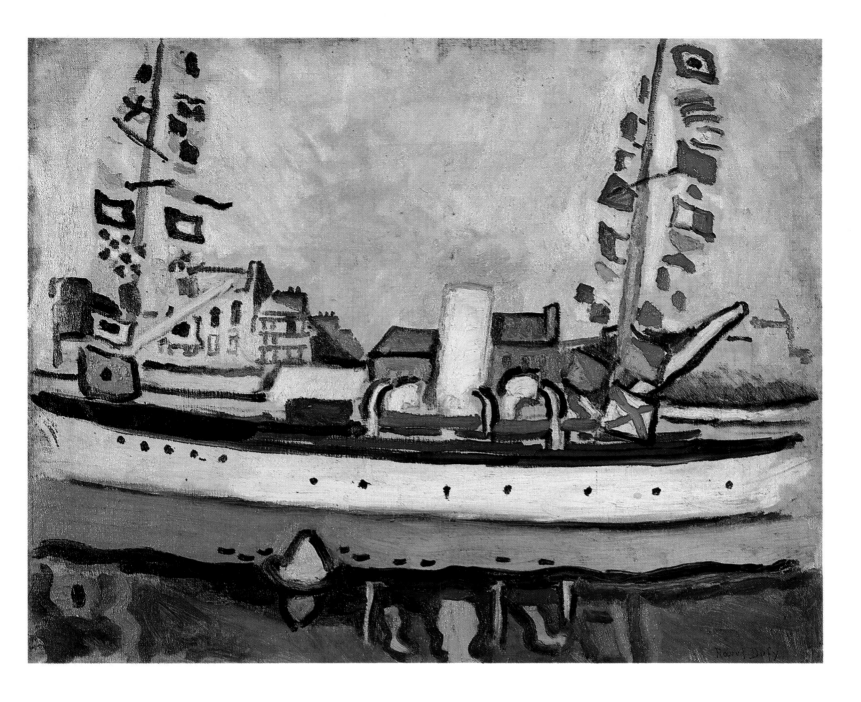

other I would sit down and start looking at my tubes of paint and my brushes. How, using these things, could I succeed in conveying not what I see, but that which *is*, that which exists for me, *my reality*? That is the whole problem [. . .]. I then began to draw, choosing the nature that suited me [. . .]. From that day onwards, I was unable to return to my barren struggles with the elements that were visible to my gaze. It was no longer possible to show them in their external form.'[29]

The paintings of his friends, shown at the 1905 Salon d'Automne, which saw the eruption of the scandal of the Cage des Fauves (in which Dufy was not involved), confirmed him in his new direction. Until the end of 1905, he painted works marked by a lyrical elation that would find its full expression in 1906 and 1907.

The Fauve Years (1906–1907)

Raoul Dufy's art had taken on a dynamic which led him further from realism with each passing day. He had become aware of the need to recreate observed reality in terms of his own 'reality', and now went on to elaborate his theory of '*couleur-lumière*', with which he experimented during these two years, and which he would apply to his entire *oeuvre*: 'I was spontaneously led towards what was to become my real preoccupation. I had discovered a system, whose theory was this: to follow the

17 *Boat Decked out with Flags*, 1905. Oil on canvas.

light of the sun is a waste of time. Light in painting is something completely different: it is a light distributed throughout the composition, a 'couleur-lumière'.[30]

In a long, unpublished manuscript Dufy provides a detailed exposition of this principle which was to guide his career.[31] This important text categorically contradicts the often repeated assertion that Raoul Dufy never wrote about his painting. The following are extracts from it: 'When I talk about colour, it will be understood that I am not talking about the colours of nature, but about the colours of painting, about the colour[s] of our palettes, the words from which we form our pictorial language [...] – do not imagine that I am confusing colour with painting, but since I make colour the creative element of light – as we should never forget – since I see colour itself as being nothing but a generator of light, it is clear that it shares this role with drawing, the great 'builder' of painting, its principal element [...]. Colour reduced to coloration is fit only for popular prints, and cannot bring real or profound or brilliant pictorial satisfactions.'

From 1906 Dufy would compare his experiment in the transposition of the visible world with the studies made by Marquet, one of the original Fauves, during the summer which they spent together in Normandy. Marquet had been working in Paris with his fellow pupil from the Gustave Moreau studio, Matisse, who was generally seen as the leader of the movement. Indebted to him for the turning-point in his own work, Dufy remained impressed by Matisse, who treated him with a certain degree of hostility.[32] He felt a greater affinity with his friend Marquet, with whom he remained in close contact from 1901 onwards. He had previously worked with Marquet in Fécamp in 1904 and Le Havre in 1905. Marquet guided him and led him on to the Fauvist path. The summer of 1906 saw them working side by side in Le Havre, in Trouville and in Honfleur. They painted the same motifs on canvases which show strong similarities despite their temperamental differences. More spontaneous than Marquet, Dufy expressed himself with a less pointed graphic style and a richer chromaticism.

Nineteen-hundred-and-six was a fertile year and a milestone in Dufy's career. He showed at the Salon des Indépendants, exhibiting early works which demonstrated a certain Impressionistic realism, conveyed in a fragmented brushstroke. Berthe Weill organized his first solo exhibition in October. At the Salon d'Automne, where Dufy showed for the first time, he exhibited Fauve works painted during the summer of 1906. *The Beach at Sainte-Adresse* and the *Baths of the Casino Marie-Christine*, which Dufy painted from 1902 onwards, inspired a large number of paintings by the two friends. In 1906, Dufy reinterpreted these subjects. His composition, extended vertically, is still stabilized by the axis of the *estacade*, but the bustle of the beach is conveyed in an airy, dynamic construction and by the use of long and incisive brushstrokes in pure and vivid colours.

During this period, this lyrical style is linked with a tighter construction which confers a greater density on the forms, as in *The Three Parasols*, a work featuring brilliant colours and subtle harmonies.

In this work Dufy leaves reality behind, stripping colour of its descriptive role to lend it an expressive power which asserts his new visual stance. The fragmentation of the brushstroke has almost disappeared in favour of variously sized simplified planes. The use of this technique derives from Gauguin, whose works Dufy had seen in 1903, in a small exhibition of his work at the Salon d'Automne and a huge exhibition of paintings, drawings and sculptures at Vollard's gallery. Gauguin, the Impressionist renegade, was the first to react against the art of those painters who heed only the eye and neglect the mysterious centres of thought. Dufy did not share his preoccupation with a 'painting of ideas'. But Gauguin attracted Dufy in a number of ways, and he may have been the source of Dufy's interest in the primitive and popular arts, particularly the woodcut. In *The Three Parasols*, the human figures assume a plastic quality. As in Gauguin's painting, forms are flattened out in a flexible syntheticism, parallel to the plane of the painting, with no vanishing point. Dufy replaced traditional vanishing perspective with a depiction in parallel horizontal bands intersected by a series of rigid verticals. The oblique angle of the pier of the Casino Marie-Christine, which derives from a Japanese aesthetic, breaks up the horizontal planes. The sky is reduced to a small area.

18 Photograph of Le Havre, Boulevard Maritime.

19 *The Three Parasols.* 1906. Oil on canvas.

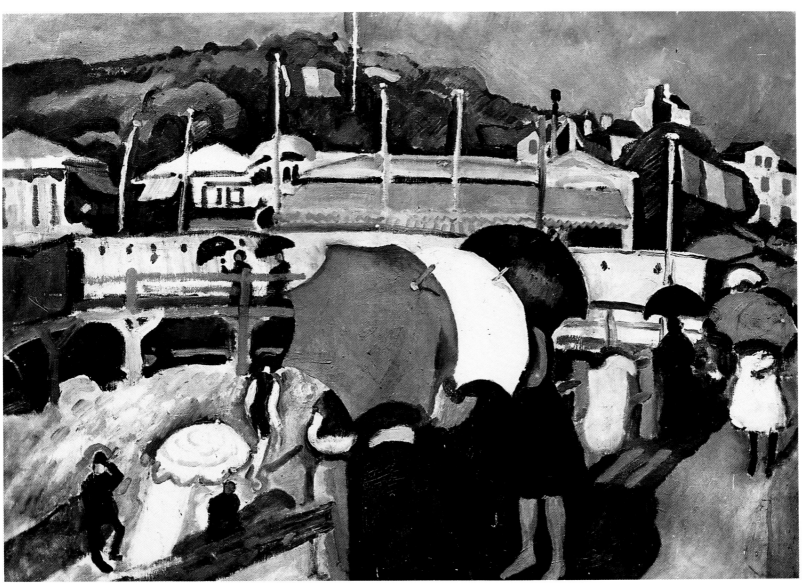

20 *Fishermen with Red Parasol near Sainte-Adresse.* 1907.
Oil on canvas.

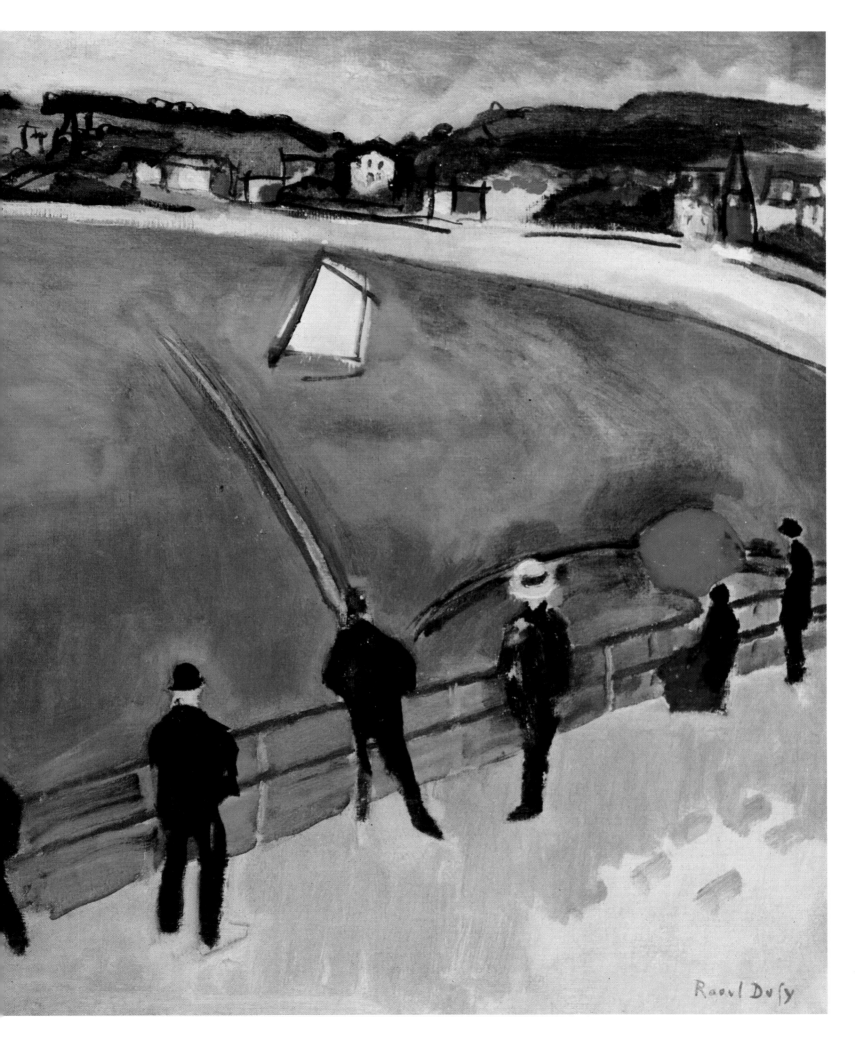

A similar concern with construction appears in *Posters at Trouville*, in which the oblique placing of the advertising posters bears out this desire to avoid any kind of perspective. It is even more striking in the second version, formerly in the Vinot collection, which was painted at the same time:[33] the palisade, parallel to the plane of the painting, shows an absolute refusal to convey space. This version has some similarities with Marquet's composition inspired by the same motif, in both its use of colour and its construction. It contains a number of details, such as the striped tent and the flags, which are absent from the work in the Musée National d'Art Moderne. In it Dufy, like Marquet, makes use of the naturally violent colours provided by the posters:[34] perceived sensation is transposed into tones which do not express any inner violence. It is clear that for these two painters Fauvism was not the 'test of fire' that it was for Derain, for whom 'colours became sticks of dynamite'. The expressive charge conveyed by colour in Dufy's work seeks essentially to capture the bustle of the promenade at Trouville, where passers-by stand outlined against the posters. He evokes them with his usual imaginativeness; their gestures and attitudes are swiftly jotted down; a few strokes of colour, arranged in planes, emphasize a swift and spontaneous line suggesting gaiety and *joie de vivre*.

Like Marquet's paintings, Dufy's works from this period reveal, in their use of black – a colour banished from the Fauve palette – the influence of the art of Manet, which both Dufy and Marquet came to appreciate when his work was shown in a

21 *Posters at Trouville.* 1906. Oil on canvas. Formerly in the Vinot Collection.

retrospective organized at the 1905 Salon d'Automne. They too drew upon this straightforward way of simplifying forms and constructing them through the arbitrary use of pure colours.

The theme of the *Street Decked out with Flags on the 14th of July* (1906) inspired more than eleven paintings by Dufy.[35] He kept creating new variations on the subject like a composer constantly repeating his melodic phrase. This procedure reveals his full control of his means: he gives free rein to his lyricism in order to transpose reality to the advantage of his poetic and visual imagination. It is interesting to compare two important versions from this series. In the version in the Bellier collection, Dufy punctuates his composition with a sequence of tricolour flags which drape a series of houses arranged in tiers in a street with a rising perspective. A simplified style produces the white spaces between the patches of pure colour which run across the page and create a sense of jubilation. In the foreground, Dufy shows the outlines of passers-by crossing a flag, a detail which reappears in the version in the Musée National d'Art Moderne. This phenomenon of transparency conveys 'two impressions superimposed in time';[36] Dufy assumes an idea of duration contrary to the instantaneous vision of Impressionist thought. This is a confirmation of Dufy's new creative attitude, which has abandoned a concern with representing the fleeting appearances of reality in order to portray nothing but the essential. In *The 14th of July in Le Havre* (Musée National d'Art Moderne, Paris), the role of plastic organization is entirely conferred on the

22 *Posters at Trouville.* 1906.
Oil on canvas. Musée National d'Art Moderne, Paris.

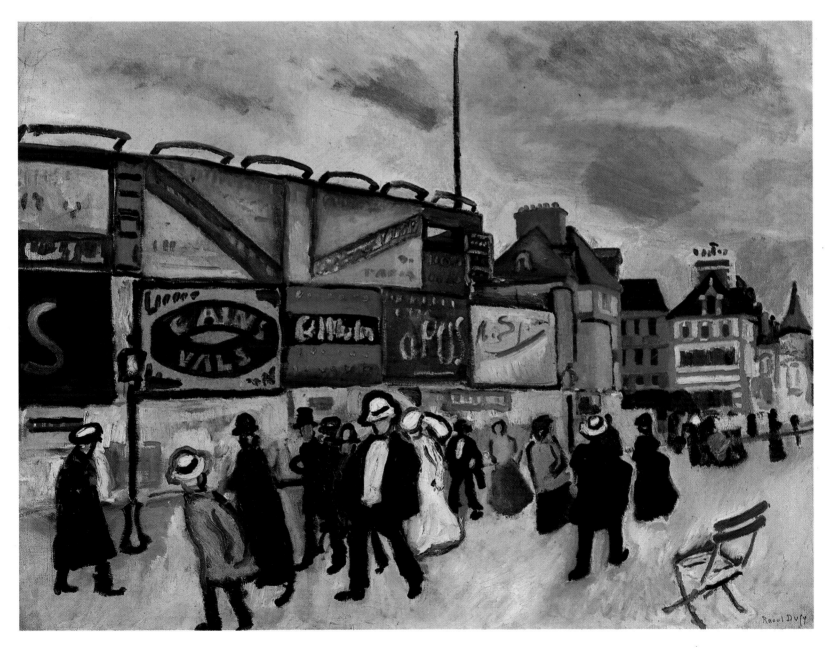

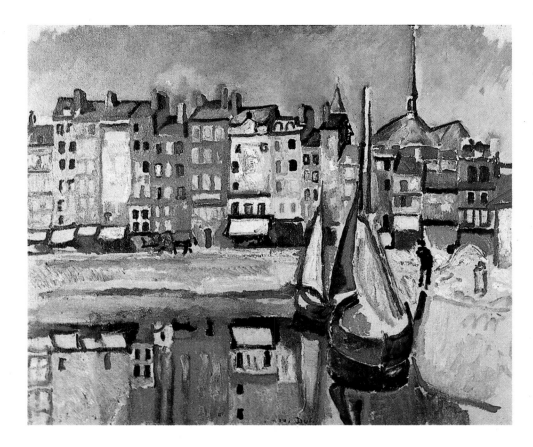

23 *Old Houses on the Docks at Honfleur.* 1906.
Oil on canvas.

24 *The Casino Jetty at Sainte-Adresse.* 1906.
Oil on canvas.

Opposite
25 *Street Decked out with Flags.* 1906.
Oil on canvas. Musée National d'Art
Moderne, Paris.

disproportionately enlarged flags, their broad and compact patches of colour lending a rhythm to this monumental composition like brilliant bugle calls.

From this point onwards, Dufy's work exhibits a tendency in common with the Fauves: rather than painting a favourite theme from life, he will be able to paint it in his studio, allowing his imagination to recreate it.

Old Houses on the Docks at Honfleur (1906) rise without any perspective across a plane parallel to the surface of the canvas. They are painted in vividly contrasting arbitrary colours, creating multiple reflections in the water and showing a more restrained lyricism.

The year 1907 saw a blossoming in Dufy's work. While his colour retained its expressive power, he clearly placed more emphasis on composition. *Jeanne in Flowers* reveals his desire to draw a decorative effect from the arrangement of pure colours, close to the style of Matisse, but doubtless also derives to a certain extent from the revived influence of Gauguin. The 1906 Salon d'Automne had just devoted a retrospective to Gauguin. The near abstraction of the foreground, with a vase of flowers standing out against it, highlights the background, whose planes are arranged in sonorous arabesques.

Abandoning all naturalistic description in *Terrace Overlooking the Beach*, Dufy recreates space with coloured surfaces which vibrate against one another in juxtaposition with bare patches of canvas. In this work Dufy shows a tendency to simplify his forms. Flattened, stripped of their outlines, they become signs verging on abstraction. The subsequent rapid maturing of Dufy's Fauve style is evident, from the beginning of 1907, by a desire for refinement and simplification, both in his composition and in his transposition of visible appearances. During the summer he returned to work in Normandy. Sainte-Adresse inspired him to paint the subject of *Anglers*. Dufy's style was becoming increasingly spare and synthetic. Superfluous details are suppressed in favour of a rigorous construction of the composition as a whole, based on a linear plan reduced to an interplay of horizontals and diagonals which make a vast abstract plastic space against which figures stand out in silhouette. The palette, too, becomes internalized, finding new resonances: a harmony of colour, limited to blues and yellows, sometimes meeting in a sea-green punctuated by the white patch of a sail, is warmed by a yellow or a red, flatly applied, next to the black tonality of the fishermen who lend a rhythm to the composition. This simplification and lack of ornamentation allow Dufy to give his

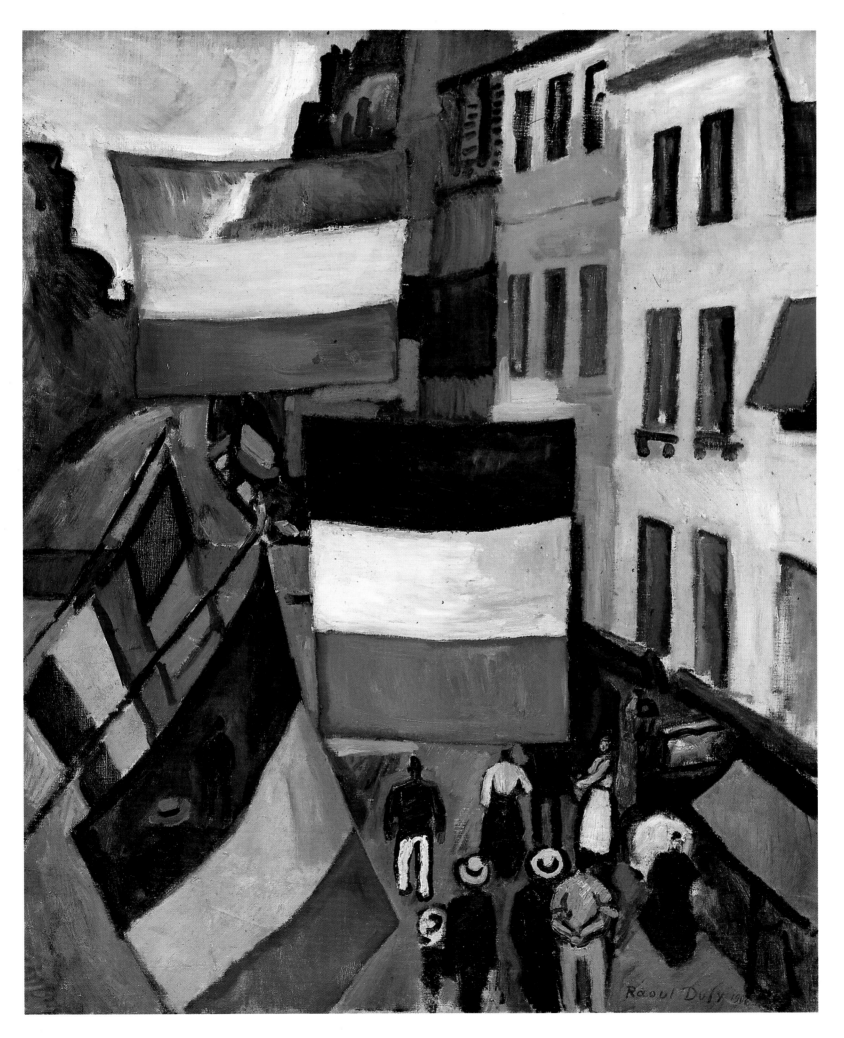

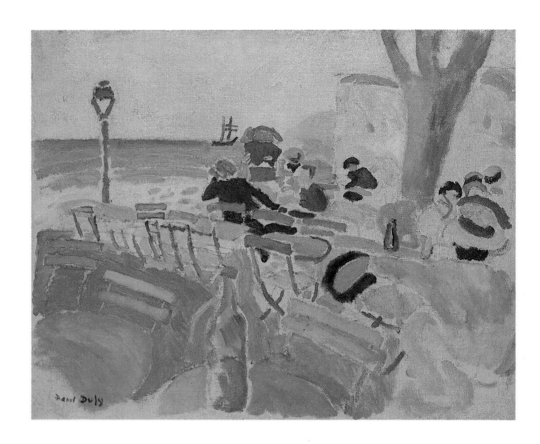

26 *Terrace Overlooking the Beach.* 1907.
Oil on canvas.

composition the greatest possible intensity. This desire to stress linear rhythm in
the construction of his composition is seen in the works painted in 1907: *The Winter
Garden*, in an intentionally heavy graphic style dominated by curves, and with a
muted tonality; and *Hall with Stained-Glass Windows*, structured in a geometry of
horizontals and verticals. It also appears in *View from the Terrace*, which is
constructed in a very similar way.[37]

In the autumn of 1907, in Marseilles and Martigues, Dufy painted a series of
works marked more by formal than by lyrical concerns. *Boats at Martigues* is one
illustration of this new direction. While he remained devoted to a sustained
chromaticism, he arranged his forms in a tiered perspective: the greatest emphasis
is placed on a rigorous geometrical style which defines the structures repeated
throughout the composition. A pivotal work, this painting reveals the influence of
Cézanne and anticipates the new direction in which Dufy's experiments were to
lead him at the beginning of 1908.

The Fauve stage was only a brief episode in Dufy's career, but he was to retain its
lesson of simplicity, the paring down of the subject. He was also never to lose the
taste for colour which it gave him.

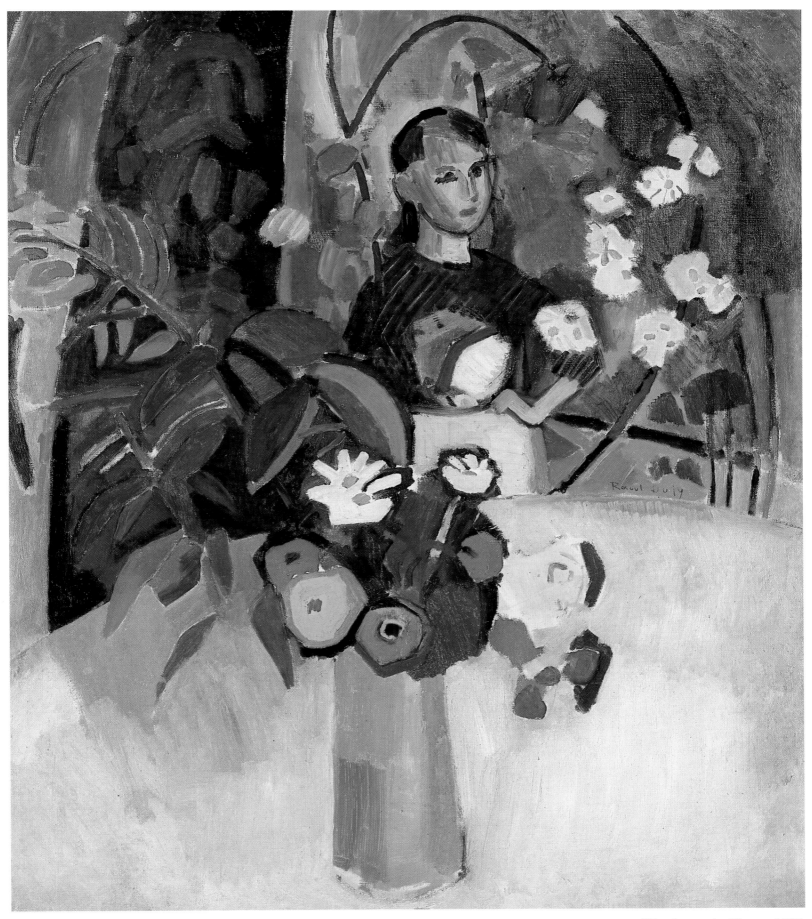

27 *Jeanne in Flowers.* 1907.
Oil on canvas.

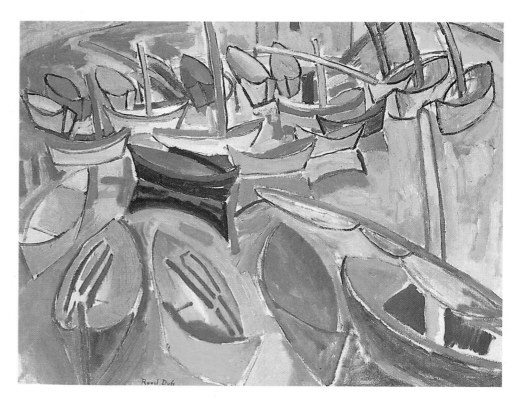

28 *Basket of Fruit.* Around 1910–12.
Oil on canvas.

29 *Boats at Martigues.* 1907.
Oil on canvas.

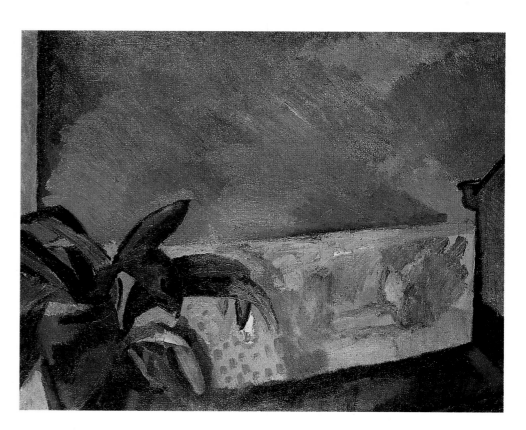

30 *View from the Terrace.* 1907.
Oil on canvas.

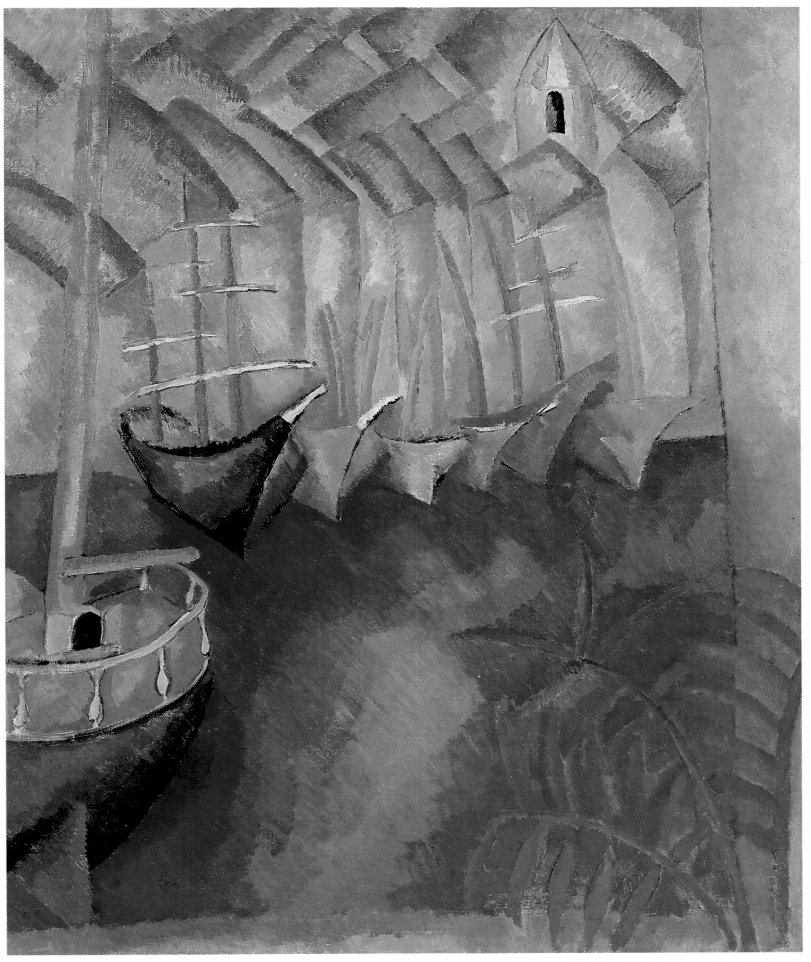

31 *Boats in the Quay at Marseilles.* 1908.
Oil on canvas.

The Cézanne Experiment (1909–1915)

After the double Cézanne retrospective at the 1907 Salon d'Automne and the Galerie Bernheim-Jeune, Dufy, influenced like many artists of his generation by this painter's innovative art, tried to find a solution to the problem of the visual representation of space, which had preoccupied Cézanne.

How does one convey the third dimension on a flat two-dimensional surface without resorting to illusionistic methods inherited from the Renaissance? 'This Euclidian perspective, taught in all academic institutions – is rigid,' Dufy declared, 'It is mathematical; it has no flexibility, it allows no modification. It takes the viewer's eye as its starting-point; and its lines converge towards a point on the horizon where they are lost in infinity, according to one combination alone. But even there everything is based on a purely physical observation. Might it not be interesting to return, in order to take it a step further, to the study of perspective as conditioned by the specific demands of the painting, which I would call the *moral perspective* in contrast with the other one?'[38]

What was Dufy able to learn from the teaching of Cézanne? What lesson could be drawn from it? After adhering to the Impressionist aesthetic, Cézanne had broken with it both in spirit and technique, as Dufy was to do in 1906; Cézanne's creative process was based on a desire to 'turn Impressionism into something solid and durable like museum art', and to devise a new elaboration of pictorial space. Having deliberately broken with traditional linear perspective, Cézanne substitu-

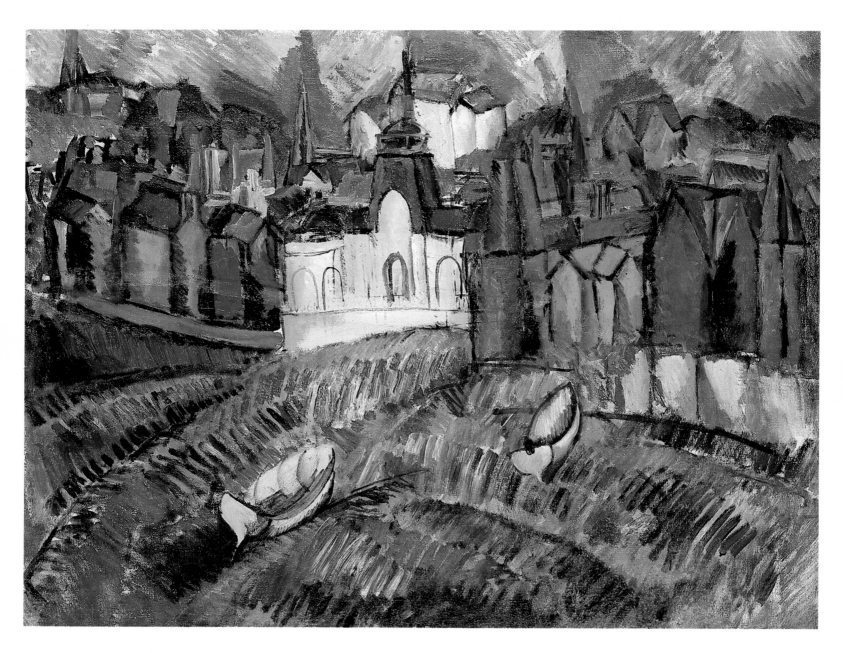

ted a tiered representation of forms which enabled him to convey space and the volumes occupying it in juxtaposed planes parallel to the surface of the painting.

With Braque, who was concerned with the same experiments, Dufy made a pilgrimage to l'Estaque, so dear to Cézanne.[39] Side by side, they painted very similar landscapes with a striking density, in which the feelings that the elements of the landscapes provoked in them were transfigured by a formal plastic analogy. For the time being Dufy abandoned the tonal elation of his Fauve period. He reduced the chromaticism of his works, limiting it to a restricted harmony of greens and ochres, in favour of a structured organization of space and a rigorous arrangement of simplified forms.

In the series of *Trees at l'Estaque*, we can see an architechtonic structuring of space in superimposed planes, framed by the tree trunks bowed into arches. The parallel diagonal brushstrokes give a dynamic balance to this fusion of geometrical forms. While Braque, like Picasso, was to take his experiments further, towards an almost hermetic analysis of forms — conveying their internal structure in an explosion of facets on the surface of the canvas, the source of the Cubist aesthetic — Dufy would go on to rediscover the spirit of the older painter's method, and intensify his experiments with the expressive possibilities of space that Cézanne's aesthetic offered to him.

What distinguished Dufy from Braque and Picasso during the same period was that Dufy preserved the familiar character of the forms he depicted, leaving them

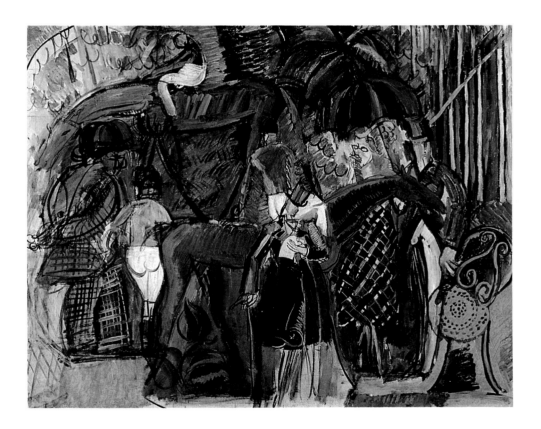

33 *The Paddock*. 1913.
Oil on canvas.

32 *The Casino Marie-Christine*. 1910.
Oil on canvas.

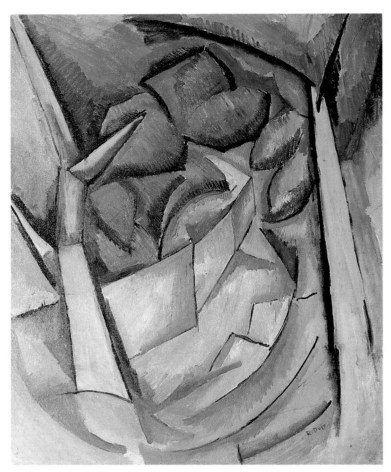

34 *Trees at l'Estaque.* 1908.
Oil on canvas.

36 *The Aperitif.* 1908.
Oil on canvas.

35 Georges Braque, *The Trees.* 1908.
Oil on canvas.

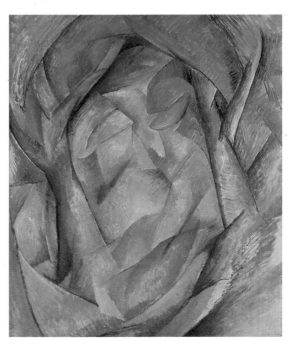

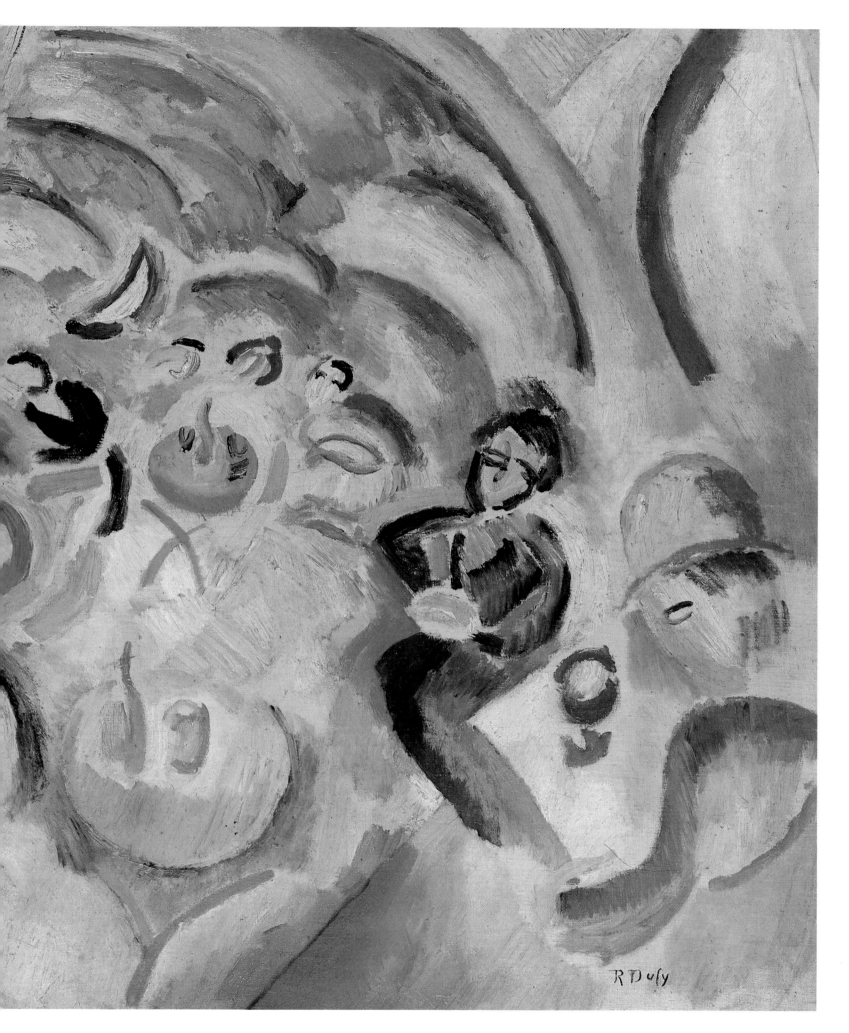

37 *Public Garden at Hyères.* 1913.
Drawing, crayon highlighted with gouache.

still identifiable. In *L'Apéritif*,[40] for example, the elements of the composition retain their meaning despite the juxtaposed rhythms that replace the coherence of anecdote; they are combined in a sort of whirlwind of arabesques on the verge of abstraction. Thus we can recognize trees, drinkers and tables.

Space is similarly defined in the works painted around 1908–10, in the South of France or Normandy. *Boats in the Quay at Marseilles, Landscapes at Vence* and *The Beach at Sainte-Adresse and Casino Marie-Christine*[41] show the same concentrated arrangement of motifs within a deliberately geometrical design; the dense composition, free of all perspective, avoids any variation in the colour of the sky. The horizon is raised and the juxtaposed planes of colour are arranged vertically. The 1913 *Paddock* draws on the same experiments in its stiff and compressed composition, its heavy construction and its chromaticism, which is reduced to severe tones.[42] *Public Garden at Hyères* (Musée Jules-Chéret, Nice, 1913), which was prepared in a large number of studies, shows a complete absence of perspectival effects, and a rendering of space based on vertical and diagonal lines of force: the siting of the two palm trees, the obelisk and the bandstand assert the autonomy of the pictorial plane on which they are assembled. During this constructive period, the still life, a theme which was dear to Cézanne and on which the Cubists placed a great deal of importance during the same period, inspired a large number of paintings by Dufy. They are spread out over the years between 1910 and 1914, distinguished by their muted tones, moving towards livelier tonalities. They all have the same frontal arrangement, inspired by Cézanne.

In accordance with Cézanne's idea that 'everything must happen on the surface of the canvas', Dufy arranges the various elements of his painting on a single vertical plane. We should note that they are actually arranged horizontally, moving from our eye towards the background. Examples of this include the *Still Life with Basket of Fruit*, and the *Still Life with Basket and Pheasant* (Paris, Musée National d'Art Moderne), whose composition is flat, and whose elements, including the fruit bowl seen from above[43] are set against the plane of the canvas, in a vertically tiered arrangement. The motif of the basket of fruit features in most of the still lifes, in which Dufy uses a style which relies heavily on curved lines.

For Dufy, the rendering of space is not restricted to the abolition of traditional perspective. Taking Cézanne's art a step further, he draws from it an idea of space broadened out into the 'spatial envelope'[44] of the objects shown: 'We have the tree, the bench, the house, but what interests me, the most difficult thing, is what surrounds these objects. How are we to hold everything together? Nobody has done

it like Cézanne: what lies between his apples is just as beautiful and significant as the apples themselves.'[45]

The Abandoned Garden, 1913, is an illustration of these ideas. Prepared in a large number of oil sketches, this painting reveals the importance that Dufy placed on the position of each of the elements in his paintings. Still using his constructive brushstroke based on long, thick parallel lines, which characterizes the landscapes of Vence and Sainte-Adresse, he gives his forms a solid structure and provides the composition with a set of interrelated rhythms which brings them all together in a 'dialogue'. At the centre of this spatial architecture there stands a cage with birds fluttering around in it: their arrangement suggests a circular rhythm which modifies the geometrical rigour of the lines.[46] Here we see Dufy's particular tendency not to respect the scale of the various elements of his paintings, as seen in the disproportionate size of the birds, hugely exaggerated in comparison with the other elements of the composition. This is probably due to the influence of the art of the French primitives who gave the various elements of the composition an importance related to their personal vision.

A comparison with *House and Garden at Le Havre* (Musée d'Art Moderne de la Ville de Paris, 1915) will enable us to follow the development of Dufy's style during this period. In this painting he provides us with a new interpretation of the house of his childhood. Faithful to Cézanne's sloping perspective, he shows us the fruit bowl from above. The forms are arranged vertically, but the composition is no longer so compact: Dufy opens it out with a pictorial allusion, and the light patch of the

38 *The Abandoned Garden*. 1913. Oil on canvas.

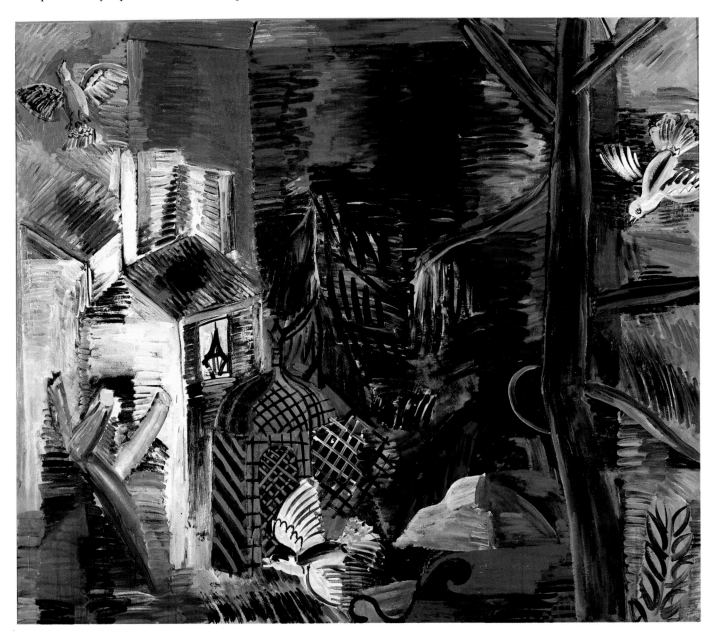

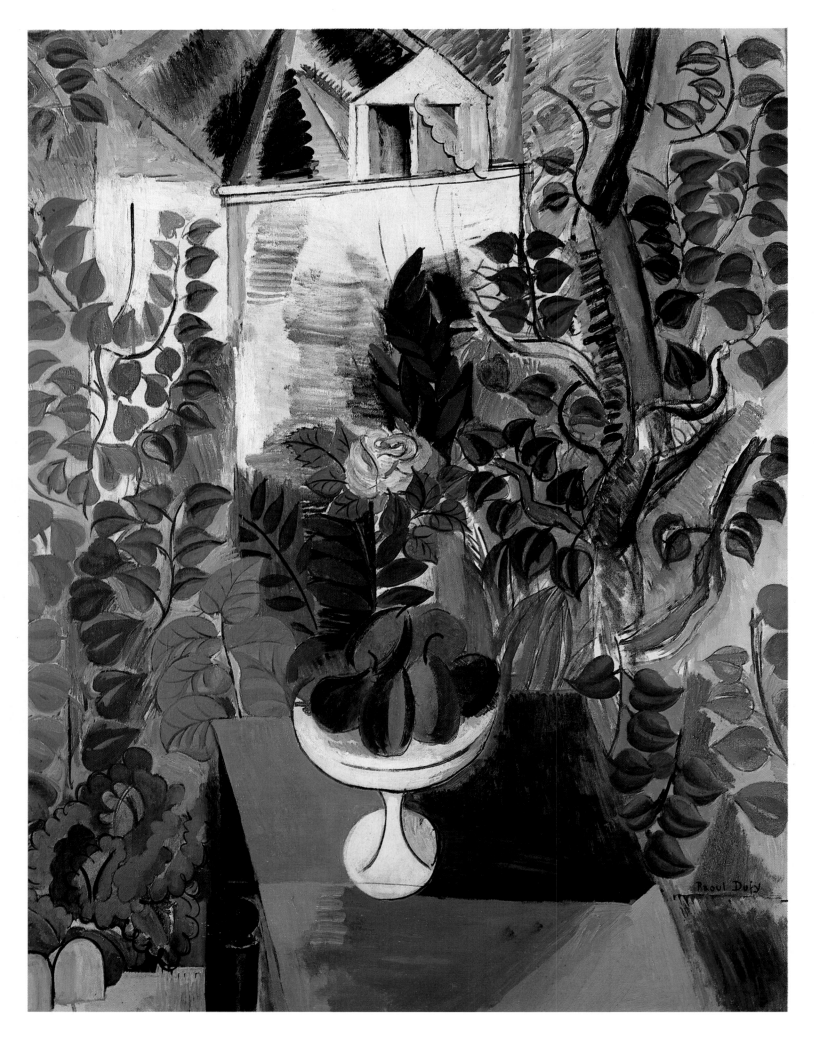

house emerges from the ensemble. The pattern made by the leaves and fruits and the curves of the fruit bowl is run through with the arabesques that will become a constant feature of Dufy's style. His line has become more supple, and the drawing and arrangement of the leaves gives his composition a less angular rhythm that is close to his decorative work of the same period. The rose emerging from the foliage provides a decorative motif which to some extent recalls the gouache designs made for Bianchini-Férier around the same time.

During this period of development a fundamental aspect of Dufy's art becomes apparent: the monumentality of the human figure. It occupies the larger part of the composition, as in the *Portrait of Madame Dufy*,[47] better known as *Woman in Pink*[48] of 1908.[49] The density of the figure derives from the lesson that he had learned from Cézanne, along with the mannerist distortion of the hands, which is exaggerated in the 1912 version. Two additional influences, inherited from the Fauve period, are brought together in this work: the influence of Gauguin in the decorative arabesques and the black outlines that surround the forms; and the influence of Van Gogh's self-portraits, in the comma-like strokes of colour that twist around in a circular rhythm.

More striking is the figure of the *Bather*, which first appears in Dufy's work at this time, and which reveals the influence of the aesthetic of Cézanne as well as that of medieval art and popular prints. During these formative years, Dufy did not restrict himself to any one aesthetic doctrine, whether that of an artistic trend or an

Opposite
39 *House and Garden at Le Havre*. 1915.
Oil on canvas.

41 *Woman in Pink*. 1908.
Oil on canvas.

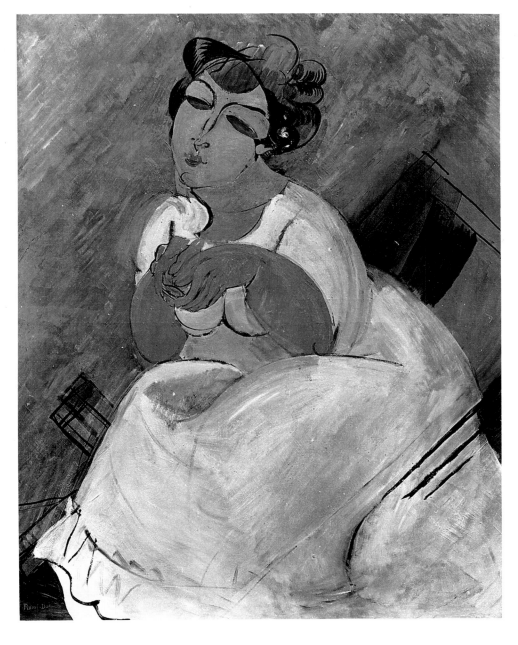

40 *Woman in Pink*. 1912.
Oil on canvas.

42 *Bather*. 1919.
Pen-and-ink drawing.

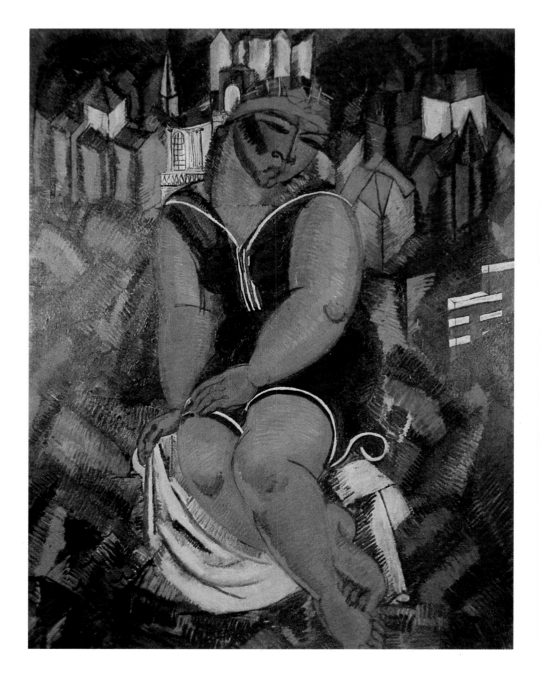

43 *The Large Bather*. 1914.
Oil on canvas.

Opposite
44 Study for *The Large Bather*. 1914.
Red pencil drawing.

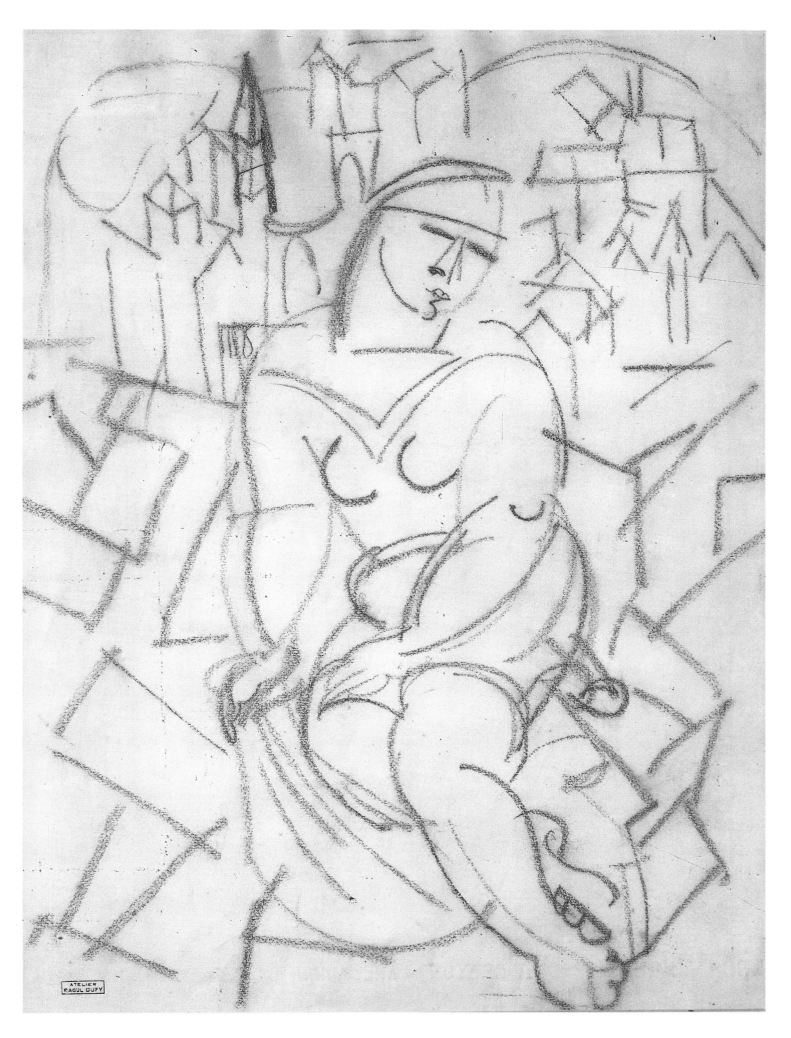

individual painter. He took from them only what he was able to use as a solution to whatever problem he had at the time. He remained open to any form of expression that was capable of enriching his experiments.

In his many different treatments of the subject, Dufy would give full expression to the Cézannesque theme of *Bathers*. This theme, particularly dear to the artist, was to be repeated in oil and watercolour, but also in engraving, ceramics and tapestry. *The Large Bather*, in the Roëlle-Jas collection in the Hague, which was painted in 1914 and prepared in studies from 1909 onwards, is the prototype of these works. A monumental figure, the bather is set in a seaside landscape, that of Dufy's childhood: the Bay of Sainte-Adresse. The figure hieratically dominates the composition, seated facing the viewer, legs folded, in an attitude of *contrapposto*. The expanse of the sea is painted in a sequence of coloured geometrical planes with intersecting peaks which bring the cliffs and buildings together in a vertical construction. The stylized treatment of the bather leads to a certain suppleness of form, a density free of any hint of stiffness. A number of influences come together here: the angular outline of the face with its slitted eyes is not unlike an African mask, while its monumental appearance evokes the figures of medieval stained-glass windows, those of the Cathedral at Evreux, from which the work derives its chromatic range of deep blues, yellows and reds.[50]

Dufy had visited the Cathedral with André Lhote during their stay in Orgeville, in the Villa Médicis Libre.[51] We should recall that at the same time Dufy was referring to popular prints in his experiments in the technique of wood engraving for the illustration of Apollinaire's *Bestiaire*, whose plates derive from medieval woodcuts. Here, the parallel hatchings used to convey the waves of the sea bear certain similarities with the wood engravings. Dufy alternated between the two techniques, allowing both to benefit reciprocally from his experiments. His studies for *The Large Bather*[52] are the source of this theme and reveal a concern with the landscape setting and the integration of the figure within it.

Another unpublished drawing in red pencil, which can be dated around 1913–14, shows the bather facing in the opposite direction.[53] Her face is schematized and a number of corrections are apparent in the contours of her arms and body. The composition is arranged around her in a geometrical outline of sea and cliffs. The background silhouette hints at the houses surrounding the Casino Marie-Christine, with the bay and its balustrade, painted in the canvases of 1910. Dufy made this drawing with a view to making a lithograph, hence its reversed direction. A copy of this lithograph features in many of the studio interiors, and its presence attests to Dufy's particular fondness for this *Bather at Sainte-Adresse* and all the works that followed on from it, such as *Three Bathers* (Musée National d'Art Moderne, Paris, 1919–20), contemporary with a sketchbook[54] whose date is confirmed by a reference to Mallarmé's *Madrigaux*, which Dufy also illustrated at this time. The sketchbook includes a study that is closely related to an unpublished drawing in pen and brown ink,[55] for a *Bather*, made on the back of a drawing for the *Madrigaux*, and which refers to the style of the *Three Bathers* in its softer contours and the painting of the waves in a series of arches.

Contemporary with *The Large Bather* in the Hague, distinctly bulky monumental figures make their appearance in Dufy's work, including the *Little Breton*,[56] the *Gardener*,[57] the *Neapolitan Fisherman*[58] and the *Fisherman*, all of which fill the surface of the canvas. They draw on the same combination of influences: Cézanne, stained-glass windows and popular prints. The theme of the fisherman, of which Dufy was very fond, forms the motif of one of his first wood engravings from 1910, *Fishing*, repeated in a fabric created by Bianchini-Férier. These works are characteristic examples of the influence of the practice of wood engraving on Dufy's oil painting. This, along with the influence of popular prints, is evident once more in the contrasts of large coloured planes, the stressed outlines of the figure and the painting of surfaces in long hatchings, which derives from the wood engravings that Dufy was making at around the same time.

The end of this phase of Dufy's work also includes the *Homages* to his favourite composers, including Mozart, 'his God'.[59] A testimony to his passion for music, this is the first time that this theme appears in Dufy's work, forming a prelude to all of his compositions on musical subjects. Dufy dedicated a number of paintings to the

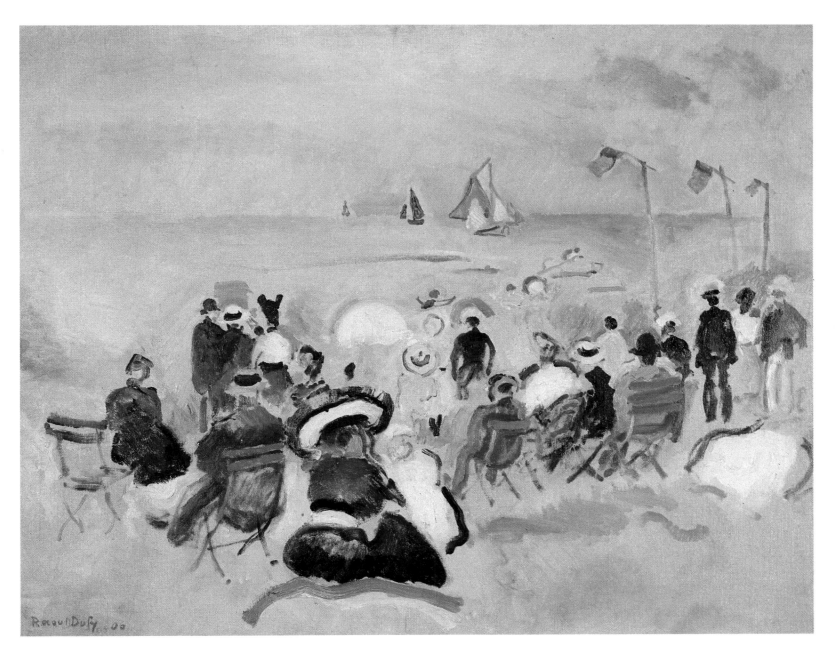

45 *The Beach*. 1906.
Oil on canvas.

46 Photograph of Raoul Dufy on the beach at
Le Havre.

master of Salzburg, structured around Mozart's house seen framed in a window, with a symphonic score in the foreground, or around a bust of the composer, next to a violin and a keyboard, as in the 1915 *Homage to Mozart*. This work illustrates Dufy's Cézanne phase at its peak. The superimposed forms, bringing together the score, the metronome, the roofs and the closed shutters, create a series of almost abstract geometrical planes. Their hatched construction is juxtaposed with large coloured surfaces which confirm Dufy's return to a more brilliant palette. Despite a degree of distortion, the component parts of the violin are in the correct place, and its rounded forms are easily recognizable; their baroque concave and convex curves provide a visual rhyme for the forms of the keyboard, and reveal Dufy's tendency towards decorative art.[60]

For almost six years Dufy's approach had displayed less of an actual conversion than an initiation into Cézanne's art, from which he retained the principles of structure, balance and clarity. His Cézanne-inspired 'para-Cubism',[61] based on a plastic organization of angular and geometrical forms using a constructive brushstroke, was coupled with an interest in other forms of artistic expression, suggestions of which engage in a dialogue which frees him from slavish devotion to a formula. His work was in a process of development. His angular style and severe chromaticism gradually made way for a softer style and a vivacity of tone more in keeping with his temperament. The decorative works which Dufy was making at the same time, in particular his gouache and watercolour fabric designs for Bianchini-Férier, were not unaffected by this development.

During this period of experiment and change, which was interspersed with journeys to Germany,[62] Dufy realized that he was working in a creative artistic context of which he was himself a part. Although his art lacked the revolutionary character of Cubism, he had a definite place in the Modernist tendency of the period, along with Derain, Matisse, Othon Friesz and Herbin. It was for this reason that Herwarth Walden, the founder of the avant-garde Berlin magazine and art gallery, Der Sturm, and organizer of group exhibitions of foreign movements, showed some of Dufy's Cézannesque works in 1912.[63]

Dufy's works were also well known in the United States. He sent two paintings to America[64] at the request of the organizers of the Armory Show, which opened in New York before moving to Chicago and Boston.[65]

Dufy did not work in isolation. He was aware of all the avant-garde artistic events during this period of change, and felt himself to be a part of them even if he had not yet found himself, even if there was still some experimenting to be done.

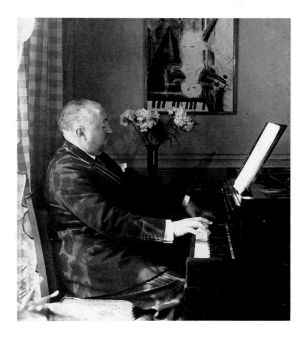

47 Photograph of Paul Poiret in May 1926. On the wall is Dufy's painting, *Homage to Mozart*.

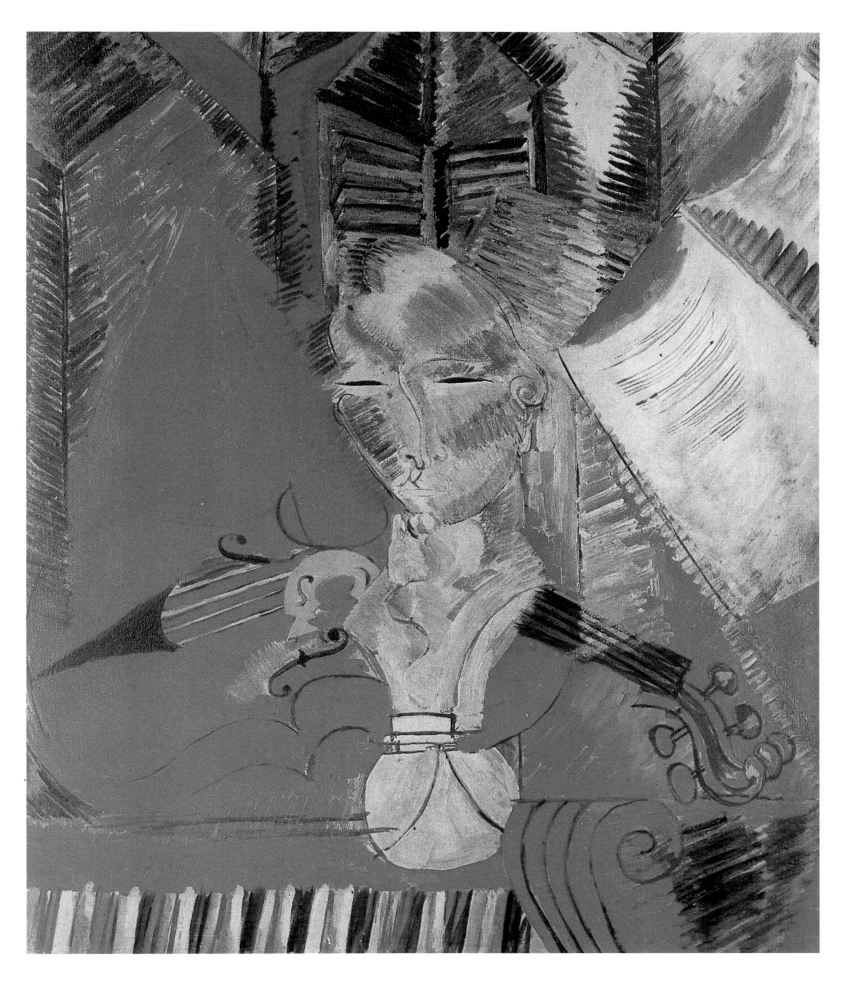

48 *Homage to Mozart.* 1915.
Oil on canvas.

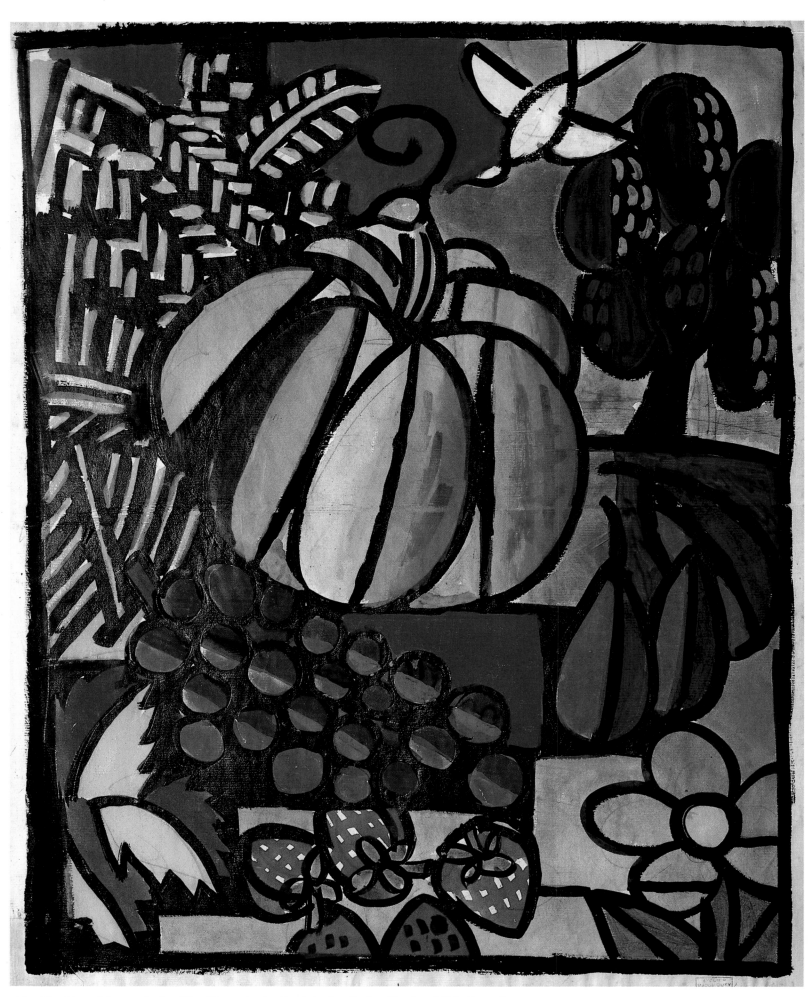

49 *The Pumpkin*, study for *The Mouse*, in *Le Bestiaire* by G. Apollinaire. 1910. Gouache.

II

THE WOOD ENGRAVINGS
LE BESTIAIRE OU CORTÈGE D'ORPHÉE
BY GUILLAUME APOLLINAIRE

50 *The Condor*. 1910–11. Wood engraving. Illustration
rejected from *Le Bestiaire* by G. Apollinaire.

From 1908, the Cézanne-influenced orientation of Dufy's painting began to cause him problems. He was dropped by his dealer, Blot. Berthe Weill, finding no more buyers for 'her' Dufy, tried in vain to bring him back to his Fauvist manner.[1] Dufy would not be discouraged. Resolutely committed to his chosen path, he experimented with new styles in the field of the applied arts.

This natural tendency towards decorative art found a guarantee, a kind of confirmation, in the work of Gauguin. Of all his elders and contemporaries, it was Gauguin to whom Dufy was closest in his attraction to the most diverse techniques and his rejection of any hierarchy among the visual arts. In 1906, when the Salon d'Automne held a retrospective exhibition of Gauguin's works, the artist's masterful primitive and decorative art came as a real revelation to Dufy. He now discovered Gauguin's astonishingly forceful and stylized wood sculptures, his wood engravings with their vigorous contrasts of black and white, and his ceramic pieces.

Dufy's own leanings towards decorative work were echoed in the movement for the rehabilitation of the decorative arts which had begun in Europe at the end of the nineteenth century, starting in France with the establishment of the Union Centrale des Arts Décoratifs in 1882. We should also mention the important part played by the dealer Siegfried Bing, whose galleries collected all manner of contemporary works in the field of decorative art from 1895 onwards. This trend in favour of the applied arts was also found in Belgium, in Brussels, where the Groupe des Vingt, founded in 1884, gave them pride of place in their exhibitions of 1892 and 1893. Similar ideas about the unity of art were developing in Britain, where they led, in 1888, to the creation of the Arts and Crafts Movement, which launched a far-reaching revival of the creation of art fabrics, furniture and craftwork under the aegis of William Morris.

This move towards the reinstatement of the decorative arts was also taking place in Munich, and would certainly have struck Dufy when he stayed there with Othon Friesz in 1909. He had been invited by Hans Purrmann, one of Matisse's first pupils

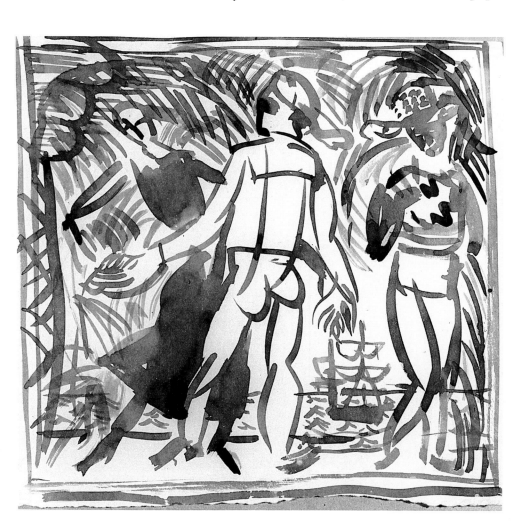

51 Study for *The Dance*. 1909.
Indian ink wash.

and the *massier* in his studio. It was a visit that greatly interested Dufy: it showed him the world of the Munich decorative arts, consecrated in the Bavarian capital in 1908 and revealed to the Paris public at the 1910 Salon d'Automne, along with the works of the artists of the Deutscher Werkbund, founded in 1907, whose ideas were to lead to the Bauhaus.

Well before this time, as he himself stated, Dufy had been occupied with decorative work: 'In 1907 I had engraved a few little vignettes for my friend Fernand Fleuret's *Friperies*; but at that time no publisher was willing to bear the modest costs of this little work, which would have to wait fifteen years before appearing in the *Nouvelle Revue française*.'[2] Moreover, Dufy stated that it was to the poet that he owed his work in the field of literary illustration: 'I have always had an instinctive liking for books, but it was the companionship and friendship of Fernand Fleuret that showed me the reasons for this love, and how important it could be in my work and for myself.'[3]

It is very likely that the first instance of Dufy's taking an interest in a decorative art based on a national tradition – the art of the medieval woodcut – was stimulated by his friendship with Fleuret.[4] In his poems, *Friperies*, Fleuret sought to bring to life the antiquated customs of seventeenth- and nineteenth-century France, and Dufy, respecting the spirit of the text, evoked them with a great deal of humour, lending these little vignettes an archaic charm that is not unattractive, and which is very close to the fanciful nature of the poems.[5]

For almost four years, from 1907 until 1911, Dufy practiced this technique which goes back to the Middle Ages. He revived an old tradition by making relief engravings on wood cut across the grain, with a penknife and gouge, showing, like the carvers of the fifteenth century, a concern with modelling and with creating the illusion of relief through the play of black-and-white contrasts. The woodcuts made during this period also reveal an interest in the popular print, the traditional extension of this medieval art, for which Dufy had shown a particular liking early on in his work.[6]

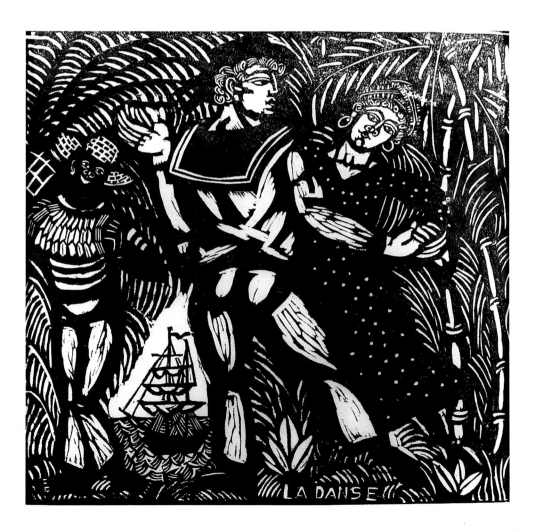

52 *The Dance*. 1910.
Wood engraving.

Dufy remained in Munich until the beginning of 1910. During his visit he had done little painting,[7] but he had been intrigued by his discovery of the woodcuts of the German Expressionist painters. On his return, he engraved four plates, unrelated to a text, which convey his fascination with the decorative resources offered by wood engraving.[8]

Before making these four engravings, Dufy produced a large number of preparatory studies.[9] They testify to the careful method of an artist who leaves nothing to chance, who is concerned only with bringing his experiment to a successful conclusion. Their treatment with an Indian ink wash reveals a free and dexterous execution that enabled the artist to set out the major lines of the composition, to arrange its structuring areas of light and shade and to fix the placing of the human figures and their settings.

In these small engravings,[10] Dufy sought to define space by means of a balanced distribution of intense blacks and luminous whites, at the same time using their carving to throw into relief the bodies and postures of the figures in *The Dance*, *Love*, *Fishing* and *Hunting*. These figures are set in a décor of vegetation which participates in the composition, and are integrated within it by a play of arabesques and concave curves. The austerity of the black and white of these engravings echoes the limited palette of Dufy's paintings from the same period. Also, according to the principle derived from Cézanne with which Dufy was experimenting at the same time, these works show the same frontal construction, in which the tiered forms abolish perspective. *The Dance* may be seen as an exception to this: in that engraving the space is opened up to reveal a fine sailing-ship. The vessel floats on a choppy sea whose waves are portrayed in a fish-scale pattern characteristic of Dufy's formal vocabulary of the period.

The rigour of black and white is tempered by the ornamental appearance of the vegetation. Dufy obtains this effect through the variety of his line, the interplay of rectilinear contrasts that he brings to it and the forms moulded in decorative arabesques. Thus in *Love* a constant dialogue is established between black hatchings on a white ground and white lines on a black ground.

In his simplification of forms and the clear opposition between areas of light and dark, free of shading, Dufy places himself in the tradition of Vallotton and shows an affinity with Munch. But although he may use the same technique and, in this case, a subject which Munch often treated, the theme of the couple, Dufy is very far removed from him in spirit. Unlike Munch, Dufy exalts the pleasure and plenitude of a couple devoted to the joys of love. His work, whether engraved, drawn or painted, would always reflect his characteristic *joie de vivre*, serenity and optimism.

Dufy's imagination is given free rein in his drawing of flowers and leaves: white-petalled daisies, tulips and white anemones with black-striped petals stand out against a black ground, as do the white leaves which frame this composition on each side. This graphic style was typical of Dufy's wood engravings when, some months later, he was commissioned by the couturier Paul Poiret to print fabrics at the Petite Usine. On a hanging made in that makeshift factory he was to reproduce the motif of *The Dance*. The wood engravings used for *The Dance*, *Fishing* and *Hunting* would be used to print fabrics in the Bianchini-Férier studios at Tournon.

For the next few months Dufy exercised his skill with penknife and gouge in his illustrations for Guillaume Apollinaire's *Le Bestiaire ou Cortège d'Orphée*. The poet had commissioned him after the project had been abandoned by Picasso.[11] Dufy worked on his woodcuts for almost a year, starting in the summer of 1910, the date of his stay in Orgeville, Normandy, in the Villa Médicis Libre.[12] There Dufy worked on his engravings during the autumn of 1910 and the beginning of the winter of 1911. He continued his work in Paris, in the studio room of a little student hostel in the Rue Linné,[13] and in Villepreux.

In collaboration with Apollinaire, who provided constant assistance and advice, Dufy conceived the architecture of the work. The engravings consist of twenty-six images within the text showing animals, all in a square format and taking up the majority of the space – two-thirds of the page compared to the quatrain beneath them, which they thus appear to illustrate – and four full-page inset plates devoted to the iconography of Orpheus, illustrating poems on the facing page, which punctuate the work as a whole.

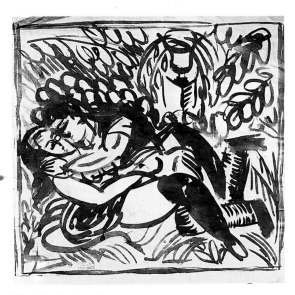

53 Study for *Love*. 1910.
Indian ink wash.

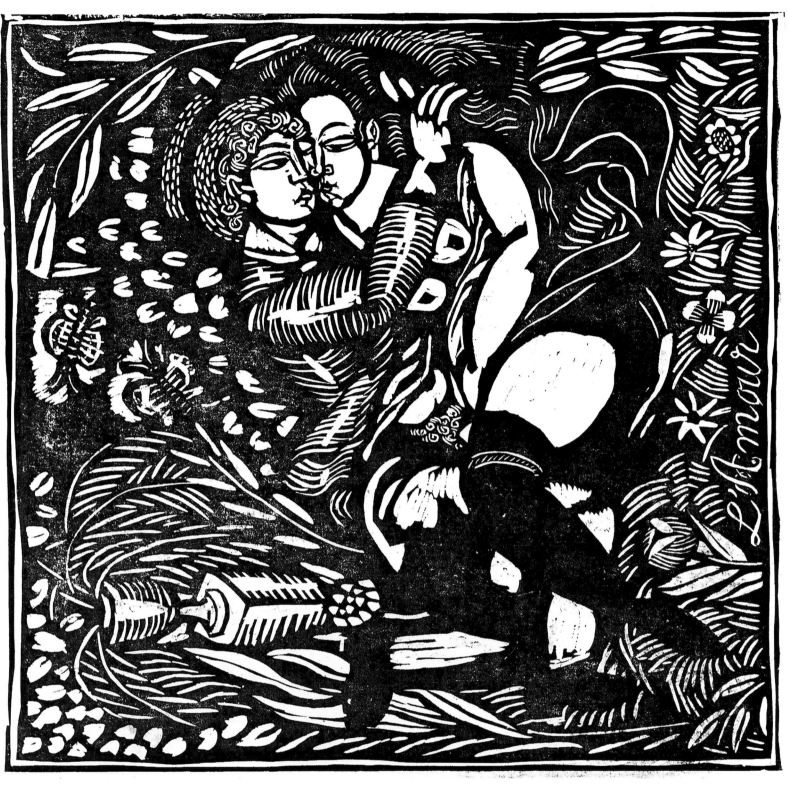

54 *Love.* 1910.
Wood engraving.

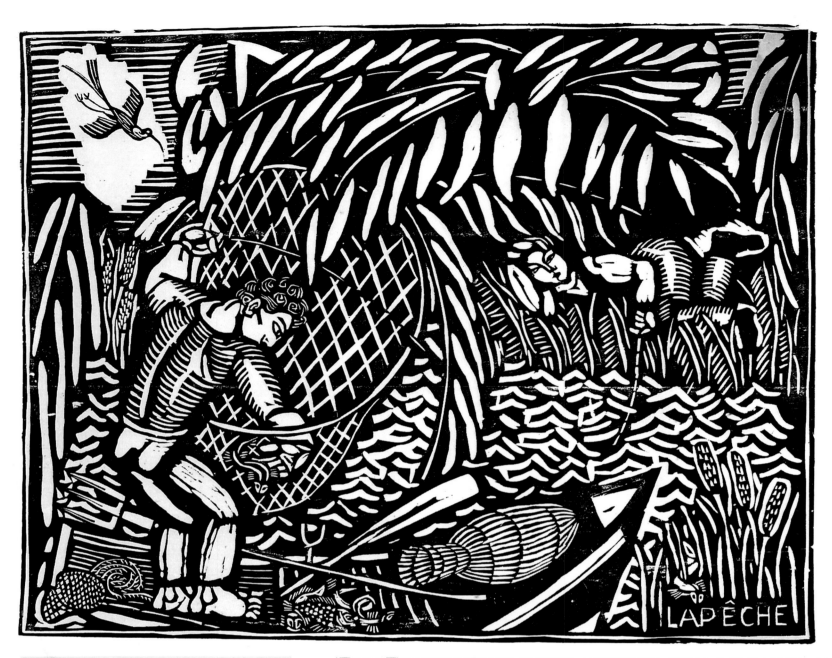

56 Study for *Hunting*. 1910.
Pen and Indian ink.

Top
55 *Fishing*. 1910.
Wood engraving.

57 *Hunting*. 1910.
Wood engraving.

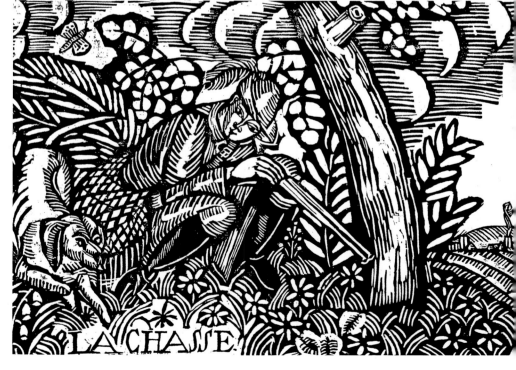

The painter and the poet worked together on the typography, Dufy's concern being to harmonize the intensity of his blacks with the black of the typographical characters. He thus restored wood engraving's true role in the decoration of the book, as part of a process of osmosis. Although they were printed in two separate operations, the text and illustrations give the illusion of having been engraved on the same block of wood, like fifteenth-century incunabula. The true source of the project lies in Apollinaire's wish to accompany his poems with illustrations engraved in wood,[14] according to the conception of the bestiaries or heraldic books of the Middle Ages and the Renaissance.[15] The typography, and to a certain extent the imagery, reveal this influence, along with that of picture books, popular volumes of natural history, calendars and chapbooks.[16] A perfect understanding united these two experts: 'The inspiration of this collection, very modern in feeling, is closely related to the works of the highest humanistic culture. The same spirit that inspired the poet fired the illustrator Raoul Dufy who is, as is well known, one of the most original and capable artistic reformers that France can currently boast.'[17]

In his account of the 1910 Salon des Indépendants, Apollinaire remarks upon the primitivism of the wood engravings shown by Dufy.[18] Fleuret stresses a certain archaism in these engravings while also emphasizing the painter's originality. Dufy transcends the traditional practices of the blackline method of wood engraving, and rejuvenates it with a process of hatching. While the illustrators of medieval woodcuts created shadings between pure white and black by the use of parallel or crossed strokes of varying degrees of fineness, Dufy adapts these hatchings to other purposes: his aim is to create light rather than to convey modelling and volume. As he himself explained: 'The hatchings must be arranged along the edges of the object, so that the object receives the light in its centre, and it is the construction, the balancing of all the luminous centres of all the objects, *expressed by volumes of white*, that gives the plate its balance and style. There must be only particular and independent sources of illumination, rather than a general light like that of Nature.'[19]

Dufy's woodcuts, a language of light, prefigure one of the essential aims that he pursued throughout his painted and decorative work: a constant explosion of light.

In his notes to the *Bestiaire* the poet praises 'the line that formed the images, the magnificent decorations of this poetic entertainment. Soon, we read in the *Pimandre*, darkness fell . . . and from it emerged an inarticulate cry that sounded like the voice of light.' Thus, 'the light conveyed by the opposition of light and dark masses finally captures the essence of things.'[20]

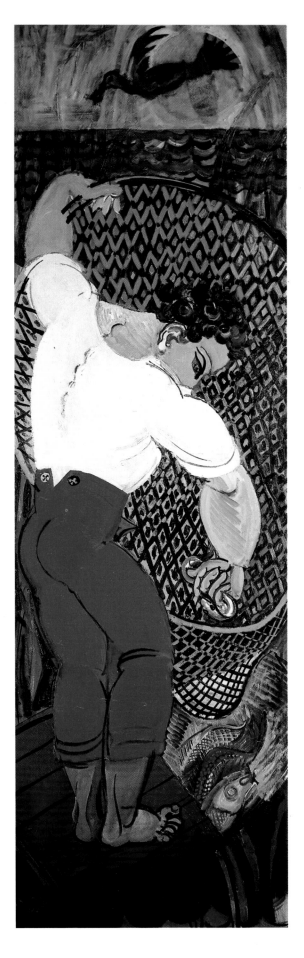

58 *Fishing*, or *The Fisherman with a Net*. 1914. Oil on canvas.

60 *Orpheus.* 1910.
Wood engraving for *Le Bestiaire* by
G. Apollinaire.

59 Study for *Orpheus.* 1910.
Crayon and black lead.

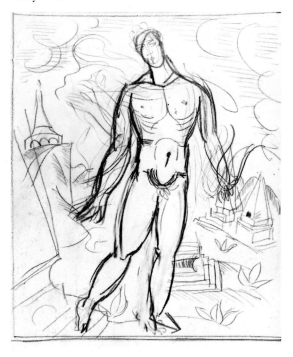

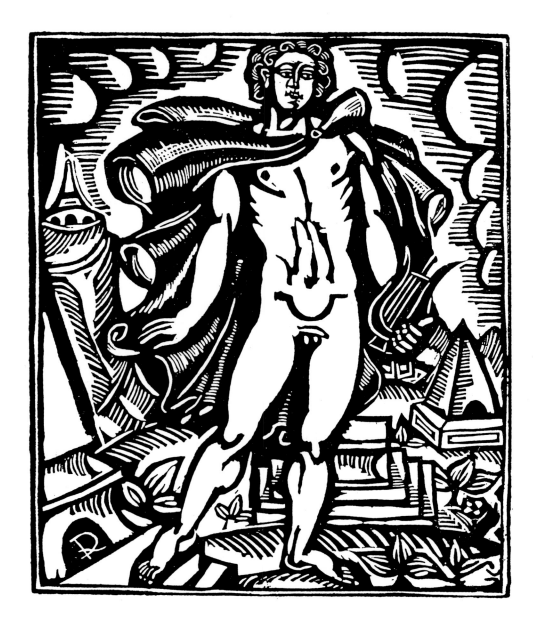

In his plates Dufy seeks that perfect unity of colour between black and white, aiming at a balanced and harmonious arrangement of contrasts. He gives white a specially important role to play: that of creating spaces of light intensified by deep black. 'He is aware of the power of solids and voids, of reserves of black and extended areas of light on which the eye can rest after being dazzled by the hatchings.'[21] Dufy particularly excels in the assurance with which he creates his effects from these oppositions. Thus light strikes the centre of the naked body of the figure at Orpheus' feet, the first inset plate of the *Bestiaire*, and the plasticity of this youthful body stands out strongly against the vigorously carved black mass, outlined in white, of the drapery clutched around his neck, its ample folds swollen by the wind.

We should note the stylistic similarities between the engravings of Orpheus and the painted works from the same period, in particular *Woman in Pink*, whose rounded volumes reveal Dufy's liking for curved lines and arabesques and anticipate his progressive detachment from the rigorous style of his Cézanne period and his movement towards an original style. Derain's wood engravings illustrating Guillaume Apollinaire's *L'Enchanteur pourrissant*, made a year before Dufy's compositions, are striking in their more obvious contrasts and synthetic planes. The primitive, stylized appearance of these figures evokes the characteristics of the African sculpture by which Derain was influenced at the time, while Dufy's woodcuts recall popular bestiaries.

58

It is also easy to note similarities between these woodcuts and the plates of the *Horapollo*, particularly the plate in which the stance of the naked *Good Man* recalls that of Orpheus balanced on his left leg, his right leg slightly to one side. Dufy was to repeat this posture for the figure of the *Horapollo* holding his lyre, and for the figure of the *Harlequin in the Venetian Manner*, both painted in 1939, when he was staying in Saint-Denis-sur-Sarthon, in the Orne region of France. These examples reveal the enriching contribution that Dufy's experiments in the field of decorative art made to his painted work.

The figure of Orpheus was to feature in one of the lithographs to Apollinaire's *Poète assassiné*[22] as well as on the belly of a ceramic vase made in collaboration with Artigas. Finally, the theme of Orpheus, accompanied by his cortège of animals from the *Bestiaire*, would be repeated in a cartoon painted in oil to be made into a tapestry by Mme Cuttoli, around 1939. In both cases, Dufy took a single theme and gave it new life by bringing to it what he had learned from his successive experiments in different techniques.

Likewise, the absence of any study of depth in the engravings must echo the lesson of Cézanne, with which Dufy was experimenting in oil at this time: the central figure is placed harmoniously in an ornamental setting which covers the entire surface of the plate. Dufy seeks to give each of his compositions a resolutely decorative character. Thus, the decorative elements combine, and sometimes mingle, with the main subject to form a homogeneous ensemble. Dufy's imagination is given play in his balance of contrasts of black and white. He varies his flora and the style in which they are carved: the black backgrounds form a counterpoint to the white contours and striations. He also uses an outline in which curvilinear arabesques are juxtaposed with a rectilinear graphic style. These infinite variations rid the compositions of any monotony, and create an astonishingly vital impression as, for example, in the plate illustrating the *Horse*, Pegasus – the symbol of the lyrical soaring of poetry which Apollinaire dreams of riding – with his wings spread, lit from behind and standing against a landscape of wooded hills and stylized vegetation running alongside a stream. Dufy has varied his construction in this piece: some of his lines are long and deep, others finer, carved in arabesques. He also makes the horse palpitate with life by scattering its robe with a host of luminous white dots.

Dufy returned to the iconography of Pegasus in one of his fabric compositions for Bianchini-Férier, as he did with *The Elephant* and *The Tortoise*.[23] From the latter engraving he would retain only the motif of the animal repeated at the four corners of the design, and not the whole of the plate, in which the highly balanced ornamentation of the surface is divided between animal and vegetable motifs: their arabesques and garlands answer the verticality of the strings of the lyre; the emphasis on the decorative is also apparent in the treatment of the figures in black, standing out against the white of the background.

The Tibetan Goat[24] was also used as a decorative theme for a printed fabric for Bianchini-Férier. Here, too, Dufy repeated his play between the antitheses of black and white: against the dominant black background, he emphasized the carved white parts of the animal's fur, the better to integrate it within the decorative framework. In the left-hand background there stands a pagoda, a reference to the animal's place of origin,[25] while its formal interpretation is created by the meaning of Apollinaire's poems, which give the animals some of the physical and moral characteristics of man.[26] Although their titles refer to the animal world, they are strangely free of its particularities,[27] and thus Dufy's plates include certain details referring to man. One exception to this is *The Peacock*, engraved according to precise instructions from Apollinaire.[28] In luminous cascades that evoke its plumage, Dufy shows the bird's 'dragging tail', majestically spread into a fan, against a black triangle extending towards the bird's graceful neck and head. He creates an eminently decorative effect from the contrast of this black, which assumes the role of a colour, with the white of the balustrade and the floral elements which frame the peacock on each side.

The allegorical poem about the *Mouse* is an excuse for showing fruits and flora from the four seasons in a vertically tiered composition: it is surmounted by two fine birds which appear in a large number of subsequent decorative works. In the

61 *The Tortoise.* 1910–11. Wood engraving for *Le Bestiaire* by G. Apollinaire.

62 *The Tortoise.* 1910–11. Wood engraving for *Le Bestiaire* by G. Apollinaire.

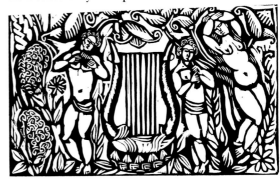

64 *The Mouse.* 1910–11.
Wood engraving for *Le Bestiaire* by
G. Apollinaire.

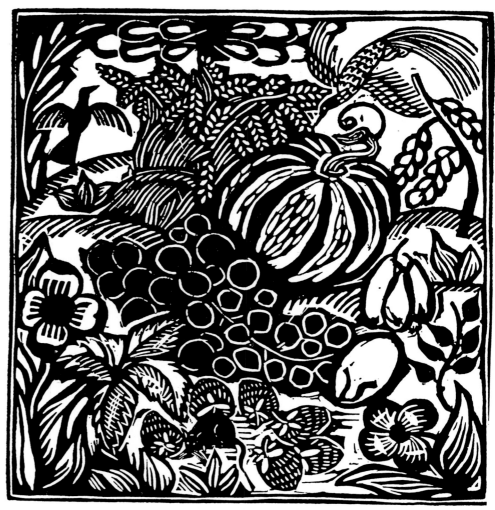

63 Study for *The Tibetan Goat.* 1910.
Black pencil.

65 *The Tibetan Goat.* 1910–11.
Wood engraving for *Le Bestiaire* by
G. Apollinaire.

66 *The Peacock.* 1910–11.
Wood engraving for *Le Bestiaire* by
G. Apollinaire.

67 *The Sirens.* 1910–11.
Wood engraving for *Le Bestiaire* by
G. Apollinaire.

midst of all this profusion it is difficult to spot the small rodent, hidden among the fruits in the foreground. This plate was preceded by a watercolour study in which the stylized decorative setting is structured by a series of broad lines, but from which the mouse is absent. However, in the woodcuts themselves Dufy shows a greater mastery of his material and his tools, obtaining from his oppositions of black and white an effect of colour which is superior to the chromatic harmonies of the watercolour.

The theme of sirens forms the subject of one of Dufy's most decorative illustrations: the parallel hatchings arranged around its edges distribute the light which converges on the dazzling torso of one of the sirens, a triumphant goddess, her wings firmly stretched, her face framed by long curvilinear curls. Apollinaire commented on Dufy's unusual interpretation of the *Sirens* when the sequence of plates of the *Bestiaire*, with the exception of *The Carp*, was exhibited at Druet's gallery at the end of December 1910.[29]

In each of his illustrations Dufy demonstrates an acute understanding of Apollinaire's text, to which he adapted his own work in a remarkable visual transposition. In these plates he reveals an inexhaustible imagination and creative inventiveness, aided by a series of experiments and studies in light, which he would never abandon. Thus, the preparatory studies carried out in 1909 for certain woodcuts,[30] either in the form of sketches or more complete works, tell us something about Dufy's creative process. He was keen to satisfy a discipline, an inner need to give his very best. We should not forget that because he was wary of a virtuosity that he had acquired very early, and which tended to lead him towards a systematic facility to which he did not wish to succumb, Dufy forced himself to work with his left hand: this was the hand with which he made his paintings and drawings. The plate of the *Snake*,[31] for example, passed through four different stages,[32] preceded by studies in black lead, before the creation of the definitive version, in which Dufy included the figures of Adam and Eve.

The engravings for the *Bestiaire* fully reveal Dufy's capacity for original creation. Placing himself in the tradition of the wood engravers of the past, he brought a highly ingenious style to the discipline, along with considerable mastery and a remarkable sense of his materials and tools. While satisfying his own liking for decorative art, he also provides a formal equivalent for the spirit of Apollinaire's quatrains. Dufy's collaboration with Apollinaire produced one of the masterpieces of twentieth-century graphic art, whose quality and importance went unnoticed by their contemporaries when it was published in March 1911.[33] However, one talented, intensely creative and innovative man in the field of decorative art understood the importance of these works and recognized Dufy's masterly and inventive qualities. Paul Poiret was to provide him with the means to exploit his decorative genius.

68 *The Snake*. 1910–11.
Wood engraving for *Le Bestiaire* by G. Apollinaire.

69 *The Snake.* 1910–11.
Wood engraving for *Le Bestiaire* by
G. Apollinaire.

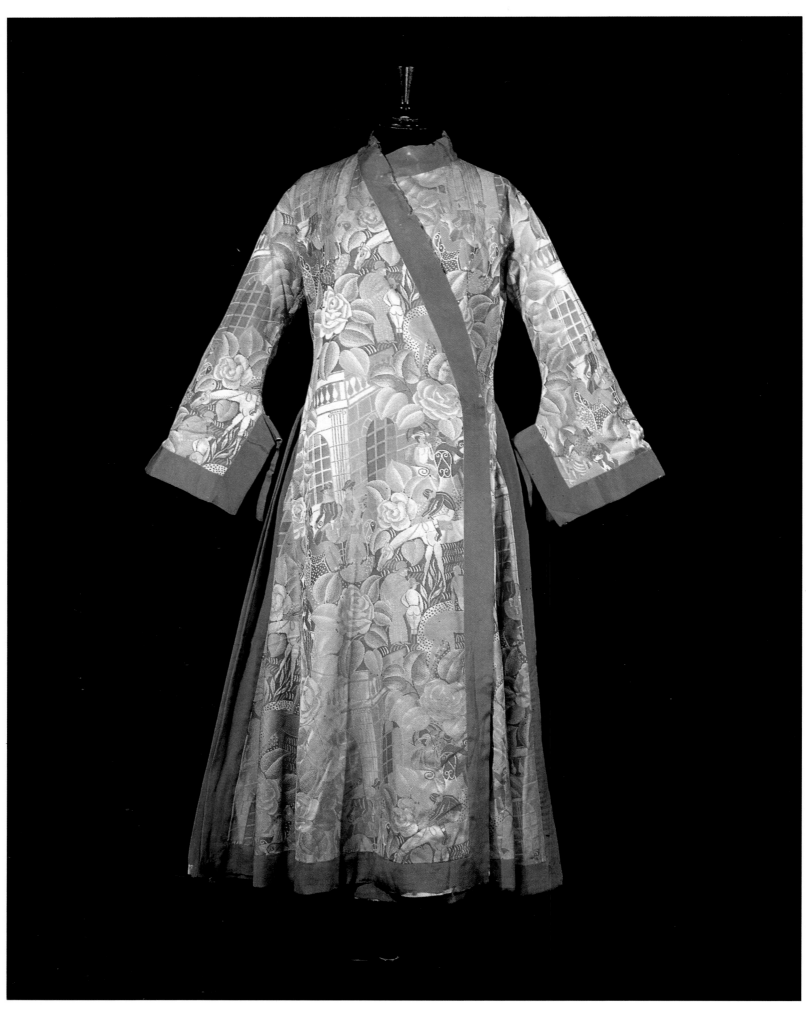

70 Dressing-gown by Paul Poiret, Bianchini-Férier fabric *Bagatelle*. 1923.

III

RAOUL DUFY AND FASHION

71 *The Skaters.* Around 1920.
Gouache for a Bianchini-Férier fabric.

72 Vignette for the headings of Paul Poiret's writing-paper. 1910.
Wood engraving.

73 Cravat, fabric made at the Petite Usine by
Raoul Dufy himself. 1910–11.

Work for Paul Poiret (1910–1925)

From their first meeting around 1909–10, Paul Poiret and Raoul Dufy formed a firm friendship, encouraged by their shared liking for decoration.

Himself an amateur painter, and a collector of primitive and modern art like his teacher, Jacques Doucet, Poiret particularly enjoyed the company and the talent of the artists whom he gathered round him: Derain, Vlamink, Fauconnet, Dunoyer de Segonzac, Camoin, Picabia and Raoul Dufy.[1]

He was immediately won over by Dufy's decorative imagination when he commissioned him to design the vignettes for the letterheads of his writing-paper. These illustrations, in which the typography plays an ornamental part, are charming evocations of Poiret's professional activities, arranged according to the days of the week. Their bright hand-painted colours stress Dufy's mastery of the technique of wood engraving and his sense of composition.[2]

At this time Poiret was the most established of the leading creators of twentieth-century fashion. His daring innovations had radically transformed the female silhouette. He had abandoned the corset for the brassière, freed the waist and brought in a fluid style of dress inspired by the French Directory and the Orient. In particular, he had replaced the subdued colours of the *fin de siècle* with brilliant hues: 'I brought beauty to muted shades.'[3] An ambassador of fashion, he imposed Parisian elegance on Europe and the United States. His triumphant tours to the capital cities of the world established his reputation.

Poiret returned from his journeys to Munich and Vienna filled with new ideas. Impressed by the creations of the Wiener Werkstätte studios,[4] he founded the École Martine, a school of decorative art which encouraged the spontaneous and 'primitive' flourishing of decorative inventiveness in girls aged between twelve and fourteen.

I set up the Martine school of decorative art, naming it after one of my daughters [. . .]. I recruited my pupils from working-class districts on the outskirts of the city, young girls of about twelve who no longer had to go to school. I set aside several rooms in my house for them and had them work from nature, without teachers [. . .]. These children, left to themselves [. . .] [rediscovered] all the spontaneity and freshness that lay within their nature.[5]

A short time after, Poiret set up the Maison Martine, which specialized in furniture, wallpapers and women's accessories inspired by the work of the pupils of the École Martine.

Poiret commissioned Dufy to design the invoices for the Maison Martine. He devised the layout and the typography. The heading, illustrated by a basket of flowers, is an engraving, for which the woodblock had been used in the decoration of

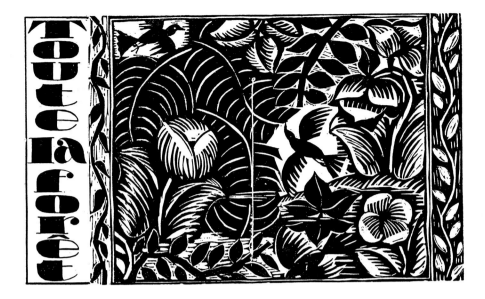

the band around the contents page of the *Friperies*. The stylized leaves and flowers with their decorative arabesques reappear in the border of the plates made later for the Petite Usine studio.

In the same year, 1911, Poiret became the first Paris couturier to launch a range of perfumes: with the opening of the boutique Rosine, he started a trend which the major fashion houses still follow today. He commissioned the artists in his immediate circle to make designs for the presentation of his products: Dufy made a wood engraving for the perfume 'Toute la Forêt', printed in the *Almanach des arts et des lettres*, 1917, published by the Maison Martine. Dufy was employed as art director, and made little vignettes as frontispiece engravings for each month of the year, illustrating the themes of work and the days of the week.

Poiret had a questing spirit and was eager for novelty and invention. Dufy's talent was already plain to him and he was keenly interested in Dufy's woodcuts. This is why, at the end of 1910, he suggested transposing the wood engraving technique on to fabrics: 'We dreamed of sumptuous curtains and dresses decorated in the taste of Botticelli. With no regret for personal sacrifice, I gave Dufy, who was just starting out in life, the means to realize some of his dreams.'[6] Dufy was delighted by this offer, not only because it provided him with a reliable source of income, but also because he was always open to any new means of enriching his art. It was typical of Dufy never to abandon one technique for another, and throughout his career he would always keep several activities going at once. At the same time as he was carrying out his experiments in the field of painting, studying the work of Cézanne, he was making the woodcuts for *Le Bestiaire* and doing his first work in fabrics.

A past master of the art of printing, because of his experiments with woodcuts, he threw himself enthusiastically into the adventure of textiles. Poiret and Dufy decided to set up a studio, the Petite Usine. It was established some weeks later with the capital of 2,500 francs advanced by Poiret, in a little shop at the end of a courtyard at 141, Boulevard de Clichy. Using second-hand material, Dufy set to work with the collaboration of Zifferlin, an Alsatian chemist who, according to Poiret, had an expert knowledge of colourants, aniline dyes, batik techniques and mordants. Having learned the various practical operations of printing, Dufy created some remarkable pieces. 'There the two of us were', Poiret wrote, 'Dufy and I, like Bouvard and Pécuchet, at the forefront of a new profession that would bring us new joys and new excitements.'[7]

Dufy took charge of all the manufacturing operations: 'He designed and engraved the woodcuts, planned the colours and either did the printing himself, or at least kept a close watch when it was being done.'[8] In this way he learned all the subtleties of a process that was to bring new life to the style of printing on fabric. At

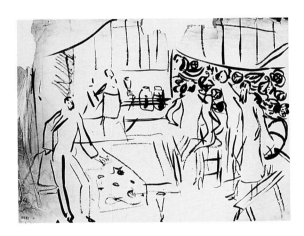

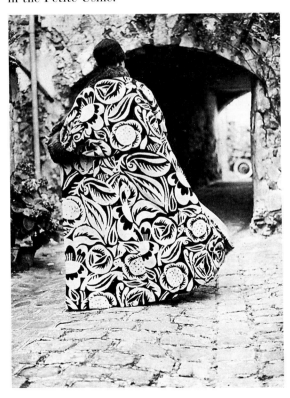

that time the patterns on silk, velvet or satin fabrics, when they were not woven into the material, were usually embroidered, appliquéd in relief, hand-painted or stencilled. Dufy used the material as the creative support for an original work.

The products of the Petite Usine, which was originally set up to make furniture decoration and later devoted to the manufacture of the fashion designs of the Maison Poiret, are clearly directly related to the woodcuts. The hangings, of which only one copy was made, combine the techniques of painting and printing. The central part of each was drawn in outline and painted in by hand, and only the leaves which appear in these works were, like the surrounding border, printed by the repeated application of a single block.

The characteristic features of Dufy's graphic style during this period are clearly visible in these works: a clear opposition of black and white which balances the composition and echoes the limited palette of the painter's early Cézanne period; a lack of proportion in the scale of the various elements, in particular that of the vegetation in relation to the model. However, the introduction of colour into

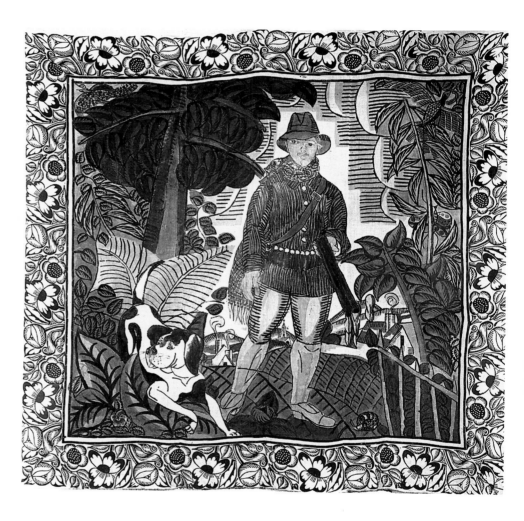

77 *Hunting*. 1910. Hanging.

certain of his creations increasingly led Dufy towards a less muted and severe chromaticism, one closer to his temperament, and towards a less angular and a softer style.

The Shepherdess, the first of these hangings, which Dufy made in 1910, is very small and bears only a single coloured border, instead of four borders printed in black.[9] His theme, close to that of popular prints, is very similar to certain pastoral motifs which were fashionable in factories in the provinces, such as those in Normandy, with which Dufy may have been familiar.

Inspired by popular art, the theme of the hangings are *The Dance, Autumn, Still Life with Fruit* and *Hunting*, themes to which Dufy would return in the Bianchini printing studios in Tournon, around 1919.[10] The floral decoration of their borders

68

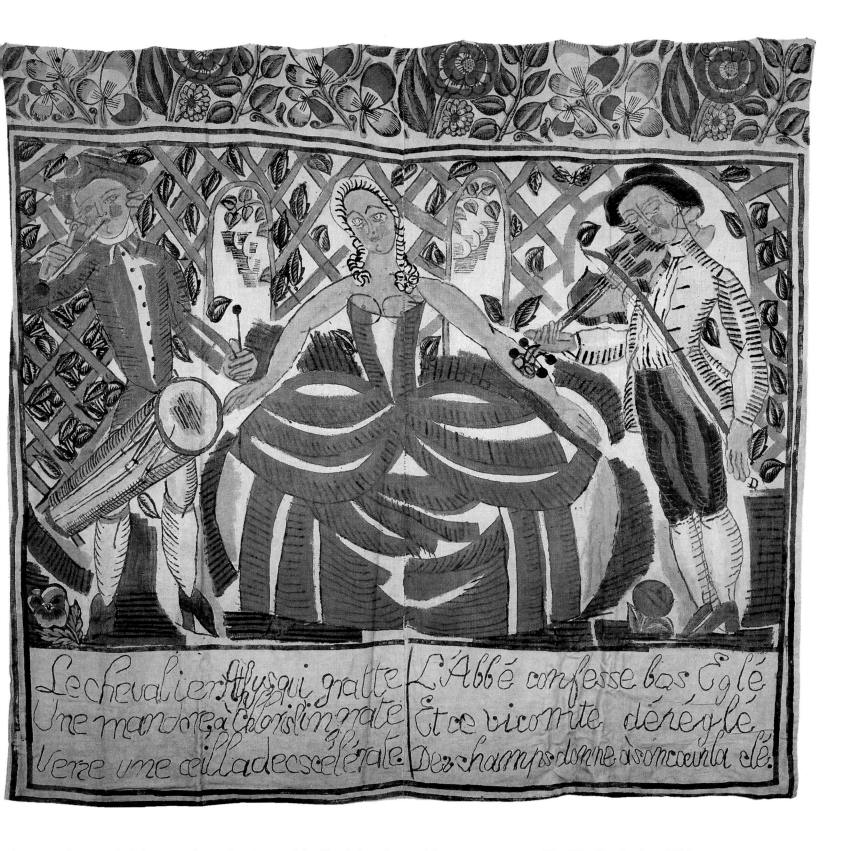

Le chevalier Athys qui gratte
Une mandore à Chloris ingrate
Verse une œillade scélérate

L'Abbé confesse bas Églé
Et ce vicomte déréglé
Des champs donne à son cœur la clé.

features the round pink peony from the plates of the *Bestiaire*, along with anemones and tulips mingled with stylized foliage.

Dufy also used these floral motifs in the manufacture of fabrics for Poiret's dresses and coats. The magnificent coat in printed velvet, *La Perse*, inspired by the Orient, is one of the finest examples of this. A 1923 photograph reveals that Poiret had no hesitation in using a fabric designed for clothing in his furnishings: the walls of the salons of his *maison de couture*, for example, were hung entirely with *La Perse* material.

The original productions of the Petite Usine made a great contribution to the success of Paul Poiret's creations. It would appear that Poiret was not the only couturier for whom Dufy worked. One of Dufy's unpublished letters, dated 15

78 *The Shepherdess.* 1910. Hanging.

December 1911, suggests that he provided designs for other fashion houses, in particular for Doeuillet, in the Place Vendôme.[11]

The Petite Usine ceased production at the end of 1911. With Poiret's agreement, Dufy accepted a proposition from Charles Bianchini, a major Lyons silk producer, who offered him the means to print his creations on fabric.

His brief collaboration with Poiret acted as a springboard for Dufy's career. Having entirely immersed himself in printing, he had mastered the various aspects of the technique: most importantly, he had tackled the problems of dyes, which his natural curiosity had led him to resolve by assimilating various chemical formulae. His work with Poiret was a crucial event in his career. It enabled him both to make a gradual break from the formal rigour of an aesthetic with a 'Cubist slant' and to rediscover his enthusiasm and natural imagination. It also introduced him to textile decoration – essential for the full development of his art – convincing him that he would find in it 'a logical application of his organization of colour'.

Dufy also contributed to the decoration of sumptuous parties, which earned the couturier the nickname 'Magnifique'. In 1911, for the invitation card to the feast of the 'Thousand and Second Night',[12] Dufy designed a polychromatic floral decoration of stylized foliage, inspired by Persian miniatures, illustrating a handwritten text by Dr Mardrus. He also made the enormous blue canopy designed to cover the courtyard of 107, Faubourg Saint-Honoré,[13] inscribed with Poiret's initials: on it he painted Poiret's portrait as a gilded, pot-bellied Buddha, surrounded by a garland of flowers similar to those on the invitation card and on the border of the satin handkerchief which Dufy had given to Mme Poiret as a token of his esteem.

Poiret, as the 'great organizer', subsequently arranged other parties at the Pavillon du Butard.[14] Dufy was given the opportunity to take part in their decoration: 'Dufy's spontaneous and eager genius took the green panels of the doors of my dining-room in the Pavillon du Butard and splashed them with flowers.'[15]

During the winter of 1912, 'The Festival of Kings under Louis XIV',[16] showing the Sun-King awakening, is captured in a set of unpublished sketches which give a witty account of the event.[17] Spontaneous and lively, they show an acute sense of observation.

A gouache including a *Homage to Mme Poiret* preserves the memory of the 'Festivals of Bacchus' organized in the summer of 1912.[18]

Even after their collaboration had come to an end, relations between Raoul Dufy and Poiret remained close and amicable. Dufy agreed to do secondary decorative work for Poiret, one example of which is the watercolour painted in 1920 for the programme and poster of the Théâtre de l'Oasis.[19] Another example is the panorama of eleven watercolour sketches published as plates by the *Gazette du bon ton* in 1920,[20] showing Paul Poiret's *Dresses for Summer 1920*, for which there is a highly sensitive preparatory drawing in black lead.

In 1925, the 'Exposition des Arts Décoratifs et Industriels' gave Raoul Dufy another opportunity to work with Paul Poiret.[21] At Poiret's request, Dufy made fourteen hangings designed to decorate the walls of *Orgues*, one of three barges moored along the Quai d'Orsay.[22]

These hangings, which measure some three by four metres (ten by thirteen feet), are all made up, according to the same principle, of three or four horizontal bands of different colours. Dufy worked on the bands separately; they were then sewn together and framed in a checkered border.[23]

With a great deal of imagination and ingenuity, Dufy created completely original works by developing a new process based on mordant colours.[24] In his printing on fabrics, Dufy applied his theory of '*couleur-lumière*', which he had conceived during his Fauve period. In an unpublished text, essential for the understanding of his work, Dufy gives us very precise indications of his thoughts on the subject:

This is how I was led to use my principle for my compositions made in mordant colours in the Bianchini dyeing works, for Paul Poiret: for a long time I had been planning to use these mordant colours on cotton to make large compositions which had the advantage that they could be folded like drapes and hung on the walls for parties. The problem we had to overcome consisted in transforming this nearly impossible method of creating designs, at that time on a background of solid colour, of flat, mounted or ornamented forms – but if I had done that I would have made a poster, and that wasn't what it was all about, I wanted to be *decorative, that is, pictorial*. So I made my background out of three strips, three widths of dyed cotton, each of a different colour selected so as to produce a suitable horizontal modulation. Over these, in mordant colours, I drew and then painted landscapes, human

82 *Dresses for Summer 1920* for the *Gazette du bon ton*. 1920. Pencil drawing.

83 *Dresses for Summer 1920* for the *Gazette du bon ton*. 1920. Gouache.

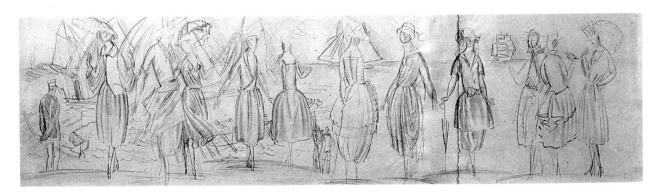

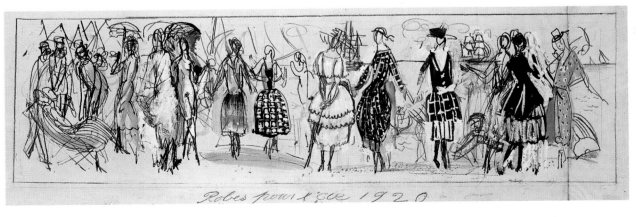

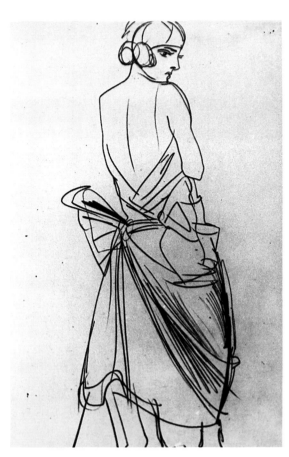

84 Detail study for the hanging, *The Reception at the Admiralty*. 1925.
Pen and brown ink.

figures, animals, objects and various other things, choosing that low side-lighting that divides forms vertically into areas of light and shade. All the forms in the right-hand part of the composition, with the colour on the right-hand side of the form, and the left-hand part of the object, facing the centre, were drawn only by a white or black line, occasionally with a part reflected. The left-hand part of the composition was treated the other way around. This vertical modulation of light and shade crossed with the broad horizontal modulation of the solid background thus united provided a sense of space, with my white and black perfectly conveying shadow and our left- and right-hand parts which bore the colour supplying the light – thus I became pictorial. The principle was in operation. I have often used this play of light and shade in my painting since then: but using the infinite resources of the brush, it looks neither mechanical nor artificial.[25]

What method did Dufy use when making these hangings?

For each strip, he made studies on white paper, which he transposed on to transparent paper, so that he could enlarge this drawing in a proportion decided beforehand, with the help of a lamp – a method which he would use in 1937 when painting *La Fée Électricité* – on tracing paper, following the outlines with an Indian ink wash. He superimposed the tracing paper over the pre-dyed band of cotton fabric, following the line with a dressmaker's tracing wheel which pricked holes in the tracing paper, to reproduce the design on the fabric by spreading chalk on it. Starting out from this initial design, Dufy worked with the maquettes and original drawings close by him. All of these hangings were prepared in sketches designed to site the human figures and the various elements in relation to one another. The preparatory studies were made in pen and brown ink and they confirm the close relationship between a drawing by Dufy and the finished work: 'My drawings [*dessins*] are also plans [*desseins*], none of them is done for its own sake, it is always a plan for a painted work.'[26] His drawings were made with a simple outline of great vitality, free of either hesitation or correction. His spontaneous, supple and vigorous line captures the attitudes and gestures of his figures; there is great authority in the way he sites the figures: 'It must be remembered that a line describes a movement more than a form – a silhouette is a movement, not a form.'[27]

The white outline in which Dufy encloses his forms, and which contrasts with the coloured background, is echoed in the technique of wood engraving; whether it is a matter of human figures, as in *Amphitrite*, '*Sea-Horses' and Boats* or the stylized flora of *The Aqueduct or Summer*. An interplay is established, a balance between the various techniques, mastered with a remarkable professional assurance and ease. Sometimes this white outline gives the human figures the appearance of being mere silhouettes, apparitions belonging to another world. This sense is present in the panels of *The Reception at the Admiralty* and *The Presentation of Models at Poiret's* (better known by the title *Bridge Game at the Casino*). He would portray these themes in his later compositions dealing with the same subject.[28]

In these panels, Dufy made no attempt to show perspective. In his *Entretiens* with Pierre Courthion he confirms that the three background bands do not represent the foreground, the distance and the sky. 'I can assure you that in my painting [. . .] there are only colours whose interrelations create space, and nothing more.'[29]

Dufy seldom uses traditional perspective. In *Poiret's Models at the Beach*, the depiction of the sailboats floating on the water shows that he is hardly concerned at all with the problem of the scale of motifs in terms of their proximity or distance. The same is true of the fish and the seagulls, which are disproportionately enlarged in relation to the human figures and the small boats, and of the boats and butterflies in the two panels on the theme of *Amphitrite*.

Dufy saw his hangings as complementing one another. Their iconography is based on his favourite themes, which he was also treating in his painting: allegorical images; scenes from contemporary life; landscapes, or a panoramic view of Paris.[30]

High society entertainments and festivities were the inspiration for *Baccara, The Reception at the Admiralty*, and *The Presentation of Models at Poiret's*.[31]

One writer, seeing Dufy as a descendant of the eighteenth-century painters, wrote that he had 'all the grace of Watteau or Fragonard. Like them he will have been the painter of a pampered, frivolous and useless society, the witness of an era in which life was nothing but a game.'[32] Unlike Daumier or certain contemporary

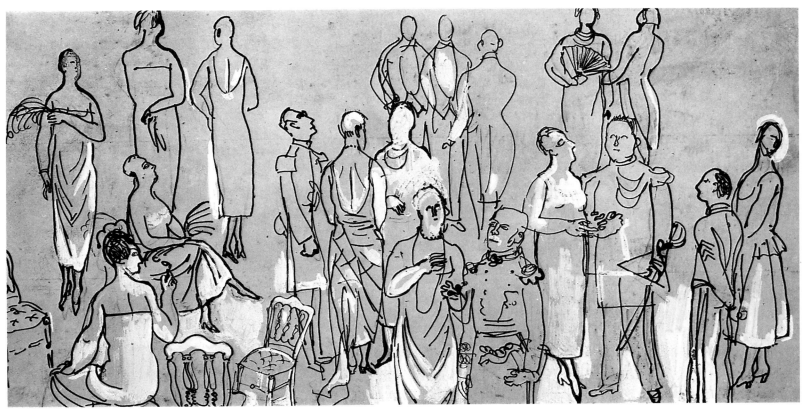

85 Ensemble study for the hanging, *The Reception at the Admiralty*. 1925.
Pen and gouache.

86 *The Reception at the Admiralty*. 1925.
Hanging.

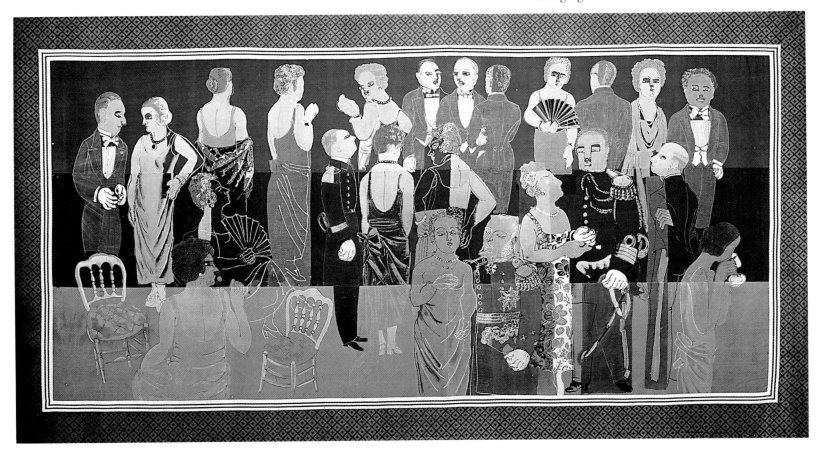

87 Detail study for the hanging, *The Presentation of Models at Poiret's*. 1925. Black lead.

Top
88 *The Presentation of Models at Poiret's*. 1925. Hanging.

89 *The Presentation of Models at Poiret's*. 1941. Gouache.

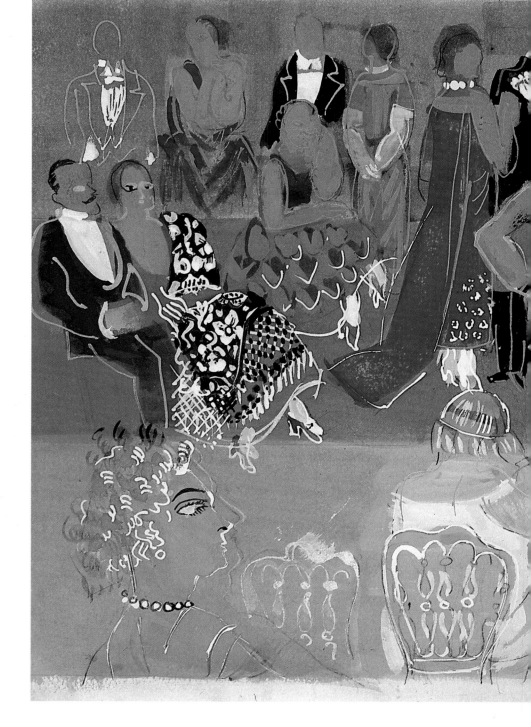

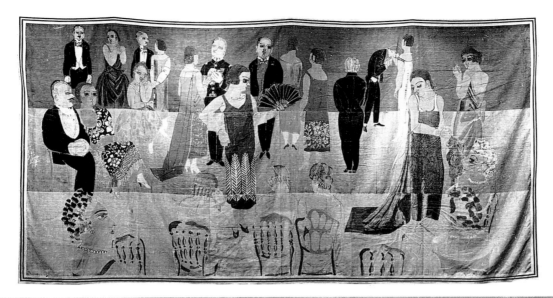

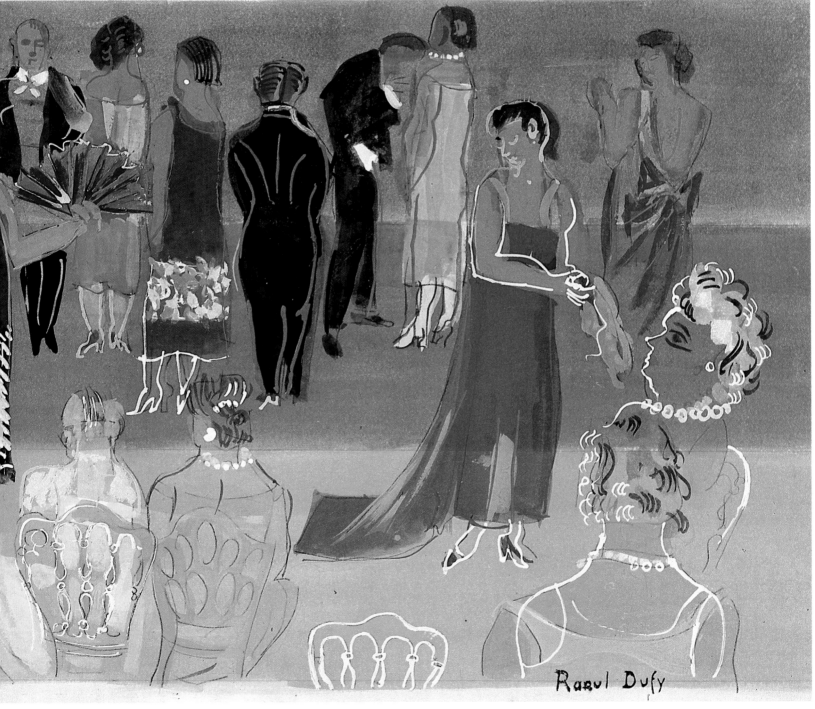

Raoul Dufy

painters, such as Rouault, whose works reflect existential anxiety and 'mankind in an aimless state', Dufy sang the praises of the happy and carefree moments of life. Gertrude Stein declared that 'Dufy is pleasure', and Christian Zervos wrote that 'everything in Dufy is in party dress.'[33]

But Dufy did not see painting as a palliative, and was pleased that Matisse had reconsidered this concept.[34] Although it is true that Dufy's work evokes the joy of life, he does not express this only by means of the images of the leisure of the society of his time, but more particularly in his treatment of it, a graphic style in which humour vies with imagination: 'He loves the nicely turned phrases that pour out the joy that enlarges the universe. Dufy is fashionable neither by training nor inclination,' adds Zervos, '[. . .] if he has depicted the parties and frivolous gatherings of fashionable society, it is because he finds a rich fund of visual material in them: something that will exercise his mind, which is acute and yet very indulgent, full of tenderness [. . .] [The figures] have a degree of irony that is just incisive enough to show up everything that is artificial in elegant social life, but they never go as far as satire.'[35] Dufy showed no hostility towards these people, and the irony with which he treated them remains superficial.

In these hangings, Dufy retains that style of construction in which objects and human figures each preserve their independence while at the same time being part of the ensemble of the composition through the rhythm that they are given by a graphic interplay of antitheses and visual rhymes.

The same visual vocabulary that Dufy used in his painting appears in these panels; thus, in *Poiret's Models at the Beach* or *Amphitrite, 'Sea-Horses' and Butterflies* the wavelets with their lacy foam are treated in a succession of arabesques united in a set of arches that echoes the scalloped outlines of the white clouds. In *The Beach* and *Amphitrite, 'Sea-Horses' and Boats*, Dufy conveys the glittering of the sea with a mass of circumflex accents.

91 *Baccara.*
Hanging.

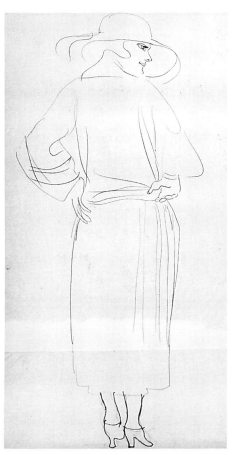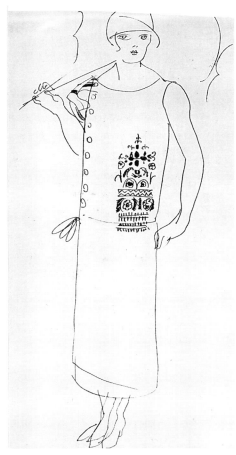

Opposite
90 Detail study for *Poiret's Models at the Beach.* 1925.
Black lead.

92 Study of a detail for the hanging, *Poiret's Models at the Races.* 1925.
Black lead and Indian ink.

93 Study of a detail for the hanging, *Poiret's Models at the Races.* 1925.
Black lead and Indian ink.

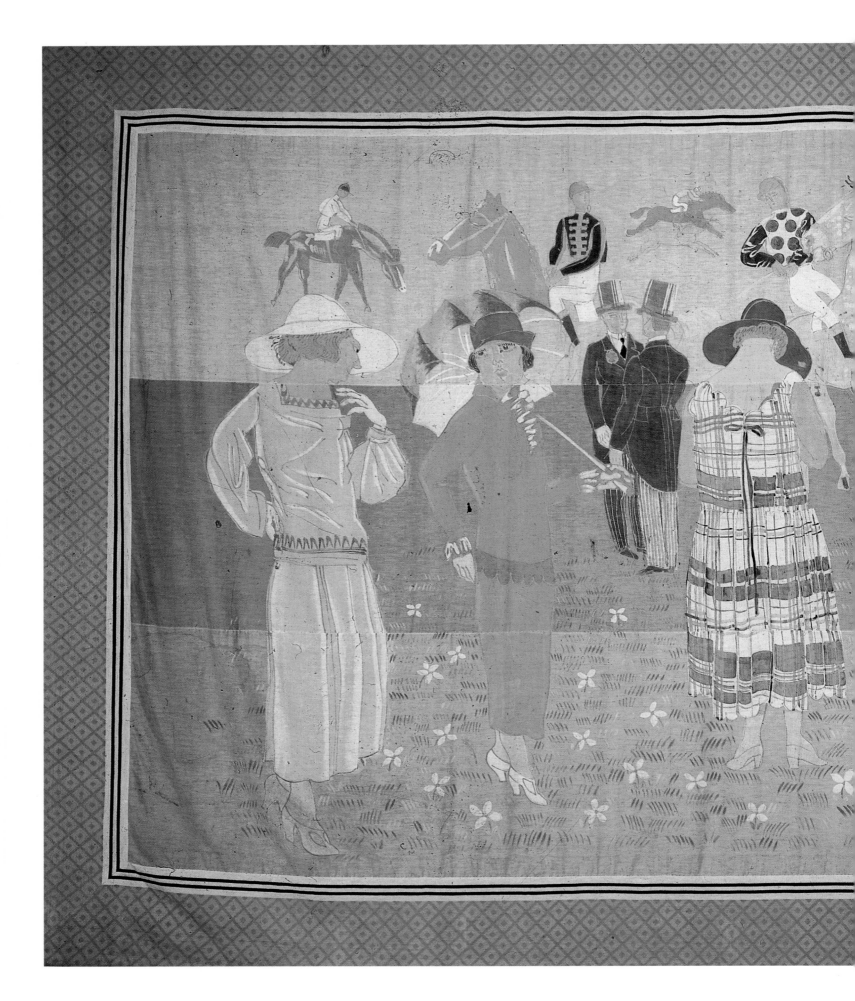

94 *Poiret's Models at the Races.* 1925.
Hanging.

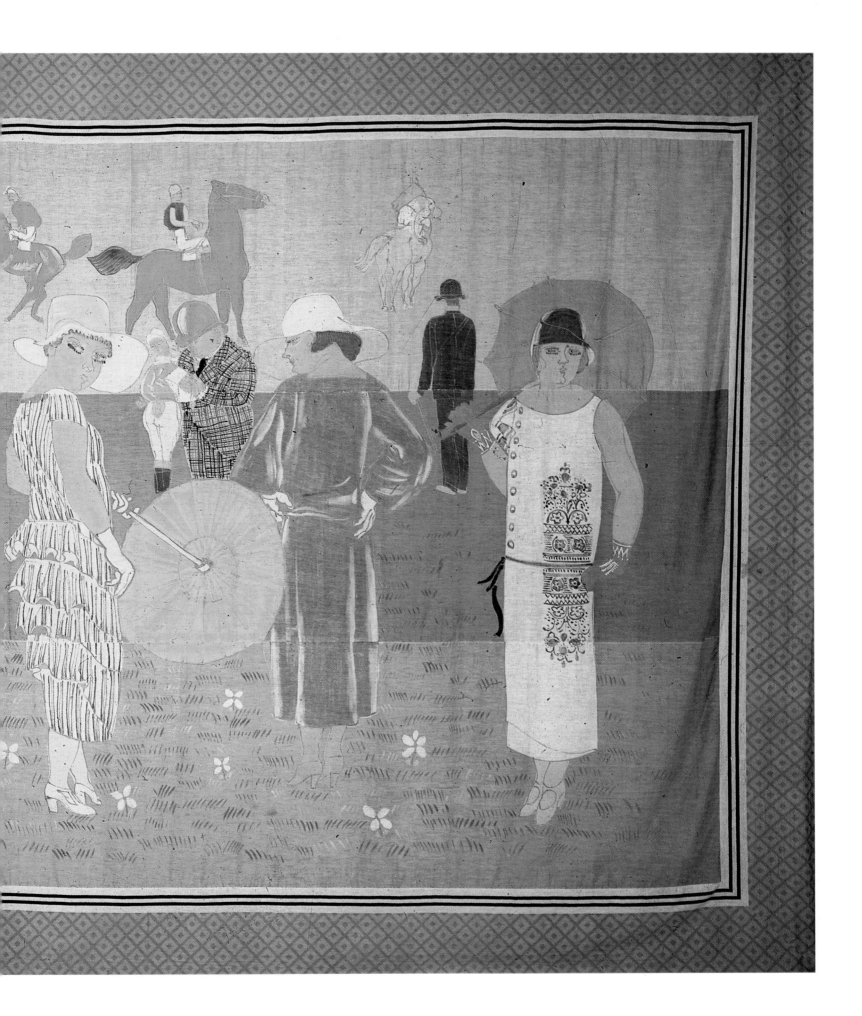

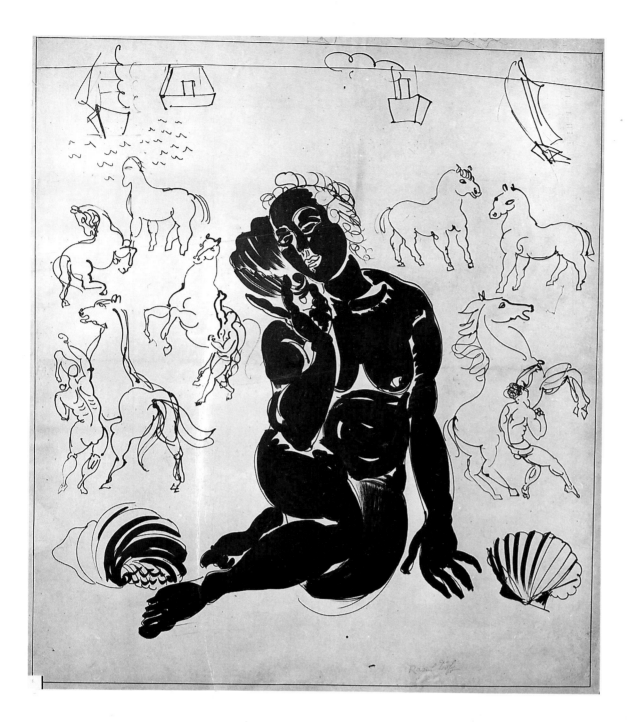

95 *Amphitrite*. 1925.
Wash.

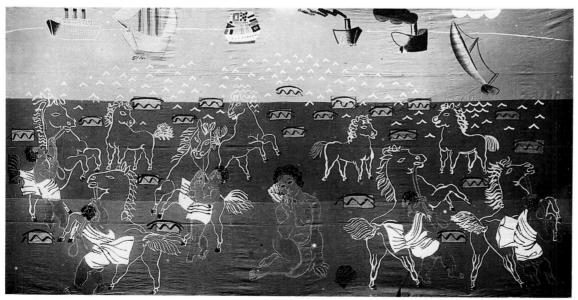

96 *Amphitrite*, 'Sea-Horses' and
Boats. 1925.
Hanging.

97 *Paddock*. 1925.
Indian ink.

98 *Paddock, The Owners' Enclosure.*
Around 1925–28.
Watercolour and gouache.

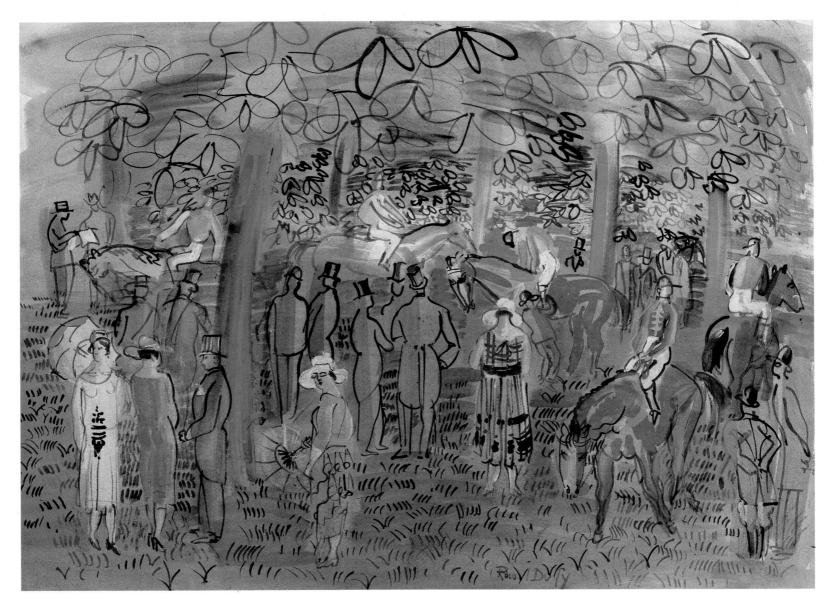

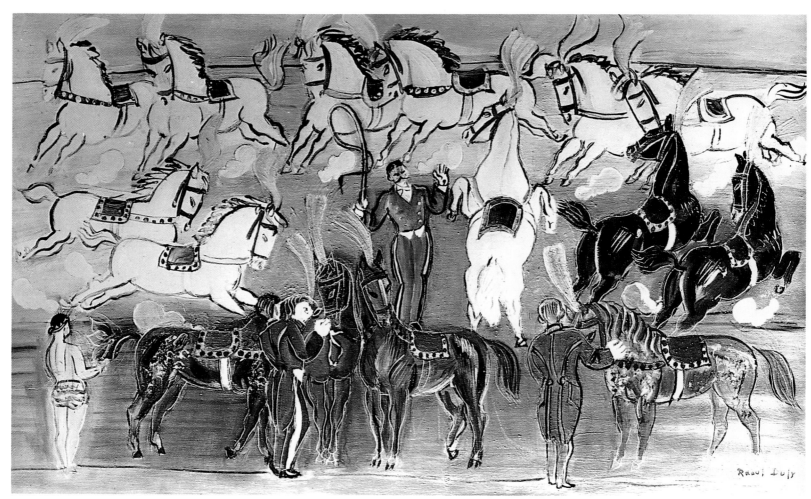

99 Preparatory study for the hanging, *The Circus*. 1925.
Oil on canvas.

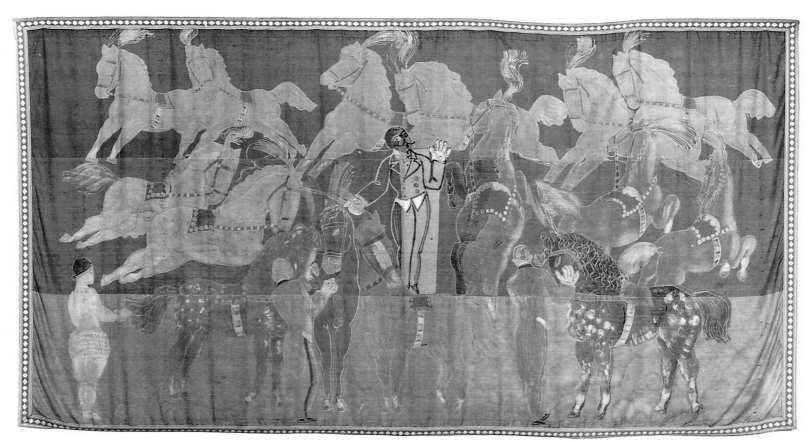

100 *The Circus*. 1925.
Hanging.

82

The theme of *Amphitrite* is accompanied here by the motif of the 'sea-horses', rearing up, their manes in the wind, reined in by boys in classical dress.[36] During the same period, Dufy made a watercolour on the same subject for Bianchini-Férier, which was later made into fabrics with various colour combinations.

His love of the sea and his attachment to the city of his birth led Dufy to choose a view of the Bay of Sainte-Adresse with the regattas as the subject of one of his hangings.

A frequent event in Le Havre, the regatta played an important part in the life of the people of the city. The sailboat race shown in this hanging is based on the one organized for the visit of the English flotilla. It provides Dufy with an excuse to portray the Seine estuary and the Bay of Sainte-Adresse with its cliffs stretching off to the north, encouraging daydreams and escapism.

The panoramic portrayal of Paris forms the subject of one of the hangings for Poiret's barge. One of the painter's favourite themes, Dufy would return to it in the four-part *Screen* for the Mobilier National: a frieze of blooming roses runs underneath its panoramic portrayal of the city. The city's monuments appear in cartoons for lounge-seat tapestries woven in Beauvais and dining-room chairs woven at Aubusson. The Musée National d'Art Moderne has two tapestries on this subject, woven in 1927 and 1934. In Dufy's painted work, Paris reappears in *Views from the Balcony* between 1924 and 1934.

Testimonies to a still undiminished curiosity, a desire for renewal and an interest in all kinds of technical and visual experiment, the hangings made for Paul Poiret are a prelude to the large mural decorations. When the hangings were completed, Dufy wrote a letter to Poiret, dated 24 March 1925, telling him of his astonishment at the sight of the finished work.[37]

However, Poiret's barges were barely visited during the Exposition, which explains the lack of success of Dufy's decorations at this time. Poiret went bankrupt and was forced to dispose of the hangings in 1931. The Parisian public were able to see them at the Galerie Bernheim-Jeune in 1927, when they were exhibited along with the artist's ceramics.

Work for Bianchini-Férier (1912–1928)

In March 1912, Raoul Dufy signed a contract with the company Atuyer, Bianchini et Férier which was then at the peak of its success.[38] This agreement offered him industrial opportunities which allowed him to continue his experiments in fabrics. The artist set about supplying the Lyons silk manufacturers with compositions that were either drawn or painted in gouache and watercolour, designed to be transposed on to prints on fabrics for furniture and clothing in their studios at Tournon in the Ardèche. Skilled collaborators freed Dufy from any technical concerns, so he was able to devote himself to his true object of study, colour. He did not look upon his work in fabrics as an expedient providing him with financial security. A painter first and foremost, he was to carry out his experiments in the field of printing with the same sensitivity, to the benefit of his pictorial work.

Dufy's projects were preceded by sketches, most of which are preserved in the Bianchini-Férier archives;[39] some of them required two or three studies for individual motifs or for the ensemble of the compositions, a testimony to the artist's professional conscientiousness: when he was unsatisfied with an initial 'sketch' or idea, he repeated his work until he reached the best solution.

'Flowers, which are naturally colourful',[40] were one of the essential elements in his experiments aimed at returning to the use of colour. Dufy remained faithful to a secular tradition deriving from the '*indiennes*', which themselves originated in the art of Islam and Persia, in which flowers are the predominant motif in the decoration of materials.[41] He depicts the rose, his favourite source of inspiration, in constantly new ways. The spherical, schematic rose of the Petite Usine period, which he was still using around 1912, is replaced by a more open and natural bloom. Shown individually, gathered in bunches or strewn across the fabric, it is arranged as a repetitive motif, in quincunxes, horizontal bands or *semis*. He creates an attractive effect from the ensemble of its open corollas, its vertical leaves and the scalloped pattern of its petals. Colette described the pattern in these terms: 'How

peremptory it is, this patch, big and red as a heart, which has flowed, until it practically covers it, over the first sheet of our flower-pressing book. A patch? Would you not do as I did? Just with a finger I had tenderly violated the curve, like an aroused breast, with its throbbing vein, its voluptuous cleft [. . .]. Acknowledge her, here she is, Dufy's Rose.'[42]

His love of pure tones and the arabesques of his Fauve period allowed Dufy to make a valuable contribution to the ornamental art of fabric design; the effort that he put into this work was to have an obvious effect on the development of his painting, satisfying the taste for colour innate in his *joie de vivre*, his 'pleasure in painting'.

Apart from the rose, a large variety of floral species appears in his decorations: the lily and majestic arums, convulvulus and amaryllis, asters and althaeas, the bouquets of wildflowers made up of poppies, cornflowers and daisies. Dufy portrayed them with great tenderness: they are depicted with characteristic detail, and given a highly poetic interpretation. Their simplicity brings together the freshness and brilliance of the colours with the blooming forms. Painted in bright and harmonious colours, they create an effect of radiance. While their arrangement is highly considered, it still derives a spontaneous appearance from Dufy's natural vivacity and imagination. Sometimes painted in black and white, the flowers and leaves acquire a remarkable density of expression equal to the most brilliant colorations, and a balanced construction. The vigorous line of the woodblocks, in which these contrasts first appeared, is now replaced by a soft, ornamental outline of arabesques. The structured pattern surrounding the coloured forms softens

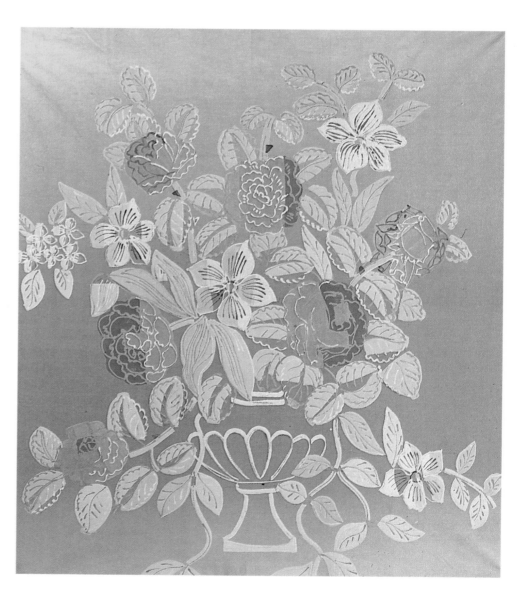

101 *Amours, Délices et Orgues.* 1925.
Bianchini-Férier cotton fabric.

around 1919–20; it was at this time that Dufy allowed himself a greater degree of freedom in his application of colour, letting it spill over the outline of the form. This principle is applied in Dufy's paintings of the same period, as we shall see below. Having become independent, the patch of colour spreads out, stressed by the fluid arabesque of the brush: lighter, more airy, the flowers seem to move in space and invite us to breathe in their scent. During this final period which lasted until 1928, the integration of gold and silver, along with the play of the black ground, gives these flowers their sumptuousness.

The ornamental design of the Kashmiri palmette, of Indian inspiration, makes its contribution to a number of his decorations. This borrowing from oriental imagery reveals Dufy's liking for a certain exoticism, as demonstrated in the choice of animal motifs: the Asian elephant, the tiger, the panther, the bird of paradise, the multicoloured butterfly. Particularly significant is his borrowing of the elephant, directly related to the wood engraving for the *Bestiaire*, designed to illustrate the original poster of the 'Exposition Orientale' in 1925.[43]

A recent exhibition in Strasbourg stressed the crucial effect of oriental art on the painters of the early twentieth century. Even Matisse was influenced by it. In Paris, the collections of decorative oriental objects, fabrics, pottery and ceramics at the Musée Guimet and the Musée Cernuschi constituted a repertoire of forms which was drawn on by a large number of artists. At the end of the nineteenth century, an *Encyclopédie des arts décoratifs de l'Orient* had been published for the use of Art Nouveau designers and manufacturers. The chapter on Persian ornaments had inspired Dufy and the organizers of Poiret's 'Thousand and Second Night' in 1911.

102 *Thirty, or La Vie en Rose*. 1931. Oil on canvas.

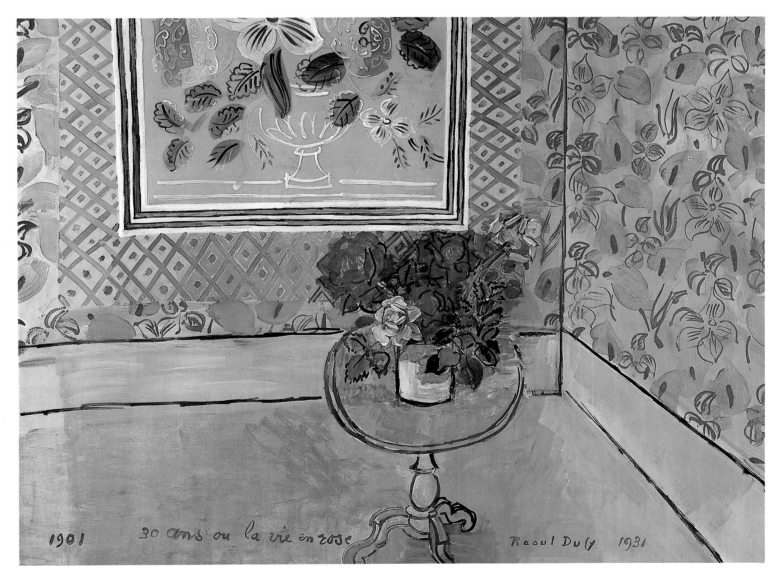

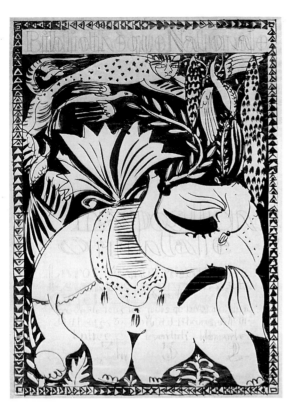

103 Study for the poster of the 'Exposition Orientale'.
Indian ink, pen and wash.

Opposite
105 *The Journey to the Islands*. Around 1915.
Bianchini-Férier cotton fabric.

104 *Fishing, Hunting* and *The Dance*, with preparatory drawings and engravings.
Bianchini-Férier exhibition panel.

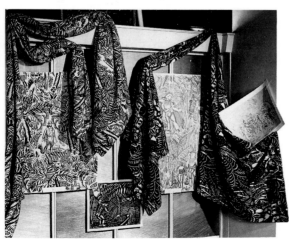

It is highly likely that Dufy referred to the sections on Chinese and Japanese ornaments in his illustrations to the *Bestiaire*; certain animals in the *Cortège d'Orphée*, which he then used again in his fabrics for Bianchini and adapted in his compositions, may be seen as deriving from these ornaments.

In some cases the elephants, facing one another in pairs after the manner of Assyrian iconography, embellish the corners of large silk squares. Standing out against a red background, their black mass is thrown powerfully into relief; the resulting tonal contrast is just as essential to the realization of the ornamental work as the construction of the work. In order to reproduce this piece, the engraved plate was printed by hand, which gives the piece an unparalleled depth and richness of colour. The elephant is almost always accompanied by the lotus flower motif. Sometimes it emerges from the midst of palm trees with spread branches drawn in arabesques. This exotic vegetation, which also features in *The Dance*, is an interpretation of the botanic images in the *Encyclopédie*.

Some of the watercolour and gouache fabric designs unite tigers, elephants and tropical birds in the same composition. The richly coloured plumes of the parrots greatly attracted Dufy: the sinuous lines describing the spread wings and the complementary colours of red and green, combined with brilliant yellows, create a decorative ensemble. The originality of Dufy's inspiration becomes apparent when he shows the parrots alongside the motif of the open cage: their flight enlivens these compositions, in which curved lines unite with arabesques. Certain of Dufy's designs using birds and flowers place him in the French textile tradition of Oberkampf's *toile de Jouy*.

Originating in the *Bestiaire*, the winged Pegasus stands in the middle of a stylized vegetation according to the rules of the popular print. Dating from 1920, it forms the theme of gouaches used in the printing of furniture fabrics, like the motif of the *Tibetan Goat* or that of *Orpheus*, accompanied by his cortège of animals. Exotic butterflies, which receive the same treatment as the floral motifs, form part of the decorative embellishment of certain gouaches, with the arabesques of their antennae and the coloured patterns of their spread wings. All of these themes were used in the printing of furniture damasks.

Around 1919, in the Tournon factory, Raoul Dufy designed furnishing fabrics which made the factory's reputation and which were used as supports for compositions that he had treated in his first wood engravings. These are *Fishing*,[44] *Hunting, Harvest, Fruit* and *The Journey to the Islands*; their vigorous, rustic character is preserved.[45] The year 1925 saw the production of a Tournon canvas, *Amour, Délice et Orgues*, which Dufy liked so much that he used it in the decoration of his own dining room.[46] This design is not, as is often believed, a wallpaper: Raoul Dufy never made any wallpaper designs. They are 'prints [*empreintes*]', engraving and colour tests applied to sheets of paper before being printed on fabrics. Likewise, the walls of his bedroom in his apartment in the Impasse Guelma were hung with a printed fabric, with a different motif, showing arum lilies.

Raoul Dufy was to breathe new life into the design of fabric print motifs by his choice of modern iconographic themes for furniture fabrics. 'Like you', Bianchini wrote to him, 'I think that we can expect a great deal from furniture fabrics painted in the modern style: you have opened up a path in this direction, which demands only to be followed with less restraint by everyone who is creating anything new! Let us to work, we are impatient to see more Dufys, but with yet another new tone'.[47] These furniture fabrics bore certain iconographic themes which were later to appear in Dufy's painting, his tapestry cartoons and his ceramics.

The theme of the sea inspired motifs which allowed him to give free rein to his imagination and his innate sense of ornament. He took pleasure in depicting the scalloped whorls of *Shells*, either in groups of various sizes and colours, or individually in a repeated rhythm. The symbolic shell accompanies the allegorical figure of Amphitrite in a design on silk, made in September 1925 and used for a cape by Poiret: the figure most frequently appears in pairs, as a naiad or seated looking out at the viewer, legs folded, her body describing a graceful 'S'. Another source of inspiration for fabric designs was the theme of Paris, a traditional favourite of the Jouy factory, and one which was entirely transformed by Dufy. In Jouy all the monuments are set in rigid surroundings, surmounted by trophies and figures

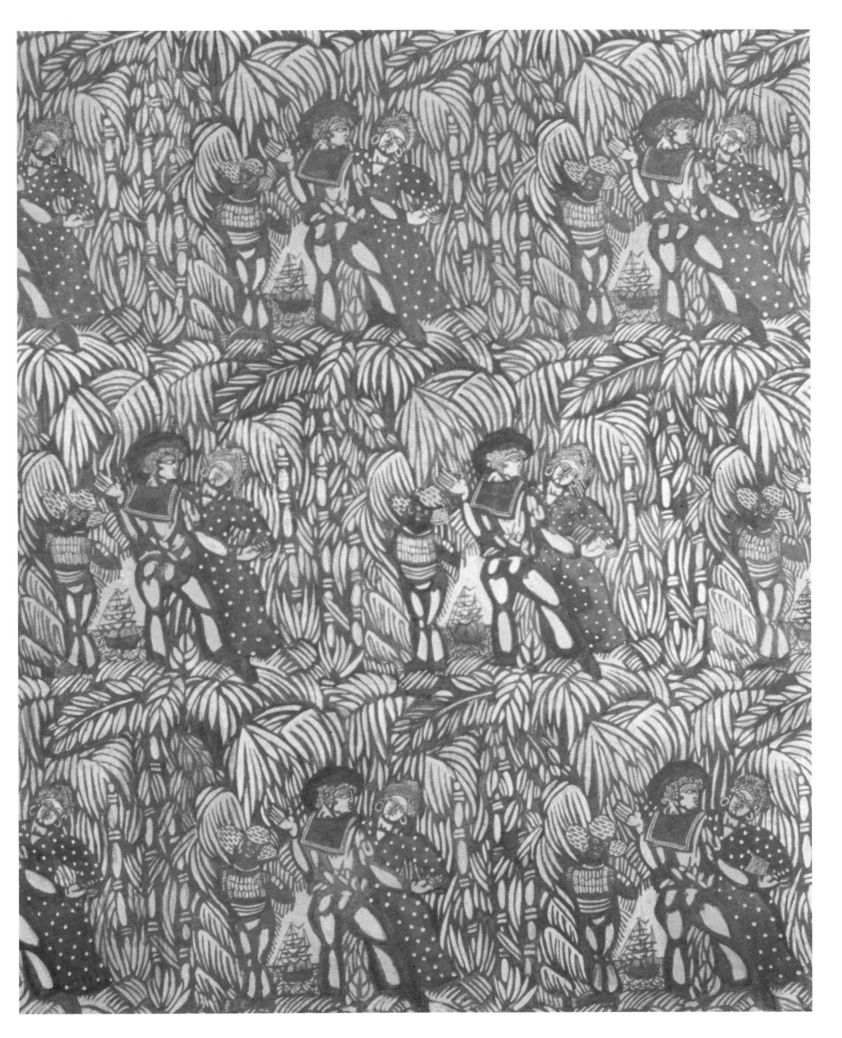

representing Fame in the classical style, according to the eighteenth-century taste. In Dufy's work they appear to be floating among flowers or dancing a farandole, lent a rhythm by a series of festive fans.

We are also shown Paris in a 'vue cavalière', from a balcony blooming with roses and lilies framing a cage, a composition similar to the decoration of the back of a couch from the *Paris* suite of furniture, made between 1924 and 1930 for the Mobilier National. Dufy's originality is revealed in his transformation of a theme realized in various different techniques and adapted to its vehicle with both vigour and imagination.

Dufy scoured his imagination for scenes of contemporary life: *The Dance*, *A Walk in the Bois*, *Tuileries* and *Bagatelle* all convey the distractions of Parisian bourgeois society in the 1920s. These anecdotal scenes, after the manner of *toiles de*

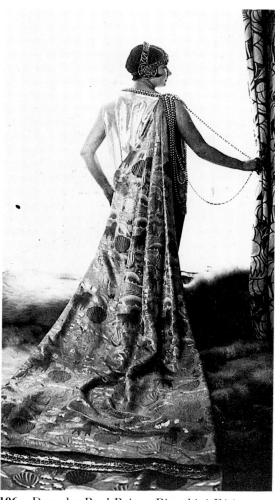

106 Dress by Paul Poiret, Bianchini-Férier satin crêpe *'Sea-Horses' and Shells*. 1925.

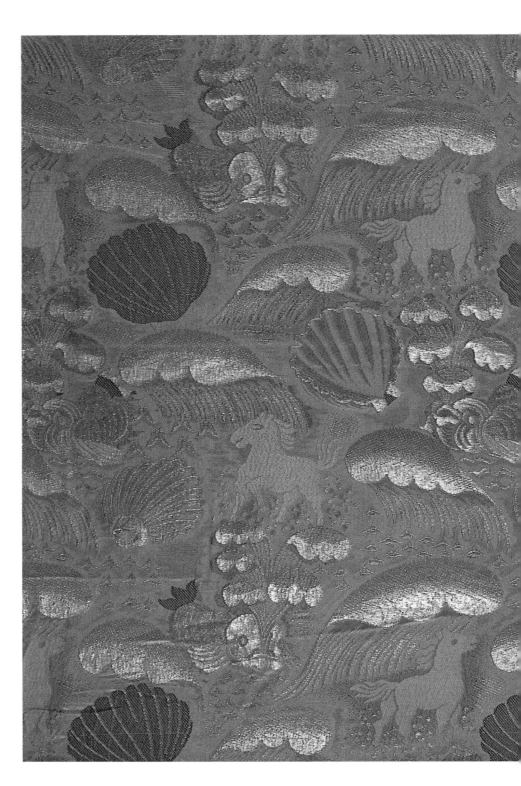

107 *'Sea-Horses' and Shells*. 1925. Bianchini-Férier satin crêpe.

Jouy, juxtapose groups of figures and floral motifs in a decorative rhythm. Once again, Dufy attaches little importance to the rules of perspective and respect for scale. This same construction reappears in other designs: *The Court of China*, with an oriental influence; *The Swing*, a favourite eighteenth-century subject; *Tennis*, a contemporary sport.

Of Dufy's most important modern iconographic themes, *The Races* and *The Circus* inspired him to paint gouaches designed to be printed on fashion fabrics, and were used to decorate shawls and sumptuous silks. *The Violins*, an expression of Dufy's love of music, combines a treatment that derives from the aesthetic of Cubism – the dislocated scroll of the instrument's neck, out of line with the strings – with a brilliant chromaticism whose reds and greens punctuate the ensemble of the composition. This piece shows that Dufy's decorative works after 1915 had taken

Continued on p. 111

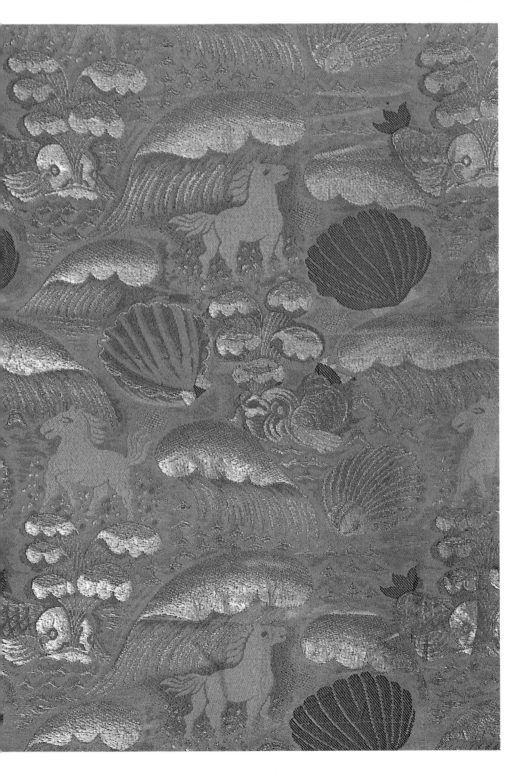

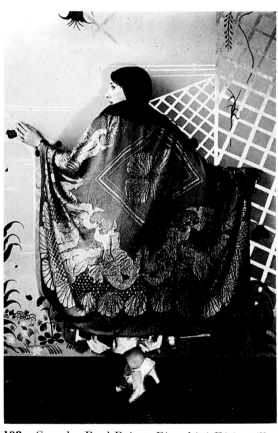

108 Cape by Paul Poiret, Bianchini-Férier silk *Amphitrite*. 1925.

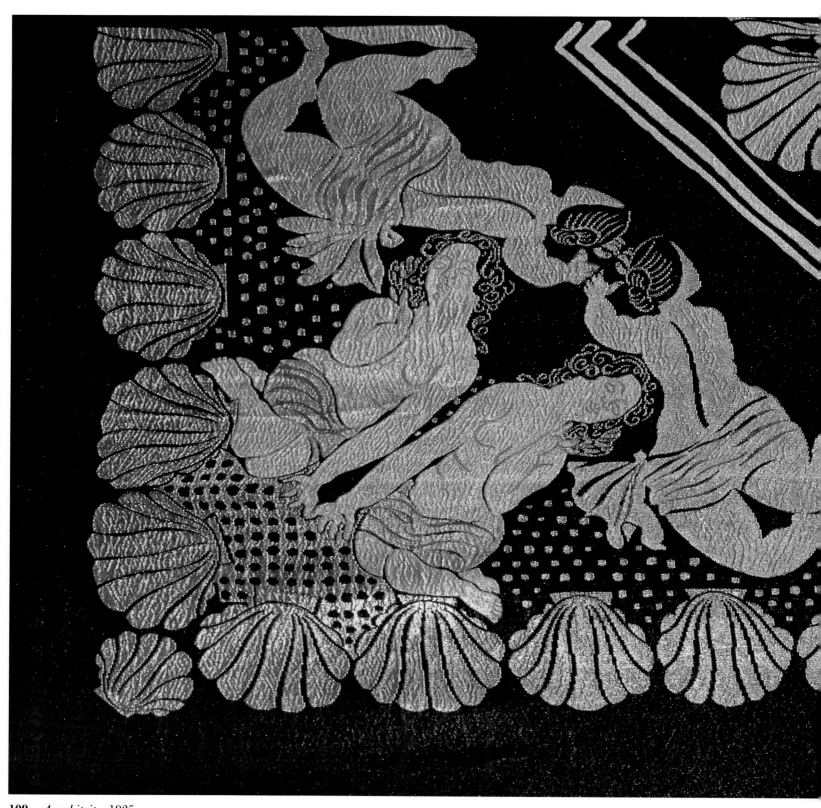

109 *Amphitrite*. 1925.
Bianchini-Férier faconné silk crêpe.

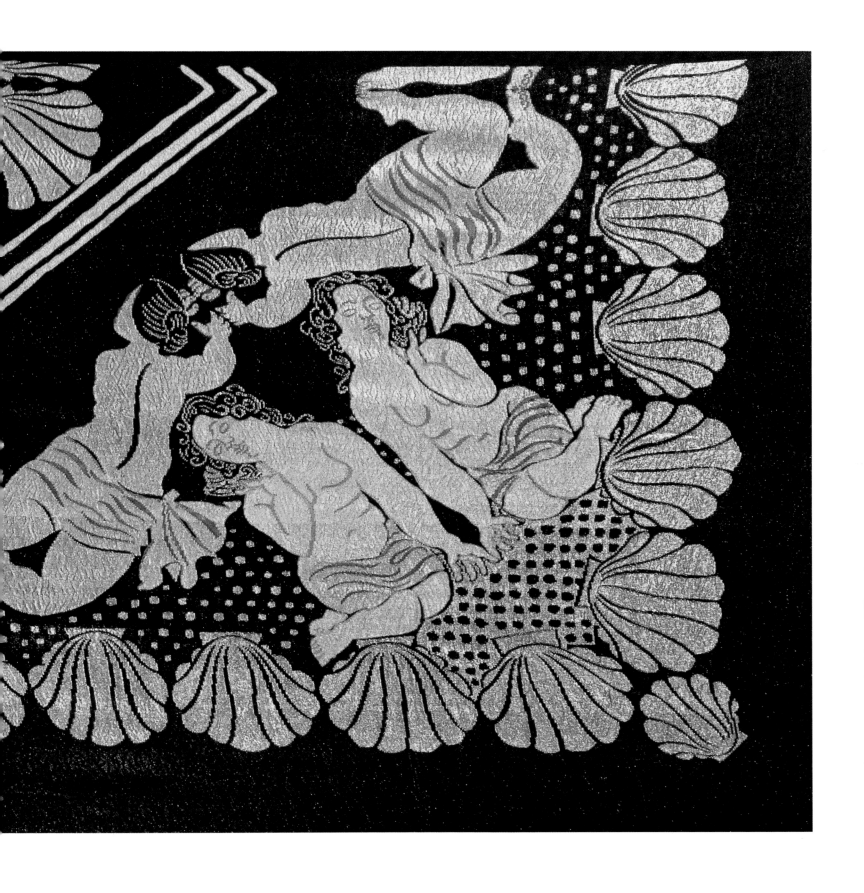

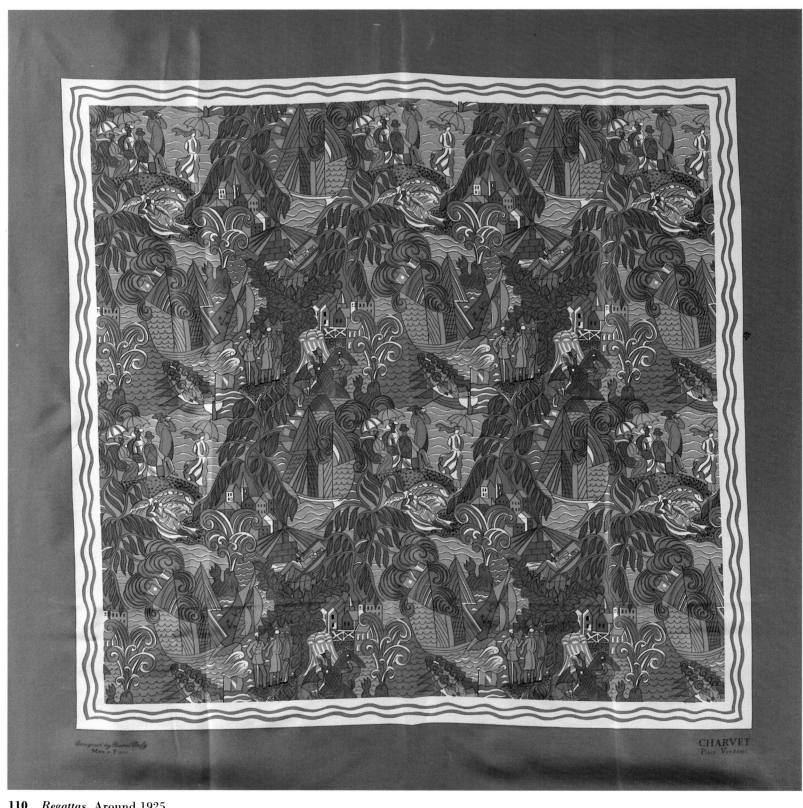

110 *Regattas.* Around 1925.
Square of Bianchini-Férier silk twill.

111 Dress by Paul Poiret, Bianchini-Férier
silk *Regattas.* 1925.

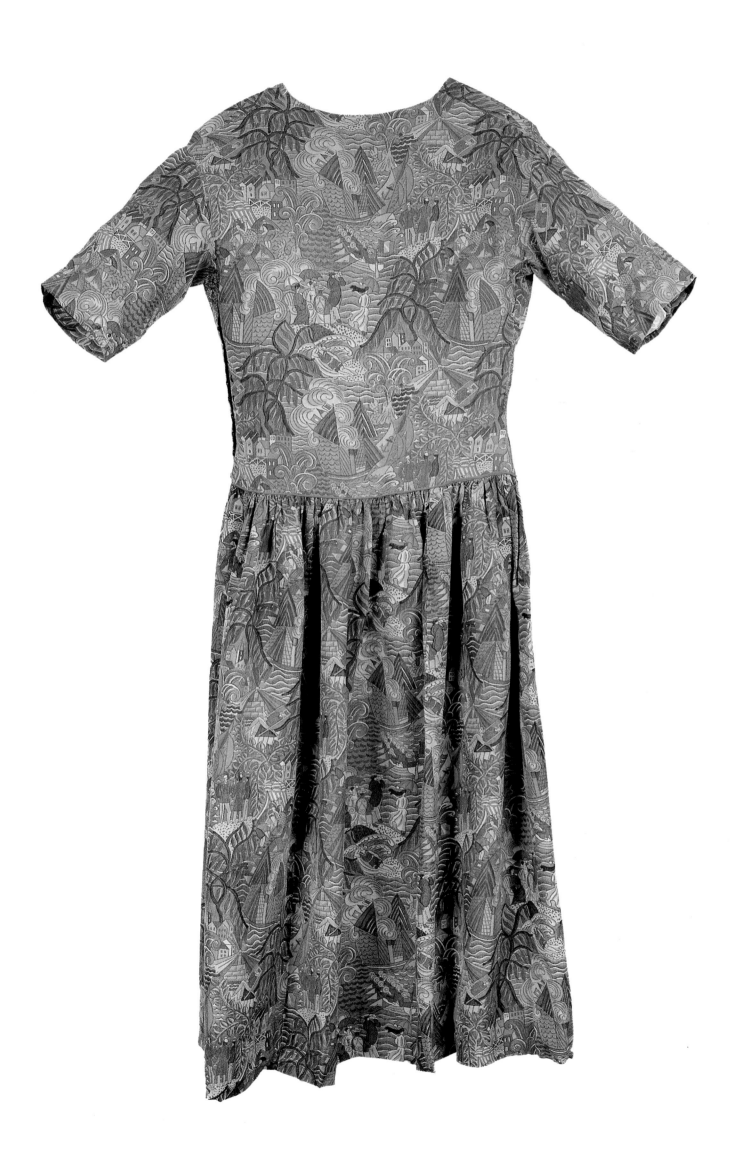

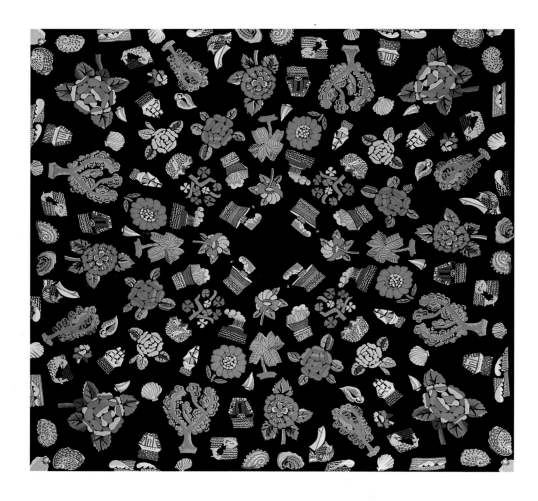

Opposite
115 *Parrots*. Around 1925–28.
Gouache for a Bianchini-Férier fabric.

112 *Floral Composition and Boats*. 1922.
Square of Bianchini-Férier silk crêpe de Chine.

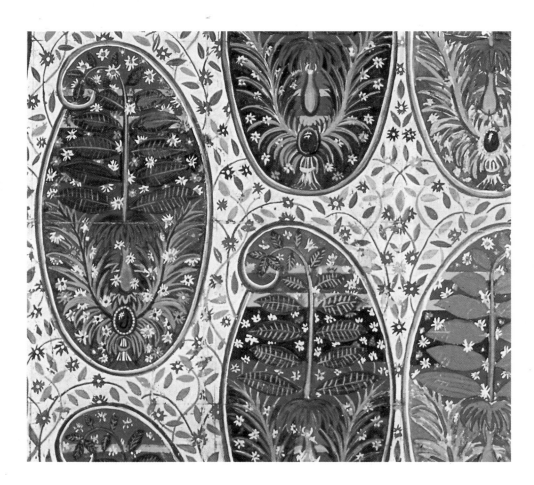

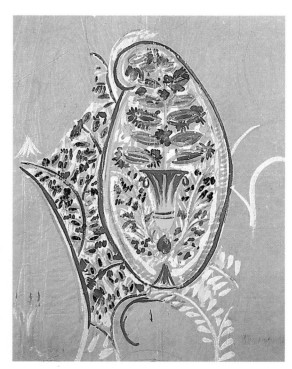

114 *Kashmir Palmette*. 1920.
Gouache for a Bianchini-Férier fabric.

113 Kashmir Palmettes. Around 1920.
Gouache for a Bianchini-Férier fabric.

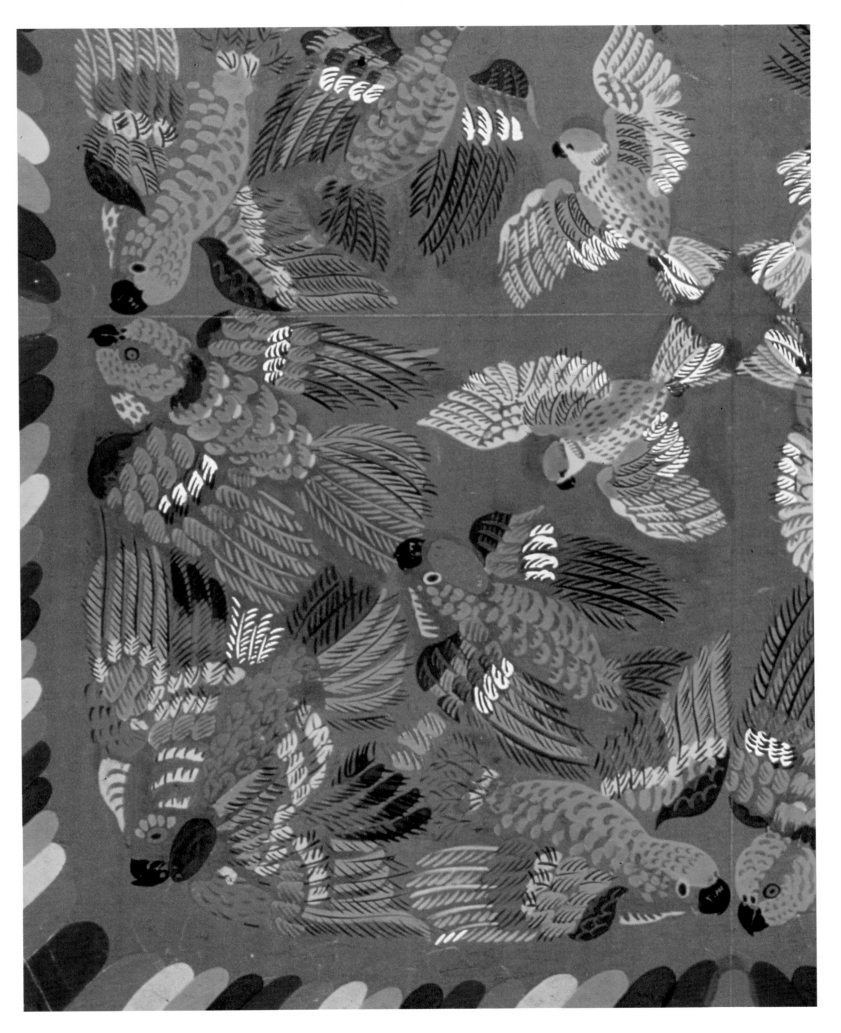

116 *Arums*. Around 1920.
Gouache for a Bianchini-Férier fabric.

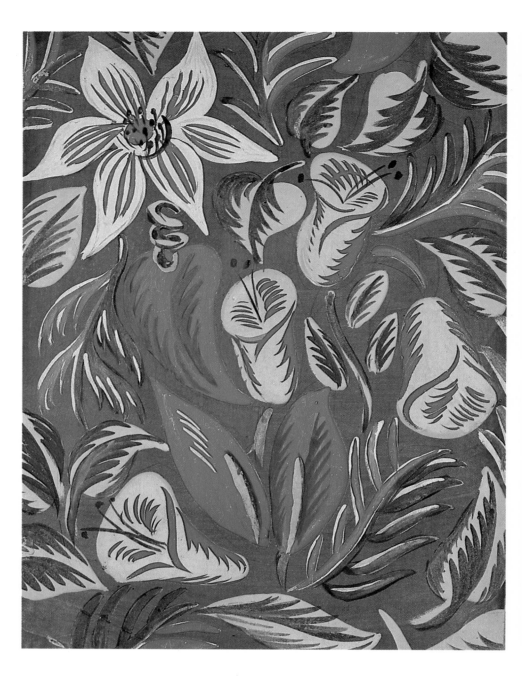

117 *Leaves, Horses and Birds*. Around 1918.
Gouache for a Bianchini-Férier fabric.

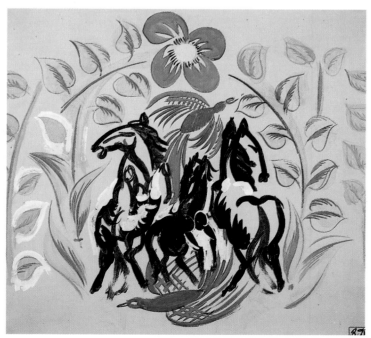

Opposite above
118 *Tortoises*. Around 1919–20.
Gouache for a Bianchini-Férier fabric.

Opposite below
119 *Tortoises*. 1920.
Bianchini-Férier façonné satin.

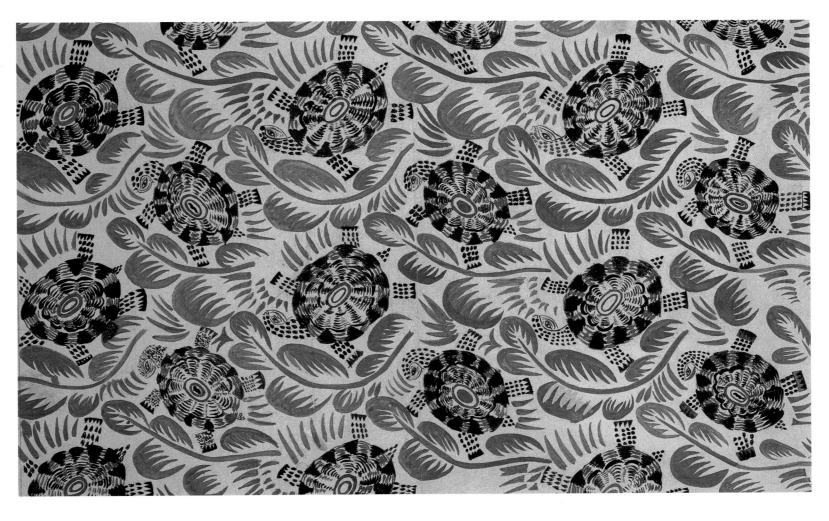

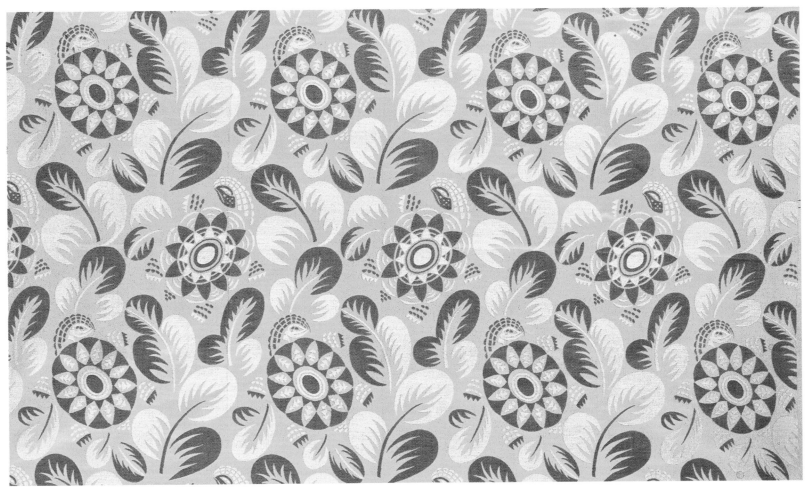

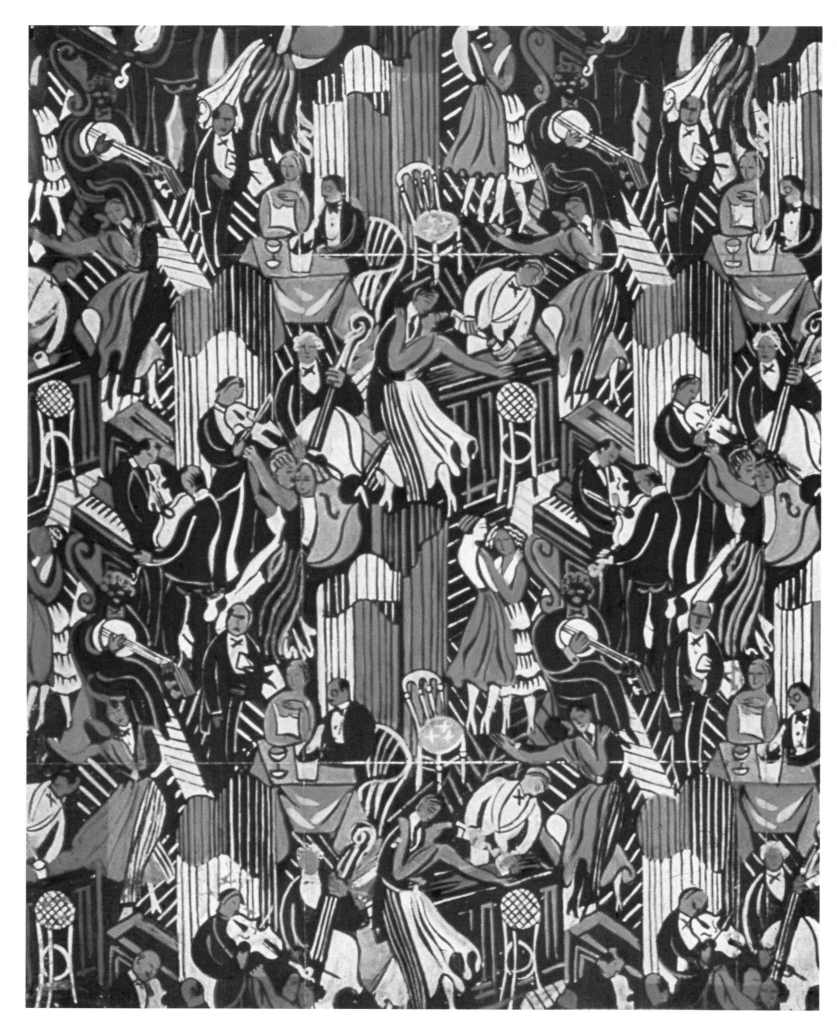

98

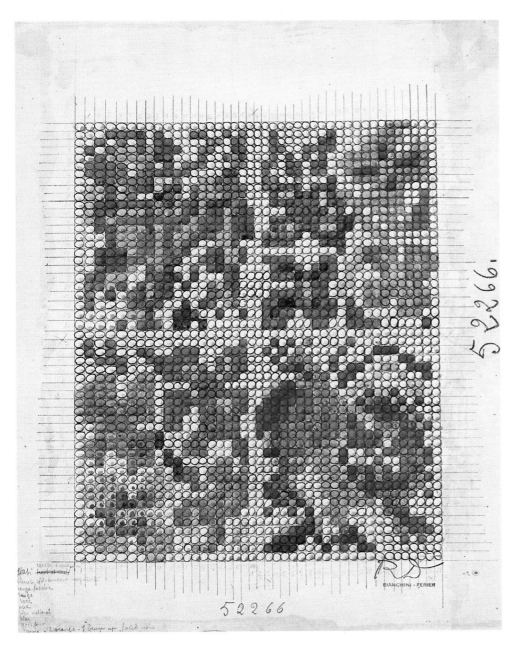

52266.

52266

BIANCHINI - FÉRIER

Left
121 *Roses*. Around 1920.
Jacquard drawing in gouache for a Bianchini-Férier fabric.

Below left
122 *Abstract Composition*. Around 1920.
Watercolour for a Bianchini-Férier fabric.

Below
123 *Geometrical Flowers*. Around 1920.
Gouache for a Bianchini-Férier fabric.

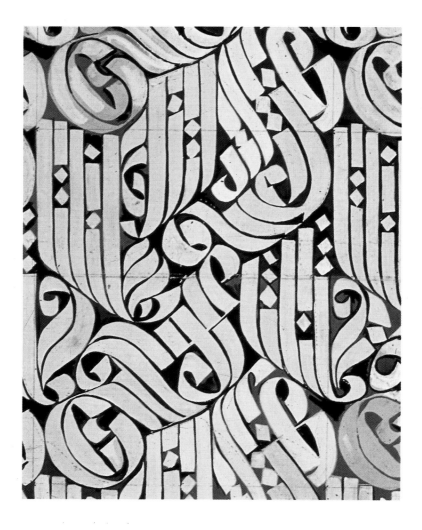

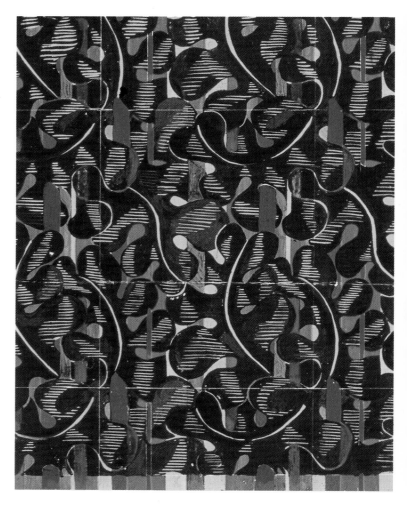

124 *Arabesques.* Around 1915–20.
Gouache for a Bianchini-Férier fabric.

125 *Palmettes on Gold and Black Background.*
Around 1925.
Gouache for a Bianchini-Férier fabric.

126 *Butterflies.* 1921.
Gouache for a Bianchini-Férier fabric.

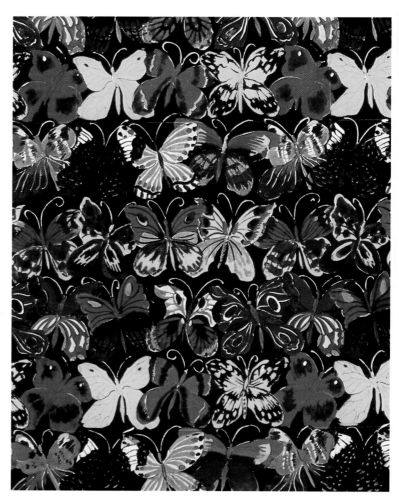

Opposite
127 *Althœas.* 1914–20.
Watercolour and gouache for a Bianchini-Férier fabric.

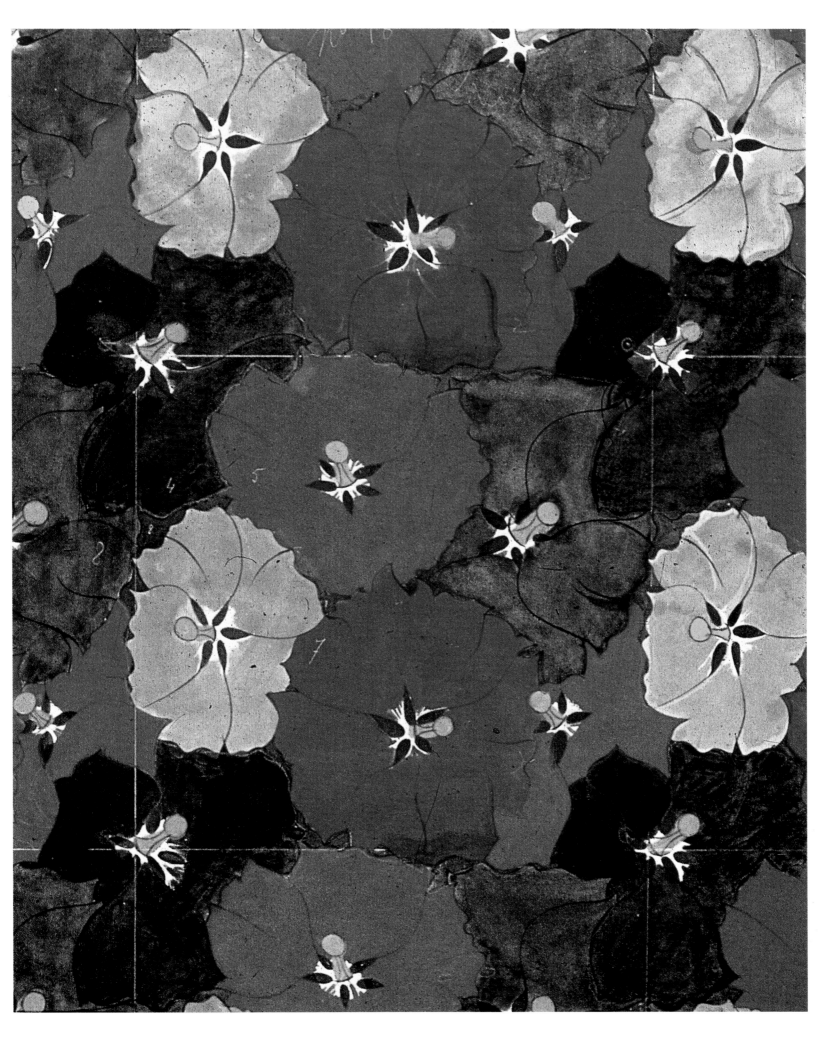

128 *Floral Composition*. Around 1913–14.
Gouache.

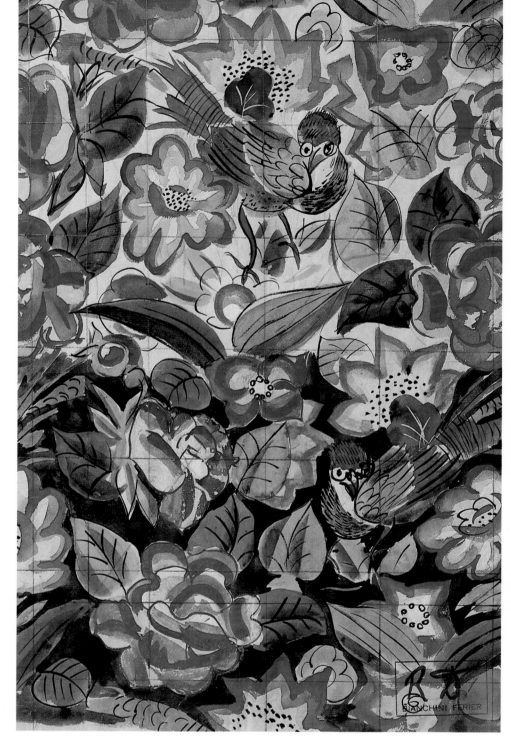

129 *Leaves and Parrots*. Around 1925–28.
Watercolour on pencil squaring.

Opposite
130 *Roses*. Around 1921.
Bianchini-Férier faconné satin.

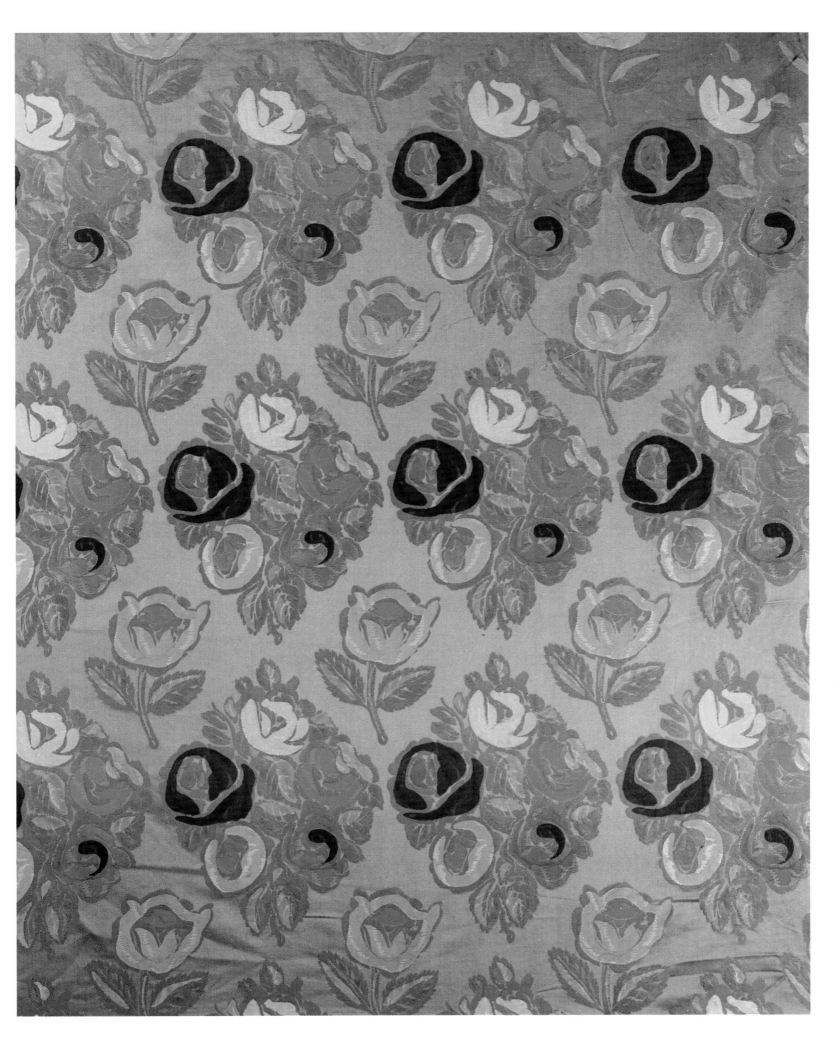

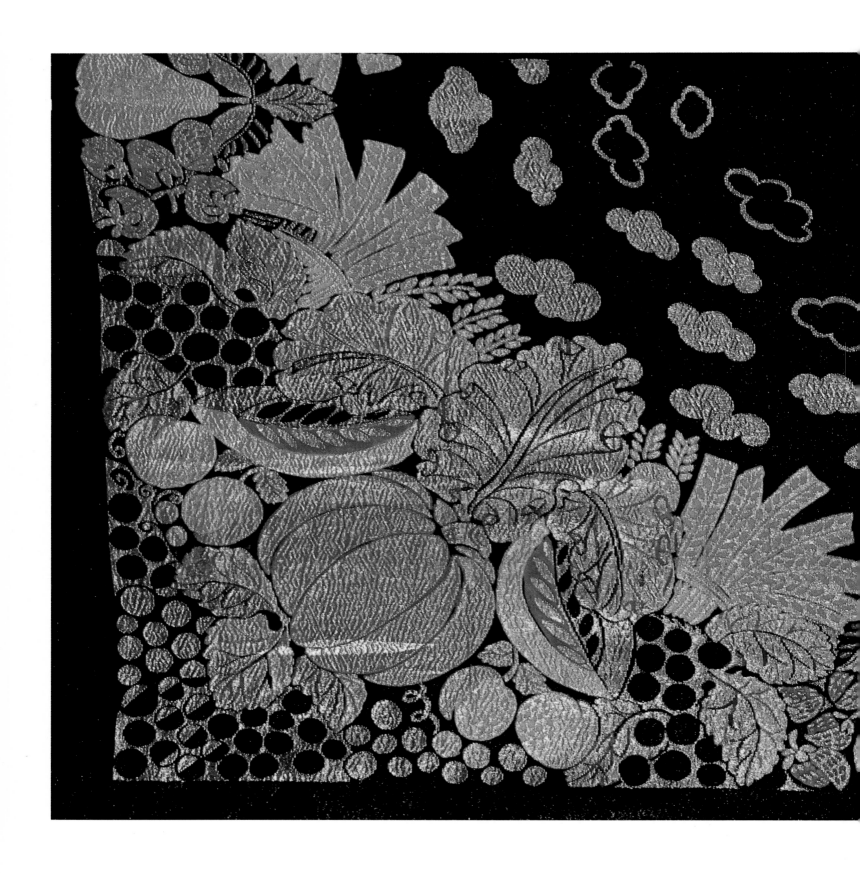

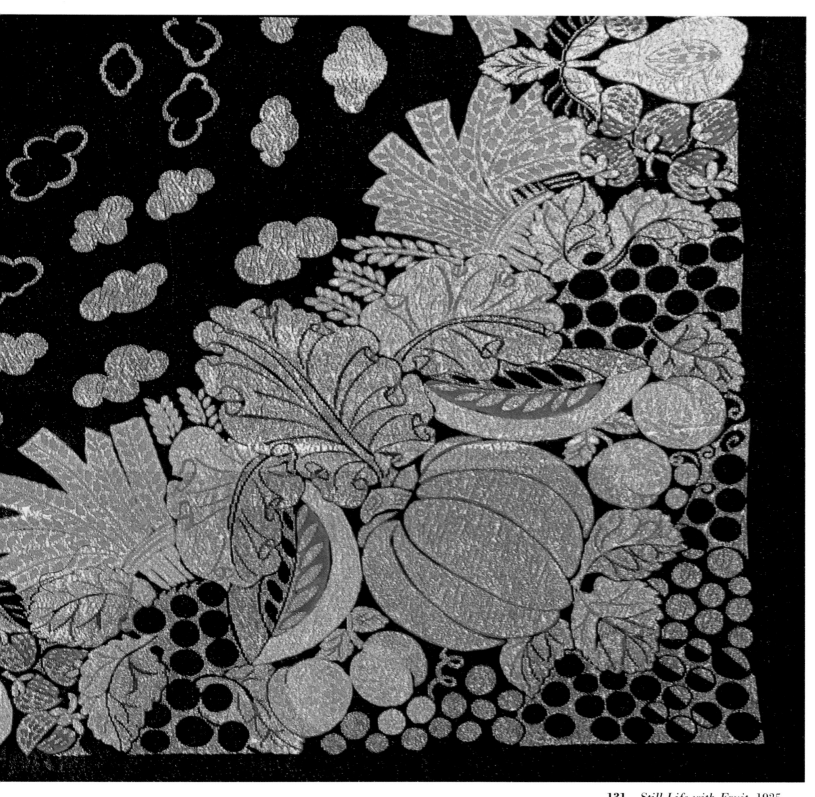

131 *Still Life with Fruit.* 1925.
Bianchini-Férier faconné silk crêpe.

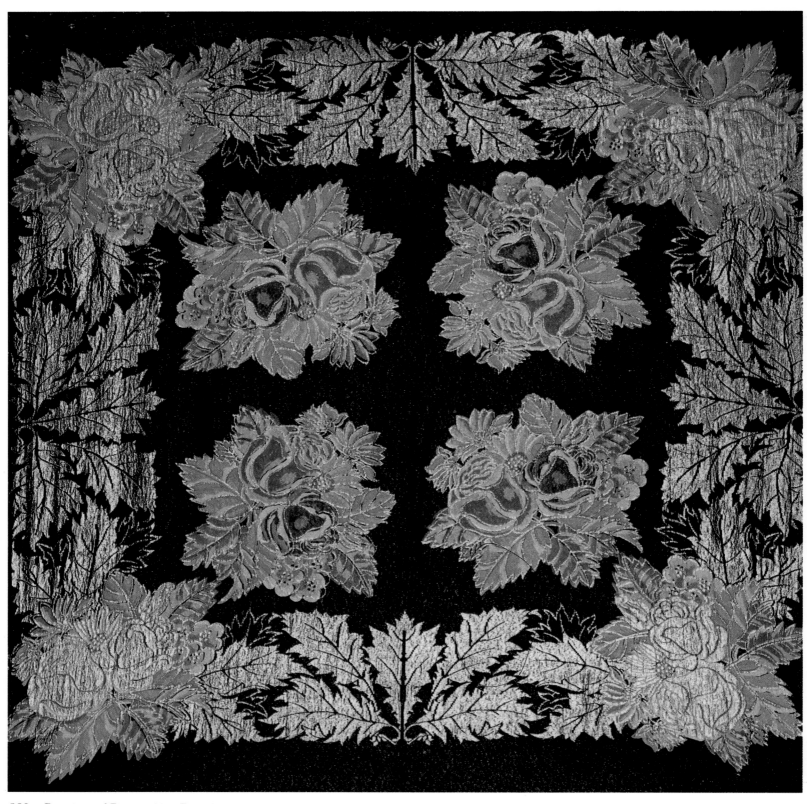

132 *Bouquets of Roses*. 1925. Bianchini-Férier
faconné silk crêpe.

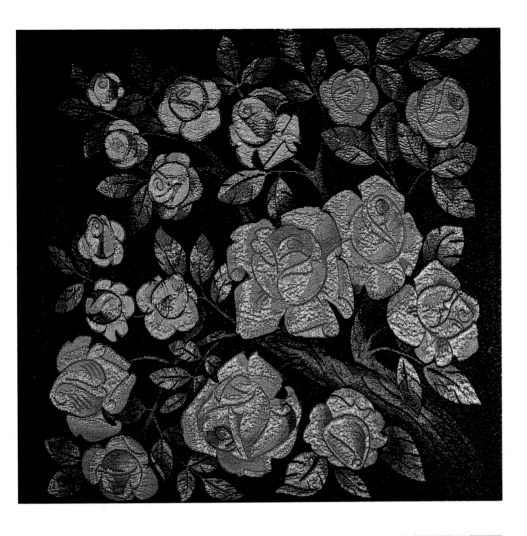

133 *Roses and Leaves.* 1925. Bianchini-Férier
faconné silk crêpe.

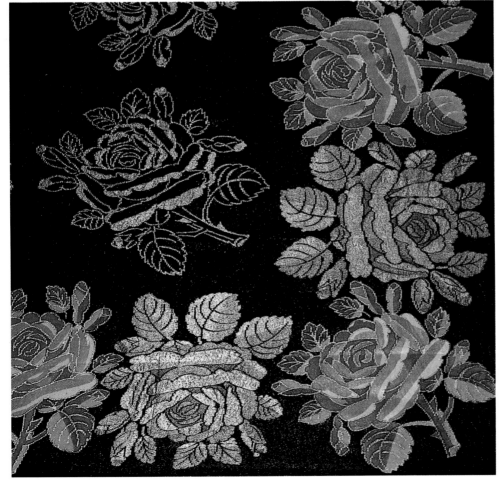

134 *Roses.* 1925.
Bianchini-Férier faconné silk crêpe.

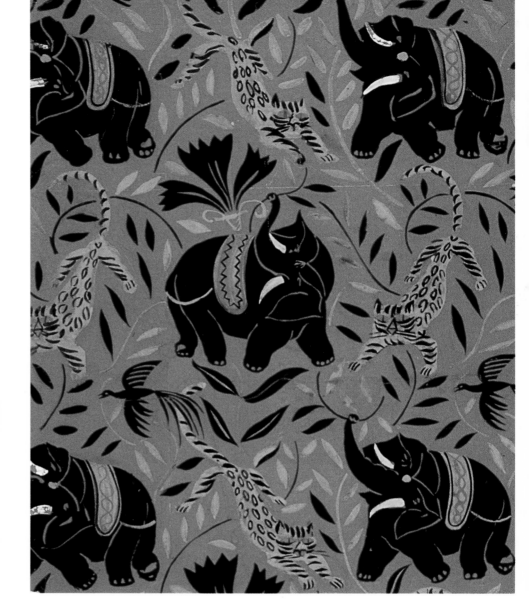

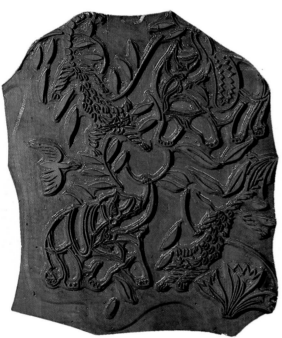

135 *Elephants and Tigers.*
Wood engraving for fabric printing.

Opposite
136 *Elephants and Tigers.* Around 1925.
Gouache for a Bianchini-Férier fabric.

137 *Elephants.* Around 1925.
Stencil and gouache for a Bianchini-Férier fabric.

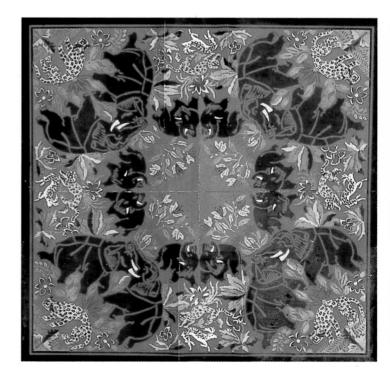

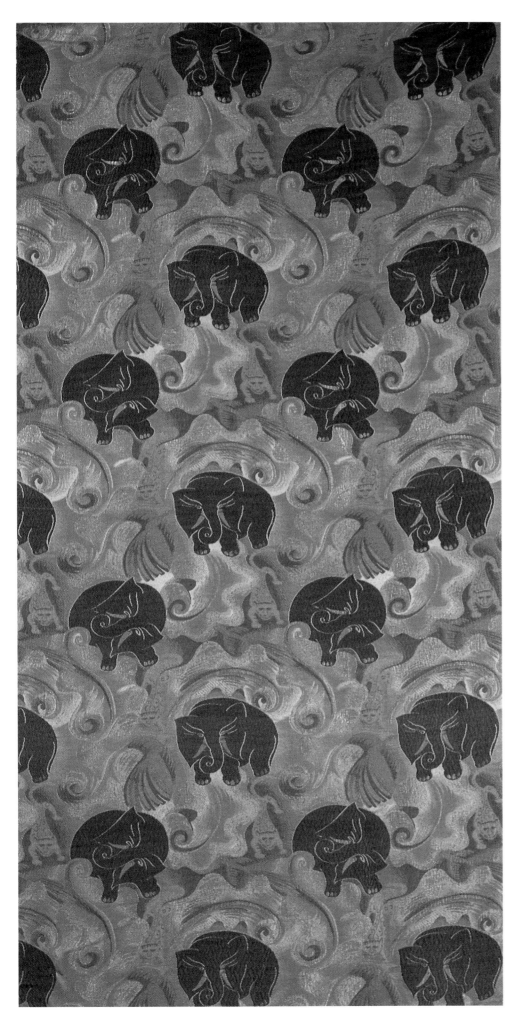

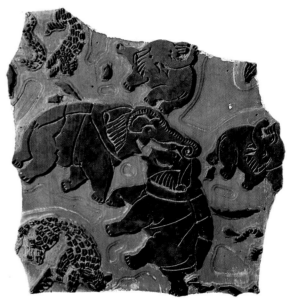

139 *Elephants and Tigers*. Wood engraving fo fabric printing.

140 *Elephants*. Wood engraving for fabric printing.

138 *Elephants*. Around 1922–24. Bianchini-Férier silk crêpe de Chine.

141 *Polychromatic Abstract Geometrical
Composition*. Around 1920.
Watercolour for a Bianchini-Férier fabric.

him beyond Cubism by allowing him to rediscover his taste for colour and to acquire an individual style.

The geometrical motifs are particularly interesting. They form a contrast with the rest of Dufy's production for Bianchini-Férier and show his creative verve: the stylized floral motif is set within a pattern of diamond shapes; some of the gouaches depict a sort of checkered canvas, in a weave pattern [armure][48] in which the flower is broken down into little coloured squares: the rose motif also appears in negative and positive against a complex network of lines. Some geometrical compositions are reduced to simple colour graphics that evoke mathematical abscissas and axes. Certain of the gouaches are made up of arabesques which are free of any thematic association, their intertwining and overlapping lines capturing the rhythm of a fugue, so justifying Dufy's statement: 'Nowhere else but in fabrics do we have the pleasure of witnessing the optical phenomena of lines and colours [. . .]. It is here that we can enjoy the grace of a beautiful unfolding line, like a delightful melody.'[49]

Reduced to its essence, the design tends towards a certain stylization in its forms, such as the motifs of palmettes, boats or waves. This stylization became so extreme that it led to abstract compositions whose subject was colour itself. Certain watercolours, such as a set of coloured crystals, appear jumbled together like a kaleidoscope; sometimes they resemble the colourful rhythms of Kupka.

Dufy did not dissociate his figurative motifs from his abstract compositions: from 1919, he worked on both at the same time. In this he resembled Sonia Delaunay who, along with Raoul Dufy, made the most important contribution to the revival of textile art. Unlike Dufy, Delaunay made a total break with tradition by refusing floral themes and devoting herself entirely to geometry, transposing the colourful rhythms of her paintings on to her printed fabrics.

Dufy's collaboration with the Maison Bianchini-Férier in the Avenue de l'Opéra continued uninterrupted throughout the war. Although Dufy's textile production decreased when he enlisted on 8 March 1915 in the motorized services, first at

143 *The Swing.* Around 1920. Pen drawing with gouache highlights for a Bianchini-Férier fabric.

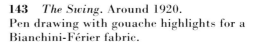

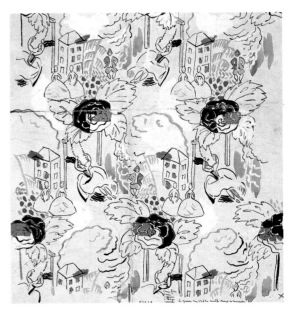

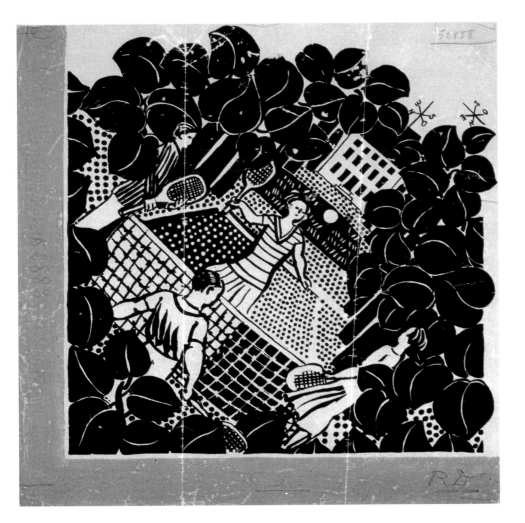

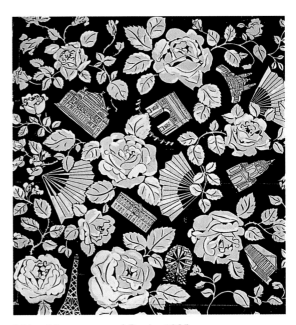

144 *Monuments of Paris.* 1925. Indian ink and gouache for a Bianchini-Férier fabric.

142 *Tennis.* Around 1920–25. Indian ink and gouache for a Bianchini-Férier fabric.

Vincennes and then at Charenton,[50] he continued to deliver his designs to Bianchini every Wednesday. On 17 January 1917, having been granted exemption from military service and transferred to the Ministry of Arts and Education, Dufy was employed at the Musée de la Guerre, where Camille Bloch,[51] by a ministerial decree dated 28 February 1918, found him the post of assistant curator at the Bibliothèque-Musée de la Guerre. During his time at the museum he reorganized its collections and introduced the works of contemporary artists, including Luc-Albert Moreau and his friend Dunoyer de Segonzac.

During the war Dufy returned to his studio in the Impasse de Guelma every day at 5 o'clock, prepared his sketches for Bianchini-Férier and painted a number of compositions related to political events – occasional works directly inspired by the popular prints of the Napoleonic era. Around 1915, he brought out a little album, *Les Alliés*,[52] composed of ten wood-engraved plates showing small uniformed figures, coloured by stencil, similar to those of the *Allied Nations for the Triumph of Justice and Freedom*, which were published around 1916. The Musée de la Guerre has a pen-and-ink study with gouache highlights for this composition, the background of which evokes Rude's *Departure of the 1792 Volunteers*. The Musée National d'Art Moderne has preserved a study for the plate showing the six allied nations. It was used in the decoration of a handkerchief. Dufy returned to the tradition of the commemorative handkerchiefs of Rouen, illustrated with a central motif surrounded by ornaments or secondary scenes. The leaders of the six allied armies are represented on horseback, in the centre of a square whose corners are decorated with roses. The inscription '1914' appears along one edge; the border represents the allied flags (France, Great Britain, Belgium, Russia, Japan and Serbia).

In 1916, on a single plate divided into two horizontal bands, Dufy made ten engravings of French army uniforms, their names given in French and Russian calligraphy. The artilleryman is given the face of Apollinaire, and the infantryman that of Dufy himself.

The image of the Gallic cock, crowing, standing on its spurs, surrounded by a crown of laurels, illustrates *The End of the Great War* and *The Cry of Victory*.

A gouache design for Bianchini-Férier, preceded by a pen-and-ink sketch with watercolour highlights, in the Musée National d'Art Moderne, was used for the print of *The Flag of Victory*.

Immediately after the armistice, Dufy decided to leave the army; he returned to civilian life and resumed his work for Bianchini-Férier.[53]

Dufy's drawings, watercolours and gouaches for fabric show no sign of the technical rigour involved in their transfer to fabric: 'Both in weaving and printing, the decorative artist requires technical skills [. . .], and those skills can only be acquired by personal effort,' he explained. Whatever fabric the design is made for, whether it be damask, brocade, façonné satin, brocatel, serge or even cotton, the fabric's relationship to the design is different in each case, because 'depending on the weave or the texture of a damask, the subject assumes a different appearance. That is why the composition of a fabric design must not be designed in haste. The designer, before delivering his design for production, must examine it scrupulously; in a small design, as in a large one, all the elements must be very well organized, very measured, made subordinate to one another.' Dufy is aware that, 'in order to help the manufacturer, the artist must be familiar with the material and the manufacturing process. For the artist, this means putting in a great deal of time, apprenticing himself to a trade.'[54]

Technical mastery must be combined with the intelligent and efficient collaboration of specialists. Dufy places central importance on the card-cutter, calling him 'a translator, an interpreter who can elevate his role to that of a true artist, according to his ability, not to mention his application, in bringing taste and invention to the work [. . .]. The card-cutter is the indispensable collaborator of the designer; so all my admiration and thanks go out to all these artists, our collaborators who are so often nameless. The only explanation for their self-denial is their taste for beauty and their love of their profession.'

On occasion this translator can fail the decorator's art, as happened when Dufy embarked on a textile collaboration with the Onondaga company of New York: his

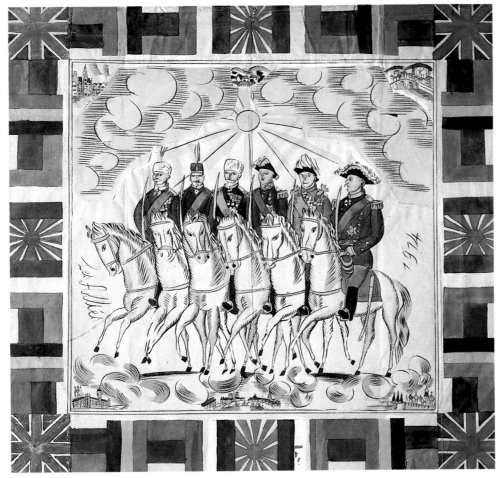

145 *The Allies*. Around 1916.
Silk square.

146 *The Flag of Victory*. 1918.
Gouache for a Bianchini-Férier fabric.

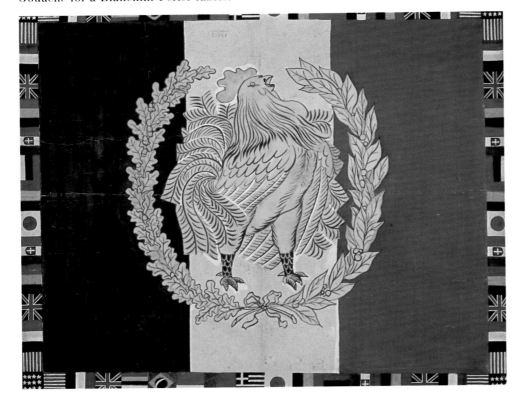

147 Study for *The Flag of Victory*. 1918.
Black lead.

many designs for silk, carried out between 1930 and 1933, suffered from a bad interpretation: the original watercolours and gouches, so brilliant and bright, produced finished works that were merely mediocre.

In 1928, Dufy decided to terminate his contract with Bianchini-Férier.[55] Fortified by the experience that he had acquired during this long period of work on textiles, which was now coming to an end, his art achieved an ease and a brio which were served by his mastery of the principle of 'couleur-lumière', a principle which he was to apply from now on in his painting.[56]

From 1928 Dufy was able to devote himself to painting, and to develop his work in such areas as illustration, ceramics, tapestry and monumental decoration.

IV

THE STAGE DESIGNS

LE BŒUF SUR LE TOIT

150 *Le Bœuf sur le toit*, the Redhaired Lady and the
Lady in the Low-cut Dress.

The period between 1918 and 1920 saw the birth of the friendship between Raoul Dufy and Jean Cocteau.

Dufy had been introduced to literary circles by Guillaume Apollinaire, with whom he had embarked upon the 'adventure' of the *Bestiaire* between 1910 and 1911. The painter was friendly with the group based around the magazine *Les Soirées de Paris*: Blaise Cendrars, André Salmon and particularly Max Jacob, who held him in high esteem.[1] It is very likely that he frequented the salon of the Baroness d'Oettingen (whose literary works were written under the *noms de plume* of Roch Grey and Léonard Pieux), the sister of the painter Serge Férat. Although Dufy remained outside the abstract art movement, he would certainly have met at these salons the avant-garde painters that the magazine supported, such as Survage, Larionov and Goncharova. Apollinaire, who from 1915 onwards wrote a regular column in the *Mercure de France*, also introduced Dufy to Rémy de Gourmont. To accompany the publication of de Gourmont's *Pensées inédites*, Dufy published in 1913–14 a series of drawings in which he captured the many facial expressions and characteristic attitudes of Rémy de Gourmont.[2]

Dufy also associated with the literary set based around the avant-garde magazine *Montjoie*. Its director, the poet and writer Riciotto Canudo, a friend of Apollinaire's, very much enjoyed the company of the painter, who was to record his features in a pencil drawing (Musée Jules-Chéret, Nice).

Dufy was also a close friend of the poet Joachim Gasquet, whose portrait he painted in oil in 1919.

In 1921 Dufy was commissioned by the *Nouvelle Revue française* to paint a portrait of Paul Claudel for the *Ode jubilaire pour le six-centième anniversaire de la mort de Dante*.[3] This finely observed portrait is the culmination of a series of studies showing the author in various different attitudes.[4] Dufy was to meet Paul Claudel once again in 1934, when the writer was France's ambassador to Brussels, at the opening of the exhibition of his works at the Palais des Beaux-Arts.[5] Two very spirited drawings (Musée National d'Art Moderne, Paris) record with imagination and humour the moment when H.M. Queen Elizabeth opened the exhibition in the company of Claudel, and show the artist commenting on his works.

Dufy was also friendly with Fernand Fleuret and Roger Allard, whose *Élégies martiales* he had illustrated with wood engravings in 1917. He enjoyed the company of the poet Vincent Muselli, a relative of Fleuret, whom he had met at the gatherings of the group of composers known as Les Six, with whom he shared a love of life and worldly pleasures.

It was to Roger Allard, the editor of the *Nouvelle Revue française*, that he owed his introduction to Jean Cocteau in 1918. At the poet's request, Dufy undertook the illustration of Mallarmé's *Madrigaux*.[6] His drawings, mostly inspired by fashion catalogue engravings from the end of the Second Empire, reflect the spirit of these little occasional poems which became *Adresses* or *Boutades*. *Les Demoiselles Cazalis* is one example of this. The drawing of a young woman in a kimono recalls the influence of the Japanese aesthetic on the artists of the last quarter of the nineteenth century. It should be remembered that around 1919–20, when he first entered the world of fabrics, Dufy himself referred to this aesthetic in his choice of orientally inspired motifs. He was to return to the seated figure of the thoughtful young sailor, the subject of another illustration for the *Madrigaux*, in his work for Bianchini-Férier. In these drawings, which were prepared in a large number of sketches[7] in a supple and skilful style, the modulations of the line harmonize with a remarkable assurance and with a simplicity unburdened by superfluous details. But their reproduction in stencilled prints on zinc comes close to a style of popular print which the artist was in the process of abandoning. During this period, the relaxation that Dufy shows in his painted work, characterized by an agile and simplified style, has its origins in his works as an illustrator.

At this point, Raoul Dufy and Jean Cocteau were very close friends. It was thanks to Cocteau, and in a completely fortuitous way, that Dufy was to enter a completely new area – that of stage design. In 1919, Cocteau gave him the opportunity to make his first contribution to this field: 'I knew Dufy when he was illustrating Mallarmé's *Madrigaux*. Fauconnet had just died. He had been working

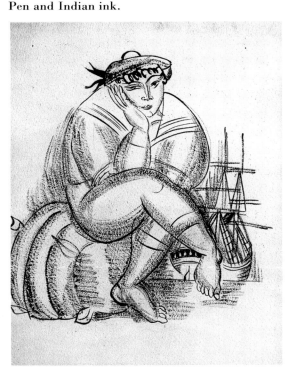

151 *The Sailor.* Drawing for *Les Madrigaux.*
1918.
Pen and Indian ink.

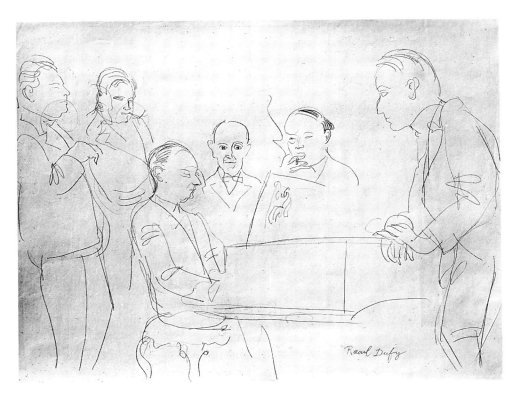

Raoul Dufy

152 Igor Stravinsky at the piano, surrounded by Arthur Honegger, Darius Milhaud, Max Jacob, Léon-Paul Fargue and Francis Poulenc. Black lead.

153 From left to right: Céline Bugnon, Elsa Collaert, François Fratellini, Paul Fratellini, Darius Milhaud, Albert Fratellini, Darius Milhaud's mother, at the time of the staging of *Le Boeuf sur le toit*, in 'L'Enclos' (Aix-en-Provence).

on the play *Le Bœuf sur le toit*.[8] Within a few days Dufy replaced him, designing the set, costumes and masks.'[9]

During his two-year stay in Brazil, where he was secretary to Paul Claudel, Darius Milhaud had been captivated by Brazilian music: 'The rhythms of this music [. . .] intrigued and fascinated me.'[10] On his return he took pleasure in collecting these popular tunes, which he 'transcribed [. . .] with a *ritornando* theme between each tune, like a credo'.[11] He intended to use this '*fantaisie*' as a syncopated accompaniment to a Charlie Chaplin film.

Cocteau dissuaded him from this, suggesting that he stage a show instead, a farce in the spirit of *Parade*, which had been staged in 1917 with music by Satie and with a backdrop, set and costumes by Picasso. Cocteau himself took charge of the staging, with the help of the Comte de Beaumont.

Cocteau wrote the scenario for *Le Bœuf sur le toit*, while Milhaud adapted the music. The action took place in a bar during Prohibition: 'very typical characters moving about; a boxer, a black dwarf, an elegant woman, a red-haired woman dressed *à la garçonne*, a bookmaker, a "gentleman" in a suit. The barman with the face of Antinous is serving everyone cocktails. After a number of incidents and various dances a policeman arrives. The bar immediately becomes a milkbar. The drinkers play out a bucolic scene and a pastoral while drinking milk. The barman switches on a big fan which decapitates the policeman. With the head of the policeman, the red-haired woman starts to dance, ending up on her hands like the Salome in Rouen Cathedral. The characters gradually leave the bar. The barman presents the revived policeman with an enormous bill.'[12]

The conductor of the twenty-strong orchestra was the young bandleader Vladimir Golschman. For the various roles Cocteau hired the Fratellini, the clowns from the Cirque Medrano.[13] He decked out the actors in huge cardboard masks which made their bodies look smaller. The characters had to adopt slow-motion mime and dance movements which contrasted with the quick rhythm of the South American music: 'To Milhaud's music, Jean Cocteau's characters move as slowly as divers at the bottom of the sea, performing the basic gestures that make up their lives. The most fascinating experiment. Cocteau breaks away from the frozen arbitrariness of life transposed to the theatre. He gives it a synthesis applied with the greatest intelligence to the very sense of its realization on the stage.'[14]

A great music-lover, Dufy had long appreciated the works of Milhaud and the other members of Les Six: Arthur Honegger, Georges Auric, Francis Poulenc,

119

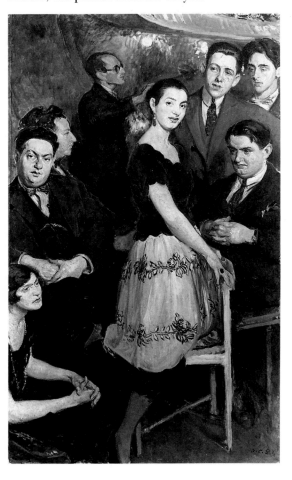

154 Jacques-Emile Blanche, *Les Six*. 1924. Oil on canvas. From left to right: Germaine Tailleferre, Darius Milhaud, Arthur Honegger, Georges Auric, Jean Wiener (replacing Louis Durey), Jean Cocteau, Francis Poulenc. In the middle, the pianist Marcelle Meyer.

Germaine Tailleferre, and Louis Durey. A spontaneous sketch captures one of the Saturday gatherings at Milhaud's house, where the group met with the performers Marcelle Meyer, Juliette Meerovitch and Andrée Vaurabourg; the painters Marie Laurencin, Valentine Gross, the fiancée of Jean Hugo, Irène Lagut, Guy-Pierre Fauconnet; the writers Jean Cocteau, Raymond Radiguet, and others.

Raoul Dufy enjoyed working on *Le Bœuf sur le toit*, which was first performed on 21 February 1920, at the Comédie des Champs-Elysées.

Photographs taken at the time give us some idea of the appearance of the characters, their costumes and the set against which the action took place. In addition, sketches by Dufy, which have since been discovered, show each actor's cardboard mask and costume.[15]

For the set, Dufy made a watercolour sketch showing the inside of the bar in which the scene takes place. In the background on the right-hand side we can see the bar with its geometrical décor, with the silhouette of the barman drawn behind it, arms raised, along with the shelves where bottles of alcohol alternate with napkins folded into triangles. Around the pale double helix of a ventilator hang green and red garlands. The blue doors of the room frame the stage; in the foreground on the left-hand side the red mass of a curtain contrasts with a yellow screen bearing a pattern of curving lines. A character standing cross-legged leans casually against a little red table; next to him, a white armchair stretches its arms towards him. The set in Dufy's sketch is filled with life, giving a dynamism to the contorted poses of the characters, which is echoed in the curved lines of the accessories and the use of warm tonalities.

Some elements of this set reappear in the colour lithograph that Dufy made for the poster, which was published in the album *La Vogue musicale*. This shows the curtain and the screen, as well as the barman stirring his cocktail. The rows of bottles on the shelves serve as a background to the bookmaker and the besuited gentleman, perched on stools and playing dice. The policeman appears from behind the screen while in the middle of the stage the red-haired woman and the elegant woman do a jerky dance; the left foreground is occupied by the black boxer, slumped in an armchair and in the process of being revived by the dwarf, who is fanning him.

In this lithograph Dufy brilliantly recreates the atmosphere of a scene from the piece; his lively style is in harmony with the spirit of the scenario. We can see, too, the variety of his costume designs. The red-haired woman is dressed *à la garçonne* in a short tartan skirt and a hip-length jacket. Her companion wears an elegant and brightly coloured dress with a series of flounces, which contrasts with the severity of the policeman's uniform. The large woollen pullover, with its central star,

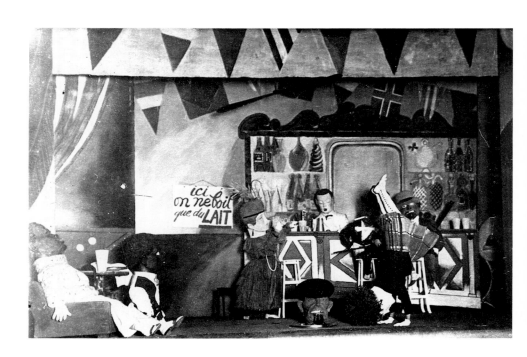

155 *Le Bœuf sur le toit*, photograph of the first performance at the Comédie des Champs-Élysées, 21 February 1920.

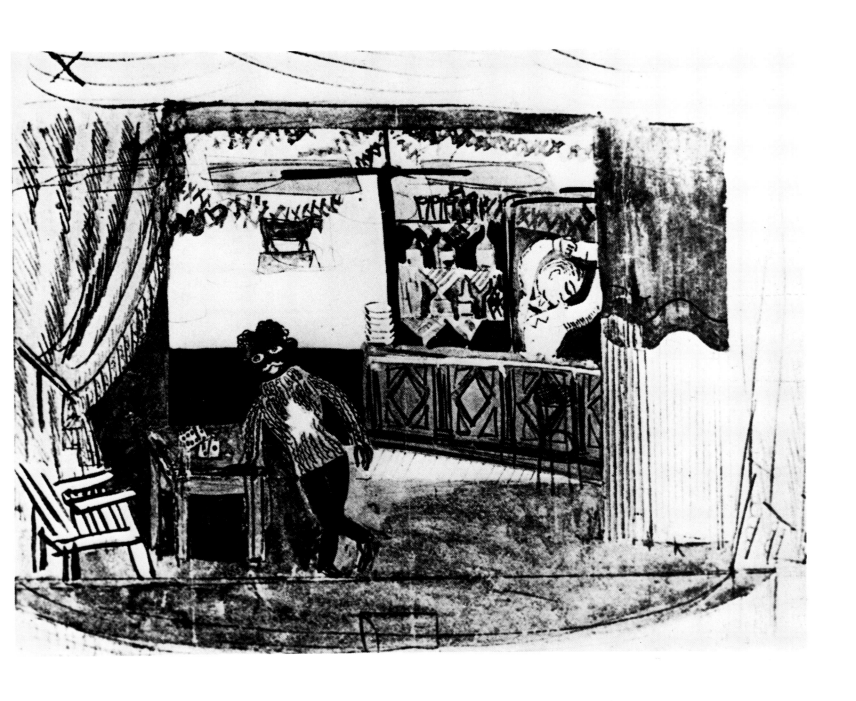

156 *Le Boeuf sur le toit*, stage design. 1920.

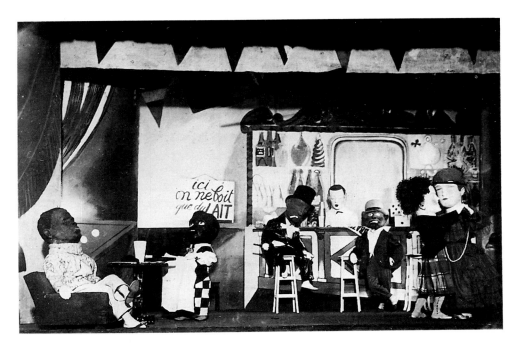

157 *Le Boeuf sur le toit*, photograph of the first performance at the Comédie des Champs-Élysées, 21 February 1920.

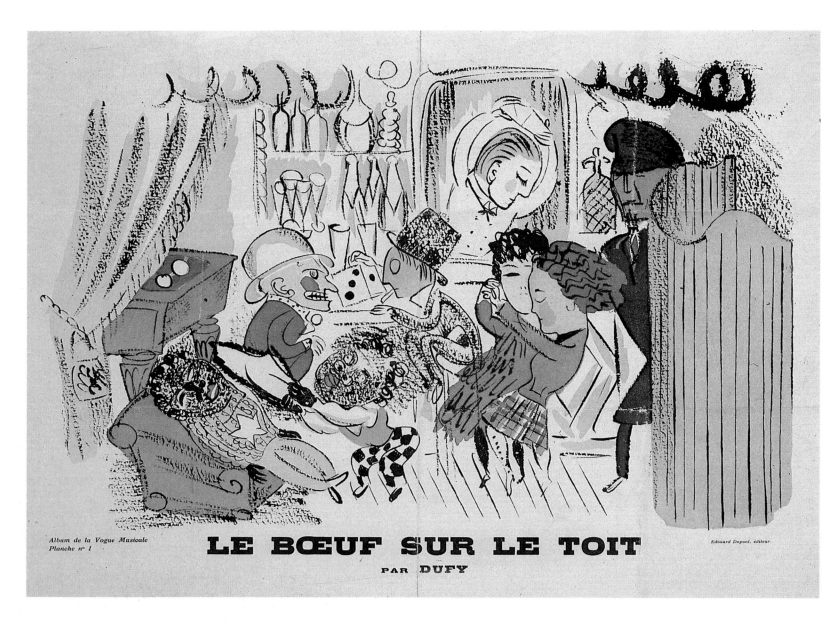

158 *Le Boeuf sur le toit*, lithograph printed in
La Vogue musicale. 1920.

159 *Le Boeuf sur le toit*, drawing for the Jockey.

161 *Le Boeuf sur le toit*, the Man in the Suit and the Lady in the Low-cut Dress.

stresses the boxer's athletic build, while the dwarf's checkered trousers emphasize how short his legs are. In the background, the gentleman's evening dress, sober in cut and colour, contrasts with the gaudy suit of the bookmaker. The variety of clothing and colour serves to underline the mocking tone of the farce.

In a highly expressive pen-and-ink drawing Dufy closes up the composition, giving it a vertical format. He captures the silhouettes and movements of the figures in a mass of satirical lines. This design was used to make a lithograph which shows the same stylistic qualities as the drawing.

Le Bœuf sur le toit intrigued the public and enjoyed a great success, which was orchestrated by Jean Cocteau: 'From the boxes of Guermantes to the front rows of Montparnasse and Montmartre, from the "stalls" of what was still known as the *Faubourg* Saint-Germain, to the "balconies" of our friends, everything was mixed up to the great confusion of the journalists, wandering about on the Avenue Montaigne.' The next day, 'all of Paris knew, if not the farce itself, at least its title, so intriguing and amusing at the same time'.[16]

Between 1922 and 1934, Dufy continued his work on stage designs, which he had started with *Le Bœuf sur le toit*, bringing to them the same experimental spirit that he brought to his paintings. In his theatrical design he recreated his own universe, and its decorative creation became a kind of painting adapted to the needs of the stage. It is possible that in choosing seaside themes in the stage designs he made between 1922 and 1934, Dufy was guided by the subjects he was portraying during the same period in his painted *oeuvre*, such as nautical festivals and regattas.

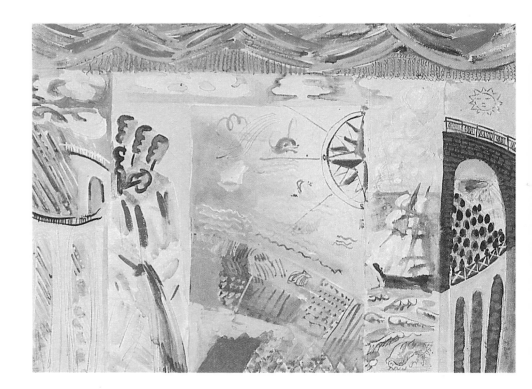

163 *Frivolant*, design for the stage set. 1922. Watercolour.

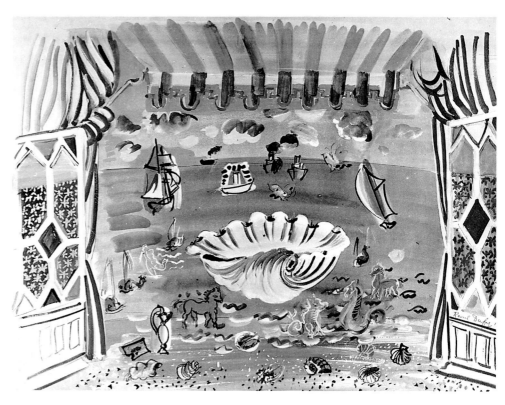

164 *Palm Beach*, design for the stage set. 1933. Watercolour and gouache.

In 1922, for the one-act ballet *Frivolant*, shown at the Opéra in April,[17] he made a set[18] and costumes which contain motifs from the Normandy of his birth: the aqueduct overshadowed by rain-filled clouds reveals the countryside between its arches; a fine sailing-ship floats on an endless sea.

The sea, dotted with steamboats, sailboats with upright masts, yachts with billowing sails and flag-decked boats, reappears in 1933 in Dufy's set for the ballet *Palm Beach*,[19] commissioned by Comte Étienne de Beaumont. Dufy created a theatrical architecture which provided the illusion of space: he conceived his set as a window which allows a view from above, increasing the size of the stage and enabling the painter to extend his vision across the great expanse of the sea. He

places a great deal of emphasis on the scallop-shell motif, whose whorls and rounded edges echo the swirls and arabesques of the shells scattered on the sand. The image of this scallop-shell is disproportionately enlarged; Dufy uses an imaginary perspective and gives certain elements of his composition an importance related to his own personal vision. Allowing his imagination free rein, he enlivens the foreground with the unexpected presence of 'sea-horses' and sea animals, with foaming waves running along beneath them.

Dufy gives his colours a non-descriptive function which reveals the 'colour imagination' of his Fauve period. The white patch of the scallop-shell[20] heightens the major tones of red and blue which unite the sea and the sky.

Dufy made numerous designs for the costumes of his dancers, some of them in watercolour, others sketched in pen and ink. They are simple sketches with handwritten annotations. These include an unpublished set of studies[21] and the collection of sketches traced on paper with the heading of the Hôtel Monte-Carlo or L'Altana.[22] One of these reads: 'Dancer holding scarves that imitate the sea so that her head and torso become those of a naiad, while the rest of her is a bather.' On this schematic figure Dufy sketched a rectangle covered with waving lines to convey the movement of the little waves. He places the dancer within a marine setting, a simple pencil sketch showing 'sea horses' and fish.

On the cover of the programme of the Ballets Russes de Monte-Carlo of 8 June 1934 is a watercolour showing the costumes designed by Dufy: the dancers are dressed in swimming costumes and bathing suits after the fashion of the time, sometimes with striped scarves over their shoulders. A photograph in the programme of the Royal Opera House at Covent Garden, London, from 1936, shows the costumes worn by the actors on the stage.

The theme of the sea reappears in one of the two sketches painted in watercolour and highlighted in gouache for the set of *L'Oeuf de Colomb* by René Kerdyck. This one-act farce in verse was first staged at the Comédie Française on Saturday, 15 December 1934. In quite a natural way, Dufy's brush creates a marine landscape evocative of Christopher Columbus's yearning for new lands. The caravels with their spread sails – a reference to the *Santa-Maria*, the *Pinta* and the *Niña* – allow him to play with the verticals of the masts, the horizontals of the yard-arms and the curves of the sails, echoing the arabesques of the white clouds and the billows of black smoke from the freighters. This watercolour provides another example of Dufy's elliptical graphic style, made up of expressive notations transcribing the choppy waves of the sea in little triangles pointing towards the surface of the water, while faint strokes give the sailboats a barely perceptible swaying motion.

The second set features the interior of a bourgeois drawing-room, in which all the elements come together in a graphic play of curves and arabesques.

With reference to Dufy's stage sets, we should mention a series of drawings showing the great actor Émile Dehelly of the Théâtre-Français in a number of the roles from his repertoire, in particular that of a Marquis in *Le Misanthrope*.[23] Dufy captures his character with a striking accuracy of gesture and attitude: the assured line delights in the suggestive accents of the lace of his jabot and sleeves.

In 1944 Raoul Dufy, who was then in the South of France, returned to theatre design at the request of Armand Salacrou;[24] he was commissioned to design the sets and the costumes for *Les Fiancés du Havre*. This three-act play was first shown on 18 December 1944, at the Comédie-Française. Salacrou had written it during the war, in 1942, while he was a refugee in Lyons. The play is set in his birthplace, Le Havre, in 1908, and in it the author, drawing on childhood memories, recalls a story that occurred during this period. A cleverly balanced melodrama, *Les Fiancés du Havre* is rescued from being merely a portrait of provincial customs by Salacrou's poetry and imagination.

Dufy created a *fin-de-siècle* bourgeois interior in a winter garden with a large window looking out over Le Havre. The view of the city is outlined against a sky embellished with a big white cloud, that stands out (in a pictorial device familiar from Dufy's many *Amphitrites*) against the backdrop of the set. On the right-hand side, Dufy shows the houses of Sainte-Adresse, and places sailboats, yachts and steamers at the entrance to the bay. The interior, furnished in a Louis XV style, is in perfect harmony with the architecture of the set. A floral carpet partially covers

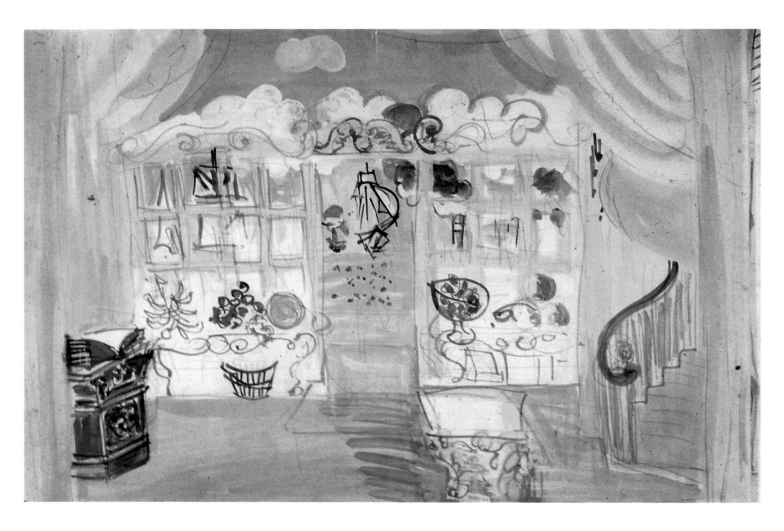

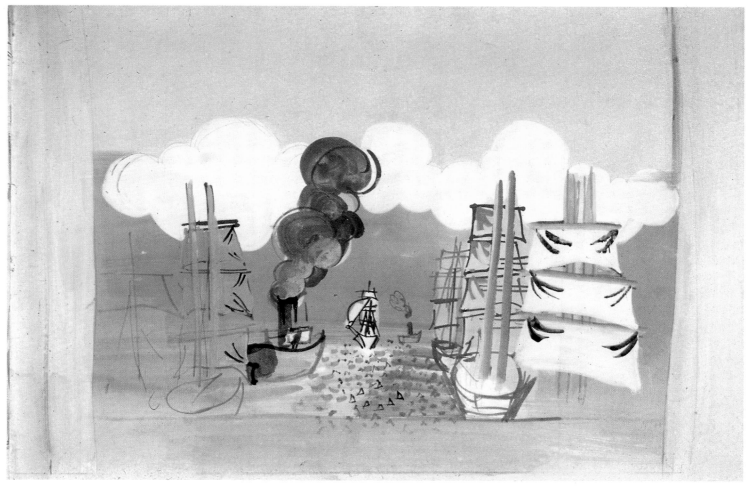

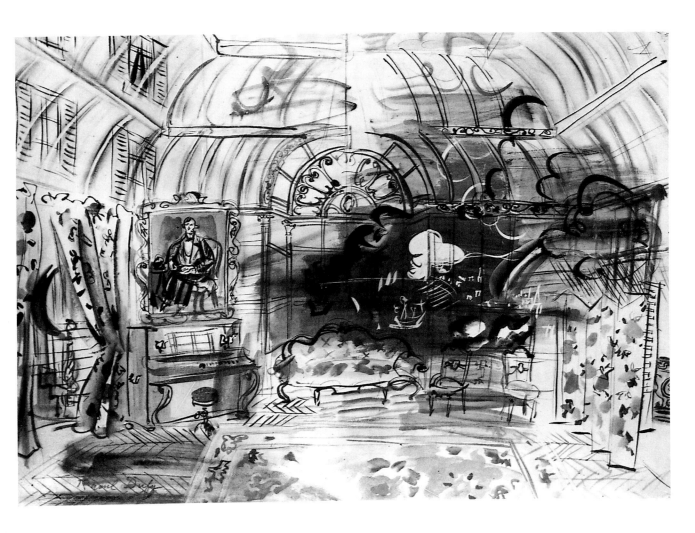

a chevronned parquet floor, harmonizing with the decoration of the screen in the corner. Prominence is given to the portrait of the *Paterfamilias* or *The Founder*,[25] seated, legs crossed, in a familiar pose. On the left-hand side a staircase leads off towards the terrace. Dufy made a sketch (in the collection of the Comédie-Française) showing the characters in this set, which was not only painted but actually built. The staircase leads the actors to the terrace whose windows look out on to the winter garden. To honour the original design a large backdrop was hung behind the set, and the frame of the set was painted in a series of horizontal bands featuring the same shades as the landscape.

Raoul Dufy also created the costumes: they were made from his sketches by the Maison Robert Piguet. For the role of Clotilde Duval-Lavallée, played by the actress Germaine Rouer, he designed a *fin-de-siècle* muslin dress decorated with ochre lace. In this dress we see a repetition of the brilliance that Dufy had shown in his work for Paul Poiret: with a sure hand he traces the undulating contours of the lace flounces and embellishes the bottom of the garment with little bows.

Contemporary reviews reveal that the costumes and the set were a success. 'From the moment when the curtain rises, Raoul Dufy's set, delightful and sardonic, takes us to a bourgeois Le Havre of 1908, with its wind and sea. The actors, dressed by Dufy, are quite at home in Salacrou's atmosphere'.[26] 'All in all [. . .] Dufy's set and costumes are a constant pleasure, amusing and delightful.'[27]

In 1944, *Les Fiancés du Havre* was shown at a gala evening arranged by General Koening, the governor of Paris, for the young orphans of the stricken city of Le Havre. During the second interval one of the set-designs was auctioned off, with the permission of Dufy, who was in Aspet, Haute-Garonne, at the time.

Raoul Dufy's work in the field of stage design was to continue until three years before his death, in 1953. In 1950, during his stay in the United States, where he went in the hope of ridding himself of the chronic polyarthritis which first afflicted him in 1937–38, he made the designs for the set of Jean Anouilh's play *L'Invitation au château*, retitled *Ring Round the Moon* and staged in New York by Gilbert Miller.

167 *Les Fiancés du Havre*, design for the stage set. 1944.
Watercolour and gouache.

Opposite
165,166 *L'Oeuf de Colomb*, designs for the stage set. 1934.
Gouache.

169 *Maxim's*. Maquette for *Ring Round the Moon*. 1950.
Watercolour and gouache.

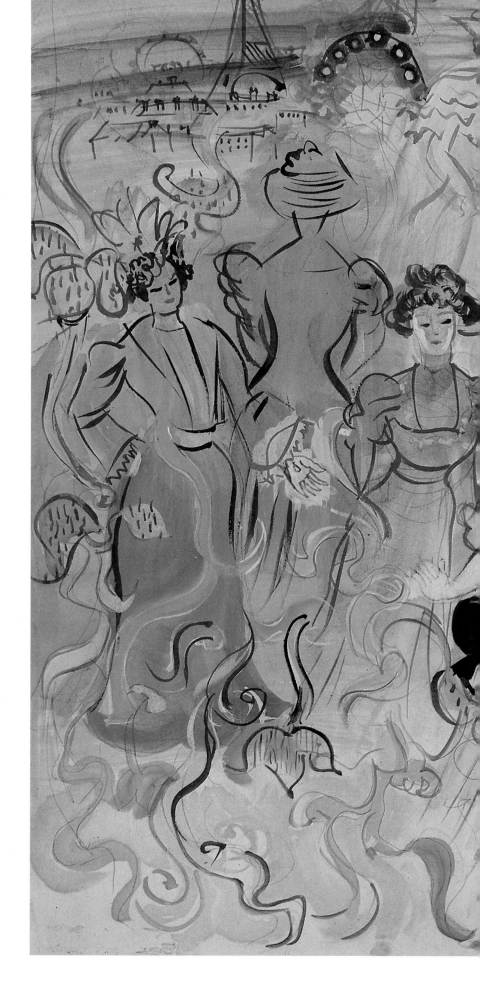

168 *Baccara*. Maquette for *Ring Round the Moon*. 1950.
Watercolour and gouache.

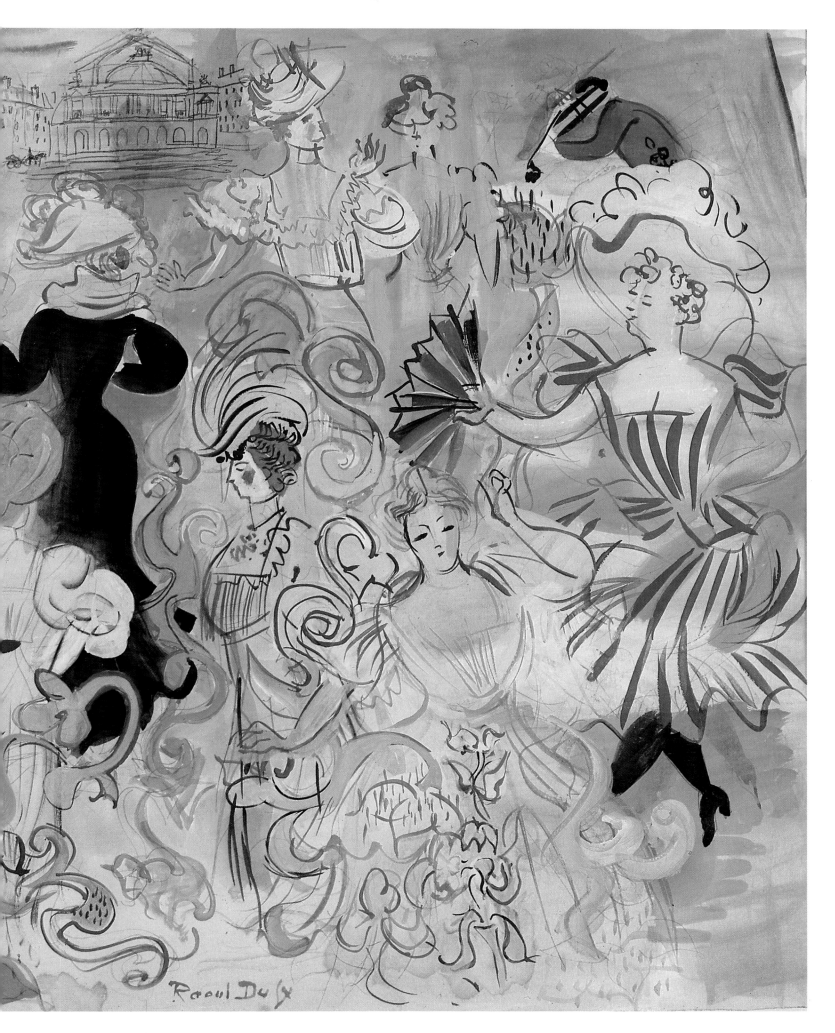

In France, this five-act play was directed by André Barsacq, who also designed its set and costumes, with music by Francis Poulenc. It was first shown at the Théâtre de l'Atelier on 5 November 1947 and was a huge success.

It was less popular in New York, where Dufy's designs for the backdrops were enlarged to such an extent that they lost all their charm, much to the disappointment of Jean Anouilh.[28] The themes of the six watercolour designs[29] evoke the elegant lifestyle of the 'jet-set', with its taste for casinos, large restaurants and ballets. Until the end of his life, Dufy would continue to paint witty parodies of gay and diverting subjects well-suited to his imagination.

The theme of *Baccara*,[30] which was the subject of a number of oil and watercolour paintings in 1925 and used in a hanging for Poiret's barge, *Orgues*, also adorns one of the stage designs. Dufy's visits to the Casino during his frequent stays in Deauville had given him the opportunity to capture – with his characteristic gift of observation – the behaviour and psychology of the card-players, whom he depicted with irony. He based the composition of his design on a graphic play of undulating lines, which echo one another and provide a rhythm to the stage set. The scalloped design of the gilded chairs, which seem to dance a kind of ballet in the lower part of the composition, match the long arabesques of the set with its combination of flowers and stylized leaves. These seem to hover above the gaming table like the kings and queens that rise out of the cards to give advice to the players.

Whirls of waving and curved lines fill the composition of *Maxim's*. These rounded lines stress the curves of the elegant women, the flow of their dresses and hats. This soft style and graphic rhythm give the scene an impression of frenetic activity. In Dufy's customary way, the composition is defined by different-coloured zones: the outlines of the figures, ringed by a simple line, are in some cases bathed in the ambient colour; others take on the local colour – the two figures in the centre, for example, who provide a contrast with their patches of black and white. In a quite unrealistic manner, Dufy places the monuments of Paris side by side – the Opéra, the Moulin Rouge, the Eiffel Tower and the Big Wheel.

Dufy was a lover of good food;[31] *Gastronomie* shows a luxury restaurant, its sumptuousness conveyed in the gilded wooden chairs, upholstered with red velvet, and the richly decorated panels of a Bianchini-Férier hanging which recalls the painting *Thirty or La Vie en Rose*. The curtains draped in the foreground lend the composition an air of opulence, along with the silverware, the *maîtres d'hôtel* with their impeccable bearing, and the clientele of elegant women and besuited men. With piercing irony Dufy depicts a privileged and cosseted society which is no longer capable even of appreciating its leisure.

In his watercolour designs for the backdrops to the set, *Arrival*,[32] *Ballet* and *Firework*, Dufy creates fine decorative effects. They provide a visual equivalent to the ballet on stage: the coming and going of coaches and horses against a background of greenery; giant multicoloured butterflies twirling about against a fantastical setting, and sumptuous arrangements of luminous sheaves of corn.

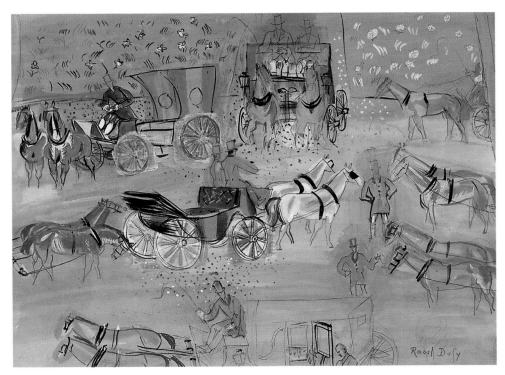

170 *Arrival.* Maquette for *Ring Round the Moon.* 1950.
Watercolour.

171 *Gastronomy.* Maquette for *Ring Round the Moon.* 1950.
Watercolour.

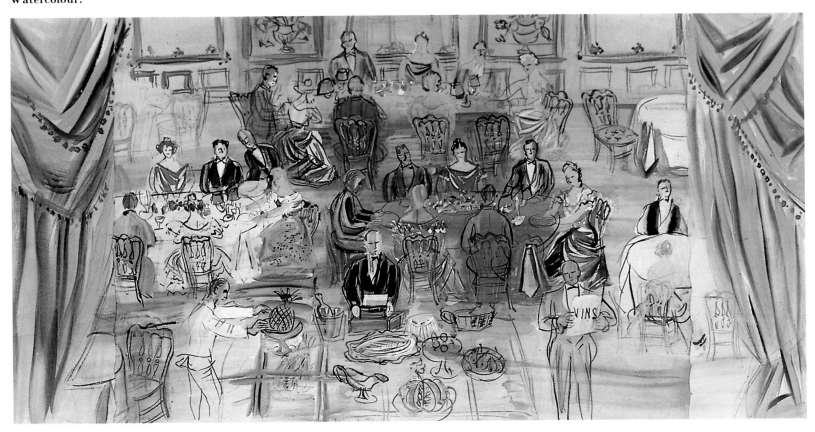

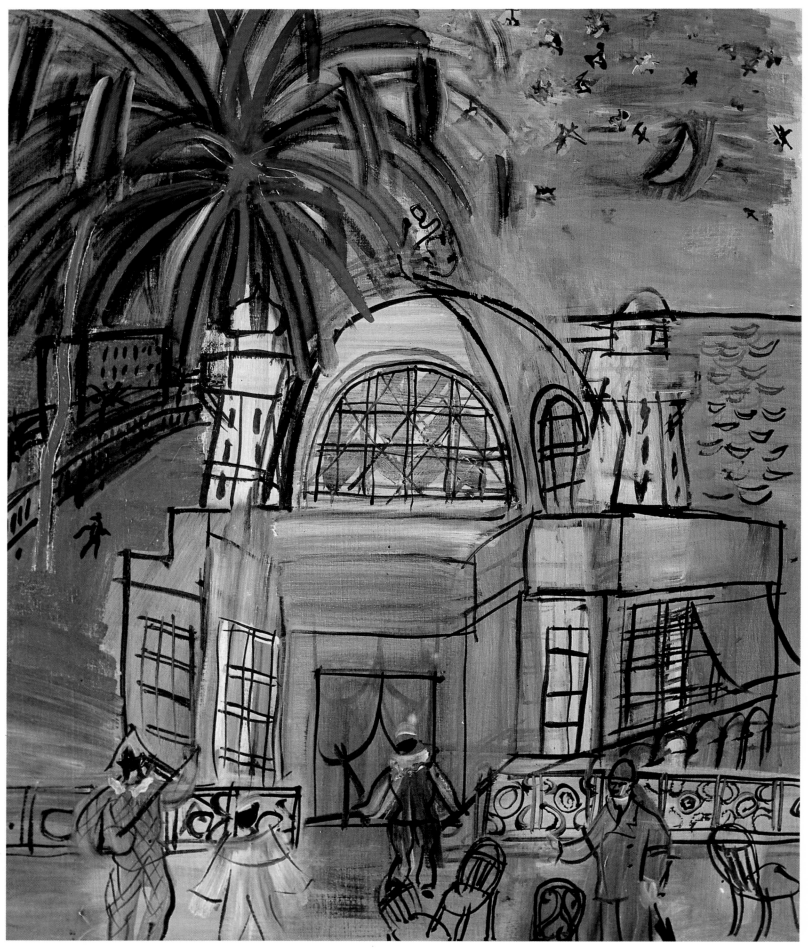

172 *Fireworks at Nice. The Casino de la Jetée-Promenade.* 1947. Oil on canvas.

V

SOUTHERN LIGHT

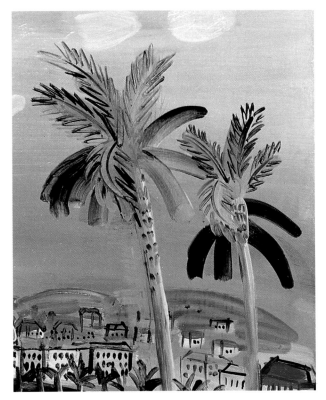

173 *The Baie des Anges at Nice* (detail of ill. 193).

While he continued his collaboration with Bianchini-Férier until 1928, Dufy's stays in Paris were interspersed with a series of journeys in France and abroad. His travels were divided along an East-West axis: on one side the South of France and the Côte d'Azur, Italy, Sicily and Morocco and, on the other, Normandy and the Côte Fleurie and England.

Provence attracted him most of all. From 1919 onwards he continually returned to Vence, the southern base of his studies on Cézanne. He stayed there a number of times, repeatedly attracted by the medieval architecture and ramparts of the town surrounded by olive-trees. He depicts them in a new light, far removed from his former concern with the representing of structured forms in a closed space. The hatched lines of his style in 1908 made way for a more flexible graphic mode, using brilliant colours, which supports the organization of these landcapes stretched out below the viewer or seen from a bird's-eye view. Between 1919 and 1923 he painted many variations on the subject of Vence[1] in which a mature and original pictorial style becomes apparent. Dufy's experiments under the influence of Impressionism, Fauvism and Cézanne's Cubism made him more aware of his own abilities. His work in fabrics helped him a great deal, too, providing him with a refined and coherent practice of 'couleur-lumière'. Confronted with the light of the South of France, he reinvented it and distributed it over broad areas of colour modulating the surface of the painting. 'Light is the soul of colour [. . .], without light, colour is lifeless,' he wrote.[2]

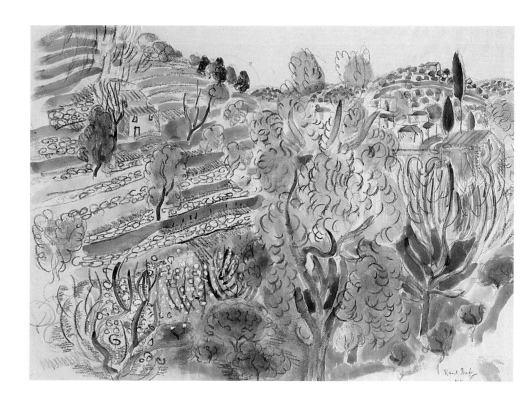

174 *The Hills of Vence.* 1919. Pencil and watercolour.

It was in Vence that Dufy adopted, in his paintings and watercolours, a method inspired by the practice of wood engraving and intensified in his works on fabrics for Bianchini-Férier, in which the colour was allowed to spill over the outline of the forms. This autonomy of colour and line gives each of these elements their maximum intensity, and asserts their complementarity. He would later explain that his desire to keep colour and form distinct was reinforced by a chance observation: the patch of colour of the dress of a little girl in red, running along the pier at Honfleur, stayed longer on Dufy's retina than the outline of her silhouette. Creating dynamism in this way gave Dufy the means with which he could reproduce in his landscapes a sense of depth.

The series of paintings of Vence and nearby Saint-Jeannet enabled him to pinpoint the essential elements of his landscape and retain in a light and simple

style the aspects that were constant in it: the olive trees and the terraced vines on the hillsides are depicted in a series of arabesques and loops; the roofs with their undulations representing tiles, or the leaves of the trees shown as supple and vivid curlicues: 'I am going to apply myself to studying the dynamic characteristics of the appearances of nature, those which are not immediately evident [. . .]. Those mysterious elements which come to light more slowly and which, once they have been identified, reappear in every view of a particular climate, a particular region, a particular environment. I shall therefore ignore the immediate appearance of things in order to seek their more profound face [. . .] I shall devote myself to truth to the point where only the true will appear.'[3] He very quickly built up a vocabulary of pictorial devices which summed up his original vision.

The Fountain at Vence is one of the series of paintings of Vence. The fountain's design, with its baroque lines, attracted Dufy: it was well-adapted to his stylistic imagination, as is *The Fountain at Hyères*, whose lively waters spouting from their decorative sculptures would later, around 1927–28, attract this eternal lover of waves.

The year 1920 was a milestone in Raoul Dufy's career. In April he signed a contract with the Galerie Bernheim-Jeune,[4] which gave him a one-man exhibition in 1921.[5] This was the first time that his talent received recognition. From that point onwards, Dufy's fame was confirmed in private and public commissions in the fields of tapestry and mural decoration.

175 *Le Baou de Saint-Jeanne.* 1929. Watercolour.

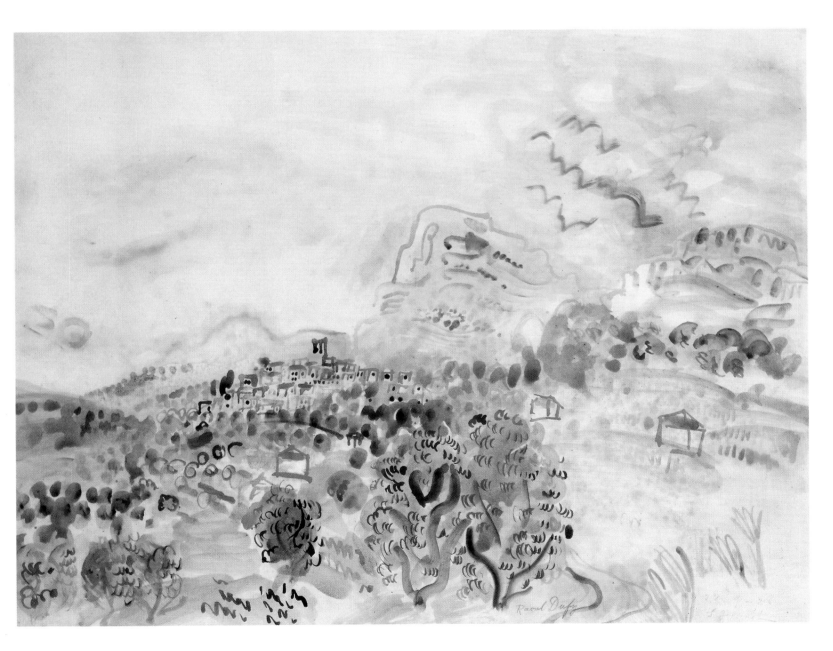

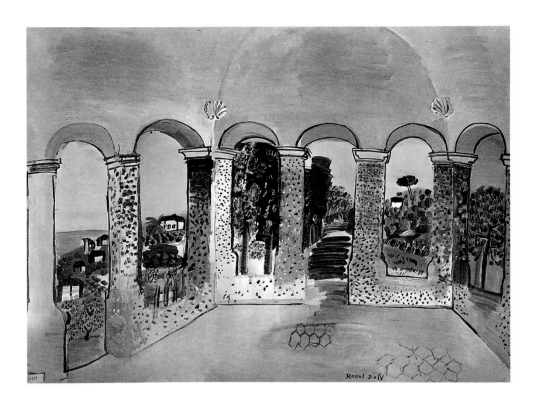

176 *The Chapel at Vallauris.* 1927.
Oil on canvas.

It was a man sure of his art who left the South of France in 1922 to travel to Italy and then to Sicily, in search of new forms of expression. His stopovers in Florence, Rome and Naples gave Dufy the opportunity to visit museums until he had 'indigestion'.[6] But he was not yet ready to confront the masters of the past. This he was not to do until around 1936, and later around 1943, by which time he had acquired a total mastery of his art and was equipped to interpret some of their works.

He was more attracted by the buildings in the Italian cities. A large number of watercolours and paintings depict Italian architecture. In Rome, the imposing façade of Saint Peter's Basilica, with its colonnade by Bernini, delighted him just as much as the building's interior. One of his travel notebooks[7] narrates his journey through Italy before reaching Sicily in a host of Indian-ink sketches.[8] One sketch shows the baldacchino with its twisted columns beneath Michelangelo's dome, a work by Bernini whose baroque design fascinated Dufy. Another study depicts a pontifical ceremony, with a great deal of accuracy and some humour. This same notebook, which he used in Sicily from the day of his arrival – 16 April 1922 – contains notes about the towns of Catane, Caltagirone, Calatabiano, Scordia, Alcantara (where he states that he has to go '248 Km to do the umbrella pine and Etna'), all places which would feature in numerous compositions.

Inspired by these Mediterranean landscapes, attracted by the ancient and modern buildings bathed in light, Dufy brought new life to the ruins of the Greek temple at Taormina, where, at the beginning of May, he was to meet up with Pierre Courthion: 'In Taormina [. . .] the air, touched by a fiery light, throbbed between the columns of the Greek theatre, above the overhanging rocks, from which the eye plunges into the sea spread out below [. . .] [Dufy] had taken up his position on the terraces, in the ruins of the Greek theatre, painting its columns.'[9]

For Dufy, Sicily's main attraction was the light. His diagrammatic construction, which had first appeared in Vence, characterizes his landscapes of Caltagirone and Taormina. With his simplifying line, he lays out his intense colours in strong horizontal hatchings, blue and brick red, highlighted by luminous white, which lend a rhythm to the arrangement of his architectural sites. The stone, caressed by the light and fed by the sea air, is given new life beneath his brush, and the slender shafts of the columns standing out against the sky seem to stretch towards him. The downward-sloping view shows us the Ionian Sea, whose surface is broadly modulated with deep blue, embellished with glittering white strokes. In his Sicilian watercolours, Dufy uses softer and more transparent tonalities, limited to pinks,

136

177 *Ancient Theatre of Taormina.* 1923.
Black lead.

178 *Taormina, Etna.* 1923.
Oil on canvas.

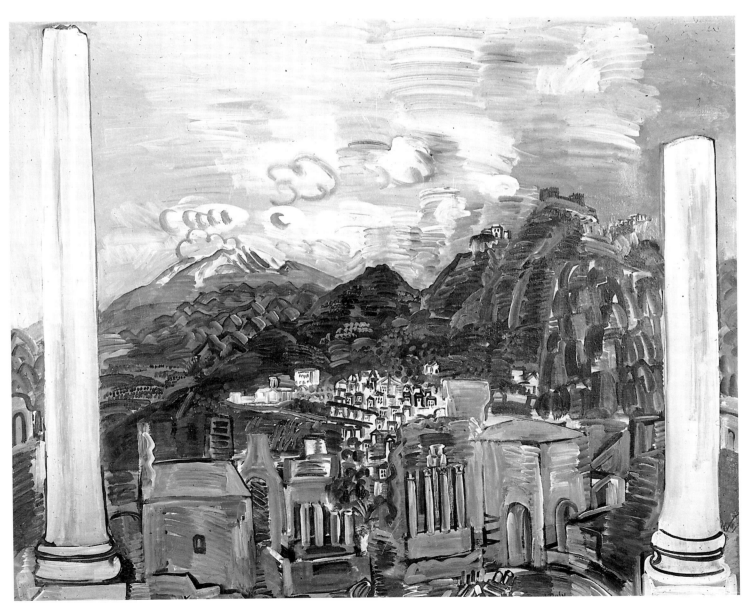

179 Study for *Nogent, the Oarsmen*. 1935.
Black lead.

180 *Nogent, Pink Bridge and Railway*. 1935–36.
Oil on canvas.

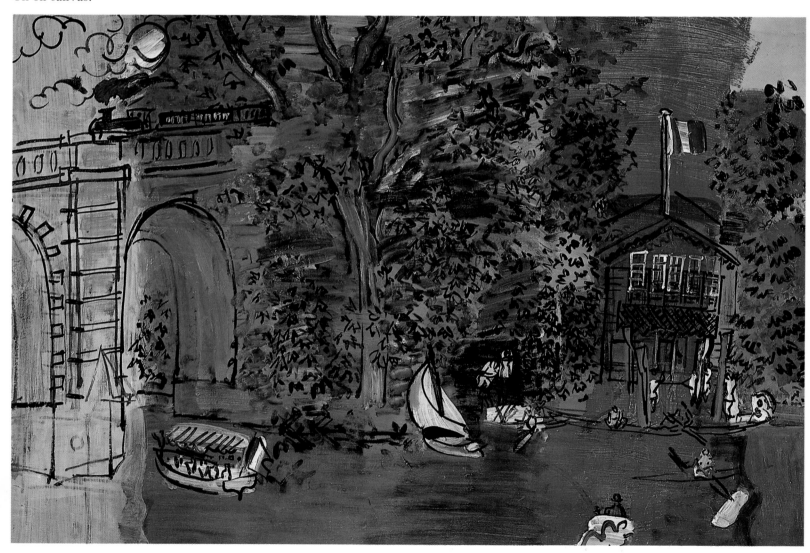

deep purples and lighter and more luminous blues. The bare white areas of the paper reflect the dazzling effect of the light on the colonnade of the theatre.[10] These lyrical landscapes glorify the beauty and nobility of Sicily.

The effect that his discovery of classical antiquity had on Dufy was not that of a 'retour à l'ordre', that characteristic reaction, in the immediate postwar period and at the beginning of the twenties, of the intellectual upheaval that the war had produced.[11] Dufy's reaction was very different. The expression of his art followed a logical development, based on a considered study of his visual media. His painting does not refer to the past: it remains original in its constant and profound quest for the expression of the 'couleur-lumière' that transcends his works, while capturing the permanence of a transposed reality. The effect of Greco-Latin culture was to encourage his taste for mythology and allegory.

On his return to France, Dufy used these studies to paint a large number of Sicilian landscapes in the studio. From now on, he would alternate paintings from life with studio paintings. Contact with nature remained a necessity for him; he referred to it in order to verify his own impressions and experiments. Work in the studio never replaced work done from life, however: 'One may paint from nature throughout one's life, but one may also accept that, having learned by years of practice which have shown us all the outward appearances that things can assume, and having discovered, through analysis and reflection, the main causes behind the phenomena of light and colour [. . .] you have a clearer opinion on the matter, and you have been able to establish a system for yourself that enables you to express yourself, brush in hand, without being forced constantly to go back and check each individual thing checked so often before [. . .] and that is why I have stuck with this principle of 'couleur-lumière' that has allowed me to venture, with both pleasure and ease, down many paths which had previously seemed entirely overgrown.'[12]

Although the theme of oarsmen appeared in his work in 1919, it was not until around 1923 that Dufy, still preoccupied by the problem of light, painted a series of Oarsmen on the Marne, on which he worked from 1921 until 1935–36.[13] This series of works, numbering around nineteen, was prepared in numerous pencil and pen-and-ink studies. They reveal a great deal about Dufy's working method,[14] and show the different stages in his experiments with the organization of the elements that make up these different versions. Most of his compositions are centred on the boathouse, sometimes embellished with a viaduct. The centre of interest is sometimes the surrounding landscape, sometimes the men by the river who are either getting ready or struggling with their boats. As Marcelle Berr de Turique stresses, Dufy is attracted by human activity: the oarsman on the water, the peasant in his field or the musician in an orchestra.[15] What he is seeking to capture is man at work, surrounded by light. Dufy distributes this light over the surface of the canvas according to a three-colour principle which allows him to modulate it by ridding himself of shadow. Refusing to divide each object into light and shade, he illuminates the vertical objects facing the source of light, arranging them vertically in relation to the light. Thus, he juxtaposes, vertically or horizontally, three zones of contrasting colours. Divided up in this way, these paintings are like the fabrics and hangings printed on different bands of colour, free of any modulation in their shading, which Dufy was making for Bianchini-Férier at the same time. Here one can see the effect that his experiments in the field of decoration had on his painting.

The year 1925 marked a turning point in Dufy's career. A protégé of the Galerie Bernheim-Jeune, he became a highly acclaimed painter. The gifts that he showed in his work for Bianchini-Férier won recognition. He received State commissions for the Mobilier National. Eulogies of his work poured from the pens of the most celebrated critics. Élie Faure published an article about his drawings in L'Amour de l'art, which also included writings by René Jean[16] and Pierre Lièvre.[17] Pierre Courthion wrote at length on his Fantaisies in L'Art vivant.[18] Roger Allard devoted an issue of L'Art d'aujourd'hui to him. Christian Zervos wrote a commentary on his oeuvre in Les Arts de la maison.[19] André Salmon devoted an article to him in Plaisir du bibliophile.[20] In Belgium, Dufy was already famous: the Antwerp magazine Sélection published two major articles on him.[21] His hangings for Paul Poiret allowed him to take part in the 1925 'Exposition des Arts Décoratifs et Industriels'. From that date on, Dufy returned to his work as an illustrator of literary works,

181 *Portrait of Eugène Montfort.* 1930.
Pen, wash and black lead.

which he had to some extent abandoned since the 'adventure' of the *Bestiaire*, apart from the drawings for *Madrigaux* and the making of vignettes. At the end of his life, Dufy expressed his idea of the painter-illustrator as follows: 'You must never follow the text. That is an invasion of the reader's mind. Illustration is an analogy'.[22] For Dufy, illustrating a text meant evoking its spirit by creating an original work beyond descriptive fidelity. Illustration is a formal expression, different in nature from the text, which leads the reader in the same direction as the writer's words, but using the media of the painter: it is a matter of providing a visual equivalent, of proceeding by 'analogy'; the image is not literal, and its relation to the text is established by correspondences. In demonstrating his sense of the text and its interpretation, Dufy acted as a creator, giving free rein to his natural imagination.

La Terre frottée d'ail by Gustave Coquiot in 1925,[23] and then, in 1930, *La Belle Enfant ou l'Amour à quarante ans* by Eugène Montfort,[24] and in 1931 Daudet's *Tartarin de Tarascon* gave him the opportunity to return to the South of France, which he was to glorify in all its splendour.

In the drawings illustrating Coquiot's text, whose flavour had appealed to him, the etchings for *La Belle Enfant*, and the colour lithographs for *Tartarin*, Dufy conveys the atmosphere and aroma of the towns of the Mediterranean. His lively, dexterous and concise line produces images full of imagination and humour: bustling streets, little squares and markets lend themselves to his gifts of observation and his acute sense of reality. A detail or an attitude convey the vigour and vividness of the figures painted from life. The landscapes of Provence spread out in vast panoramas, bathed in light, broadened out by the elevated viewpoint. The spectacle of the ports, and Marseilles in particular, was of great interest to him, and they are portrayed from various points of view. His 1930 etchings are even more skilful than his 1925 drawings: his graphic style has developed unparalleled breadth and refinement, and the constructions of his page-settings are highly daring. The many variations on the port of Marseilles are arranged in a symphony of visual rhymes: undulating convex and concave curves formed by the curved hulls of the ships whose vertical masts bear the oblique angles of their taut sails. Beams of light are reflected in long parallel horizontal brushstrokes on a glittering sea. These vibrations are conveyed in a great mass of circumflex accents, more or less sharp according to the movement of the waves. One thing is plain: Dufy never repeats himself. In this homage to the city and port of Marseilles he began afresh in each of his works.

The art dealer and publisher Ambroise Vollard commissioned Dufy to illustrate *La Belle Enfant*.[25] Since Dufy was not a close friend of the author, the very fact of the commission is an indication of his fame. Indeed, Vollard 'wanted a book that would be the masterpiece of a great painter.'[26] Out of this banal text, which he

182 Study for *Le Salon d'Aline*.
Pen and black lead.

183 *Le Salon d'Aline*, etching for *La Belle Enfant ou l'Amour à quarante ans* by Eugène Montfort. 1930.

found less inspiring than the city of Coquiot's novel – Dufy made a masterpiece, through the perfection of the refined line of his etchings.[27]

The preparatory studies for these engravings reveal Dufy's highly exacting nature. Vollard relates in his memoirs, with regard to the *Salon d'Aline*, that such an intimate evocation of a brothel was the result of a personal visit by the painter who was determined to record and recreate its atmosphere.[28] The Musée National d'Art Moderne has a sketch of the spiral staircase with its steps covered by a print carpet, its sinuous banister stressing the vertiginous aspect of the composition. He takes us inside the salon which is the subject of a drawing[29] with numerous accents in pen underlined by corrections and repetitions in black lead.

When he was making the lithographs for *Tartarin*, the same rigorous working method led Dufy to travel first to Tarascon,[30] and then to Algeria.[31] The quality of the illustrations makes this work one of the greatest bibliographic successes of our time. This success did not come easily, and the illustrations took five years to complete.[32] Commissioned in 1931 by Dr Roudinesco for the group of bibliophiles and art-lovers, Scripta and Picta,[33] *Tartarin de Tarascon*, illustrated with seventy colour lithographs, was not published until 1936. The mastery of Dufy's style

184 Study for the staircase of *Le Salon d'Aline*. 1930.
Pen and Indian ink.

185 The staircase of *Le Salon d'Aline*, etching for *La Belle Enfant ou l'Amour à quarante ans* by Eugène Montfort. 1930

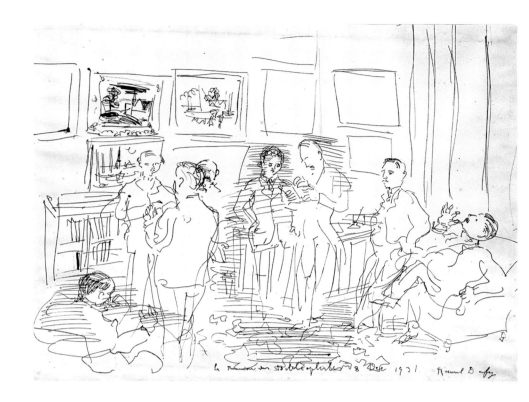

186 *The Meeting of Bibliophiles.* 1931.
Pen and Indian ink.

matches the authority that he shows in his choice of colours. In many of the illustrations, Dufy adopts the now familiar method of three-colour tonality. His chromatic scale ranges from the use of binary tones – such as green brought together with violet – to the use of primary colours which are explosively orchestrated into a brilliant fanfare.

By the time of his visit to Algeria in 1934, Dufy was already well acquainted with the landscape of North Africa which he had discovered in Morocco, in 1926, with Paul Poiret. This Orient presented itself to him in all its splendour during a journey which took him from Fez to Meknes, Casablanca, Marrakesh and Demnat, into the Atlas Mountains, and allowed him to travel to Spain via Tangiers, Seville – where he was able to see the *corridas* in Holy Week – and Madrid, where he admired the works of Titian in the Prado.

Dufy was dazzled by the light, which transposed colours and transformed nature. He was fascinated by the people: like Delacroix who, at the sight of those men majestically draped in their burnouses, thought he had rediscovered classical antiquity, and noted in his *Journal*: 'Rome is no longer in Rome.' Dufy wrote to his friends: 'Imagine that all the people in the Bible were still alive [. . .] we are rubbing shoulders with the descendants of the Old Testament tribes.'[34] He was impressed by the royal reception of the Glawi, the Pasha of Marrakesh, who organized a series of grand celebrations in honour of his guests. His letters home, which read like a superb traveller's journal, reflect his enthusiasm,[35] referring to his 'wonderful stay', 'his enchanted journey', from which 'we could not send picture postcards, as photography would seem like a profanation of the spectacles that we enjoyed'.[36] 'How can I give you an idea of this phantasmagoria?' he wrote to his friends. 'I have been working, and am bringing back about forty watercolours and twenty drawings [. . .] I shall turn them into an exhibition at Bernheim,' he announced. Watercolour was his favourite medium: 'watercolour, watercolour everywhere [. . .], and when I return not a drop will be left in Morocco, the watercolorists who try their luck after me will have to wait for the next rainy season'.

His Moroccan works, painted with great freshness, capture the memory of sumptuous banquets: '[. . .] meals with forty dishes eaten with the fingers', pastillas or couscous served by 'bejewelled slaves, framed by mosaics as intoxicating as dancing or the songs of the Boche', fantasias organized for their benefit, heat-scorched Moroccan landscapes, the internal courtyards of palaces with their marble latticework, and gardens with fountains cooling the air. An atmosphere of peace

142

187,188 Lithographs for *Tartarin de Tarascon*
by Alphonse Daudet. 1931–36.

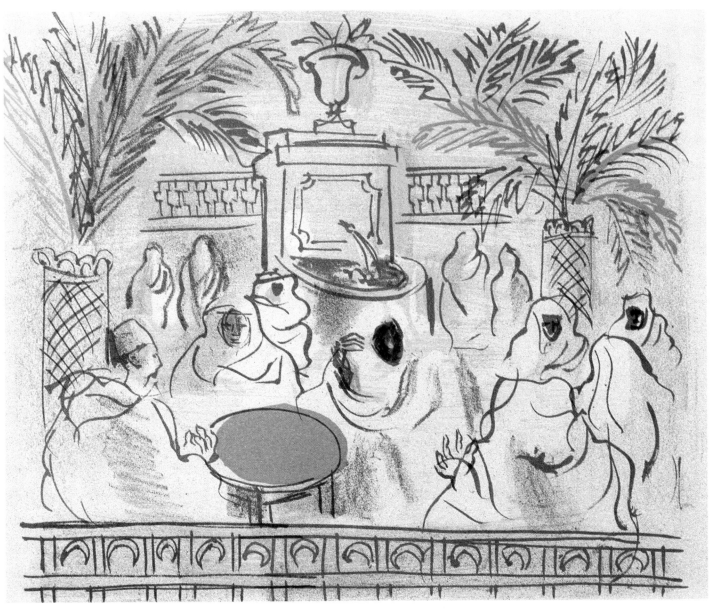

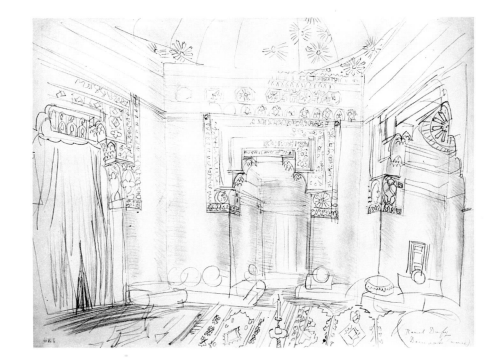

189 *Interior in Morocco. Demnat.* 1926.
Black lead.

190 *Café in Morocco.* 1926.
Watercolour.

191 *La Pastilla*. 1926. Gouache.

192 *The Pasha's Garden*. 1926. Watercolour.

bathes these richly decorated Moorish interiors, particularly at Demnat, which Dufy so admired: '[. . .] a wonder, Provence twenty times over'. In his *Mémoires* Poiret writes of 'the blue cedars and the massive oaks and the hundred-year-old olive trees and the courtyards planted with lemon trees, deliciously fresh'.

Dufy's Moroccan watercolours affirm his desire to place the highest importance on '*couleur-lumière*'. He plays with clear, light tonalities, applied with a broad brushstroke, over which he draws, with a lively line and without the slightest correction, people, landscapes, buildings and decorative motifs. Thoughtful and spontaneous, this spirited style testifies to a virtuosity sparing in its means of expression.

The watercolour *Souvenir of the Prado*, painted after he returned from his travels, in Golf-Juan, April 1926, reveals the shock felt by Dufy when he saw 'the most beautiful painting ever painted, Titian's *Venus, Cupid and an Organist*': 'There is a moment in the life of an artist', he declared to Zervos, with regard to this work, 'when admiration fortifies the personality.'[37]

Returning to France, Dufy stayed on the Côte d'Azur. His favourite spot was Nice, his wife's place of birth. The Jetée-Promenade and the Baie des Anges, spread out before him, recur a number of times in his paintings. *The Casino de la Jetée*, with its 'composite oriental baroque' style was a favourite subject.[38] He took pleasure in depicting the arabesques of its domes in juxtaposition with the curves of the palm-trees framing it. The building sometimes appears on its own, but most often the composition is animated by little groups of fashionable people and the comings and goings of the barouches. The 1947 version is the most fully accomplished: a dazzling firework display surrounds the Carnival, crowning it with a burst of fire. Dufy was always attracted by these beams of light, symbols of festivity and joy, and included them in many of his compositions.[39] He gave these transient flashes the consistency of colourful rays as permanent as the buildings they illuminate.

Another favourite subject was *The Baie des Anges at Nice*.[40] Its range of blues is modulated in a series of gradations ranging from a cerulean blue to cobalt blues mixed with clear blacks, which convey a profound luminosity: 'Blue', he declared, 'is the only colour which, whatever its tone, preserves its own individuality. Look at blue in all its different shades, from the darkest to the lightest; it is always blue.'[41] This dominant blue bathes the entire composition, and the various elements all participate in this tonality: the hills on the horizon, the façades of the houses and the human figures.

The Open Window at Nice looks out over the Baie des Anges. The theme of the window in painting, its role in the definition of space and the way in which it relates one space to another are matters that have always preoccupied painters, 'from Alberti to Cézanne',[42] from the Cubists and the Surrealists to contemporary artists. 'Do not imagine that if artists so often paint windows this is a reflection of their concern with framing. No, it is because painting is the opening of a window, the two things are the same.'[43]

The window motif, which Dufy had painted at the beginning of his career, in 1899, as an iconographic element within the space of the painting itself, returns with great force between 1915 and 1924. A link between the still life and the landscape, the window articulates the interior space of the still life and the panorama, and leads to their interpenetration in a play of chromatic forms. For the Surrealists, the window shown in an imaginary space forms the site of the discovery of another reality: oneiric space.

This theme is a favourite of Robert Delaunay's; his series of *Windows* is not anecdotal: in these paintings he pursues a dynamic representation of light by means of colour, using a harmonious accord of contrasts. The many *Windows* painted by Matisse should be seen as a means of creating a unity from the pictorial plane and the three-dimensional space of the painting. Raoul Dufy could have made Matisse's statements his own: 'If, in my painting, I have been able to bring together that which lies outside, for example the sea, and that which lies within, it is because the atmosphere of the landscape and the atmosphere of my room are one and the same [. . .] I do not have to bring the outside and the inside together, as they are united in my senses.'[44]

146

193 *The Baie des Anges at Nice.* Around 1926.
Oil on canvas.

Windows play a part in many of Dufy's compositions. Later on we shall study
the role that he gives them in his *Studios*. He includes doors or curtainless windows
in his interiors in order to establish a dialectic between the interior space and the
exterior perspective.

This interplay is apparent in the *Interior with Open Window*. In this work he
shows a remarkable skill in composition, brilliantly orchestrated by a clever
interaction of the different spaces and the establishment of chromatic and formal
interrelations. The two bay windows open wide on to the Gulf of Nice, and the
'*couleur-lumière*' that depicts the sea and the sky invades the interior of the room;
this unification of colour abolishes the boundary between the two spaces. Dufy uses
the metaphor of the mirror: placed against the light between the two bay windows,
it constitutes a point of transition, another 'open window' on to the closed space of
the room, and thus enlarges its dimensions and heightens the interior-exterior
juxtaposition. The floral motif of the carpet with its shrill colours highlights the
elegance and freshness of the bouquet of broad-leaved white arum lilies.

Dufy resorted to the same subterfuge when painting the interior of the *The Royal
Yacht Club at Cowes* in 1936. The large bay window of the lounge, looking out over
the port where pleasure craft are sailing, by its very transparency deepens the space

147

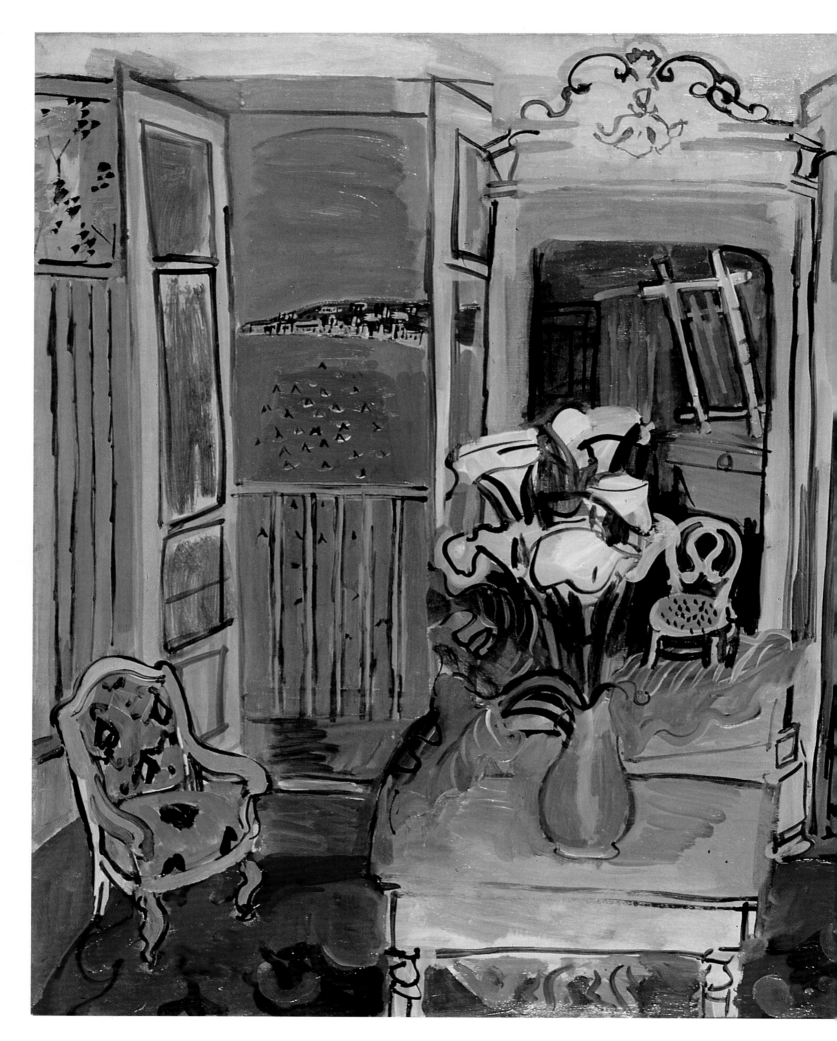

194 *Interior with Open Window.* 1928.
Oil on canvas.

of the room, which is extended into the external expanse by means of the same green tonality.

In certain works the motif of the window, sometimes with shutters or curtains, serves as a frame for the landscape outside; whether this landscape consists of the monuments of Paris, the port of Marseilles or the city of Aix-les-Bains, it is no longer a question of a 'contagion' between external and internal spaces.

The idea of a homage to Claude Lorrain had been developing in Dufy's mind since his return from Sicily, where he had made his decisive discovery of light. It was to come to fruition in the works which he devoted to Lorrain in 1927. 'Claude Lorrain is my God,' he declared. It is not difficult to understand the reasons for this fascination, if we consider the central importance that Dufy gave, in his work, to a subjective vision of reality, a conception of non-traditional space and to ways of expressing light. The new solutions which he had already found for the problems that concerned him are confirmed in the work of Claude Lorrain. In his homage to the artist he made a series of watercolours and oil paintings which testify to an understanding and a personal interpretation of the aesthetic of the great classical master. Having long since abandoned an objective imitation of nature, a simple 'hypothesis', Dufy, following Lorrain's example, offers us his idealized conception of a re-composed landscape. He devises a location unrelated to any precise reality: in a fully classical symmetrical structure he places invented buildings around his composition, a synthesis of memories of the Provençal cities that he has known; he arranges a background of sailboats returning to port; with a luxurious arbitrariness he includes a fountain with tritons – the fountain at Hyères, the subject of earlier compositions (1927–28); he introduces cabs and sleeping drivers, an accordionist and a violinist, children and horses.

From the art of Lorrain, Dufy retained the depiction of the luminous atmosphere, creating the sensation of space and depth. Finding in Lorrain's work a lighting method corresponding to his own efforts in the transcription of light, he experimented with his own solutions in his lyrical composition. The light that bathes the landscape is invented and distributed according to Dufy's principle of 'couleur-lumière'. The value of one tone in relation to another and their equivalent in light are more important to him than true colour: 'The colour captures the light that forms and animates the group as a whole. Every object or group of objects is placed within its own area of light and shade, receiving its share of reflections and being subjected to the arrangement decided by the artist.'[45] This is a summary of

195 *Homage to Claude Lorrain.* 1926. Watercolour.

Dufy's pictorial credo, which derives from Cézanne: 'One must not imitate the sun, one must make oneself into a sun.'[46] Dufy further explains his idea in his notebooks:

I paint with my material, colour, which produces its own rays from within itself, while in reality the star-sun is there to animate the colours by illuminating them. If I had a star-colour at my disposal, I would use it to illuminate my colours. But in my painting, the material, colour, creates the star, it is not produced by it; that is, each coloured object represents the reflection of a star absent from the painting, and when the object itself is present on the canvas, you can give it a colour, either yellow or white, but you cannot create all the lights of the different objects with the colour that you have chosen to represent the sun, the source of light; rather you are obliged to substitute for the objects, even those parts illuminated by the direct rays of the sun, their local and objective colours, and it is the harmony and distribution of these 'lumières-couleurs' that create the composition and the harmony by not giving it a local colour, since it is the confluence of all possible colours: it is here that my practice of 'couleur-lumière' joins the system of the theory of colours.[47]

Dufy's *Homages to Claude Lorrain* are dominated by his science of colour relationships: the use of a black dominant that floods the painting – a transparent black that is synonymous with light, already used to convey the luminosity of the Mediterranean in his views of *The Bay of Nice*, and which recurs in contemporary compositions made between 1925 and 1928, such as the *Regattas* and *The Nautical Festivals* in Le Havre, or *Bathers in the Sea*. Dufy uses it to orchestrate the blues and greens of the Channel in a joyful symphony of colour. He uses the colour black not to try to convey the depth of the water, but rather to express the intensity of the light, a method used by Matisse in 1914 in his *Window at Collioure*, and before him by Odilon Redon, who gives black a value of luminosity.

In *Bathers in the Open Sea and Scallop-shells*,[48] Dufy highlights this harmony of colour accents: red for the bathers, white for the sailboats dotted across the expanse of the sea. From now on he would adopt a bird's-eye perspective which would allow him to tier the composition and increase the sensation of space by raising the line of the horizon, mingling sky and sea. This composition, in which the invented is combined with the observed, unites its various elements according to an imaginary scale that accords the same importance to bathers and boats, following a principle legitimating the originality of his vision. The imaginary aspects of this arrangement are stressed by the simultaneous presence of contemporary sailboats and steamers and a three-master, sails unfurled, dating from 1890. The evocation of

196 *Homage to Claude Lorrain.* 1927.
Oil on canvas.

151

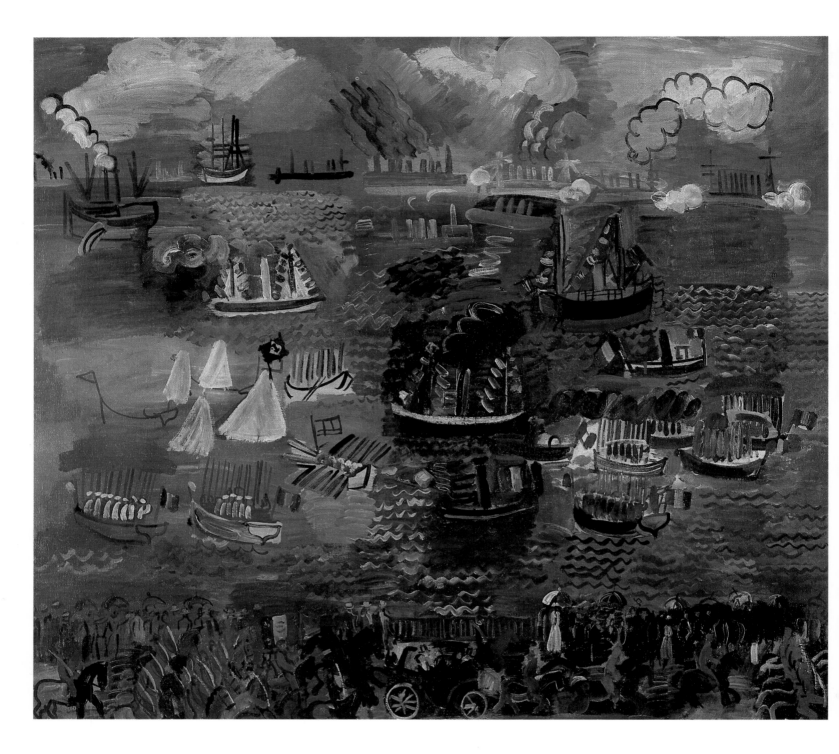

197 *Nautical Festival at Le Havre.* 1925.
Oil on canvas.

this ship was doubtless suggested to him by a small-scale model from the fine collection of miniature ships, exact replicas of life-sized models, which he kept in his studio.

Bathers and sailboats float on a sea portrayed in a vocabulary of characteristic pictorial devices that convey the glittering of the light on the surface of the water. The same vibrancy recurs in Dufy's views of the *Nautical Festival at Le Havre* and the *Naval Review at Le Havre*; it stresses the importance of the expanse of the sea, leaving only a small amount of space to the sky that sometimes mingles with it. Giving the far distance the same degree of definition as the foreground, Dufy uses it as a vertical backdrop with sailboats and steamers attached to it, portrayed with precision, but with no variation in scale according to their real proximity or distance: for the painter it was enough that they should provide a rhythm to the composition with their flags and raised masts. The decorative harmony of the multicoloured flags and the smoke, mingling their coloured arabesques with those of the clouds, contributes to the evocation of an atmosphere of festivity and jubilation.

152

Returning to Normandy in 1928, Dufy spent some time at Villerville, between Honfleur and Deauville. Many views of this site show his big house with its tiled roof and half-timbered red-brick walls, facing the sea. The elevated perspective gives us a direct view of the sea with steamboats and pleasure craft floating on it. These evocations create an impression of dreamlike serenity. It is no wonder that during the same period they were a major inspiration behind Dufy's painting of an original poster commissioned by the French Railways, which has since entered the history of the railway poster.[49]

In his depictions of *The Jetty at Honfleur* and *The Harbour at Deauville* Dufy reveals his stylistic mastery and conciseness. The artist keeps his details to a minimum in favour of a higher level of figuration in his compositions. *The Jetty at Honfleur* and *The Jetties at Trouville and Deauville* were the subject of numerous compositions animated by the rhythm of the strollers, often evoked by patches of colour of various degrees of brightness, whose alternation stresses the dynamic of the painting. These works convey an increasing independence of form and colour. We should remember that it was on the jetty at Honfleur that Dufy had, in 1926, seen a little girl running in a red dress, and confirmed that colour remained longer on the retina than form. He applied this process at the very spot where this fortuitous experience had occurred. The spontaneity of the brushstroke, broadly applied, the free style in which he paints the sea and the sky, modulated with the same tonalities of blues and greens, give the painting the appearance of spontaneity. The construction of the painting and the apparently arbitrary choice of the colours have been thought out with great maturity: the visual rhymes of the curves of the jetty and the shore, juxtaposed with the verticals of the strollers, the lighthouse and the steam-funnel; bright complementary tones of red and green are opposed to the contrasts of the light and dark tonalities that characterize the human figures.

199 *Normandy*. 1928. Advertising poster for the Société Nationale des Chemins de Fer Français.

198 *Railings*. n.d.
Pen and Indian ink.

200 *The Jetties at Trouville and Deauville. The Return of the Regatta.* 1930.
Pen and Indian ink.

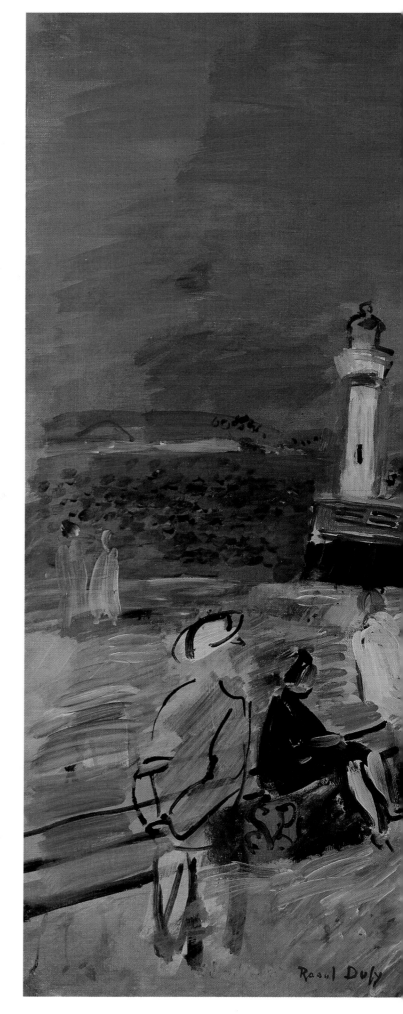

201 *The Jetty at Honfleur.* 1928.
Oil on canvas.

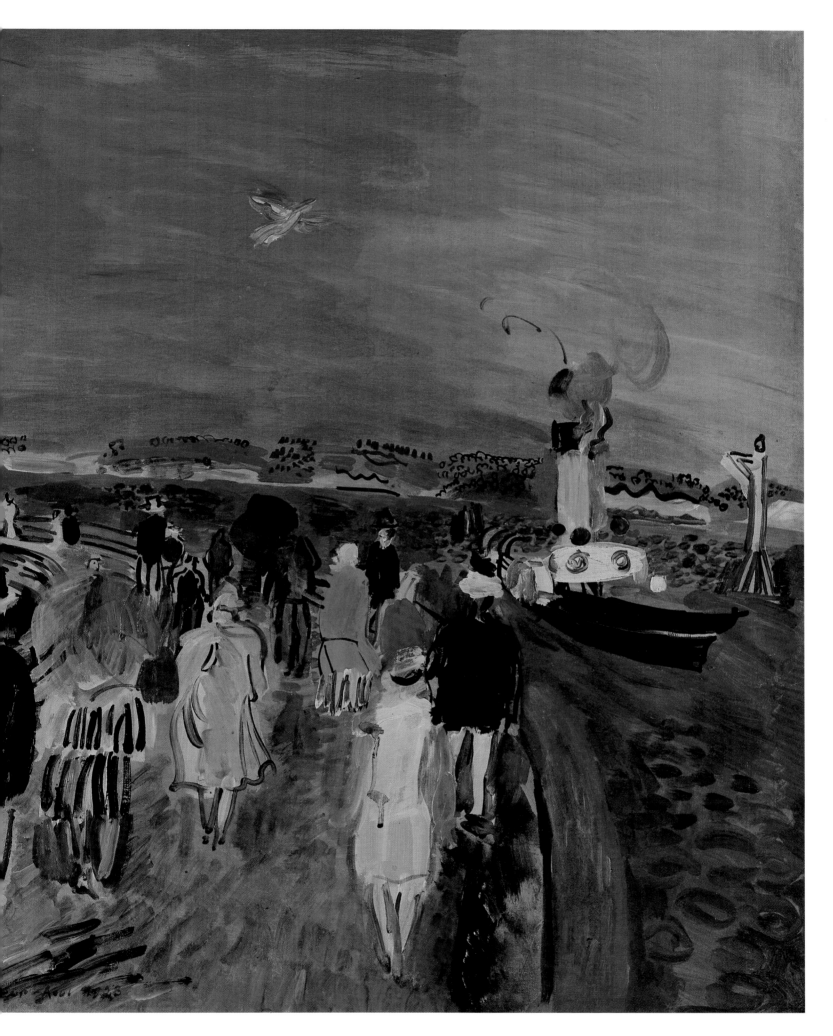

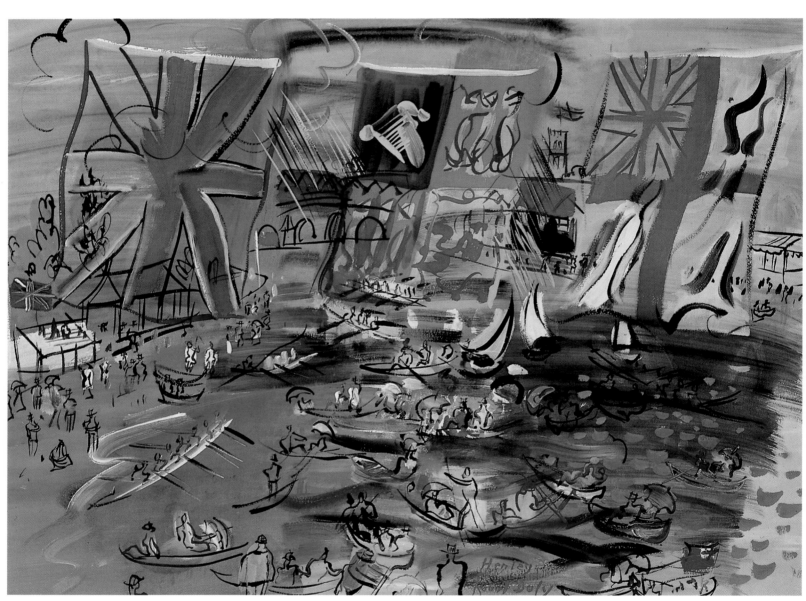

202 *Henley Regatta.* Around 1933. Gouache.

VI

REGATTAS AND RACES

203 From a sketchbook of the races at Deauville.
Pen-and-ink drawing.

204 *The Harbour at Deauville.* Around 1928.
Oil on canvas.

205 *Cowes Regatta.* 1935.
Oil on canvas.

Apart from Le Havre and the Bay of Sainte-Adresse, to which he would constantly return, Dufy was particularly fond of Deauville.

Deauville meant festivities, and the various sights of the town prompted a large number of compositions on the themes of races, regattas and social gatherings at the Casino.

In the various versions of *The Harbour at Deauville*, the boats are merely outlined, and prime importance is given to the representation of the flags hoisted on their masts or on the rigging of the sailboats. They lend the composition a rhythm with their bright coloured dots, echoed in the broadly applied patches of colour of the onlookers gathered on the shore. In some cases Dufy paints them from the opposite shore of Trouville, from which we can discern the half-timbered houses of Deauville alongside the boating-port. Looking in the other direction, we sometimes see the tiered houses of the hill of Trouville, with the big coloured flags standing out against it.

Here we have the pleasure craft decked out for the regattas. Dufy enjoyed conveying the liveliness of the departing sailboats that articulate his compositions, with their masts thrust out against a sea and a sky painted in broad brushstrokes.

His place of birth, Le Havre, serves to explain Dufy's fascination with the sea. During his *Entretiens* with Pierre Courthion, he stresses its importance in the training of a painter: 'Unhappy the man who lives in a climate far from the sea, or unfed by the sparkling waters of a river! [. . .] The painter constantly needs to be able to see a certain quality of light, a flickering, an airy palpitation bathing what he sees', and speaking of 'that estuary light' that has transported him since childhood, he adds: 'Do not forget the Seine estuary formed by the triangle of Le Havre-Honfleur-Trouville.' Elsewhere he says to René Coty: 'I can see the light of the bay of the Seine wherever I am.'[1] For Dufy, obsessed by the problem of '*couleur-lumière*', the sea – either the Channel or the Mediterranean – provided a range of constantly changing experiences.

The sea attracted his attention as a backdrop for human activities and as an excuse for painting lively spectacles bathed in light.

The theme of regattas appeared very early in Dufy's *oeuvre* (1907–08). He was to orchestrate it in many different variations, preceded by a large number of ensemble and detail studies – in Le Havre and Deauville, between 1925 and 1930 and, in England, at Henley and Cowes between 1930 and 1934 – from which he would make lively compositions.[2] He returned to this theme over and over again, expanding and transforming it. The variations arise in the structure of the paintings and the choice and arrangement of colours. A master of his technique, he made use of an increasingly free and dynamic composition, with vibrant colours exploding in a fanfare to announce the start of the race. His lines sacrifice detail in order to convey the general impression.

Even more important than the flags on the boats of *The Harbour at Deauville* are the banners of the *Regattas at Henley*, with their brilliant colours and disproportionate dimensions. They are placed in the foreground to orchestrate this explosion of joy and happiness. The constant factor in all these variations is the general feeling of elation, the atmosphere of jubilation.

The theme of horse racing is also the subject of numerous variations. Having first appeared in Dufy's Cézanne phase, with the 1913 *Paddock*, which reveals his concern with structure and composition to the detriment of colour, it assumed particular importance between 1923 and 1925. During this time, Poiret was taking Dufy to race-courses to paint his elegant models playing coquettishly with their parasols, in the company of the top horse-owners who had come to admire their animals at the weigh-in. Dufy's interest turned increasingly to the horse in action on the race-track. In his sketchbooks he jotted down the silhouettes of the figures in the spectator area and the various attitudes of the horses captured mid-race. These studies reveal his attention to evocative details: his paintings and watercolours admirably convey the special atmosphere of race-courses and the gaily coloured crowd of spectators.

These race-course scenes – whether in France, at Deauville, Longchamp or Chantilly or, in England, at Epsom, Ascot or Goodwood – allowed Dufy to put his '*couleur-lumière*' theory into practice. When the light ran parallel to the earth he

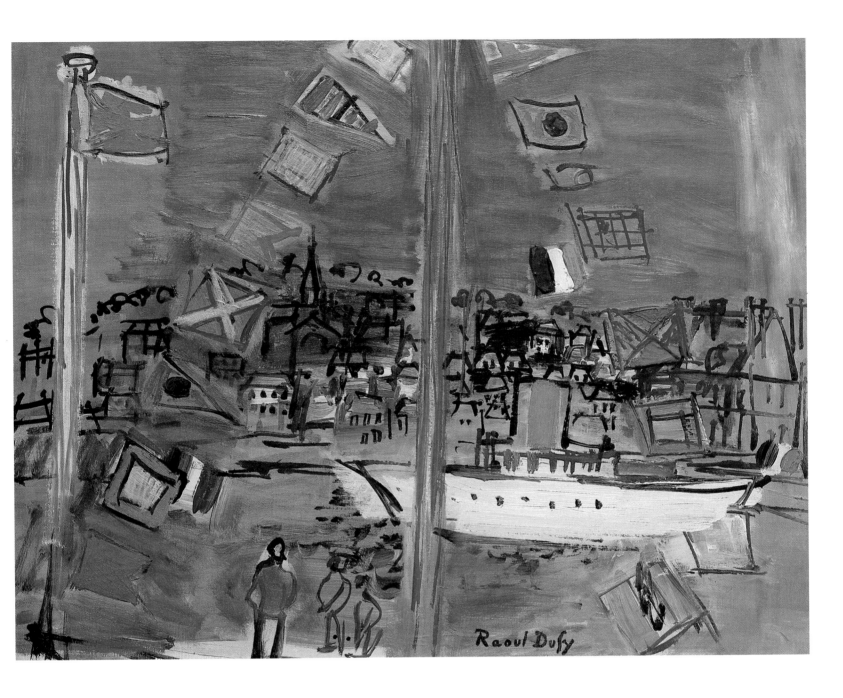

Raoul Dufy

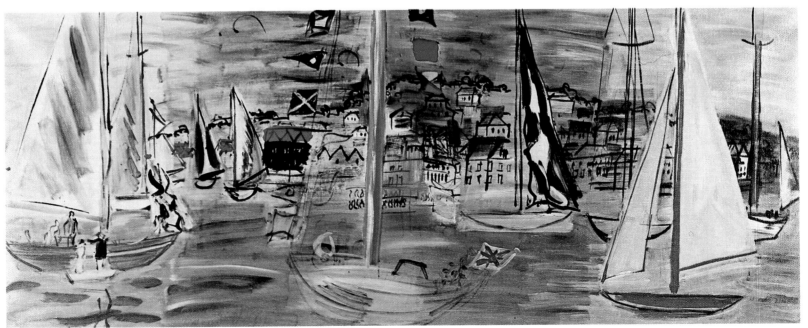

206 From a sketchbook of the races at Deauville.
Pen-and-ink drawing.

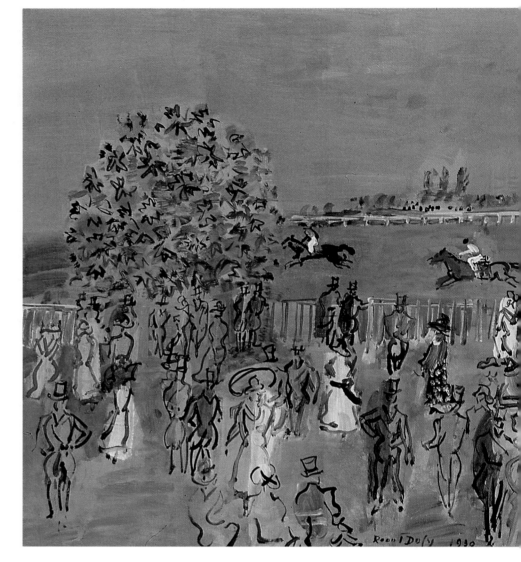

207 *The Races at Ascot, the Royal Enclosure.*
1930.
Oil on canvas.

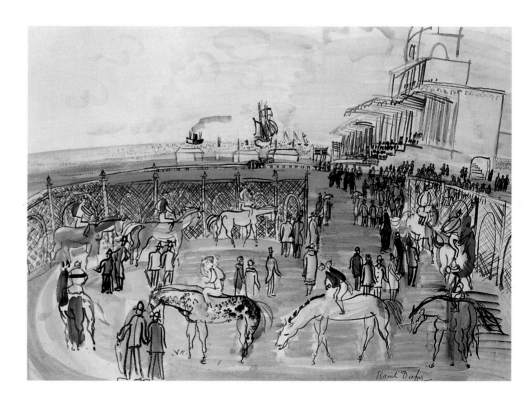

208 *Paddock at Nice.* 1927.
Watercolour.

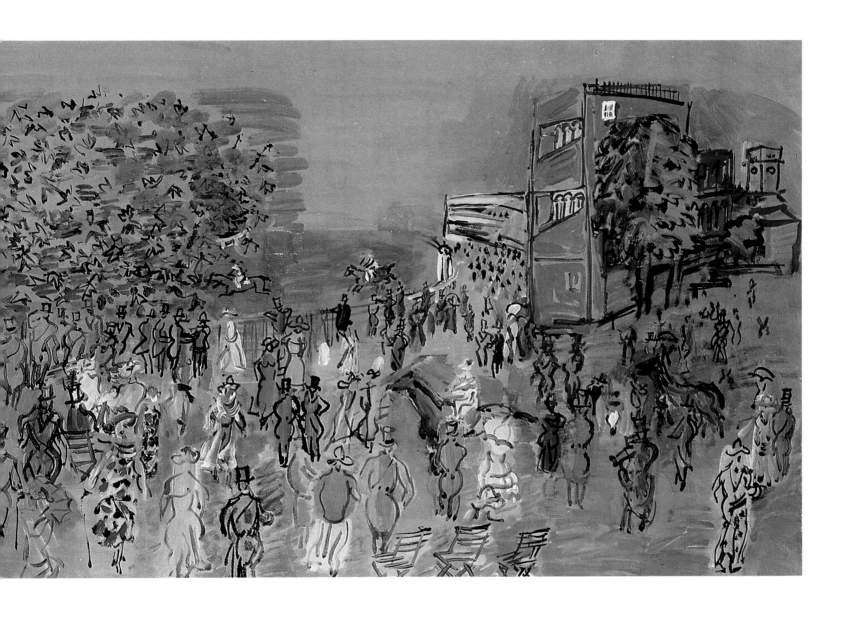

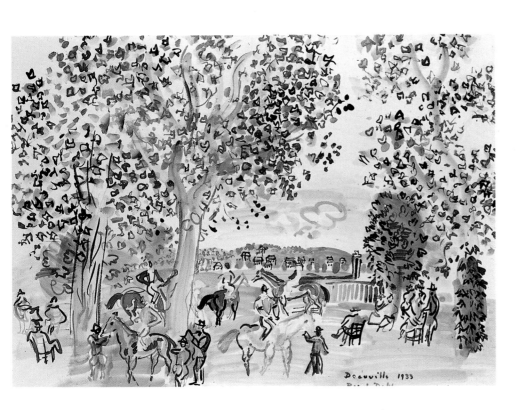

209 *The Races at Deauville.* 1933.
Watercolour.

observed that it struck the vertically represented object from one side only, while the other side remained in shadow. He decided to convey light by means of colour; the absence of colour characterizes the unlit area. When he was composing his painting, Dufy chose to have the light coming in from both sides, since he believed that 'every object has a centre of light: it is modelled towards its outer edges where it is in pure or reflected shadow. It is therefore connected to the object next to it by means of an area of shadow or reflection before it reaches the centre of the object next to it. For this reason one will never find two pure colours in contact with one another.'[3] For Dufy, the balance of the composition comes from the distribution of all the points of light in the centre of each element of the painting. It was here that he found the secret of his composition.

Distinguishing between local tone (the particular colour of an object) and ambient tone (the tonality that bathes the painting as a whole), Dufy observes in his notebooks: 'The ambient colour of a painting is determined by the colour of the object that forms the main motif of the painting. When I apply the local tone to the canvas, I neutralize the colour of the object, and this colour ceases to personify a particular object, and thus, for the other elements of the painting, I am freed from the constraint of imitation, and the way is open for an imaginative use of colour.'[4]

The paddock enclosures, and the general views of the race-courses, which encompass the gallery, the spectator area and the race-tracks, lend themselves to compositions arranged according to a trichromatic coloration that divides the painting into contrasting zones. In this way, spectators, horses and jockeys take on

210 *Elegant Women at Epsom.* 1939. Gouache.

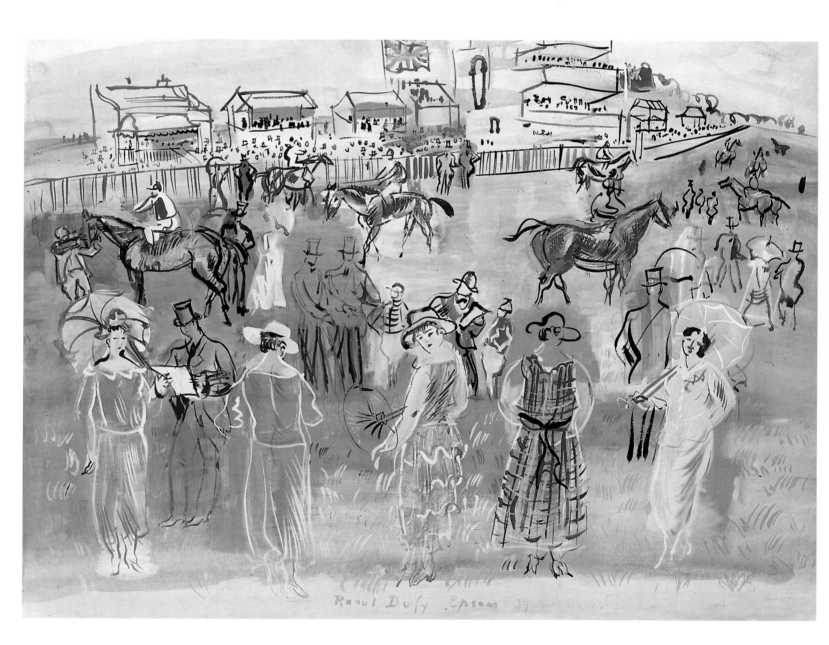

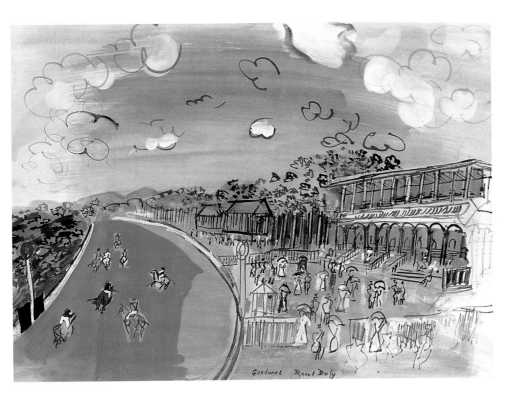

211 *The Races at Goodwood*. Around 1935.
Watercolour and gouache.

212 *Paddock at Ascot*. Around 1935.
Gouache, watercolour and ink.

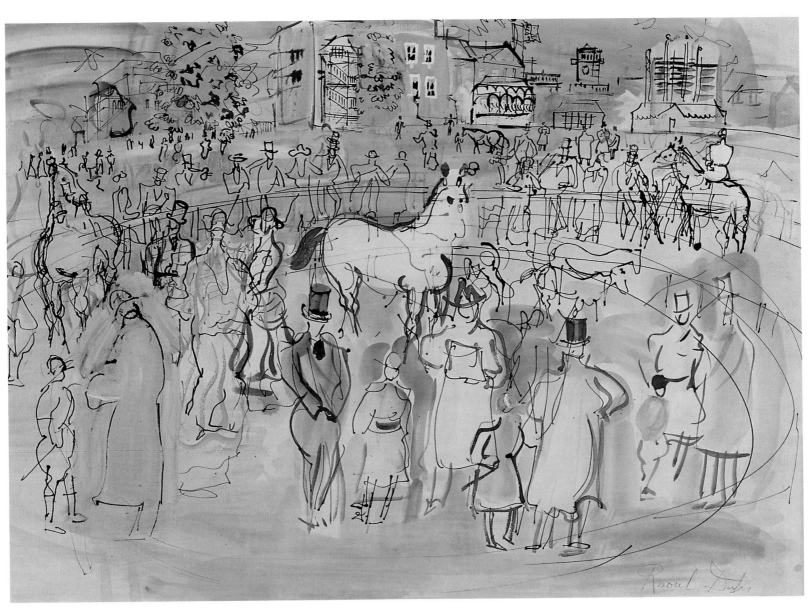

163

the ambient colour of the areas across which they pass. If they are crossing the axis of a bipartite division, they assume both tonalities at once and are divided by them. Separating colour and form, Dufy animates the silhouettes with an elliptical and airy outline that gives the spectacle an extraordinary dynamism. Let us not forget, as Marcelle Berr de Turique and Pierre Courthion have stressed,[5] that these scenes were received with such enthusiasm that Dufy, not wishing to become trapped within the genre, abandoned this theme for a while, to return to it sporadically in compositions showing an ever-increasing freedom of construction.

Painting scenes of regattas and races was not Raoul Dufy's primary purpose in England, but during his various stays in London in 1930 and then in 1932 he was able to enjoy the spectacle of the regattas at Cowes and Henley, and to attend the races at Epsom, Ascot and Goodwood.[6]

The reason for this first stay in England, in June and July 1930, was the painting of a portrait of the Kessler family, a commission that had been procured for him by the London dealers, Reid & Company, the English associates of his dealer Étienne-Jean Bignou.[7]

This was the first time that Dufy had the opportunity to paint a portrait that was both collective and equestrian. Until then, his interest in portraits, which had been apparent since the start of his career, as one can see from his self-portraits or those of the members of his family, had been limited to portraits of individuals. Encouraged by his familiarity with horses, he set about attempting a new experiment.

He spent three weeks at Gunthorp, the Kessler property at Oakham in Norfolk, working for a long time on numerous preparatory studies detailing each of the faces of the members of the family and each of the horses.[8] The landscape was a particular object of attention, as can be seen from certain notes that accompany his studies.

Dufy also worked on compositions drawn in watercolour, preparing the ensemble of the work and studying the arrangement of the group. These numerous studies, together with his handwritten notes which take into account the minutest details and show the care he took over the composition and arrangement of the colours, represent the preliminary stage of his work.

On his return to France he completed a first version of the work in the autumn of 1931: the relaxed construction of the painting dissolved the outlines of the forms, and the colours that he had inherited from the Fauves vibrated with light. This vibration reappears in the treatment of the leaves, and this play of light modifies the outlines of the human figures and the horses.

By its very theme, this equestrian portrait of rich bourgeois in the park on their estate joins a tradition of English painting. But Dufy's imagination led him to paint a work that broke with that tradition in both its conception and its treatment. According to Mrs Kessler, it seems that the daring of Dufy's style and interpretation was the reason why the family refused to accept the painting. They were disconcerted by its originality and disturbed by the embarrassed reactions of their friends.[9]

For this reason Dufy returned to London in 1932 and, staying at the Savoy Hotel, made a second version, which differed from the first in the importance it placed on the landscape, whose details are better defined, and by a more detailed treatment of the portraits and the horses. The static appearance which the group has as a result does not exclude an imaginative portrayal of the faces, which prevents the group from being in any way monotonous.

These versions emphasize Dufy's decorative stylistic qualities: the curtain of vegetation which forms a backdrop to the group does away with the idea of perspective. By means of the foliage and the flowers surrounding his sitters, Dufy gives his painting a monumental role like that of a medieval hanging.[10]

The Kesslers were pleased with the second version, and before being returned to them it was praised by painters and critics at its vernissage. Dufy's standing consequently rose in England, and was further enhanced by exhibitions mounted in Paris from studies carried out in England. These were racing and regatta scenes, to which Dufy dedicated himself with his characteristic seriousness and thoughtfulness.[11]

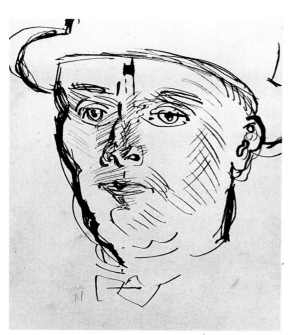

213 Head study for *Les Cavaliers sous bois*.
1930.
Pen and brown ink.

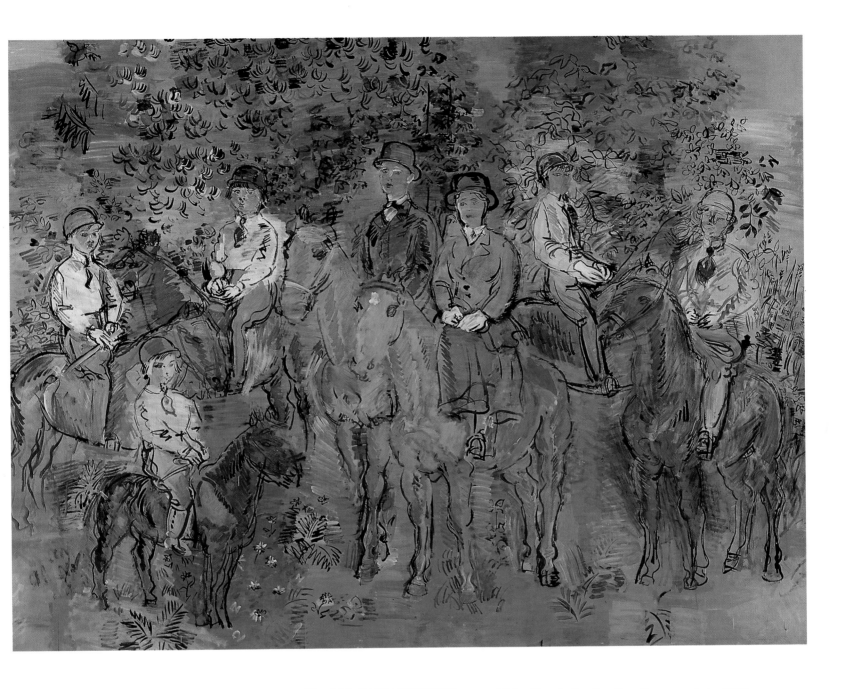

214 Sketch for *Les Cavaliers sous bois*. 1931. Oil on canvas.

215 Handwritten notes, study for *Les Cavaliers sous bois*. 1931.

In England as well as in France he continued to watch out for events that would produce works which gave full play to his enthusiasm and talent. Official ceremonies attracted him and, in 1936, he attended the celebrations of George VI's coronation, of which he left faithful impressions.

During his second stay in London he was present at a boxing match at the Albert Hall on 23 March 1932, in which the world heavyweight champion Primo Carnera met the English boxer George Cook, a fight that was won by Carnera. A series of sketches from life captured the various stages of this event. Dufy's jerky style conveys the rapid exchanges of the combatants in the ring; their bodies are sketched in a broken line, which is drawn over twice. A few intersecting lines organize the shadowy areas stressing the physical power and height of Carnera, the 'giant of the ring'. These drawings can be linked to one of the nineteen watercolours used in 1936 to illustrate *Mon Docteur le vin* for Les Établissements Nicolas. They are all characterized by the imagination that dominates Dufy's *oeuvre*.

On his return from England, Raoul Dufy found himself officially commissioned, in July 1936, to make a large fresco devoted to the history of electricity. It was to decorate the Pavillon de l'Électricité, built by Robert Mallet-Stevens, at the 1937 Exposition Internationale in Paris.

216 *The Boxing Match.* 1932.
Pen-and-ink.

217 *The Fall of the Water-Drinker*, illustration for *Mon Docteur le vin*, Plate 12.

166

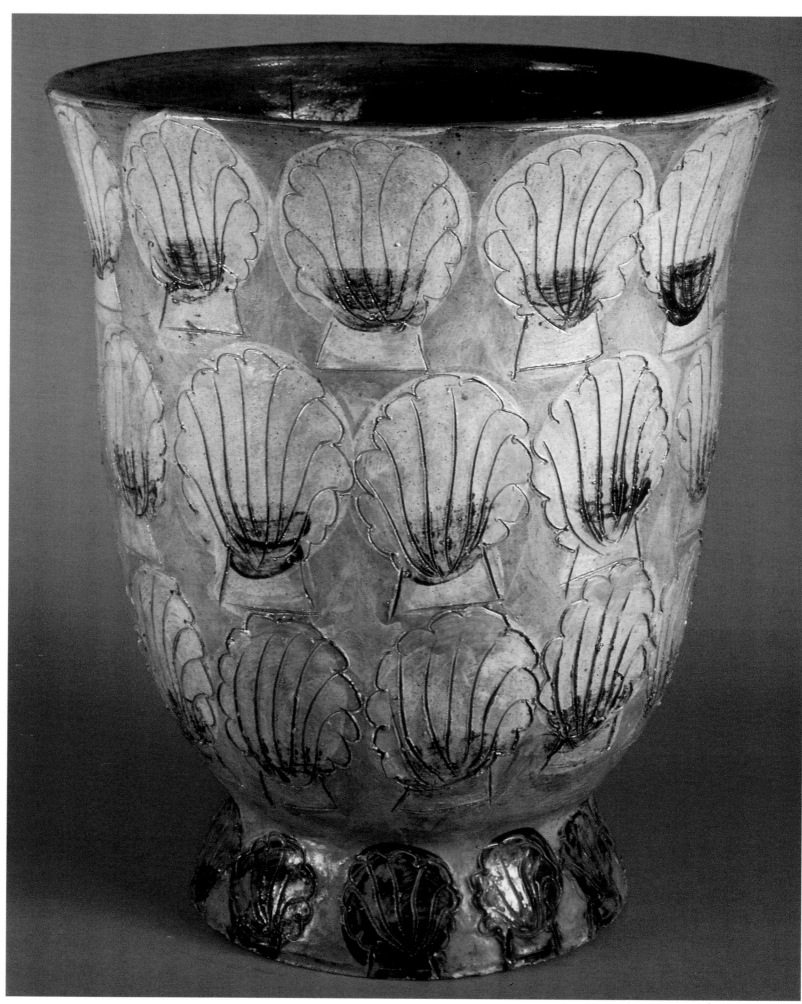

218 *Vase with Scallop-Shells. 1927–30.*

VII

THE CERAMIC WORK

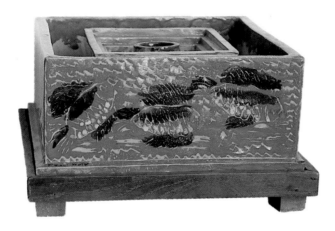

219 *Garden with Fish.* 1925.

In 1922 Dufy's interest in visual experiments led him to the technique of ceramics, and the expressive possibilities it offered, with a particular interest in enamels.

Dufy's contribution to this tradition transformed it. He placed himself alongside his contemporaries, Rouault, Vuillard, Redon, Maurice Denis, Matisse, Vlaminck, Derain, Van Dongen, Bonnard, Jean Puy and Maximilien Luce. On the initiative of Ambroise Vollard,[1] all of these painters, in search of novelty, had collaborated with the famous ceramicist and decorator André Metthey, who opened his Asnières studio to them. From 1903 until 1907, delighted by this experiment, they decorated almost five hundred pieces of tin-glazed earthenware, which were then shown at the 1907 Salon d'Automne.

As François Mathey stresses, the public was not yet ready to accept a total artistic creation, and these painters were unable to pursue this discipline any further.[2] However, they did open up the way for other painters such as Gleizes, Chagall, Dufy and Picasso, who said: 'In ceramics, the artist can demonstrate his creativity and the power of his inventiveness, just as he does in a painting, but here, on top of that, he can preserve the quality of spontaneity produced by the concrete and material creation of the work that he makes with his hands.'[3]

In 1922 Dufy made the acquaintance of the Catalan ceramicist Josep Llorens Artigas, to whom he was introduced by Paco Durio, another Spanish ceramicist and sculptor. 'I was born in Barcelona, which is the second home of the Catalans, since Paris is the first,' said Artigas. He settled in France in 1924 after leaving Barcelona for political reasons; in Barcelona he had practised as a ceramicist and also taught at the Escola Technica d'Oficis d'Art. His meeting with Dufy was the beginning of a fruitful collaboration, as both made equally rigorous demands on themselves.[4]

Artigas would later say to Pierre Courthion: 'I started up in France and worked, apart from my own work on undercorated stoneware ceramics, with Raoul Dufy, a witty, imaginative and talented artist, who really knew how to put the decoration in the right place, and soon knew all the secrets of enamelling.'[5]

Dufy's first experiments, before he began working with Artigas, are very disappointing. In 1923, the State paid him 2,000 francs for *Vendémiaire*, a composition designed to be reproduced by the factory at Sèvres.[6] 'In Sèvres', says Artigas,[7] 'Dufy had been invited to draw on a plaster model; then he had transferred his design to paper. To create a gentleman in a riding-coat, an "artist" from the factory came to transfer Dufy's design on to the vase itself. Was there anything of Dufy left in that? Nothing at all.'[8] Dufy's talent was unable to find expression in such a rigid method.

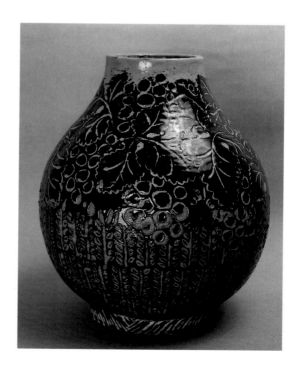

220 *Vase with Ears of Corn and Bunches of Grapes.* Dated 10.XI.1924, signatures and stamps of R. Dufy and LL. Artigas.

Before his collaboration with Dufy, Artigas had been interested in the ceramics of the Sung dynasty, which were fired at a high temperature. His own production consisted exclusively of undecorated stoneware with highly refined forms. He did everything himself, disdaining all artificial aids: the electric kiln, pre-prepared clays, commercial enamel. This authenticity lends his work a special value.

For Dufy, Artigas returned to the French tradition of Moustiers and created ceramic pieces in tin-glazed earthenware. He used a clay from Toul, which was soaked in water for a full year. After this he sieved it, kneaded it and then modelled it. He and Dufy worked together on the shape of his vases. Once the desired shade had been obtained he let the pieces dry, then gave them a first firing in a 'warm-up' fire to harden them into biscuitware. After this phase of the firing was complete, the pieces had a matt appearance and were dipped in a white glaze, then covered with a transparent enamel in preparation for further decoration.

At this stage Dufy intervened to apply his decoration to the ceramics, without making preliminary studies.[9] He was happy to draw themes and motifs from his painted work, which he then adapted to this technique. Having marked certain reference points on the piece to be decorated, he worked spontaneously and in a freehand manner. He used an awl to define the decoration of his pieces with a fine incision, after the manner of Gauguin, giving them the appearance of '*escorgrafiat*'.[10] He generally used soft brushes to apply the enamels prepared for him by Artigas. Artigas liked to mix the enamels himself, grinding and measuring them. He presented the painter with samples of fired enamel, giving him a palette bearing the numbers of the enamel powders corresponding to their colours when fired. The tones which were revealed by the firing process form the indispensable references for the selection of the colours.

Once the decoration had been applied, the ceramic pieces were fired for a second time, for twenty-four hours, at around 1,300 degrees. This last operation sometimes produced blisters or craters in the enamel layer and cracks in the ceramic: 'The kiln', said Artigas, 'is a sphinx: at each firing, however precise one's calculations may be, one never knows what may emerge.'[11] He set the imperfect or inadequate pieces aside and disposed of them. If the pieces had become tarnished because the enamels required a longer period of firing, Artigas would fire them for a second time while new pieces were receiving their biscuit firing, so as to obtain a perfect result.[12]

The collaboration between Artigas and Dufy produced a large number of works: 109 vases, almost 60 indoor gardens, some 100 tiles and a luminous fountain. This last, a monumental ceramic work, was designed for the pavilion of the magazine *La Renaissance*, erected at the Cour de la Reine, in the luxury arts and industries

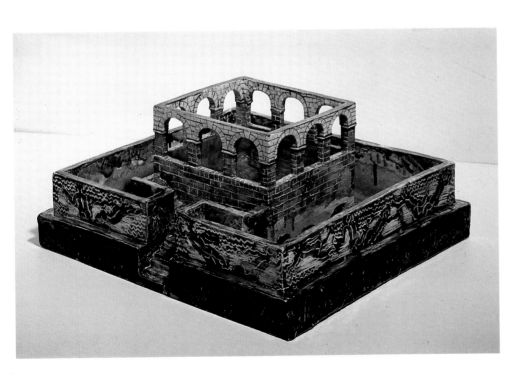

221 *Garden with Bathers*. Around 1924–25.

171

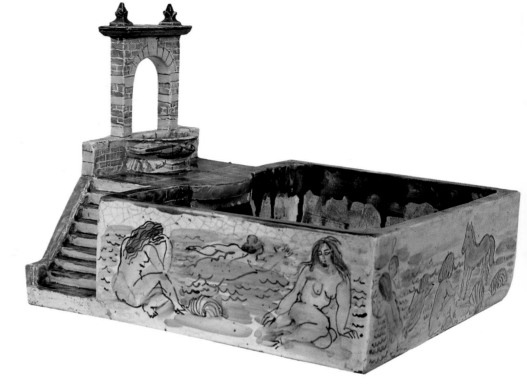

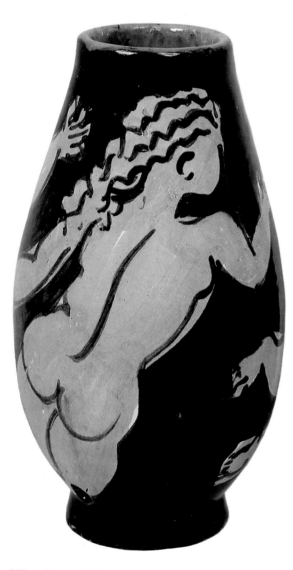

222 *Vase with Bathers on a Black Background.* Around 1926. Signed by R. Dufy and LL. Artigas, No. 63.

section of the 1925 Exposition Internationale des Arts Décoratifs.[13] The octagonal basin occupied the centre of the pavilion; it was decorated with a motif of pink naiads against a black background, above scallop-shells arranged around the bottom of the basin. At the centre of the basin stood a fish with a jet of water spouting from its open mouth. A testimony to Dufy's imagination and gaiety, this work was much remarked upon at the Exposition and highly praised.[14]

In the plans that he drew up for them, the young Catalan architect Nicolau Maria Rubió i Tuduri contributed to the creation of the indoor gardens, modelled by Artigas and decorated by Dufy from 1926 or 1927.[15] Fountains, basins and patios were arranged between walls intersecting with arches and stairways leading to little terraces built to receive ornamental dwarf plants.

These small gardens bear no resemblance to Japanese miniature gardens, which reproduce reality on a reduced scale. Nor are they tiny, precisely detailed models intended to be realized at a later stage. They are rather the simplified expression of a garden. According to Forestier, who introduced the young Rubió to the art of architecture, 'they are the evocation of old traditional forms of our Western gardens. Precisely because of their reduced scale and the materials selected, complicated ornaments were sacrificed in favour of the proportions, the strict forms of the ensemble.'[16] First shown to the public in July at the Bernheim-Jeune Gallery, along with seven of the fourteen hangings made in 1925 to decorate Poiret's barge, *Orgues*, these indoor gardens were later shown in Brussels, and then in London, where they enjoyed a great success.[17]

Dufy's method of decorating these gardens was the same as his method for the vases: giving free rein to his imagination, he covered them all with his favourite themes and motifs. The special theme of bathers and naiads, with which we are familiar in many different variations, was treated most frequently.

The allegorical figure of Amphitrite, seated on a rock covered with drapery, her legs crossed and wearing a black swimming costume, appears beside the sea, sometimes alone in the foreground, accompanied by tiny sailboats floating in the distance – as in the tile bearing the inscription: '*Pour Émilienne, le 11 octobre 1926*' – or standing out against the houses of Sainte-Adresse, profiled in the background. Once more, Dufy takes an obvious pleasure in portraying the sea-goddess in connection with a region so closely associated with his own life. Her full forms, the curves of her body and the arabesques of the drapery lend monumentality to this allegorical figure and an assured rhythm to these small-scale compositions. As in his

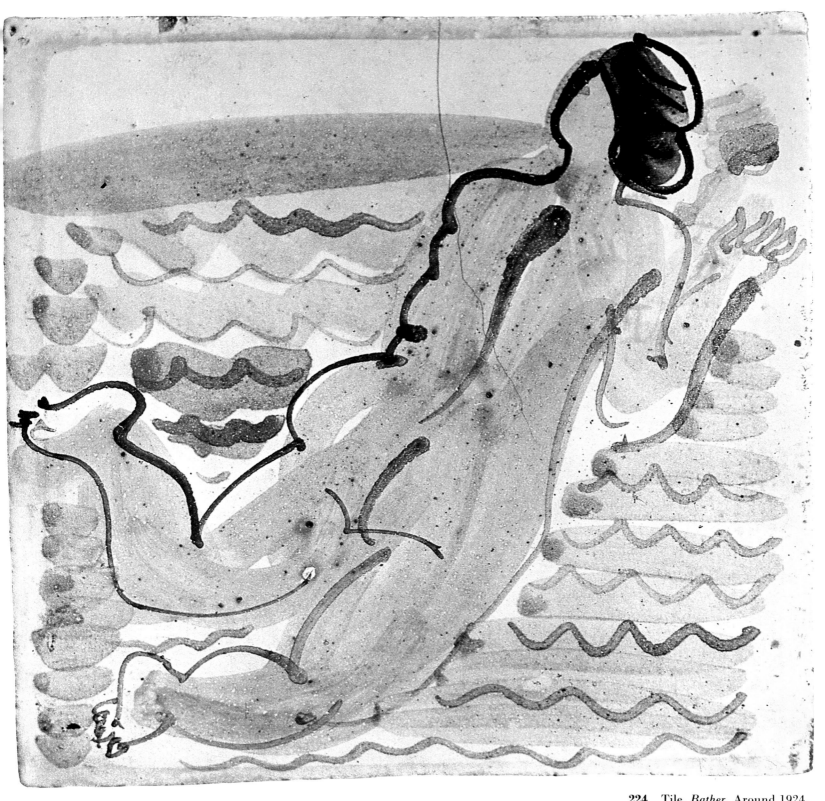

224 Tile, *Bather*. Around 1924.

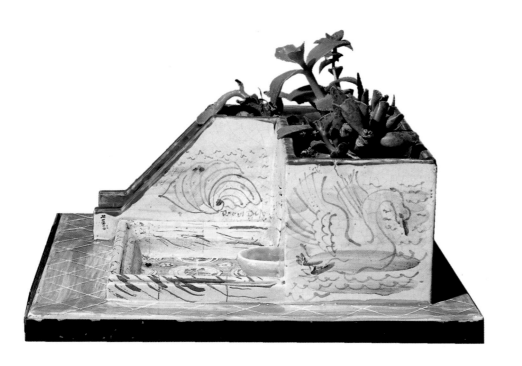

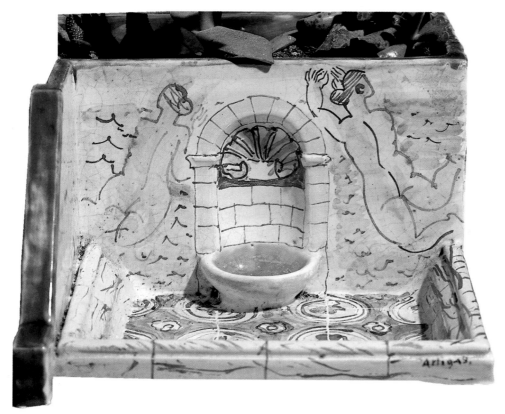

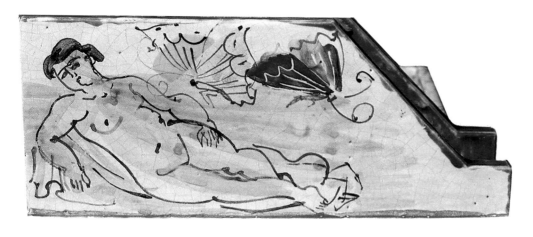

225 Garden, *Bathers and Amphitrite*. Around 1924.

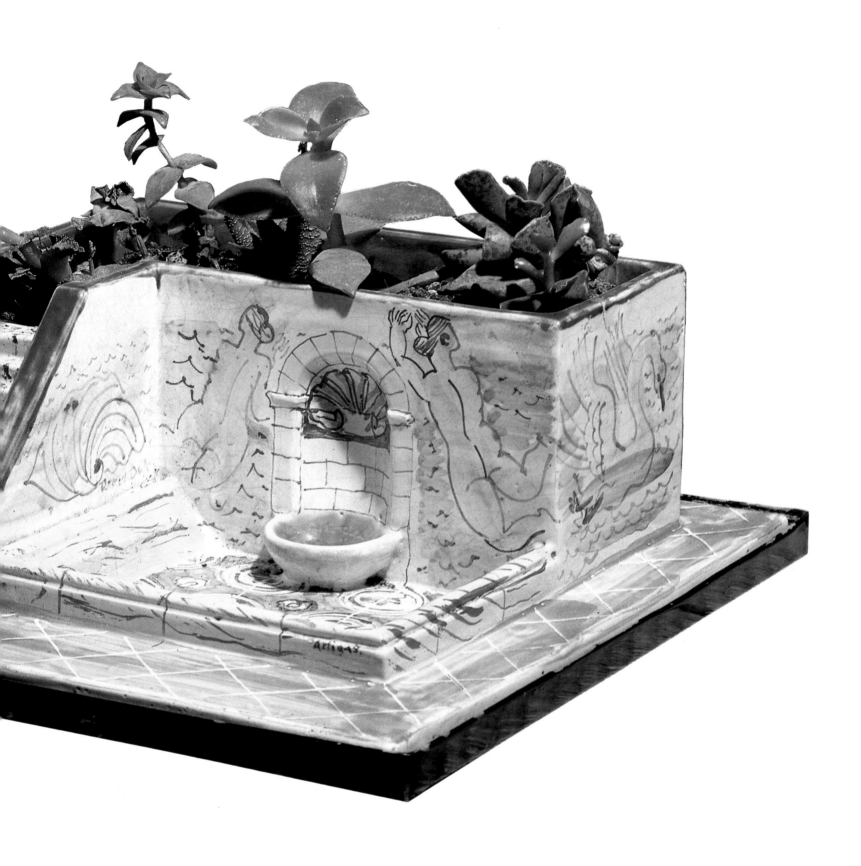

watercolours and his painting, Dufy dots the sea with little notations that evoke the vibration of light on the surface of the water and the small foam-tipped waves breaking on the beach.

In a number of cases, the naiads floating in the water are shown from behind, their legs bent and arms gracefully stretched out in front of their bodies or arranged on each side. They appear as individual figures decorating the surface of tiles or garden walls, or silhouetted in groups of two or more, adorning the surfaces of the tiles and decorating the dado walls of many of the gardens. The repetition of the motif, which is given a different attitude each time, brings such animation to this succession of figures in a restricted space that these little compositions are finally reminiscent of swimming pools. Dufy generally chooses a cobalt blue that sets off the silhouettes of the bathers haloed with a luminous white line; the style of their drawing, entirely in curves and undulations, intensifies the sense of movement. This occurs in the *Cuttoli Goblet* and certain of the gardens. In some other pieces, the bodies form blue patches, against a white background, surrounded by an incised outline; the little sea waves are conveyed in white lines on a blue background: here the composition is enlivened by a pattern of contrasting planes. Elsewhere, following the example of the Fountain in the Pavillon de la Renaissance, in his *Vases with Bathers*[18] Dufy employed a black enamelled background, brightened by the presence of five pink female figures that follow the body of the vases in a continuous round-dance. The supple design of these figures, with their delicate curves, turning, dancing or embracing, animates these compositions. Sometimes, in a true aquatic ballet, Dufy humorously allows some of the figures to pass over the heads of the others: this happens in the *Cuttoli Goblet*, for example, and in the *Vase with Bathers on a Pink Background*. The latter is similar in its composition to a 1925 gouache showing seven swimming women in various aquatic postures. To increase the sense of space in a small-scale garden, Dufy centres his figures in a Japanese style, showing one of the naiads emerging from the water to her waist in a graceful breaststroke motion; this figure somewhat resembles Gauguin's wood sculpture, *Soyez mystérieuses*. Dufy added a kinetic effect to this bather by placing her next to the detailed figure of a swimming woman rapidly beating her legs. In some of the vases Dufy established an interplay of contrasts between a red-ochre background and the black tone of the figures, highlighted by white lines. He plays on the negative-positive opposition between the white of a female body with black hair and the black silhouette of a light-haired bather.

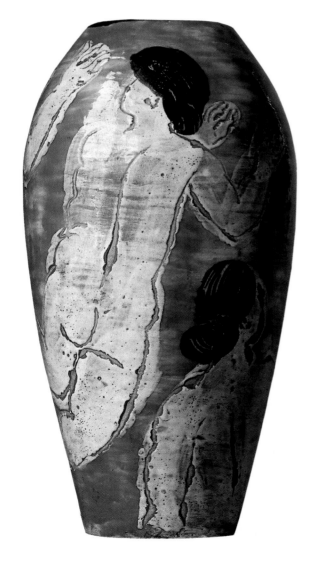

The shell reappears several times in Dufy's ceramic decorations. One of his most successful pieces, the *Vase with Scallop-Shells*, in which the decoration stresses the form with a pattern of shells, repeats the motif, painted in monochrome on a yellow ochre background, all around the belly and the base. In many cases, the shell spread in a fan-shape surrounds the base of the vase. In this instance Dufy brings it together with the figure of the bather emerging from it like Amphitrite, her ample forms highlighted by an incised outline. He took pleasure in creating visual rhymes between the curves of the female bodies and the scalloped outlines of the shell. A series of vases bears this decoration, differentiated by the colours chosen: we might mention the harmony of the turquoise background linked with the red ochre of the bathers and the scallop-shells, and the happy conjunction of the pink of the bodies and the black background. The repeated image of the scallop-shell sometimes occurs around the base of the dado walls of the ceramic gardens, their uprights decorated with naiads. The scallop-shell on its own is the subject of a tile dedicated to Émilienne Dufy. Drawn with a soft brush, in red ochre with white stripes, it spreads its whorls across the whole of the surface, harmonizing them with the looped pattern and the blue of the little clouds in the upper corners.

Dufy also creates decorative effects from the motif of the swan. In the vase in the Musée des Beaux-Arts du Havre, he links the curve of its long neck, the arabesques of its plumage and its spread wings with the rounded body of a naiad. He thus evokes the theme of Leda, which he painted in watercolour three times between 1926 and 1928. The outline of the swan appears on its own on one of the low garden walls; Dufy drew it in a fine line against a solid background. The whorls of its body and wings harmonize with the undulations that evoke the water of a river or a lake. They are echoed in the scrolls of the shell lying on the shore, which occupies another

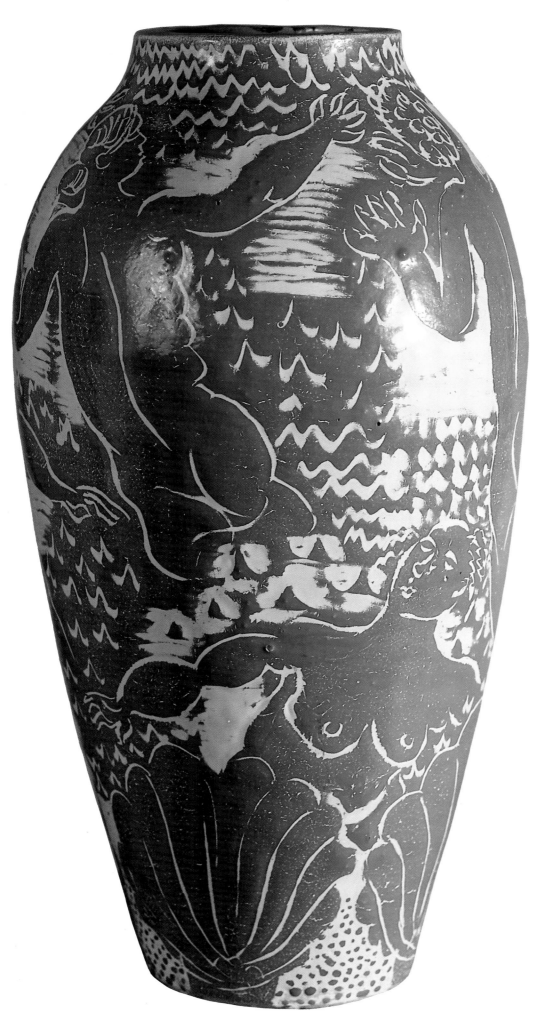

Opposite
226 *Vase with Bathers*. Dated 28.X.1923, signatures and stamps of R. Dufy and LL. Artigas, No. 89.

227 Vase, *Bathers and Scallop-Shells*. Dated 15.II.1925, signatures and stamps of R. Dufy and LL. Artigas.

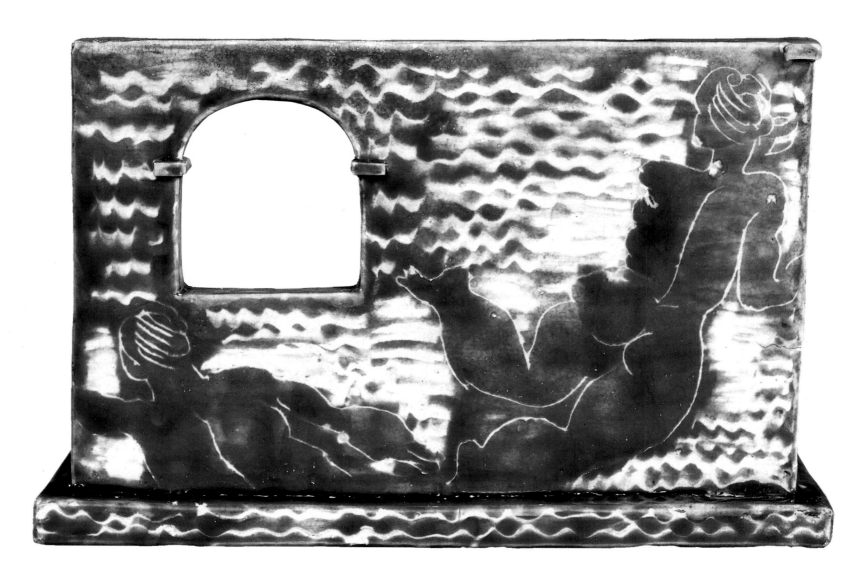

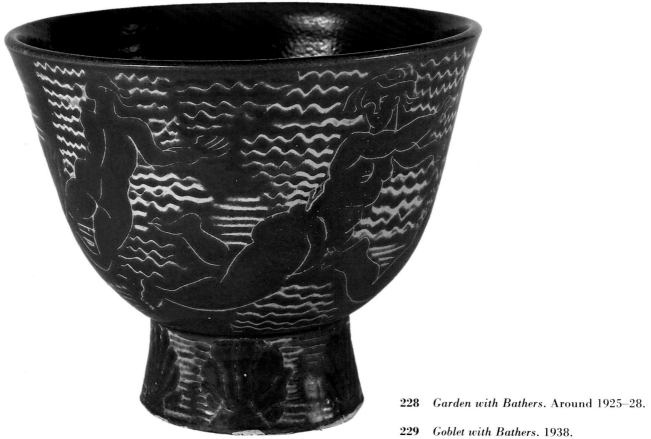

228 *Garden with Bathers. Around 1925–28.*

229 *Goblet with Bathers. 1938.*

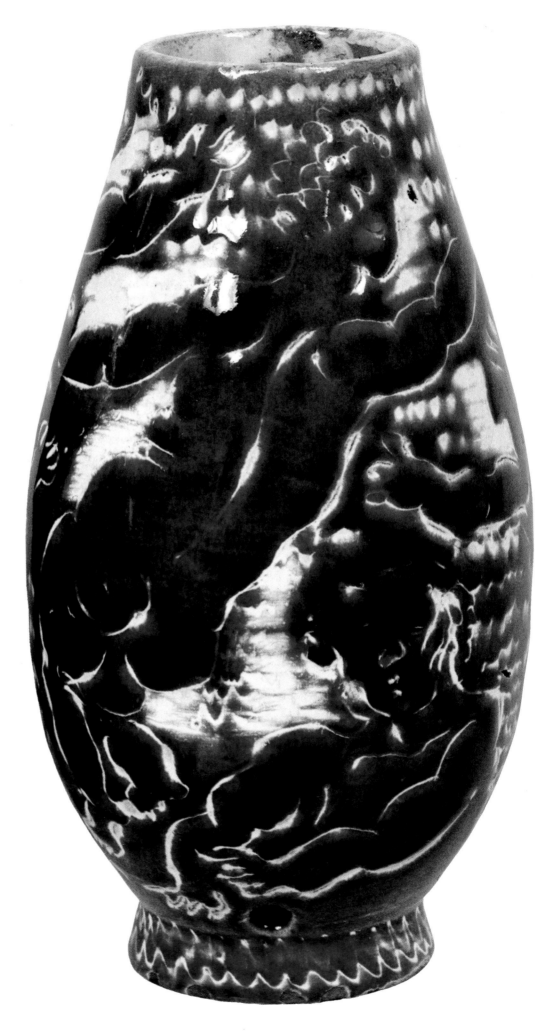

230 *Vase with Bathers*. Around 1925. Signed
R. Dufy and LL. Artigas.

wall surrounding a little pond. These two motifs, placed on a single axis, are captured in a highly charming vision.

The motif of the vase entitled *The Springs* shows three female figures pouring water from a vase. It is inspired by Ingres' *The Spring*,[19] which is interpreted in the decoration of a set of tiles.[20] Here Dufy adopted the method, which he was developing in his painting during the same period, of dissociating the outlines of forms from the colour. The freshness of the colours evokes the fluidity of watercolour. The figures, surrounded with a fine line, with no corrections, reveal the range of Dufy's stocky and strong-thighed nudes, free of any erotic allusion.

Dufy's passion for horses becomes apparent in the decoration of many of his vases and gardens. Sometimes they are 'sea-horses', incised in intaglio, arranged in a frieze around the belly of the vase above the naiads. He strongly emphasizes their vitality. With a nervous line, Dufy conveys the movement of their manes, their legs and the expressions on their faces, their necks stretched forwards, their mouths open and their eyes piercing. Sometimes he brings them together with bathers in a dynamic and vertically tiered composition. The horses cavort and prance in the water, their agitation contrasting with the placidity of the voluptuous female figure on the shore. Elsewhere, Dufy unites his favourite motifs: bathers, horses and shells. Attracted by the correspondence of the finely shaped curves of the female body, the scrolls of the scallop-shells, the whorls of the sea-shells and the rounded rumps of the horses, he took delight in transcribing these full forms in simple and ornamental lines. One of these gardens illustrates the effect that Dufy draws from the contrast of light and dark tones; the use of a fine layer of enamel gives the ensemble a lightness and clarity that resemble watercolour painting. During the same period Dufy made numerous variations in watercolour on the theme of the naiad and 'sea-horses', combined with the shell motif. We might remember that in 1925 he had made the two hangings designed to decorate Poiret's barge, *Orgues*, which are thematically very close to this: *Amphitrite, 'Sea-Horses' and Boats*, and *Amphitrite, 'Sea-Horses' and Butterflies*. His genius particularly excelled in his varied treatment of identical motifs.

The figures of plump *Reclining Nudes* – based on the model Rossetti, who posed for numerous versions of the nude lying stretched on a drapery – decorate some of the gardens. In most cases Dufy shows them accompanied by butterflies, their arabesques, with which we are already familiar, harmonizing with those of the female body. Some vases are decorated by butterflies alone; following the example of his fabric designs, which he was making at the same time, Dufy enjoyed presenting different species, playing with their chromaticism and their forms.

The butterfly features in the decoration of the large vase, *Orpheus*. Here Dufy returns to the iconography of the hero with the lyre, in a walking posture which allows his drapery to float behind him. He is escorted by Pegasus, whose black wings stand out intensely against the white background, and the Asian elephant, which recurs several times in Dufy's decorative work. This ceramic shows us that Dufy can treat a theme in one technique – wood engraving for the illustration of Apollinaire's *Bestiaire* – and return to it in another, giving it an entirely different treatment. Thus he never repeated himself when making his fabric design for Bianchini-Férier, contemporary with this vase, or the tapestry cartoons for a suite of drawing-room furniture commissioned by Mme Cuttoli.

Sailboats and caravels appear in the decoration of certain ceramics. Particularly interesting is a large vase showing flag-decked pleasure boats recalling the many different views of *Regattas* at Deauville and Cowes, made between 1928 and 1932. Even in such a reduced format, they manage to convey an atmosphere of jubilation.

The theme of the sea is illustrated by the motif of the fish – either individually or in groups – which recurs both in the tiles and around the belly of one of the vases. Dufy chooses an enamel whose seaweed green or blue shades evoke the seabed. In many cases they are surrounded by a carved outline. Dufy enjoyed making their fins vibrate and their scales glitter in the geometrical design by using little white brushstrokes. Sometimes he brought them together in tiered shoals of various colours, making them pass from one area to the other as if they were in motion. This treatment gives them a remarkably lifelike appearance.

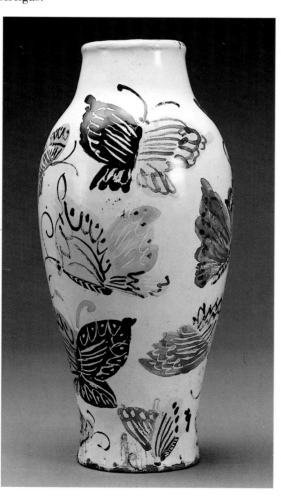

231 *Vase with Butterflies*. Dated 14.VIII.1925. Signatures and stamps of R. Dufy and LL. Artigas.

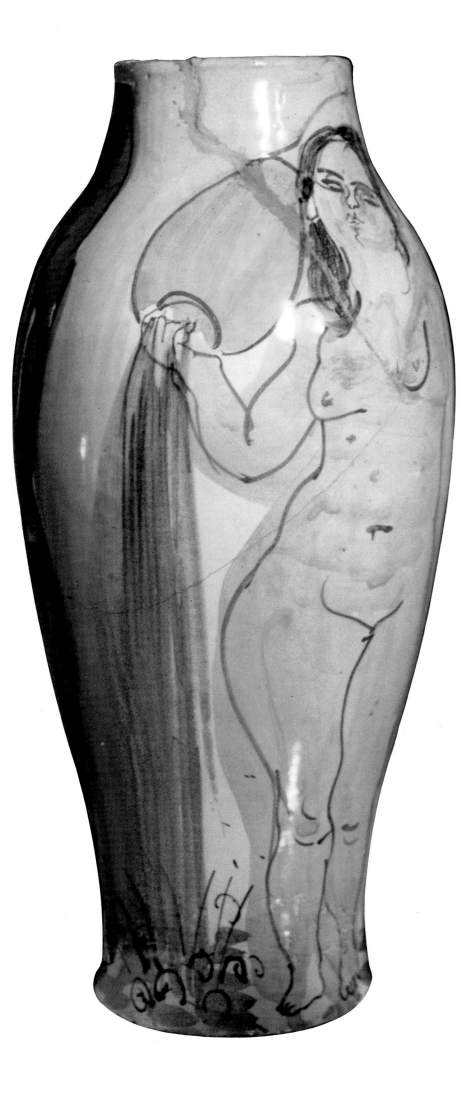

232 Vase, *The Springs*. Dated 24.XII.?, monogram LL. Artigas, No. 65.

233 *The Spring*, set of 40 tiles. Dated 13.VIII.1925, signatures and stamps of R. Dufy and LL. Artigas.

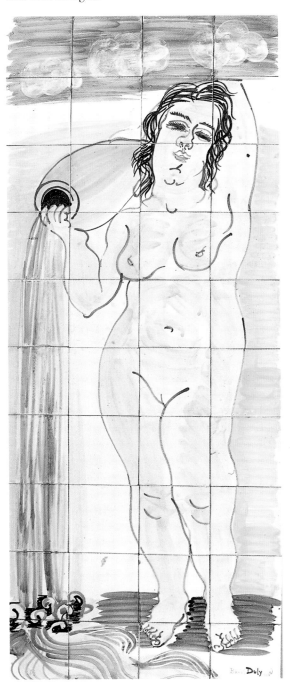

181

235 *Tile with Fish*, dedicated 'A Pierrette'. 1925. Signed R. Dufy and LL. Artigas.

234 *Vase with Fish*. 1924.

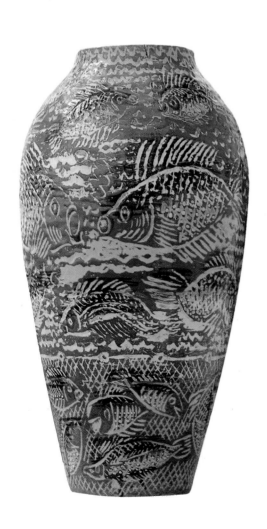

Dufy also made use of the portrait. Two tiles dedicated to Mme Dufy bear her likeness. We are familiar with a number of his portraits. The first of these, *Woman in Pink*, from 1908, was followed by many others. The most significant is the bust-length portrait in the Musée de Nice, which shows Mme Dufy in a dress with patterns designed by Dufy, seated at a table bearing a multicoloured cloth. She stands out against a blue background, the blue with which Dufy had painted the walls of his studio in the Impasse de Guelma. In ceramic or painting, these portraits show a highly refined psychological approach: her energetic expression conveys her resolute character, while the pouting of her outlined mouth suggests her mischievous side.

On the belly of a vase of imposing dimensions,[21] Dufy painted the portrait of Ambroise Vollard,[22] from the etching that he made at the same time. Set in a medallion surrounded by the inscription 'Ambroise Vollard 1930', the face, set off by a high white collar highlighted by a black tie, stands out against the yellow ochre enamel of the background. It shows the features of the famous art dealer, reproduced by many of the painters from his gallery, including Cézanne,[23] Bonnard[24] and Picasso.[25] Dufy could not resist placing bathers in the midst of luxurious vegetation all around the medallion.

Dufy returned to *Paris*, the theme of the tapestry designs he had made between 1924 and 1928 for the national factory at Beauvais, for the decorations of a ceramic garden with a hall of arches forming its upper level, reached by two staircases on either side of a little central terrace. Between these two levels he showed the façade of the Hôtel de Ville, while the dado walls at the base show frontal views of the arches of Saint-Denis and Saint-Martin, and the houses nearby, profiled in perspective.

Heavy ears of ripe corn – symbols of abundance – evoke the theme of the harvest, which Dufy had first painted in 1924. They cover the whole of the surface of a ceramic tile, and stand next to bunches of grapes in the decoration of a potbellied

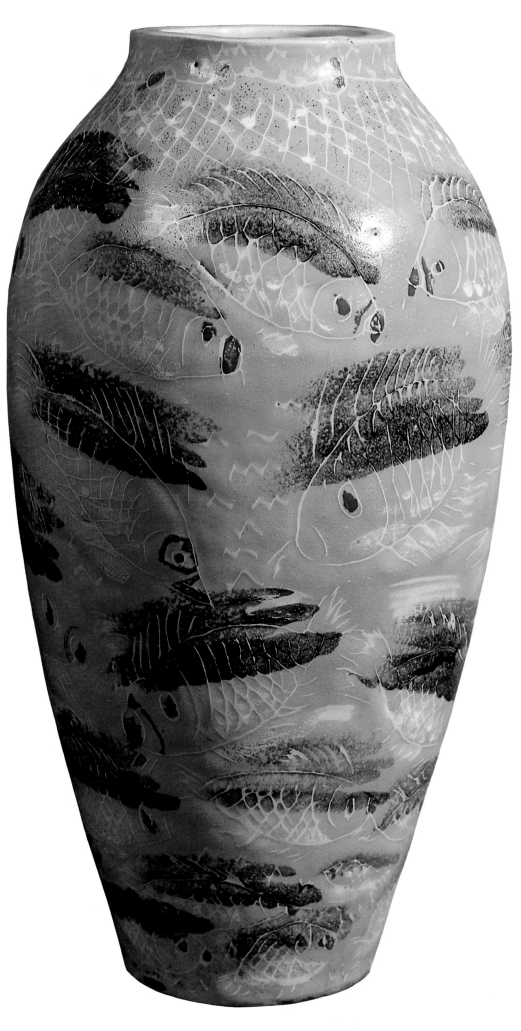

236 *Vase with Fish*. Dated 15.II.1925.
Signatures and stamps by R. Dufy and LL.
Artigas.

237 *Madame Dufy*. 1930.
Oil on canvas.

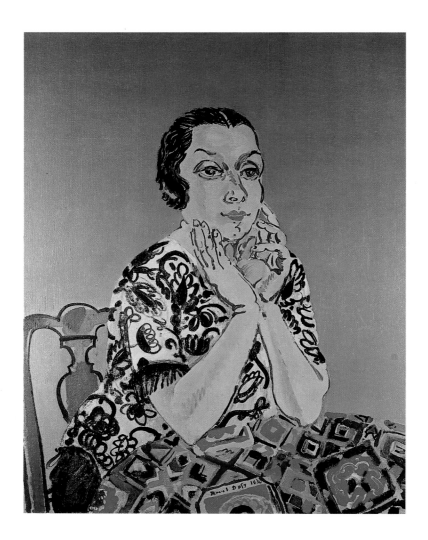

238 *Vollard Vase*. 1930. Signed R. Dufy and
LL. Artigas.
Oil on canvas.

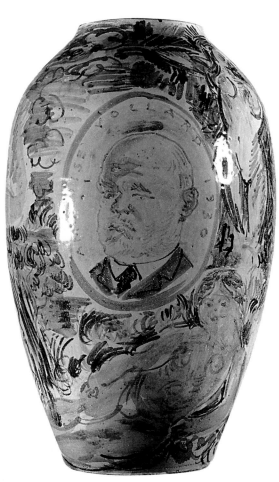

vase. The stylization of the vine leaves, the stalks of corn and the circles of the grapes come together to create an ornamental composition.

The palm-tree of the Promenade des Anglais in Nice forms part of the composition of a tile in which the arabesques of its spread branches blend with the full curls of the hair of a bather. In the decoration of the base wall of one of the gardens, the palm-tree frames a fountain reminiscent of the fountain at Hyères.

The decorative repertoire is enriched by the theme of the Corrida, which inspired the artist when in 1926 he passed through Seville, a city which impressed him by its Moorish architecture. This influence is seen in the ceramic garden in the Musée Jules-Chéret at Nice. Surmounted by two little temples with arcades of horseshoe arches, decorated with alternating yellow ochre bands, this work evokes the details of Islamic architecture, referred to in the little domes decorated with green diamonds that sit atop the temple. The base wall is covered with a geometric pattern, while the upper level shows a bullfight. Two picadors followed by two toreros lead the procession of officiants shown in sumptuous costumes painted in brilliantly radiant yellows, greens, blues and pinks. Opposite this a *cuadrilla* is advancing towards a threatening bull, the brown mass of which stands out against the pale yellow background. They hold their capes open, ready for attack, while the matador dodges the bull in a volte-face. The scene is punctuated with the figures of the toreros; the elegance and refinement of their costumes are enhanced by their bright colours. More than any other, this attractive piece, on a very small scale, shows an astonishing sense of composition, balanced but never monotonous.[26]

Dufy also made ceramics on religious themes, for example, a Virgin in enamelled ceramic made in haut-relief, whose posture recalls that of the *Notre-Dame-de-Bonne-Chance*, an engraving from 1915. Certain themes from the Book of Genesis also appear in Dufy's work, in the decoration of the surrounding wall of a garden showing *The Creation of Woman, The Expulsion of Adam and Eve from Earthly Paradise, The Angels* and *The Creation of Man*. In the first and third of these scenes

239 *Tile 'À Émilienne'.* 1924. Signed R. Dufy and LL. Artigas.

Dufy employed a method used in the ancient illustrations of religious codices and medieval bibles showing three successive scenes in a single panel. He brings new life to the tradition by means of his graphic style and his skill at compression, avoiding any superfluous detail.

The collaboration with Llorens Artigas, which began in 1922 and was interrupted in 1930, recommenced in 1937 to end just before the Second World War. The works made during these periods, marked by that freedom and vitality that are so characteristic of Dufy's style, reveal his skill and mastery in a technique that he had penetrated to its very depths.

In 1935, while his collaboration with Artigas was temporarily suspended, Raoul Dufy was commissioned by the Compagnie Générale Transatlantique to make designs for the ceramic decoration of the swimming-pool of the cruise-ship *Normandie*. This piece was to be 63 metres (207 feet) long and 2 metres (6½ feet) high. However, shortly after, in order to avoid any charge of favouritism, the Compagnie Générale Transatlantique revoked its decision and launched a competition for this decoration. Dufy then refused to take part in the competition.[27]

In the meantime, however, after studying the plans and discussing the realization of this huge composition with the ceramicist Mayodon,[28] he had made a series of highly accomplished watercolour sketches showing familiar themes and motifs evoking the Channel and Mediterranean, in thirteen tableaux arranged according to a logical conception. The semi-circular decoration was to include a central motif with thematically related motifs on its side walls. The central part of this massive composition was to represent a legendary sea, symbolized by the enormous scallop-shell with its rounded edges, and the mythical horses of Amphitrite, reined in by male figures.[29] This image is very similar to the decoration of the curtain for *Palm Beach*, made in 1933. It is shown next to a depiction of Monte Carlo, tiered along the cliff. Opposite this view is a panorama of Deauville and its Norman buildings, and the Channel with the port of Le Havre and Sainte-

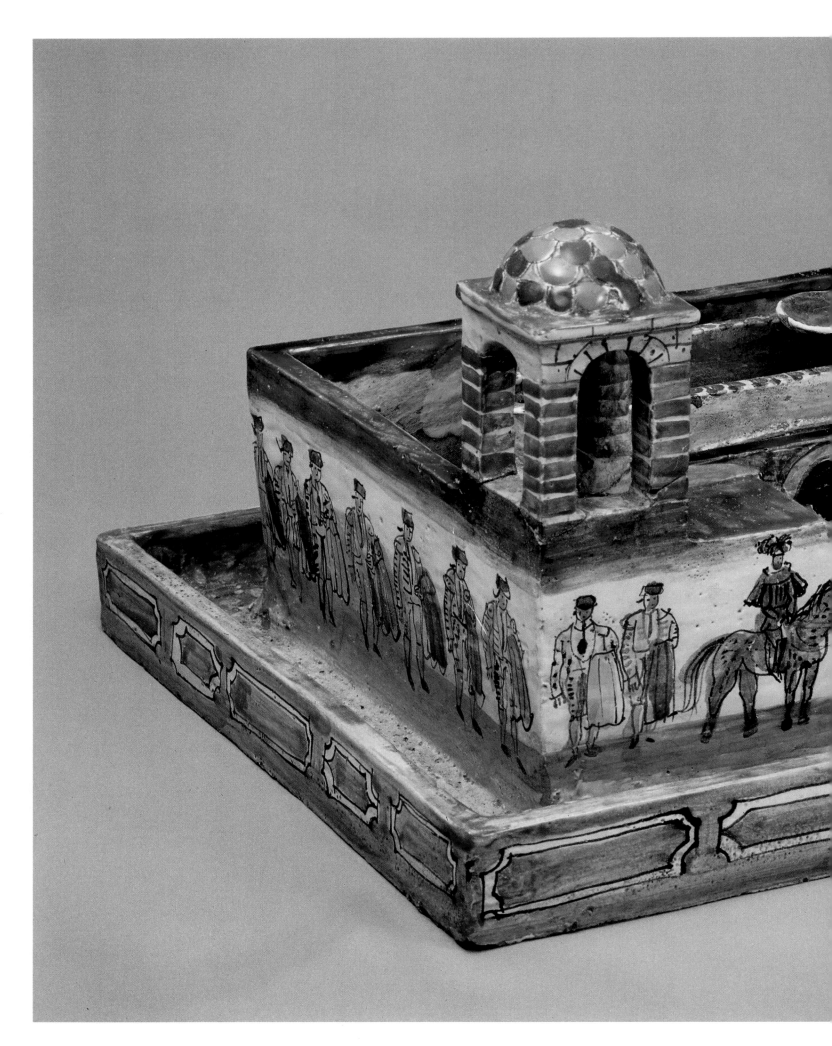

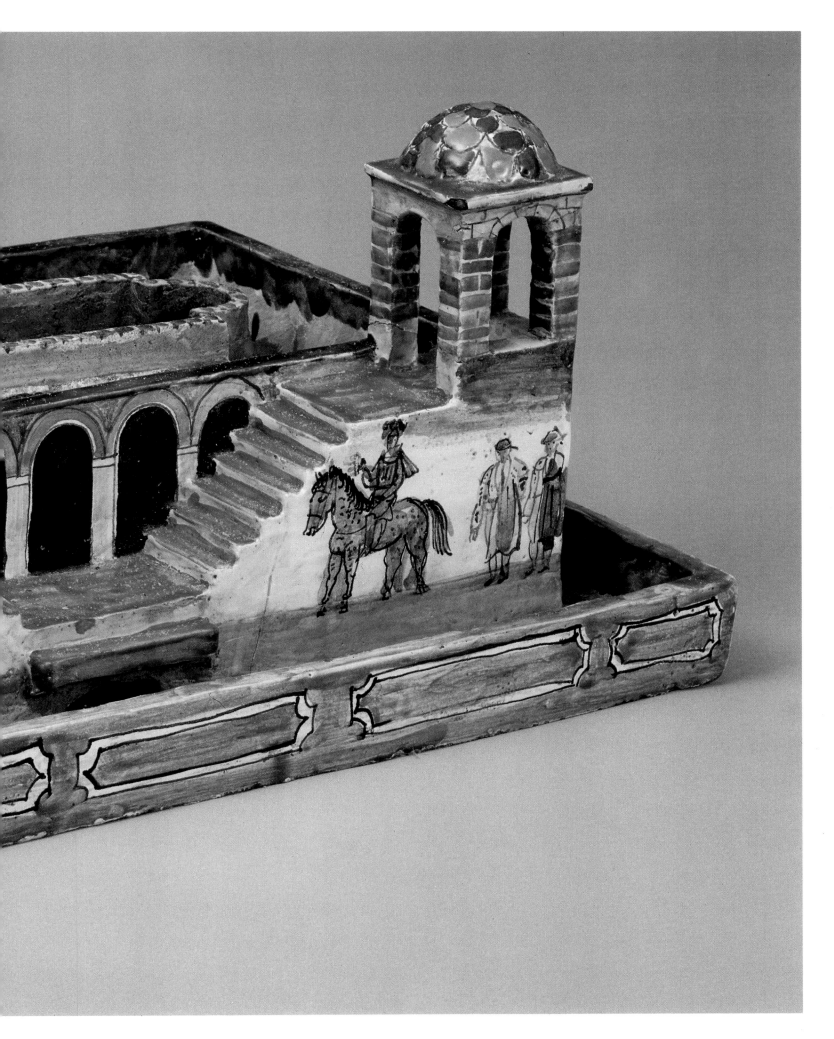

Preceding pages
240 Garden, *Tauromachie*. Around 1927.
Signed R. Dufy.

Adresse, animated by regattas, flag-decked ships, yachts and steam freighters. With their familiar forms, these boats underscore the various compositions that go to make up this decoration, uniting them in a rhythm punctuated by ponds and fountains: the fountain of Latone in Versailles and the fountains of the Place de la Concorde.

Dufy introduced very few human figures into his composition – only a few shadows cast on the beach, and the statues of the fountains – so as to avoid any confusion with real bathers.

This decoration is embellished by gigantic stylized leaves which link some of the tableaux together. Dufy uses a very light line style to stress certain details in his architecture and vegetation. He uses characteristic stylistic abbreviations to evoke the sea, which glitters with the peaks of a thousand waves, or to depict little boats.

Despite the variety of these illustrations, with their rich chromaticism – dominated by yellows and blues, supported by reds and greens – and a more or less dense structure, unity of the ensemble is brought about by the evocation of a single general theme, the sea, and by Dufy's talent, which reveals the same relaxation here as it does in his large monumental decorations.

While he was in Perpignan, during the war and after the Liberation, Raoul Dufy was able to return to his work in ceramic decoration. The painter and ceramicist Jean-Jacques Prolongeau,[30] who had given him a little white stoneware horse, placed his studio and his kiln at Dufy's disposal. Their collaboration, which continued until Dufy's death, produced numerous pieces of tin-glazed earthenware fired at a low temperature (980–1,000 degrees Celsius), decorated with the familiar motifs of bathers, shells and portraits. In some of these works,[31] such as the blue earthenware tiles, *Bather* and *Girl and Scallop-Shells*, we can clearly see the originality of Dufy's composition, the lightness and spontaneity of his style and the grace of his figures.

241–246 Designs for the swimming-pool of the cruise-ship *Normandie*. 1935. Watercolours.

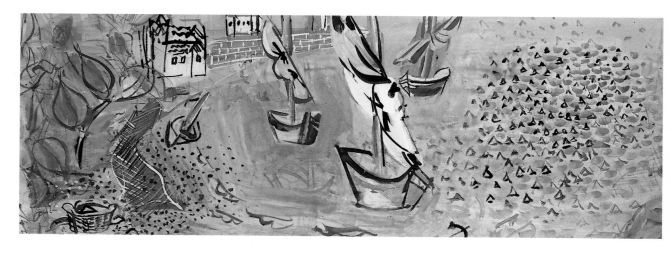

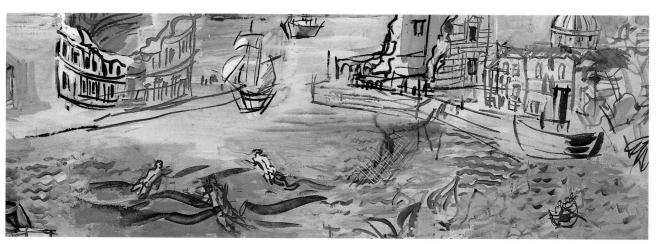

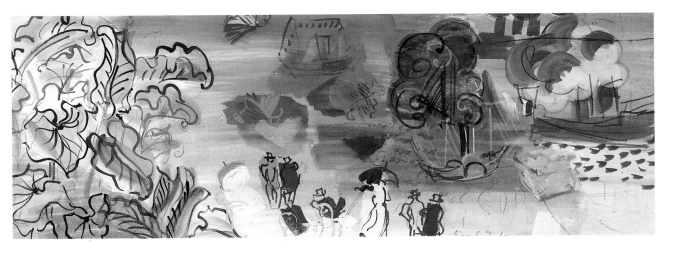

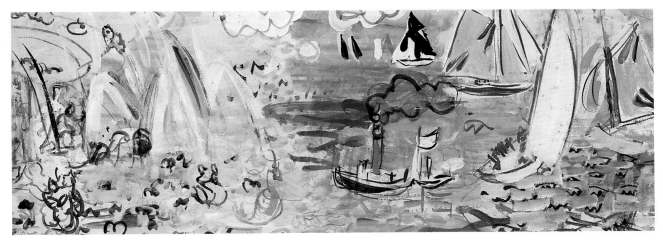

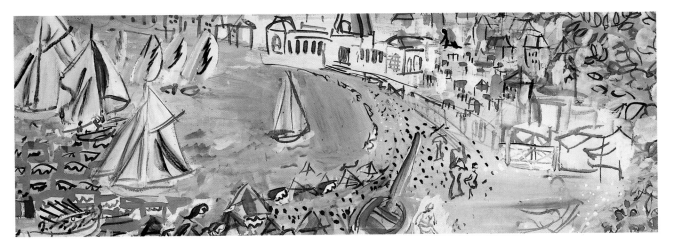

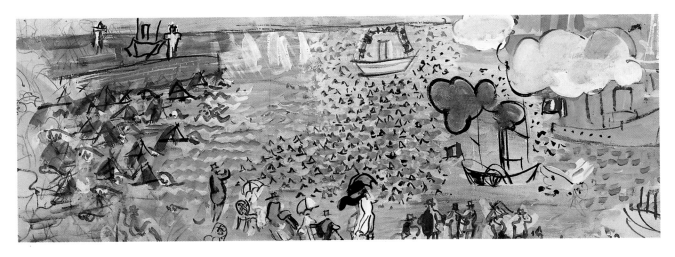

The same is true of certain vases, notably the *Vase with Bathers*, whose form derives from the works of René Buthaud.[32] The two tiles showing *Reclining Bathers*,[33] wrongly attributed to the collaborative work of Artigas and Dufy – and previously dated 1924–25 – reveal a graphic intervention by Prolongeau who, as he himself has pointed out,[34] decorated certain pieces from sketches given to him by Dufy. These pieces, as well as a tile showing the *Portrait of Berthe Reysz*, were made in 1949.[35]

Most of the works made during this period, signed with the monograms P and R, were kept by Raoul Dufy until his death.

247 *Vase with Bathers*. Around 1945–49.

248 Tile, *Girl and Scallop-Shells*. Around 1945–49.

249 Tile, *Bather*. Around 1945–49.

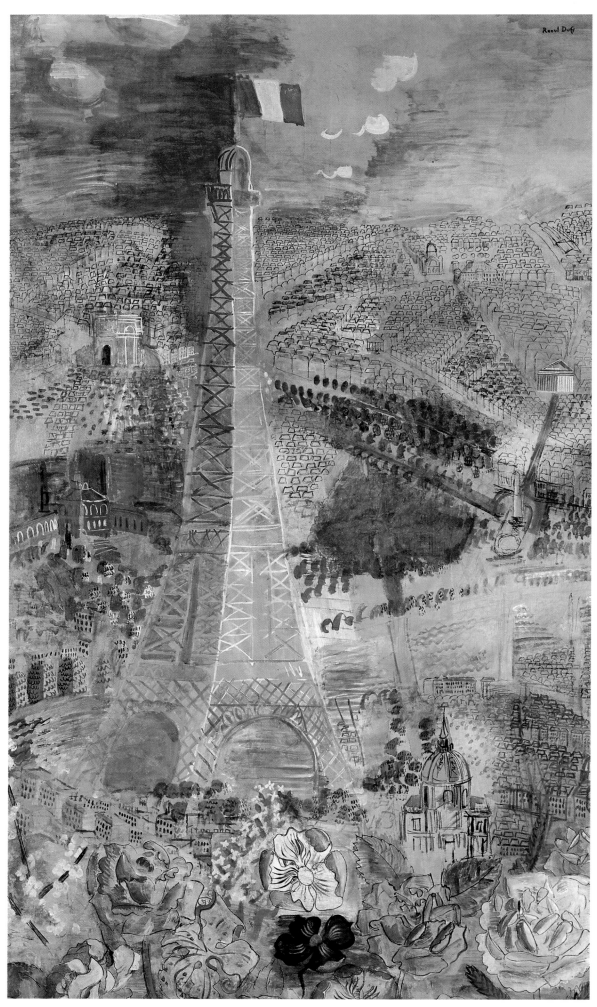

250 Design for the screen, *Paris*. 1930. Gouache.

VIII

THE TAPESTRY CARTOONS

251 Tapestry for one of the seats from the dining-room suite,
Monuments of Paris, for Marie Cuttoli. 1936.

Raoul Dufy's curiosity, which always drew his experimenting spirit towards new techniques, naturally led him the the art of tapestry. His interest in this area began in 1924, when the State commissioned him to make cartoons for a suite of drawing-room furniture.

Problems very soon arose, which Dufy sought to resolve with new experiments which he carried out first with Marie Cuttoli and then with Jean Lurçat. It was not until 1947–48 that Dufy managed to overcome his difficulties by linking his work with that of his medieval predecessors: it was from that point onwards that he was to produce his most successful works in this field.

Works for the Beauvais Factory

When Dufy became interested in tapestry, this art was still suffering from the excesses of the eighteenth century, in particular the reforms of Jean-Baptiste Oudry, the court painter, artistic director of the Beauvais factory and inspector of the Gobelins factory. Oudry had decreed that tapestries should be perfect copies of oil paintings. To achieve this he had had to overcome the resistance of the master weavers who were deprived of all interpretative freedom. These weavers had been forced to increase the number of tones so as to achieve a perfect copy, and to reduce their point-size in order to convey all the shades of the painting,[1] which involved lengthy and expensive work.

This 'contamination' of tapestry by painting, which resulted in the loss of its originality, continued into the nineteenth century, when few painters of note took an interest in the technique. Weavers were content to reproduce the tapestry works of the eighteenth century, using the same methods.

The experiments carried out at the beginning of the twentieth century, such as those of Maillol, Sérusier and Bonnard in Paris, or Flandrin in Grenoble, were short-lived. 'The factories of Gobelins and Beauvais are vegetating in the shadow of the past,' wrote Lurçat.[2]

However, the State set aside a budget for the development of contemporary models. With Paul Léon as Director of Fine Arts and Jean Ajalbert in the National Factory at Beauvais, a programme was developed to award commissions to the decorators and painters of the period. In order to avoid any favouritism a referendum was held at the beginning of the 1920s.[3] Dufy was named as the artist best qualified to introduce modernism to the Beauvais factory: 'I voted for Dufy', said Lurçat, 'and I cannot have been alone, since the vote for his name was unanimous [...]. Certainly, Dufy knew nothing about tapestries, but we saw him as coming closest to our notion of the ideal tapestry-maker, and we naturally gave some thought to the Middle Ages, to the millefleurs side of his work, his pastoral side, in short the gentle [*gentil*] aspect, in the old sense of the word, of Dufy's painting.'[4]

By an order of 11 February 1925,[5] Dufy was commissioned to design a suite of furniture on the theme of *Paris*, comprising four chairs, two armchairs and a sofa, to be made into tapestries by the National Factory at Beauvais. These works were followed by an additional commission for cartoons for two armchairs and two wing chairs.[6]

Ajalbert did not involve Dufy in any of the technical considerations, asking him only to make the cartoons. This was the source of Dufy's reproach when he said: 'The knowledge of a skill is a treasure which an artist can endlessly and profitably explore. He will even find enough in it to feed his imagination.'[7]

The correspondence between Dufy and Ajalbert reveals difficulties that arose in the realization of this set of furniture, which required seven years of work. Dufy, who was involved in other decorative work – the making of hangings for Poiret's barge *Orgues*; ceramic works with Llorens Artigas; book illustrations, notably *La Terre frottée d'ail* – and in his travels in the South of France and Morocco, took some time to deliver his first cartoons, a fact which partly serves to explain their disagreement.

The decorators Süe and Mare were originally to have made the frames for the furniture, but in the end this task fell to André Groult. Groult was Poiret's brother-in-law and a member of the factory's administrative committee. He made

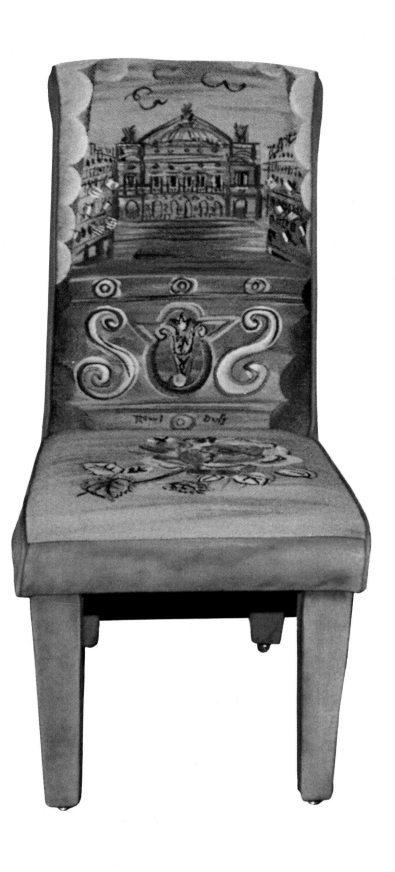

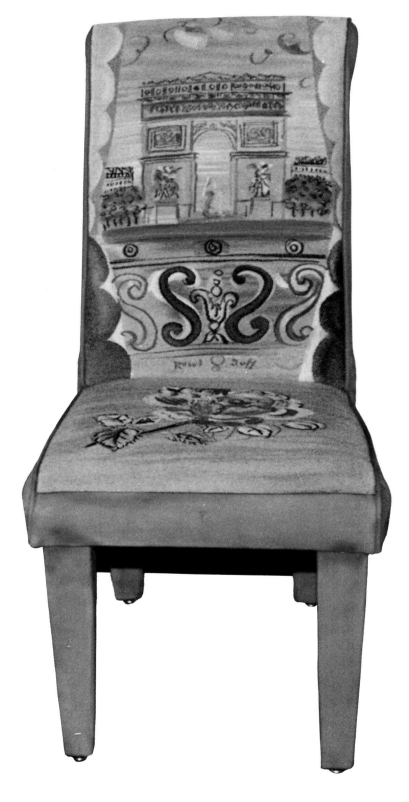

252 Chairs of the dining-room suite,
Monuments of Paris, for Marie Cuttoli. 1936.

254 Tapestry for one of the seats of the dining-room suite, *Monuments of Paris*, for Marie Cuttoli. 1936.

255 Tapestry for one of the seats of the dining-room suite, *Monuments of Paris*, for Marie Cuttoli. 1936.

253 Tapestry design. 1936.
Oil on canvas.

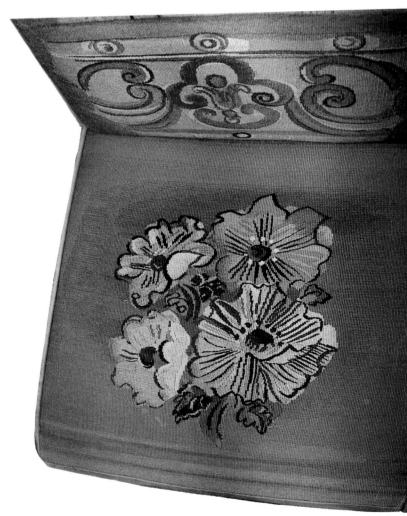

Opposite
256 Chair from the dining-room suite, *Monuments of Paris*, for Marie Cuttoli. 1936.

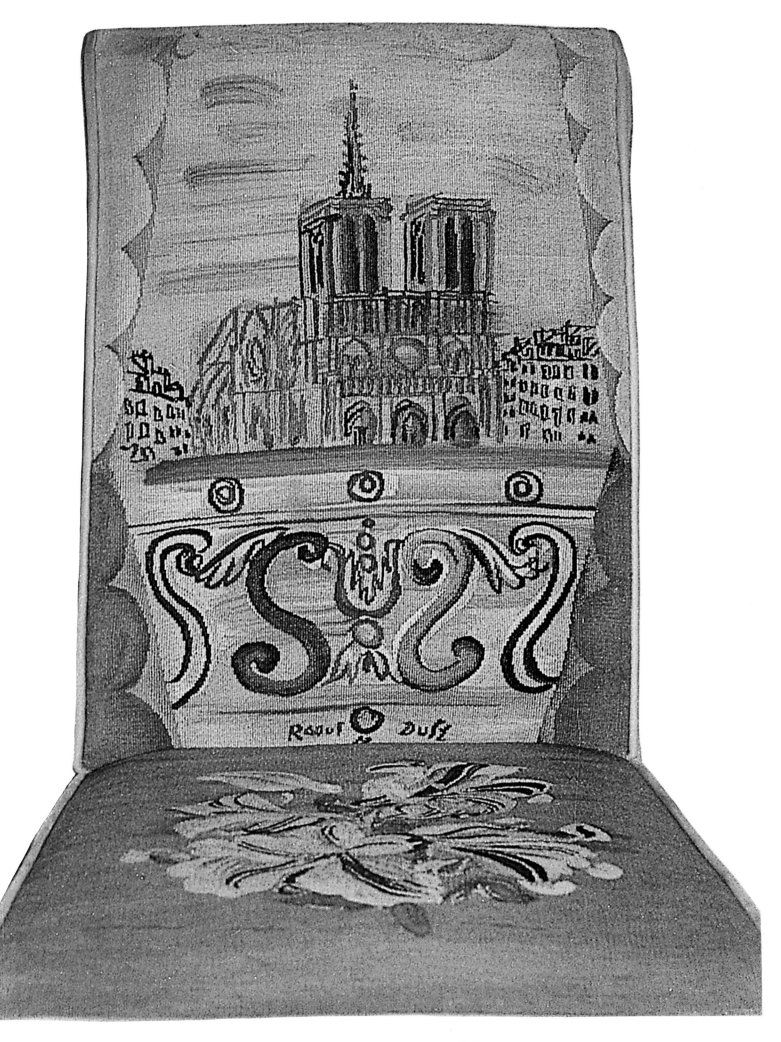

lacquered frames, brown 'nuagé' with gold, on which the fabrics woven from Dufy's cartoons for this suite of furniture were later mounted.

An unpublished letter from Dufy, sent from Golf-Juan in February 1927, tells us that the sketches for the cartoons for the sofa and the two armchairs were ready at that time, and in November 1928 Dufy delivered to the factory all the cartoons for the sofa, the two armchairs and the four chairs.[8]

However, the second commission placed a great strain on his relations with the factory's director. Ajalbert and the Minister of Fine Arts eventually sent court orders.[9] All the cartoons for the two other armchairs and the two wing chairs from the second commission were delivered at the end of 1930, and in October 1931 the screen and the complete suite of *Paris* furniture were completed at Beauvais.[10]

This set of furniture (Mobilier National, Paris) was shown in the Galerie Bernheim-Jeune between 22 February and 4 March 1932 and was hailed by the critics as a landmark in the development of the National Factory of Beauvais.

Paris and its monuments form the decorative theme of the set. For each view of the city Dufy chose an elevated viewpoint; but his representations have neither fastidious topographical precision nor the banality of a picture postcard. Guided by his natural imagination, he gives us a playful view of them. He manipulates perspectives according to an arbitrary compromise which allows him to locate the monuments of Paris in a series of foreshortenings and lines that bear no relation to reality.

The ensemble of the four-panelled screen was dominated on the left-hand side by the majestic eminence of the Eiffel Tower. Here Dufy returned to the panoramic evocation of Paris that he had used in one of his wall-hangings decorating Poiret's barge, *Orgues*. With a magical line unburdened by any mathematical logic, he shows us the façades of the monuments, from the Invalides to the Madeleine and the Sacré-Coeur, from the Panthéon to the Bastille, regardless of their respective situation. These monuments are interspersed with collections of houses, shown as a mass of little cubes, and the green spaces between them, framed in a geometrical web of streets and avenues which lends the ensemble of the composition its decorative rhythm.

In the lower band of the screen, magnificent blooming flowers, as sumptuous as the '*tapisseries aux mille fleurs*' of the Middle Ages, underscore the poetry of Paris. Red and yellow roses, highlighted in white, and tiger lilies combine with red-rimmed anemones and golden ears of corn in a symphony of tones, forming a counterpoint to the blue of the sky that bathes the witty circle of pink and white clouds, underscored in red. The white tonality of the metal grid on one of the sides of the Eiffel Tower, set off by the red of the other side, orchestrates the harmony of the composition. At the same time as this work was being made, Dufy was painting his most beautiful watercolours with rose motifs for Bianchini-Férier.

A host of preparatory studies preceded the creation of the cartoon for this screen, plans in which the floral motifs are lent an almost tactile velvety relief by their treatment in gouache. The pen-drawn lines, which intervene to stress the baroque outline of the corollas and petals, and which are unrelated to the coloured brushstrokes, give them a certain freshness and lightness. Many preparatory sketches went into the development of these works; these show a spontaneity, freedom and liveliness that hide the effort and study that went into their making.

The decorations on the backs of the four armchairs depict Parisian monuments in a space between a pair of tulle curtains, from a window with a wrought-iron balcony. *The Opéra, The Moulin Rouge, The Madeleine* and *La République* are bathed in a general tonality of cerulean blue interspersed with little white or red-tinted looped clouds. It was no accident that Dufy, a great lover of music, opera and ballet, should have chosen to portray the Opéra, a temple of music and dance. In combination with the multicoloured bunting of the buildings along the Avenue de l'Opéra, it evokes a festive spirit with its colourful rhythm. At the same time, Dufy made a series of works on the theme of the *Balconies of Paris*, in which each window looks out over a monument.

In his cartoons for the two wing chairs Dufy abandoned the motif of the curtains in order to provide an unimpeded view of the Place de la Concorde from two different perspectives. Punctuated by a sequence of large coloured planes and

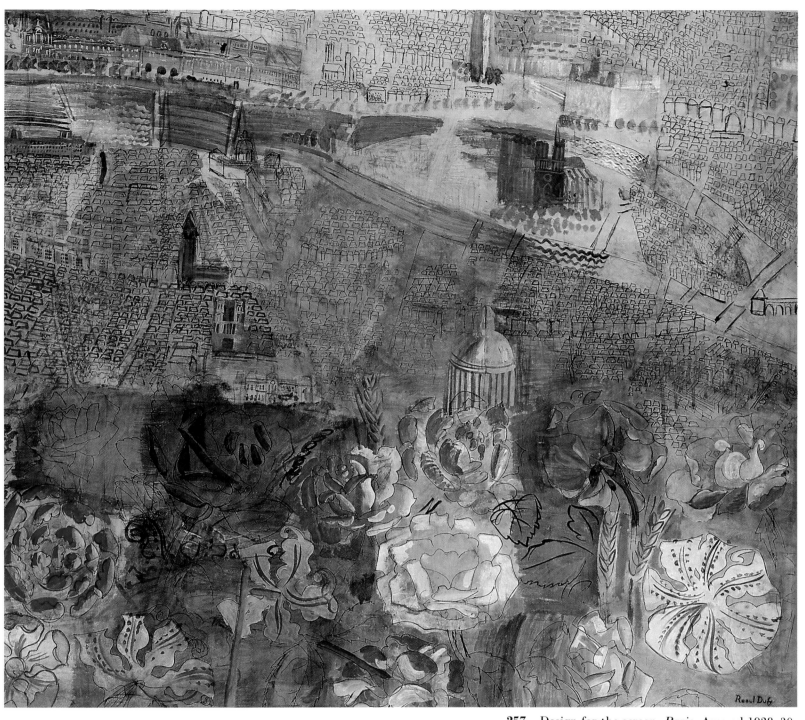

257 Design for the screen, *Paris*. Around 1928–30.
Pen-and-ink and gouache.

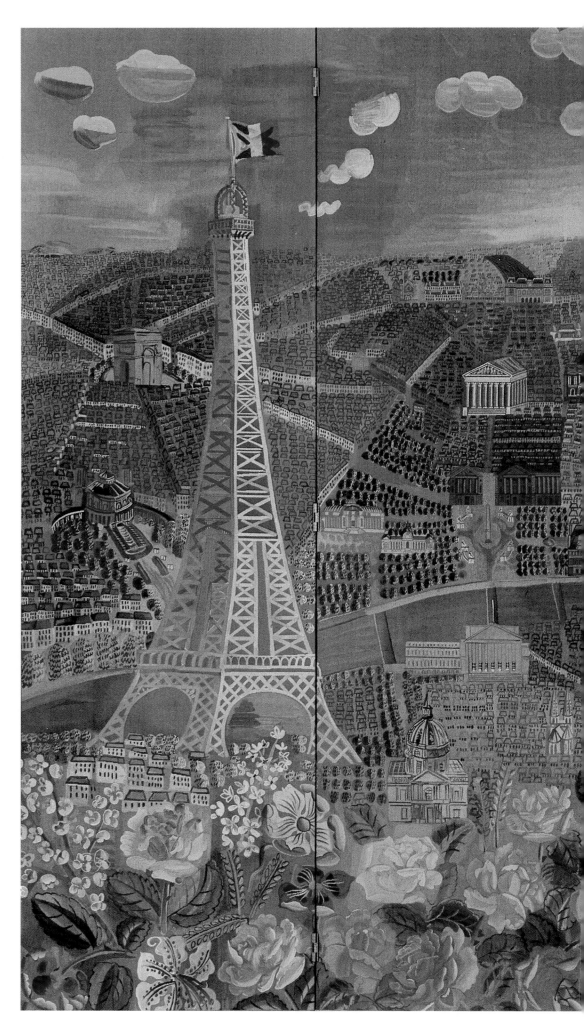

258 Screen, *Paris*. 1930–31.
Beauvais tapestry.

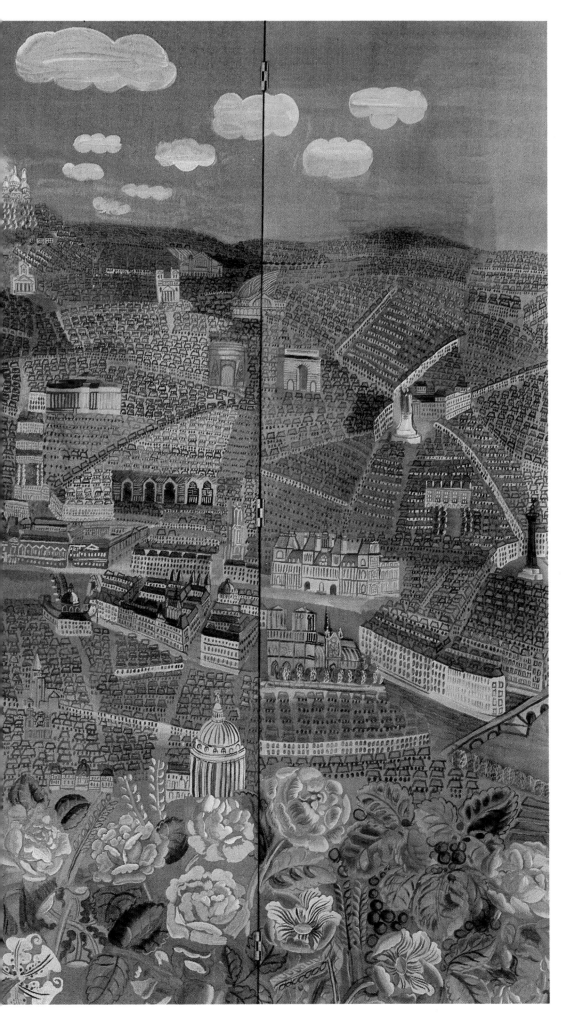

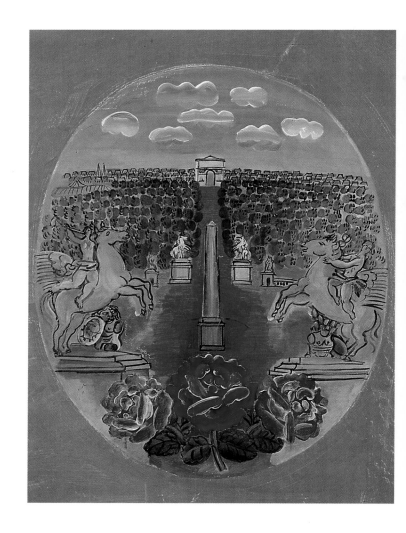

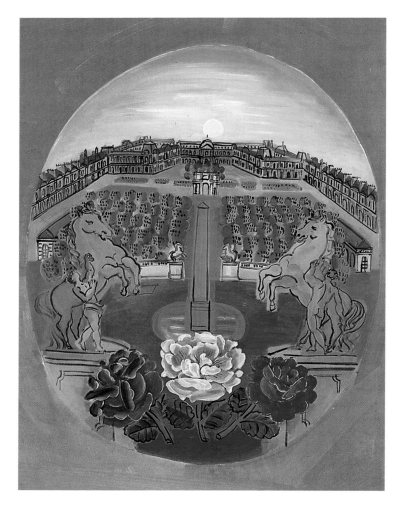

underscored by a set of geometrical lines answering or countering one another, these two compositions provide a reversed perspective. The first looks out on a panorama that includes the Place de la Concorde, the Tuileries, the Arc de Triomphe in the Carrousel and the Pavillon de l'Horloge of the Louvre. The middle ground is occupied by the two sculpted groups of horses by Coustou, while the brilliant tones of three blooming roses decorate the foreground. The second composition starts out from the pillars of the entrance to the Tuileries, surmounted by the horses of Coysevox, symmetrical with those of Coustou, goes down the Place de la Concorde, returning up the Avenue des Champs-Elysées to end at the Arc de Triomphe. The stature of this monument stands out against a sky bearing a band of white clouds that soak up the blue of the sky and the pink of the lights that illuminate it. Once more the composition is decoratively underscored by three roses in full bloom.

Other monuments, treated in various different ways, decorate the backs of the four chairs which complete the *Paris* set. These compositions, which have a bouquet of flowers, leaves and ears of corn along the bottom, show *Notre Dame*, from which no architectural detail has been omitted; the *Arc de Triomphe*, stripped of its surroundings, floats in space. The ring of clouds floating above these monuments reappears around the buildings of the dome of the *Invalides* and the *Porte Saint-Denis* which decorate the backs of the other two chairs.

For the decoration of the seats of all the chairs, Raoul Dufy designed various floral motifs in a garland, with a luxurious ornamental richness which comes from the variety of their forms and their warm chromaticism.

In his cartoon for the back of the sofa, Dufy returned to the motif of the parted tulle curtains, their lace borders echoing the scalloped curves of the rose petals, whose ornamental lines embellish the composition. From a flower-filled balcony with a decoratively curved wrought-iron surround, we are given two views of Paris on either side of a sumptuous composition of lilies, amaryllis and roses framing a birdcage and a fishbowl. On both sides of the composition apple-blossom adorns the decorative arrangement of this design, for which Dufy returned to a gouache for a satin fabric published by Bianchini-Férier in August 1923.

In the suite of chairs, sofa and screen of the *Paris* furniture Dufy brought new life to the traditional use of flowers, combining it with the decidedly modern theme of the monuments of Paris. However, the treatment of this subject is still within the tradition of eighteenth-century tapestries, in which the buildings of the châteaux played an important part. But the choice of Paris, that symbol of *joie de vivre*, as well as the use of brilliant and refined colours, designed to evoke gaiety and elation, make this suite of furniture one of Dufy's most successful artistic creations.

Even if the making of a suite such as this testified to the skill of the weavers, who were obliged to work with a low warp, using an enormous number of wools and thousands of points, it still required a great deal of care and attention. This method discouraged Dufy, who was unhappy with the way in which the master weaver – 'that artist-craftsman' mocked by 'the sinister Ajalbert'[11] – was deprived of any interpretative function, and it explains the difficulties that he had in completing his work. His collaboration with Ajalbert left Dufy with bad memories and kept him away from this technique for some time.

The Cartoons for Marie Cuttoli

Dufy returned to the art of tapestry in 1934 when he was commissioned by Mme Cuttoli. He made cartoons painted in oils on Parisian themes in 1934 and 1937, and on the theme of Amphitrite in 1936, designed to be made into mural tapestries at Aubusson. Between 1938 and 1939 he made a series of cartoons for a drawing-room suite based on the subject of the Cortège of Orpheus, and a set of ten dining-room chairs on the theme of Paris.

The *Paris* mural tapestries[12] show the same characteristics as the *Paris* screen in the Mobilier National. Dufy organized his composition without reference to the traditional conventions of perspective inherited from the Renaissance. He adopted the same elevated viewpoint. This high perspective affords a view of all the main areas of Paris and the façades of their buildings, depicted in a foreshortened style

263 Tapestry cartoon for armchair seat of the *Paris* suite of furniture. 1925. Watercolour and gouache.

that Dufy had made his own, and which can be seen in the houses, in the form of trapeziums, that stretch into the distance.

The lighting for this composition is unrealistic. Moonlight in a cloud-filled, rainy sky is set next to sunlight brightening a sky in which a rainbow announces the coming of good weather.

These two tapestries are distinguished by their reversed layout, the 1937 version being closer to reality. They are differentiated by their chromaticism, with the warm tones of ochres and pinks contrasting with the cold tonalities of greens and blues, warmed by the pink shades of the monuments and the red streak across the Eiffel Tower.

Both tapestries are faithful reproductions of Dufy's cartoons in oil,[13] as is the tapestry *Amphitrite*, made in 1936. In each case the master weavers merely played the part of copyists.

The Amphitrite theme, which reveals Dufy's attraction to water and the sea, is also a homage to the city of his birth. In this work, showing the Bay of Sainte-Adresse, he arranges some of his favourite motifs around the goddess, allowing the real to mingle with the imaginary. From a reality that he has observed many times – shrimp fishermen, bathers, naiads, freighters, sailboats and three-masters – Dufy creates a world of his imagination. The realistic framework is given the appearance of unreality by being a mirror-image of the real landscape, since the translation of the design into a tapestry places the houses and cliffs of the coast of Le Havre on the left- rather than the right-hand side. From this elevated perspective, the raised line of the horizon provides a clear view of the distance. Dufy plays with scale once again, and the interrelations of forms and objects construct the space by 'taking on the notation of a musical stave'.[14] However, although Dufy may play with the proportions of his objects, he does not distort them.

Seated in the foreground, the allegorical figure of Amphitrite[15] dominates the composition, along with her symbolic scallop-shell. Derived from *The Large Bather* (1914), this figure has a certain monumentality that recurs in *Nude with Shell*, in which the goddess stands out against a background, originally blue and subsequently repainted in a deep pink, in an identical posture. In the tapestry a sea breeze is suggested by the wind-swollen sails and the choppiness of the surface of the sea, conveyed by triangular accents.

In the middle of the sky, the scallop-shell with its rounded outline is echoed in the whorls of the baroque-shaped shells at the edge of this tapestry, a poetical transposition of reality. 'You will observe', Dufy said to a friend one day, 'that there are not very many shells in my apartment. My shells come from within. I know the sea as a bather, as a sailor and as a painter. It is as a painter that I like it best.'

Mme Cuttoli commissioned Dufy to make cartoons for a set of ten dining-room chairs on the theme of *Paris*. On the back of each piece, according to the same principle as his Beauvais furniture, Dufy showed the view of a Parisian monument across a balcony framed with scalloped curtains. The more vertical format of these pieces allowed him greater imaginative freedom in his treatment of the wrought-iron motifs, which vary from one chair to another. The buildings stand out against a larger area of sky with clouds floating across it, either scattered or in groups but always conveyed in Dufy's individual style: open loops underscored by a patch of colour, over the *Bourbon Palace* or the *Arc de Triomphe*, streaks of paint knotted into a highly ornamental motif floating over the *Eiffel Tower* and the *Moulin Rouge*.

These cartoons show monuments which do not feature in the decoration of the Beauvais suite: the *Arc de Triomphe in the Carrousel*, framed by the leaves of the Tuileries; the *Pont Neuf* shown twice from different angles; the *Hôtel de Ville*, surmounted by the sailboat that refers to the motto of Paris, *Fluctuat nec mergitur*. Dufy's imagination comes into its own once again in the representation of this swollen-sailed ship standing out against the blue sky, an affectionate motif, its curves modelled with evident pleasure.

The seat of each chair has an individual floral motif: rose, tiger lily, anemone, the sinuous lines of their corollas and petals turned into the most decorative arabesques. In this set of chairs,[16] Dufy chose a variety of monochrome colours –

264 *Monuments of Paris.* 1816.

265 *Paris.* 1934.
Aubusson tapestry.

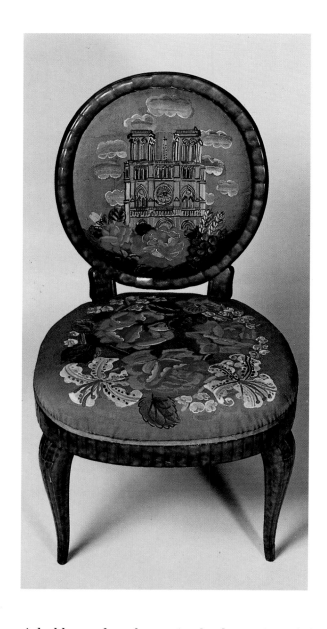

266 Chair, *Notre-Dame de Paris*, from the *Paris* suite of furniture. 1925.

Opposite
267 Sofa from the *Paris* suite of furniture. 1928.

268 *Paris*. 1930.
Gouache on canvas for a Bianchini-Férier fabric.

green, yellow, pink, blue, red – whereas in the decoration of the Beauvais *Paris* furniture he had used only a blue tonality.

In 1939, again for Marie Cuttoli, Dufy made cartoons for a drawing-room suite comprising a sofa, two chairs and two armchairs on the theme of *Orpheus*. Here Dufy returned to certain motifs from the engravings that he had made in 1910 for Apollinaire's *Bestiaire*. Along the base of the tapestries for the chairs there runs a quatrain taken from this work, standing out in white against a coloured background. The back of the couch is decorated with a frieze showing Orpheus holding his lyre, dressed in a loincloth, haloed by his drapery and accompanied by his cortège of animals in the midst of stylized vegetation.

Pegasus, the tortoise, the Asian elephant, the dolphin – which Dufy had chosen as ornamental motifs for fabrics for Bianchini-Férier – decorate the backs of the chairs and the armchairs.

In these compositions Dufy took delight in using a sinuous style of arabesques and a harmonious balance of colours. He put the stylization of the floral elements to good decorative use, bringing Orpheus and the animals together without regard for their proportions.

Despite the technical methods advocated by Marie Cuttoli, which went against his own aspirations and experiments in the field of the tapestry, Raoul Dufy was pleased with this collaboration, which led to the creation of works of a very high quality.

Particularly well-known for her notable collection of avant-garde paintings, Mme Cuttoli had announced her intention of making tapestries in collaboration with contemporary painters. She wished to be instrumental in the revival of

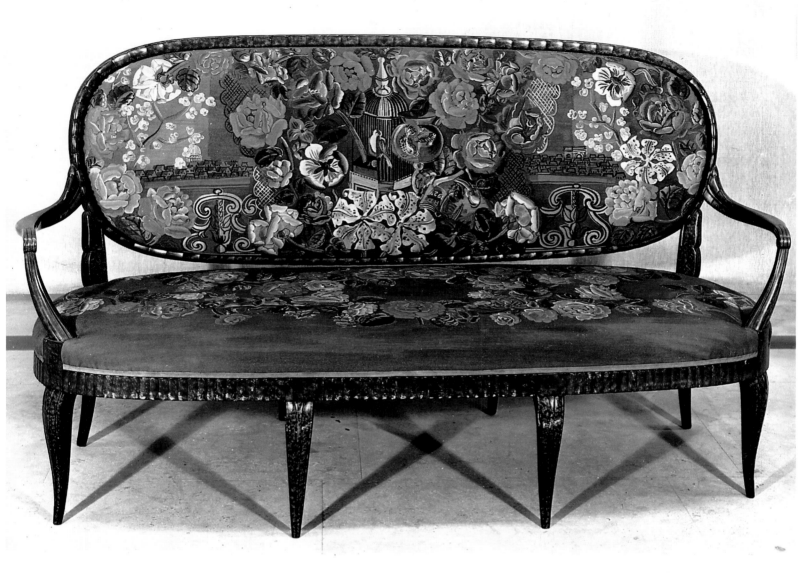

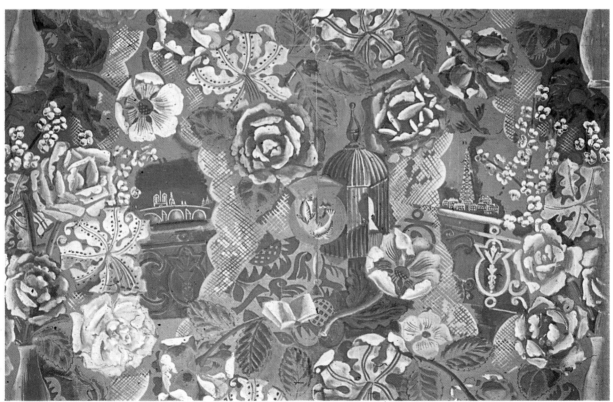

271 Sofa from the suite of furniture, *Orpheus*, for Marie Cuttoli. 1939.
Aubusson tapestry.

272 Chair and armchair from the suite of furniture, *Orpheus*, for Marie Cuttoli. 1939.
Aubusson tapestry.

269 Cartoon for the back of the sofa, *Orpheus*.
1939.
Oil on canvas.

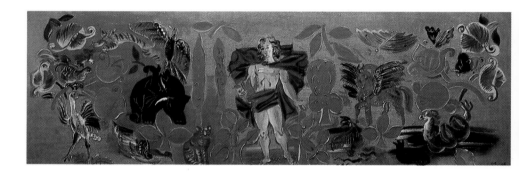

270 Armchair and chair from the suite of furniture, *Orpheus*, for Marie Cuttoli. 1939.
Aubusson tapestry.

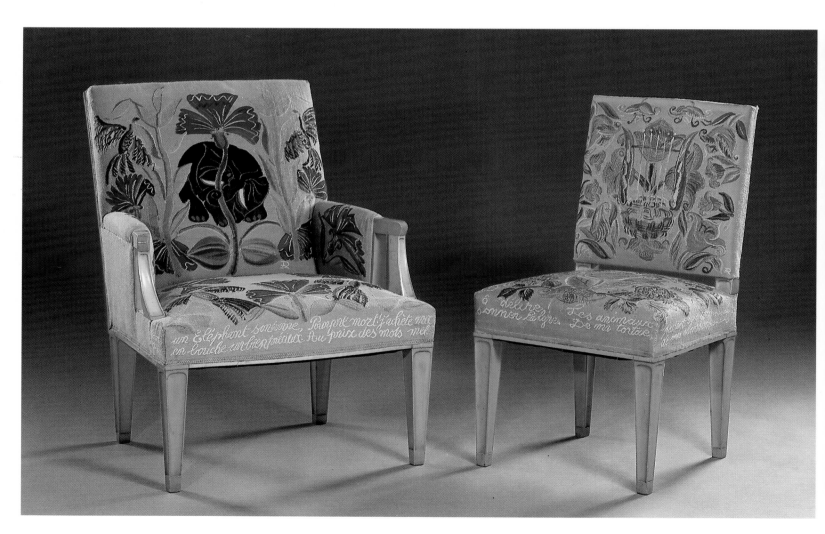

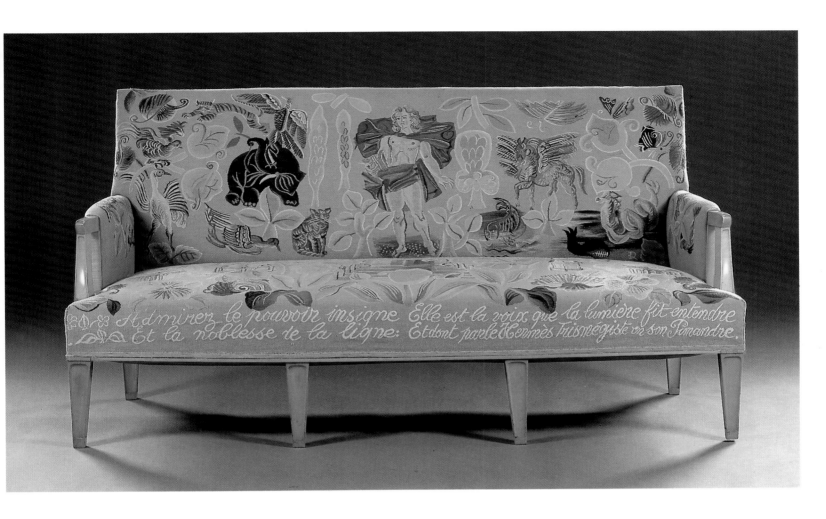

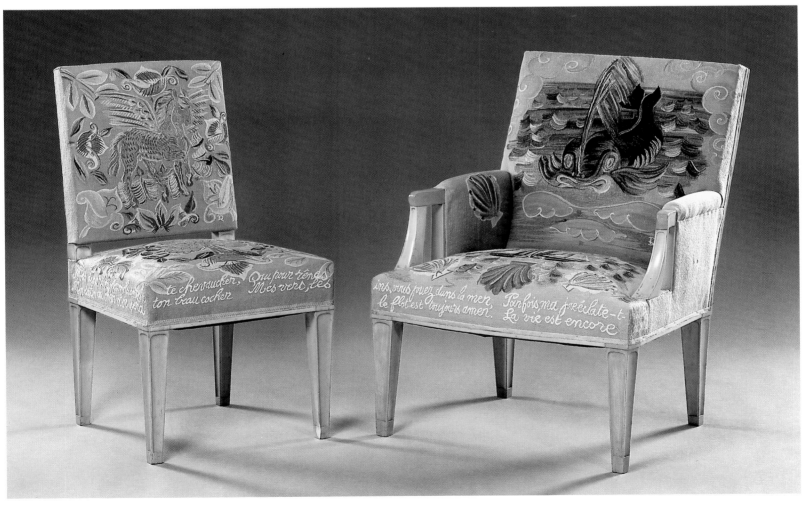

tapestry from 1929 onwards, commissioning cartoons painted in oil from the great painters of the time, to be reproduced as tapestries. But her experiment was short-lived. She was actually recommending what Jean Lurçat described as a 'reactionary' method, returning to the ideas of the eighteenth century. Apart from Miró, only Lurçat supplied her with true cartoons. Rouault, Braque, Léger, Matisse, Picasso and Dufy all supplied oil paintings.[17]

Mme Cuttoli, who was opposed to any transposition or simplification of painted models, demanded that the workers at Aubusson conform entirely to the painters' works.[18] In so doing she remained far removed from the true technique of medieval tapestry-making, to which Lurçat was to return. Nevertheless, her enterprise encouraged discussions, questions and reflections in artistic circles, which would restore nobility to the art of tapestry.

The Collaboration between Raoul Dufy and Jean Lurçat

It was with Jean Lurçat that the art of tapestry would truly come into its own. His reform consisted in a return to the medieval tradition, which gave tapestry a mural function: all vanishing and modelled perspectives were banished from it, and borders were discarded. For Lurçat, the tapestry had to be entirely independent of painting. He abandoned the Chevreul range and restricted himself to some forty shades. His major innovation lay in the development of a black-and-white cartoon, schematized and covered with technical notes, in which all the colours and their shades were numbered. His method led to a high fidelity of execution, and the weaver once more became the painter's collaborator and interpreter.

With Jean Lurçat, Dufy attempted a new experiment in the technique of tapestry. At the time he was one of a group of professional Parisian painters making cartoons for tapestries, along with Gromaire, Lurçat, Bazaine, Derain, Bauchant, who advocated a complete harmony between weavers and the painters who learned the secret of the profession and its yarns.

In 1941, having moved to Perpignan,[19] Dufy, along with Lurçat, made the cartoons for the two tapestries, *Collioure* and *The Fine Summer*, worked in *gros point* in 1942 in the Tabard studios at Aubusson. These cartoons, whose layout is a mirror image of the final version, were executed in black and white, their colours and shades simply numbered according to the method advocated by Lurçat.

A preliminary draft in watercolour and gouache exists for the cartoon of the tapestry *Collioure*, which, like the tapestry itself, shows a rustic landscape, developed on four well-defined planes of colour. The rays of a setting sun illuminate a raised horizon, counterpointed in the gold of the ears of corn and the brilliant yellow of the basket in a still life in which white daisies, leaves and fruits harmonize within an ornamental wickerwork design. This composition is enlivened by the sinuous pose of a young woman, and framed on the right-hand side by a curtain which stresses the decorative aspect of the tapestry.

In *The Fine Summer*, Dufy assembles a landscape from various visions of nature, which he sees as being merely a 'hypothesis'. In this broad landscape, with its lively and robust tones, framed by curtains, Dufy united his favourite themes within a single composition. The large arched red-brick wall of the old castle keep, which borders the composition on the right-hand side, stands opposite the motif of the sloping cliff, from which a spring pours into the river. These images had first appeared in *The Harvest*, and Dufy returned to them the following year in *The Aqueduct or Summer*, a hanging which he made for Poiret in 1925. Familiar motifs are reinterpreted with a new vision, such as the olive tree that forms the centre of the composition with its rich network of branches, and the opulent still life of fleshy and colourful fruits and vegetables spread out beneath it. Dufy also returned to the theme of the harvest, with the field of golden corn, the thresher belching smoke, the bound sheaves and the swaths whose clearly outlined furrows cut across the ploughed fields. A fisherman sitting nonchalantly on the grass beside a river[20] is balanced on the left-hand side by the figure of a cowgirl seated in a flower-filled meadow, watching over her herd.

A sun at its zenith, a rainbow, and black and white looped clouds divide the sky that stretches over this rich composition. A rhythm is provided by planes of colour

273 *Collioure*. 1941. Aubusson tapestry.

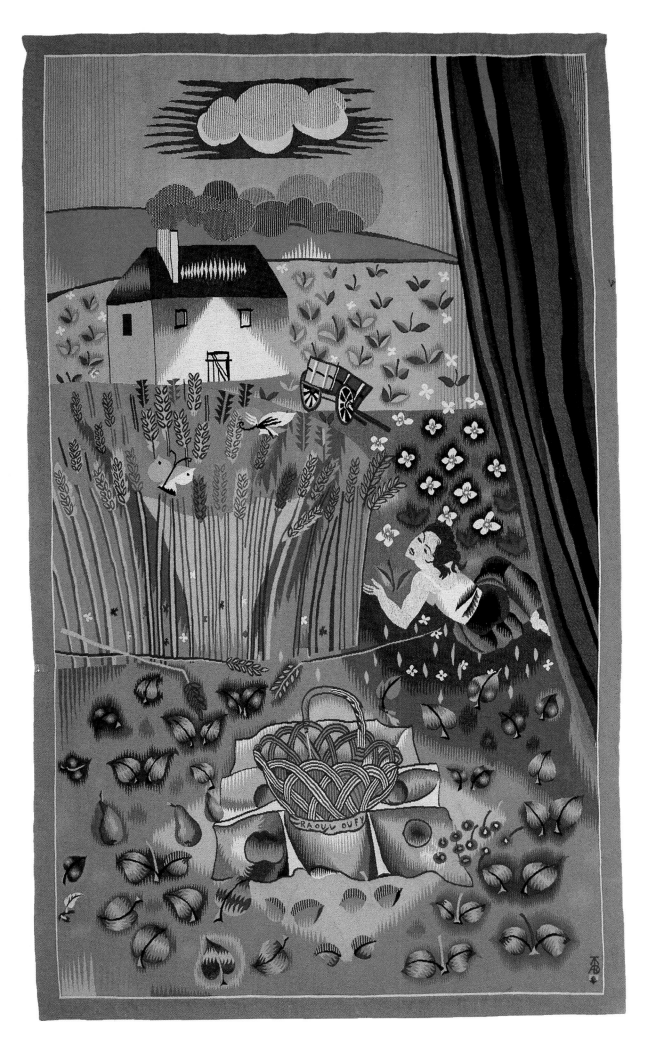

stressing nature's riches. In this work Dufy expresses his profound sensitivity towards nature. It has been described as a poem celebrating the earth and the seasons, and thus linked to the *Très Riches Heures du duc de Berry* (Musée Condé, Chantilly).

This tapestry, with its balanced composition, its precise design and shimmering colours, was prepared in a large number of pen-and-ink, gouache and watercolour studies.

It was perhaps in his studies that Dufy was closest to nature, since drawing gave him the opportunity to interpret it in a simplified language. This is the first manifestation of that sensitivity that allowed him to grasp and represent the essence of his vision: 'Drawing', wrote Zervos, 'provides us with a glimpse of the process of the transmutation of the artist's sensory impressions into visual facts.'[21]

In two separate studies, freely painted in gouache, we see once again the graphic shorthand notations characteristic of Dufy's style; in a few basic lines rapidly applied he captures the main elements of his composition. He neglects detail in favour of simple and basic signs with which he reduces nature to its essentials.[22]

His line curves into looped arabesques that convey clouds, distant vegetation and the smoke of the thresher. The straight lines of the stalks of corn, tempered by the curve that encloses them, are part of the great play of diagonal, vertical and horizontal lines that make up this composition, embellished by the repetition of little parallel furrows. Dufy had the gift of being able to 'summarize' the gestures and attitudes of the figures in his compositions. He does this with the fisherman, whose body is described in a single continuous line, reinforced at the knee to stress his posture, while a simple outline encloses the form of the cowgirl, set within the landscape.

The round tower of the keep and the cliff with its spring[23] formed the subject of two individual studies. Dufy made two watercolour ensemble sketches for the composition of *The Fine Summer*. Their poetical arrangement has an essentially decorative character appropriate to its architectural destination, which is preserved in its reproduction as a tapestry.

In 1943, between his collaboration with Lurçat and his making of black-and-white cartoons, Dufy made a painted cartoon for a tapestry that was woven in 1946,[24] *The Statue with Two Red Vases*. This theme, which Dufy painted in a large number of variations, was based on a work from 1908 (Musée des Beaux-Arts, Marseilles), bearing the same title, painted at the beginning of Dufy's 'Paracubist' period, in which he abandoned the subjects and composition of his Fauve period, when he had been influenced by Cézannne. Dufy broadened this theme in a 1942 composition (left by Mme Dufy to the Musées Nationaux), which appears to be the painted cartoon for this tapestry, and which is similar in both arrangement and style.

The Cartoons for Louis Carré

In his conversations with Pierre Courthion, Dufy acknowledged his debt to Jean Lurçat, stressing the important part played by Lurçat in the revival of tapestry: 'In this field, Lurçat did considerable work whose importance and value will never be sufficiently known. He encouraged me to make my first tapestry cartoon. I was delighted. But then, when they brought me the finished object, the weaver's work seemed to me to be inadequate. I am in favour of *battues*, you know, that shading towards light or dark that occurs at the loom. To obtain that effect – as they did in the past – the worker must be a real artist, taking his own initiatives with regard to the cartoon, so that not everything is predictable.'[25]

Dufy could not accept Lurçat's method or a 'flat and dry' technique.[26] Wishing to remain closer to painting, he wanted to make painted cartoons rather than drawing them in black and white: 'In order to express myself, I must use objects shown in terms of their archetypal image, so to speak, and not transformed into symbols that are expressive in an exclusively poetic way. I show scenes that are closer to painting, and in order to turn them into tapestries I have to employ all the resources of painting.'[27] Dufy advocated an interaction of the two disciplines, in which neither was to be subservient to the other.

Dufy left the Aubusson studios, where 'the effects, those great *battues*, those serrations, were inadequate in conveying nuanced shades',[28] setting up a private studio in Paris with former technicians from the Gobelins factory, and returned to the technique of his medieval predecessors. He advocated the use of a hand-spun wool, dyed in natural colours and with a limited range of tones, the use of *gros point* and open and robust hatching for the shading of the colours. He used the vertical high-warp method.

He abandoned the mechanical tyranny of the numbered cartoon, made into a tapestry using the low-warp method. Dufy presented the weaver with painted cartoons and thus gave him back his function as a 'sensitive interpreter': 'I am convinced', he wrote Louis Carré, 'that the collaboration of a selected weaver is the indispensable condition for success.'

From the end of 1944, Dufy worked on subjects which would be woven using the high-warp method and shown in 1948 at the Galerie Louis Carré. The weaver was able to recreate original works from painted models, rather than relying on mechanical transcription. This is how Dufy wanted his cartoons realized, comparing the weaver to a pianist, violinist or conductor whose personality leaves its mark on the composer's work without betraying it: these last tapestries are a sensitive translation of Dufy's brilliant palette and his nervous style.

On two occasions, in 1948 and then in 1949, Dufy returned to the theme of Amphitrite to make a painted cartoon for a tapestry to be woven according to his new ideas. In a single composition he united all his favourite themes and motifs within the setting of his childhood, the Bay of Sainte-Adresse.

274 Study for the tapestry, *The Fine Summer*. 1941.
Watercolour.

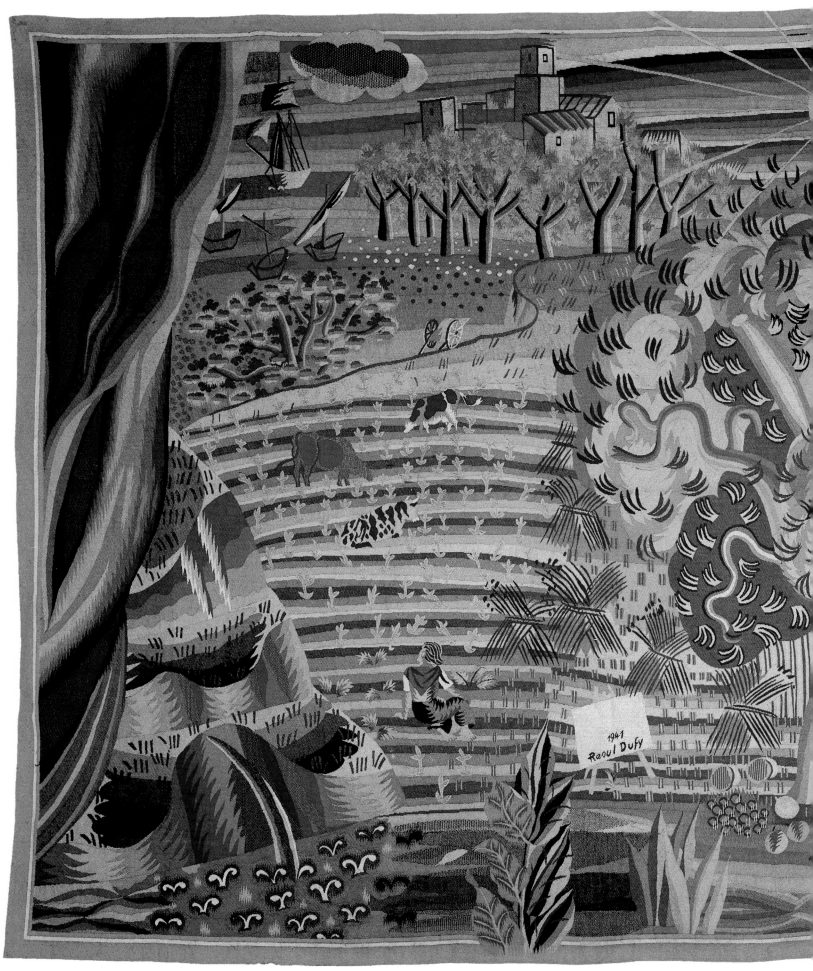

275 *The Fine Summer*. 1941. Aubusson tapestry.

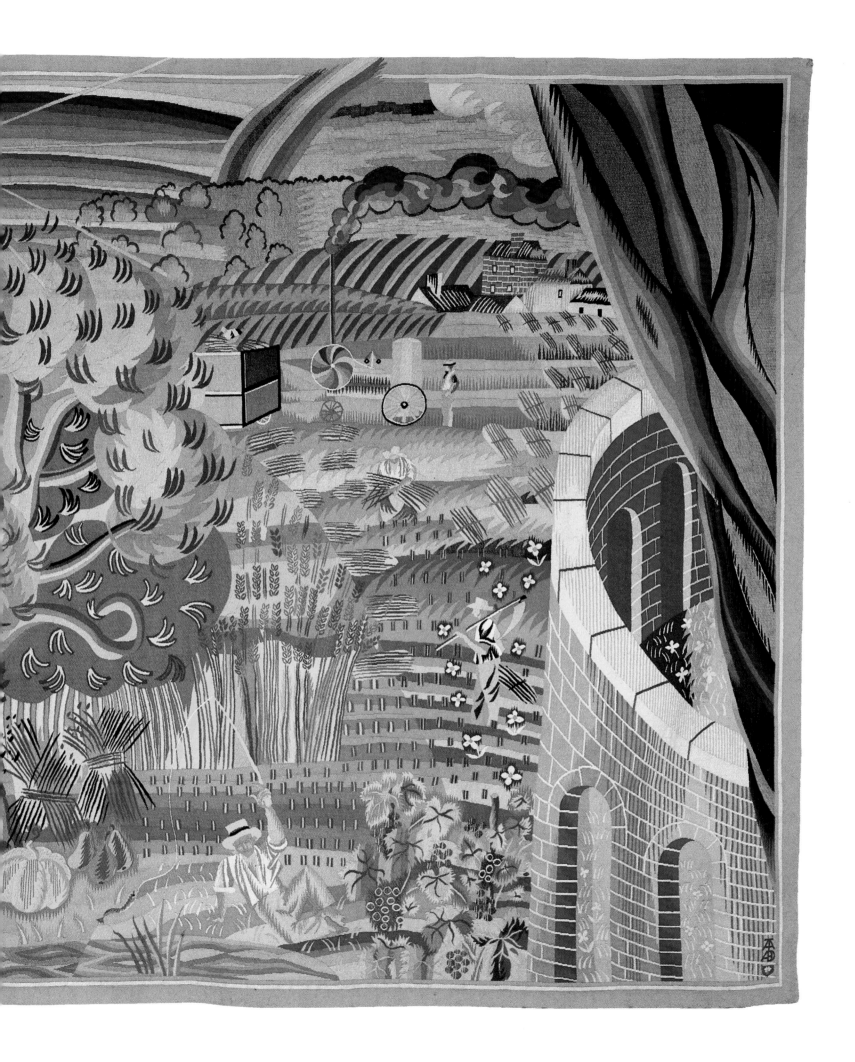

Rising from the water, the goddess appears standing in her shell with its scalloped rim, an echo of the rounded forms of the nude and the arabesques of the clouds. This figure was inspired by Botticelli's *Birth of Venus*, of which Dufy painted several versions between 1938 and 1940. At the same time as he was making this cartoon, Dufy painted a decoration on the panel of a bathroom door in a mansion in the Avenue du Bois (1946–47): the figure of the goddess, standing in her shell, takes up the entire space.

He gave the composition of the cartoon a breadth and range that reveal his sense of space, punctuated with elements whose scale bears no relation to their situation: 'You must not make a small-scale representation of nature, or you are obliged to show certain details microscopically, and a painting should contain no sign that is not visible to the naked eye.'[29]

Several works in oils can be linked to this 1948 tapestry;[30] the painted cartoon is an *Amphitrite* (Private Collection), in which Dufy made use of an extremely free graphic style and brushstroke.

At the instigation of Louis Carré, Dufy returned to the same theme for a second cartoon which was reproduced in 1949.[31] The composition is identical, but the elements are better defined. Despite its luminous coloration, the figure of Amphitrite appears more rigid than it does in the 1948 tapestry, in which it is enlivened by the freedom of Dufy's style.

Two other tapestries woven in 1948 develop a rustic theme: *Countryside*[32] and *Olive Tree*[33] include similar elements, such as the motif of the cliff with the spring pouring from it. In *Olive Tree*, the red-brick keep of the tower reappears. This composition is balanced at the centre by the representation of the olive tree, painted in a jerky style with sheaves of corn arranged in a fan-shape beneath it. Dufy's drawing is well conveyed by the woolly, thick and supple fibre that captures the light. These same qualities recur in *Countryside*, which is structured in a broader format.

Country Scene is part of the same set made for Louis Carré; it shows musicians in the countryside. It has similarities with an oil painting (Musée Hyacinthe-Rigaud, Perpignan) showing an accordionist sitting at a table in the countryside, playing a concert with a trumpeter standing in profile; two figures seated at either side frame this frieze. It includes a rainbow, a mill and a smoking thresher in the background; a raincloud and a little village stand out against the horizon. The tapestry gives a sensitive and simplified interpretation of the painted model, retaining its expressive power.

Of all the Old Masters, Dufy's greatest admiration was reserved for Tintoretto. Around 1945 he painted two interpretations of the *Ladies' Concert* (Gemäldegalerie, Dresden), which may be understood as an allegory of music. This theme is well adapted to Dufy's tastes; as we know, he had a passion for music. One of his compositions, bearing the inscription *La Musique de Tintoret*, was used as a model for a tapestry published in 1948 by Louis Carré. This piece is both a transposition of a painted work and the adaptation of that work as a tapestry. Painted in a seductive tonal harmony, its execution shows heavy outlines and broad perpendicular hatchings exphasizing both the naked bodies of the young women and the musical instruments. The variety of their attitudes lends the composition a suitably musical rhythm.

Similar hatchings stress the 'sculptural modelling' of the three allegorical figures of *The Oise, the Seine and the Marne*, the theme of a tapestry published in 1948. Here Dufy returned to the subject of the decoration for the theatre-bar of the Palais de Chaillot, simplifying the background against which the figures are standing. He omits the cranes in the port of Rouen and the churches in the city, leaving only a row of Norman houses, simply outlined. On the extreme left-hand side a black freighter is shown entering the port of Le Havre. A new edition in 1949 showed a slight variation in its representation of the female body. Both tapestries reveal a luminous symphony of golden yellow that evokes the wheat field behind them and its reflections on their bodies. The wools, hand-spun, with attractive irregularities, translate the painter's palette with maximum intensity and expression.

Raoul Dufy's last tapestry, dating from 1949, published by Carré and made according to his new working methods, takes the theme of *Le Cadre noir*, the

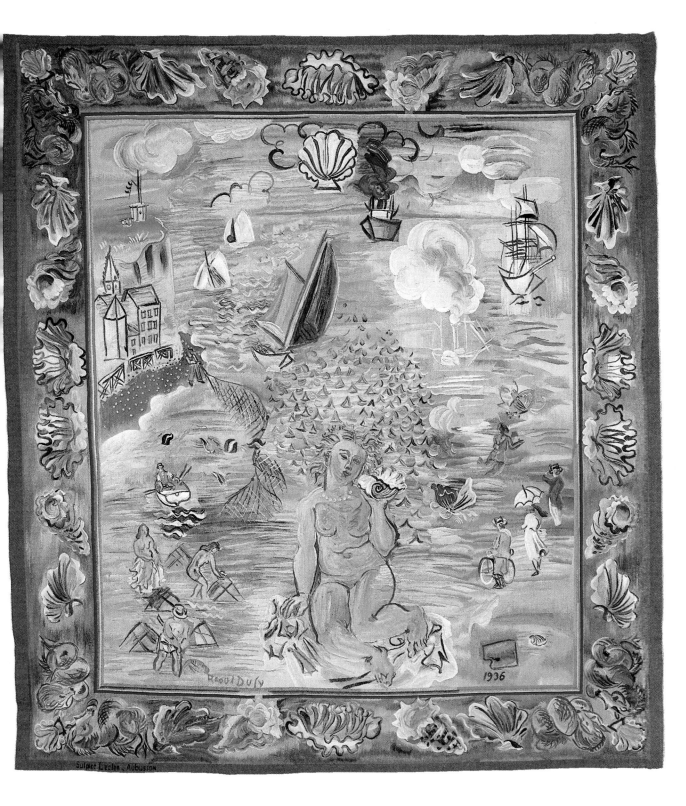

military horsemen of Saumur. In this sparse composition, with its horizontal format spread out over three bands of different tonalities, Dufy once more revealed his love of horses. He uses the black planes of their silhouettes, in ornamental attitudes, to good decorative effect. Dufy made the cartoons for this frieze in Perpignan, and drew his inspiration from some wooden horsemen that Carré had sent him.

276 *Amphitrite.* 1936. Aubusson tapestry.

Tapestry made at Aubusson from a Painted Design

In 1948 Dufy had the tapestry *Music in the Countryside* (Musée National d'Art Moderne, Paris) made at the Aubusson factory from a photographic enlargement of a design painted in oil (Musée d'Agen).[34] The band of musicians, arranged in a frieze in the foreground, is playing in a pastoral landscape, the motif of a checker-

217

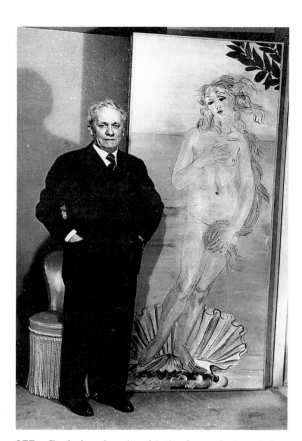

patterned bower adding to its decorative whimsy. The musicians, with their fluid outlines and expressive contours, are frozen mid-gesture.

Dufy placed a certain importance on the musical instruments which, with their luminous patches of colour – a yellow cello, a green drum, red bows – punctuate this composition, brightened at the centre by the conductor's score; the ensemble, painted with a relaxed freedom of composition, testifies to the artist's skill.[35]

This study of Dufy's tapestries enables us to confirm the artist's willingness to broaden his range of expressive possibilities. Accepting the rigours of a craft that was alien to his work as a painter, he conducted his experiments with his characteristic seriousness and desire for a 'well-made' work, until he attained a perfect mastery of the 'trade'.

277 Dufy by the *Amphitrite* door, designed for the bathroom of a mansion, Avenue du Bois. 1946.

278 *The Music of Tintoretto.* 1948. Tapestry.

218

279 Sketch for the tapestry, *Amphitrite*. 1948.
Oil on canvas.

280 *Music in the Countryside*. 1948.
Tapestry.

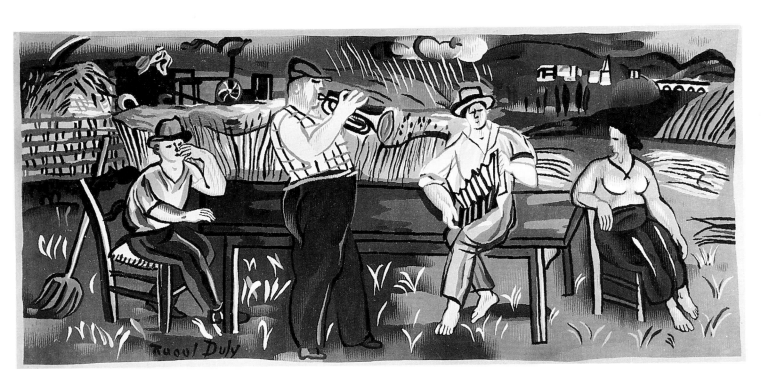

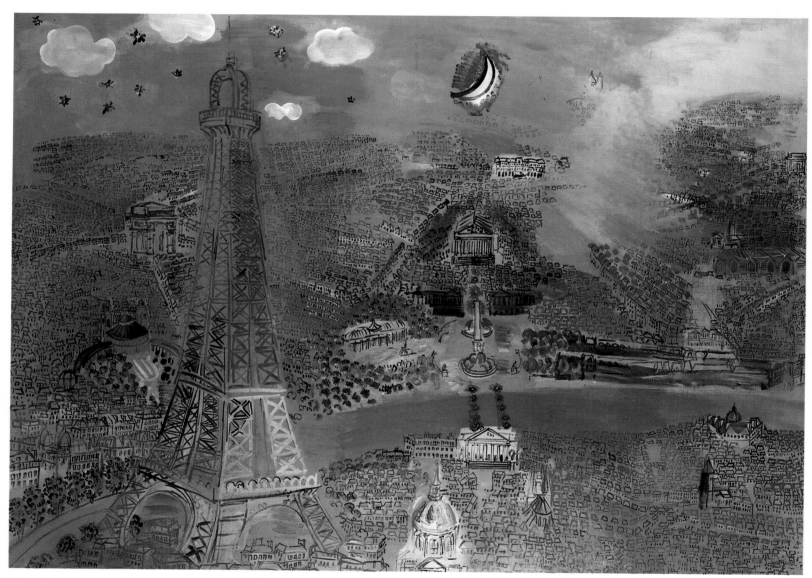

281 Panel of mural decoration for Dr Viard's dining room. 1927–33. Oil on canvas.

IX

THE PRIVATE MURAL DECORATIONS

282 *Parrots* (detail of ill. 294).

Towards the end of the twenties, Raoul Dufy was awarded two private commissions for mural decorations: one from Dr Viard[1] for his dining room, and one from M Weisweiller for the drawing room of his villa at Antibes.

Decoration for Dr Viard

Between 1927 and 1933, Dufy devoted himself to the mural decoration of the dining room of his doctor and friend, Paul Viard, in his apartment at 100, Boulevard Pereire in Paris.

This work is an oil painting on canvas re-mounted on the wall, 16.5 by 1.75 metres (54 by 5¾ feet), entitled *The Itinerary from Paris to Sainte-Adresse and the Sea*. It took Dufy five years to complete it to his own satisfaction, having painted over a first version which he finished in 1930.

There are several possible reasons why Dufy painted over his first version against the advice of his patron. Some problems of a technical nature concerning the material used and the conditions in which it was to be dried may not have been resolved. The artist had not yet carried out the experiments which he was to undertake, in *La Fée Électricité*, with the Maroger medium, which he used only after 1936. His perfectionist nature probably had much to do with this decision.

But there is another possibility. This was Raoul Dufy's first commission to paint a mural composition and the first time that he found himself confronted with the problem of representing space on a large surface. He did not like traditional perspective and did not intend to 'carve a hole' in his enormous composition, or resort to a two-dimensionality that could have made this decoration flat and static. He had to 'breach the wall', confronting it in a 'fight that was to prove memorable'.[2]

Finally, we should remember that in 1930 Robert Delaunay made a mural composition on the theme of *Circular Forms*, for Dr Viard's drawing room. Dufy thus faced an inevitable challenge: withstanding comparison with Delaunay. This seems the most likely reason for his dissatisfaction with his first version.

What crucial elements could Delaunay's work have revealed to Dufy? First of all, it shows an intense exploration of the character of decoration. Moreover, Delaunay was primarily concerned with giving his composition a mural unity, which he achieved with a flat construction and a light palette. Colour – both the form and subject of the work – is the theme examined on this single panel. Its division into circular bands of contrasting colour gives the ensemble a rhythm and dynamic compatible with the architectonic function that Delaunay sought.

In Delaunay's work Dufy rediscovered his own preoccupation with the '*couleur-lumière*' that creates space. He uses light colours that find an echo in Delaunay's palette, dominated by blues and yellows and punctuated with reds and greens. This luminous chromaticism lends a rhythm to the composition, which unfolds quite

283 Robert Delaunay, *Circular Forms*. Panel of mural decoration for Dr Viard's drawing room. 1930.

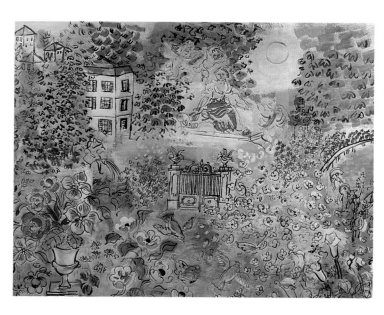

naturally along the walls of Dr Viard's dining room and integrates perfectly with the thirties interior decoration and furniture.

The octagonal room features a dado bearing a decoration of wooden trellises interspersed with little columns. Dufy's decoration, which begins with an evocation of Paris, finishes with a tall Ionic column that forms the boundary with the drawing room decorated by Delaunay. From this point it covers the entire height of the wall, masking the double ventail of a cupboard and the door leading to the kitchens, from which the dado is absent.

The decorative ensemble is illuminated by a window, in front of which a giant aquarium was formerly installed.

This 'itinerary' is devoted to the evocation of the city, the country and the sea. In it, Dufy unites his familiar themes in a dazzling arrangement which unfolds before our eyes. The perspective, which Dufy had employed before, and which shows his landscape 'as the crow flies', allows the artist to evoke, in his final composition, a dynamic space on a surface developed in a sequence of ten panels that vary in height and width according to their location. The work underlines his ability to recreate an impression with poetry and imagination.

The mural begins with Paris, bathed in a blue tonality that is itself illuminated by a moonlight which outlines the monuments, the houses and roofs of the city, condensed into a mass of geometrical signs. This dominant blue lends a unity to the decorative ensemble. The outline of the Eiffel Tower watches over an unreal Paris crossed by the Seine, which is also blue. It is a festive Paris, in which the colours ochreous red, Veronese green and mauve dazzle with their rich tones.

The familiar motif of the aqueduct signals the borders of Normandy. An old red-brick building, it overlooks a green pasture and the statue on its pedestal washed by a morning shower. The course of a stream runs along the edge of this panel and continues into the next, where an ancient oak, its dense foliage conveyed by the artist's quicksilver brush, shades a huge sheaf of corn, its heavy, dry ears painted a warm ochreous red. Dorgelès was right when he said that 'Dufy chased colours as one chases butterflies'.[3] The effect is that, by a happy stroke of good fortune, Dufy has chanced upon the blue, yellow and green tones, bringing them together in a bright and skilful harmony that is given voice by the golden tone of the huge wheatfield in the next composition. The little train so dear to Dufy, shown in his *Landscape of Langres*, passes along the horizon beneath its plume of smoke.

A still life with symbols of painting and music, the counterpoint of the still life with fresh fruits that invites the viewer to dine, serves as a transition to the next panel. Then, before a backdrop of chestnut trees, comes a paddock in which jockeys are training, watched by racegoers and elegant women. Dufy, we should remember, was painting racing scenes at Deauville and in England at this time. He could not resist portraying this theme which aroused his curiosity and contributed to his experiments with colour. He then leads us, through a field of flowers with birds and

284–287 Panels of mural decorations for Dr Viard's dining room. 1927–33. Oil on canvas.

223

butterflies flying over it, into a park, 'an enchanted realm', a closed and mysterious fenced-in space. Ironwork always satisfied Dufy's taste for arabesque lines. This motif, which he painted in oils (Metropolitan Museum, New York, 1930), was also the subject of a vibrant pen-and-ink study, which sketches a dance of curved forms punctuated by a succession of verticals which lend a rhythm to the space. The statue of Flora stands in this park, surrounded by mischievous *putti*. Here we see the first houses along the cliffs next to the Bay of Sainte-Adresse.

On four successive panels Dufy shows an imaginary stretch of sea bearing bathers, 'sea-horses' and an Amphitrite lying in her round-rimmed scallop-shell. Seagulls and butterflies fly alongside the yachts, sailboats and steamers that float on the choppy waters in the midst of the regattas. A large diagonal line decked with multicoloured flags provides a fanfare to announce the end of the journey.

This mural decoration for Dr Viard[4] was a prelude to the monumental compositions that were to follow, notably the mural that Dufy would paint on the same theme for the smoking-room bar of the theatre in the Palais de Chaillot in 1938. This work reveals Dufy's masterly compositional abilities, his sense of pictorial space, and the innate poetry of his style.

Decoration for 'L'Altana'

In this decoration,[5] which precedes the final work made for Dr Viard, Raoul Dufy demonstrated a remarkable facility. Its success is explained by his feeling for the surrounding nature and by the scale of the work, which is smaller than the painting that he made for Viard.

Dufy painted this work between 1928 and 1929, in oil on re-mounted canvas, for the drawing room of the villa L'Altana in Antibes. This property, owned by Arthur Weisweiller,[6] is situated inland, overlooking the old city. The view from the room looks out over a panorama including a broad bay and the sea on the horizon. In his conception of the work as a whole, the artist imaginatively designed an interior decor that would be integrated with the decor of the nature beyond. The window frame disappears, allowing direct communication between the space outside and the atmosphere within, which assumes the appearance of being a natural continuation of the external space.

The decoration unfolds over four panels of identical height but varied width, in which the broader compositions frame the window. The structure of Dufy's work is arranged according to a skilful distribution of light, more muted on the back walls and brighter towards the window. A dawn light bathes the decoration in which the aqueduct appears. Below, in the shadow of broad nasturtium leaves, stands a still life, previously painted in *Composition* (Museum of Santa Barbara, 1924), in which summer fruits which surround a gracefully curved pitcher are placed next to a large pumpkin, a folded white towel and a shell. A sense of calm emanates from this quiet

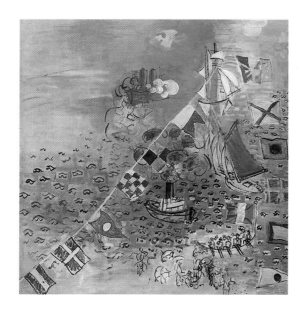 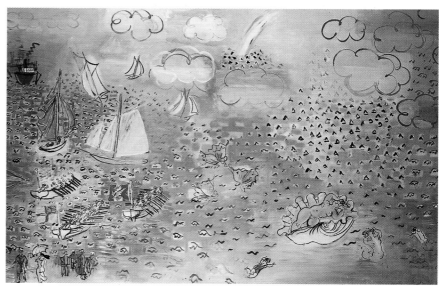

mosphere, interrupted by the song of birds and the fluttering of their wings. These serve as a link with the second panel on the curved wall next to the window: ey join the graceful flight of two parrots. Here Dufy returns to the motif of ebirds which he borrowed from popular prints, and which recurs in the gouaches r Bianchini-Férier. The birds spread their flame-red plumage in a grand corative effect, among huge arum leaves, giant nasturtiums and large palms rsting forth in a ray of sunshine. The artist spreads out his colours, with an quisite freshness, in informal splashes arranged in planes with a broad ushstroke that spills over the outline. This often arbitrary chromaticism rmonizes with arabesque lines of great decorative suppleness. In the upper band the composition a cloudless sky, illuminated by rays of light, appears to be the rmonious continuation of the sky outside.

On the other side of the window this clear sky is spread out over a caravel sailing the Baie des Anges, which appears through the clear glass. This subterfuge helps lighten the space within. Dufy thus combines the real and the imagined in the ppiest of unions. This effect is completed in the final panel, lit by the rays of the nset. The graceful flight of birds and parrots, among leaves of disproportionate ze, animates this unrealistic space. In it he introduces the elegant architecture of e obelisk from his first paintings of the *Public Garden at Hyères* (1913), to which he d returned in his versions of the *Square at Hyères* (1926–28).

The ensemble of the decoration for L'Altana creates a sense of limitless space. his effect is particularly apparent in the extremely free way in which Dufy mbines reality with an entirely imaginary world. The transparency of his light aterial increases the impression of space and contributes to the success of this coration.

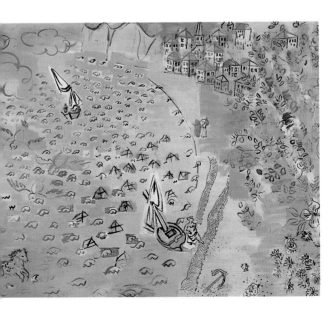

288–290 Panels of mural decorations for Dr Viard's dining room. 1927–33. Oil on canvas.

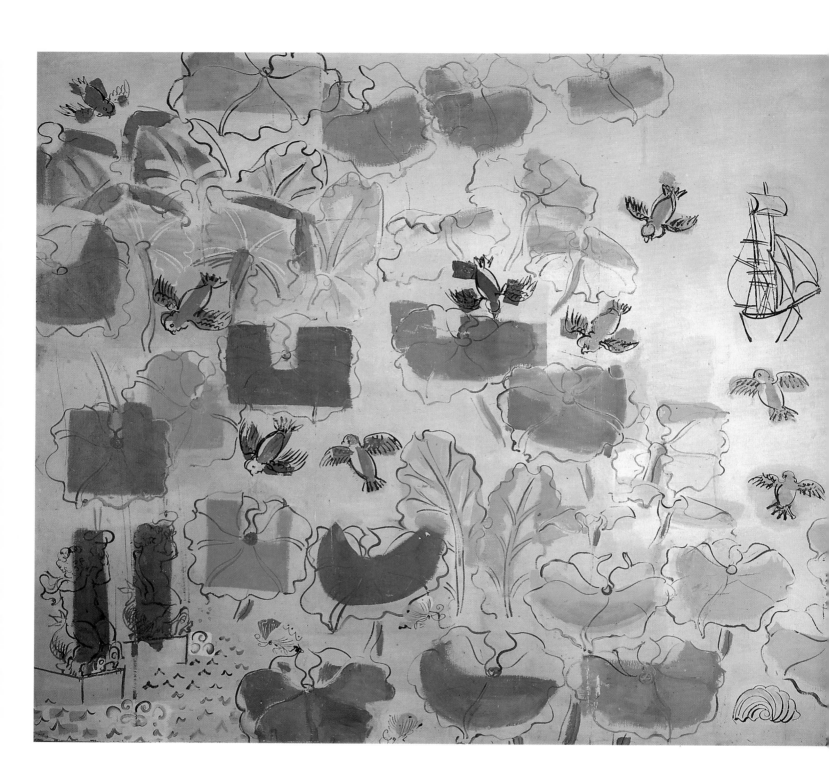

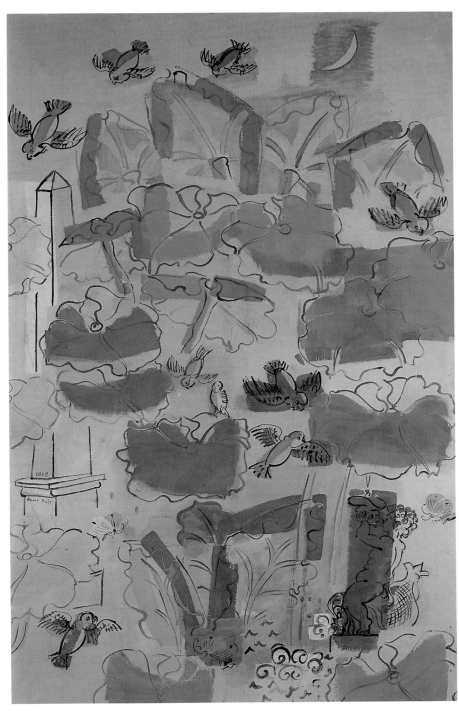

292–295 Panels of mural decorations for the villa 'L'Altana' in Antibes. Left to right: *The Obelisk, Caravel, Parrots, The Castle Keep.* 1928. Oil on canvas.

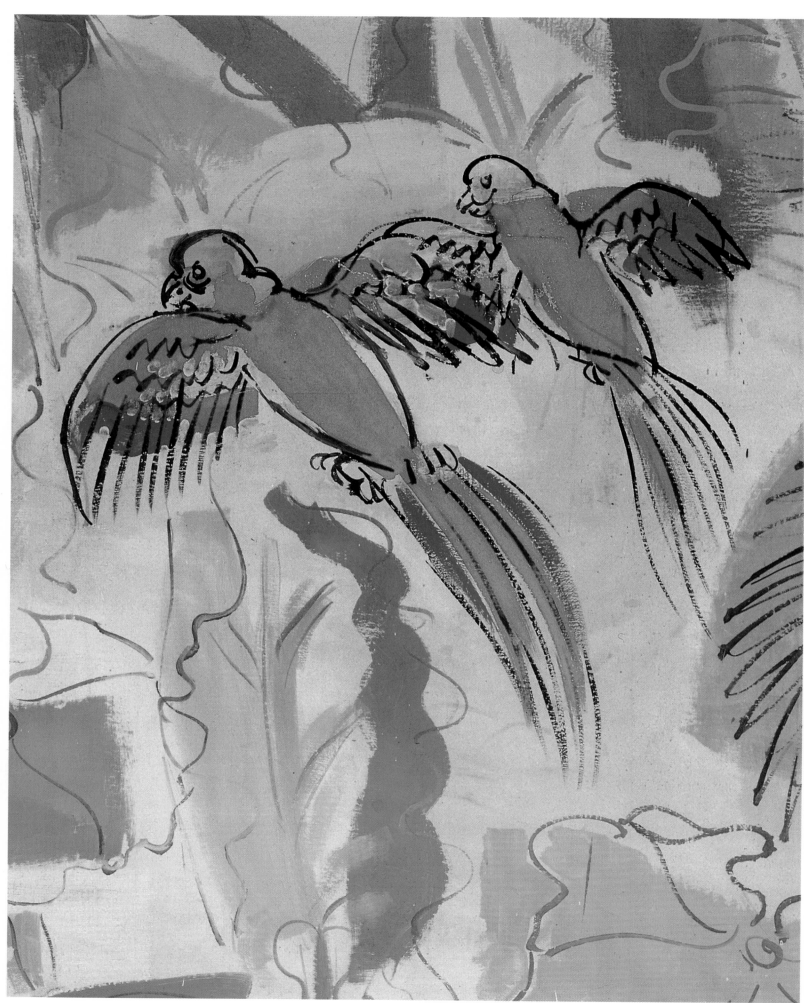

291 Panel of mural decoration for the villa 'L'Altana' in Antibes, *Parrots* (detail).

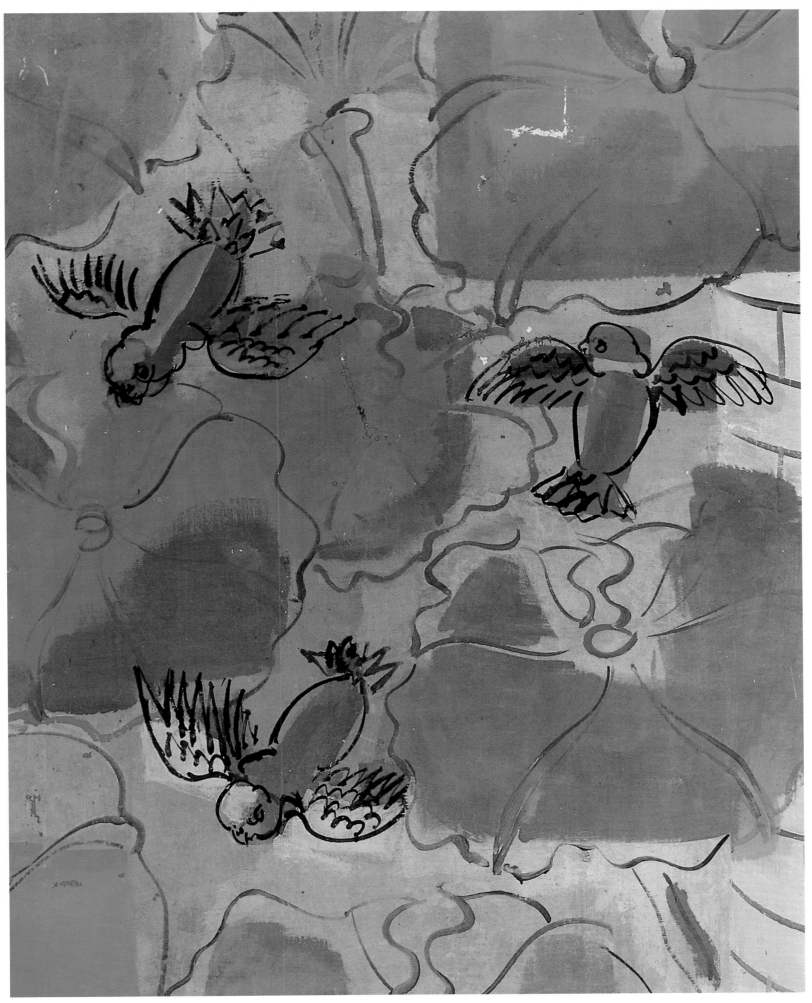

296 Panel of mural decoration for the villa 'L'Altana' in Antibes, *The Castle Keep* (detail), 1928.

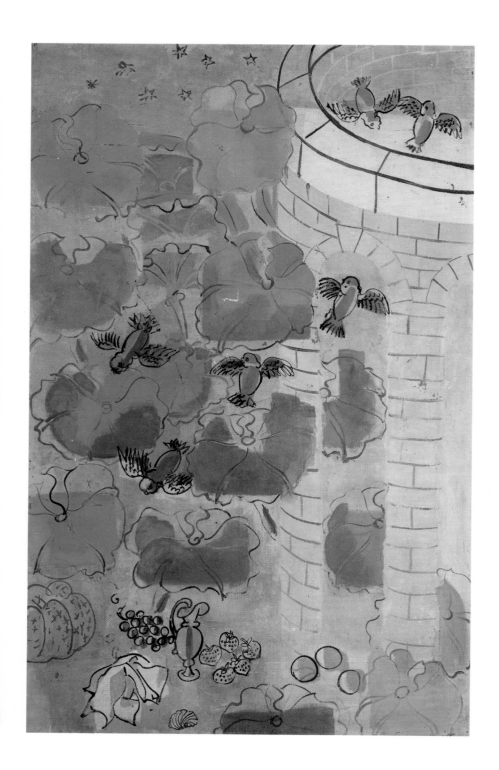

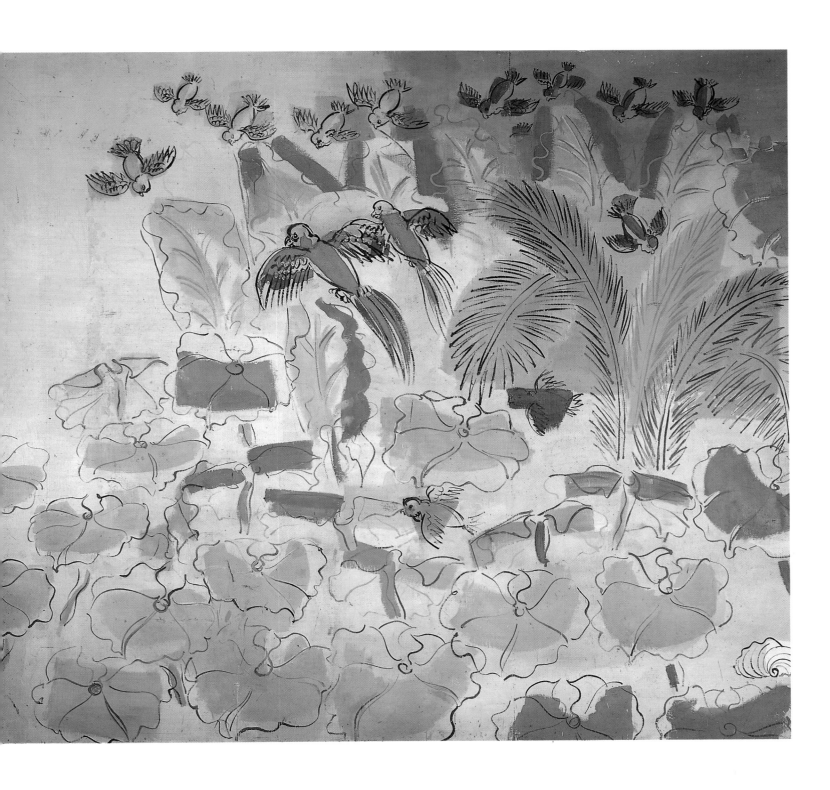

297 *The Martinican Woman.* 1931. Oil on canvas.

X

THE THEME OF
THE NUDE
AND THE STUDIO

298 *Kneeling Nude.* Around 1930.
Pen and Indian ink.

Since classical antiquity, the themes of the studio, the painter and his model have been a major subject in Western painting, and have given rise to many different interpretations.

In earlier paintings, the studio was a more or less complex allegory, designed to demonstrate the painter's status and condition. It was then conceived as an enclosed space in which the painter, at his easel, depicted himself along with the accessories of his art or showed himself painting a religious subject, a still life or a model. It subsequently became a meeting-place, a conventional studio where life-study sessions alternated with visits to the master, a room where bohemianism held sway, or, alternatively, a studio stripped down to the bareness that lends itself to the act of painting. The studio was also presented as an allegory of painting, as a homage to a painter or his work, or even as the stage of a drama.

The subject was transformed by the Impressionists, when studio painting made way for the creation of the work *en plein air*.

After this interlude it was enriched by a new meaning: the studio became 'the metaphor of a mental space in which the apprehension of the work itself occurs'.[1] This was the meaning of Corot's studios, from which those of Matisse derive, launching the era of modern and contemporary studios, those of Braque and Dufy as well as those of Giacometti, Vieira da Silva and Nicolas de Staël.

Although it does not occupy a special place in Raoul Dufy's work, the theme of the studio does appear a number of times, marking the various stages in the development of his *oeuvre*.

299 *The Studio in the Rue Séguier with Vase of Flowers and Painting.* 1909. Oil on canvas.

The Studio in the Rue Séguier begins the series in 1909, and gives rise to representations that pay tribute to the influence of Cézanne. Dufy abandons a traditional construction of space, seeing the walls of the attic room as planes, painted in broad strokes, arranged according to a Cézannesque perspective. This allows him to take a bird's-eye view, looking down into the very depths of this space, in which the pictorial and visual qualities of the subjects are given prominence. In certain compositions the bare canvases on the two easels become the plane of the picture.[2] While he himself is absent, the painter substitutes his palette for his physical presence. The reflection in a mirror of the nude model sitting

in the corner of the room illustrates the transition from reality to fiction, emphasized by the image of the face which is seen frontally rather than in profile, as it should be. The same lessons learned from Cézanne reappear in the version in the Fondation Prouvost, Marq-en-Baroeul, in which the landscape, which seems to be framed by the window, lies on the level of the pictorial plane. But here Dufy makes a comparison between illusion and reality by bringing the image of the same view of the neighbouring roofs to the canvas on the easel. He thus abolishes all distance between art and reality in favour of art.[3] The bouquet of flowers on the table, seen from above and underscored by a shadowy crescent shape, foreshadows the bouquet of anemones in the studios in the Impasse de Guelma and at Perpignan.

Raoul Dufy has given us a souvenir of his studio in Le Havre in a famous composition, *The Artist and His Model* (1929). It is one of his rare studio interiors in which the painter appears in person, sitting at his easel before a nude model lying on crumpled drapery. This painting is one of Dufy's major works, evoking the many different ideas that the theme of the studio can suggest. Like all his interiors, it includes a window looking out on to the world outside. The window, rather than marking a boundary with this external space – in this case, the sea, dotted with pleasure-craft and steamers – serves as a means of entry for the light that floods the room and connects it with the world beyond. Here Dufy joins Matisse, who wrote on this subject: 'For me, there is but one space, from the horizon to the inside of my studio room, and the passing boat inhabits the same space as the familiar objects around me, and the barrier of the window does not create two different worlds.'[4]

300 *The Artist and his Model in the Le Havre Studio.* 1929.
Oil on canvas.

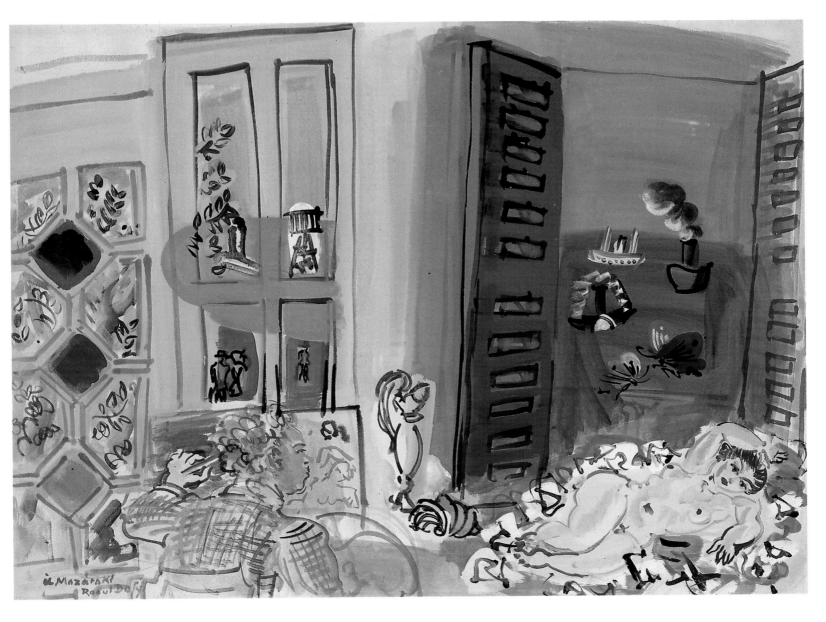

235

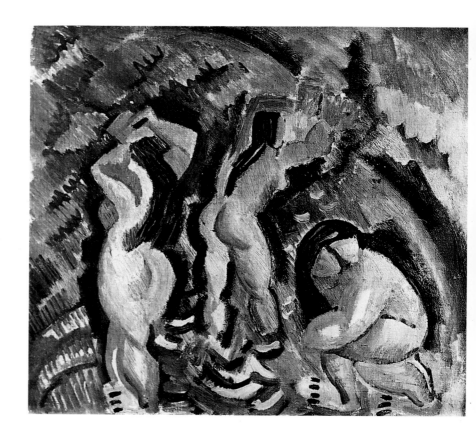

301 *Three Bathers.* 1908–09.
Oil on canvas.

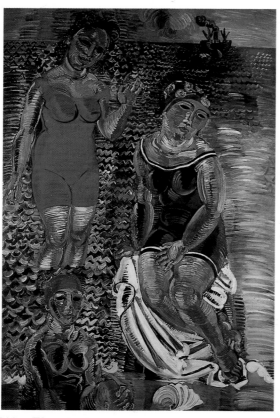

302 *Three Bathers.* 1919.
Oil on canvas.

303 *Pink Nude with Green Armchair*, or
Claudine from Behind. 1906.
Oil on canvas.

Two butterflies flutter about within this space, portrayed with that disproportion of scale of which Dufy is so fond. In 1930 he was to isolate the figure of the *Reclining Nude* accompanied by butterflies in numerous watercolours in which their arabesques harmonize with the curves of the female body.

The subterfuge created with the window is taken even further in the left-hand part of the composition. The transparency of the window-panes allows Dufy to bring into the studio the image of what lies outside. Thus, the trees in the garden, the strollers on the jetty and the lighthouse are made to look like framed pictures hanging on the walls.

The theme of the studio here evokes 'the painter-model-work trio in action.'[5] There is a confrontation between the model, situated in an existing reality, and her virtual image painted on the canvas, through the presence of the painter who acts as intermediary. Both nudes have the same pictorial equivalence, provided by the creative act of the artist, who emerges from it exalted.

Aside from the nude studies in the École des Beaux-Arts, Paris, dating from around 1900, this theme captured Dufy's attention very early in his career. Evidence for this is provided by *Pink Nude with Green Armchair*,[6] recently acquired by the Musée de l'Annonciade, Saint-Tropez, Dufy's only known Fauve nude, painted in 1906. Colour plays a dominant part in the depiction of this monumental figure which goes beyond the reality of the female body, to be given a highly expressive visual equivalent through the use of arbitrary colours.

During the period in which he was influenced by Cézanne, Dufy's interest in the nude figure is demonstrated in the theme of *Bathers*, the treatment of which, inspired by the Master of Aix, is apparent in *The Three Bathers* (1908–09), in which stylized forms are reduced to their essential volumes. The angular distortion of the right-hand figure evokes Braque's *Nude* (formerly Cuttoli Collection); the figure is set within an enclosed space, fragmented into juxtaposed hatched planes. After 1914, and *The Large Bather* which constitutes one of the essential milestones of his work, Dufy's nudes cease to show any affinity with those of Cézanne, which evolve into timeless beings elevated to the level of concepts of a real image.

The *Nude Reclining on a Drapery* in a studio bare of any artistic accessories is the subject of numerous compositions featuring the model Rossetti, painted between 1928 and 1930. Dufy emphasized her rounded forms with an intentionally distorted line, making use of foreshortening, with accents of light and shade applied in a

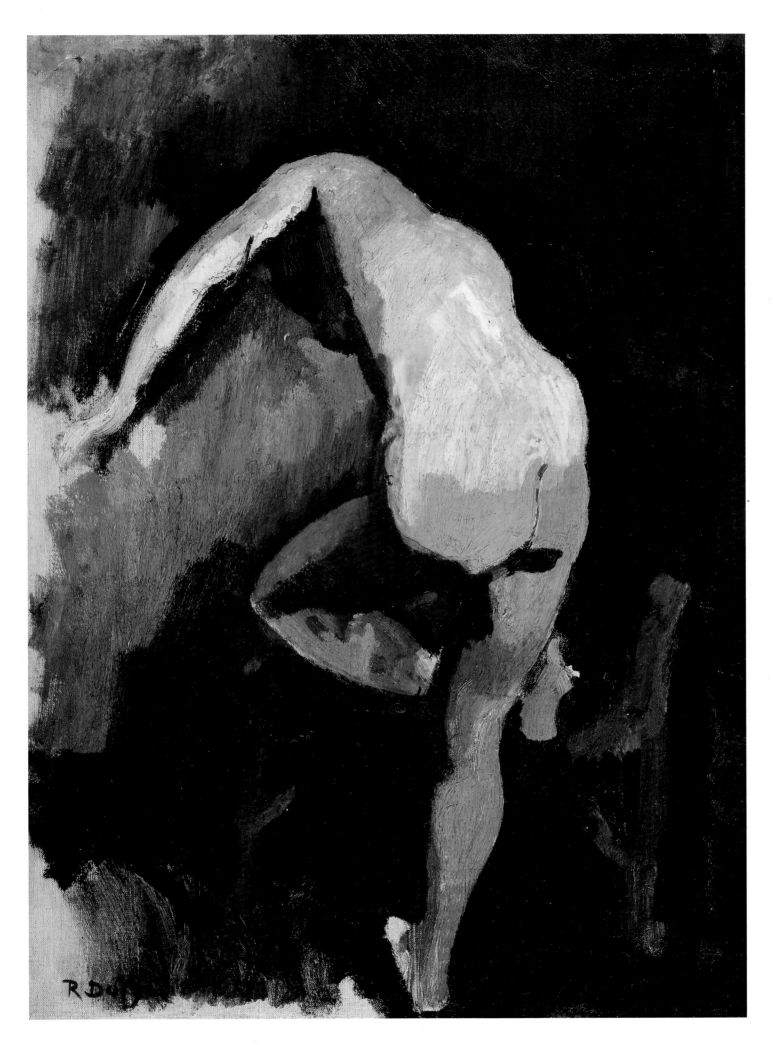

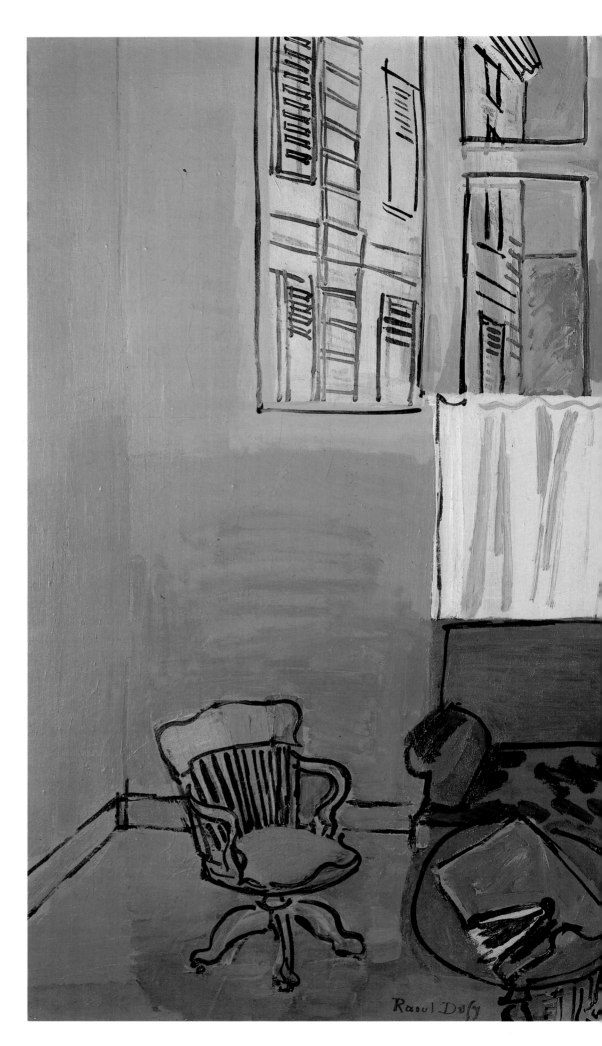

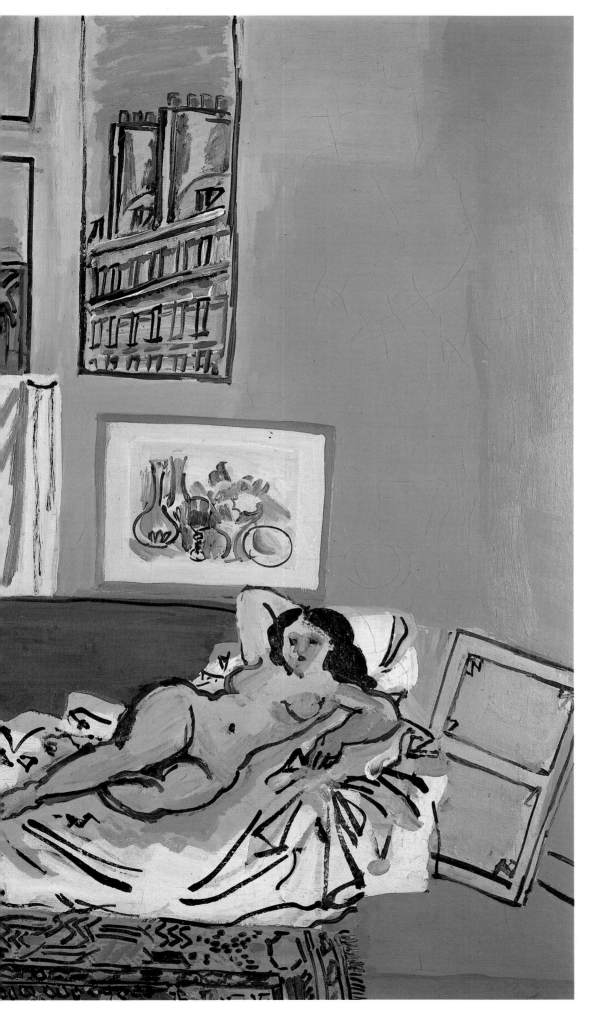

304 *The Studio in the Impasse de Guelma.*
1928.
Oil on canvas.

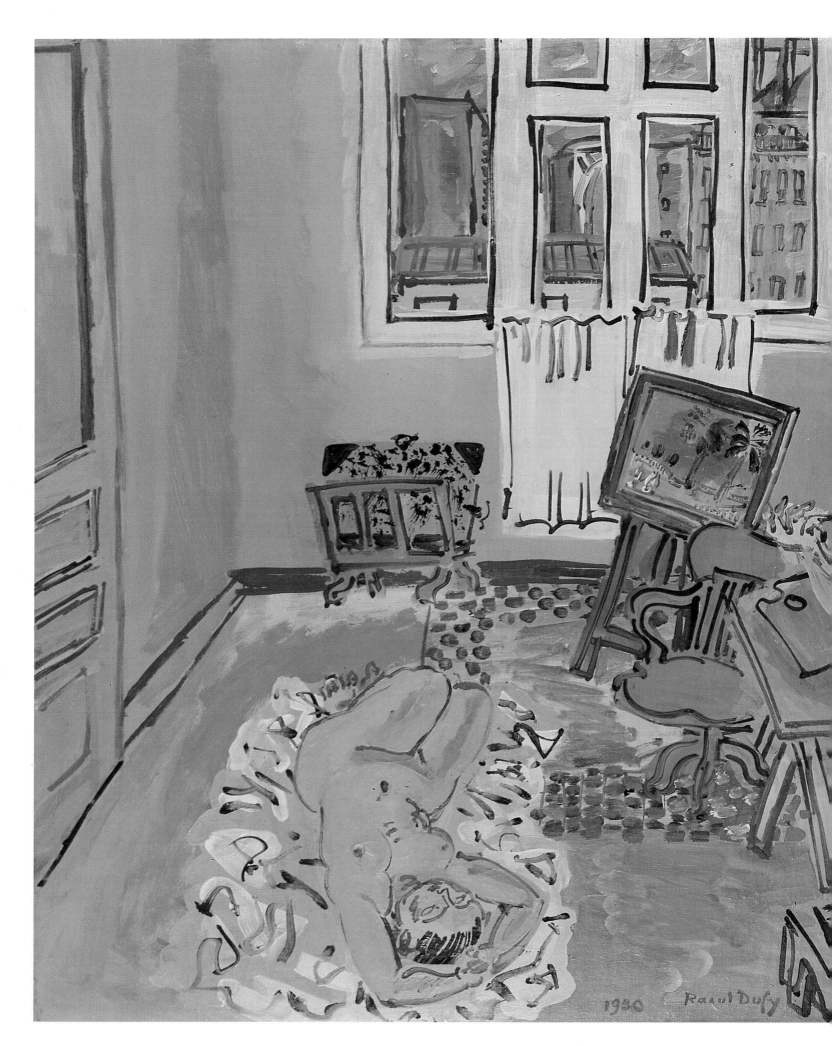

1930 Raoul Dufy

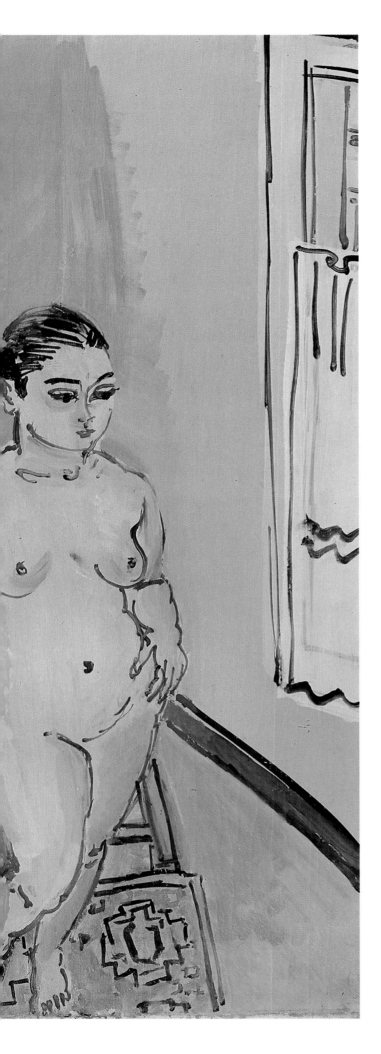

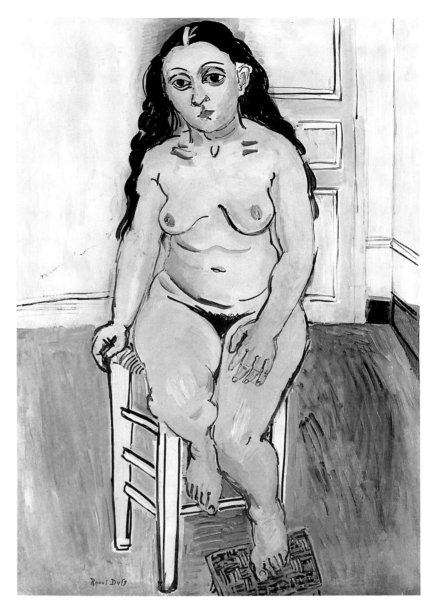

306 *Seated Nude*. 1932.
Oil on canvas.

305 *Two Models*. 1930.
Oil on canvas.

241

nervous brushstroke. Examples of this are the versions in the collection of Pierre Lévy de Troyes and the Musée d'Art Moderne de la Ville de Paris. During the same period, the nude appears in Dufy's work in large drawings with a graceful outline traced in a precise line that encloses the volume of the body. The painted *Reclining Nudes* are marked by a cold chromaticism, reduced to the blue of the material united with the pale pink of the female body, in contrast to the warm colours of the studio interiors with standing nude models.

These nudes pose in a studio in the Impasse de Guelma, Montmartre, to which Dufy moved in 1911 and which he was to keep until his death despite his extended absences. He had the walls painted blue, the blue which was to become his dominant colour and which he was to introduce into his painting in innumerable variations. It was to this studio, immortalized in numerous compositions, that he liked to return after his travels, to develop a work that had long been maturing in his experiments and discoveries.

From 1929, and for almost another five years, the standing nudes occupy this studio and substitute their presence for that of the painter. The models pose on opulent oriental carpets, surrounded by finished works. An example of this is the *Nude with Arum Lilies*, who stands out against a *Homage to Mozart* and poses beside *The Artist and His Model*, painted in the same year. Often the model is depicted against the blue background of the studio, among the painter's works and accessories: the palette, the easel with canvas, the portfolios.

Huddled in crumpled draperies, reclining like an odalisque, standing in the middle of the studio or seated on a stool, the nude model of the thirties portrays a single type of woman. Her unprepossessing lines and full forms with their relaxed muscles correspond to Dufy's taste for the arabesque. Her stocky torso, accentuated by the elevated perspective, is stressed by the raw and flat lighting of the studio. In Dufy's work, the model is created by colour; the light of the painting emanates from the model's flesh. Nudes without the grace and charm of those of Matisse, they are portrayed without any concessions to realism. Their far from idealized physiques and the shadow of melancholy that seems to surround them touch us as they touched Dufy, who looked on these women with eyes full of tenderness. These nudes are at rest; the painter does not surprise them, as Degas does, at their toilet, seeking to interpret their movements, or like Bonnard, who models Marthe's body in a golden light, making it palpitate beneath his brushstroke. Their opulent appearance is devoid of vulgarity. 'They are "nudes of women" rather than nude women.'[7]

In 1928–30, the place of the model Rossetti in the studio on the Impasse de Guelma was often taken by the Indian model Anmaviti Pontry. She frequently poses nude, reclining on an Indian shawl whose decorative sumptuousness is matched by that of the hangings printed with oriental motifs: her lascivious pose and the explosion of colour suggest an atmosphere of unequivocal eroticism.

The Indian model appears seated, full-face, wrapped in a printed sari which echoes the hanging stretched behind her. A preparatory pen drawing reveals the attention that has been paid to her facial expression. Giving her full characterization, it intensely conveys the profundity of this young woman's gaze and personality. This study from life reveals Dufy's graphic mastery. He uses a nervous and vigorous line with up- and downstrokes, with frequent interruptions and vibrant repetitions in the treatment of the arm and hand. The hatchings, sketched with a free hand, use areas of untouched paper to model the volumes.

A similar authority is apparent in the pen-and-ink study for the model *Anmaviti Pontry* (Royal Museum of Fine Arts, Copenhagen) in which she is shown seated in the middle of the studio, standing out against the same hanging with its decorative patterns. This is a work painted in an extremely free style, in which the line runs along, stopping to clarify certain details, slowing down over the facial expression or in the treatment of the carpet on the floor, rapidly sketching in a landscape on the canvas on the easel. In this very detailed drawing, the painter's presence is made apparent by his palette and brushes placed on a ladder. The extreme vivaciousness of the graphic style, which captures the 'snapshot' of a posture, is more seductive than the painted model, which is somewhat stiff despite the warmth and harmony of the colour.

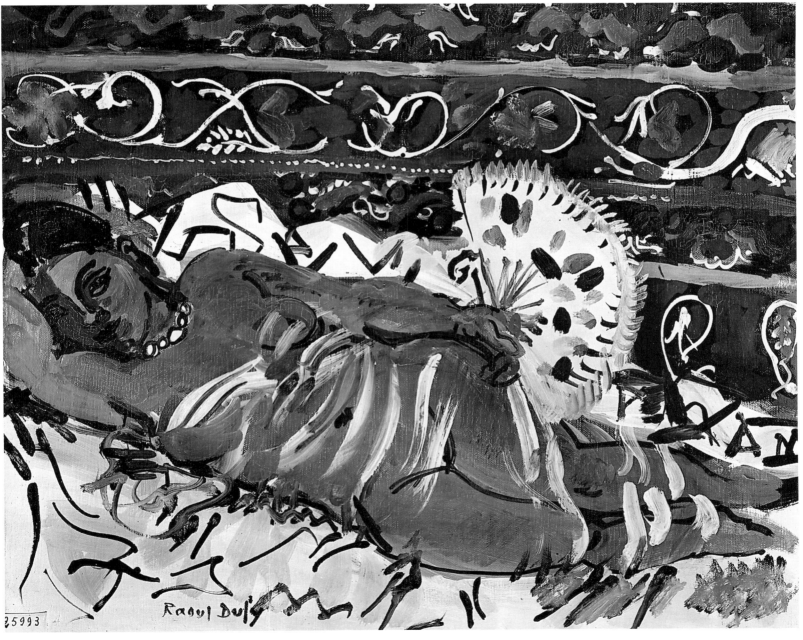

25993

Raoul Dufy

310 Model, four-master with tug and two-mast fishing-boat, around 1900.

311 Raoul Dufy in his studio in the Impasse de Guelma, around 1932.

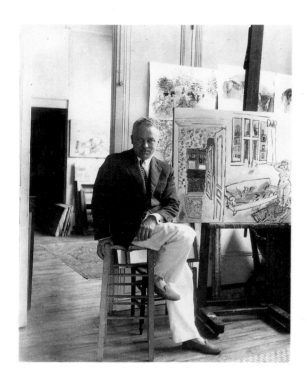

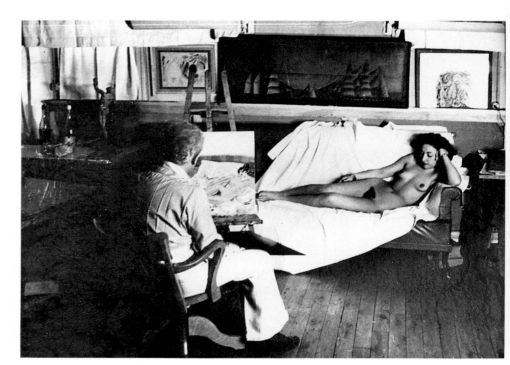

312 The studio in the Impasse de Guelma, Raoul Dufy and his model, around 1928.

While *The Martinican Woman* attests to Dufy's liking for a certain exoticism, she also contributes to a seductive and decorative composition. This combines the warmth of a range of colour stressing reds, pinks, ochres and yellows, punctuated with white and green, and an ornamental richness which does not weigh down the composition as a whole. The figure remains admirably in the foreground despite the flatness of this composition, counterbalanced by the oblique angles of the folds of the dress and her arms and feet, and by the faint hints of the bed. Dufy has painted the model in his bedroom, sitting on the edge of the bed, with a fabric bearing a Bianchini-Férier pattern of arum lilies draped over the walls of the room. Behind the model stands a canvas panel in intense colours, painted in Tournon in 1930, from an initial watercolour design.[8]

Around 1935 Dufy shows the interior of his studio in the Impasse de Guelma, now deserted by his model. Of the four known versions, the most highly refined is the version in the Musée National d'Art Moderne, Paris, which he first sketched in 1935, then resumed and completed in 1952. The presence of the painter is indicated by his palette on the pedestal table, which is the same tone of blue as the walls, and by a painting, *The Red Violin*, a monochrome work from 1948, which hangs at the back of the studio. This lack of ornament, emphasized by the decorative notes of the floral hanging and the carpets on the floor, contrasts with the studious atmosphere and clutter of the three other versions. Close to Matisse[9] in their

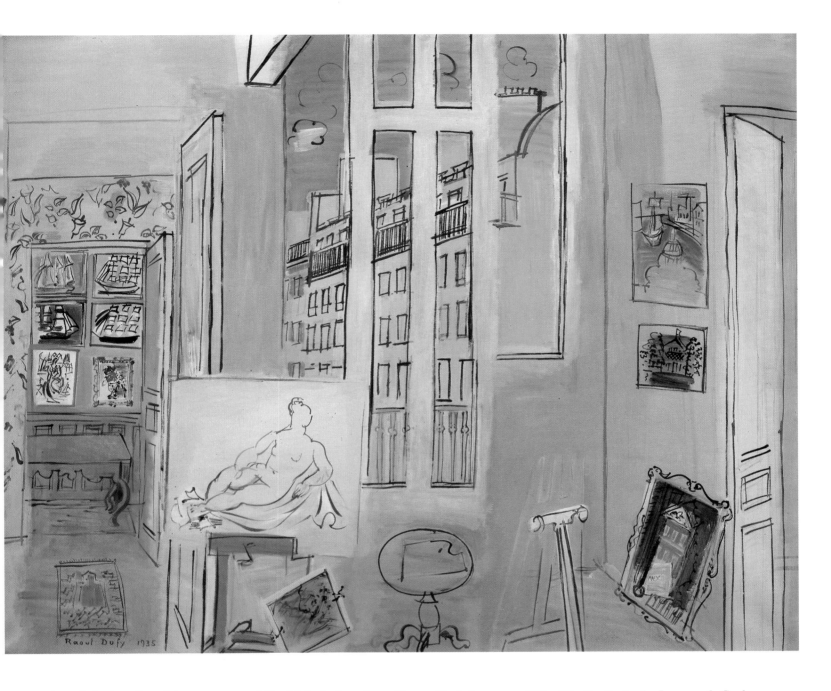

conception of the 'studio without a master',[10] which derives from Corot, Dufy here presents a retrospective exhibition of his works. The painting in the Phillips Collection in Washington is the most successful example of this. On the right-hand wall, a *Homage to Claude Lorrain* (1927) hangs next to the *Boathouse on the Marne* (1921) and a *Homage to Mozart* (1934), while against the back panel, on the left, stand a landscape and the lithograph of *The Large Bather* beneath four sketches of old ships[11] from Dufy's collection. On the easel in the centre foreground is a nude reclining on a drapery. All of these works, like the palette, the portfolio and the easel, bear witness to the painter's activity in this space and to his virtual presence. Although physically absent, he shows us the various angles and recesses of his studio. Thus he juxtaposes two parallel perspectives which reveal, on the right-hand side, through the transparent glass of the large bay window – which is open on both sides in the version in the Musée National d'Art Moderne, Paris – a view out on to the hill of the Impasse de Guelma, while, inside, the side doors open out on the left on to a suite of rooms. The appearance of his studio is unified in a symphony of colours, for in all four variations Dufy employs the same polychromy, based on a harmony of blue and peach-pink, warmed with ochres and reds and punctuated with greens.

The series of the *Studios at Perpignan*, interspersed with views of the *Studio at Vence* concludes this theme in which Dufy retranscribes his familiar universe. This

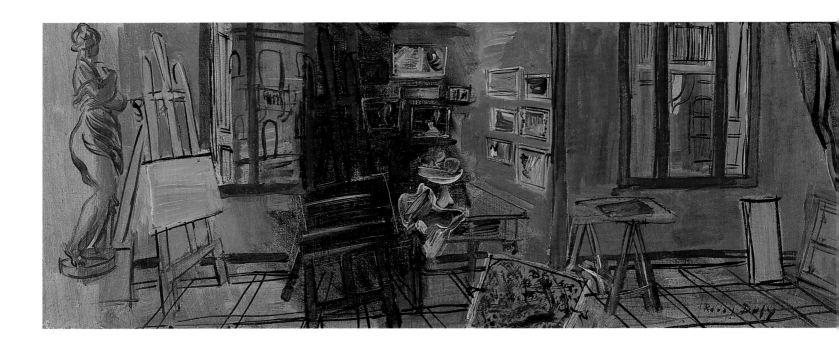

314 *'La Frileuse', Studio in the Rue Jeanne-d'Arc.* 1942.
Oil on canvas.

series contains the largest number of paintings. One of the first compositio[..]
(formerly collection of Dr Pierre Nicolau, 1942) provides a view of the whole of th[..]
Studio in the Rue Jeanne-d'Arc, on the ground floor, its transparent bay windo[..]
revealing the neighbouring houses and the bustle of the street. The portfolio on th[..]
floor, the canvases hung on the wall – *View of the Place d'Hyères*, the sketch of th[..]
Fine Sunday – and the artist seen from behind, seated at his easel, before the nud[..]
model reclining on a couch, reproduce the intimate atmosphere of the studio. Th[..]
violin on the low table and the plaster-cast of the '*Frileuse*', a statuette of a woma[..]
shivering with cold, are the constant elements within this setting. It is the onl[..]
work from this period in which the painter includes his physical presence in th[..]
studio.

In the *Studio with Palette* (1943), the two easels, of which one bears the canvas [..]
the *Reclining Nude on Couch*, the palette on the table and the empty armcha[..]
strongly suggest the painter's activity. The *Studio with Chandelier*, Rue Jeann[..]
d'Arc (1942), bounded on the left by a curtain, is presented as a theatrical space i[..]
which an intrigue is going on between the realistic model posing nude on th[..]
canopy, the sketch of her virtual image on the easel, the '*Frileuse*' standing on h[..]
pedestal and the *Large Bather at Sainte-Adresse*. Dufy places central importance o[..]
this figure, which was at the forefront of his pictorial experiments. In the form of [..]
lithograph, printed in 1919, it appears on the walls of all of Dufy's views of hi[..]
studios in the Impasse de Guelma and the Rue Jeanne-d'Arc. The figure is n[..]
completely naked, but as a form transposed from reality it participates in th[..]
composition and the dialogue established between reality and fiction. All th[..]
elements which bear witness to the power of the absent artist to transform thi[..]
reality lead us back to the artist himself. Examples of this are the *Studio with Blu[..]
Portfolio* (1942), or the *Studio with Wheatfield*, 'spaces that he has marked with hi[..]
stamp'.[12]

The '*Frileuse*' occupies a privileged place in the Perpignan studios. Thi[..]
sculpture is not made of clay, but is a nineteenth-century plaster-cast, which ha[..]
been kept in Dr Nicolau's family for generations. Dufy adopted it and depicted i[..]
not as an archetype of the plaster-cast – the emblem of all classical representatio[..]
of studios – but in order to accord it the same interest as the nude model.

These studio views share the warm and golden light of Roussillon, which Duf[..]
conveys with a range of ochreous pinks and yellow ochres, set off by notes of th[..]
blue and green which bathe the atmosphere in this region.

After the war, in 1945, Dufy stayed in Vence, where he returned to the theme o[..]
the nude and the studio. His model, with a more slender and elegant torso than th[..]
models of the thirties, is portrayed with an extended brushstroke that i[..]
characteristic of Dufy's style in this period. This treatment is as free as the paintin[..]

of the landscape seen through the large bay window beside which the model is posing. It presents a view of the town of Vence, with its recognizable terraced hills of olive trees and their surrounding walls. This landscape, which is framed in the rectangle of the window, is flush with the pictorial plane, and can be understood either as a real view or as the painted image of a landscape, a 'painting within a painting', like the works hanging on the walls which form a part of the composition.[13]

The views of the *Studio in the Place Arago*, in Perpignan, where Dufy worked from 1946 until 1951, constitute the theme's apotheosis. The three bay windows and the open door between the two rooms of the studio increase the dimensions of the interior space, in which the canvases on the easel become more important. In the version in the Musée des Beaux-Arts, Le Havre, the nude is once again shown in two different representations: the posing model and the painting in progress. In *The Artist's Studio with Red Sculpture*, the large version of the *Black Freighter* on the easel reveals the stage of Dufy's experiments at the time. The *Yellow Console*, placed between the two windows, is the sole motif, during this period, of the compositions that form a part of Dufy's experiments in 'tonal painting'. The '*Frileuse*', relegated to the corner of the room, contributes her warm chromaticism, while the palette on the easel refers to pictorial creation.

These various approaches to the representation of the nude and the artist's studio views enable us to understand how Dufy united these two traditional themes of painting in a single vision. This union gives them a new importance and a new role which fall within a resolutely modern conception.

315 *Studio with Chandelier, Rue Jeanne-d'Arc*.
1942.
Oil on canvas.

316 '*La Frileuse*', plaster sculpture, 19th century.

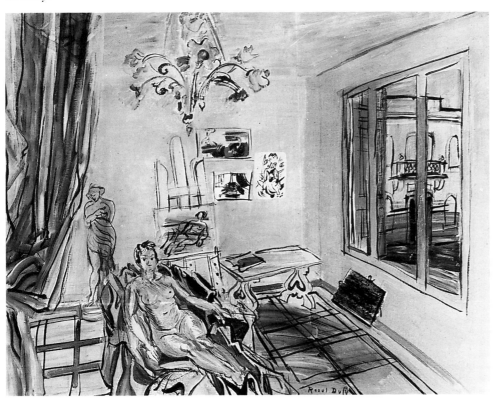

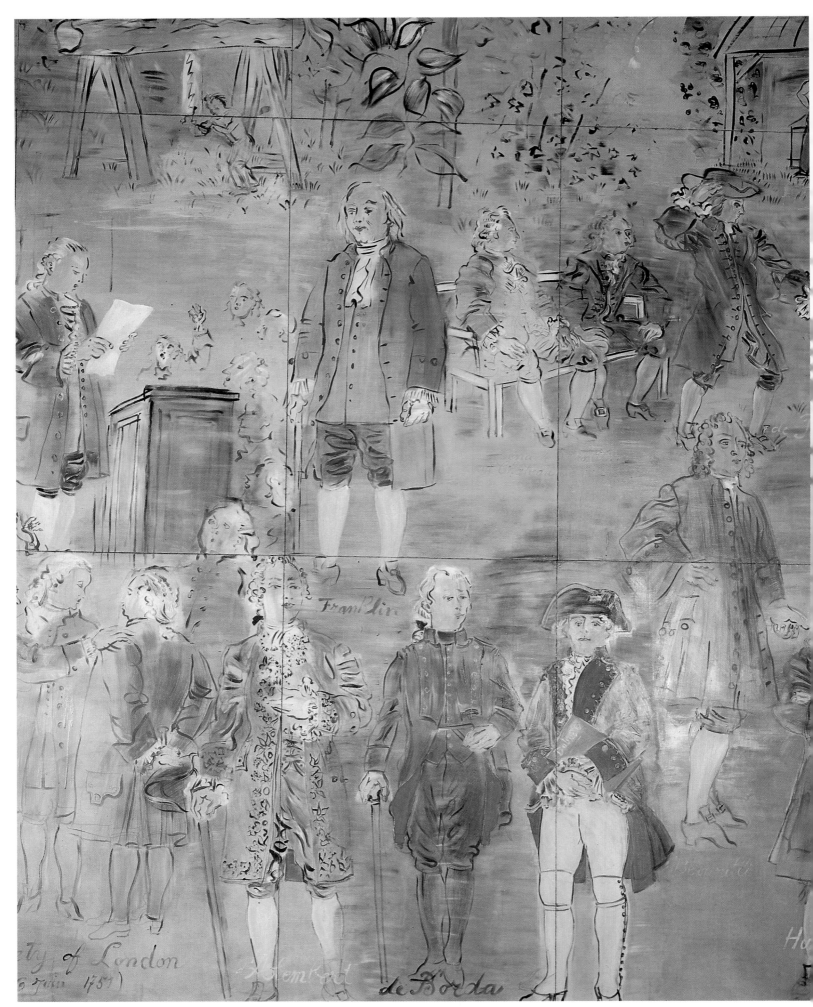

317 Original sketch for *La Fée Électricité* (detail). 1936.

XI

THE OFFICIAL
COMMISSIONS

THE 1937 'EXPOSITION INTERNATIONALE'

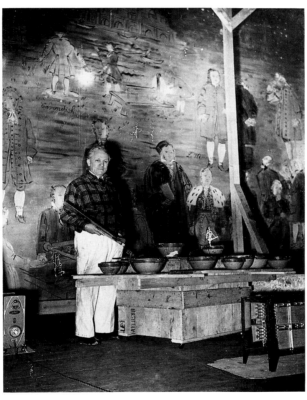

318 Raoul Dufy in the Saint-Ouen studio, in front
of *La Fée Électricité*, March 1937.

The 1937 Exposition Internationale[1] was a major event in France, despite a troubled political climate and social and economic crises. The crisis in the economy that followed the 1929 Wall Street crash reached France in 1931.

France was divided by confrontations between the Left and the extreme Right under the government of Léon Blum's Front Populaire. Strikes were paralysing the country, slowing down work on the building sites of the Exposition. They were one of the reasons for the delays in the completion of a number of the buildings.

The primary aim of this exhibition of the arts and technologies of modern life – the revival of the French economy – was accompanied by a desire to reduce unemployment and to assist artists who were no longer enjoying financial support from commissions and private sales. 'The fight against unemployment, not only that of the workers but also of the intellectuals and artists working in the world of ideas' was the programme of the General Commissariat of the Fine Arts in 1937.

The organizers of the Exposition followed a policy of 'major projects' designed to assist the construction industry, engineers, manual workers, architects and artists in confronting the crisis.

The 1937 Exposition Internationale gave rise to intense architectural activity which led to the building of the two Musées d'Art Moderne, the Musée de la Ville de Paris and the Musée de l'État, Auguste Perret's Musée des Travaux Publics[2] and the Palais de Chaillot,[3] redesigned by the architects Carlu, Boileau and Azéma. Further down the river, the two foreign pavilions of Germany and the USSR stood opposite one another.

Pride of place was given to architecture, with painting assigned only a decorative role. The architects alone decided on the location and space that were to be given to pictorial decoration. Thus the Exposition Internationale sought to forge that alliance between art and technology that artists so much desired. They found themselves commissioned to paint enormous compositions testifying to the expansion of mural art. The 1937 Exposition contributed to a revival of the art of the fresco, to its integration within urbanization and thus within contemporary life. In the thirties, the major painting salons were no longer meeting with the same public enthusiasm that had greeted them before the First World War. The launch of a salon of mural art in 1935, by the Galerie Bernheim, anticipated this new tendency towards decorative art. This coincided with the wishes of Raoul Dufy who, from the beginning of his career, had sought to elevate the 'minor' arts to the rank of great art. *La Fée Électricité* was his opportunity to realize his dearest aspirations in such a large-scale work: integrating visual art with everyday life, and bringing together two forms of expression which had complemented one another harmoniously since ancient times: painting and architecture.

Given the high number of artists working on the decoration of the French pavilions,[4] it is more difficult to identify a style for the year 1937 than it had been in 1900 and 1925. The artistic landscape was complex, but the tendency towards figuration in art was predominant, despite the presence of avant-garde painters. The representatives of abstract art, Robert Delaunay,[5] Félix-Tahar Aublet, Albert Gleizes, Fernand Léger,[6] Jean Metzinger, Auguste Herbin and Georges Valmier, were confined to the decoration of the Pavillon de l'Air and the Pavillon des Chemins de Fer, those of Solidarité and the Union des Artistes Modernes.

The variety of inspiration behind the works of these artists is a good illustration of the situation of the visual arts during the thirties. The opposition of the different groups came to public attention in 1936, with the 'querelle du réalisme', which brought to light the antagonism between figuration and abstraction. The conflict was between the followers of a figurative and descriptive tendency which gave priority to the subject, and which had the support of Louis Aragon, and the defenders of an innovative tendency, preoccupied with essentially visual experiments aimed towards pure abstraction, the *Nouveau Réalisme* championed by Fernand Léger and Le Corbusier.[7]

This debate faded into the background during the Exposition, on the margins of which three exhibitions displayed the various trends of artisic work in the first third of the twentieth century.

The first, set up on the initiative of Léon Blum, was held at the new Musée d'Art Moderne in the Palais de Tokyo. Dedicated to the masterpieces of French art from

the Middle Ages to Gauguin, Cézanne and the Douanier Rousseau, its intention was to stress 'the French tradition in its magnificent continuity'.[8]

At the Musée du Petit Palais, the public were able to see works by independent artists. Conceived as a continuation of the exhibition in the Musée National d'Art Moderne, this wide-ranging exhibition presented a panorama of French art from 1895 until 1937. Raymond Escholier, the curator of the Petit Palais – one of the first, along with Andry Farçy, to show an interest in modern art – chose to show works 'by French artists, or foreign artists who are living or have lived in France for many years'.

Raoul Dufy was among the first ten painters[9] to be officially included at the first meeting of the Action Committee,[10] headed by Albert Sarraut, the former president of the Council. This is an indication of the fame that Dufy was enjoying at the time. The remaining artists[11] were selected by secret ballot. We should note that the selection, dictated by the taste of the individual members of the Action Committee, tended essentially towards the figurative art made in France during the first third of the twentieth century. Abstract art was barely represented: the exhibition featured only a few *Circular Forms* by Robert Delaunay, two paintings by Auguste Herbin and three by Georges Valmier. Surrealism was entirely excluded,[12] less than a year before the major Surrealist exhibition held in Paris in 1938.

The exhibition entitled 'Origines et Développement de l'Art International Indépendant', organized during the same period at the Musée du Jeu de Paume by André Dezarrois, the museum's curator, completed this panorama of early twentieth-century art by stressing the major trends running through it: Fauvism, Cubism, Abstraction and Surrealism.[13]

Thus, two of the three exhibitions organized at the same time as the 1937 Exposition, taken together, set the seal on the official recognition of the modern art to which Paris had been home for almost forty years.

The 1937 Exposition was held under the sign of light, a symbol of progress and modernity. The use of illumination in spectacular nocturnal productions[14] makes it one of the factors of the success of this event.

La Fée Électricité

Visitors to the Exposition were shown the greatest hymn to electricity in the form of Raoul Dufy's fresco, *La Fée Électricité*. This decorated the interior of the Pavillon de l'Électricité, one of the largest buildings in the Exposition, designed by Robert Mallet-Stevens in collaboration with Georges Pingusson, who worked on its interior design, and the engineer Salomon, who created the lighting for the pavilion, between November 1936 and March 1937.[15]

This pavilion, a true 'palace of light', which was opened to the public on 26 June 1937, was erected at the end of the vista of the Champ de Mars; its slightly curved 600-square-metre façade became a giant screen at night. It was permanently illuminated by a 7-metre spark running between two solenoid columns rising from a pond at the entry to the building. Staircases at either side led visitors into the hall, at the end of which stood Dufy's painting *La Fée Électricité*, 60 metres (200 feet) long and 10 metres (33 feet) high. Lit from above by spotlights, its brightness was intensified by the total darkness of the space. In front of the fresco stood a permanent exhibition comprising enormous parts of electric machines and devices, designed to complement this magnificent illustration of the power of electricity in industry: thermal and hydraulic rotors, and an 11.5-metre-high circuit-breaker with a power of 500,000 volts.

La Fée Électricité celebrates the union of nature and technology, confronted by mythological divinities, and shows the protagonists of the history of electricity from ancient times through to the present day.

On the advice of the curator of the Musée du Luxembourg, Louis Hautecoeur, who was then director of artworks for the Exposition, the directors of the Compagnie Parisienne de Distribution d'Électricité, M Malagarie, and the head engineer, M Gabriel Dessus, chose Raoul Dufy for this huge fresco to the glory of electricity.

251

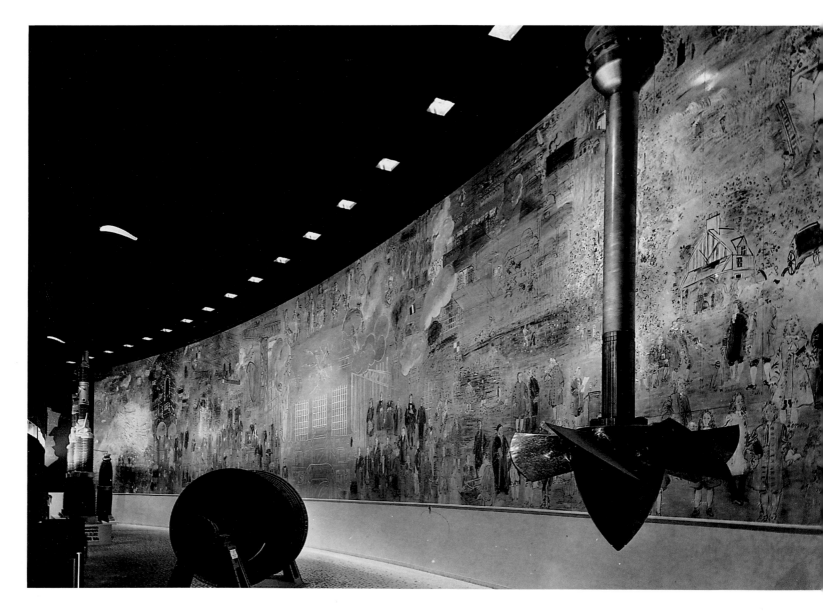

319 General view of *La Fée Électricité*, taken
at the 1937 'Exposition Internationale'.

The commission was officially confirmed on 7 July 1936.[16] Like a Renaissance master-craftsman, Dufy paid scrupulous attention to the tiniest material, scientific and aesthetic details. He tried to acquire a complete familiarity with everything related to the history of electricity from its origins onwards, even rereading Lucretius' *De Natura Rerum*.[17] He left nothing out: the advances made in electrical energy throughout history, the scientists who contributed to its development, and then its various applications and work in the fields of industry and leisure.

Dufy gave his brother, the painter Jean Dufy, the task of assembling the documentation of historical works, such as those of Louis Figuier,[18] which he was able to consult at the Conservatoire des Arts et Métiers. Raoul Dufy himself carried out precise research into all the discoveries and experiments that had advanced the knowledge and application of electrical energy.[19] To these scientific ducuments he added information on the lives of the scientists and their portraits as painted or described by their contemporaries. He turned to contemporary scientists for information on the scientists of the past, as is revealed by his correspondence with the Société d'Archéologie at Beaune with regard to Mariotte.[20] Unpublished letters from the Laboratoire de Chimie Générale and the Faculté des Sciences in Paris show that Dufy asked Professor Wolkringer for a list of dead and living scientists and information on the history of physics.[21] This correspondence contains references to two volumes of *La Lumière électrique* containing an article by Crooks and diagrams for the machines used in Dufy's studies of cathode rays, examples of arborescent sparks.

Dufy carried out research into the practical and industrial applications of electricity. He studied machines and their on-site operation. Frédéric Joliot

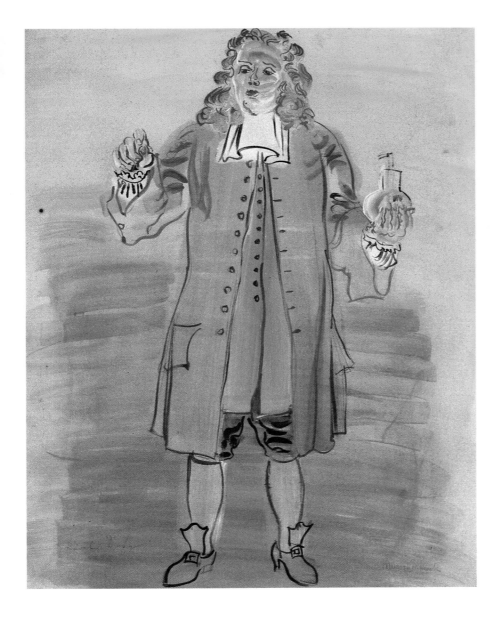

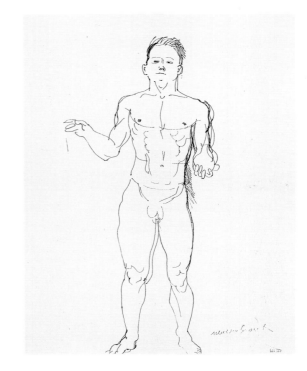

allowed him to paint sketches of his machine.[22] He visited the electrical supply centre at Vitry-sur-Seine, some steelworks and the Navy Arsenal at Brest where, in March 1937, he was able to make a large number of sketches 'involving nothing likely to contravene the requirements of national defence'.[23]

Finally, Dufy posed actors from the Théâtre-Français in his studio, first drawing them nude, according to a thoroughly classical tradition, then dressed in costumes of the era of the scientists concerned.[24]

His other concern was with resolving the many technical problems that he encountered. His unpublished correspondence with the directors of the Compagnie Parisienne de la Distribution de l'Électricité reveals his concern with joinery, the varnishes to be applied to both sides of the plywood, parqueted on arched frames, that was designed to bear the fresco, the drying-time of the chosen varnish – warm glue size – and the sanding. He was also concerned with the moisture level of the studio where his works were to be made, a hangar in Saint-Ouen placed at his disposal by the C.P.D.E., and the lighting of his fresco during painting, which had to be identical to the lighting that would be used in the Pavillon de l'Électricité.

Finally, *La Fée Électricité* gave him the opportunity to blend his paint with a medium developed by the chemist Jacques Maroger,[25] with whom he had recently become acquainted. The stability of this medium, with its fade-resistant properties, allowed him to superimpose his colours, retouching while wet, while also giving them a lightness and clarity of colour comparable to those of watercolour. 'In [this medium], Raoul Dufy [has] found an ease of application, a brilliance of colour and a chromatic play even more subtle and more dazzling than the material he has used in the past.'[26]

324 Study for *La Fée Électricité*, 'The Power Station'. 1936.
Watercolour and gouache.

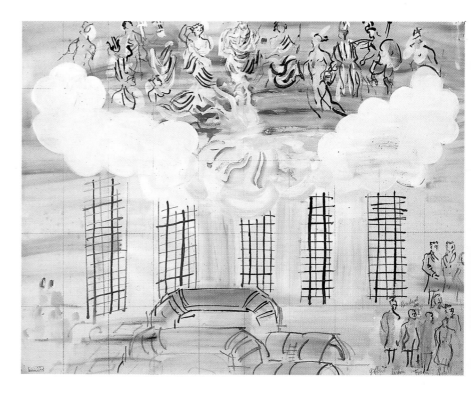

323 Glass slide projector, used for *La Fée Électricité*.

His palette consisted of paints manufactured by the Bourgeois company in their factory at Montreuil-sous-Bois. They were then ground in the studio and blended with the medium under the directions of Maroger.

Having resolved his material and technical problems, Dufy assembled his graphic documentation and chose, from among his sketches, drawings on themes that he had already painted. Before undertaking the final work, he made a gouache sketch, one-tenth of the final size,[27] in order to study the layout of his composition.

A series of watercolour and gouache drafts, in pencil on squared paper, sometimes with handwritten notes, preceded the final creation of certain parts of the fresco: *Thales, Archimedes and Aristotle*, for example, and *The Power Station* with its machines. The studies for the portraits of some of the scientists were complemented by works in gouache, such as the figure of Musschenbroek and certain details in the costume of D'Alembert, given added precision in watercolour.

On 17 January 1937, Dufy, who was staying in Saint-Ouen, finished this huge panorama, consisting of 250 panels, each 2 metres (6½ feet) high by 1 metre (3¼ feet) wide. His original method was to use a lamp to project a glass slide of his line drawings on to each panel. The pictures, enlarged to the desired scale, were reproduced with a special ink, made up of a varnish-gum lacquer and blue-tinted lampblack, a sort of highly indelible Indian ink, with alcohol in place of water.

In the making of the work, Dufy was helped by his brother Jean and his assistant, André Robert. These two covered over the drawing by applying a first coat of paint to the panels. Then, the next day, following Dufy's directions, they coated it with additional colours, the transparency of the paint revealing the drawing beneath. Having mounted the scaffolding, Dufy then returned to this work, applying his paint to the flat panels, using more or less dark colours, redrawing without regard for the original drawing, altering the line and adding new details.

The structure of Dufy's work was conceived in two horizontal bands, in the centre of which the gods of Olympus sit enthroned beneath stylized machines – which the artist had studied at the newly built power station at Vitry – generating a massive lightning flash. The lower band shows a collection of scientists (one hundred and ten in all) who have contributed to advances in science and technology; some of them are shown with their instruments or at work on their experiments.

The composition progresses chronologically from right to left. The list of scientists runs from Thales of Miletus, Aristotle and Archimedes to Fresnel, Biot

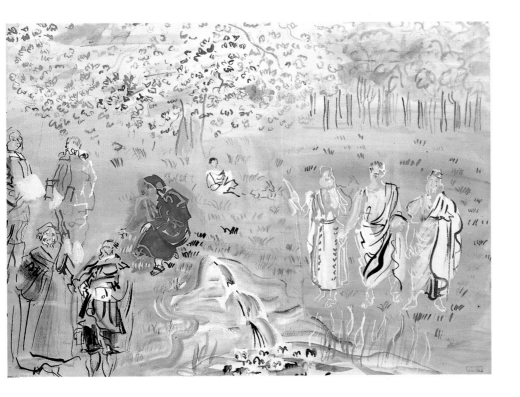

325 Study for *La Fée Électricité*, 'Aristotle, Thales and Archimedes'. 1936. Watercolour and gouache.

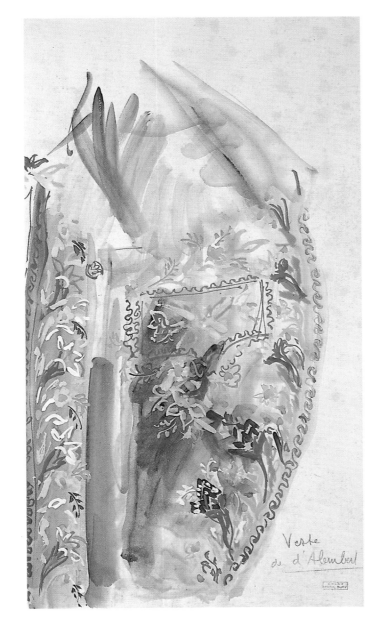

326, 327 Studies for *La Fée Électricité*. Alembert's waistcoat and jacket. 1936. Watercolour and gouache.

and Ampère. The procession, interrupted by turbines at the centre of the composition, then continues with the figures of Faraday and Poncelet, finishing up with those of Pierre and Marie Curie, Hertz and Edison, responsible for the most recent discoveries.

In the upper band, Dufy depicts the forces of nature and the work of man, followed by the material advances that electricity has brought about: nature is confronted by technology. First come the natural phenomena: lightning, an aurora borealis, a rainbow, a storm. A bright sun casts its rays over a Normandy landscape: a grove, an old aqueduct and a Norman farm are set into an agrarian landscape complete with harvesting scenes. They are enlivened by the motifs of the peasant, the cart, the combine harvester and the mill. The golden tones of these figures are well suited to the play of the painter's palette. This portrayal of human and natural energy, followed by that of the steam from the boats dotted about on the stretch of sea, leads us from the country to the city. While the urban landscape is animated by the birds that fly freely about, factory chimneys now peep through at the entry to the harbour. Then the transformation of nature begins; the tall furnaces and cranes of hydro-electric factories rise up, followed by naval yards, electric rails and metal railway bridges. Technology has mastered the modern world.

In the upper left-hand area of the painting, Dufy invites us to a celebration. The brilliance of the colours, the glitter of the fireworks and the beams of light dance to

328 Study for *La Fée Électricité*. Pierre Curie.
1936.
Pen and ink.

329 Study for *La Fée Électricité*. Violinist.
1936.
Pen and gouache.

ae sounds of a symphony orchestra whose music is carried into the distance by the radio towers.[28] The tricolour flags and luminous banderoles orchestrate a great fanfare from the popular holiday of the 14th of July, recalling a favourite theme from Dufy's Fauve period, when he was attracted to advertising posters. Here Dufy is painting advertisements in light; advertising was one of the themes of the Pavillon de la Lumière, in the adjacent galleries, and it also had its own pavilion.[29]

The great epic of electricity culminates in the final panels on the left-hand side, with the appearance of the radiant fairy rising up in a huge ray of light, the beam of the Ouessant lighthouse. Its 80-kilometre range made it the world's most powerful light source. We should note that Robert Mallet-Stevens had installed the new light of the Ouessant lighthouse on the rear façade of the Pavillon de l'Électricité.

The flight of this huge allegorical figure unites Paris, the City of Light, with the other capital cities of the world, identified by their major monuments. A true 'hymn to modernity', this gigantic fresco, which brings together the acquisitions of the past, the creations of the present and the conquests of the future, had an educational scope not unrelated to the building of a large number of museums during this period, such as the development of the Palais de la Découverte, which was devoted to scientific discoveries.

It was a huge success with the crowds of visitors, who took great pleasure in identifying the portraits of the scientists. Le Corbusier conveyed this admiration on the part of the public by comparing the attitudes of viewers before the two main works of the 1937 Exposition, Picasso's *Guernica*, shown at the Spanish pavilion, and Raoul Dufy's *La Fée Électricité*: 'Almost all that Picasso's painting saw was [. .] the backs of the crowds', while 'on the contrary, the public could be seen stopping for a long time in front of Dufy's huge fresco'.[30]

La Fée Électricité was a milestone in Dufy's work. It was the culmination of his experiments in the fields of colour and technique, not only as a painter but also as a decorator (designs for fabrics, hangings, and experiments with large surfaces, such as those of Viard and Weisweiller). The themes and motifs to which he constantly returned – the sea, harvests, popular festivals, Paris, the aqueduct, birds, the Norman farm, corn, the thresher, boats – find full expression in this work. *La Fée Électricité* was also the source of new themes in Dufy's work, such as that of the orchestra.

The use of luminous and transparent colours, created by the Maroger medium, and the freedom of Dufy's style, to which the work owes its brilliant improvisatory quality, give no indication of the detailed and thoughtful preparation that went into it.[31]

Raoul Dufy and Robert Mallet-Stevens were among the few architects and artists whose work was ready on the day of the opening, 24 May 1937. Some pavilions did not open until the second-last day, 28 November 1937. It took Dufy only four months to make this huge fresco,[32] rising to the difficult challenge of covering a surface of 600 square metres (717 square yards).

The 1937 Exposition confirmed the official recognition of Raoul Dufy's role in the country's cultural life. Having already been made Chevalier de la Légion 'Honneur, on 22 May 1926, for his role in national education as a painter and engraver, Dufy was raised to the rank of Officier on 5 August 1938. Just before the war, his fame was established with the public authorities and among a privileged clientele which remained untouched by 'the crisis', and with whom Dufy remained in contact. We need not do as some have done and defend Raoul Dufy's art against the charge of uselessness by overlooking his 'dandy' side. While he observed the high society of his time with a mixture of irony and tenderness, he enjoyed mingling with that society and going to the places that it frequented. His simplicity did not prevent him from enjoying the honours that he was awarded until the end of his life: in 1949 he was promoted to the rank of Commandeur de la Légion d'Honneur.

Before it left the Pavillon de l'Électricité, at the request of the directors of the Compagnie Parisienne de la Distribution de l'Électricité Dufy made a miniature version of *La Fée Électricité* (Musée d'Art Moderne de la Ville de Paris), the same size as the original preparatory drawing.

After the end of the 1937 Exposition the original painting faced an uncertain future. The war put a stop to the plans for having the work permanently installed.

Continued on p. 264

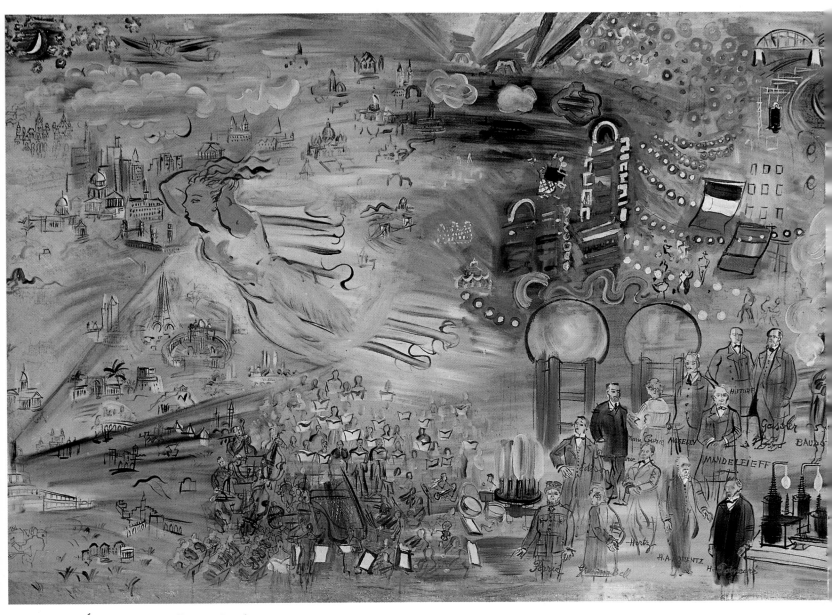

331 *La Fée Électricité*. 1937. Decoration for
the 'Exposition Internationale'.
Oil on canvas, remounted on to panel.

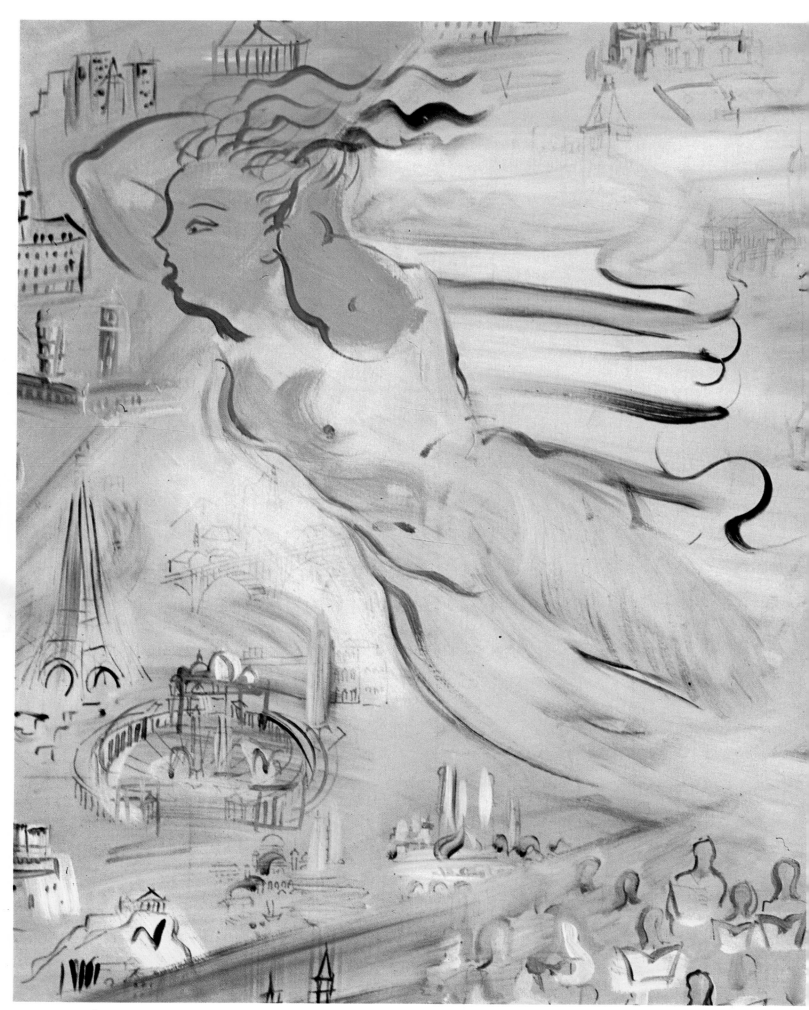

330 *La Fée Électricité* (detail).

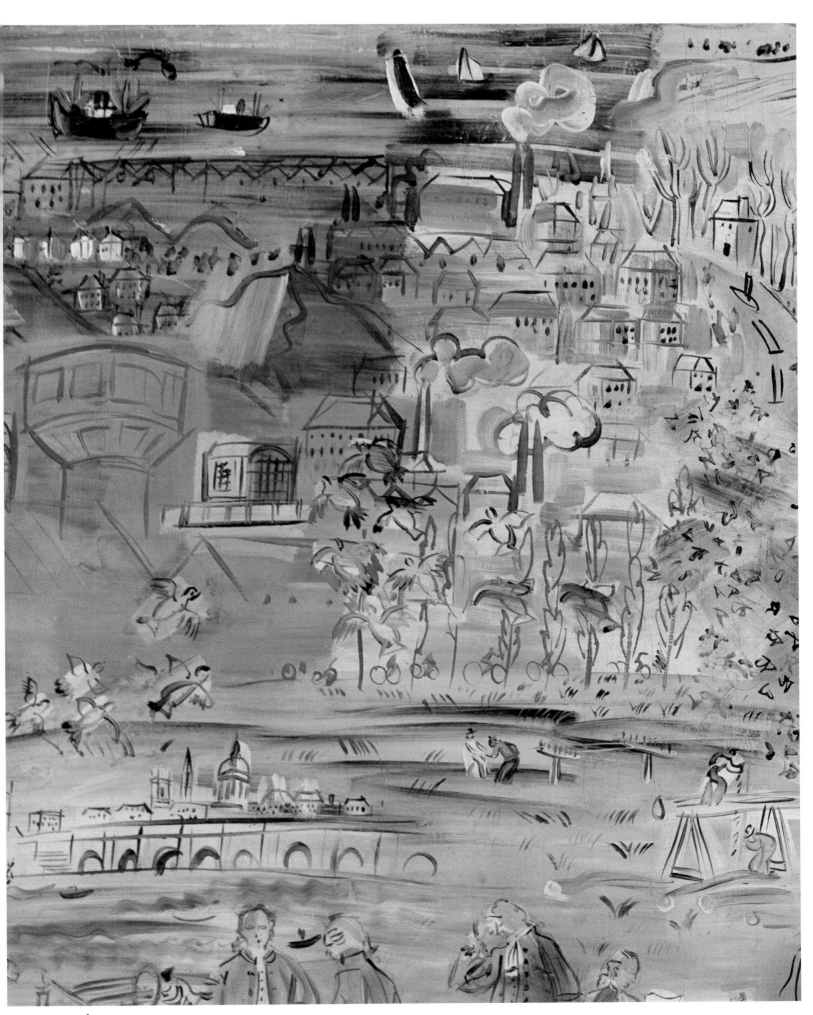

332 *La Fée Électricité* (detail).

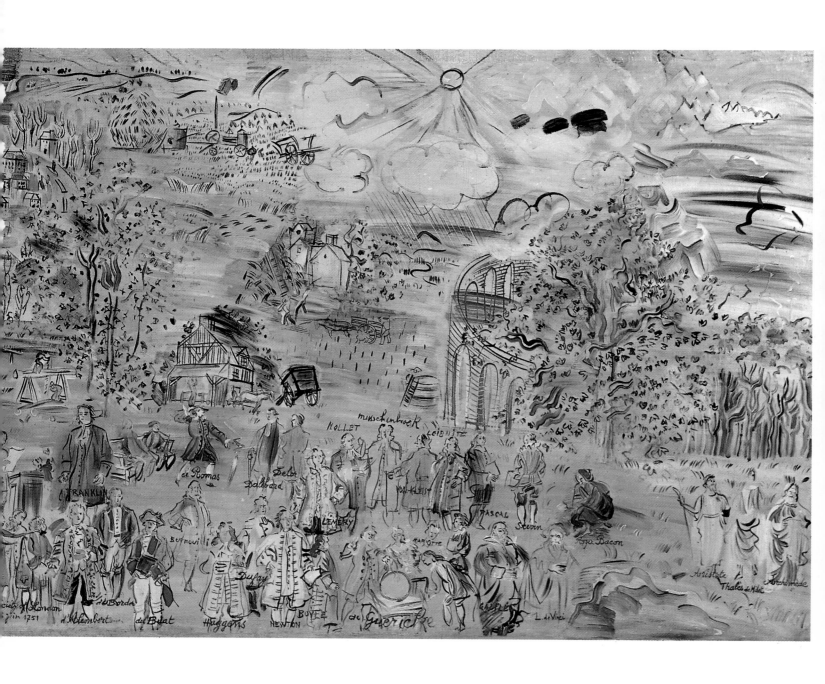

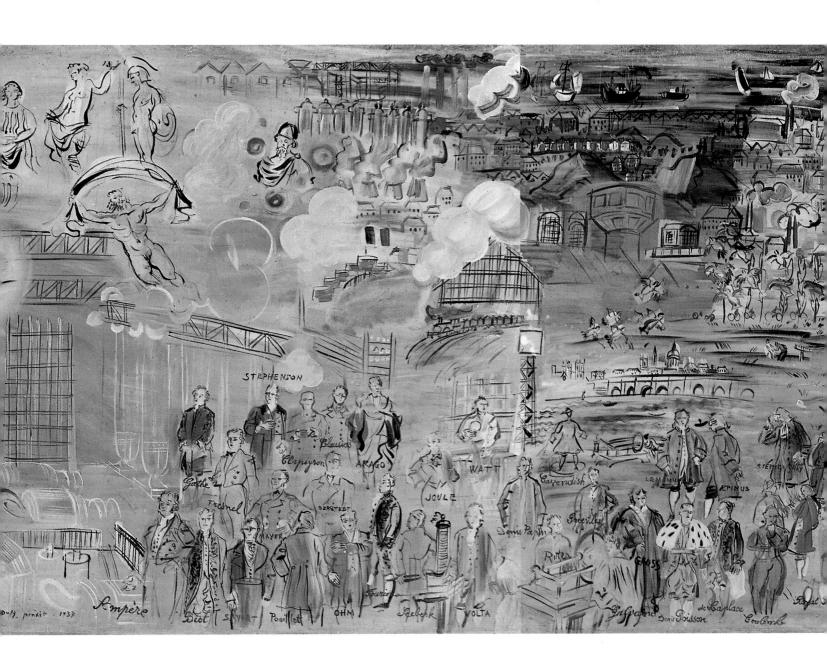

The 250 dismantled panels remained in storage with the C.P.D.E. and the publi
was unable to see the painting again until 1964, when it was reassembled in th
Musée d'Art Moderne de la Ville de Paris,[33] where it is now on permanent displa
The mastery of *La Fée Électricité* enabled Dufy to accept official commissions f
mural paintings, such as the decoration of the theatre bar at the Palais de Chaill
and the Monkey-House in the Jardin des Plantes.

Decoration for the Theatre Bar at the Palais de Chaillot

In June 1936, while he was working on the design of *La Fée Électricité*, Raoul Duf
was commissioned, still under the auspices of the 1937 Exposition, to make
monumental decoration for the semicircular smoking room and bar of the ne
theatre at the Palais de Chaillot.[34]

The Niermans brothers' construction of this theatre, which was to house Pa
Abram and Jean Vilar's Théâtre National Populaire, was accompanied by th
development of a programme of mural paintings celebrating the arts of song, danc
and drama. The state awarded commissions to artists of different styles an
tendencies.[35] Only the panels allocated to Dufy and Othon Friesz, for th
semicircle, are thematically divergent. Dufy's work, *The Seine, from Paris to th*

333 *The Seine, the Oise and the Marne.* 1938.
Watercolour, gouache and pencil.

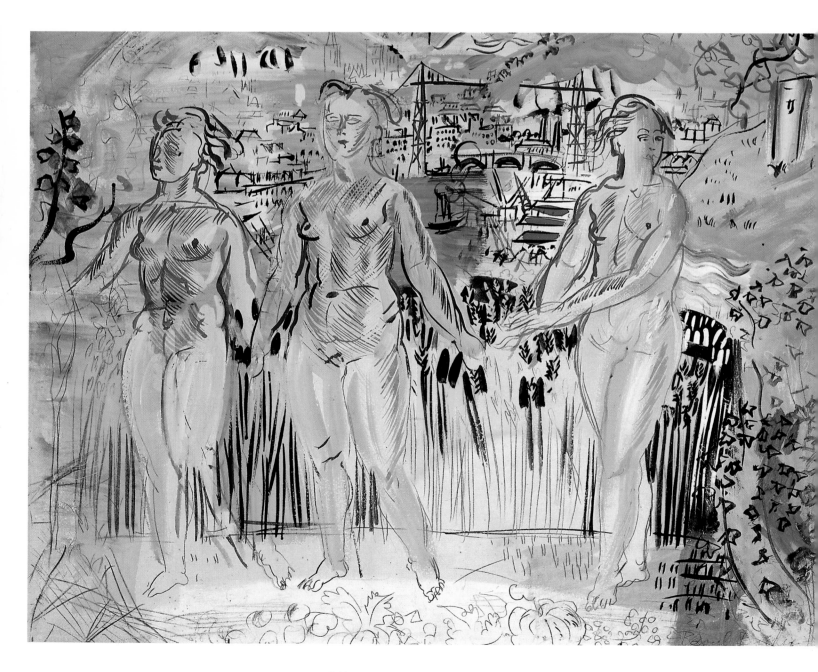

Sea, later known as *The Seine, the Oise and the Marne*, was a companion piece to the painting commissioned from Friesz, *The Seine, from Its Source to Paris*.

Conceived as a triptych, Dufy's work was finally installed in 1940,[36] having encountered great difficulties along the way. These difficulties are revealed by the correspondence between the painter and his patrons,[37] a series of registered letters and threatening formal demands in response to Dufy's delays.

The painting of this decoration posed a large number of technical problems for the artist, which were compounded by problems of structure and composition.

The Musée des Beaux-Arts at Rouen has preserved the three panels of a first version which Dufy intentionally left unfinished. Dufy feared that the work would be poorly preserved if remounted on staff without his supervision, a situation which would have darkened the tonalities of the painting.[38]

He began the work again, this time in the Maroger medium – with which he had recently experimented in *La Fée Électricité* – the emulsion of which ensured the brilliance and transparency of the colour by protecting it from the effects of bitumen. The new work was noticeably changed. The elements of the first version, which brings together the familiar themes – steam freighters, metal bridges, the sea, cliffs, monuments, orchards, harvests – reappear in the final work. On the other hand, the composition is entirely different, and the central panel – which includes

334 *The Seine, the Oise and the Marne*, central panel. 1938. First decoration for the theatre bar of the Palais de Chaillot. 1938.
Oil on canvas.

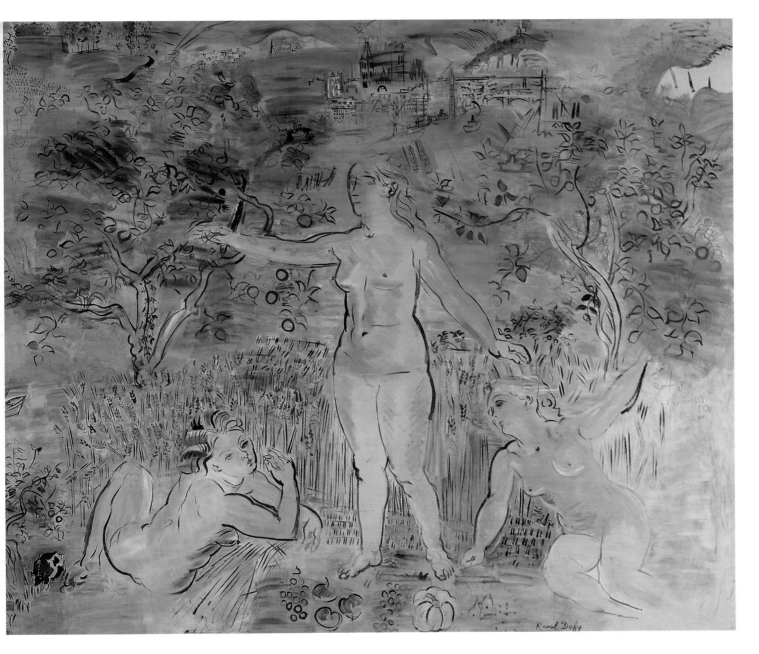

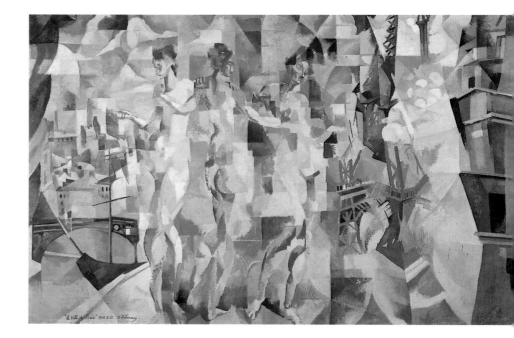

335 Robert Delaunay, *The City of Paris*. 1910–12. Oil on canvas.

the three allegorical figures of the Seine and its tributaries – shows a quite different arrangement.

The sketch for the first version reveals that Dufy, wishing to move away from the traditional representation of the *Three Graces* in an upright posture, and to avoid the structure of Robert Delaunay's *The City of Paris* (Musée National d'Art Moderne) chose a representation of three figures arranged in a pyramid formation the Seine stands in the middle, framed by the Oise and the Marne lying at her feet.

A large number of individual studies in pen and ink, watercolour or gouache led to the realization of this composition. There is a preparatory drawing (Musée des Beaux-Arts, Bordeaux), in which, in a very assured style, Dufy portrays the young nymph on the left lying on her back, her face turned three-quarters towards the viewer.[39] In addition, there are watercolours highlighted in gouache, studies for the layout of the composition as a whole.

In the final composition, Dufy returned to a more traditional conception; his three standing figures, grouped within a single plane, hold one another by the hand.

He finally solved his compositional difficulties in a watercolour study (Musée d'Art Moderne de la Ville de Paris), in which the free and spontaneous outline of his figures seems to be painted with the tip of the brush. The vibrancy of the brushstroke and the modulations of light and shade on the bodies make them seem to move in space, giving them a dynamism that is less evident in the final version. Their postures are roughly sketched. The landscape in the background is painted with a broad and fluid brushstroke.

336 Study for the first decoration of *The Seine, the Oise and the Marne*. 1937. Gouache.

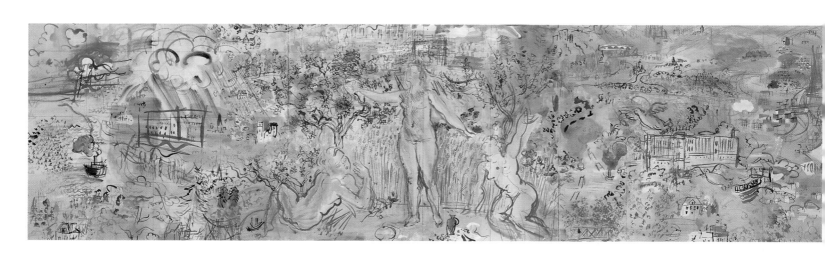

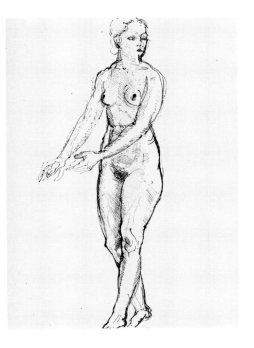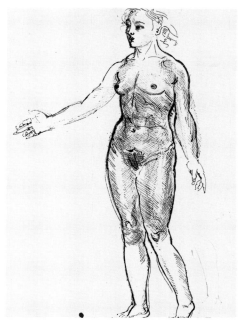

337 *Standing Nude*, study for the figure of the
Marne. 1937.
Pen, Indian ink and gouache.

338 *Standing Nude*, study for the figure of the
Oise. 1937.
Pen, Indian ink and gouache.

This central panel of the final version is both more refined in its execution and
more precise in its details than the Rouen painting. It was the final result of a large
number of pen-and-ink studies of the *Standing Nude* for the allegorical figures of
the Oise,[40] the Seine[41] and the Marne.[42] They reveal Dufy's uncertainties and
experiments with regard to the posture of the bodies, the movements of the heads
and the positioning of the arms, hands and legs. The bodies are modelled in an
individual style of variously spaced hatchings that provides a contrast of light and
shade. These different studies reveal how concerned Dufy was to provide a
satisfactory solution to the problem of setting figures within a landscape.

In this central composition of the triptych, Dufy chose a construction based on
three verticals, those of the three figures facing the viewer, standing in the
foreground. This posture makes the work more monumental than the first version,
in which, to give his composition greater breadth and height, he included two
verticals parallel to the Seine, in the form of two trees, one at each side of the central
figure.

Here, Dufy stresses the verticality of his figures with the motif of the standing
corn that forms a backdrop for them, and by showing the tall towers of the churches
of Rouen and the cranes of its transporter bridge.

Dufy's allegories differ, in their ample forms, from the female figures in the
slender and mannerist canon of Delaunay's *The City of Paris*.

Despite the frontality and hieratic nature of these three figures, this central
composition gives the ensemble of the triptych, in its structures and its play of
lines, a certain rhythm and monumentality that harmonizes with the architectural
site for which it was designed.

The decoration should be read from right to left. It begins with a depiction of
Paris, showing the Tuileries, the bridges over the Seine and the Eiffel Tower. Two
tall-trunked trees in the foreground form the wings of the composition. They lead
the eye towards the peaceful course of the river which flows straight towards the
fields and woods, then to Rouen and the buildings of the city.

The left-hand panel shows a picture of the Normandy of Dufy's birth. This
landscape combines reality with an imaginary vision. What we recognize is Le
Havre, with its port and docks. We can make out the houses along the Bay of
Sainte-Adresse, but the sea continues far beyond, reaching into the lower band of
the composition. A triton blowing into a shell rises from the glittering waves, hailed
by a flight of seagulls, their wings spread. A castle stands in the middle of a
Normandy grove of ancient apple-trees.

The sky overhead includes a rainbow and rainclouds, typical of the Normandy
climate, a changeable atmosphere in which clouds and rain are followed by good
weather, bringing with it a diffuse and silvery luminosity.

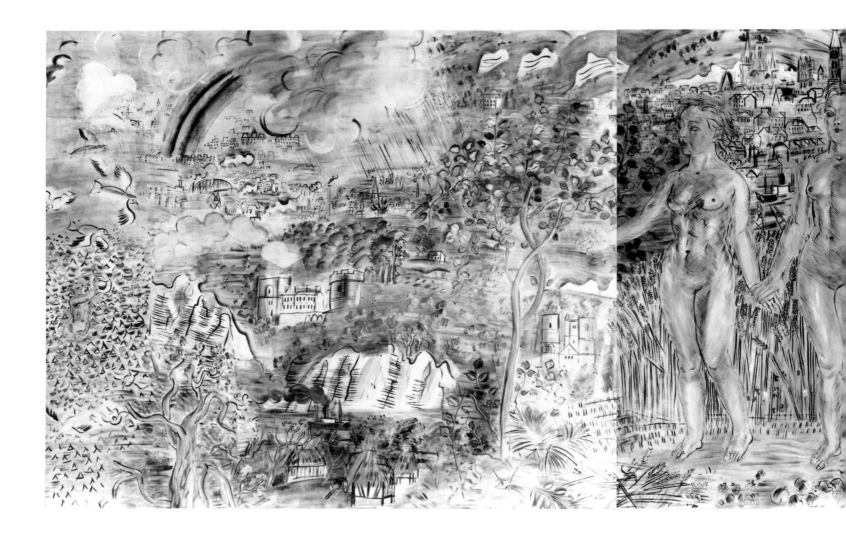

339 *The Seine, the Oise and the Marne.* 1938. Decoration for the theatre bar of the Palais de Chaillot.
Oil on canvas.

The left-hand panel of the triptych of *The Seine from Paris to the Sea* was the subject of a many preparatory studies. A sheet from Dufy's sketchbooks (Private Collection) shows a brief preliminary sketch of the extreme left-hand side of this panel, in which the figure of the triton appears, along with a study for the squaring of the composition and handwritten notes.[43] The execution of the ensemble of this work relies on a profound study of drawing, colour and the siting of the various elements of the composition, and the final realization, which seems so spontaneous, so 'relaxed', is actually the result of constant study and reconsideration.[44]

The organization of this decoration for the theatre bar of the Palais de Chaillot proves Dufy's great mastery. The various structured planes are enlivened by his expressive calligraphy, its highly inflected style outlining his forms with a light or heavy line, either enlarging on his representations or reducing them to their essence, whether they be buildings, stones, leaves, sky or sea. 'Art, said the realists, is nature seen through a temperament. Art, answered Cézanne, is a harmony parallel to nature.'[45]

Dufy and his friend Friesz met up once more during the decoration of the theatre bar of the Palais de Chaillot. Their works, though independent of one another, are geographically complementary. Friesz's works differ from Dufy's painting in its conception and style. Like Dufy, Friesz combines nature with nude figures. His one-piece work is divided into three areas and shows a series of landscapes that unite the riverside towns of Troyes, Montereau, Fontainebleau and Moret, linking them with scenes of grape-picking and harvests. The foreground shows two large female nudes standing out against the large trees which divide the work into a balanced structure;[46] allegories of the tributaries of the Seine, they are shown as naiads lying across the course of the river. These strongly modelled bodies, painted in a very solid style, give the work a monumental quality that harmonizes with its architectural setting. Nymphs and dryads are also a part of nature; recalling *La Joie de vivre* by Matisse, the group of nymphs on the right contributes to the

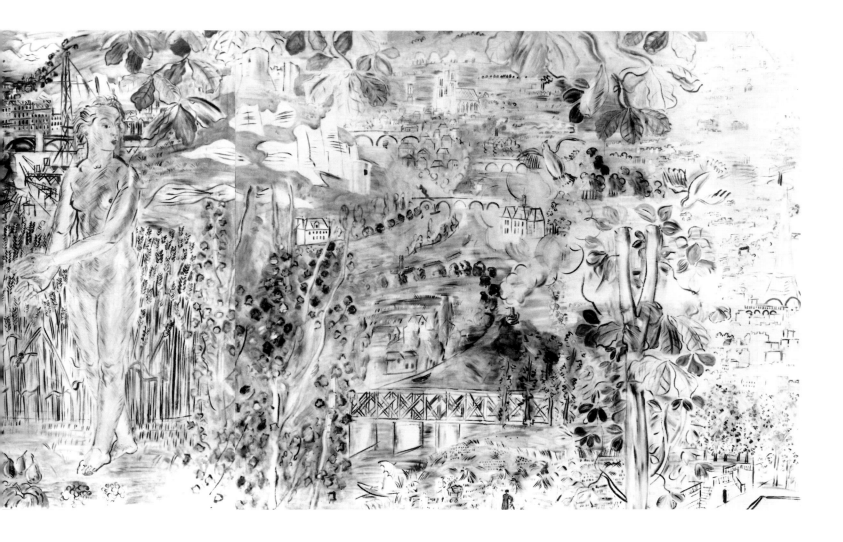

evocation of a classically conceived idyllic landscape. While Friesz's composition has a certain gravity that is absent from Dufy's work, in which fantasy and the imagination predominate, his chromatic range, a sober harmony of blues, greens and golds warmed by luminous golden accents, illustrates his mastery of colour.

Decoration for the Monkey-House in the Jardin des Plantes

The painting of two decorative panels designed for the Monkey-House in the Jardin des Plantes at the Muséum d'Histoire Naturelle, a new building erected in 1933 by the chief architect Chaussemiche, was Raoul Dufy's third official State commission, awarded on 30 August 1937.[47]

Dufy had previously been anxious to conceal the amount of preparation that went into his works. The fact that he admitted the difficulties and worries that arose during the making of these decorative panels gives some indication of the problems that he had in completing them. In his correspondence with his dealer Bignou he wrote: 'I have got quite far with my work, but how long these paintings take, and how difficult they are to conceive and arrange!' In December 1939 he told Bignou: 'I have finished the *Monkey-House* five days ago. The last part is drying; the first is rolled up in its box and needs only the other half [. . .]. I shall therefore be in Paris on the 30th to give it to the architect of the Jardin des Plantes.' In another message he stated, 'The Trocadéro will be finished tomorrow [. . .] I shall send my second version of *The Seine* to the Palais de Chaillot in the first week of January and will then have done with all of these labours that have caused me and everyone else such pain and worry.'[48]

'I don't show any monkeys,' Dufy said, 'They are there in front of the visitors, and I am not about to recreate them and leave myself open to such a dangerous comparison.'[49]

In the ensemble of the two paintings, in the form of triptychs, Dufy chose to depict the explorers who discovered nature and then the scientists who studied it. On the side panels he portrayed the poets who sang its praises.

In the central panel of the first decoration, Dufy grouped eleven explorers around De Brazza, who stands wearing a solar topee, and Stanley, sitting on an open map. Behind them one can see monuments evoking Asia on the left and Africa on the right. They frame a background of palm-trees, rigging and sailboats floating on the sea.

On the right-hand panel, Dufy showed two scenes illustrating La Fontaine's *Fables*: *The Monkey and the Cat* and *The Lion, the Monkey and the Two Donkeys*. The upper part is devoted to the Chinese legend of the monkey who stole an apricot tree. Opposite, on the left-hand panel, we see the Indian legend of the monkeys fighting the sea-monsters, above the two figures of Kipling and La Fontaine.

In painting this part of the decoration and its companion-piece, Dufy drew his inspiration from the documentation that he had assembled for *La Fée Électricité* concerning the scientists and naturalists who contributed to advances in anatomy, zoology, palaeontology and mineralogy. He also assembled information on the explorers of distant lands and unknown peoples, and tried to find portraits and descriptions of them by their contemporaries.

The Explorers was preceded by preparatory works including pen-and-ink studies highlighted in gouache,[50] in which he drew some of the figures within a barely defined framework.

A preparatory design in oils for this work is preserved in the Musée National d'Art Moderne.[51] This sketch shows an arrangement that differs from the final work in its placing of the figures. The central group, made up of eleven scientists, is not homogeneous; the figures of the scientists do not stand in a line but in a quincunx: De Brazza stands in profile, turned towards Saint-Hilaire, sitting in front of an open map.

In the final work, the explorers form a gentle curve behind De Brazza, who stands facing the viewer, and Saint-Hilaire, seated in the foreground. They stand outlined against a layer of palm-trees in the middle distance, behind which we can see a backdrop of buildings, vegetation, rigging and sailboat masts. In the sketch for the work, Dufy painted a backdrop showing an expanse of sea with a raised horizon, with two resplendent caravels floating upon it. This seascape is integrated within the composition as a 'painting within a painting'.

340 Sketch for *The Explorers*. 1939. Pen, pencil and gouache.

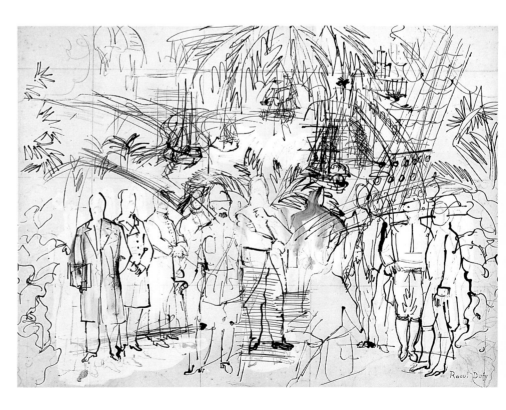

For the Monkey-House, Dufy re-used some of the nude studies which he had made for the scientists in *La Fée Électricité*, in some cases showing them facing in the opposite direction: 'In order to draw them I posed actors from the Comédie-Française in an *ad hoc* costume [. . .]. Of course I had all my documentation, the portraits and documents about my characters.'[52] Thus, for example, Dufy re-used a nude study, originally drawn for the scientist Fourier, for the figure of Freycinet (Musée National d'Art Moderne).[53] They are shown in the same pose, in left profile. The two lines across the chests of the nude figures correspond to the outline of their clothing.[54]

From the number of preparatory studies for *The Scientists*, it would appear that it was to this panel that Dufy devoted the most attention. The central composition assembles sixteen figures around a table with Buffon at its head.

The right-hand panel shows an illustration of a fable by Phaedrus, *The Wolf Pleading against the Fox, before the Monkey*, over the figure of the poet posing by a bust of Aesop.

The left-hand panel shows three scenes illustrating La Fontaine's *Fables*: *The Elephant and Jupiter's Monkey*, *The Donkey Bearing Relics* and *The Monkey and the Dolphin*.

This composition was also developed in preparatory sketches, including an initial study in pen and brown ink (Musée Jules-Chéret, Nice), squared out with the names of the figures in pencil, revealing Dufy's original intentions as to their placing within the composition. While the standing scientists are drawn in outline, Dufy spent more time over the representation of the seated figures. The way in which they are drawn reveals Dufy's hesitations, in his corrections of a line that seeks to capture an attitude, a posture, the positioning of an arm, a leg or a hand on the table, and in the depiction of clothing.

The placing of the figures was the subject of a sketch in oils (Musée Jules-Chéret, Nice), in which Dufy sought to integrate them within a landscape showing the buildings of the Museum. Appearing once more in a watercolour study (Musée National d'Art Moderne), these buildings disappeared from the final composition, to be replaced by an indeterminate background. The bust of Buffon by Pajou in the garden of the Museum did not appear in the decorative panel: Dufy filled this gap by bringing the figures of the scientists grouped behind it closer together.

This sketch reveals Dufy's experiments with colour, based on the distribution of three colours on the canvas, a method with which he had previously experimented

341 *The Explorers*. 1939. Oil on canvas.

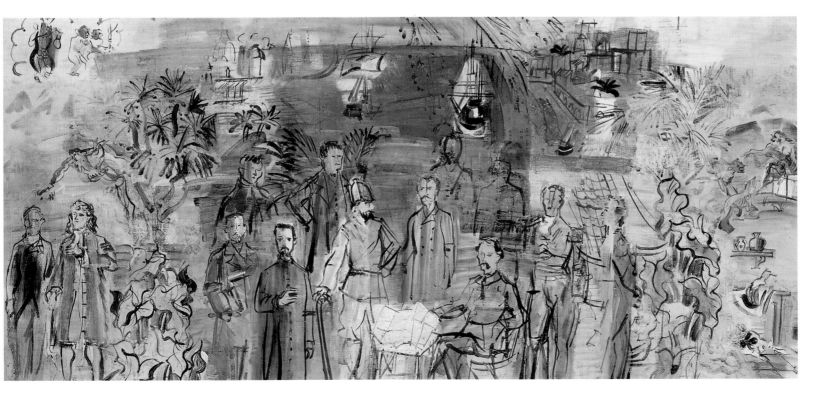

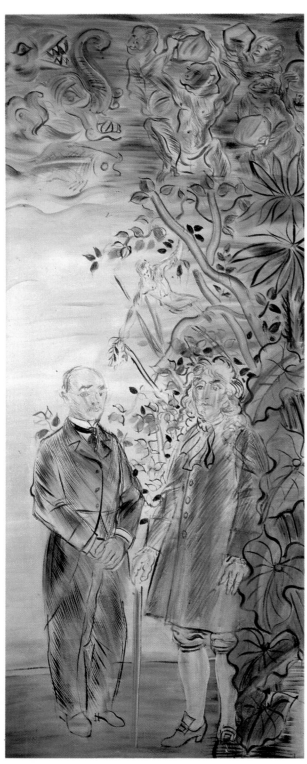
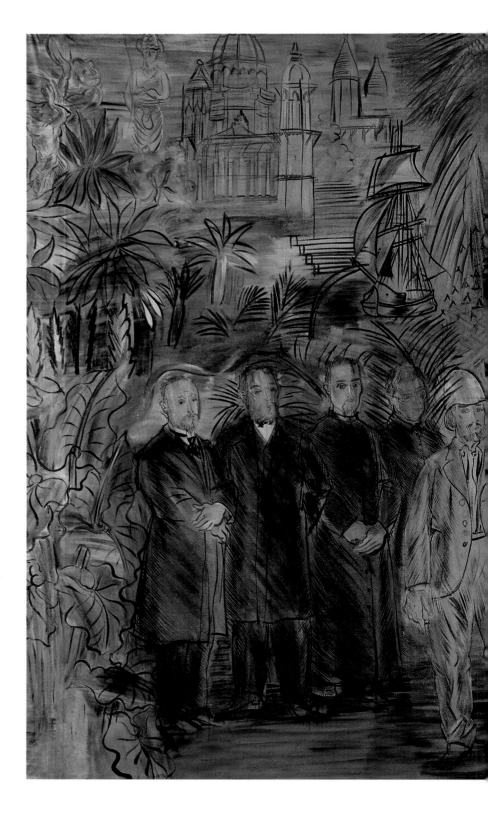

342 *The Explorers*, decorative panel for the
Monkey-House of the Jardin des Plantes. 1940.
Oil on canvas.

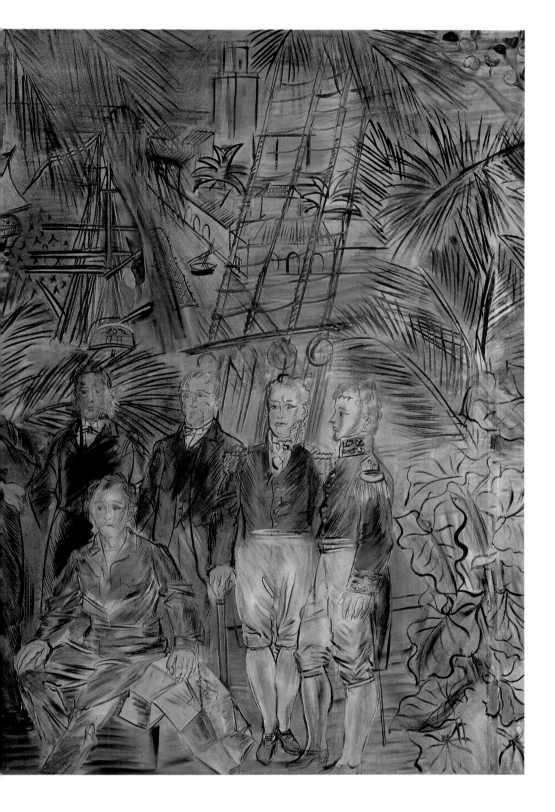

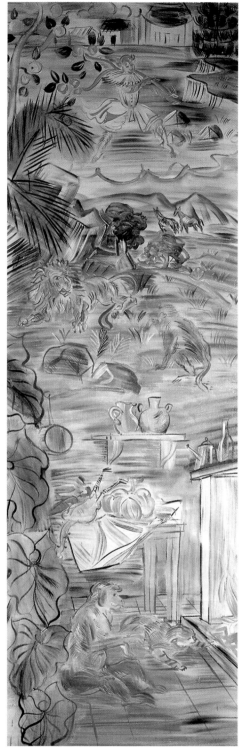

343 Study for *The Scientists*. Schlegel, nude. 1938.
Pen and Indian ink. Musée des Beaux-Arts, Nice.

344 Study for *The Scientists*. Schlegel, clothed. 1938.
Pen and Indian ink. Musée des Beaux-Arts, Nice.

in his paintings, for example in his racing scenes. This short-lived and original solution to his experiments with light allowed him to modulate it, creating shadow effects. Around 1949, Dufy's experiments with the use of the colour black to intensify light was to culminate in the series of *Black Freighters*.

Dufy covered the surface of this preparatory sketch for *The Scientists* with bands of yellow, green and blue. The figures and objects take on the ambient tone. They are given a rapidly sketched outline, like the vegetation that divides the composition into three parts. Palm-trees and huge leaves impress their decorative arabesques upon the ensemble.

The artist used this method only in the mural decoration for the Monkey-House; his other decorative compositions employ a broader palette, which becomes independent of the linear graphic style that Dufy uses to define the figures, vegetation and objects.

The watercolour in the Musée National d'Art Moderne, Paris, shows a more detailed version of this composition. It includes the outline of the table, while the bust of Buffon becomes practically invisible. The figures are seated around the table just as they are in the finished work, but the group of standing scientists has not yet been defined. Dufy is also unsure about their identities.[55]

Finally, we should also mention a preparatory study for the central panel, a sketch in oil on wood (Musée des Beaux-Arts, Nantes), in which Dufy depicts the group of scientists in broad brushstrokes.

The numerous preparatory nudes for the figures in the painting *The Scientists* (mostly in the Musée Jules-Chéret, Nice) indicate the care that Dufy took over the completion of his work and tell us a great deal about his working method. As in *La Fée Électricité*, Dufy first made nude studies of his historical figures, then showed them clothed in a more detailed drawing.

Dufy proved himself to be a remarkable draughtsman in these confidently drawn sketches. With a nimble use of the pen, he varies his lines, which are sometimes simplified, sometimes heavy, often highly descriptive in their rendering of details. His studies reveal an extremely sensitive line: one example of this is the treatment of the hands of the figure of Linnaeus and the depiction of the intense expression on his face, with its halo of curls.

A preliminary study was devoted to Schlegel (Musée Jules-Chéret, Nice), showing dynamic corrections emphasized by a pattern of close hatchings that establishes a spatial relationship between the figure and the background. When painting the portrait of the scientist in the final version, he used this texture in order to model his figures rather than to create contrasts between light and shade. This was made impossible by his principles of side lighting, since shadow in Dufy is expressed by luminous colours. Nevertheless, the intensity of the expression on the face of the figure, seen in an elaborate pen-and-ink drawing (Musée National d'Art Moderne) does not appear in this composition. The study for Desmarets (Musée National d'Art Moderne) shows the same pictorial qualities: there is an astonishing authority in this graphic style, which gives the scientist a convincing presence that is missing from the painted panel.

Dufy's stylistic qualities, with expressive lines that use interruptions, impasto and dynamic corrections, are brought together in the structure of the figure of Galen, who forms the right-hand edge of the group of standing scientists. The Musée National d'Art Moderne has an Indian ink drawing highlighted in white gouache, in which the descriptive notations of the folds and movements of the tunic give this figure a monumentality and presence which directly call to mind the figures in Masaccio's frescoes, in the Church of Sta Maria del Carmine in Florence. The figure of Phaedrus, in classical dress, in the right-hand panel of *The Scientists*, shows the extent to which the studies for *La Fée Électricité* contributed to the decoration of the Monkey-House. For this figure, Dufy used the pen-and-ink drawing of the nude of Pascal (Musée National d'Art Moderne), which shows him in a similar posture.[56] A more complete pen-and-ink sketch highlighted in gouache (Musée Jules-Chéret, Nice) which skilfully and freely describes the drapery of the poet's toga, may be considered to be a final study for this figure.

This examination of the preparatory works for the decorative compositions for the Monkey-House in the Jardin des Plantes has allowed us to stress Dufy's

masterly qualities as a draughtsman. By means of his skill and his vibrant technique, he devoted himself to expressing the inner life of the figures he depicted, giving them a remarkable vitality.

Since Dufy did not use photographic projection in the creation of this work, as he had done in *La Fée Électricité*, it is not surprising that these portraits should be superior to the portraits in the finished works. The attitudes in the finished work are more rigid, the expressions more fixed and the figures less lifelike than they are in the drawings. It is a great pity that Dufy was unable to recreate the expressive intensity of his faces when it came to painting them.

The start of the war meant that Dufy's paintings could not be hung in their intended site, in the Monkey-House at the Jardin des Plantes. They remained rolled up in storage, to be brought out for the major retrospective devoted to Raoul Dufy at the Musée National d'Art Moderne in 1953, after his death.

In the spring of 1963, when the new library building, built by M Delage, was opened at the Muséum d'Histoire Naturelle, the public was able to see them once more. Since then they have been on permanent exhibition there.

345 Study for *The Scientists*. Phaedrus. 1938. Pen, ink and gouache. Musée des Beaux-Arts, Nice.

275

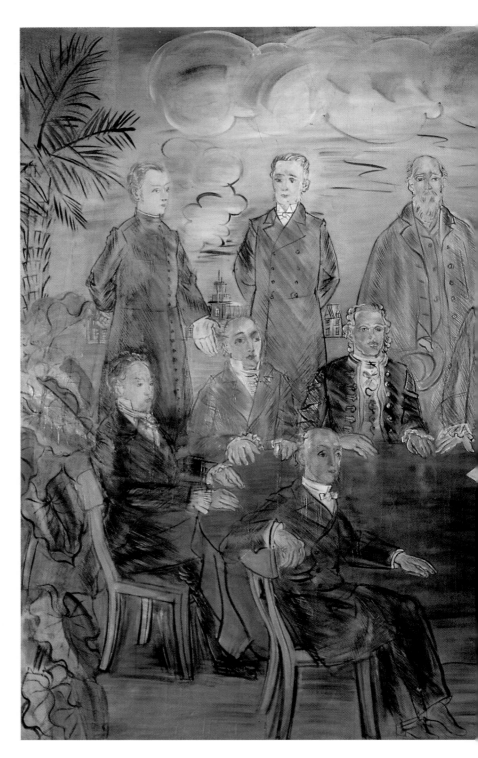

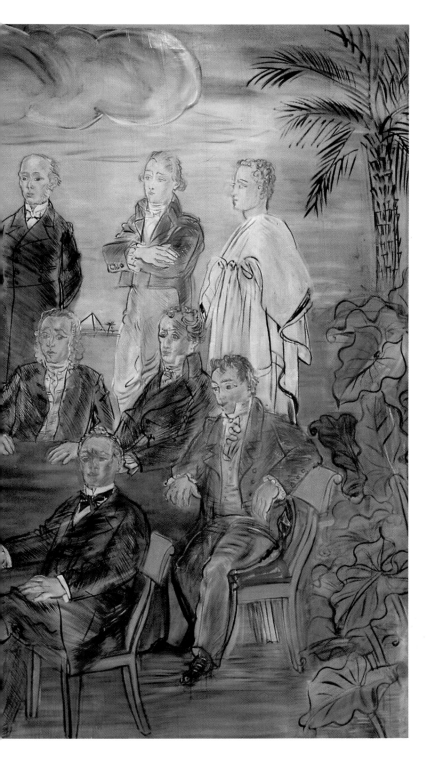

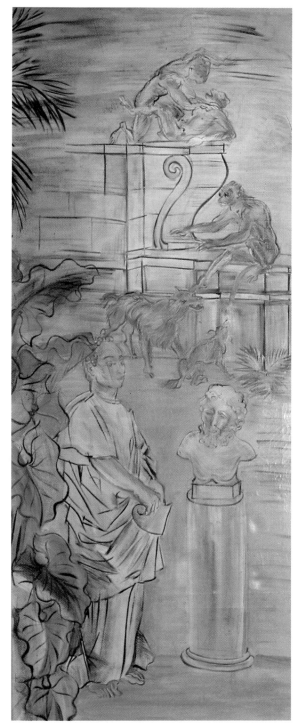

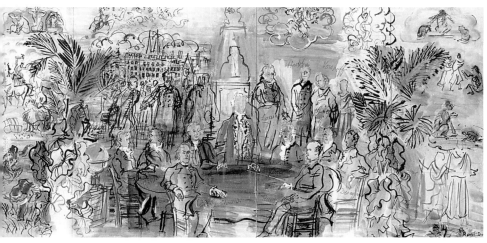

346 *The Scientists.* 1940.
Decorative panel for the Monkey-
House in the Jardin des Plantes.
Oil on canvas.

347 Composition study for *The
Scientists.* 1938.
Pencil, watercolour and gouache.

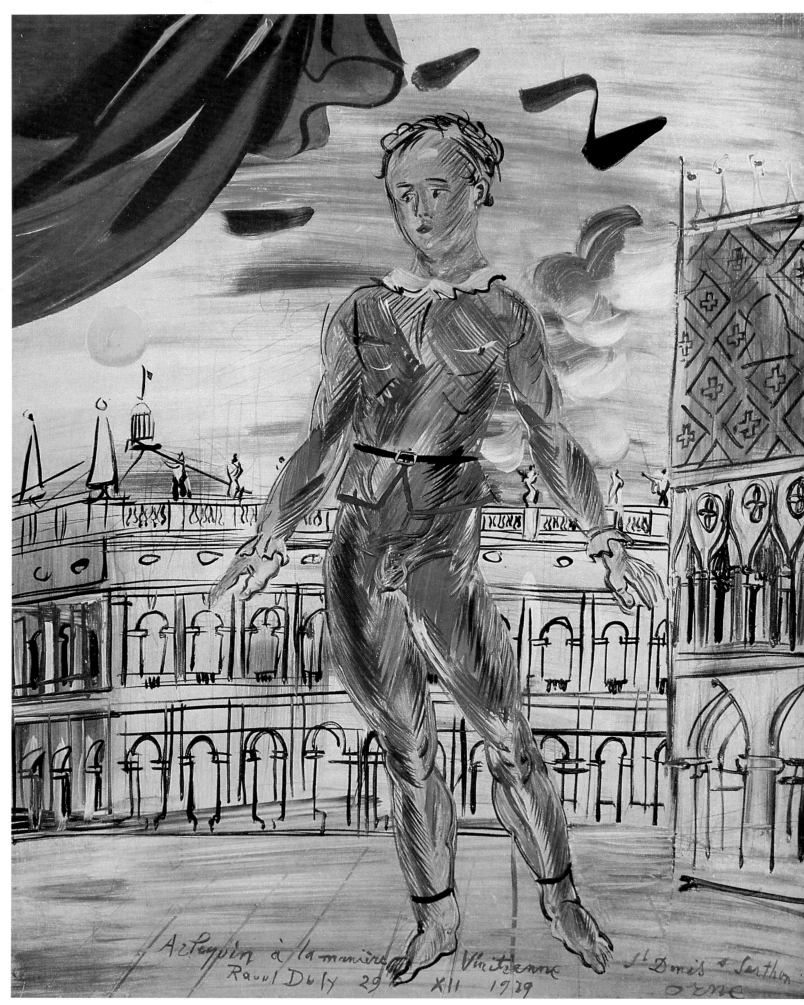

348 *Harlequin in the Venetian Manner.* 1939. Oil on canvas.

XII

RETREAT
TO THE MIDI

ARTISTIC CONSECRATION
(1938–1953)

349 *Still Life with Violin* (detail of ill. 370).

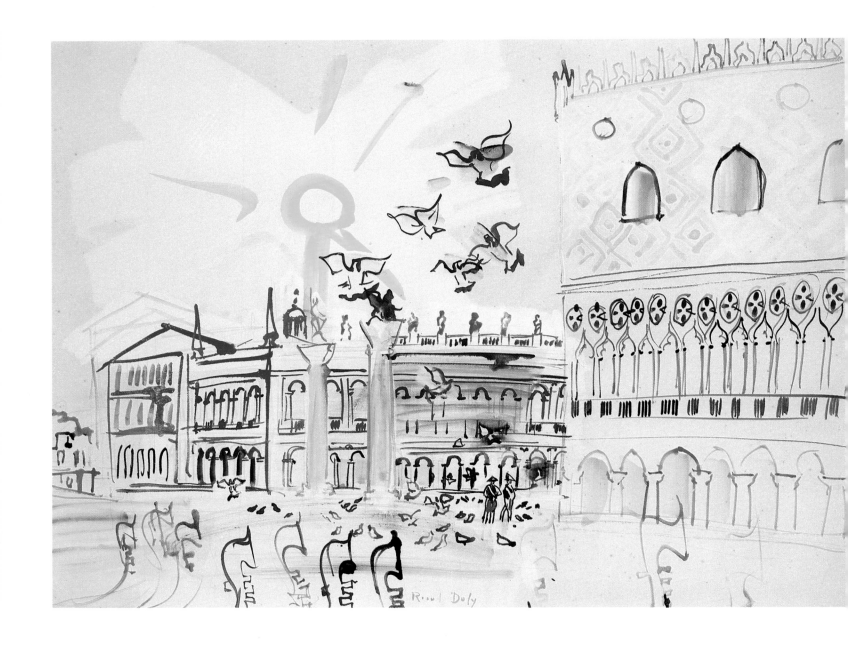

350 *Venice, the Piazzetta*. 1938.
Watercolour.

In 1938, Venice became the final stage of Raoul Dufy's prewar foreign travels. His stay in the city produced a series of watercolours, free of all the anecdotal and picturesque content that had characterized the works of the eighteenth-century *vedudisti*. They are poetical evocations of the city of the Doges, especially in their delicate tones, which convey that particular luminosity which caresses the buildings beneath the limpid skies with their constantly changing harmonies.

From the Venice Carnival Dufy took the figure of Harlequin, which he portrayed in numerous variations during his stay at Saint-Denis-sur-Sarthon in the Orne region of France, where he was to take refuge after the declaration of war. In *Harlequin in the Venetian Manner*, the figure stands against a background of the Palladian buildings and the Doge's Palace. In homage to Venice, colour comes into its own in the representation of the costume, rendered in broad intersecting lines. The same treatment, also used in the *Masked Harlequin* of 1939, recurs in the 1943 painting of the same subject, in which Harlequin appears in an imaginary landscape that combines the motifs of the rainbow, the rain-filled cloud, ears of corn, the harvest and the two ornamental fountains which frame the composition. A similar fantastic landscape shows *Orpheus* holding his lyre, a figure symbolizing the poet, the artist and the musician, who was to reappear, with his cortège, in the tapestry cartoons that Dufy was making at the same time for Mme Cuttoli's suite of salon furniture. Mythological subjects surface again in the figure of the *Venetian Apollo*, which combines an agility of brushstroke and a mastery of line – the major characteristics of Raoul Dufy's artistic maturity.

In 1939 Dufy also started work on a series of Harlequins playing music, which he was to continue painting until 1945–46. The violin-playing Harlequin of 1941, seated beside the lagoon, testifies to Dufy's interest in the Old Masters. For this figure, he drew his inspiration from a page of studies by Raphael (Dufy owned an album of facsimiles of these) in which the master analyzes the posture of the figure and the position of his hands on the instrument.

In the years that followed, Dufy, in full control of his art, felt that he was ready to confront the work of his predecessors. He did not make slavish copies of their works, but interpreted them rather freely in a way that conveyed their spirit and their method. The numerous versions, either drawn, or painted in watercolour or oils, of Renoir's painting *Le Moulin de la Galette*, of which Dufy had a reproduction, provide an example of this. While he retained the arrangement of the figures and the framing of the original painting, he entirely transformed the expressive qualities of the light: he was no longer concerned with conveying the palpitation of the light through the leaves, the glints of light that flicker across the figures with a fragmented brushstroke that alternates light with coloured shadow. Instead, Dufy applied his theory of 'couleur-lumière' to this subject: barely any light emanates from the upper part of the painting, radiating instead from the dazzling colours of the figures. A dynamic brushstroke creates a festival atmosphere – more immediately apparent than in the Renoir – which derives from his many paintings on the subject of the *Dance on the 14th of July*.

This attraction to scenes from contemporary life had appeared in Dufy's work in 1935, when he borrowed a theme painted by Constantin Guys, *The Reception of French Military Staff by an English Admiral*. His variations on this subject reveal a degree of freedom in his painting of the figures, along with a treatment of light whereby they participate in the zones of colour across which they pass.

In 1938, inspired by Botticelli, Dufy had painted numerous versions of *The Birth of Venus*. His many allegories of Amphitrite with her shell, treated in watercolour, oil, ceramic and tapestry, show how attached he was to this mythological figure.

Of the Venetian masters, Dufy's favourites were Tintoretto and Titian. He transposed Tintoretto's *Ladies' Concert* into two allegorical variations on the subject of music. Dufy now turned to treating the theme of orchestras. From Tintoretto's allegory he retained the group of female nudes which lent a rhythm to the composition, as well as the instruments, whose sonorities harmonized with those of his palette and his long brushstrokes. The decorative effect produced in this

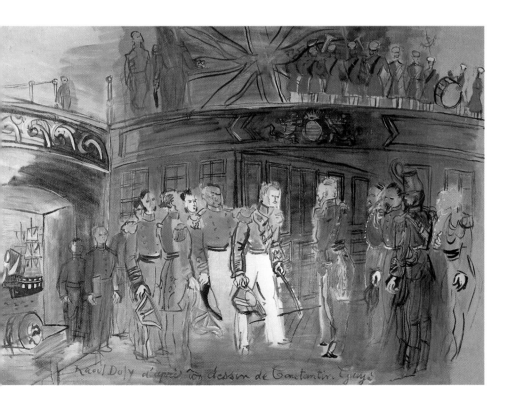

351 *Reception of French Staff*, after Constantin Guys. 1935.
Oil on canvas.

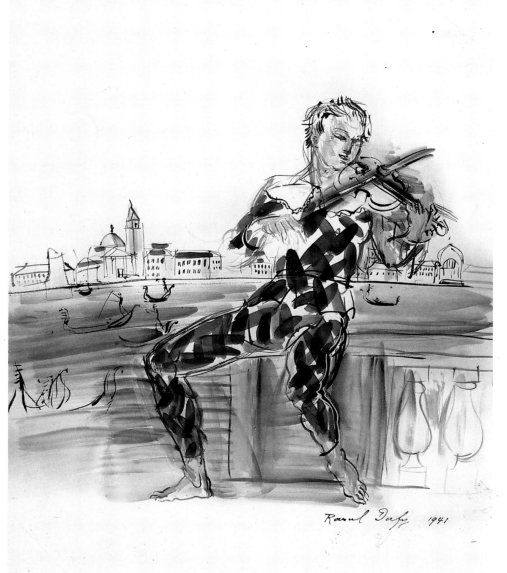

354 Study of a violinist, after Raphael. 1941.
Pen and ink.

Top
353 Raphael, Sheet from Sketchbooks.
Pen and ink.

352 *Harlequin.* 1941.
Watercolour.

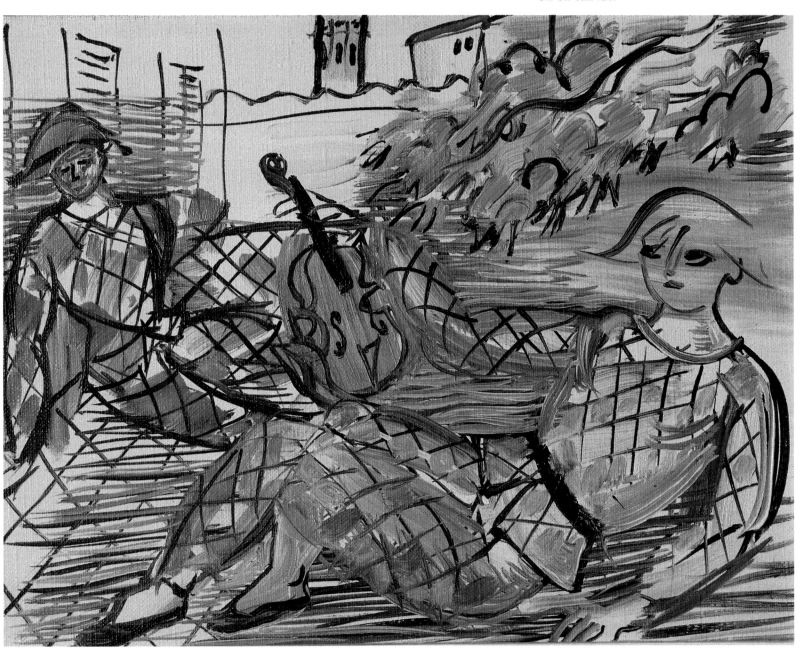

treatment of the subject reappears in his interpretation of *Susanna and the Elders*. Dufy perfectly integrated the female nude within her natural setting. He did not burden himself with any of the details of Tintoretto's composition, but tried instead tenderly to capture the light cast on this nude, evoking her beauty with a broad and brilliant brushstroke.

While the dazzling effect of *Venus, Cupid and an Organist*, which he discovered in the Prado in 1926, led him to paint a literal copy of the painting in 1949, Dufy was to interpret this *aubade* theme in his *Prado Tiziano*, an oil painting dedicated to his friends the Bergmans. He returned to this theme for the *Nude on the Terrace*, painted in the same year in Caldas-de-Montbuy.

It was not for want of subject matter that Dufy turned to these transpositions. His development followed a different course from that of Picasso who, from 1950 until 1963, painted a series of variations on the works of Delacroix, Velasquez and Manet. In confronting the Masters of the past, Picasso was seeking to 'go beyond the tradition of painting and throw down a sort of challenge to the painting of the nineteenth century'.[1] Dufy's method, on the other hand, drew on a traditional discipline which revealed his ability to establish a dialogue with the past through his mastery of his aesthetic language.

Raoul Dufy took refuge in the South of France during the years of the Occupation. Driven out by the enemy invasion, he left Saint-Denis-sur-Sarthon at the beginning of 1940, to take refuge in the unoccupied zone. From Nice, where he met up with Mme Dufy, from whom he had recently been separated, he returned to Céret in search of a cure for his rheumatic attacks. Immediately after the completion of *La Fée Électricité*, he had begun to feel the first effects of chronic progressive polyarthritis, from which he would suffer until the end of his life. The war years coincided with a worsening of his condition. It was thanks to Dr Pierre Nicolau, who treated him in his clinic 'des Platanes', in Perpignan, that he would recover the use of his limbs. In Dr Nicolau, Dufy found not only a physician but also a considerate friend who helped him with his accommodation and working conditions and gave him affectionate support.[2]

At the beginning of 1941, Raoul Dufy was staying with Dr Nicolau in the Rue Jeanne-d'Arc where, for almost six months, he used the doctor's drawing-room as a studio. He left it for a ground-floor studio on the same street.

Immobilized by his illness, he devoted himself to his painting; he was able to take stock of his experiments and discoveries in order to establish his 'theology'. Although he remained concerned about the tragic events affecting his country and Europe as a whole, whose 'sorrows he suffered inwardly',[3] he did not abandon his art: 'The period of my illness and the cataclysms of the world should not be apparent in my collected work.'[4] The only thing that mattered for Dufy was his painting. On this subject it is worth noting the statements that he made around 1936, on the occasion of a survey on the role of the painter in a society in crisis: 'The influence of social events on inspiration? Nil. Painting is a natural function.'[5] Dufy claimed that in his paintings he granted the same importance to flowers, people and butterflies. 'They are simple events in the great drama of light and colour.'[6] Pushed to the limit by a question about the war, imprisonment and Hitler, he is reported as having answered: 'If I were in prison, well! I would paint as a convict. If I were German and had to to depict Hitler's victory, I would do so in the same way that unbelievers painted religious subjects in the past.'[7] It is certain, however, that these statements do not reflect his political convictions.

We should not forget that as early as 1922, in the travel notebook that he kept in Prague and Vienna, Raoul Dufy wrote down his thoughts on the occasion of a conference on 'the new French taste', held in Prague on 23 November 1922: 'Man is becoming the sole source of the artist's originality, and this originality is no longer at the service of a moral or political idea for the development and perfection of a collective art; it is becoming something specifically human, and presenting itself for the delectation of man; it is no longer at the service of society.'[8] A peaceful man by temperament, essentially preoccupied by the act of painting, he still remained on his guard, feeling concerned when human beings were affected by the violation of certain rights. After all, in 1937, he was the cosignatory, along with Matisse, Lipschitz, Zadkine and Masereel, of Paul Westheim's protest against the Nazi

exhibition of degenerate art.[9] In 1943 he refused the official invitation of the Nazis to visit German museums.

Dufy was certainly a humanist, but his humanism was not militant. He was not concerned with that type of social humanism which seeks to demonstrate that man is only truly fulfilled by transcending himself to find solidarity with the collective will. Rather, his humanism was along the same lines as that of Montaigne or Valéry. 'Man the measure of all things': Raoul Dufy could have made Protagoras' celebrated formulation his own. He resisted all political or progressive mystifications, any call to the support of a 'cause'. He rejected any commitment which led to the transcending of the self, which he saw as mere alienation. Avoiding all excess, he accepted man with all his weaknesses, in which, for him, man's greatness lay, and asked only that man should acknowledge himself as man and enjoy his existence.

Working untiringly, Dufy made many preparatory drawings, watercolours and oil paintings for each of the themes which he painted during this period: it was in this work that he found relief from his physical suffering.

In 1943 he painted *Sunday*, a work of which he was particularly fond. He saw it as symbolizing the whole of his perception of the outside world. It shows a landscape made up of elements drawn from a reality observed in different locations, an imaginary landscape in which the bandstand on the Place de Hyères, transported to a field on the Plateau de Langres, stands next to sheaves of corn beneath a changeable Normandy sky divided between a rainbow and a rain-cloud. This composition was preceded by a large number of studies. A highly detailed drawing, very close to the finished work, shows how much attention he devoted to the structure of the composition and reveals the masterly qualities of his style. The bandstand occupies the centre of the composition, while, gathered around it, walkers and passersby are captured with a nimble line that conveys the essence of their poses and attitudes. A sequence of arabesques and curlicues suggests the presence of strollers listening to the orchestra, standing about on the platform. Dufy's line, highly refined, free of corrections, and sometimes reduced to elliptical signs, uses parallel hatchings to capture the shadowy areas of a building. Conveyed by white spaces in the painted composition, they support the brilliant colour of a patch of wall. The raised horizon which Dufy chose for this composition enabled him to compose a panoramic landscape, painted, in the finished work, according to a trichromatic division which provided the visual organization for the piece. A palette consisting of green, yellow and blue gives the elements of the painting their ambient tonality. From this imaginary landscape, in which he combined his favourite motifs, Dufy creates a joyful rustic poetry.

Raoul Dufy went very often with Dr Nicolau and his family to their property near Perpignan, at Vernet-les-Bains.[10] As evidence of his stays there, brilliant watercolours show the village dominated by the castle tower, while in the distance we can see the outlines of the peak of the Peña and the mountains of the Alzine. In his oil paintings Dufy shows the vegetation surrounding the house. Seen through the windows on the terrace, this landscape enters the interior of the winter garden where Dufy was able to paint at his leisure. He created fine decorative effects from the curved lines of the rattan armchairs in the drawing room, the geometrical design of the earthenware tiles on the floor and the bunches of flowers and leaves decorating the low table.

During this period, Dufy painted a large number of watercolour still lifes with arrangements of flowers in crystal or earthenware vases, in both Vernet and Perpignan, in his studios in the Rue Jeanne-d'Arc and in the Rue de l'Ange. He returned to the floral theme, which he had treated many times in his work for Bianchini-Férier. In these paintings, his brushstroke becomes light and airy in order to capture the simplicity of the wild flowers or the roses with their transparent corollas. He did not apply the paint according to the lines of a drawing that he had already made, but painted directly on to Rives paper with both suppleness and authority.[11] Dufy's love of flowers led him to paint them in a dazzling bouquet, like a firework display, in celebration of *Cortisone*, a cure whose effectiveness he discovered during his stay in the United States in 1951. Just prior to this, Dufy had decorated Colette's *Un Herbier* with delicate watercolours, delighting the author

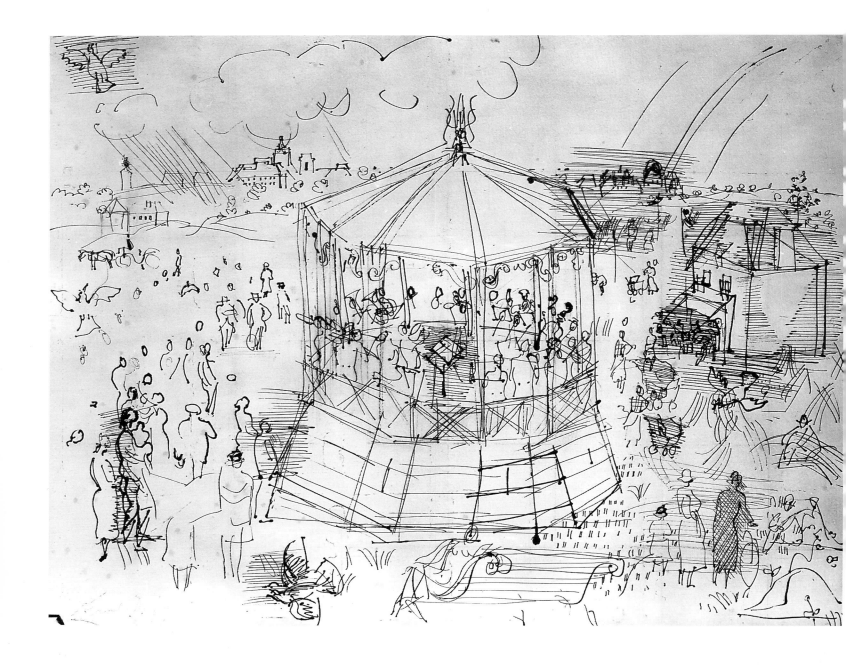

356 Study for *Sunday*. 1943.
Pen and brown ink.

with his illustrations. Right up until his death, Raoul Dufy would paint studies of all kinds of flowers in fine and richly coloured watercolours, their freshness matched only by their brilliance and liveliness. Drawn in a quick sketch, they blossom in space, graceful and fragile.

During the Occupation, paintings on rustic themes, which Dufy had begun to paint in 1924, make their reappearance in the artist's work. *Composition*, also entitled *The Harvest* (Museum of Santa Barbara), is the prelude to the numerous *Harvests* of the thirties: it combines the recurring motifs of the castle keep and the cliff around a bucolic still life. Inspired by the countryside of the Plateau de Langres and the Normandy of Dufy's birth, these big cornfields spread out in waves of trembling stalks stretching into the distance. Their rhythm is stressed by streaks of golden light accentuated to various degrees. Dufy sometimes shows a peasant on his harrow or a little train on the horizon. Although these paintings are homages to Van Gogh – Dufy had always owned an album of facsimiles of his drawings – they do not reveal a tragic metaphysical vision, but are rather a hymn to the nourishing earth, showing a pantheistic joy in painting which Dufy easily succeeds in making us share. Dufy is attuned to nature: he exalts its inner life.

He was to return to this rural source of inspiration during his various stays in the countryside of the South of France. Between 1942 and 1943 Dufy spent time with his friends Roland and Hania Dorgelès at Montsaunès, in Haute-Garonne, a village

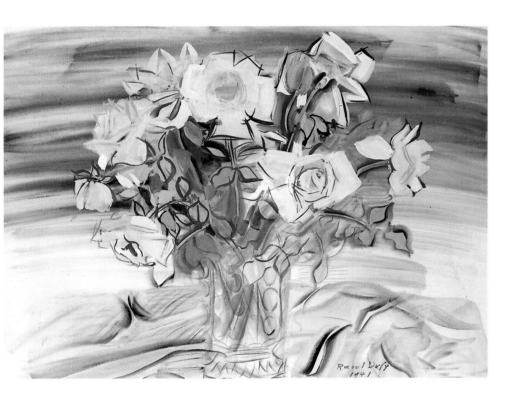

overlooking Salies-du-Salat. He was therefore able to 'install his easel in new locations'.[12]

Watercolours, painted spontaneously from life, commemorate Dufy's stay. The Dorgelès house and the shady corner of the garden where he often relaxed with his hosts and Berthe Reysz are brought to life by his brush, whose agile strokes skim across the white paper and exploit the transparency of the light material and the luminous colours. An atmosphere of peace emanates from these views, which show the poetic arrangement of a little bench, a flower-covered table and humble rattan seats.

The village farms, their farmyards and granaries, became his favourite motifs during this period, and he painted many watercolours on these subjects. Having exhausted the site of Montsaunès itself, Dufy explored the surrounding area in a cart, with all his painting equipment. In the little village of Lestelle, in the depths of the countryside, he made numerous watercolours, sketches and drawings of the area and of the work in the fields. These sketches, with their indications of colour, were the preparation for a whole series of works on rustic themes painted in oil on canvas two years later, in 1945.

The pantheistic feeling of his harvest paintings is absent from his threshing scenes. His peasants do not display the grave and modest simplicity of those of Millet. What Dufy's paintings convey is the joy of man at work. 'I was a travelling

357 *Vase of Roses*. 1941. Watercolour and gouache.

painter type, joining in meals with old and young alike [. . .]. We sampled so many hams and sausages that townspeople have never tasted, and casseroles seasoned with garlic, and cassoulets and cheeses and delicious fruits, eaten amidst the laughter of flirtatious girls and bare-chested boys, at a table laid beneath the granary, as if decorated with the white threads of gold of the straw that hung all around.'[13] It was not his intention to stress the reality of the peasant condition, and his paintings are free of any sentimentality. Here again, what interests him is human activity, the harvester carrying out his tasks with good humour. The combine harvester, which appeared in his country scenes, occupies the foreground in this work. Dufy does not reject the machine: it gives him the chance to create a wonderful portrayal of the golden dust that rises from the threshing. Painting, 'the source of profound joys', is his sole motivation.

He adapted all his visual resources to this theme. The structure of his paintings is dominated by light: the chromatic intensity of the golds of the swaths and the straw, singing in unison with the reds, interrupted by contrasting areas of greens and blues, is tempered by the white shadows which punctuate the composition. Dufy uses short lines and a jerky rhythm to express the dynamism of the scene.

After leaving Montsaunès for Perpignan, Raoul Dufy went to Paris at the end of 1943. Isolated in the oppressive atmosphere of the occupied capital, deprived of the affectionate attention of the Nicolau family and the care lavished on him by his 'guardian angel', Berthe Reysz, who had stayed in Perpignan, he secluded himself in his studio in the Impasse de Guelma and took stock of his entire production: 'I had to examine all my past: I opened boxes and drawers and destroyed everything that struck me as bad; I wanted to erase all trace of my mistakes. I was disgusted by this task, but a little relieved. I was comforted by the appearance of a number of paintings produced by the gentle light of these parts, which look more dense than they did under the light of Roussillon, which lays everything bare.'[14] At the same time, he wrote to Berthe Reysz: 'All I did was to put all my drawings and studies in order, destroying about three hundred bad drawings and watercolours, and there are as many left in the drawers: the good ones, the informative works, and the ones to which I am attached by the memory of my youthful efforts to arrive at my

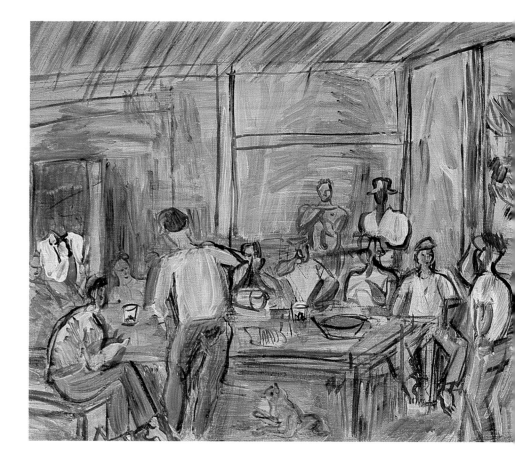

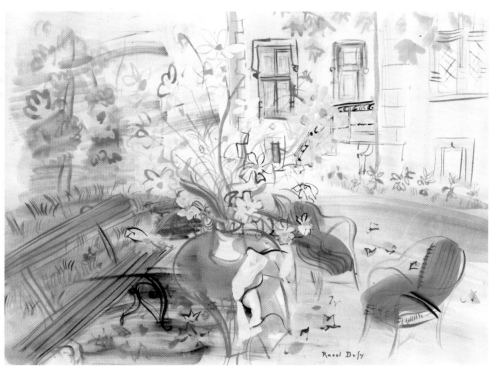

358 *Our House at Montsaunès.* 1943.
Watercolour.

359 *Threshing Scene.* 1945.
Oil on canvas.

present state. Comparing all of that past with my most recent works, I have been able to see that I have gained a great deal in the clarity of my technique and the precision of my ideas. That, then, is the fruit of these last three years.'[15]

This stay in Paris was a trial for Dufy; his repeated rheumatic attacks obliged him to take a prolonged thermal cure at Aspet, in Roussillon. Dufy still did not abandon his painting. He preserved his good humour and remained hopeful of perfecting his work, a hope that is echoed in his letters to Louis Carré, his new dealer from 1941 onwards.

Illuminating this dark period, the theme of music reappears in Raoul Dufy's work, punctuated by the numerous versions of *Orchestras*. His passion for music encouraged early on by the musical atmosphere of his childhood, helped him to preserve his *joie de vivre*.

His first treatment of this theme was in his 1902 painting, *The Orchestra of Le Havre*. He pursued the subject in Cubist-inspired works dedicated to Mozart. Around 1925–27, *The Orchestra at Arles*, shown in the open air in the little square bathed in green, illustrates the constancy of the theme in his work.

Dufy regularly attended the rehearsals of the Société du Conservatoire des Concerts Colonne and was able to exercise his gifts of observation, sitting above the musicians' desks, next to the famous drummer Passerone. Noting the posture of an

360 Handwritten inscription on the back of the watercolour *Orchestra with Pianist*. 1941.

arm or a foot, the inclination of a head, the position of a bow, the detail of a string or wind instrument, he accumulated innumerable sketches of musicians and instruments, which he was to use during the forties in the composition of his series of *Orchestras*.

His first ensemble studies, preludes to the large concerts that he painted in his maturity, appeared around 1930. His drawings of orchestras, showing a full complement of musicians in action, create a musical rhythm. The instruments appear in simplified forms, as arabesques set into a network of hatched lines; with a few notations he indicates the essential details suggesting the mass of an instrument. He thus establishes graphic harmonies or contrasts providing a vibration, a dynamism for the ensemble. These compositions encourage a certain play of black and white which leads to a harmonious distribution of light. They resonate in unison with Dufy's musical sensibility. In some cases his evocations of

361 *Orchestra.* 1941.
Black lead.

362 *Orchestra with Singer.* 1942.
Oil on canvas.

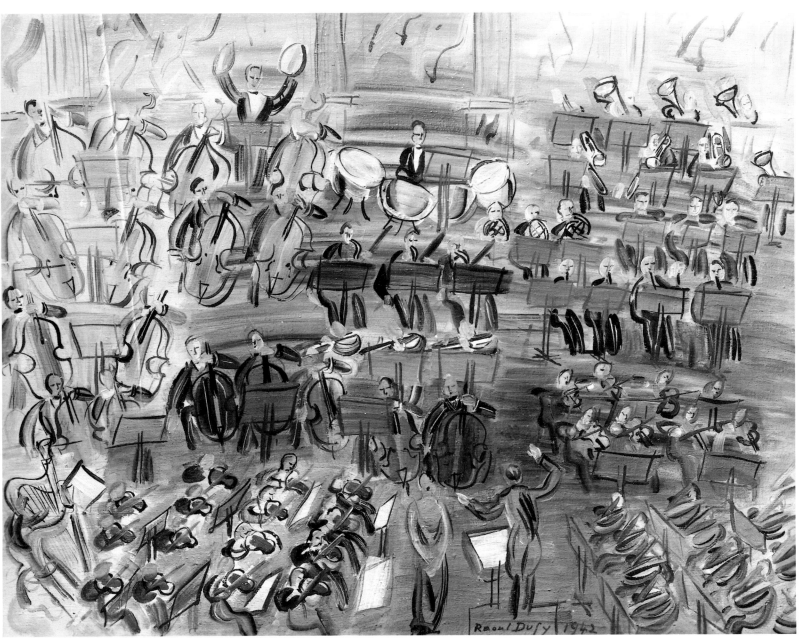

363 Study for violinist. Around 1946.
Pen and black lead.

orchestras are simplified to the point where they suggest a musical score with staves, with violins and cellos, flutes and oboes attached to them like musical notes.

Dufy's first symphony orchestra rang out its fanfare in 1937, in *La Fée Électricité*. In 1941 he began his series of paintings of orchestras. He painted symphonies, violin concertos, piano concertos, orchestras and choirs, orchestras with solo singers. Dufy's efforts were concentrated on finding a visual equivalent to musical sonorities. These compositions are the synthesis of his many views of orchestras. They seek to visualize the concerto or symphony that is being played.

Dufy felt the need to bring painting and music together. His passion for music, combined with his painterly sensibility, led him to emphasize and experiment with the interrelationships between these two artforms. He listened out for chromatic sonorities, and, in painting an orchestra, he tried to retranscribe music into an analogy of colours and lines, to base his pictorial composition on those relations. The entire orchestra is bathed in 'couleur-lumière'; the individual sonorities of the musicians and instruments resonate within the composition.[16]

The clash of the cymbals is expressed in yellow. A rapid movement in the score is conveyed, in the painting, by intense green. The white of the music-stands and the scores plays the part of rests in the musical score. A harmonic relation is established in the construction of the painting: it reveals similar cadences and similar melodic phrases, so much so that Dufy's friend Pablo Casals[17] told him: 'I cannot tell what piece your orchestra is playing, but I know which key it is written in.'

292

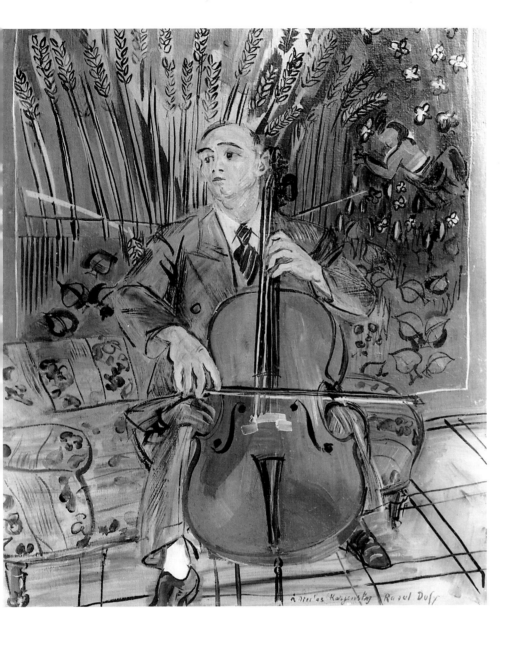

364 *Nicolas Karjinsky.* 1942.
Oil on canvas.

365 Study of a cello. Around 1946.
Pen and black lead.

Raoul Dufy met Casals at the home of the Nicolaus. Fleeing Franco's Spain, the
famous cellist had taken refuge in Roussillon, in Prades, not far from Perpignan.[18]
In his works in oil or watercolour, the painter vividly evoked the musical
gatherings at the home of his hosts, at which Yvonne Lefébure accompanied Casals
at the piano in the performance of a Beethoven sonata. Dufy particularly enjoyed
the times when his great pianist friend played works by Mozart and Debussy.

Dufy painted a highly affecting portrait of Nicolas Karjinsky, a regular visitor to
the area. The cellist is posed in the studio in the Rue Jeanne-d'Arc: he is seated on a
méridienne, standing out against the decoration of the *Collioure* tapestry. The
painter has captured the movement of his hands guiding his bow and pressing the
strings, while the musician turns his head away from the viewer, the better to hear
the sounds of the instrument propped up in front of him.

Dufy made numerous individual studies of the cello, of which the drawing of
around 1946 in the Musée Hyacinthe-Rigaud is particularly striking. He let his pen
linger over the detail of the neck of the instrument, relishing the opposing
arabesques of the instrument's curves. Two pencil studies of violinists[19] and violins,
with sensitive corrections to the line, stress the authority of a style of drawing that
is based on the precision of a detail of the instrument or on the examination of the
posture of the instrumentalist.

Dufy showed his interest in music and musicians again around 1946, during the
Carnival at Perpignan, where, under the green palm-trees and around the golden

366 *The Sardane*. Around 1946.
Black lead.

mimosas of the Place Arago, the spectacle of the *Sardane* was played out to the sound of the 'cobla'. Dufy was seduced by this Catalan dance 'of unity, love, freedom and peace',[20] which he was able to admire from the windows of his new studio in the Rue de l'Ange.[21] In this dance, Dufy found an echo of his own gaiety and *joie de vivre*,[22] his sense of universal tenderness. He recreated the grace of the dance in numerous drawings and sketches. His lines, light, nimble and reduced to their basic essentials to express the airy appearance and nobility of this dance, capture the rhythms of the steps of the dancers: a vertical, swift, joyful rhythm; a slow rhythm, swaying to the left and the right, lending itself to meditation and reflection. Their arms raised, their hands joined into a garland on either side, they form concentric circles, which constantly open and broaden as new participants join, without regard for age or class.

Dufy found the popular orchestra of the 'cobla' as fascinating as any symphony orchestra. In his view there was nothing folkloric about the *Sardane*: 'It's as beautiful as Bach,' he used to say. Casals, who had himself composed a large number of *Sardanes*, also stressed that 'the *Sardane* contains the nature of the symphony'. The musicians and their instruments seized the painter's attention, as we can see from certain drawings concentrating particularly on them. They bear handwritten notes specifying the name of the instrument: 'fiscorn, tenor, prima'.[23]

Throughout this decade, which was marked by illness, Raoul Dufy showed a constant interest in music and its expression in painting. This period saw the apotheosis of his homages to the great composers. Some *Homages to Mozart* (Musée d'Art Moderne de la Ville de Paris, around 1945 and 1949) are distinguished by the presence of a bust of the composer on a keyboard instrument, next to a violin and a score, or by a view of Mozart's birthplace accompanied by the score of a symphony, and are painted in a varied range of colours. But the essence of these 'homages' lies in a restricted chromaticism. The last years of Dufy's career were characterized by his progressive abandonment of complementary and contrasting colours. This was when Dufy was establishing his 'theology'; he wanted to 'wring painting's neck', and his works from now on would tend towards the monochromatic, sometimes interrupted by a very few tones, a 'tonal painting'.

367 *Homage to Claude Debussy*. 1952.
Oil on canvas.

368 *Homage to Bach*. Around 1950.
Pen and ink.

The *Homage to Bach* (1952) reveals an intense modulation of reds centred around a violin highlighted by a dazzling patch of white. In both technique and composition it shows certain similarities with the contemporary *Homage to Claude Debussy* (Musée des Beaux-Arts, Nice; Musée des Beaux-Arts, Le Havre), and *Homage to Mozart* (New York, Private Collection).[24]

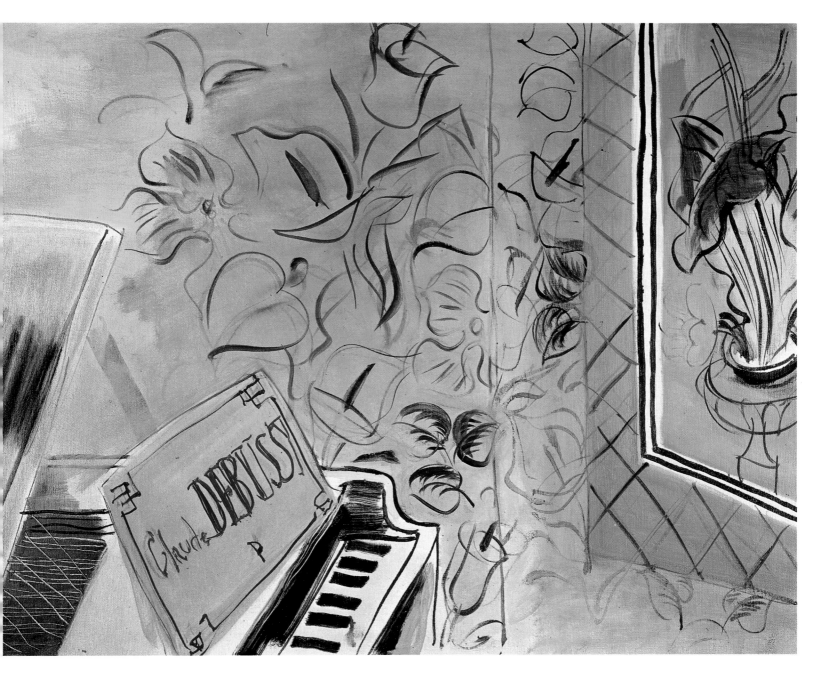

369 Raoul Dufy and André Robert around 1950.

370 *Still Life with Violin*. 1952.
Oil on canvas.

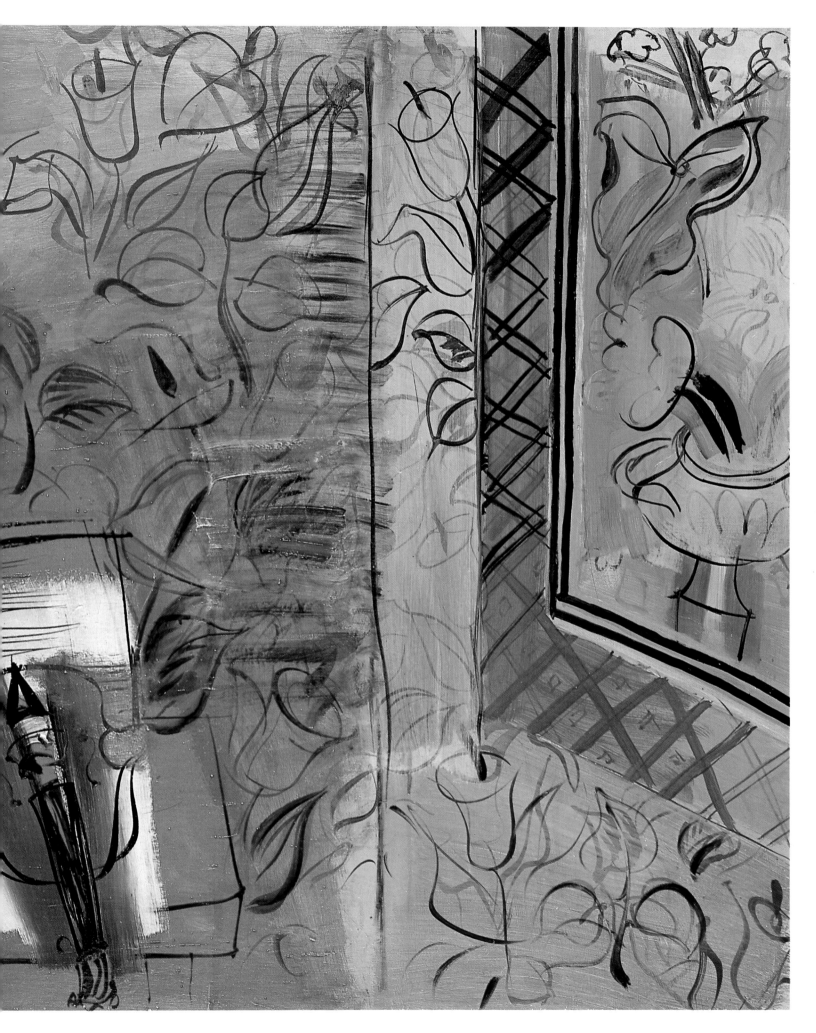

In one of his *Homages to Bach*, vigorously drawn in pen, colour plays no part. A violin, the artist's palette and a shell combine their own swirling music with the tubular accents of a flute and a trumpet, in celebration of the Master. A triumphal arch and a figure of 'Fame' float in unison over the musical still life; an unexpected sailboat bears the composer's glory into the distance.

The violin, which occupied a prominent place in Dufy's work during these last years, assumes various tonalities in the different versions of his homages to Bach and Mozart. In the *Pink Violin* (Eindhoven Museum, 1948), the *Red Violin* (Musée d'Art et d'Histoire, Geneva, 1948; Musée des Beaux-Arts, Le Havre), or the *Blue Violin* (Bergman-Jerusalem Collection, around 1950), the extremely sparse composition is given a quite particular monumentality and resonance. Chromatic concentration along with simplification of design produce a tension and a power to match Dufy's love of music and joy in painting.

In certain works the white notation of a score (*The Little Mozart*, 1949) with musical staves (*Violin and Red Orchestra*, 1946; *Red Violin*, Musée National d'Art Moderne, 1948) heightens the intensity of the colour.

His orchestral paintings after 1944 reflect a feeling of completeness and a radiant serenity, as if the inspiration of the music brought him an inner fulfilment which his physical suffering could not mar. *Mozart Concerto* (Haatgalerie, Stuttgart, 1948) shows that music is still the sole subject of his painting. The musicians of the symphony orchestra, gathered together aound a Mozart score, contribute to the aesthetic delights of this concert with the patterns of their bows, the melodious arabesques of their instruments and the harmony of their movements: the rhythm that Dufy gives to his work echoes Mozart's musical phrasing. *The Grand Concert* (1948) is another example of a work in which he transposes his painting into pure musicality.

Dufy reproduces the calm atmosphere of chamber music with consummate artistry. His series of *Quintets* (between 1946 and 1948) assumes the colour of each of the musical variations. Violet, red, blue, orange: the arrangement of the quintet is painted monotonally. Dufy understands music so well that he succeeds, through the subtle play of his style, colour and lighting effects, in arousing our emotion through his lyrical interpretation.

Another example of a great economy of means, *The Yellow Console* (1947) illustrates Dufy's ability to give a musical rhythm to any object. This Louis-Quinze console, placed between two windows, appears in many of the views of his new

371 *The Yellow Console with Two Windows.*
1948.
Oil on canvas.

372 *The Quintet.* 1948.
Oil on canvas.

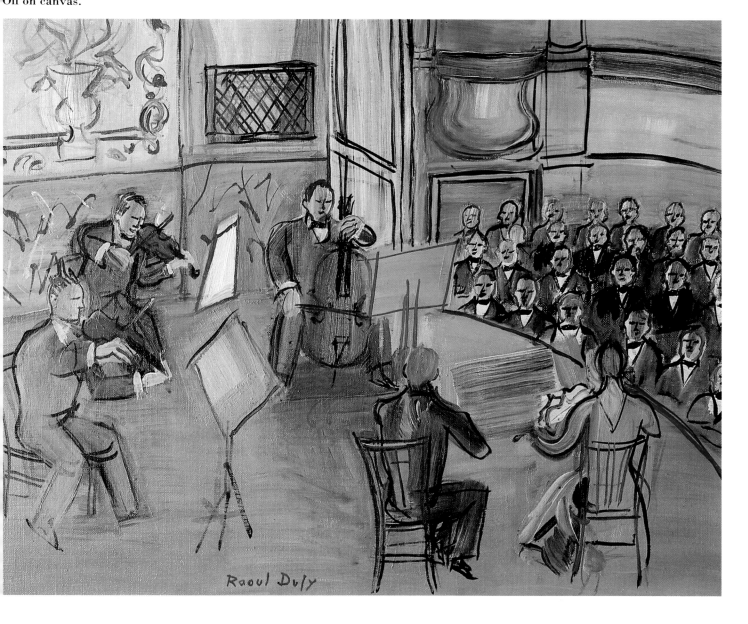

373 Raoul Dufy in his Forcalquier studio in 1952.

374 *The Grand Concert.* 1948. Oil on canvas.

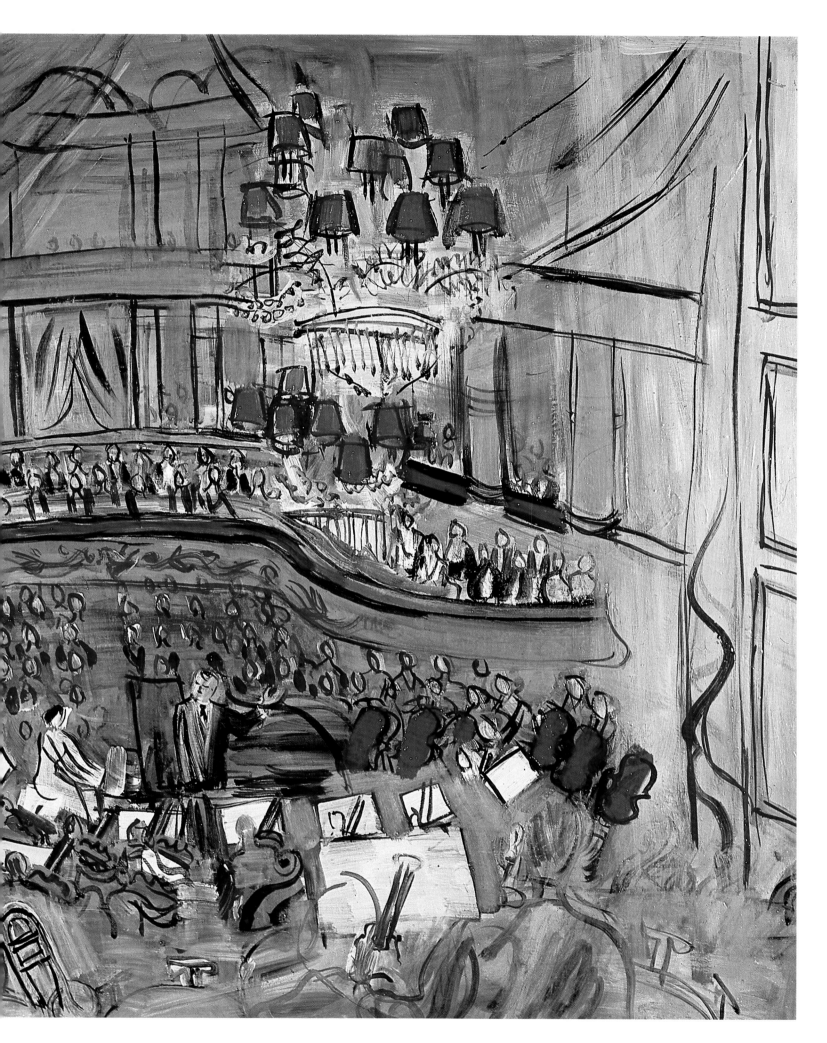

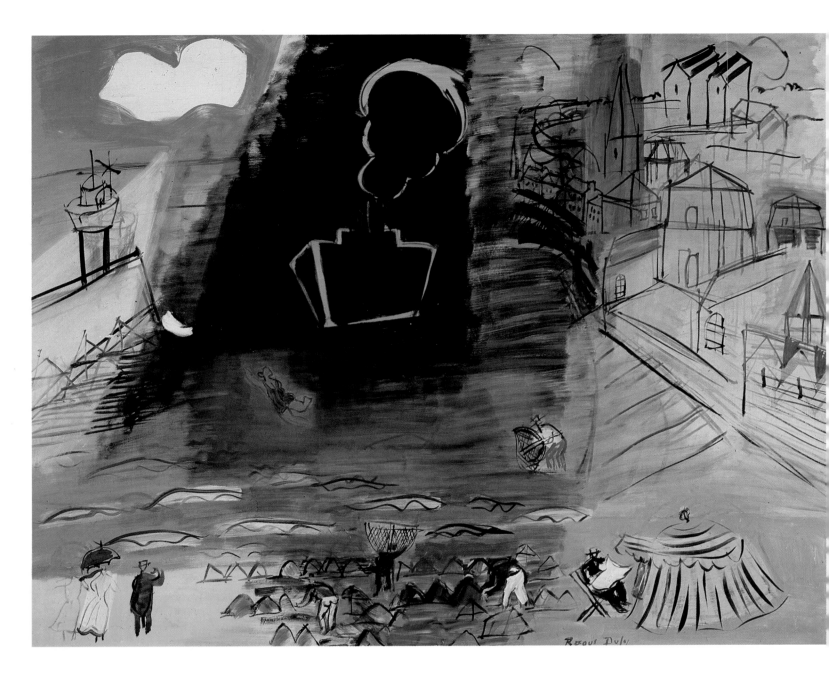

studio overlooking the Place Arago, from 1946 onwards. He bathes it in a sumptuous yellow and exploits to the full the cadenced pattern of its curves and swirls.

During this period, between 1946 and 1953, the theme of the black freighter, a motif which had appeared in his paintings from 1925 (*Bathers in the Open Sea and Scallop-Shells*, Musée National d'Art Moderne) developed into a whole series. Haloed in white (*Black Freighter II*, 1948) or green (*Black Freighter*, Musée de Lyon, 1952), the vessel moves in the Bay of Sainte-Adresse, to the centre of a patch of the very deepest black which, for Dufy, expresses the dazzle of a sun at its zenith. The black conveys absolute colour, so incandescent that it seems to have burned the very canvas. 'A pretext for [his] new experiments in painting',[25] the black ship, with its ghostly appearance, seems to suggest the intimation of death, which was to come shortly afterwards, in 1953. And when, in 1949, he painted his bullfighting scenes in Toledo, Dufy would evoke the silhouette of the bull, in the centre of the arena, soaked in a burning, dazzling light, its black mass, haloed in white, symbolizing the idea of the death to which it is condemned.

During this period, Raoul Dufy was only able to continue his work in painting because of his treatment by Dr Nicolau and regular cures in the thermal baths of the region: Thuées, Font-Romeu, Amélie-les-Bains. Far from Perpignan, he stayed in the region of Rozès, near Saint-Lizier, in the Ariège.[26] He also returned to his

302

work as an illustrator in 1946, at the request of Dr Roudinesco, who suggested that he illustrate Virgil's *Bucolics*, translated by Paul Valéry. An unpublished correspondence reveals their disagreements. In opposition to the unanimous opinion of Roudinesco, his circle of bibliophiles and Mme Paul Valéry, who had been pleased with a first effort made up of colour engravings,[27] Dufy chose to illustrate the Virgil in black and white alone: 'The case of Virgil and Valéry is not the same as that of Daudet.[28] While Daudet can stand to a certain extent the triviality of colour, the work of Virgil and Valéry is too noble and too beautiful to put up with such an insult. This is what I feel as a man of taste.'[29] To convince his clients, he decided to return to colour illustration painted in watercolours, 'with all the lightness and elegance of the Virgil and Valéry text',[30] in order to compare them with his black-and-white drawings.[31] Convinced that his 'new colour pictures are pretty, but [his] drawings in black are beautiful',[32] Dufy persisted in his initial decision.[33] He had thought that by using black on white paper, he would be able to find a more suitable equivalent to the greatness and power of Virgil's poetry. This determination led to tensions which left the project uncompleted.[34] All that remains of it are all the pencil drawings made on a copy of the book and some watercolours which have never been published.

Dufy's illustrations reveal his qualities as a draughtsman. In these works he demonstrates his sense of foreshortening, his skilful use of the simplified line with

377 *Le Rond-Point de la Vierge*, illustration for *Les Bucoliques*. 1946.
Watercolour.

Opposite:
375 *Black Freighter*. 1952.
Oil on canvas.

376 Raoul Dufy in his Perpignan studio in 1946.

303

which he defines his figures, the essence of their gestures, attitudes and faces. Scene of country life and agricultural work, farmgirls busy gathering and tying sheaves o corn, a ploughman at work: Dufy depicts them in spare little pictures brought t life with a great economy of means, within a simplified rustic framework. Hi profound attachment to nature finds an echo in the bucolic evocations of th Mantuan poet, as well as in the melodious and aesthetic qualities of his poetry. 'Th whole of Virgil's poetic career', wrote Paul Valéry, 'amounts to the most gracefu expansion of the Latin language and its musical and visual resources.'[35]

In the majority of his illustrations, Dufy repeated certain themes which he had treated in his paintings during this decade. This is true of the *Fine Summer*, th subject of a large number of watercolour paintings used in the preparation for a tapestry woven by Tabard, in Aubusson, for Louis Carré in 1941. Another exampl is the *Orchestra in the Country*, very close to the painting in the Musée Hyacinthe Rigaud, Perpignan, which reveals the painter's sensitivity to the musicality o Virgil's pastoral poetry. We should note that the same scene appears in one of th illustrations for *La Source des jours* by Gaston Massat (1948). Certain of th paintings evoke the landscapes of the South of France, such as the coasts of Vence the chapel of Vallauris with its terrace and arches and the views of Golfe-Juan captured in a panoramic vision: 'All the landscapes and scenes that I have chose are Mediterranean.'[36]

Other drawings for the *Bucolics* are taken from the studies and sketches that he had made in Sicily; an example of this is a landscape of Catane which decorates th fourth Bucolic: 'In a book of sketches of Sicily I found a landscape of the Catan countryside: it shows a crossroads, a kind of shepherds' meeting-place, with a big picture of the Madonna at the end of a wall.'[37] From this sketch, Dufy made a sequence of five studies, in which he seeks to arrange the shepherds and thei animals in a precise setting which would give a rhythm to this little composition.

It might seem paradoxical that Dufy, the great poet of colour, should have chosen to abandon it in favour of black and white. This decision testifies both to his honesty and to his concern for the well-made work. Some of the scenes which he als painted in full colour, in watercolour, and which have been brought to ou attention, show a delicacy in their use of colour and a *fa presto* in their style, which Dufy correctly judged to be ill-suited to convey the greatness of Virgil's poetry.

But he turned to the watercolour between 1949 and 1950 in his illustrations fo Gide's *Les Nourritures terrestres*.[38] The dialogue between Gide's poetic writing which combines sound and meaning, and the painter's image, which provides a very general reading and which has the function of capturing the 'colour' of th passage, makes this work a success in the field of illustration.

In September 1948, Raoul Dufy went to Spain. Stopping in Barcelona, he wa delighted to meet up with his friend Llorens Artigas and his circle of Spanish artists

379 Illustration for *Les Nourritures terrestres*.
1950.
Watercolour.

378 *Musicians in the Countryside*. 1948–49.
Oil on card.

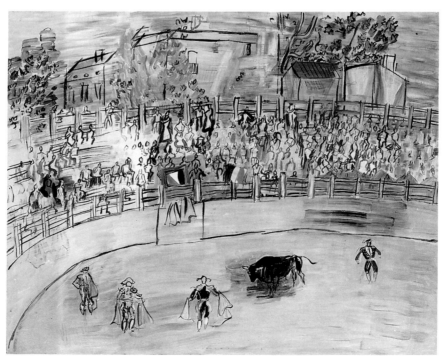

He visited Caldas de Montbuy to undergo treatment to ease his rheumatic pains. He returned there in July 1949 and made a trip to Toledo. The corridas attracted him more than those of Céret and Collioure which he had seen in 1944 and 1946, and which he saw as a 'masquerade'.[39]

Dufy did little work during his stay in Spain: his return to his cure brought about a violent attack of rheumatism which forced him to take complete rest: 'I am laid out by the heat and the pain.'[40] On his return to Roussillon, his health became worse, despite the colloidal gold treatment which he was undergoing once more. In December 1949 he decided to leave Perpignan and France for the United States, at the invitation of Dr Homburger of the Jewish Memorial Hospital, Boston, who suggested a course of cortisone treatment.

Before he left, Dufy returned to his studio in the Impasse de Guelma for a time; he had to use crutches to walk. Here he was able to analyze his painted work. He classified the works which had remained in Paris and those which he had brought back from the South of France, with a view to his retrospective at the Palais de Tokyo: 'This task was, as you can imagine, fairly moving and comforting, allowing me to reexperience my past and to understand the order and method that I have put into my life and my work [. . .], which helps me a great deal in the organization of my exhibition.'[41]

On 10 April 1950, Dufy went to Le Havre where, despite his pain, he attended a memorial service for his old friend Othon Friesz, who had died the previous year. On 11 April he embarked for the United States on the ship *De Grasse*, 'ad cortisam'.[42]

The treatment in Boston improved his condition: 'I can walk for ten minutes without a cane or crutches, my articulations are fairly free, but it is extremely difficult to recover from muscular atrophy.'[43] He gradually recovered and returned to his work. Sitting in his wheelchair he was able to enjoy the spectacle of Boston harbour, which inspired him to paint many light and airy watercolours.

Soon he was well enough to leave Boston for New York, where he stayed for a while with his friends Louis and Charlotte Bergman before going to Arizona. Dufy had been to the United States once before, in 1937, when he was nominated as a member of the jury of the Carnegie Foundation's annual exhibition. That journey had inspired watercolours of the port of New York and the Manhattan skyscrapers overlooking the Hudson, with boats and steam freighters sailing about. Now, once again, the city and the port of New York and Brooklyn Bridge stimulated numerous light watercolours with monotonal modulations (*The Port of New York with a Red Sun*, Musée Cantini, Marseilles). In the United States Dufy was happy to meet up with Maroger, 'who had pursued all his experiments which had led to the production of a truly magnificent medium with which I worked the very afternoon of my arrival in New York'.[44] At the request of Gilbert Miller, he made the watercolour designs for Jean Anouilh's play, *Ring Round the Moon*, which Miller was to stage in New York.[45]

During this stay, Dufy repeated some of his old themes from memory – scenes of orchestras, a view of Sainte-Adresse in which the centre is filled with a large green patch like the black area of his freighters. At the same time, between October and November 1950, Louis Carré organized a group exhibition in his New York gallery at 712 Fifth Avenue, in which a *Threshing* and a view of *Langres* were hung alongside seven works by Fernand Léger and four by Jacques Villon. Shortly after this, in January-February 1951, he devoted a solo exhibition to Dufy, from which the proceeds were to be donated to the Arthritis and Rheumatism Foundation, as a gesture of Dufy's gratitude. The exhibition included twenty-four watercolours of New York and Boston, the designs which Dufy had made for Miller, and five portraits.[46]

In February 1951, Dufy left New York for Tucson, Arizona, a city which had been recommended to him for its dry climate.[47] He worked on paintings and watercolours which were thematically akin to his previous compositions. The spectacle of 'marching musicians, a new element in [his] musical paintings'[48] gave rise to a series of *Mexican Orchestras*, lent a rhythm by means of coloured accents and a simplified and dynamic calligraphy. His taste for the festive led him to share enthusiastically in the popular jubilation which he evoked with an agile and playful

380 *The Arenas at Toledo*. 1949. Watercolour.

381 *Bullfight*. Around 1944. Oil on canvas.

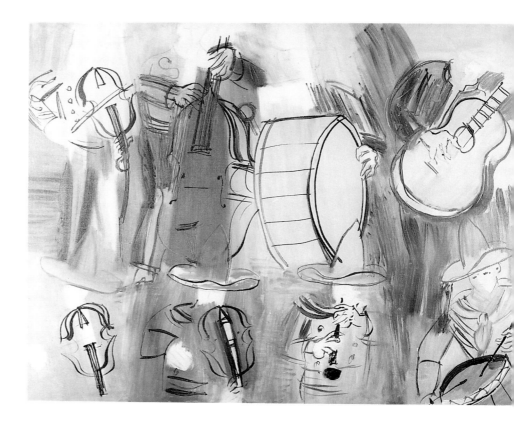

382 *Mexican Musicians.* 1951.
Oil on canvas.

line in *Parade in Tucson*. The *Rodeo in Tucson* also provoked his curiosity, reawakening his love of horses and racing.

On 26 July 1951, Raoul Dufy returned to Paris. In his studio in the Impasse de Guelma he returned to several of his major compositions – studio views, orchestras – seeing the need to bring the whole of his work into focus for the major retrospective organized for him by his friend Pierre Courthion at the Musée d'Art et d'Histoire, Geneva, and for the Venice Biennale, where forty-one of his works would be shown in a hall specially set aside at the French Pavilion.

The moment of his artistic consecration had arrived. In June 1952, President Delessert opened the Geneva exhibition, which was enthusiastically received. Congratulatory telegrams poured into Venice from all parts of the world, to the Palazzo Gritti where Dufy was staying, having come to accept the Biennale's *grand prix* for international painting,[49] outmatching Fernand Léger, who was to win it the following year.

In July Dufy returned to Paris, his portfolios filled with watercolours painted from his balcony overlooking the Grand Canal, works made with an extreme freedom in both their execution and their interpretation, and with an exquisite freshness.

He was pleased with his two recent exhibitions, 'since', as he wrote to Ludovic Massé, 'I have made the acquaintance of a Dufy whom I did not know. Now I have made the closest acquaintance of myself, and am the more peaceful for it.'[50] He had just retired, in September 1952, to Forcalquier, recommended by the Météorologie Nationale for having the driest climate in France. Here he set up 'Le Mas Chanu', a comfortable house with a lift to take him from his bedroom to his studio.[51] In this house he continued to develop his themes of the red violin and the freighter:

The orchestras are more sonorous, more grand; as for the threshings, they are tending to become mythological manifestations – and capitalist manifestations too, since my last painting – painted on a '100'-size canvas – is called *Ceres at the Landlord's*. I also told you that I have returned to watercolours and little paintings of the Perpignan studio, with the yellow console and the red [illegible] and have reached, with these subjects, a very precise synthesis of the character of the light in Perpignan. So much so that this interior that you knew in the Place Arago contains all of Roussillon for me, with its mountains, its vineyards and rocks, and all the work that I have done in Perpignan has given me the same revelation that Matisse had in Collioure.[52]

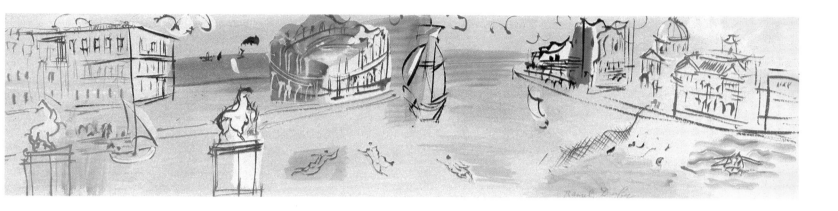

Dufy was not to remain in Forcalquier for long. He died on the morning of 25 March 1953, at five o'clock, from a pulmonary congestion. In the end he had not been able to enjoy the Parisian consecration for which he had waited so long: the grand retrospective, organized by Jean Cassou and Bernard Dorival in the Musée National d'Art Moderne – for which he himself had designed the plan for the hanging of his works – took place several months later, in June 1953.

After Dufy's death, art historians and art critics were unanimous in their homage to the many different facets of his artistic creation. As the years passed, however, all that was to remain was the image of Raoul Dufy, the painter of society parties. The time has come to acknowledge the universal character of his work and its eminent place in the history of art, as anticipated by Charles Lapicque in the speech that he delivered at the Union des Arts Plastiques on 14 June 1953: 'Of the man whose memory we are honouring today [. . .] I retain the image of a wonderful, fine, generous and authentic man, an essentially civilized man, cultivated in the strongest sense of the word, with a culture so profound that it sheltered him from the resentments and ruptures which threaten everyone in our time [. . .]. His work is eminently contemporary [. . .], his message very much of our time [. . .]. Dufy's career was so long and fruitful; it goes beyond our past, fulfils our present and launches us into the future.'[53]

383 *Imaginary View of Venice*. Around 1950. Watercolour.

384 Raoul Dufy on his terrace at Forcalquier, shortly before his death.

NOTES

CHAPTER I

1 Private collection.

2 Pierre Courthion, *Raoul Dufy*, Geneva, Cailler, 1951.

3 Salacrou describes this period of his youth in Le Havre as follows:
'The memory of Raoul Dufy is bound up with childhood and my youth. For years his brother Léon tried to teach me piano and harmony: without knowing it, it was Raoul who introduced me to painting. From the age of eight, every week in a little waiting room, I saw all the paintings that Raoul Dufy had made throughout the week. All the joys that the love of painting has brought me I owe to Raoul Dufy.' In *Beaux-Arts*, 27 March – 2 April 1953, p. 7. It was at Salacrou's request that Raoul Dufy would paint the sets for his play, *Les Fiancés du Havre*, in 1944.

4 Raoul Dufy had five sisters and three brothers.

5 Dated 1903–08, Musée des Beaux-Arts, Bordeaux.

6 *See The Abandoned Garden* (1913) and *Garden and House at Le Havre* (1915), both in the Musée d'Art Moderne de la Ville de Paris.

7 'I love you, my darling parents, I love you. I remember all your care, your attention and tenderness, I think about it every day, wondering what I could give you as an expression of my gratitude. But I have nothing to give you as a New Year's gift, not even my heart: as you know, it has long belonged to you, my beloved Parents.'

8 This deep affection is strongly present in a letter to his friend Ludovic Massé, filled with eloquent emotion: 'I was very moved when I read your letter. Believe me when I say that I understand and share your suffering, for when I lost my mother I felt the same grief, I felt abandoned, I was inconsolable. Even today the memory of that separation brings back my suffering.' Unpublished letter, 25 February 1951, Tucson, Arizona.

9 In the treatment of this theme, to which he returned in 1902, Dufy concentrated on the orchestra pit, and the page-setting shows that he has followed the example of Degas. This orchestra is depicted again in another unpublished drawing from 1950, with the same violinist in the foreground.

10 Raoul Ernest Joseph Dufy was born in Le Havre on 3 June 1877, at 7 a.m., at 46, Rue des Pincettes.

11 'I had been taught languages; that was how I knew enough German to be able to read books on economic subjects,' Courthion (note 2), p. 53.

12 As Gabriel Reuillard observes, 'The very names of these quays and docks conjure up dreams of journeys to far-off places; Quai de Hambourg, Quai de Southampton, Quai de New York, Quai de Nouméa, Quai de Rotterdam, Quai du Brésil', *Grasse Normandie*, ed. André Delpeuch, 1926.

13 *Éloge de Raoul Dufy*, Paris, Manuel Bruker 1931, p. 1.

14 'You are in a beautiful city. You've got the Delacroix and all the rest,' Othon Friesz wrote to him from Paris (unpublished letter).

15 Dufy divided his periods of leave between Le Havre and Paris, where he met up with Friesz. 'We have developed a real need to see one another often, and I am waiting for it to become a daily event. You are the only friend I have towards whom I have feelings like these,' his 'best friend' wrote to him, lamenting the intervals between these visits, which were often subsequently delayed by military skirmishes (unpublished letter).

16 It seems, nevertheless, that he was not impressed by the major Van Gogh retrospective organized by the Galerie Bernheim-Jeune. We might even wonder whether he actually visited the exhibition. It was only a few years later that his work would reflect an interest in Van Gogh's art.

17 'In Paris, when I was with Bonnat, I did not dare go to the Louvre. All that frightened me. I felt a grandeur there, but one which remained strange to me. I felt more relaxed at Durand-Ruel, in front of the Pissarros and the Monets,' Courthion (note 2), p. 55.

18 'Neither of us took much pleasure in the exams we had to do at school. Nevertheless, we stayed there for a few years enjoying varying fortunes, without a lot of scholarly success, but with – as we learned later on – the respect of the headmaster,' Courthion (note 2), p. 55.

In *Une Vie de travers* (Lyons, 1982, p. 150), Marcelle Berr de Turique tells us of Dufy's memories of the Bonnat studio: 'Everyone worked for himself and no one ever publicly admitted the secret of his aspirations. A strong sense of camaraderie in our studio life generally kept our concerns and ideas out of our conversations and out of our faces. Despite this reserve, they sometimes showed through. On rowdier days arguments would erupt about matters which proved delicate as far as our camaraderie was concerned, and we insulted each other about Renoir or Bouguereau. It was unusual for us to discuss painting.'

19 'I think you will end up being a good draughtsman.'

20 Towards the end of his life he said to Pierre Courthion, who was surprised to see him painting with his left hand: 'I've always done that. It's my painter's hand,' adding that his first drawings were done with his left hand. Courthion (note 2), p. 60.

21 Friesz passed the studio on to him in 1901 when he moved to the Place Dauphine.

22 Roland Dorgelès, *Portraits sans retouches*, Paris, Albin Michel, 1952.

23 Extract from an unpublished letter from Friesz to Raoul Dufy.

24 Berthe Weill had a great flair for spotting the young unknown artists who were to constitute the avant-garde in modern painting – Picasso, whom she supported from 1900, the Fauves, then Metzinger, La Fresnaye, Gromaire, Lhote, Dunoyer de Segonzac and Bissière; they all left her once they won recognition. Scrupulously honest, she never became rich and died in 1951.

25 One of the eight works on show was bought by Maurice Denis, and Dufy remained grateful to him throughout his life.

26 Marcel Giry, *Le Fauvisme*, Neuchâtel, Ides et Calendes, 1981.

27 Courthion (note 2), p. 66.

28 *Carnet* No.23, page 13 (No. A.M. 36–66–D, Musée National d'Art Moderne).

29 *Ibid.*

30 Courthion (note 2), p. 66.

31 This manuscript is in a private collection. In the margin it includes a fairly detailed sketch of the 1927 portrait of Mme Wakefield-Mori, and may be dated from the same year.

32 Described by Berthe Weill (*Pan dans l'oeil, ou Trente ans dans les coulisses de la peinture contemporaine, 1900–1930*, Paris, 1933, p. 119) with reference to a group exhibition that she organized in November 1905: 'As Dufy had told me of his wish to be a part of this group, I agreed and informed Matisse who cried, in a state of rage: "Oh no! That little chap wants to mingle with us, and we won't have it! Put him in the other room, if you like." Our cherished hope was not to be. So Dufy was part of the group and not part of it at the same time; he had his own solo show in the other space.'

33 This version was probably painted first, according to Bernard Dorival in 'Les *Affiches à Trouville* de Raoul Dufy', *Revue des arts*, No. 5, September October 1957, pp. 225–28.

34 It is interesting to note the original use of this theme. Certainly the Nabis, Bonnard and Toulouse Lautrec made posters; Dufy would only come to it late in his career. But along with Marquet he was the first to put them into one of his paintings. We might say that in this he showed himself to be a 'painter of modernity' in the Baudelairian sense of the term and – why not? – a precursor of the hyperrealists.

35 Before Dufy and Marquet, this theme of the National Holiday had inspired a number of great painters in the second half of the 19th century. We should remember Monet's *National Holiday on Rue Montorgueil* (1878), with flags waving in a multitude of vibrant colours. The same year saw the painting of *The Rue Mosnier Decked with Flags*, by Monet which shows certain visual similarities with Dufy's painting. In 1887 the theme was taken up by Van Gogh, who slashed his canvas with long red and blue clashing strokes, which expressed his internal turmoil.

36 Giry (note 26), p. 182.

37 This could lead us to date it around 1907, despite its very free style and its similarity with a *Street in Le Havre*, painted in 1906.

38 Courthion (note 2), p. 68.

39 Raoul Dufy (Le Havre 1877 – Forcalquier 1953) and Georges Braque (Argenteuil-sur-Seine 1882 – Paris 1963) knew each other from childhood in Le Havre. Both pupils of Charles Lhuillier at the Ecole Municipale des Beaux-Arts, they came to Paris in 1900. They were converted to Fauvism after the 1905 Salon des Indépendants and both acknowledged their debt to Matisse. With Othon Friesz, also from Le Havre, they were among the founder members of Le Havre's Cercle de l'Art Moderne. Dufy and Braque would both follow Cézanne during the summer of 1908, painting landscapes in l'Estaque based on the aesthetic of the master of Aix.

40 The Musée National d'Art Moderne has a sketch in oil for this composition.

41 The Casino Marie-Christine, beside the beach of Saint-Adresse, was a favourite spot for society gatherings, frequented by the people of Le Havre. In 1880 it was transferred to the park of the villa 'Mon Désir'. In 1910, a building of the same name was erected in its place. Damaged during World War II it was demolished in 1965 to make way for a residential home. 'A huge and well-designed establishment including, apart, of course, from the gaming hall, a charming theatre and a well-frequented dance-hall. After the last war, the Casino theatre enjoyed a certain degree of fame: a season of operettas with a resident company, plays, music-halls, etc. During the 'années folles', Ray Ventura et ses Collégiens, who were just starting out on their career, played there with great success; then in a quite different genre, classical concerts were held there, conducted by Ernest Bourmanck. The composers Maurice Ravel, Vincent d'Indy and Arthur Honegger came to conduct a fine orchestra (*Havre-Presse* no. 9415, 29 and 30 December 1979, p. 3).

42 From 1913 onwards Dufy showed an interest in the world of racing. From 1908, however, the theme of the *Avenue du Bois* inspired a large number of compositions containing horses.

43 The fruit bowl, on its own, was the theme of a number of still lifes from 1912 to 1913. During the same period, Dufy painted it along with the sideboard in his parents' dining room in Le Havre, in *Still Life with Yellow Sideboard* (Musée National d'Art Moderne), arranged around the opposition of rectilinear peaks and arabesques in the form of a reversed S.

44 L. Brion-Guerry, in the preface to the catalogue

of the exhibition 'Cézanne – Les Dix Dernières Années', 1978, Grand Palais, Paris.
45 Courthion (note 2), p. 58.
46 This is the first time this much-loved theme of a cage with birds makes it appearance in Dufy's work.
47 The maiden name of Madame Dufy, known as Émilienne, was Eugénie Brisson. She married Raoul Dufy on 9 February 1911, in the Mairie of the 18th Arrondissement.
48 As well as a preparatory sketch in the Musée National d'Art Moderne, we know of two other later versions of this portrait, one of them in the Musée de Grenoble.
49 According to Bernard Dorival, this date was confirmed by Raoul Dufy himself, at the 1937 exhibition of the 'Maîtres de l'Art Indépendant' in the Petit Palais, in which the work was given the number 21 (See Michel Hoog and Bernard Dorival, Le Legs de Mme Raoul Dufy aux Musée National d'Art Moderne', in La Revue du Louvre, No. 4–5, 1963, p. 211).
50 Bernard Dorival, 'Le Thème des Baigneuses chez Raoul Dufy', in Revue des Arts, No. 4, 1955.
51 Created by Président Bonjean, a Parisian philanthropist, for young painters who had failed to win the Rome scholarship, and for whom a two-year scholarship was instituted.
52 Hoog and Dorival (note 49), pp. 223–24.
53 Another drawing in pen and black ink, of the bust of the bather facing the same direction, in a similar style, is reproduced in Roger Allard's 'Raoul Dufy et Son Oeuvre', Le Nouveau Spectateur, No. 6–7, 25 July–10 August 1919, p. 128.
54 Carnet No. 2 (No. A.M. 36–45 D, Musée National d'Art Moderne).
55 Private Collection.
56 Collection of Helmuth Zeelner, Köln-Marienburg.
57 Formerly in the Mazaraki collection.
58 Collection of Peter A. Rubel, New York.
59 Marcelle Berr de Turique, L'Amour de l'art, special issue on Raoul Dufy, 1953, p. 40.
60 It is not surprising that Poiret owned this work, which held pride of place on the walls of his drawing room, as is shown by a photograph taken at this time.
61 Bernard Dorival, preface to the catalogue of the Raoul Dufy Exhibition, Tokyo, 1968.
62 In 1909, Dufy went with Friesz to Munich, returning with views which were austere in their chromaticism and composition. In 1914, he went to Berlin, as is revealed by Carnet No. 10 (No. A.M. 36–53–D, Musée National d'Art Moderne), and met Walden who, in the same year, was exhibiting works by Chagall.
63 We should remember that in 1913, the Galerie Der Sturm showed works by Robert Delaunay in the presence of the painter, who published a text about light in the magazine Der Sturm, translated into German by Paul Klee.
64 These are a Munich Landscape (No. 331 in the New York catalogue; No. 113 in the Chicago catalogue; No. 44 in the Boston catalogue) and a view of Regattas on the Channel from 1909 (No. 332, New York catalogue; No. 114, Chicago; No. 45, Boston).
65 An exhibition held in New York in a military building, the Armory of the 29th Regiment on 25th Street, on 17 February 1913. The aim of the organizers was to introduce European painting to the United States, to reveal the sources of the new American spirit in art. It gave rise to a large number of controversies and scandals (such as Marcel Duchamp's Nude Descending a Staircase). In Chicago an effigy of Matisse was burned. The Armory Show was successful in so far as it educated the taste of the American public and made art collectors of a large number of people (Dr Barnes, Merion Foundation, near Philadelphia; Walter Arensberg, whose prestigious collection of the works of Marcel Duchamp is held at Philadelphia Museum of Art; Duncan Phillips in Washington, etc.). Critics, artists and dealers responded with great enthusiasm. A large number of art galleries were opened in 1915.

CHAPTER II

1 See unpublished letter, signed, dated 9 April 1908, from Berthe Weill. 'You used to have qualities that art-lovers appreciated, and you're trying to complicate matters; why not just be yourself? You think too much about what you want to do, you shouldn't think about it or you'll fall on your face. [. . .] Try to find a little money and get to work, you absolutely have to shake off your torpor and not let yourself get muddled. [. . .] People ask after you: I tell them you have a lot of things in the pipeline but nothing finished as yet; they're waiting. You see how it's all your fault. Your images d'Épinal are of no interest to me, there's no point going on with them. I send you my love and await news from you soon.'
2 'Comment j'ai illustré mon premier livre', in Plaisir du bibliophile, No. 7, 1926, p. 7. Friperies was not published until 1923. Neither of them had any money to put into this project: Fleuret was just starting out, and Raoul Dufy was known only to a small number of admirers.
3 Conversation with Pierre Camo, 'L'Atelier de Dufy', in Le Portique, No. 4, 1946, p. 11.
4 Fernand Fleuret was part of the group L'École Romane, set up in 1891 by Jean Moréas, who described it 'not only as an aesthetic necessity, but also as a patriotic duty'; he thus revealed that conservative and nationalist trend which 'praised, in literature and art, the return to traditional and national values, which was developing at the beginning of the 20th century at the same time as a progressive trend', Marcel Giry, Le Fauvisme, Neuchâtel, Ides et Calendes, 1981, p. 16.
5 In his Éloge de Raoul Dufy, Paris, 1931, p. 1, Fleuret described this period: 'We were living in Provence, where you made thirty drawings every morning. They were every bit as good as Van Gogh. As for me, I did nothing but miss Normandy and plumb the depths of the future.' The poet had no hesitation, given their meagre resources, in producing 'a little candle so that in the evening you could go on with your woodcuts for the Friperies while eating that hazelnut nougat that generally constituted our dinner.'
6 Navigational maps, playing cards and the labels of colonial products fascinated him from his earliest youth.
7 'When I was in Munich', Dufy continued, 'I had no desire to paint, it became a chore, a duty,' Pierre Courthion, Raoul Dufy, Geneva, Cailler, 1951, p. 56.
8 'I had devoted a few free hours to the engraving of four plates: Fishing, Hunting, The Dance and Love, later published by the Éditions de La Sirène, under the title Les Plaisirs de la paix.' Paul Istel, 'Entretien R. Dufy', in Plaisir du bibliophile, No. 7, 1926, p. 161.
9 Some of them, from the legacy made by Mme Dufy to the Musées Nationaux in 1962, are in the Musée Jules-Chéret, Nice, listed under the numbers A.M. 29–23–D–661, 662 and 326.
10 31.5 × 40.8 cm (12½ × 16 in.).
11 The conception of an illustrated bestiary was planned in 1906 by Apollinaire and Picasso, who, after sketching two figures, the figure of The Chicken and that of The Eagle, abandoned this project. See Apollinaire, Oeuvres poétiques, text edited and annotated by Marcel Adéma and Michel Décaudin, N.R.F., Paris, 'La Pléiade', 1956, p. 1027.
12 The printing of the Bestiaire, begun on 6 February 1911, continued until 5 March 1911. The edition (Delplanche, Paris) comprised 120 copies, numbered at the press.
13 'I can see you on the Rue Linné, going at the woodcuts of the Bestiaire with your gouge and your penknife, those plates of a size to which you were unaccustomed. You were becoming involved in printing and typography for the first time, and you only ate about three days a week, since the wood was so expensive,' Fernand Fleuret, Éloge de Raoul Dufy, Paris, 1931, p. 2.
14 Thus eighteen of the thirty poems in the book were published in La Phalange, No. 24, 15 June 1908, p. 1118, under the title La Marchande des quatre saisons ou le Bestiaire mondain, accompanied

by a note in which Apollinaire states that La Marchande (replaced in the final version by the figure of Orpheus) 'praises the wood engravings which, when it appears in the bookshops, will accompany the entertainment of which this is a poetical fragment', Adéma and Décaudin (note 11), p. 1027.
We should also note that the Bibliothèque Littéraire Jacques Doucet has a manuscript of the Bestiaire (No. B–VI–7) in which Apollinaire has drawn some sketches of animals in the margin.
15 George T. Nozlopy, Professor of Art History at the University of Birmingham, has shown that Apollinaire's chief source of inspiration was the French edition, from 1543, of Horapollo. See his article in Apollinaire, Allegorical Imagery and the Visual Arts, Vol. IX, No. 1, January 1973.
16 From childhood, Dufy had had a particular liking for the popular prints of Normandy, produced in the busy centres of Rouen, Caen and Falaise.
17 Guillaume Apollinaire, 'Bulletin de souscription du Bestiaire' (1911), in Chroniques d'Art, 1960, p. 151.
18 In this Salon, Dufy showed four separate engravings: The Dance (No. 356 in the catalogue), Love (No. 357), Hunting (No. 358), Fishing (No. 359) and a frame including four woodcuts and the title page for Le Bestiaire.
19 Fleuret (note 13).
20 Quoted in Louis Carré, Dessins et croquis extraits des cartons et carnets de voyage de Raoul Dufy, Paris, October 1943.
21 Claude Roger-Marx, La Gravure originale de Manet à nos jours, Paris, 1939, p. 61.
22 Guillaume Apollinaire, Le Poète assassiné, Paris, Éditions Au Sans-Pareil, 1926, p. 35.
23 A private collection contains a plate that is a first draft for The Tortoise, revealing Dufy's experiments, which was rejected because of its wide format and elaborate composition. Two musicians, their bodies clothed with little loincloths, frame the central motif of the tortoise, the space is filled by profuse vegetation and the long body of a nude. The style in which the bodies are drawn, in luminous geometrical fragments, is very close to that of the figures painted during Dufy's 'para-Cubist' period.
24 In 1920, the Éditions de la Sirène published six songs by Francis Poulenc on some of the poems for the Bestiaire, 'La Chèvre du Thibet', 'Le Dromadaire', 'La Sauterelle', 'Le Dauphin', 'L'Écrevisse' and 'La Carpe'.
25 In the same way, pyramids appear in The Dromedary, the Orangerie at Versailles in The Carp, a steamboat in The Dolphin, caravels in The Lion; The Grasshopper and The Rabbit are shown in a rustic landscape, The Tortoise accompanied by a lyre, The Hare by a hunting horn and a rifle.
26 Gérard Bertrand, L'Illustration de la poésie à l'époque du cubisme 1909–1914, Derain, Dufy, Picasso, Paris, 1971, p. 56.
27 See François Chapon, Le Peintre et le livre, Paris, 1987, p. 132.
28 In issue No. 24 of La Phalange (1908), Apollinaire notes that 'the picture shows a peacock seen from behind, dragging its tail'. In a letter to the artist, dated 29 August 1910, he adds that 'the picture must therefore show a peacock seen from behind letting its tail drag, and in the background you can show one fanning its tail, but you need one, the main one, dragging its tail'.
29 In L'Intransigeant of 28 December 1910, Apollinaire writes that 'we must point out Dufy's curious interpretation of the fabulous figure of the sirens. Since they disappeared with the Gulf of Scylla [. . .] it would be difficult to ascertain what they really looked like. The Greeks gave them the faces of birds and the breasts of women, while for the Romans these charming monsters ended in a fish's tail, desinit in piscem, and Dufy has remembered both ideas; his sirens are winged and the ends of their bodies are lively, round and firm like those of tuna-fish'.
30 There are thirteen of these studies in the Graphic Art Department in the Library of Harvard College. See Eleanor M. Garvey, 'Cubist and Fauve

Illustrated Books', in *Gazette des beaux-arts*, January 1964, p. 44. The Musée National d'Art Moderne has preserved other studies in crayon and black lead, all from the legacy of Mme Dufy to the Musées Nationaux in 1962: *Orpheus* (A.M. 29–23–D–594 and 597), *The Octopus* (591) and *The Tibetan Goat* (588).

31 Apollinaire wrote the quatrain of 'Le Serpent' to replace the poem for the 'Condor', 'rejected because it was too free', as he said, along with that of the 'Scorpion', which was removed for the same reason. In 1931 they were published at the expense of an admirer, illustrated by two wood engravings, in the same square format, made by Raoul Dufy.

32 'I started afresh on a number of plates with which I was unsatisfied.' Raoul Dufy, in *Plaisir du bibliophile*, Summer 1926, p. 163.

33 *Ibid.* Dufy humorously related the circumstances and consequences of the publication of the book, pp. 162–63.

CHAPTER III

1 Poiret commissioned Paul Iribe to assemble an album of his dress designs, *Les Robes de Paul Poiret, racontées par Paul Iribe*, published in 1908. In 1911 it was Georges Lepape's turn to be revealed to the public with the album *Les Choses de Paul Poiret*.

2 It is due to the extreme kindness of André Robert that we have had access to certain of Dufy's designs, in pen-and-ink or black lead, since Poiret did not keep these engravings, probably because they had little to do with his profession. These studies attest to the effort, integrity and care that Dufy brought to the creation of even his minor works.

3 'The shades of "*cuisse de nymphe*", lilacs, swooning mauves, the delicate blue hortensias, eau-de-nils, corns, straws, anything that was gentle, pale and faded was in favour. I set a few good solid cats among these pigeons: reds, greens, violets, royal blues set off the other colours.' Paul Poiret, *En Habillant l'Époque*, Paris, Grasset, 1930.

4 Viennese studio set up in 1903, by Joseph Hoffmann and Koloman Moser, members of the Secession, with the aim of creating universally accessible art objects and bringing the arts and crafts professions back into the public eye.

5 Poiret (note 3), p. 150.

6 *Ibid.*

7 *Ibid.*

8 J.M. Tuchscherer, preface to the catalogue of the exhibition 'Raoul Dufy, créateur d'étoffes', Mulhouse, France, 1973–74.

9 *The Shepherdess* measures 1.50 × 1.55 m. (59 × 61 in.). The other four hangings are each two metres square.

10 In *Hunting*, the hunter, a self-portrait of Raoul Dufy, is wearing a scarf printed by the artist in the studio at the Petite Usine.

11 'In confirmation of our discussion this afternoon, I agree to supply M Dœuillet, a dress designer on the Place Vendôme, with three wood engravings which he will purchase, and the right of reproduction of which is reserved exclusively for him, that these reproductions will be made for him in full colour and on three fabrics which you will choose and which I shall supply to you', extract from the letter addressed to M Henri Vidal, Maison Dœuillet et Cie, Paris.

12 It was held on 24 June 1911.

13 From 14 October 1909, Poiret left his mansion on the Rue Pasquier to receive his clientele in this beautiful 18th-century building, entirely restored for him by the architect Louis Süe, on the corner of the Faubourg Saint-Honoré and the Avenue d'Antin (now Avenue Franklin-D.-Roosevelt).

14 In the spring of 1911 Poiret rented this 'folly', built in the woods of Fosses-Reposes by the architect Ange Gabriel. He restored this hunting lodge of Louis XV and Louis XVI to its former glory, and kept it until 1917.

15 Poiret (note 3), p. 150.

16 It was held on 6 January 1912.

17 The sketches are preserved in the archives of the Poiret foundation.

18 It was held on 20 June 1912. The costume of Bacchus, worn by Poiret, and that of the Bacchante, worn by his wife, are preserved in the Musée Galliera.

19 In 1919, Poiret, who was beginning to encounter setbacks in his business, decided to set up a theatre which was also to be used as a dance-hall and a *café-concert* in the gardens of his fashion house. Leaving his retreat in Courtenay, Aristide Bruant came in his famous black suit, highlighted by his red scarf. Poiret also brought Yvette Guilbert there.

20 Issue no. 4, May. An elegant magazine founded in 1912 and run by Lucien Vogel, the *Gazette du bon ton* was also published in Berlin, by Cassirer, a famous art dealer and a publisher in his own right. Each of these issues presented one or more of Poiret's designs, drawn by the artists who had worked on them.

21 'An exhibition planned around 1906–1907 by the Société des Artistes Décorateurs (established in 1901). The Exposition Internationale des Arts Décoratifs et Industriels Modernes presented an inventory of work going back to 1910. Programmed in 1915, postponed in 1916, deferred because of the war until 1922 and then until 1924, the exhibition finally opened in 1925. It was a huge celebration of the *"années folles"* that followed the dark and bloody years of the First World War, which had swallowed up the last splendours of the *Belle Époque*', Y. Brunhammer, preface to the catalogue *Expo 1925–1975*, Musée des Arts Décoratifs, Paris, 1976.

22 The official Pavillon de l'Élégance, showing the salons of the competing fashion houses – the Callot sisters, Worth and Lanvin. Poiret preferred to show his work separately. To this end he moored three luxurious barges along the Quai d'Orsay, named *Amour*, *Délices* and *Orgues*. *Amour*, painted blue, contained a suite of apartments decorated by Martine; *Délices*, painted red, was a restaurant; *Orgues*, entirely white, had been turned into a theatre, where the Poiret collection was displayed every day.

23 Dufy made these hangings in the Bianchini-Férier studios at Tournon.

24 Introduced from Turkey to Europe around 1790, mordant colours had previously been used only with silk, as Pierre Courthion confirms: 'We were aware of mordant colours, but we only used them for silk. For the first time, Dufy used them on cotton [. . .], a technique of which he alone knew the secret', preface to the catalogue *Exposition R. Dufy*, Geneva, 1952. These mordant colours, also called '*enlevages*' or '*degravées*', became inlaid within the fabric, replacing the background colour without adding any thickness, as the printed colour automatically obliterated the colour upon which it was applied, even if the latter was darker. Thus, when Dufy printed a white on a brown background, this white was solid beneath the light, and translucent when held up to the light. In order to apply the mordant colour in a line, Dufy used a spouted cupel, formerly used in Java to apply liquid wax to the fabrics for batik. To spread it over larger surfaces, he used a brush or a wooden blade.

25 Private Collection. *See Note 31, Chapter I.*

26 *Carnet* No. 23, Sheet No. 4 (No. A.M. 36–66–D, Musée d'Art Moderne), note framed in pencil by Dufy.

27 *Carnet* No. 23, sheet No. 5 (No. A.M. 36–66–D, Musée d'Art Moderne).

28 Dufy treated these themes between 1930 and 1942, in paintings in oil or watercolour, recreated from documents in his possession.

29 Pierre Courthion, 'Mes Conversations avec le peintre', preface to catalogue *Raoul Dufy*, Geneva, Musée d'Art et d'Histoire, 1952, unpaginated.

30 'He is bringing together all the themes that he has ever painted to make the fresco of our time, an art which owes no more to decoration than it does to subject matter', observes Pierre Courthion in *Chroniques d'Art*, 1929, p. 32.

31 This title is preferable to the name which has previously been given to the work, a hanging

preserved in the Musée National d'Art Moderne, *The Game of Bridge at the Casino*, which we believe to b[e] erroneous. The figures shown are not playing card[s] as is evident from the absence of gaming tables or [. . .] a décor like that of a gaming room in a casino. Th[e] subject of a presentation of dress designs is su[g]gested by the mannequins who pose before [. . .] showing their dresses to the seated customers; th[e] various groups of people are an audience selecte[d] from among Paul Poiret's regular clients. In 194[.] Dufy returned to this theme in a series of wate[r] colours, one of which is preserved in the Muse[e] Jules–Chéret, Nice (Inv. M. 8092).

32 Jean-Jacques Levêque, *Le Quotidien du méd[e]cin*, 21 October 1976.

33 Christian Zervos, *Sélection*, 1928, p. 3.

34 'Dufy reminded me of the text by Matis[se] which he had previously published in *La Gran[de] Revue*: "Painting must be soothing, something lik[e a] good armchair for a tired businessman." I told hi[m] that Matisse had now renounced this definition, a[nd] did not like to be reminded of it. "If he renounces [it] then he is right to do so, because it is real[ly] somewhat inadequate," said Dufy, "It turns pain[t]ing into a mere diversion".' Courthion, *Raoul Duf[y]*, Geneva, Cailler, 1951, p. 56.

35 Christian Zervos (note 33), p. 5.

36 This motif seems to recall Géricault's paintin[g] *The Race of the Barbary Horses*. Elsewhere [it] resembles the group sculpted by Coustou for th[e] Château de Marly, reproduced by Dufy in his desig[n] for a wing chair for the Mobilier National, showin[g] the Place de la Concorde looking towards th[e] Avenue des Champs-Elysées, made between 192[.] and 1927.

37 'I have been absolutely breathless, as one [is] when first confronted by something that one ha[s] never seen before, and these hangings give a sense [of] something completely new. In terms of its colou[r] the effect goes beyond anything I could imagin[e] and its subject matter was what really astonishe[d] me.'

On this subject, we should point out that all th[e] panels, whose chromaticism originally revealed th[e] intensity and luminosity of Dufy's brilliant palett[e] have not proved resistant to either light or tim[e] Today they are strongly discoloured. But it [is] possible, by looking at the reverse sides of some [of] them, where the original colouring has remaine[d] undamaged, to imagine their original effect.

38 Bianchini-Férier was a company specializing [in] the design, manufacture and distribution of to[p] range fabrics for women's dresses and furnishing[.] Established in 1888 by MM Atuyer, Bianchini an[d] Férier (Maison Atuyer-Bianchini-Férier), the fa[c]tory moved from the Place Tolozan to the R[ue] Vaucanson in 1900. The founders, whose ages, [in] 1888, totalled 78, were awarded many prizes for th[e] quality and originality of their work (such as th[e] Grand Prix de l'Exposition Universelle de Paris [in] 1900). In 1913, with the death of M Atuyer, th[e] company assumed its current name of Bianchin[i] Férier. In 1988, after one hundred years of desig[n] which are reflected in its archives, the compan[y] which transferred to new offices in September 198[.] continues to pursue its activity in the same fiel[d] (history provided by the Maison Bianchini-Férier[.]

39 His sketchbooks, in particular *Carnet* No. 2[.] (No. A.M. 36–67, Musée National d'Art Modern[e]) contain sheets covered with flower, shell and oth[er] motifs for printed fabrics.

40 Raoul Dufy, in *L'Amour de l'art*, 1920, p[.] 18–19.

41 The word '*indiennes*' was for a long time used [to] describe the printed fabric from India brought bac[k] to Europe by 16th-century navigators (in Europe [at] the time only woven material was used). This India[n] product enjoyed a tremendous vogue in Europ[e] until the end of the 19th century, particularly [in] France, despite its importation being forbidden. [In] the middle of the 18th century, however, Fran[ce] launched its counter-attack against foreign pr[o]ducts, setting up factories that were technical[ly] superior to those of the Orient. In 1759, nea[r] Versailles, at Jouy-en-Josas, Oberkampf opened h[is] factory and created the particular motif of the *to[ile]*

Jouy which was to make his reputation. In 1843 it
~~osed~~ its doors against the advances that were being
~~~ade~~ in the field of dyes. Developments in
~~~emistry~~ and technology encouraged the industria-
~~~zation~~ of factories towards the end of the 19th
~~~ntury~~. The major centres of production in the 20th
~~~ntury~~ were still Lyons and Mulhouse.
**2** *See L'Amour de l'art*, special issue on Raoul
~~~ufy~~, 1953, pp. 14–15.
~~.~~ 1950, Raoul Dufy illustrated Colette's *Un Herbier*
~~~th~~ twelve watercolours and additional drawings
~~~~ black lead, published by Mermod in Lausanne.
~~~ Exhibition held at the Bibliothèque Nationale,
~~~m~~ 19 May until 19 June 1925.
~~~~ At the request of Bianchini, Raoul Dufy used
~~~is~~ woodcut for the firm's ex-libris.
**~~~** Dufy used two of these compositions in an
~~~vertisement~~ for the Maison Bianchini and Tour-
~~~n's~~ fabrics, published in *L'Art et la mode*, 23
~~~ctober~~ 1920.
~~~ This fabric was reproduced in 1931 in the oil
~~~inting~~ *Thirty or La Vie en Rose*, in the Musée d'Art
~~~oderne~~ de la Ville de Paris, which shows a corner of
~~~e~~ dining room in the apartment in the Impasse
~~~uelma~~, where Dufy had set up his studio in 1911.
~~~veral~~ *Homages to Bach* (Musée National d'Art
~~~oderne~~), *Homages to Debussy* (Musée de Nice and
~~~usée du Havre~~), as well as *The Martinican Woman*
~~~ar~~ this motif, in different colours.
~~~ Unpublished letter from Charles Bianchini, 8
~~~pril~~ 1919, addressed to Raoul Dufy, who was
~~~aying~~ in Vence.
~~~ *Armure*: a way of crossing warp and weft
~~~reads~~.
**~~~** *Carnet* No. 23, p. 13 (No. A.M. 36–66–D, Musée
~~~ational~~ d'Art Moderne).
~~~ Library archives, Musée de la Guerre.
~~~ Dufy was very close to the publisher Camille
~~~loch~~, whom he had met at the home of Gabriella
~~~eval~~ (who was then the wife of Fernand Fleuret).
~~~~ 1919 he commissioned him to make a woodcut for
~~~r~~ ex-libris and also illustrations for Georges
~~~uhamel's~~ *Elegies*, including an ornamental band,
~~~~ imprint page and the headings of the various
~~~apters~~. This decoration was to Duhamel's satis-
~~~ction~~, as we can see from an unpublished letter of
~~~~ February 1920 (archives of André Robert).
**~~~** Pierre Schneider quotes a letter from Raoul
~~~ufy~~ dated 30 May 1916, addressed to Simon Bussy,
~~~friend~~ of Matisse: 'I have been to see M Bréhal [*sic*]
~~~ho~~ received me with great kindness, thanks to you,
~~~~ he did the idea that I had come to submit to him.
~~~llow~~ me to tell you what it consists of: the making
~~~~ colour prints, like *images d'Épinal*, showing the
~~~artime~~ deeds of our colonial soldiers, so that the
~~~alls~~ of the houses or shacks of the Blacks of Africa
~~~~d the Yellow Men of Asia will bear a souvenir of
~~~eir~~ participation in the Great War, just as our own
~~~asants~~ had prints of the Napoleonic wars in their
~~~ttages~~. My idea has already been very well
~~~ceived~~ by some departments of the Ministère des
~~~olonies~~, and I thought it would be useful to go to
~~~e~~ Bureau de la Propagande. Tomorrow, M Bréhal
~~~ould~~ give me an answer as to the practical way of
~~~~ing about my proposal' *Matisse*, Paris, Flammar-
~~~~n, 1984, p. 736, note 1.
~~~~ It is also very interesting to learn (Schneider, p.
~~~~5) that 'as Matisse's brother had been deported to
~~~~ermany, to Heidelberg, Matisse made and sold
~~~~chings to finance the parcels he sent him. These
~~~~ints were dedicated to the civilian prisoners of the
~~~~wn of Bohaim.'
**~~~** 'After the war, when the Library moved to
~~~incennes~~, Camille Bloch wanted to keep me in my
~~~~st. I was obliged to let him down, answering that I
~~~~as an artist and not a civil servant. I didn't find all
~~~~ose files very entertaining! [. . .] I wasn't badly
~~~~id. They gave me 1,200 Francs per month, which
~~~~asn't bad at the time, was it? René Jean took over
~~~~om me. That was also how I came to know Claude
~~~~oger-Marx,' Courthion (note 34), p. 70.
**~~~** Unpublished manuscript, *see* note 31, ch. I.
**~~~** Courthion (note 34), p. 73, describes the
~~~~inter's refusal to accept any of the profits of the
~~~~isiness: 'I had just refused millions, just to keep
~~~~y painting, not to paint for the dealer's taste. Well!

The boss didn't see me as a "lunatic": "You've got
character," he told me, looking me full in the face.'
56 Dufy was to declare: 'For me there has always
been a certain order of colour which could be
formulated as follows: colour = light. A painter's
concept? Doubtless. But I hoped to find a practical
decorative application for this principle, which I had
discovered around 1908. Should the brilliance of the
colours printed on the silk not reveal either the error
or the excellence of my principle more convincingly
than oil paints and a canvas on an easel? [. . .] So that
was how I was led to decoration and fashion, not for
relaxation or amusement, but to engage in a serious
experiment. This exciting period of my life awakens
so many echoes in me! Thanks to Poiret and
Bianchini-Férier I was able to establish that rela-
tionship between art and decoration, and more
particularly to show that decoration and painting
drink at the same source.'

CHAPTER IV

1 Raoul Dufy and Max Jacob were friends of long
standing. An unpublished letter dated Saint-
Benoit-sur-Loire, 29 May 1924, mentions an illus-
tration featuring 'a tableau of the bourgeoisie',
planned for a work by Max Jacob, to be published
by Gallimard. It would seem that Dufy did not
make this illustration. The poet's postscript conveys
his affectionate admiration for the painter: 'I hope
that you are still working for the joy of those who so
love everything that you produce.'
2 Rémy de Gourmont died in 1915, and this book,
whose publication was postponed by the war, did
not appear until 1920, when it was published by
Éditions La Sirène. In the meantime, Dufy's draw-
ings had been bought by Jacques Doucet, who had
provided the loan for the publication.
3 From 1921, the Éditions de la Nouvelle Revue
Française commissioned Raoul Dufy to make por-
traits of authors for the illustration of one of their
works, published in the collection *Une Oeuvre, un
portrait*. They included the lithograph of Jean
Pellerin for *La Romance du retour*, and that of
Boylesve for *Ah! Plaisez-Moi . . .*
4 Examples of this are the portrait in the Musée
National d'Art Moderne (No. A.M. 26–48–D), a
sketch in Indian ink, and the portrait in the Musée
des Beaux-Arts, Orléans, drawn in pencil on white
paper. Antoinette Rézé-Huré, in 'Raoul Dufy, le
signe', *Cahiers du Musée National d'Art Moderne*,
No. 5, 1980, pp. 410–22, also mentions three studies
in blue ink and pencil for the *Portrait of Paul
Claudel*, signed, undated (bought by the Wadd-
ington Gallery at Sotheby's sale, 3 December 1970);
a study in blue ink and pencil, signed and undated,
featured in the 'Exposition Paul Claudel' at the
Bibliothèque Nationale (bought by Peretti at Soth-
eby's sale, 8 July 1971); another study in blue pencil
also exhibited at the Bibliothèque Nationale
(bought by Vanhelsham at Sotheby's sale, 29 June
1972).
5 Between 13 January and 24 February five
hundred works were exhibited: drawings, water-
colours and decorative panels.
6 This date is confirmed by a letter from Dufy,
dated 20 June 1918, addressed to the editor of *La
Sirène* (reproduced in *Le Portique*, 1946, p. 11).
Elsewhere, in sheets 11 and 12 of *Carnet* No. 24 (No.
A.M. 36–67–D, Musée National d'Art Moderne),
bearing the date 1918, Dufy mentions '*Les Madri-
gaux* by Mallarmé/Some twenty illustrations/in
colour/supervision of printing and correction of
colours/2,000 F $\frac{1}{3}$ upon the signature of the contract/
$\frac{1}{3}$ upon the delivery of the first drawing/$\frac{1}{3}$ three
months after publication.' *Les Madrigaux*, unpub-
lished, collected by Jean Cocteau, was published in
June 1920 by Éditions La Sirène. An unpublished
letter from Cocteau to Dufy containing the quatrain
dedicated to Monet is dated 3 August 1918.
7 *Carnet* No. 2 (No. A.M. 36–45–D, Musée Natio-
nal d'Art Moderne).
8 Title of a Brazilian popular song. For the origins
of this mime, *see Littérature*, No. 2, April 1919, pp.

21–23, and Darius Milhaud, *Ma vie heureuse*, Paris,
Belfond, 1974, p. 87.
9 *Arts*, 3–9 April 1953, p. 1.
10 Milhaud, *Ma vie heureuse* (note 8), p. 67.
11 *Ibid.*
12 *See Gazette du bon ton*, March 1920.
13 Dufy regularly went to the Cirque Medrano,
close to his studio in the Impasse de Guelma. The
Saturday gatherings at Milhaud's house, 5 Rue
Gaillard, generally ended up at the fair in Mont-
martre, the music hall or the circus. For Dufy, as for
all the artists of the first quarter of this century, the
spectacle of the circus was a real attraction, inspir-
ing works that were very diverse in spirit. Rouault
took horse-riders and clowns as his models, stressing
the tragedy of the existence of these marginal
characters. In contrast, Van Dongen sought to
convey the coarse sensuality of faces and postures.
For Dufy, this attraction to the circus was combined
with his love of horses. In his portrayal of the
spectacle he concentrated on capturing the general
atmosphere and the movement of the artistes
around the ring. The theme of the circus, chosen in
1925 for one of the fourteen hangings decorating
Paul Poiret's barge, *Orgues*, was also treated in a
1924 painting in gouache, and an oil painting made
in 1934–35.
14 Georges Auric, 1967.
15 Archives of André Robert.
16 Georges Auric, *Quand j'étais là*, Paris, Grasset,
1979.
17 From Pierre Ortola's libretto, to music by Jean
Poueig.
18 According to A. Levinson, the backdrop, show-
ing the triumph of the Sun over the Clouds, was
painted in such brilliant colours that 'it soaked up
all the light and so successfully reduced the cloudy
haze of the costumes to nothing that the company
was forced to abandon it', *Candide*, 29 August 1922.
19 *Palm Beach* was a '*plein-air*' ballet in three
scenes, from a libretto by René Kerdyck, to music
by Jean Françaix, interpreted by Léonide Massine.
Organized by the Comte de Beaumont, it was
presented at the Théâtre des Champs-Elysées. This
ballet, whose action takes place in Monte Carlo, was
performed at the Royal Opera House in Covent
Garden in 1936. Comte Étienne de Beaumont was
friendly with everyone of any importance in the
literary and artistic avant-garde of the day, and for
the first third of the 20th century acted as an
enlightened patron and theatre director.
20 According to the critics of the time, this set had
the great disadvantage of dazzling light: 'The white
scallop-shell in the middle of the white canvas gives
off such a brilliant light that the characters are
plunged into the gloom of an aquarium'. However,
'the marine set enchanted some and disconcerted
others with the vivacity of its raw tones and the
subtle ingenuity of its composition, the absence of
perspective and the little boats borrowed from
children's drawings', A. Levinson, in *Candide*, 29
June 1933.
21 Archives of André Robert.
22 These indications would lead us to conclude
that Dufy drew all these sketches during his stay on
the Côte d'Azur in 1928 and 1929, while working on
the decoration of Auguste Weisweiller's villa in
Antibes.
23 Pen and black ink on cream paper, Musée
National d'Art Moderne. Déhelly, having left the
Comédie-Française in 1934, posed in Dufy's studio
in several of his stage costumes.
24 Salacrou was born in Le Havre in 1900. His
piano teacher was Léon Dufy. At Dufy's home he
was able to see the paintings of his brother Raoul
hanging on the drawing-room walls. At the request
of Marcelle Oury, the author of *Lettres à mon peintre*
(Paris, Perrin, 1965), he addressed Dufy in the
following terms: 'Your brother never managed to
make me learn the piano, and you, without knowing
it, taught me painting, and I am indebted to you not
only for your watercolours, which have enchanted
my life, but also for all the other canvases by all the
other painters whom I have come to like because I
had played my scales before your works, admiring
them all with the simplicity of the trusting child.'

25 Painted in gouache by Dufy (50 × 65 cm [19⅝ × 25⅝ in.]), preserved in the Comédie-Française.
26 *Le Figaro*, 17 December 1944.
27 Article by J. Lemarchand in *Combat*, 27 December 1944. In *Fraternité*, 12 January 1945, E. Borel notes that 'Raoul Dufy's set, over-large though it may be, is a pleasure to the eyes.'
28 'I had five very large, very beautiful Dufys, but I only saw photographs of them. An excessively wealthy American producer – whom I suspect of having crushed one of my plays beneath the weight of his dollars – had permitted himself the luxury of five enormous curtains the size of five Broadway curtains (five delightful designs of Dufy that I can imagine on the wall of my New York apartment), whose Cyclopean reproductions inexorably fell five times, taking the time required for the contemplation of such costly masterpieces, and, no less inexorably, broke up the light and dancing rhythm of the play. Indeed – the mystery of theatrical blunders – the choice of Dufy was a good one: he is a light and dancing painter, the Marivaux of painting, one of the few men of his art who has the supreme gift: the gift of play. Two little marks by Dufy, winged and witty on a sheet of paper, would have been enough for me. The conspiracy of snobbery and dollars has left me only with the memory of the failure of *L'Invitation au château* in New York, and five excessively large and useless curtains. But the five designs – adorable beyond all doubt – that he had painted while thinking about my little story, remain in my heart.' Jean Anouilh, in Marcelle Oury (note 24), p. 65.
29 *Maxim's* (50 × 66 cm [19⅝ × 26 in.]); *Baccara* (50 × 92 cm [19⅝ × 36¼ in.]); *Ballet* (53 × 66 cm [20⅞ × 26 in.]); *Arrival* (50 × 66 cm [19⅝ × 26 in.]); *Gastronomy* (50 × 92 cm [19⅝ × 36¼ in.]); *Fireworks* (50 × 65 cm [19⅝ × 25⅝ in.]).
30 The curtain, painted from the design for *Baccara*, is in the collection of the Metropolitan Museum, New York.
31 Dufy particularly relished 'Berthe [Reysz]'s sauerkrauts, Bougarreyt [Massat]'s saucisses de Toulouse, mirabelle, havanas, good wine [. . .] chocolate creams'. Unpublished notes (from around 1951) by the writer Ludovic Massé, a great friend of Raoul Dufy from Perpignan.
32 A sketch in watercolour over pencil lines was given, in 1951, as a Christmas present to Dufy's friends Louis and Charlotte Bergman, with whom he stayed during his time in New York.

CHAPTER V

1 There are more than fifty of these, including those owned by the Art Institute of Chicago and the Hanover Museum.
2 Letter to André Lhote, 1943, quoted in Jacques Lassaigne, *Raoul Dufy*, Geneva, Skira, 1951, p. 30.
3 Marcelle Berr de Turique, *Raoul Dufy*, Paris, Floury, 1930, p. 204.
4 This one-year contract was renewed on 11 October 1921 for a three-year period, renewable every three years.
5 Held between Thursday 10 and Saturday 19 April 1921. The catalogue includes 42 titles of paintings. In *Carnet* No. 17 (No. A.M. 36–60–D, Musée National d'Art Moderne), Dufy notes twenty-seven works with the names of potential buyers, including Maurice Denis.
6 Pierrre Courthion, *Raoul Dufy*, Geneva, Cailler, 1951, p. IV.
7 *Carnet* No. 5 (No. A.M. 36–48–D, Musée National d'Art Moderne).
8 Dufy would re-use some of these studies for lithographs illustrating *Le Poète assassiné*, by Guillaume Apollinaire.
9 Courthion (note 6), pp. 14 and 53.
10 From this date onwards the watercolour was to occupy a larger part of Dufy's *oeuvre*: 'The watercolour', he observed in his notebooks, 'is the art of intentions. It is perhaps the pictorial medium that provides the greatest amount of freedom for improvisation; it is a medium that is barely material, since the transitions between colours occur naturally

through the white of the paper.'
11 This '*retour à l'ordre*' was expressed in various ways in the work of different artists. After his stay in Rome in 1919, de Chirico, struck by the art of the Renaissance Masters, was to develop a new Neo-Classical style, making a total break with his metaphysical painting. Derain, in Paris, returned to the art of the past, relying on a solid museum culture. The work done by Picasso between 1917 and 1925 reveals his contact with the classical art that he discovered in Rome. His painted figures, with their massive and powerfully modelled forms, refer to classical sculpture, which provided him with a new way of going beyond appearances and of transposing the present.
12 Unpublished handwritten text, pp. 9 and 10.
13 *Carnet* No. 17 (No. A.M. 36–60–D, Musée National d'Art Moderne) includes the first sketches for the *Oarsmen at Nogent*, which can be dated from 1921, since the work was part of his exhibition at Bernheim-Jeune.
14 *See* Michel Hoog and Bernard Dorival, 'Les Legs de Mme Raoul Dufy au Musée National d'Art Moderne', in *Revue du Louvre*, Nos. 4–5, 1963, p. 227.
15 Article in *L'Amour de l'art*, special issue on Raoul Dufy, 1953.
16 René Jean, 'Raoul Dufy, peintre et portraitiste de la mer', in *L'Amour de l'art*, August 1924.
17 Pierre Lièvre, 'Raoul Dufy', in *L'Amour de l'art*, 1921.
18 Pierre Courthion, 'Les Fantaisies de R. Dufy', in *L'Art vivant*, August 1920.
19 Christian Zervos, 'Raoul Dufy', in *Les Arts de la maison*, Summer 1925. In the *Cahiers d'art*, 1926, and then in 1927, Zervos published articles on the work of Raoul Dufy.
20 André Salmon, 'Raoul Dufy, un imagier moderne', in *Plaisir du bibliophile*, July 1925.
21 De Ridder, 'Raoul Dufy, le peintre' and Van Eycke, 'Raoul Dufy, le décorateur', in *Sélection*, No. 7, 1925. In 1928, *Sélection* devoted an entire issue (No. 1) to Dufy, including the article by Fernand Fleuret in praise of the artist, 'Raoul Dufy, illustrateur', pp. 16–24.
22 Courthion (note 6), p. 48.
23 *La Terre frottée d'ail*, illustrated with ninety-four line drawings including twenty large plates, was published in 1925 by Delpeuch, and launched a new collection, 'L'Invitation au voyage'. This work was received with great acclaim (*see* Rene Fauchois, in *La Renaissance*, 1926). The original drawings were the subject of a solo exhibition at the Galerie Le Portique in 1927.
24 The work was published in 1930, decorated with ninety-four etchings. Its author, Eugène Montfort, published the magazine *Les Marges*.
25 The publisher and the painter worked together on the design of the book, ensuring the harmony of text and image: a regular rhythm featuring a fully decorated title page, followed by a full-page illustration framing the text, embellished with a historiated heading; the plates articulate the work as a whole.
26 André Suarès, quoted in François Chapon, *Le Peintre et le livre*, Paris, Flammarion, 1987, p. 52.
27 As Marcelle Berr de Turique observes (note 3), Dufy always denied that he was an engraver because, in fact, since he does not press down upon his line he barely cuts into the metal, merely drawing on a plate coated with varnish using a sharp point, without any incision; the areas thus exposed are corroded by the aqua forta. This is why his clean line, despite its great firmness, appears extremely light and fine.
28 Ambroise Vollard, *Souvenirs d'un marchand de tableaux*, Paris, Albin Michel, 1937, p. 289.
29 Private Collection.
30 An unpublished letter from Dr Roudinesco, addressed to Dufy on 8 August 1931, refers to this journey during which he made life-studies of the landscapes, monuments and people of the city. Some of the sketches were published by Louis Carré in 1944, in *Dessins et croquis extraits des cartons et carnets de Raoul Dufy*, published in Paris.
31 In Algiers, then in Constantine, where he went in 1934, Dufy filled his travel notebooks with

sketches (Private Collection). An unpublished letter from Dr Roudinesco, dated 22 April 1934, tells us that Dufy was preparing to set off: 'Don't forget to go on your little trip to Algeria before it gets too hot. I love the idea of a few ports in Algiers that will give a voice to the ports of Marquet.'
32 The fact that Dufy did not like Daudet (*see* Courthion [note 6], p. 65), and that his only 'saw the book as an excuse to exercise his virtuosity as a lithographer' (*see* Gérard Bertrand, *L'Illustration de la poésie à l'époque de cubisme 1909–1914, Derain, Dufy, Picasso*, Paris, 1971, p. 9), could be one of the reasons for this.
33 Dufy drew all the members of the group with pen and brush, in a drawing and a watercolour that are both stylistically extremely free, conveying the surroundings and atmosphere of the clique.
34 Letter dated 14 March 1926, addressed to Gustave and Mauricia Coquiot.
35 Poiret describes it in an unpublished letter to Raoul Dufy, dated 12 April 1926: 'My own pleasure is enhanced by being shared by you, who react so well and so youthfully to all the expressions of life and nature.'
36 Letter of 10 April 1926, written from Golf-Juan, upon Dufy's return from Morocco.
37 Dufy commented on this work in the course of an interview with *Beaux-Arts* (No. 156, 27 December 1935, p. 1): 'The beauty of the dazzling colours, as well as the enamel, the nobility and the facility of the design are in perfect harmony with the poetic beauty of the subject.'
38 This building, rebuilt in 1891 after a fire, was the centre for the society functions of the period. It was demolished after the war, in 1944. But Dufy used it in his paintings even after its demolition, so fond was he of this motif, which was synonymous with *Festivity*.
39 We should mention *Fireworks in the Port of Trouville*, 1938, and one of the designs he made at the end of his life, in 1951, for a stage set for Jean Anouilh's play *L'Invitation au château*, staged in New York by Gilbert Miller under the title, *Ring Round the Moon*.
40 For details about the famous *Promenade des Anglais* in Nice, *see* the catalogue *Raoul Dufy*, Musée Jules-Chéret, Nice, 1986, note 21.
41 Pierre Courthion, *Raoul Dufy* (note 6), p. 52.
42 Anne-Marie Lecocq and Pierre Georgel, 'D'Alberti à Cézanne', in the exhibition catalogue *D'Un Espace à l'autre, la fenêtre*, St-Tropez, Musée de l'Annonciade, 1978.
43 Jean-Michel Royer, in *D'Un Espace à l'autre, la fenêtre*, (note 42) p. 92.
44 Henri Matisse, *Écrits et propos sur l'art*, Paris, Hermann, 1972, note 54, p. 100.
45 *Carnet* No. 23, p. 13 (No. AM. 36–66–D, Musée National d'Art Moderne).
46 Pierre Schneider, *Matisse*, Flammarion, Paris, Thames and Hudson, London, 1984, p. 150.
47 *Carnet* No. 6 (No. A.M. 36–49–D, Musée National d'Art Moderne).
48 Musée National d'Art Moderne, Legacy of Mme Dufy, 1962. A painting very similar to the work in the Musée des Beaux-Arts, Le Havre, *Bathers, Cargo-Boat, Sailboats and Butterflies*, which can also be dated from between 1925 and 1927 (*see* Bernard Dorival in *Revue du Louvre*, No. 4–5, 1963).
49 To attract customers, Dufy turned to painting landscapes. He continued the tradition of the first railway posters by extolling the advantages and charms of the regions served rather than the means of transport. At this time, holidays were still a luxury to which few had access, and Dufy wished to awaken dreams in the bulk of the population, who had never left the town or village of their birth.

CHAPTER VI

1 Quoted in Marcelle Oury, *Lettres à mon peintre*, Paris, Perrin, 1965, p. 23.
2 *Carnet* No. 11 (No. A.M. 36–54–D, Musée National d'Art Moderne), dated 3 July 1930, Henley, includes a series of sketches from life, which Dufy used for finished works dealing with the same

bject between 1930 and 1936. In a letter dated 25 June 1930, sent from London to his dealer Étienne-Jean Bignou (Bignou auction, Paris, Drouot, 6 June 1975), he wrote: 'I have painted the regattas at Henley, I still have to see the regattas at Cowes and the races at Goodwood, and after that I think that will be England covered!'
Unpublished text, 1927, pp. 11–12.

Carnet No. 23 (No. A.M. 36–66–D, Musée National d'Art Moderne).

Marcelle Berr de Turique in *L'Amour de l'art*, 1953, p. 33, and Pierre Courthion, *Raoul Dufy*, Geneva, Cailler, 1951, p. 44.

See letters from Dufy to Bignou (Bignou auction, Paris, Drouot, 6 June 1975): I have painted the Cowes regattas and the races at Goodwood', and in another letter dated August 1930, he writes: 'The races at Goodwood are now captured between the sheets of two of my sketchbooks.'

During the crisis of 1929, 'Étienne-Jean Bignou [. .], as well as having a gallery on the Rue la Boétie, opening another one in London with Reid and Lefèvre.' Pierre Assouline, *L'Homme de l'art, D.H. Kahnweiler*, Paris, Balland, 1988, p. 305.

Carnet (No. A.M. 36–63–D, Musée National d'Art Moderne).

Bryan Robertson in the catalogue of the 'Raoul Dufy Exhibition', Hayward Gallery, London, 1983–4, p. 54.

0 *See* Bernard Dorival, 'Raoul Dufy et le portrait', in *Revue des arts*, No. 3, September 1955, pp. 75–80.

1 'I am still working like a slave, my London exhibition is in two months, and so I am bent over my race courses and regattas, and they're starting to go well. It's some of the most thankless work I have ever done. It is hard to express my feeling for nature and English life in these studies that I made last summer with all the speed of a film cameraman. So I have unrolled my films and they will have to be better than, or at least as good as, anything the English painters have been able to do on these subjects. Otherwise I shall be put to shame.' Unpublished letter to Marcelle Oury, 2 March, Paris. In this letter it seems that Dufy is referring to the exhibition of his works (37 paintings, 6 watercolours, 1 drawing) at the Reid & Lefèvre Galleries in 1936, which would date the letter as 1936.

CHAPTER VII

See Michel Hoog, in *Cahiers de la céramique, du verre et des arts du feu*, Paris, 1971, p. 65.
'Les Céramiques des peintres', in *Métiers d'art*, October 1981, p. 110.
Ibid.
Their unpublished correspondence reveals their cordial friendship: Artigas's letters to Dufy finished in this way: '*Veuillez bien, Monsieur et Madame Dufy, recevoir l'expression de mon affection et la reconnaissance de ma famille envers vous. Inconditionnellement votre dévoué* [Please, Monsieur and Madame Dufy, accept my affection and my family's gratitude towards you. Unconditionally, your devoted servant]' (letter, 31 December 1924). Artigas had a deep respect and admiration for Dufy.
Pierre Courthion, *Artigas*, Paris, Société Française du Livre, 1979, p. 125.
Minute for 30 July 1923, in the Archives Nationales, file F 21–4204.
Pierre Courthion, *Artigas* (note 5), p. 99.
The archive service of the Musée de Sèvres contains a correspondence relating to this commission, which confirms Dufy's completion of the work (minutes 4770, 16.6.23, No. 47912, 6.7.23, No. 50472, 8.2.24, No. 61721, 27.8.24). But there is no concrete trace of the work, either in the factory or the museum at Sèvres. The vase supposed to have been made for exhibition at the 1925 'Exposition des Arts Décoratifs et Industriels', in the Pavillon de la Manufacture, is not mentioned in the catalogue.
According to André Robert, his assistant.
0 Incised intaglio decoration.
1 Courthion (note 5), p. 125.
2 'As I am doing some more [. . .] biscuit firing, I

might put some of the perfect vases back in [. . .] in my opinion it is better to fire them again in order to achieve the result that your designs require so as to bring out the best in them' (unpublished letter from Artigas to Dufy, 11 January 1926).
13 Artigas refers to it in an unpublished letter, addressed to Dufy from Spain, 31 December 1924: 'I have had the opportunity to see a number of fountains which have been useful in giving me proportions, but no detail that I could copy [. . .]. We will manage to make something perfect – a frame worthy of the bathers and shells, not to mention the providential mackerel'. When Artigas returned to Paris on 6 January 1925, they set to work.
14 'The fountain by Raoul Dufy and Artigas in the Pavillon de la Renaissance de l'Art Français is another excellent example of the decoration that the gaiety of enamelled earthenware can bring to a modern garden.' Henri Clouzot, article in *La Renaissance de l'art français et des industries de luxe*, 1925, pp. 564–76.
'Elsewhere, as regards M Raoul Dufy, when we speak of the Pavillon de la Renaissance, we shall come across a quite different conception which sees it as a part of natural figuration to tend deliberately towards pure ornament.' Arsène Alexandre, 'Les peintres à l'exposition', in *La Renaissance de l'art français et des industries de luxe*, 1925, pp. 337–48.
15 Nicolau Maria Rubió i Tuduri (1891–1981), architect, urbanist, designer of gardens, director of the public parks of Barcelona; his particular achievement is the arrangement of the gardens of the Royal Palace at Pedralbes (1925–27).
16 Preface to the catalogue of the 'Exposition Raoul Dufy', Bernheim-Jeune, 1927.
17 A rich and detailed account of this London exhibition is given in an unpublished letter from Artigas, sent to Dufy from London.
18 Two of these are preserved in the Musée National d'Art Moderne, under the code numbers A.M. 11–65–OA, signed, dated and numbered on the base, Raoul Dufy, Paris 101, 13/XII/1938, with Artigas' monogram, and A.M. 10–97–OA, signed on the base, Raoul Dufy, and, in a cartouche, the monogram of Artigas, 14/VIII/1925.
19 Dufy also interpreted Ingres' *The Spring* in one of his etched illustrations for *La Source des jours*, by Gaston Massat, in 1948.
20 *The Springs* is signed, dated 24/XII, with no mention of the year. An unpublished letter from Artigas to Dufy, dated 11 January 1925, which mentions the making of this vase, leads us to date this ceramic piece from the same year. The similar arrangement of the set of tiles and its inscription, '13.VIII.1925' confirms this date.
21 There are several copies of this vase. *See* Bernard Dorival and Michel Hoog, 'Les Legs de Mme Raoul Dufy au Musée National d'Art Moderne', in *Revue du Louvre*, 1963, No. 3–4, p. 235.
22 On the subject of Vollard, we should note that, at his request, Raoul Dufy, having made the illustrations for *La Belle Enfant ou l'Amour à quarante ans* in 1930 – between 1930 and 1932, begun the colour lithograph illustration of the work by President Édouard Herriot, *La Forêt normande*. This work remained unfinished after the accidental death of Vollard in 1939, as his inheritors had no wish to continue with the project.
23 *Portrait of Ambroise Vollard*, in the Petit Palais in Paris (Legacy of Ambroise Vollard, 1945). We should recall that Vollard was the author of the first biography of Cézanne, published in 1914.
24 *Portrait of Ambroise Vollard*, Zurich.
25 *Portrait of Ambroise Vollard*, Pushkin Museum, Moscow.
26 Signed on the back, on the bottom left-hand side, this ceramic piece is not dated. We suggest that it was made between 1926 and 1927, corresponding with Raoul Dufy's return from his journey to Morocco and Spain.
27 An unpublished letter from Raoul Dufy to the Compagnie Générale Transatlantique establishes that a definite commission was agreed by both parties after numerous discussions, and confirmed by an official correspondence, which would explain Dufy's disappointment and withdrawal.

28 In 1925 Mayodon (1893–1967) was artistic adviser to the Sèvres factory. He was artistic director of the factory from 1940 until 1942.
29 Sketch preserved in the Musée National d'Art Moderne (No. A.M. 29–23–D 477v).
30 Jean-Jacques Prolongeau, born 12 January 1917, trained in Bordeaux in Buthaud's studio. After moving to Perpignan in 1940, he was responsible for the revival of ceramics in Roussillon.
31 The decorations showing the *Bather* and *Girl and Scallop-Shells*, as well as those featuring *Reclining Bathers* (Musée National d'Art Moderne), were drawn on tiles made as a set by the firm of Pierre Maurel in Aubagne, Eastern Pyrenees, whose mark is engraved on the back, confirming the date of these works. We should remember that Artigas, who did not have a press for making his tiles, obtained them from Jules Loebnitz in Paris, whose mark is engraved on the back.
32 The back of the right-hand thigh of one of the bathers shows the monogram P for Prolongeau, drawn by Raoul Dufy.
33 The two tiles are preserved in the Musée National d'Art Moderne, Paris.
34 In a letter dated 21 July 1988, Jean-Jacques Prolongeau wrote to us confirming that he had worked with Dufy and clarifying certain details, notably the fact that on certain ceramic pieces Dufy allowed him to reproduce the preparatory designs that he had given him.
35 The Musée d'Art Moderne de la Ville de Paris owes the most important ceramic pieces in its collection of Raoul Dufy's works to the generosity of Berthe Reysz, who was the painter's assistant during the last part of his life.

CHAPTER VIII

1 The Chevreul range used comprised 14,600 shades.
2 Claude Faux, *Lurçat à haute voix*, Juillard, Paris, 1962, p. 92.
3 '[. . .] around 1920–21, the Galerie Bernheim published [. . .] *Le Bulletin artistique de la galerie Bernheim*. This publication was sent to museums, collectors and painters. One day, the publishers of the *Bulletin* launched a [. . .] survey. [. . .] It was said that the Beauvais factory wanted to try and revive tapestry. And painters were asked the following questions: "Vote, confer and send in your vote [. . .]. In your opinion, who, at present, is the painter most capable of making a major tapestry for Beauvais?"' Faux (note 2), p. 92.
In an interview published in *Le Bulletin de la vie artistique*, 15 April 1923, Dufy said: 'What do I think about the survey? I think it's admirable, obviously, because it chose me. If it hadn't turned out in my favour, maybe I would be pessimistic about it. What's the point, I would say, of bothering with tapestry in the present day? But I am optimistic. I shall therefore say that I shall gladly contribute to the revival of the tapestry, in accordance with the wishes of Jean Ajalbert. The director of the Beauvais factory will have his eye on me all the more since I have devoted ten years of my life to weaving and printing techniques. The technique of tapestry is less complex, but in my opinion a painter still needs to be familiar with it before making a cartoon. In any case, this circumstance does not frighten me, given what I have achieved in the field of weaving.'
4 Faux (note 2), p. 92.
5 Official files, Archives Nationales, No. F 21.4204.
6 Ajalbert refers to this in an unpublished letter to Dufy dated 21 May 1929: 'I should be very happy to speak to you about a work to follow *Paris*, along lines that I should like to suggest to you.'
7 As well as the unpublished letters on this subject, in the file in the National Archives mentioned above (note 5), a letter from Dufy dated 30 December 1926, to M Moullé, the head of the Bureau des Travaux d'Art de la Manufacture, contains this phrase: '[. . .] stand up for me with Ajalbert'.
8 Delivery confirmed by a letter from Ajalbert, 9 January 1928, to the minister (note 5).

For this set of furniture, Dufy received an initial deposit of 5,000 Francs on 5 May 1925, then a balance of 10,000 Francs on 11 January 1928.

9 On 21 March 1930, at the request of the Ministère des Beaux-Arts and Ajalbert, a Parisian bailiff sent Dufy a court order, on penalty of damages and interest, as he had still not sent the promised designs (unpublished).

10 Dufy did not receive his 3,000–Franc fee, agreed when the work was commissioned, until February 1932, as is revealed by the (unpublished) message sent to him by the factory's accountant.

11 Letter from Dufy to his dealer Louis Carré, 24 November 1944, in the catalogue of the exhibition 'Tapisseries de Raoul Dufy', Galerie Carré, 1953.

12 *Paris, 1934* was presented to the Musée du Luxembourg by the American collector Barnes.

13 The design for *Paris, 1934* was formerly in the collection of Dufy's dealer, Bignou.

14 Raymond Cogniat, *Raoul Dufy*, Paris, Flammarin, 1977, p. 14.

15 Having first appeared in two hangings made for Poiret in 1925, in 1928 Amphitrite was the theme of the illustration for the frontispiece of Mallarmé's *Poésies*.

16 This set of tapestries was mounted by Mme Cuttoli on frames of white lacquered wood, in a 'modern style' designed by the decorator and architect Szivessy. These chairs were sent to New York for public auction on 30 June 1982 at Sotheby's. Their new owner replaced Szivessy's frames with frames covered in a warm-coloured suede that intensifies their decorative appearance.

17 The Aubusson weavers did, however, show great virtuosity in making these works, which were displayed, framed under glass, alongside the original works and at lower prices, in Paris, London, Stockholm, Chicago and New York. The tapestries were most successful in the United States.

18 According to Jean Lurçat, one of the weavers who had reproduced and woven a work by Picasso swore that he would never engage in anything of the kind again. And 'If we are to believe our friend Rayssignier, Matisse thought that *Papeete* was badly made,' Pierre Schneider, *Matisse*, Paris, 1984, note 144, p. 657.

19 At this time, Raoul Dufy was staying in Perpignan with Dr Pierre Nicolau, who lavished constant care upon him.

20 Dufy returned to this figure in an illustration for Gaston Massat's *La Source des jours*, 1948, p. 87, and in one of the pencil drawings for Virgil's *Bucolics*, illustrations which went no further than the planning stage, in which Dufy returned to the figure of the peasant crossing his field, a scythe over his shoulder, and the figure of the farmer's wife binding the sheaves.

21 *Cahiers d'art*, 1953.

22 'He captures the essential signs, setting up a veritable arsenal of them, using them to sum up, for our benefit, that real and magical world that was his own.' Marcelle Berr de Turique, *Raoul Dufy*, Paris, Floury, 1930.

23 In 1937, these two motifs featured in *La Fée Électricité*.

24 The dates 1943 and 1946 are mentioned in the catalogue of the exhibition 'La Tapisserie française du Moyen Age à nos jours', Musée National d'Art Moderne, 1946, Note 259.

25 Pierre Courthion, *Raoul Dufy*, Geneva, Cailler, 1951, p. 57.

26 Letter from Dufy addressed to Louis Carré from Aspet, 6 December 1944.

27 *Ibid.*

28 *Ibid.*

29 Quoted in Jacques Lassaigne, *Raoul Dufy*, Geneva, Skira, 1951, p. 61.

30 *Amphitrite* tapestry, 1948, 118 × 277 cm (46½ × 109 in.).

31 *Amphitrite* tapestry, 1949, 136 × 297 cm (53½ × 116⅞ in.).

32 *Countryside*, 1948, 107 × 414 cm (42½ × 167 in.). We might mention a work very similar to this painting, the *Landscape with Urn*, in the collection of Pierre Lévy, Troyes.

33 *Olive Tree*, 1948, 130 × 257 cm (51⅛ × 101⅛ in.).

Around 1949, Dufy returned to the composition of the cartoon for *Olive Tree* in a panel painted in oil, *The Tower in the Normandy Countryside*, in which a shower of rain is falling over the tower.

34 This tapestry may be linked with two oil paintings from 1949, very similar in their subject, composition and style: *The Pastoral Concert* (Musée d'Art Moderne de la Ville de Paris) and *The Musicians in the Countryside* (Musée National d'Art Moderne).

35 In this chapter devoted to the study of tapestries made from cartoons by Raoul Dufy, we should mention two works woven from compositions painted in oil, which were not designed to be made into tapestries. The first of these tapestries, *The Bay at Sainte-Adresse* (195 × 326 cm), was made between 28 October 1966 and 14 February 1968 in Beauvais, from the photographic enlargement of a work painted in oil (Musée des Beaux-Arts, Rouen, Legacy of Mme Dufy, 1962), whose free structure and relaxed style of composition would lead us to date it from around 1945. In this work Dufy returned, in a simplified form, to the theme of three bathers in a group, painted in 1919 (Musée National d'Art Moderne). *Shells by the Sea* (253 × 154 cm [99⅝ × 60⅝ in.]), preserved in the Musée des Beaux-Arts, Dieppe, a work painted in oil, was used as a model for the second tapestry commissioned by the Mobilier National for the Beauvais factory, woven between 18 February 1965 and 5 July 1966.

CHAPTER IX

1 Raoul Dufy was introduced to Dr Viard by Dorival, the pseudonymous Georges Lemarchand, from the village of Orival, near Elbeuf, an actor in the Comédie-Française which he joined in 1918 after starting out at the Odéon in 1896. He taught Fernand Ledoux in the Montbel course of dramatic art, which he directed. After training as an apprentice porcelain painter at the same time as Renoir, he joined the set of Montmartre painters, which he supported with his own funds. It was Dorival who sent an actor from the Comédie-Française to Raoul Dufy to pose for the figure of Tartarin. It was thanks to him that other actors came to pose in period costume for the figures in *La Fée Électricité*. Dorival also introduced Robert Delaunay to Dr Viard.

2 Dr Viard, in the catalogue to the 'Exposition au Profit de la Sauvegarde du Château de Versailles', 1953, pp. 20–21.

3 Roland Dorgelès, *Portraits sans retouches*, Paris, Albin Michel, 1952, p. 24.

4 Stored in a state of perfect preservation around 1949–50, when Dr Viard left the Boulevard Pereire to move to his property in the region of Fontainebleau, this decoration left France for Japan.

5 This painting can be compared with four cartoons painted in watercolour and squared out with a view to being made into tapestries (Collection of Pierre de Tartas, Moulin de Vauboyen).

6 Arthur Weisweiller (14 June 1877 – 16 October 1941), a great art lover, was a polytechnician and banker.

CHAPTER X

1 Pierre Schneider, *Matisse*, Flammarion, Paris, 1984.

2 The paintings in the Musée Jules-Chéret, Nice, and formerly in the collection of John Quinn.

3 Pierre Georgel, 'L'Image de l'atelier depuis le romantisme', in *Technique de la peinture, l'atelier*, documents in the Department of Paintings in the Louvre, Paris, 1976.

4 Henri Matisse, *Écrits et propos sur l'art*, Paris, 1972, p. 100.

5 Pierre Schneider (note 1), p. 439.

6 Also called *Claudine from Behind*.

7 Raymond Cogniat, *Raoul Dufy*, Paris, Flammarion, 1977, p. 73.

8 This decorative motif features in both versions of *Thirty, or La Vie en rose* (1931).

9 *The Red Studio* (Museum of Modern Art, New York) and *The Pink Studio* (Pushkin Museum, Moscow), both from 1911.

10 Pierre Georgel, catalogue of the exhibition 'I Peinture dans la Peinture', Musée des Beaux-Art Dijon, December 1982 – February 1983, p. 185.

11 These are not, as was often thought, paintin by the artist.

12 André Chastel, 'Le Secret de l'atelier', lecture Musée d'Orsay, 10 January 1987.

13 André Chastel, 'Le Tableau dans le tableau', *Fables, formes, figures*, Paris, Flammarion, 197 vol. II, pp. 75–98.

CHAPTER XI

1 In November 1929 the socialist member parliament Durand proposed that the Assemb should organize a 'new exhibition of the decorativ arts' for 1937. In January 1933 the *Journal Offici* published the decree announcing a general interna tional Exhibition in Paris in 1937, which, in 193 became 'L'Exposition des arts et techniques de vie moderne'.

2 Opened after the Exhibition, in 1938, th building was never used for its original purpose. It now occupied by the Conseil Économique et Soci in the Place d'Iéna.

3 The Palais de Chaillot includes: the Musée Sculpture Comparée, now the Musée des Monumen Français and the Musée Éthnographique, now th Musée de l'Homme.

4 'As director of artworks for the 1937 Exhibitio I was able to devise a programme and awar commissions to 464 painters, 271 sculptors and 2(decorative artists,' Louis Hautecoeur, *Les Beau Arts en France, passé et avenir*, Paris, 1948, p 153–54.

5 It was Léon Blum who finally approved Dela nay's involvement in the decoration of the Pavillo de l'Air and the Pavillon des Chemins de Fer.

6 *Le Transport des forces* (4.7 × 4 m [15.5 × 13 ft]), Léger's most important mural painting, wa installed in the Palais de la Découverte. An assem lage of landscape elements and industrial constru tions, in which colours and motifs are arrange according to a plan that is far from traditional, th work reconciles technology with nature, which seen as the very source of all energy transform into electricity.

7 *La Querelle du réalisme*, preface by Serge Fa chereau, Paris, Diagonales, 1987.

8 See the catalogue to the exhibition 'Paris 1937 Cinquantenaire', Musée d'Art Moderne de la Ville Paris, 1987, p. 31.

9 These were Bonnard, Braque, Derain, Matiss Picasso, Rouault, Dunoyer de Segonzac, Utrillo Vuillard.

10 Mme Paul Guillaume, Dr Girardin, Gertru Stein, Ambroise Vollard, Léonce Rosenberg, Je Cassen, Raymond Cogniat, Francis Carco, Mauri Raynal and André Salmon were among t members of this Action Committee.

11 Including: Léger, Delaunay, Chagall, Jacqu Villon, Juan Gris, La Fresnaye, Friesz, Marque Vlaminck, Marcoussis, Maria Blanchard, Modi liani, Pascin and Kisling. A special homage wa made to Sérusier, Émile Bernard and Signac. should be noted that Fautrier and Marcel Duchan were excluded, not having received sufficient vote

12 Surrealism was represented by one canvas Max Ernst, which was warmly recommended Jean Cassou. De Chirico was represented by t *Premonitory Portrait of Apollinaire*, which ha preceded Surrealism, and three other later work and the two works by Picabia were likewise not t product of his Surrealist period.

Arp, Masson and Tanguy did not feature in th exhibition.

13 The exhibition occupied the first floor of t museum (the ground floor was devoted to t permanent collections), and began with a homage the precursors of modern art: Ensor, Seurat, Redo Cross and Bonnard. After this, a large amount space was devoted to Picasso, and then to Braqu Derain, Juan Gris and Matisse. And, as somethi completely new, the works of the Surrealists as we as those of Kandinsky, Mondrian and Klee we officially integrated into the exhibition (See Mich

Hoog in the catalogue to the exhibition 'Paris 1937: l'art indépendant', Musée d'Art Moderne de la Ville de Paris, 1987, pp. 22–28).

14 The Eiffel Tower was made the subject of various illuminations, transformed in turn into luminous fountains or peacock's fans. Beams of light rose from it into the sky, and fireworks were set off from the platform. The park of the Exhibition was crisscrossed with paths of light.

15 In the side wings of the pavilion, several spaces and galleries were devoted to the 'social role of light' over the previous thirty years: along with the lighting of streets and schools, these showed the interior decoration of apartments, studios and offices, and prestigious window displays, notably the Bianchini-Férier display on which Dufy had collaborated. An unpublished correspondence between Marcel Roche, the secretary of the committee of honour of the 'Salon de la Peinture Lumineuse', and Raoul Dufy, written between 25 January and 11 May 1937, reveals the artist's contribution to the realization of Bianchini's window-display (2.5 m [98⅜ in.] broad, 1.5m [59 in.] deep, 4 m [157½ in.] from floor to ceiling): the choice of fabrics, arrangements of the display and lighting effects.

16 Unpublished letter dated 7 July 1936, from M Malagarie to Dufy. It confirms the commission, agrees the financial conditions under which the work was to be done (the price was fixed at 290,000 Francs), identifies the duties and responsibilities of both parties and stipulates the artist's obligation to make a small-scale version, after the completion of the fresco, for C.P.D.E.

17 Lucretius, in his De Natura Rerum, sought to abolish the power of the gods over natural phenomena such as storms, thunder and lightning, giving a materialist explanation for physical phenomena.

18 These are mentioned in one of Dufy's Carnets No. A.M. 36–51–8, Musée National d'Art Moderne). They are La Vie des savants illustrés depuis l'Antiquité à nos jours (Paris, 1860–70), with a brief appreciation of their works, and the Merveilles de la science (Paris, 1867–91), from which Dufy drew his inspiration in reconstructing the scientists' discoveries and experiments.

19 See André Berne Joffroy, Zig-zag parmi les personnages de la Fée électricité, Musée d'Art Moderne de la Ville de Paris, 1983, a book about the scientists and their experiments.

20 Unpublished letter of 17 December 1936, from E. Epailly, the curator of the Musée de Beaune, addressed to Dufy in reply to his questions.

21 Letters from Professor Wolkringer, dated 11 October, 9 November and 13 December 1936, and 8 March 1937.

22 Unpublished letter, 22 March 1937.

23 Unpublished letters dated 26 November 1936, 30 November 1936 and 13 December 1936, which also deal with a portrait of Coulomb in his possession.

24 See Bernard Dorival, La Belle Histoire de la Fée électricité, Paris, La Palme, 1953, p. 8.

25 'Resinated oil, emulsified in gummed water'. This medium, subjected to scientific tests in laboratories in London and Paris, was the subject of two papers delivered to the Académie des Sciences sessions held on 26 October 1931 and 9 October 1933).

26 Jacques Maroger, 'Comment J'ai Découvert le Médium', in La Renaissance, February 1936.

27 Its removal from the studio in the Impasse de Guelma necessitated the demolition of one of the room's partition walls. See M. Havel, in Journal de l'amateur d'art, June 1964.

28 Dufy painted a large number of individual studies for each of the musicians in the orchestra, and then painted ensemble studies.

29 The Pavillon de la Publicité, in the Champ de Mars, beside the Eiffel Tower, had a façade 15 metres long, made up of a metal grille designed to bear enormous messages in lights.

30 Text from 14 December 1937, in 1937 – Exposition internationale des arts et techniques, Paris, Musée National d'Art Moderne, 20 June – 20 August 1979, p. 12.

31 'The miraculous rightness of a particular line or a particular patch of colour is not the fruit of some divine chance; it is the fruit of a long development, doubtless governed by a supreme creative power,' letter from Gabriel Dessus to Louis Carré, 23 June 1953.

32 The conception, development and execution of the work took ten months (7 July 1936 – 24 May 1937). The painting alone took four months (end of January 1937 – May 1937).

33 Some parts of La Fée Électricité could be seen during this period, at temporary exhibitions, such as the one at the Musée National d'Art Moderne, in 1953, devoted to Raoul Dufy (No. F8 78 in the catalogue). La Fée Électricité and its small-scale replica were a gift of the E.D.F. to the Musée d'Art Moderne de la Ville de Paris, where they bear the inventory number 1689.

In the meantime, the C.P.D.E. was nationalized. In 1951 the E.D.F., with Gabriel Dessus and the publisher Pierre Bérès, decided to publish a colour lithograph reproduction, 1 metre high by 60 centimetres wide. It was made by Fernand and Maurice Mourlot, with the assistance of Charles Sorlier.

Between 1951 and 1952, Raoul Dufy repeated the work in gouache, retouching the figures, modifying certain of the colours, eliminating certain details and making an original work that appeared in 1953, after his death. It is preserved in the Musée National d'Art Moderne (Gift of the friends of the Museum, 1957). See Bernard Dorival, 'Un Chef D'Oeuvre de Raoul Dufy entre au Musée d'Art Moderne', in Revue des arts, No. 4, July–August 1957. In 1954, Pierre Bérès published a six-square-metre lithograph from the original sketch.

34 The bar was destroyed in 1963 to make way for the Salle Gémier, in the theatre of the Palais de Chaillot. The ensemble of Dufy's decoration, made up of three panels, was transferred to the Musée National d'Art Moderne. Friesz's composition, preserved at the Palais de Chaillot, was remounted in the building's conference room.

35 See Catalogue of the 'Paris 1937 – Cinquantenaire (note 8), p. 372.

36 The contract between Dufy and his patrons was signed in 1936. Dufy received his fees, which totalled 66,000 Francs, in April 1937.

37 Unpublished letter from Raoul Dufy, dated 22 October 1937, to MM. Jacques Carlu, Louis Boileau and Léon Azéma, the architectural directors at the Ministère des Affaires Culturelles.

38 This first decoration was discovered in 1978, during the cleaning of the offices of the department of French Monuments in the Palais de Chaillot.

39 We prefer to date this study from between 1937 and 1938 rather than the earlier dating of 1925.

40 Three pen drawings of Standing Nude (Musée des Beaux-Arts, Dijon, Inventory Nos. 4671, 4673 and 4674).

41 Drawing of Standing Nude (Musée Jules-Chéret, Nice, Inventory No. M.81.04), originally believed to date from 1928, and which we must now date 1938.

42 Three pen drawings of Standing Nude (Musée Jules-Chéret, Nice, Inventory Nos. A.M. 29–23–D.727, 728, 729).

43 'For the upper part of the composition, we must forget the point of view of the distance, spread the colour flat and draw freely. Thus, the far-off twists and turns of the Seine in the right-hand part of the Île-de-France, and more particularly in the top left-hand part, the sky, La Hève and Le Havre should be given a cobalt and white tone, freely applied, as in my painting of the Regattas, the drawn-in clouds are set in blue or white, but there are no white patches apart from the large cumulus cloud that appears over La Hève. The sea is grey, the wave effects captured in pearly black and white, the triton in the grey area among black pointed waves forming a shadow cast by a large cloud imagined far above, the blue of the sea only returning with the ship returning up the Seine, the blue spreading to the bottom of Honfleur', unpublished handwritten document.

44 A squared-up pencil drawing, highlighted with watercolour and gouache, can be linked with this third panel. It is a landscape, preserved in the Musée

Jules-Chéret, Nice, Legacy of Mme Dufy 1962, Inventory No. A.M. 29–23–D.774 C5639. We suggest 1938 as the date of its execution, rather than the earlier date of 1925–30.

The reverse of this drawing shows a squared landscape drawn in pencil, very roughly sketched, with handwritten notes identifying cities and sites (Saint-Cloud, Pontoise, Sèvres, Mantes, etc.) which we consider to be a preparatory work for the right-hand panel.

45 Waldemar-George, introduction of the catalogue for the exhibition 'Raoul Dufy', Paris, Galerie Kaganovitch, 1936.

46 One of the standing nudes in this composition resembles the figure of Peace made by Friesz for the cartoon of a tapestry for the Gobelins factory (1936), designed to decorate the committee room of the League of Nations in Geneva.

47 The opening in 1635 of the Royal Garden of Medicinal Plants at the suggestion of Hérouard, the chief physician of Louis XIII, decreed by Royal letters of patent, was the basis for the creation of the Muséum d'Histoire Naturelle. The Monkey-House, first rebuilt between 1835 and 1837 by the chief architect Rohault de Fleury, was damaged in the bombing of 8 and 9 January 1871, and then during the First World War, and was consequently demolished.

48 Sales Catalogue of the Bignou Collection, 6 June 1975, Hôtel Drouot. Étienne Bignou, in an unpublished letter of 27 December 1939 to Dufy, who was then at Saint-Denis-sur-Sarthon, replied: 'These two damnable commissions which have been literally poisoning you for two years now,' adding philosophically, '[. . .] and, most importantly, let this be a lesson to you for the future. But, alas, I write this without fully believing it since, thanks to your eternal youthfulness, which generates such enthusiasm in you, you will still be capable [. . .] of taking on, for whatever reason, some similar 'disaster', without, of course, having asked the advice of wise old father Bignou.'

49 Quoted in Pierre Courthion, Raoul Dufy, Geneva, Cailler, 1951, p. 50.

50 One of these is preserved in the Musée National d'Art Moderne (Legacy of Mme Dufy, No. A.M. 29–23–D).

51 See Michel Hoog and Bernard Dorival, 'Le Legs de Mme Raoul Dufy au Musée National d'Art Moderne', in La Revue du Louvre et des Musées de France, Nos. 4–5, 1963, pp. 209–236.

52 Pierre Courthion, 'Mes Conversations avec le peintre', preface to catalogue Raoul Dufy, Geneva, Musée d'Art et d'Histoire, 1952, unpaginated.

53 The reverse of the drawing for Freycinet bears a handwritten pencil note, 'Freycinet', at the bottom right-hand side of a sketch of a nude, a reversal of the pose of the scientist in the painted version.

54 See Antoinette Rézé-Huré, 'Raoul Dufy, le signe', Cahiers du Musée National d'Art Moderne, No. 5, 1980, p. 947, who also compares the figures of Saint-Hilaire and Livingstone with those of Maxwell and Stanley in La Fée Électricité.

55 The identities of Wilberforce and Huxley are not specified. In the watercolour the name 'Voronoff', absent from the finished work, is written above the scientist to the right of Galen, while that of Spencer is shown on his suit. Seated in the foreground, d'Orbigny replaces De Blainville in the final version. In the right-hand foreground, Dufy substituted Schlegel for Conrad Temmynck.

56 This drawing bears the handwritten note 'Phèdre' in pencil on the bottom left-hand side.

CHAPTER XII

1 André Fermigier, Picasso, Librairie Générale Française, Le Livre de Poche, 1969, p. 364.
2 See Memories of Dr Bernard Nicolau in Bulletin des amis du Musée Hyacinthe-Rigaud, No. 4, 'Spécial Raoul Dufy' (exhibition November 1985–January 1986).
3 Letter to Carré, quoted in Jacques Lassaigne, Raoul Dufy, Geneva, Skira, 1951, p. 78.
4 Ibid.

5 *La Querelle du réalisme*, edited by Serge Fauchereau, Diagonales, republished 1987, pp. 250–51.
6 *Ibid.*
7 *Ibid.*
8 *Carnet* No. 6, sheet 12 (A.M. 36–49–D, Musée National d'Art Moderne).
9 *See* Jean-Michel Palmier, *Weimar en exil*, Payot, 1987, pp. 320–21.
10 Dr Nicolau's house is now the Hôtel de Ville at Vernet-les-Bains.
11 Raoul Dufy used sheets of newspapers as a palette for the preparation of his paints; beside him, water was held in a little iron container (a sort of cake tin); two trays fixed on collapsible stools supported his sheet of Rives paper.
12 *See* Roland Dorgelès, *Vacances forcées*, Éditions Vialetey, 1956, p. 88.
13 Letter to Louis Carré, quoted in Jacques Lassaigne (note 3), p. 87.
14 Letter to Dr Nicolau of 30 December 1943, Paris.
15 Letter to Berthe Reysz of 3 January 1944, Paris.
16 *See* Dufy's notes on the back of the watercolour *Orchestra with Pianist*, ill. 360.
17 In Catalan Pablo Casals is known as Pau Casals.
18 Every summer the town of Prades holds a Pablo Casals festival.
19 This might be Pixot, the famous violinist, a violin teacher in Perpignan, one of Raoul Dufy's friends in the city.
20 Henri Pepratx-Saisset, *La Sardane*, Perpignan, Labau, 1956, p. 9.
21 In 1946 Dufy left his ground-floor studio in the Rue Jeanne-d'Arc for a studio at 2, Rue de l'Ange, an apartment rented by Alfred Sauvy after the death of his mother.
22 The round-dance of the Sardane had inspired Matisse in 1906, in *La Joie de vivre* (Barnes-Merion Foundation, Philadelphia), and he returned to the subject in 1910, in *La Danse* (Hermitage Museum, Leningrad).
23 The complete cobla is made up of twelve instruments, played by nine musicians in Spanish Catalonia and seven musicians in Roussillon: the *fiscorn*, a brass instrument, a huge valve trumpet, plays deep notes, while the *prima* or *tible* emits high notes; the *tenor* or *tenora*, a sort of long wooden flute with a metal casing, plays the opening of the Sardane. These main instruments are joined by the *flabiol*, a tiny four-holed flute; the *tamoulette*, hung around the neck, played by the musician holding the *flabiol*; the *tambouri*, a taut two-skinned tambourine, beats a triple rhythm; the double bass; a trombone; two valve trumpets.
24 These two works reproduce two Tournon fabrics, printed at Bianchini-Férier, from original models by Dufy, *Composition with Arum Lillies* and *Still Life with Bouquet*.
25 Statement by Raoul Dufy in Pierre Courthion, *Raoul Dufy*, Geneva, Cailler, 1951, p. 65.
26 During the summer of 1948, Dufy spent almost three months with the Comtesse de Tessac, upon the recommendation of the poet Ludovic Massé.
27 *See* unpublished letter from Mme Paul Valéry to Raoul Dufy, October 1946: 'Monsieur, it has made me very happy to know that you are going to illustrate the *Bucolics* in my husband's translation [. . .] I cannot imagine a more desirable collaboration, or a more beautiful illustration of the work undertaken by Dr Roudinesco. [. . .] The glimpse that I have just had of your first two projects positively delighted me. Nothing could match the success of the colour page in terms of imagination, vigour and novelty of composition, and that magical use of colours that you have made your own. [. . .] And I am happy to imagine the series of watercolours to which these new *Bucolics* will inspire you.'
28 Between 1931 and 1936, Raoul Dufy had illustrated Daudet's *Tartarin de Tarascon*, at the request of Dr Roudinesco for the bibliophile circle 'Scripta et Picta', of which he was director.
29 Unpublished letter to Roudinesco dated 25 October 1947.
30 Unpublished letter to Roudinesco dated 4 November 1947.
31 'As I should like to put my conscience at rest, I have just repainted the whole of the illustration of the Virgil in colour, not in coloured drawings, but in real colour paintings [. . .]; of course they're very pretty, but they don't have the beauty of my black-and-white drawings, as I have explained to Roudinesco. So I shall soon have finished, and then with these colour paintings, the drawings on the pages of the Virgil and the lithos that we have printed of them, everything will make up a portfolio about which judgment can be formulated'. Extract from a letter from Raoul Dufy to André Robert, typed by his secretary, 4 November 1947.
32 Letter to Roudinesco, 4 November 1947.
33 'My decision is firm [. . .] and if they won't listen to me I shall use these drawings for some *Bucolics* of my own, with some stupid classical translation like the one by Dellile [*sic*].' Extract from a letter from Dufy to Ludovic Massé dated 24 October 1947.
34 After Raoul Dufy, an attempt was made to use Lurçat as illustrator; but in the end Dr Roudinesco commissioned Jacques Villon to make the colour plates for Virgil's *Bucolics*, published in 1953, after Dufy's death.
35 Quoted in Virgil, *Les Bucoliques*, Paris, G[?] Flammarion, 1967.
36 Unpublished letter from Dufy to Roudinesco 22 March 1947.
37 Unpublished letter from Dufy to Roudinesco, April 1947.
38 Gide's *Les Nourritures terrestres* was published in 1950. This edition, with twelve watercolours by Raoul Dufy, had as an appendix *Les Nouvelle[?] nourritures terrestres*, written in 1935. We should remember that the first edition appeared in 189[?] with Mercure de France, and that the work was republished with a preface by the author in 1927.
39 *See* unpublished letter to Ludovic Massé, dated 28 August 1946: 'I have sworn that I shall never attend another corrida in Roussillon.'
40 Unpublished letter to Ludovic Massé, 25 July 1949.
41 Letter to Ludovic Massé, 24 December 1949.
42 *See* unpublished letter to Massé, 6 April 1950[?] Boston.
43 Unpublished letter to Massé, 16 June 1950.
44 *Ibid.*
45 *See* Chapter IV.
46 The portraits are of Jacques Maroger, Olg[a] Maroger, Berthe Weill, Gjon Mili and Dr Fredd[y] Homburger.
47 'I am living in an adorable Mexican house in [a] desert of cactus [. . .]. My state of health ha[s] improved; we might say that I have gained 70% i[n] my general state and 50% in my rheumatic con[?]dition.' Extract from an unpublished letter t[o] Massé, 25 February 1951, Tucson.
48 *See* unpublished letter to Dr Nicolau, 10 Ma[y?] 1951, Tucson.
49 'Raoul Dufy has won a victory for Frenc[h] colour at the Venice Biennale,' André Warnod, *L[e] Figaro*, 16 June 1952.
50 Letter to Ludovic Massé dated 11 December 1952, from Forcalquier.
51 *Ibid.*
52 *Ibid.*
53 Raoul Dufy gave the proceeds from his Venic[e] Biennale Grand Prix to the French painter Charle[s] Lapicque and the Venetian painter Vedova.

CHRONOLOGY

1877
3 June, birth of Raoul Dufy in Le Havre

1891
Employed by Luthy and Hauser's coffee importing company

1892
Evening classes given by Charles Lhuillier, with Othon Friesz, at the École Municipale des Beaux-Arts du Havre

1895–1898
Painting from life, in watercolours, of the landscapes of the city of Le Havre and its surroundings; self-portraits and portraits of the members of his family

1898–1899
Year of military service

1900
Met Othon Friesz at the École des Beaux-Arts de Paris, in Léon Bonnat's studio

1901
Exhibits *Evening in Le Havre*, at the Salon des Artistes Français

1902
Berthe Weill accepts him into her shop in the Rue Victor-Massé, for a group exhibition. She is the first buyer of one of his pastels, *La Rue de Norvins*

1903
Exhibits at the Salon des Indépendants, showing works of Impressionist influence

1904
Journey to Fécamp with Marquet

1905
Discovers *Luxe, calme et volupté* by Matisse at the Salon des Indépendants

1905
'La Cage aux Fauves' at the Salon d'Automne. Dufy allies himself with Fauvism

1906
First solo exhibition at Berthe Weill's gallery. First work sent to the Salon d'Automne. In the company of Marquet, paints *Posters at Trouville*

1907
First work in wood engraving

1908
Stay in Marseilles, then in l'Estaque, with Braque, in Cézanne's footsteps

1908–1915
'Paracubist' experiment. Works inspired by Cézanne

1909
Dufy sets up in a studio in the Rue Séguier. Journey to Munich with Othon Friesz. Left by his dealer, Blot, a year previously, he ceases to sell his works

1910
Studio, 27 Rue Linné. Friendship with Fernand Fleuret. Stays in Orgeville, in Président Bonjean's Villa Médicis Libre, where he meets André Lhote and Jean Marchand

1910–1911
Illustrates Guillaume Apollinaire's *Le Bestiaire* with wood engravings made with pen-knife and gouge

1911
Marries Eugénie Brisson in the mairie of the 18th arrondissement, Paris. Sets up his studio, 5 Impasse de Guelma, Montmartre
Meets Paul Poiret, for whom he makes various decorative works (headings for writing paper and invoices; various decorations for the couturier's 'parties'). Starts up the Petite Usine with Poiret. Prints his wood engravings on fabrics

1912
Contract with the firm Atuyer-Bianchini-Férier, which employs him to supply designs in gouache and watercolour for fabrics. Continues his work on fabric design during the war and up until 1928

1917–1918
Employed by the Musée de la Guerre

1919
First stay in Vence

1920
Develops a personal style. Illustrates Stéphane Mallarmé's *Les Madrigaux*. Contract with the Galerie Bernheim-Jeune, renewed in 1921. Designs the sets for Jean Cocteau's *Le Boeuf sur le toit*, with music by Darius Milhaud. Makes drawings for the *Gazette du bon ton*

1921
First exhibition at the Galerie Bernheim-Jeune. Subsequent exhibitions will be held in 1922, 1924, 1926, 1927, 1929 and 1932

1922
Designs the sets for the ballet *Frivolant*. Series of *Oarsmen on the Marne*, which he had started in 1919. Meets Josep Llorens Artigas

1922–1923
Travels to Florence, Rome and Naples. Stays in Sicily, where he meets Pierre Courthion

1923–1924
Beginning of his ceramic projects with Artigas, a collaboration which will continue until 1938

1923
First exhibition in Brussels. Wins the praise of the Belgian critics

1924
First studies the technique of tapestry

1925
Makes 14 hangings for the decoration of Paul Poiret's barge, *Orgues*. Illustrates *La Terre frottée d'ail* by Gustave Coquiot. Makes a poster for the Oriental exhibition at the Bibliothèque Nationale. Designs tapestry cartoons for a set of drawing-room furniture, *Paris*, for the Beauvais factory.

1926
Makes lithographs to illustrate Guillaume Apollinaire's *Le Poète assassiné*

1926–1933
Frequent visits to the South of France and Normandy

1926
Travels to Morocco with Paul Poiret. Moroccan watercolours shown in 1927 at Bernheim-Jeune

1927–1933
Mural decoration for Dr Viard's dining room

1928

Mural decoration of M Weisweiller's villa L'Altana in Antibes. In Deauville, series of races and regattas, which he continues over the next few years

1930

Travels to England. Paints *Les Cavaliers sous bois* (portrait of the Kessler family). Illustrates Eugène Montfort's *La Belle Enfant*

1931

Begins to illustrate *Tartarin de Tarascon* by Alphonse Daudet, having been commissioned by Dr Roudinesco. The work will be finished in 1936

1932

The Paddock in Deauville, first painting to be bought by the Musée du Luxembourg

1933

Paints the sets and designs the costumes for the ballet *Palm Beach* for Comte Étienne de Beaumont

1934

Sets for *L'Oeuf de Colomb* by René Verdyck. Exhibition in Brussels. Paints a tapestry cartoon, *Paris*, for Marie Cuttoli, which is woven by Tabard in Aubusson. Makes the cartoons for a set of *Paris* dining-room chairs

1935

Meets the chemist Jacques Maroger. Perfection of the 'Maroger medium', which he adopts henceforward

1936

Designs the *Paris* tapestries for Marie Cuttoli

1936–1937

Decoration for the Pavillon de l'Électricité at the 1937 International Exhibition: *La Fée Électricité*

1937

First attacks of polyarthritis. Stays in the United States, where he is a member of the jury for the Carnegie Prize in Pittsburgh

1938

Travels to Venice

1939

Based in Saint-Denis-sur-Sarthon, he finishes the decorative panel for the bar in the new theatre at the Palais de Chaillot: *The Seine, from Paris to the Sea* (*The Seine, the Oise and the Marne*). Completes the decoration of two panels for the Monkey-House at the Jardin des Plantes. Makes cartoons for a set of drawing-room tapestries, *The Cortège of Orpheus*, for Marie Cuttoli

1940

Refugee in Nice, then in Perpignan. He stays with his doctor, Dr Nicolau, then in a studio in the Rue Jeanne-d'Arc

1941

Taking the advice of André Lurçat he makes two tapestry cartoons, *Collioure* and *The Fine Summer*. He begins the major series of studios and orchestras. Louis Carré becomes his dealer

1941–1944

Frequently stays in Vernet-les-Bains

1943–1944

Stays in Montsaunès, with Roland Dorgelès

1943

Short stay in Paris. Return to the South of France

1944

Makes the sets and costumes for Armand Salacrou's *Les Fiancés du Havre*

1945

Begins the series of *Black Freighters*. Paints the series of *Threshings*

1946

Begins his monotonal painting. Sets up in a new studio at 2 Rue de l'Ange, Perpignan

1946–1950

In drawings and watercolours he designs illustrations for Virgil's *Bucolics*

1948–1949

Makes 8 tapestry cartoons for Louis Carré

1949

Cure at Caldas de Montbuy. Stay in Toledo

1950

Travels to the United States. Stays in Boston, at the Jewish Memorial Hospital, where he receives cortisone treatment from Dr Homburger

1951

Sets for Jean Anouilh's *L'Invitation au château*, staged by Gilbert Miller under the title *Ring Round the Moon*. Stays in Tucson, Arizona. Returns to Paris

1952

Receives the Grand Prix of the 226th Venice Biennale. The Musée d'Art et d'Histoire, Geneva, organizes an exhibition of his works. Dufy sets up in Forcalquier

1953

On 25 March, Raoul Dufy dies in Forcalquier; he is buried the same day in the Cimiez cemetery

LIST OF ILLUSTRATIONS

The initial L refers to Maurice Laffaille's catalogue raisonné, and GL to the catalogue raisonné by Fanny Guillon-Laffaille; the Roman numerals indicate the volume, and the arabic numerals the number of the reproduction. The initials BF refer to the inventory numbers of the Société Bianchini-Férier.

CHAPTER I

1 *Self-Portrait.* 1901. Watercolour, 28 × 19 cm (11 × 7½ in.). Private Collection. GL I, 15. Photo Flammarion.

2 *House and Garden at Le Havre* (detail of ill. 39).

3 *The Quay on the Bassin du Commerce.* Around 1950. Pen-and-ink drawing, 29 × 21 cm (11¾ × 8¼ in.). Photo Flammarion.

4 *The Le Havre Brass Band.* Around 1950. Pen-and-ink drawing, 29 × 21 cm (11¾ × 8¼ in.) Private Collection. Photo Flammarion.

5 *Landscape near Le Havre.* 1897. Oil on cardboard, 19 × 27 cm (7½ × 10⅝ in.). Dedicated 'To my friend Friesz, January 97, R. Dufy'. Private Collection. L Supp. I, 1816. Photo Flammarion.

6 *The Family Table.* Around 1903–1908. Pen-and-ink drawing, 50.6 × 66 cm (20 × 26in.). Bordeaux, Musée des Beaux-Arts. Photo Museum.

7 *Marius Dufy Conducting a Choir.* Around 1950. Pen-and-ink drawing, 29 × 21 cm (11¾ × 8¼ in.). Private Collection. Photo Flammarion.

8 *The Orchestra of the Théâtre du Havre.* 1902. Oil on canvas, 114 × 146 cm (44⅞ × 57½ in.). Private Collection.

9 *The Offices of the Luthy & Hauser Company in Le Havre.* 1898. Around 1950. Pen-and-ink drawing, 29 × 21 cm (11¾ × 8¼ in.). Private Collection. Photo Flammarion.

10 *The Orchestra of the Théâtre du Havre.* Around 1950. Pen-and-ink drawing, 29 × 21 cm (11¾ × 8¼ in.). Private Collection. Photo Flammarion.

11 *Le Havre, the Docks.* 1898. Watercolour, 25 × 31 cm (9⅞ × 12¼ in.). Le Havre, Musée des Beaux-Arts. GL I, 4. Photo J. Foultier-Photorama.

12 Photograph of Le Havre: the Place Gambetta and the Bassin du Commerce. Photo ND-Viollet.

13 Othon Friesz, Raoul Dufy (on the right) and the sculptor Bouchard in Friesz's studio in Paris, in 1901.

14 *The Beach at Saint-Adresse.* 1902. Oil on canvas, 54 × 65 cm (21¼ × 25⅝ in.). Private Collection. L I, 59. Photo Flammarion.

15 Photograph of the beach at Sainte-Adresse in 1905. Photo Roger-Viollet.

16 *Yacht Decked out with Flags.* 1904. Oil on canvas, 69 × 81 cm (27⅞ × 31⅞ in.). Le Havre, Musée des Beaux-Arts. L I, 111. Photo J. Foultier-Photorama.

17 *Boat Decked out with Flags.* 1905. Oil on canvas, 54 × 65 cm (21¼ × 25⅝ in.). Lyons, Musée des Beaux-Arts. L I, 114. Photo B. Lontin.

18 Photograph of Le Havre, Boulevard Maritime. Photo LL-Viollet.

19 *The Three Parasols.* 1906. Oil on canvas, 60 × 73 cm (23⅝ × 28¾ in.). Formerly Roudinesco Collection. L I, 130. Photo Roger-Viollet.

20 *Fishermen with Red Parasol near Sainte-Adresse.* 1907. Oil on canvas, 54 × 65 cm (21¼ × 25⅝ in.). Private Collection. L I, 159. Photo D.R.

21 *Posters at Trouville.* 1906. Oil on canvas, 54 × 73 cm (21¼ × 28¾ in.). Formerly Vinot Collection. L I, 131. Photo Giraudon.

22 *Posters at Trouville.* 1906. Oil on canvas, 65 × 88 cm (25⅝ × 34⅝ in.). Paris, Musée National d'Art Moderne. L I, 129. Photo Museum.

23 *Old Houses on the Docks at Honfleur.* 1906. Oil on canvas, 60 × 73 cm (23⅝ × 28¾ in.). Private Collection. L I, 200. Photo Flammarion.

24 *The Casino Jetty at Sainte-Adresse.* 1906. Oil on canvas, 65 × 80 cm (25⅝ × 31½ in.). Milwaukee, A. Bradley Canpan Collection. L I, 133. Photo Rickfot-Giraudon.

25 *Street Decked out with Flags.* 1906. Oil on canvas, 81 × 65 cm (31⅞ × 25⅝ in.). Paris, Musée National d'Art Moderne. L I, 214. Photo Bahier-Migeat.

26 *Terrace Overlooking the Beach.* 1907. Oil on canvas, 46 × 55 cm (18⅛ × 21⅝ in.). Musée d'Art Moderne de la Ville de Paris. L I, 241. Photo Bulloz.

27 *Jeanne in Flowers.* 1907. Oil on canvas, 90 × 78 cm (35⅜ × 30¾ in.). Le Havre, Musée des Beaux-Arts. L I, 204. Photo J. Foultier-Photorama.

28 *Basket of Fruit.* Around 1910–12. Oil on canvas, 73 × 60 cm (28¾ × 23⅝ in.). Private Collection. L I, 393. Photo Flammarion.

29 *Boats at Martigues.* 1907. Oil on canvas, 65 × 81 cm (25⅝ × 31⅞ in.). London, Artemis and Co. Photo Flammarion.

30 *View from the Terrace.* 1907. Oil on canvas, 54 × 65 cm (21¼ × 25⅝ in.). Private Collection. L I, 245. Photo Flammarion.

31 *Boats in the Quay at Marseilles.* 1908. Oil on canvas, 73 × 60 cm (28¾ × 23⅝ in.). Paris, Musée National d'Art Moderne. L I, 346. Photo Museum.

32 *The Casino Marie-Christine.* 1910. Oil on canvas, 65 × 81 cm (25⅝ × 31⅞ in.). Le Havre, Musée des Beaux-Arts. L I, 346. Photo Museum.

33 *The Paddock.* 1913. Oil on canvas, 81 × 60 cm (31⅞ × 23⅝ in.). Musée d'Art Moderne de la Ville de Paris. L I, 322. Photo Bulloz.

34 *Trees at l'Estaque.* 1908. Oil on canvas, 54 × 65 cm (21¼ × 25⅝ in.). Private Collection. Photo Flammarion.

35 Georges Braque, *The Trees.* 1908. Oil on canvas, 73 × 60 cm (28¾ × 23⅝ in.). Copenhagen, Statens Museum for Kunst. Photo H. Petersen.

36 *The Aperitif.* 1908. Oil on canvas, 59 × 72.5 cm (23¼ × 28⅝ in.). Musée d'Art Moderne de la Ville de Paris. L I, 339. Photo Giraudon.

37 *Public Garden at Hyères.* 1913. Drawing, crayon highlighted with gouache, 50.5 × 65 cm (20 × 25⅝ in.). Nice, Musée des Beaux-Arts. Photo M. de Lorenzo.

38 *The Abandoned Garden.* 1913. Oil on canvas, 155 × 170 cm (61 × 66⅞ in.). Musée d'Art Moderne de la Ville de Paris. L I, 416. Photo Bulloz.

39 *House and Garden at Le Havre.* 1915. Oil on canvas, 117 × 90 cm (46⅛ × 35⅜ in.). Musée d'Art Moderne de la Ville de Paris. L I, 391. Photo Bulloz.

40 *Woman in Pink.* 1912. Oil on canvas, 105 × 80 cm (41⅜ × 31½ in.). Private Collection. L I, 371. Photo Giraudon.

41 *Woman in Pink.* 1908. Oil on canvas, 81 × 65 cm (31⅞ × 25⅝ in.). Paris, Musée National d'Art Moderne. L I, 331. Photo Museum.

42 *Bather.* 1919. Pen-and-ink drawing, 24 × 32 cm (9½ × 12⅝ in.). Private Collection. Photo Flammarion.

43 *The Large Bather.* 1914. Oil on canvas, 245 × 182 cm (96½ × 71⅝ in.). The Hague, Collection of A.E. Roëll-Jas. L I, 373.

44 Study for *The Large Bather.* 1914. Red pencil drawing, 56 × 45 cm (22 × 17¾ in.). Private Collection. Photo Flammarion.

45 *The Beach.* 1906. Oil on canvas, 65 × 81 cm (25⅝ × 31⅞ in.). Private Collection. L I, 38. Photo Flammarion.

46 Photograph of Raoul Dufy on the beach at Le Havre.

47 Photograph of Paul Poiret in May 1926. On the wall is Dufy's painting, *Homage to Mozart.* Photo Roger-Viollet.

48 *Homage to Mozart.* 1915. Oil on canvas, 75 × 62 cm (29½ × 24⅜ in.). Private Collection. L I, 387. Photo Flammarion.

CHAPTER II

49 *The Pumpkin,* study for *The Mouse,* in *Le Bestiaire* by G. Apollinaire. 1910. Gouache, 55 × 46 cm (21⅝ × 18⅛ in.). Private Collection. Photo Flammarion.

50 *The Condor*. 1910–11. Illustration rejected from *Le Bestiaire* by G. Apollinaire. Wood engraving, 20.5×19.5 cm $(8 \times 7\frac{5}{8}$ in.). Private Collection. Photo Flammarion.

51 Study for *The Dance*. 1909. Indian ink wash, 23.2×28.5 cm $(9\frac{1}{8} \times 11\frac{1}{4}$ in.). Nice, Musée des Beaux-Arts. Photo M. de Lorenzo.

52 *The Dance*. 1910. Wood engraving, 31.5×31.4 cm $(12\frac{3}{8} \times 12\frac{3}{8}$ in.). Nice, Musée des Beaux-Arts. Photo M. de Lorenzo.

53 Study for *Love*. 1910. Indian ink wash, 25×25 cm $(9\frac{7}{8} \times 9\frac{7}{8}$ in.). Private Collection. Photo Flammarion.

54 *Love*. 1910. Wood engraving, 16.5×16.5 cm $(6\frac{1}{2} \times 6\frac{1}{2}$ in.). Private Collection. Photo Flammarion.

55 *Fishing*. 1910. Wood engraving, 31.5×40.8 cm $(12\frac{3}{8} \times 16$ in.). Private Collection. Photo Flammarion.

56 Study for *Hunting*. 1910. Pen and Indian ink, 10.5×30 cm $(4\frac{1}{8} \times 11\frac{3}{4}$ in.). Private Collection. Photo Flammarion.

57 *Hunting*. 1910. Wood engraving, 31.5×40.8 cm $(12\frac{3}{8} \times 16$ in.). Private Collection. Photo Flammarion.

58 *Fishing*, or *The Fisherman with a Net*. 1914. Oil on canvas, 219×66 cm $(86\frac{1}{4} \times 26$ in.). Paris, Musée National d'Art Moderne. L I, 378. Photo Lauros-Giraudon.

59 Study for *Orpheus*. 1910. Crayon and black lead. Paris, Musée National d'Art Moderne. Photo Museum.

60 *Orpheus*. 1910. Wood engraving for *Le Bestiaire* by G. Apollinaire, 33×24 cm $(13 \times 9\frac{1}{2}$ in.). Private Collection. Photo Flammarion.

61 *The Tortoise*. 1910–11. Wood engraving for *Le Bestiaire* by G. Apollinaire, 33×24 cm $(13 \times 9\frac{1}{2}$ in.) Private Collection. Photo Flammarion.

62 *The Tortoise*. 1910–11. Wood engraving for *Le Bestiaire* by G. Apollinaire, 13×18 cm $(5\frac{1}{8} \times 7\frac{1}{8}$ in.). Private Collection. Photo Flammarion.

63 Study for *The Tibetan Goat*. 1910. Black pencil. Paris, Musée National d'Art Moderne. Photo Museum.

64 *The Mouse*. 1910–11. Wood engraving for *Le Bestiaire* by G. Apollinaire, 33×24 cm $(13 \times 9\frac{1}{2}$ in.). Private Collection. Photo Flammarion.

65 *The Tibetan Goat*. 1910–11. Wood engraving for *Le Bestiaire* by G. Apollinaire, 33×24 cm $(13 \times 9\frac{1}{2}$ in.). Private Collection. Photo Flammarion.

66 *The Peacock*. 1910–11. Wood engraving for *Le Bestiaire* by G. Apollinaire, 33×24 cm $(13 \times 9\frac{1}{2}$ in.). Private Collection. Photo Flammarion.

67 *The Sirens*. 1910–11. Wood engraving for *Le Bestiaire* by G. Apollinaire, 33×24 cm $(13 \times 9\frac{1}{2}$ in.). Private Collection. Photo Flammarion.

68 *The Snake*. 1910–11. Wood engraving for *Le Bestiaire* by G. Apollinaire, 14×14 cm $(5\frac{1}{2} \times 5\frac{1}{2}$ in.). Private Collection. Photo Flammarion.

69 *The Snake*. 1910–11. Wood engraving for *Le Bestiaire* by G. Apollinaire, 20×19 cm $(7\frac{7}{8} \times 7\frac{1}{2}$ in.). Private Collection. Photo Flammarion.

CHAPTER III

70 Dressing-gown by Paul Poiret, Bianchini-Férier fabric *Bagatelle*. 1923. Paris, Musée de la Mode et du Costume. Photo Chantal Fribourg.

71 *The Skaters*. Around 1920. Gouache, 64×49 cm $(25\frac{1}{4} \times 19\frac{1}{4}$ in.). BF 51850. Photo Archives Bianchini-Férier.

72 Vignette for the headings of Paul Poiret's writing paper. 1910. Wood engraving, 17×14 cm $(6\frac{3}{4} \times 5\frac{1}{2}$ in.). Private Collection. Photo Flammarion.

73 Cravat, fabric made at the Petite Usine by Raoul Dufy himself. 1910–11. Private Collection. Photo Flammarion.

74 *Toute la forêt*. Perfume by Rosine. 1917. Wood engraving, 12.5×20 cm $(5 \times 7\frac{7}{8}$ in.). Private Collection. Photo Flammarion.

75 *La Petite Usine*. 1910. Indian ink drawing, 48.7×63.4 cm $(19\frac{1}{8} \times 25$ in.). Paris, Musée National d'Art Moderne. Photo Museum.

76 Coat in the fabric *La Perse*, made in the Petite Usine.

77 *Hunting*. 1910. Hanging, 200×200 cm $(78\frac{3}{4} \times 78\frac{3}{4}$ in.). Private Collection. Photo Giraudon.

78 *The Shepherdess*. 1910. Hanging, 150×155 cm $(59 \times 61$ in.). Private Collection. Photo Flammarion.

79 Invitation card for the feast of 'The Thousand and Second Night'. 1911. Private Collection. Photo Flammarion.

30 Paul Poiret in sultan's costume. 1911. Pen-and-ink drawing. Private Collection. Photo Flammarion.

81 Decoration of one of the doors of the antechamber of Butard's villa. Seated, Denise Poiret.

82 *Dresses for Summer 1920*, for the *Gazette du bon ton*. 1920. Pencil drawing. 24×70 cm $(9\frac{1}{2} \times 27\frac{5}{8}$ in.). Private Collection. Photo Flammarion.

83 *Dresses for Summer 1920*, for the *Gazette du bon ton*. 1920. Gouache, 25.2×74.5 cm $(9\frac{7}{8} \times 29\frac{3}{8}$ in.). Lyons, Musée Historique des Tissus. Photo Basset.

84 Detail study for the hanging, *The Reception at the Admiralty*. 1925. Pen and brown ink. Lyons, Musée Historique des Tissus. Photo D.R.

85 Ensemble study for the hanging, *The Reception at the Admiralty*. 1925. Pen and gouache, 27×50 cm $(10\frac{5}{8} \times 19\frac{3}{8}$ in.). Private Collection. Photo Flammarion.

86 *The Reception at the Admiralty*. 1925. Hanging, 250×460 cm $(98\frac{3}{8} \times 181$ in.). Paris, Musée National d'Art Moderne. Photo G. Thiriet.

87 Detail study for the hanging, *The Presentation of Models at Poiret's*. 1925. Black lead, 42.5×48.3 cm $(16\frac{5}{8} \times 19$ in.). Paris, Musée National d'Art Moderne. Photo Museum.

88 *The Presentation of Models at Poiret's*. 1925. Hanging, 250×460 cm $(98\frac{3}{8} \times 181$ in.). Paris, Musée National d'Art Moderne. Photo Museum.

89 *The Presentation of Models at Poiret's*. 1941. Gouache, 32.5×65 cm $(12\frac{3}{4} \times 25\frac{5}{8}$ in.). Private Collection. Photo Galerie Malingue.

90 Detail study for *Poiret's Models at the Beach*. 1925. Black lead, 71×47.2 cm $(28 \times 18\frac{5}{8}$ in.). Paris, Musée National d'Art Moderne. Photo Museum.

91 *Baccara*. Hanging, 250×460 cm $(98\frac{3}{8} \times 181$ in.). Private Collection.

92 Detail study for the hanging, *Poiret's Models at the Races*. 1925. Black lead and Indian ink, 63.1×47.9 cm $(24\frac{7}{8} \times 19\frac{5}{8}$ in.). Paris, Musée National d'Art Moderne. Photo Museum.

93 Detail study for the hanging, *Poiret's Models at the Races*. 1925. Black lead and Indian ink, 66.9×40.6 cm $(27\frac{5}{8} \times 16$ in.). Paris, Musée National d'Art Moderne. Photo Museum.

94 *Poiret's Models at the Races*. 1925. Hanging, 280×480 cm $(110\frac{1}{4} \times 189$ in.). Private Collection. Photo Flammarion.

95 *Amphitrite*. 1925. Wash, 94×78 cm $(37 \times 30\frac{3}{4}$ in.). Private Collection. Photo Flammarion.

96 *Amphitrite*, 'Sea-Horses' and Boats. 1925. Hanging, 280×480 cm $(110\frac{1}{4} \times 189$ in.). Private Collection. Photo D.R.

97 *Paddock*. 1925. Indian ink, 50×65 cm $(19\frac{5}{8} \times 25\frac{5}{8}$ in.). Private Collection. Photo Flammarion.

98 *Paddock, the Owner's Enclosure*. Around 1925–28. Watercolour and gouache, 57×76 cm $(22\frac{1}{2} \times 29\frac{7}{8}$ in.). Private Collection. Photo Galerie Schmit.

99 Preparatory study for the hanging *The Circus*. 1925. Oil on canvas, 38×61 cm $(15 \times 24$ in.). Private Collection. L IV, 1588. Photo Flammarion.

100 *The Circus*. 1925. Hanging, 280×480 cm $(110\frac{1}{4} \times 189$ in.). Private Collection. Photo Sotheby's.

101 *Amours, Délices et Orgues*. 1925. Bianchini-Férier cotton fabric. BF 37013. Photo Archives Bianchini-Férier.

102 *Thirty*, or *La Vie en Rose*. 1931. Oil on canvas, 98×128 cm $(38\frac{5}{8} \times 50\frac{3}{8}$ in.). Musée d'Art Moderne de la Ville de Paris. L IV, 1366. Photo Bulloz.

103 Study for the poster of the 'Exposition Orientale'. Indian ink, pen and wash. Paris, Musée National d'Art Moderne. Photo Museum.

104 *Fishing*, *Hunting* and *The Dance*, with preparatory drawings and engravings. Bianchini-Férier exhibition panel. Photo D.R.

105 *The Journey to the Islands*. Around 1915. Bianchini-Férier cotton fabric, 124×118 cm $(48\frac{7}{8} \times 46\frac{1}{2}$ in.). BF 8004. Photo Archives Bianchini-Férier.

106 Dress by Paul Poiret, Bianchini-Férier satin crêpe 'Sea-Horses and Shells'. 1925. Private Collection.

107 'Sea-Horses' and Shells. 1925. Bianchini-Férier satin crêpe, 100×62 cm $(39\frac{3}{8} \times 24\frac{3}{8}$ in.), after the gouache drawing BF 16330. Photo Archives Bianchini-Férier.

108 Cape by Paul Poiret, Bianchini-Férier silk *Amphitrite*. 1925. Private Collection.

109 *Amphitrites*. 1925. Bianchini-Férier faconné silk crêpe, 65 × 130 cm (25⅝ × 51⅛ in.), after the drawing in gouache, Indian ink and watercolour, BF 16576. Photo Flammarion.

110 *Regattas*. Around 1925. Bianchini-Férier square of silk twill, 88 × 88 cm (34⅝ × 34⅝ in.). BF 85600. Photo Archives Bianchini-Férier.

111 Dress by Paul Poiret, Bianchini-Férier silk *Regattas*. 1925. Private Collection.

112 *Floral Composition and Boats*. 1922. Bianchini-Férier square of silk crêpe de Chine, 160 × 160 cm (63 × 63 in.). BF 52024. Photo Archives Bianchini-Férier.

113 *Kashmir Palmettes*. Around 1920. Gouache for a Bianchini-Férier fabric, 57 × 41 cm (22½ × 16⅛ in.). BF 593. Photo Archives Bianchini-Férier.

114 *Kashmir Palmette*. 1920. Gouache for a Bianchini-Férier fabric, 53 × 71.5 cm (20⅞ × 28⅛ in.). BF 13489. Photo Archives Bianchini-Férier.

115 *Parrots*. Around 1925–28. Gouache for a Bianchini-Férier fabric, 45.5 × 58 cm (17⅞ × 22⅞ in.). BF 52344. Photo Archives Bianchini-Férier.

116 *Arums*. Around 1920. Gouache for a Bianchini-Férier fabric, 58 × 44 cm (22⅞ × 17⅜ in.). BF 562. Photo Archives Bianchini-Férier.

117 *Leaves, Horses and Birds*. Around 1918. Gouache for a Bianchini-Férier fabric, 140 × 218 cm (55⅛ × 85⅞ in.). BF 8005. Photo Archives Bianchini-Férier.

118 *Tortoises*. Around 1919–20. Gouache for a Bianchini-Férier fabric, 105 × 70 cm (41¾ × 27⅝ in.). BF 561. Photo Archives Bianchini-Férier.

119 *Tortoises*. 1920. Bianchini-Férier faconné satin, 60 × 125 cm (23⅝ × 49¼ in.). BF 15112. Photo Archives Bianchini-Férier.

120 *The Dance Hall*. Around 1920. Gouache for a Bianchini-Férier fabric, 42 × 40 cm (16½ × 15¾ in.). BF 15099. Photo Archives Bianchini-Férier.

121 *Roses*. Around 1920. Jacquard drawing in gouache for a Bianchini-Férier fabric, 50.5 × 41 cm (19⅞ × 16⅛ in.). BF 52266. Photo Archives Bianchini-Férier.

122 *Abstract Composition*. Around 1920. Watercolour for a Bianchini-Férier fabric, 59 × 45 cm (23¼ × 17¾ in.). BF 516109. Photo Archives Bianchini-Férier.

123 *Geometrical Flowers*. Around 1920. Gouache for a Bianchini-Férier fabric, 89 × 62 cm (35 × 24⅜ in.). BF 52298. Photo Archives Bianchini-Férier.

124 *Arabesques*. Around 1915–20. Gouache for a Bianchini-Férier fabric, 78 × 64 cm (30¾ × 25¼ in.). BF 52295. Photo Archives Bianchini-Férier.

125 *Palmettes on Gold and Black Background*. Around 1925. Gouache for a Bianchini-Férier fabric, 51.5 × 36.5 cm (20¼ × 14⅜ in.). BF 14079. Photo Archives Bianchini-Férier.

126 *Butterflies*. 1921. Gouache for a Bianchini-Férier fabric, 61 × 46 cm (24 × 18⅛ in.). BF 51937. Photo Archives Bianchini-Férier.

127 *Althæas*. 1914–20. Watercolour and gouache for a Bianchini-Férier fabric, 60.5 × 48 cm (23¾ × 18⅞ in.). BF 51571. Photo Archives Bianchini-Férier.

128 *Floral Composition*. Around 1913–14. Gouache, 30 × 30 cm (11¾ × 11¾ in.). BF 297. Private Collection. Photo Flammarion.

129 *Leaves and Parrots*. Around 1925–28. Watercolour on pencil squaring, 46 × 29 cm (18⅛ × 11⅜ in.). Private Collection. Photo Flammarion.

130 *Roses*. Around 1921. Bianchini-Férier faconné satin, 75 × 125 cm (29½ × 49¼ in.). Photo Flammarion.

131 *Still Life with Fruit*. 1925. Bianchini-Férier faconné silk crêpe 65 × 130 cm (25⅝ × 51⅛ in.). Pattern Number BF 27087. Photo Flammarion.

132 *Bouquets of Roses*. 1925. Bianchini-Férier faconné silk crêpe, 130 × 130 cm (51⅛ × 51¼ in.). Pattern Number BF 27128. Photo Flammarion.

133 *Roses and Leaves*. 1925. Bianchini-Férier faconné silk crêpe, 65 × 65 cm (25⅝ × 25⅝ in.). Pattern Number BF 27128. Photo Flammarion.

134 *Roses*. 1925. Bianchini-Férier faconné silk crêpe, 65 × 65 cm (25⅝ × 25⅝ in.). Pattern Number BF 27274. Photo Flammarion.

135 *Elephants and Tigers*. Wood engraving for fabric printing. Archives Bianchini-Férier. Photo Flammarion.

136 *Elephants and Tigers*. Around 1925. Gouache for a Bianchini-Férier fabric, 86 × 57 cm (33⅞ × 22½ in.). BF 13287. Photo Archives Bianchini-Férier.

137 *Elephants*. Around 1925. Stencil and gouache for a Bianchini-Férier fabric, 82 × 82 cm (32¼ × 32¼ in.). BF 52351. Photo Flammarion.

138 *Elephants*. Around 1922–24. Bianchini-Férier silk crêpe de Chine, 155 × 80 cm (61 × 31½ in.). Photo Flammarion.

139 *Elephants and Tigers*. Wood engraving for fabric printing. Archives Bianchini-Férier. Photo Flammarion.

140 *Elephants*. Wood engraving for fabric printing. Archives Bianchini-Férier. Photo Flammarion.

141 *Polychromatic Abstract Geometrical Composition*. Around 1920. Watercolour for a Bianchini-Férier fabric, 124 × 101 cm (48⅞ × 39¾ in.). BF 16033. Photo Archives Bianchini-Férier.

142 *Tennis*. Around 1920–25. Indian ink and gouache for a Bianchini-Férier fabric, 46 × 45 cm (18⅛ × 17¾ in.). BF 52888. Photo Flammarion.

143 *The Swing*. Around 1920. Pen drawing with gouache highlights for a Bianchini-Férier fabric, 42 × 38 cm (16½ × 15 in.). BF 52025. Photo Flammarion.

144 *Monuments of Paris*. 1925. Indian ink and gouache for a Bianchini-Férier fabric, 77.5 × 88 cm (30½ × 34⅝ in.). BF 52025. Photo Archives Bianchini-Férier.

145 *The Allies*. Around 1916. Silk square, 30 × 30 cm (11¾ × 11¾ in.). Private Collection. Photo Flammarion.

146 *The Flag of Victory*. 1918. Gouache for a Bianchini-Férier fabric, 92 × 112 cm (36¼ × 44⅛ in.). BF 51727. Photo Archives Bianchini-Férier.

147 Study for *The Flag of Victory*. 1918. Black lead. Paris, Musée National d'Art Moderne. Photo Museum.

148 *Roses*. Around 1930–33. Swatches of silk fabric made by Onondaga in New York. Photo Flammarion.

CHAPTER IV

149 *Ballet*. 1950. Watercolour, 53 × 60 cm (20⅞ × 23⅝ in.). Private Collection. Photo Galerie Louis-Carré.

150 *Le Boeuf sur le toit*, the Redhaired Lady and the Lady in the Low-Cut Dress. Darius Milhaud Photo Archives.

151 *The Sailor*. Drawing for *Les Madrigaux*. 1918. Pen and Indian ink. Private Collection. Photo Flammarion.

152 Igor Stravinsky at the piano, surrounded by Arthur Honegger, Darius Milhaud, Max Jacob, Léon-Paul Fargue and Francis Poulenc. Black lead, 50 × 65 cm (19⅝ × 25⅝ in.). Private Collection. Photo M.Vaux.

153 From left to right: Céline Bugnon, Elsa Collaert, François Fratellini, Paul Fratellini, Darius Milhaud, Albert Fratellini, Darius Milhaud's mother, at the time of the staging of *Le Boeuf sur le toit*, in 'L'Enclos' (Aix-en-Provence). Darius Milhaud Photo Archives.

154 J.–E. Blanche, *Les Six*. 1924. Oil on canvas, 188 × 112 cm (74 × 44⅛ in.). Rouen, Musée des Beaux-Arts. Photo Giraudon.

155 *Le Boeuf sur le toit*, photograph of the first performance at the Comédie des Champs-Élysées, 21 February 1920.

156 *Le Boeuf sur le toit*, maquette of stage set. 1920. Darius Milhaud Photo Archives.

157 *Le Boeuf sur le toit*, photograph of the first performance at the Comédie des Champs-Élysées, 21 February 1920. Darius Milhaud Photo Archives.

158 *Le Boeuf sur le toit*, lithograph printed in *La Vogue musicale*. 1920.

159 *Le Boeuf sur le toit*, drawing for the Jockey. Darius Milhaud Photo Archives.

160 *Le Boeuf sur le toit*, drawing of the ensemble of the set. Darius Milhaud Photo Archives.

161 *Le Boeuf sur le toit*, the Man in the Suit and the Lady in the Low-Cut Dress. Darius Milhaud Photo Archives.

162 *Le Boeuf sur le toit*, the Negro Playing Billiards. Darius Milhaud Photo Archives.

163 *Frivolant*, design for the stage set. 1922. Watercolour, 50 × 65 cm (19⅝ × 25⅝ in.). Private Collection. Photo Flammarion.

164 *Palm Beach*, design for the stage set. 1933. Watercolour and gouache, 50 × 65 cm (19⅝ × 25⅝ in.). Private Collection. Photo Muller.

165 *L'Oeuf de Colomb*, design for the stage set. 1934. Gouache, 50 × 65

cm ($19\frac{5}{8} \times 25\frac{5}{8}$ in.). Paris, Bibliothèque de la Comédie-Française. GL II, 1680. Photo Comédie-Française.

166 *L'Oeuf de Colomb*, design for the stage set. 1934. Gouache, 50×65 cm ($19\frac{5}{8} \times 25\frac{5}{8}$ in.). Paris, Bibliothèque de la Comédie-Française. GL II, 1679. Photo Comédie-Française.

167 *Les Fiancés du Havre*, design for the stage set. 1944. Watercolour and gouache, 65×50 cm ($25\frac{5}{8} \times 19\frac{5}{8}$ in.). Private Collection. GL II, 1681. Photo Galerie Louis-Carré.

168 *Baccara*. Maquette for *Ring Round the Moon*. 1950. Watercolour and gouache, 50×66 cm ($19\frac{5}{8} \times 26$ in.). Private Collection. GL II, 1686. Photo Galerie Louis-Carré.

169 *Maxim's*. Maquette for *Ring Round the Moon*. 1950. Watercolour and gouache, 50×66 cm ($19\frac{5}{8} \times 26$ in.). Private Collection. GL II, 1685. Photo Galerie Louis-Carré.

170 *Arrival*. Maquette for *Ring Round the Moon*. 1950. Watercolour, 50×66 cm ($19\frac{5}{8} \times 26$ in.). Private Collection. GL II, 1688. Photo Galerie Louis-Carré.

171 *Gastronomy*. Maquette for *Ring Round the Moon*. 1950. Watercolour, 50×92 cm ($19\frac{5}{8} \times 36\frac{1}{4}$ in.). Private Collection. GL II, 1687. Photo Galerie Malingue.

CHAPTER V

172 *Fireworks at Nice. The Casino de la Jetée-Promenade*. 1947. Oil on canvas, 65.5×54 cm ($25\frac{3}{4} \times 21\frac{1}{4}$ in.). Nice, Musée des Beaux-Arts. L II, 454. Photo M. de Lorenzo.

173 *The Baie des Anges at Nice* (detail of ill. 193).

174 *The Hills of Vence*. 1919. Pencil and watercolour, 48×60 cm ($18\frac{7}{8} \times 23\frac{5}{8}$ in.). Private Collection. GL I, 87. Photo Flammarion.

175 *Le Baou de Saint-Jeanne*. 1929. Watercolour, 49×63 cm ($19\frac{1}{4} \times 24\frac{3}{4}$ in.). Private Collection. GL I, 119. Photo Flammarion.

176 *The Chapel at Vallauris*. 1927. Oil on canvas, 73×92 cm ($28\frac{3}{4} \times 36\frac{1}{4}$ in.). Private Collection. GL II, 484. Photo Bernheim-Jeune.

177 *Ancient Theatre of Taormina*. 1923. Black lead, 45×56 cm ($17\frac{3}{4} \times 22$ in.). Paris, Musée National d'Art Moderne. Photo Museum.

178 *Taormina, Etna*. 1923. Oil on canvas, 81×100 cm ($31\frac{7}{8} \times 39\frac{3}{8}$ in.). Private Collection. L II, 599. Photo Giraudon.

179 Study for *Nogent, the Oarsmen*. 1935. Black lead. Paris, Musée National d'Art Moderne. Photo Museum.

180 *Nogent, Pink Bridge and Railway*. 1935–36. Oil on canvas, 73×100 cm ($28\frac{3}{4} \times 39\frac{3}{8}$ in). Le Havre, Musée des Beaux-Arts. L III, 954. Photo J. Foultier-Photorama.

181 *Portrait of Eugène Montfort*. 1930. Pen, wash and black lead, 55×46 cm ($21\frac{5}{8} \times 18\frac{1}{4}$ in.). Private Collection. Photo Flammarion.

182 Study for *Le Salon d'Aline*. Pen and black lead, 27×20.5 cm ($10\frac{5}{8} \times 8\frac{3}{4}$ in.). Private Collection. Photo Flammarion.

183 *Le Salon d'Aline*, etching for *La Belle Enfant ou l'Amour à quarante ans* by Eugène Montfort. 1930. Photo Flammarion.

184 Study for the staircase of *Le Salon d'Aline*. 1930. Pen and Indian ink, 27×20.5 cm ($10\frac{5}{8} \times 8\frac{3}{4}$ in.). Paris, Musée National d'Art Moderne. Photo Museum.

185 The staircase of *Le Salon d'Aline*, etching for *La Belle Enfant ou l'Amour à quarante ans* by Eugène Montfort, 1930. Photo Flammarion.

186 *The Meeting of Bibliophiles*. 1931. Pen and Indian ink, 65×50 cm ($25\frac{5}{8} \times 19\frac{5}{8}$ in.). Private Collection. Photo Flammarion.

187 Lithograph for *Tartarin de Tarascon* by Alphonse Daudet. 1931–36. Photo Flammarion.

188 Lithograph for *Tartarin de Tarascon* by Alphonse Daudet. 1931–36. Photo Flammarion.

189 *Interior in Morocco. Demnat*. 1926. Black lead, 47.5×61.3 cm ($18\frac{3}{4} \times 24\frac{1}{8}$ in.). Paris, Musée National d'Art Moderne. Photo Museum.

190 *Café in Morocco*. 1926. Watercolour, 50×65 cm ($19\frac{5}{8} \times 25\frac{5}{8}$ in.). Private Collection. Photo Flammarion.

191 *La Pastilla*. 1926. Gouache, 47×59 cm ($18\frac{1}{2} \times 23\frac{1}{4}$ in.). Private Collection. GL I, 336. Photo Flammarion.

192 *The Pasha's Garden*. 1926. Watercolour, 50×65 cm ($19\frac{5}{8} \times 25\frac{5}{8}$ in.). Ottawa, National Gallery of Canada. GL I, 344. Photo Bernheim-Jeune.

193 *The Baie des Anges at Nice*. Around 1926. Oil on canvas, 61.5×74 cm ($24\frac{1}{4} \times 29\frac{1}{8}$ in.). Private Collection. L supp. 1857. Photo Galerie Malingue.

194 *Interior with Open Window*. 1928. Oil on canvas, 66×82 cm ($26 \times 32\frac{1}{4}$ in.). Private Collection. L III, 1239. Photo Galerie Malingue.

195 *Homage to Claude Lorrain*. 1926. Watercolour, 50×65 cm ($19\frac{5}{8} \times 25\frac{5}{8}$ in.). Private Collection. GL II, 1995. Photo D.R.

196 *Homage to Claude Lorrain*. 1927. Oil on canvas, 81×65.5 cm ($31\frac{7}{8} \times 25\frac{3}{4}$ in.). Nice, Musée des Beaux-Arts. L IV, 1627. Photo M. de Lorenzo.

197 *Nautical Festival at Le Havre*. 1925. Oil on canvas, 88×98 cm ($34\frac{5}{8} \times 38\frac{5}{8}$ in.). Musée d'Art Moderne de la Ville de Paris. L II, 666. Photo Bulloz.

198 *Railings*. n.d. Pen and Indian ink, 50×65 cm ($19\frac{5}{8} \times 25\frac{5}{8}$ in.). Private Collection. Photo Flammarion.

199 *Normandy*. 1928. Advertising poster for the Société Nationale des Chemins de Fer Français. Photo Flammarion.

200 *The Jetties at Trouville and Deauville. The Return of the Regatta*. 1930. Pen and Indian ink, 50×65 cm ($19\frac{5}{8} \times 25\frac{5}{8}$ in.). Private Collection. Photo Flammarion.

201 *The Jetty at Honfleur*. 1928. Oil on canvas, 65×81 cm ($25\frac{5}{8} \times 31\frac{7}{8}$ in.). Paris, Musée d'Art Moderne de la Ville de Paris. L II, 637. Photo Bulloz.

CHAPTER VI

202 *Henley Regatta*. Around 1933. Gouache, 49.5×65.5 cm ($19\frac{1}{2} \times 25\frac{3}{4}$ in.). Private Collection. Photo Galerie Malingue.

203 From a sketchbook of the races at Deauville, pen-and-ink drawing, 13×18 cm ($5\frac{1}{8} \times 7\frac{1}{8}$ in.). Private Collection. Photo Flammarion.

204 *The Harbour at Deauville*. Around 1928. Oil on canvas, 45×37 cm ($17\frac{3}{4} \times 14\frac{5}{8}$ in.). Private Collection. Photo Flammarion.

205 *Cowes Regatta*. 1935. Oil on canvas, 110×46 cm ($43\frac{1}{4} \times 18\frac{1}{8}$ in.). Private Collection. L II, 907. Photo Flammarion.

206 From a sketchbook of the races at Deauville, pen-and-ink drawing, 13×18 cm ($5\frac{1}{8} \times 7\frac{1}{8}$ in.). Private Collection. L II, 907. Photo Flammarion.

207 *The Races at Ascot, the Royal Enclosure*. 1930. Oil on canvas, 54×130 cm ($21\frac{1}{4} \times 51\frac{1}{8}$ in.). Private Collection. L III, 1297. Photo Galerie Malingue.

208 *Paddock at Nice*. 1927. Watercolour, 48×63 cm ($18\frac{7}{8} \times 24\frac{3}{4}$ in.). Private Collection. GL I, 890. Photo Galerie Malingue.

209 *The Races at Deauville*. 1933. Watercolour, 50.5×66 cm ($19\frac{7}{8} \times 26$ in.). Private Collection. Photo Galerie Malingue.

210 *Elegant Women at Epsom*. 1939. Gouache, 50×65 cm ($19\frac{5}{8} \times 25\frac{5}{8}$ in.). Private Collection. GL I, 369. Photo Galerie Malingue.

211 *The Races at Goodwood*. Around 1935. Watercolour and gouache, 50×65 cm ($19\frac{5}{8} \times 25\frac{5}{8}$ in.). Private Collection. GL I, 1051. Photo Galerie Malingue.

212 *Paddock at Ascot*. Around 1935. Gouache, watercolour and ink, 50.7×66 cm (20×26 in.). Private Collection. Photo Galerie Malingue.

213 Head study for *Les Cavaliers sous bois*. 1930. Pen and brown ink, 10.5×12.5 cm ($4\frac{1}{8} \times 5$ in.). Private Collection. Photo Flammarion.

214 Sketch for *Les Cavaliers sous bois*. Oil on canvas, 21.3×26 cm ($8\frac{3}{8} \times 10\frac{1}{4}$ in.). 1931. Paris, Musée National d'Art Moderne. L III, 1387. Photo Museum.

215 Handwritten notes, study for *Les Cavaliers sous bois*. 1931. 20×27 cm ($7\frac{7}{8} \times 10\frac{5}{8}$ in.). Private Collection. Photo Flammarion.

216 *The Boxing Match*. 1932. Pen-and-ink, 60×65 cm ($23\frac{5}{8} \times 25\frac{5}{8}$ in.). Paris, Musée National d'Art Moderne. Photo Museum.

217 *The Fall of the Water-Drinker*, illustration for *Mon Docteur le vin*, Plate 12. 1936. Établissements Nicolas. Photo Flammarion.

CHAPTER VII

218 *Vase with Scallop-Shells*. 1927–30. Height 44 cm ($17\frac{3}{8}$ in.). Paris, Musée National d'Art Moderne. Photo D.R.

219 *Garden with Fish*. 1925. Private Collection. Photo Flammarion.

220 *Vase with Ears of Corn and Bunches of Grapes*. Dated 10.XI.1924. Signatures and stamps of R. Dufy and LL. Artigas. Height 36 cm ($14\frac{1}{8}$ in.). Anguerra Collection. Photo Flammarion.

221 *Garden with Bathers.* Around 1924–25. 43 × 43 cm (16⅞ × 16⅞ in.). Paris, Musée National d'Art Moderne. Photo Flammarion.
222 *Vase with Bathers on Black Background.* Around 1925. Height 22 cm (8⅝ in.). Signed by R. Dufy and LL. Artigas, No. 63. Private Collection. Photo D.R.
223 Garden, *Le Havre Bathers.* Around 1923–24. 30 × 28 cm (11¾ × 11 in.). Private Collection. Photo Flammarion.
224 Tile, *Bather.* Around 1924. 14 × 14 cm (5½ × 5½ in.). Anguerra Collection. Photo Flammarion.
225 Garden, *Bather and Amphitrite.* Around 1924. 28.5 × 28.5 cm. (11¼ × 11¼ in.). M. Laffaille Collection. Photo Flammarion.
226 *Vase with Bathers.* Dated 28.X.1923. Signatures and stamps of R. Dufy and LL. Artigas, No. 89. Height 41 cm (16⅛ in.). Private Collection. Photo Flammarion.
227 Vase, *Bathers and Scallop-Shells.* Dated 15.II.1925. Signatures and stamps of R. Dufy and LL. Artigas. Height 38.5 cm (15⅛ in.). Anguerra Collection. Photo Flammarion.
228 *Garden with Bathers.* Around 1925–28. 25 × 25 cm (9⅞ × 9⅞ in.). Private Collection. Photo Flammarion.
229 *Goblet with Bathers.* 1938. 20.5 × 20.5 cm (8 × 8 in.). Paris, Musée National d'Art Moderne. Photo Museum.
230 *Vase with Bathers.* Around 1925. Signed R. Dufy and LL. Artigas. Height 22 cm (8⅝ in.). Private Collection. Photo D.R.
231 *Vase with Butterflies.* Dated 14.VIII.1925. Signatures and stamps of R. Dufy and LL. Artigas. Height 33.5 cm (13⅛ in.). Private Collection. Photo Sotheby's.
232 Vase, *The Springs.* Dated 24.XII.?, monogram LL. Artigas, No. 65. Height 33 cm (13 in.). Le Havre, Musée des Beaux-Arts. Photo D.R.
233 *The Spring,* set of 40 tiles. Dated 13.VIII.1925. Signatures and stamps of R. Dufy and LL. Artigas. 114 × 56 cm (44⅞ × 22 in.). Paris, Private Collection. Photo Flammarion.
234 *Vase with Fish.* 1924. Height 40.7 cm (16 in.). Private Collection. Photo Flammarion.
235 *Tile with Fish,* dedicated 'A Pierrette'. 1925. Signed R. Dufy and LL. Artigas. 14 × 14 cm (5½ × 5½ in.). Anguerra Collection. Photo Flammarion.
236 *Vase with Fish.* Dated 15.II.1925. Signatures and stamps by R. Dufy and LL. Artigas. Height 39.5 cm (15¾ in.). Anguerra Collection. Photo Flammarion.
237 *Madame Dufy.* 1930. Oil on canvas, 99 × 80 cm (39 × 31½ in.). Nice, Musée des Beaux-Arts. L III, 1362. Photo M. de Lorenzo.
238 *Vollard Vase.* 1930. Height 42 cm (16½ in.). Signed R. Dufy and LL. Artigas. Paris, Musée National d'Art Moderne. Photo Museum.
239 *Tile 'À Émilienne'.* 1924. Signed R. Dufy and LL. Artigas. 14 × 14 cm (5½ × 5½ in.). Paris, Musée National d'Art Moderne. Photo Museum.
240 Garden, *Tauromachie.* Around 1927. Signed R. Dufy. 22 × 47 cm (8⅝ × 18½ in.). Nice, Musée des Beaux-Arts. Photo M. de Lorenzo.
241–246 Designs for the swimming pool of the cruise-ship *Normandie.* 1935. Watercolours, 66 × 25 cm (26 × 9⅞ in.). Private Collection. Photo Artcurial (Fig. 241) and Photos Flammarion.
247 *Vase with Bathers.* Around 1945–49. Private Collection. Photo Flammarion.
248 Tile, *Girl and Scallop-Shells.* Around 1945–49. 14 × 14 cm (5½ × 5½ in.). Private Collection. Photo Flammarion.
249 Tile, *Bathers.* Around 1945–49. 14 × 14 cm (5½ × 5½ in.). Private Collection.

CHAPTER VIII

250 Design for the screen *Paris.* 1930. Gouache, 190 × 111 cm (74¾ × 43¾ in.). Private Collection. Photo D.R.
251 Tapestry for one of the seats of the dining-room suite, *Monuments of Paris,* for Marie Cuttoli. 1936. Private Collection. Photo D.R.
252 Chairs of the dining-room suite, *Monuments of Paris,* for Marie Cuttoli. 1936. Private Collection. Photo D.R.
253 Tapestry design. 1936. Oil on canvas. Private Collection. Photo Flammarion.
254 Tapestry for one of the seats of the dining-room suite, *Monuments of Paris,* for Marie Cuttoli. 1936. Private Collection. Photo Flammarion.
255 Tapestry for one of the seats of the dining-room suite, *Monuments*

of Paris, for Marie Cuttoli. 1936. Private Collection. Photo Flammarion.
256 Chair from the dining-room suite, *Monuments of Paris,* for Marie Cuttoli. 1936. Private Collection. Photo D.R.
257 Design for the screen, *Paris.* Around 1928–30. Pen-and-ink and gouache, 106 × 120 cm (41¾ × 47¼ in.). Arcurial Collection. Photo Artcurial.
258 Screen, *Paris.* 1930–31. Each section, 227 × 64 cm (89⅜ × 25¼ in.). Beauvais tapestry. Paris, Collection of the Mobilier National.
259 Tapestry cartoon for the back of the armchair, *Les Tuileries.* 1925. Watercolour and gouache, 92 × 73 cm (36¼ × 28¾ in.). Paris, Collection of the Mobilier National.
260 Tapestry cartoon for the back of the armchair, *The Champs-Élysées.* 1925. Watercolour and gouache, 92 × 73 cm (36¼ × 28¾ in.). Paris, Collection of the Mobilier National.
261 Tapestry cartoon for the back of the armchair, *The Moulin Rouge.* 1925. Watercolour and gouache, 55 × 46 cm (21⅝ × 18⅛ in.). Paris, Collection of the Mobilier National.
262 Tapestry cartoon for the back of the armchair, *L'Opéra.* 1925. Watercolour and gouache, 55 × 46 cm (21⅝ × 18⅛ in.). Paris, Collection of the Mobilier National.
263 Tapestry cartoon for armchair seat. 1925. Watercolour and gouache, 92 × 73 cm (36¼ × 28¾ in.). Paris, Collection of the Mobilier National.
264 *Monuments of Paris.* 1816. 225 × 80 cm (88⅝ × 31½ in.). Oberkampf factory at Jouy.
265 *Paris,* 1934. Aubusson tapestry, 195 × 155 cm (76¾ × 61 in.). Paris, Musée National d'Art Moderne. Photo Museum.
266 Chair, *Notre-Dame de Paris,* from the *Paris* suite of furniture. 1925. Paris, Collection of the Mobilier National.
267 Sofa from the *Paris* suite of furniture. 1928. Paris, Collection of the Mobilier National.
268 *Paris.* 1930. Gouache on canvas for a Bianchini-Férier fabric, 108 × 141 cm (42½ × 55½ in.). Photo Archives Bianchini-Férier.
269 Cartoon for the back of the sofa, *Orpheus.* 1939. Oil on canvas, 61 × 176 cm (24 × 69¼ in.). Private Collection. Photo Flammarion.
270 Armchair and chair from the suite of furniture, *Orpheus.* 1939. Aubusson tapestry. Private Collection. Photo Sotheby's.
271 Sofa from the suite of furniture, *Orpheus.* 1939. Aubusson tapestry. Private Collection. Photo Sotheby's.
272 Chair and armchair from the suite of furniture, *Orpheus.* 1939. Aubusson tapestry. Private Collection. Photo Sotheby's.
273 *Collioure.* 1941. Aubusson tapestry, 259 × 150 cm (102 × 59 in.). Private Collection. Photo Flammarion.
274 Study for the tapestry, *The Fine Summer.* 1941. Watercolour, 32 × 22.5 cm (12⅝ × 8⅞ in.). Private Collection. Photo Flammarion.
275 *The Fine Summer.* 1941. Aubusson tapestry, 246 × 429 cm (96⅞ × 168⅞ in.). Le Havre, Musée des Beaux-Arts. Photo J. Foultier-Photorama.
276 *Amphitrite.* 1936. Aubusson tapestry, 238 × 204 cm (93¾ × 80¼ in.). Gothenburg, Röhss Museum of Decorative Arts. Photo Museum.
277 Dufy by the 'Amphitrite' door, designed for the bathroom of a mansion, Avenue du Bois. 1946.
278 *The Music of Tintoretto.* 1948. Tapestry, 141 × 320 cm (55½ × 125⅞ in.). Private Collection. Photo Galerie Louis-Carré.
279 Sketch for the tapestry, *Amphitrite.* 1948. Oil on canvas. Private Collection. Photo Flammarion.
280 *Music in the Country.* 1948. Tapestry, 130 × 264 cm (51⅛ × 103⅞ in.) Private Collection. Photo Galerie Louis-Carré.

CHAPTER IX

281 Panel of mural decoration for Dr Viard's dining room. 1927–33. Oil on canvas, height 200 cm (78¾ in.). Private Collection. Photo H. Tabah.
282 *Parrots* (detail of ill. 294).
283 Robert Delaunay, *Circular Forms.* Panel of mural decoration for Dr Viard's drawing room. 1930.
284–287 Panels of mural decoration for Dr Viard's dining room. 1927–33. Oil on canvas, height 200 cm (78¾ in.). Private Collection. Photo H. Tabah.

ink, 65 × 50 cm (25⅝ × 19⅝ in.). Nice, Musée des Beaux-Arts. Photo M. de Lorenzo.

345 Study for *The Scientists*. Phaedrus. 1938. Pen, ink and gouache, 65 × 50 cm (25⅝ × 19⅝ in.). Nice, Musée des Beaux-Arts. Photo M. de Lorenzo.

346 *The Scientists*. 1940. Decorative panel for the Monkey-House in the Jardin des Plantes. Oil on canvas, 350 × 680 cm (137¾ × 267¾ in.). Paris, Hall of the Museum Library. Photo Flammarion.

347 Composition study for *The Scientists*. 1938. Pencil, watercolour and gouache, 50 × 102 cm (19⅝ × 40⅛ in.). Paris, Musée National d'Art Moderne. Photo Museum.

CHAPTER XII

348 *Harlequin in the Venetian Manner*. 1939. Oil on canvas. Private Collection. L IV, 1569. Photo Flammarion.

349 *Still Life with Violin* (detail of ill. 370).

350 *Venice, the Piazzetta*. 1938. Watercolour, 50 × 65 cm (19⅝ × 25⅝ in.). Private Collection. GL I, 294. Photo Flammarion.

351 *Reception of French Staff*, after Constantin Guys. 1935. Oil on canvas, 130 × 160 cm (51⅛ × 63 in.). Private Collection. L IV, 1515. Photo Flammarion.

352. *Harlequin*. 1941. Watercolour, 65 × 50 cm (25⅝ × 19⅝ in.). Private Collection. GL II, 1660. Photo Galerie Louis-Carré.

353 Raphael, Sheet from Sketchbooks. Pen and ink, 21 × 30 cm (8¼ × 11¾ in.). Private Collection. Photo Flammarion.

354 Study of a violinist, after Raphael. 1941. Pen and ink, 27 × 18 cm (10⅝ × 7¼ in.). Private Collection. Photo Flammarion.

355 *Red and White Harlequins on the Terrace at Caldas de Montbuy*. 1945–46. Oil on canvas, 22 × 27 cm (8⅝ × 10⅝ in.). Perpignan, Musée Hyacinthe-Rigaud. GL II, 1660. Photo Flammarion.

356 Study for *Sunday*. 1943. Pen and brown ink, 50 × 65 cm (19⅝ × 25⅝ in.). Private Collection. Photo Flammarion.

357 *Vase of Roses*. 1941. Watercolour and gouache, 50 × 65 cm (19⅝ × 25⅝ in.). Private Collection. Photo Galerie Malingue.

358 *Our House at Montsaunès*. 1943. Watercolour, 50 × 65 cm (19⅝ × 25⅝ in.). Private Collection. GL I, 621. Photo Galerie Malingue.

359 *Threshing Scene*. 1945. Oil on canvas, 81.5 × 32.5 cm (32⅛ × 12¾ in.). Private Collection. L III, 1044. Photo Flammarion.

360 Handwritten inscription on the back of the watercolour *Orchestra with Pianist*. 1941. Private Collection. GL II, 1627. Photo Galerie Louis-Carré.

361 *Orchestra*. 1941. Black lead, 32 × 50 cm (12⅝ × 19⅝ in.). Private Collection. Photo Flammarion.

362 *Orchestra with Singer*. 1942. Oil on canvas, 54 × 65 cm (21¼ × 25⅝ in.). Private Collection. L IV, 1401. Photo Galerie Louis-Carré.

363 Study for violinist. Around 1946. Pen and black lead, 65 × 50 cm (25⅝ × 19⅝ in.). Perpignan, Musée Hyacinthe-Rigaud. Photo Flammarion.

364 *Nicolas Karjinsky*. 1942. Oil on canvas, 81 × 65 cm (31⅞ × 25⅝ in.). Private Collection. L III, 1349. Photo D.R.

365 Study of a cello. Around 1946. Pen and black lead, 65 × 50 cm (25⅝ × 19⅝ in.). Perpignan, Musée Hyacinthe-Rigaud. Photo Flammarion.

366 *The Sardane*. Around 1946. Black lead, 65 × 50 cm (25⅝ × 19⅝ in.). Perpignan, Musée Hyacinthe-Rigaud. Photo Flammarion.

367 *Homage to Claude Debussy*. 1952. Oil on canvas, 59 × 72 cm (23¼ × 28⅜ in.). Nice, Musée des Beaux-Arts. L IV, 1513. Photo M. de Lorenzo.

368 *Homage to Bach*. Around 1950. Pen and ink, 50 × 60 cm (19⅝ × 25⅝ in.). Private Collection. Photo Flammarion.

369 Raoul Dufy and André Robert around 1950.

370 *Still Life with Violin*. 1952. Oil on canvas, 81 × 100 cm (31⅞ × 39¾ in.). Paris, Musée National d'Art Moderne. L IV, 1515. Photo Museum.

371 *The Yellow Console with Two Windows*. 1948. Oil on canvas, 65.6 × 81 cm (25⅞ × 31⅞ in.). Nice, Musée des Beaux-Arts. L III, 1215. Photo M. de Lorenzo.

372 *The Quintet*. 1948. Oil on canvas, 37.7 × 46 cm (14⅞ × 18⅛ in.). Private Collection. L supp. 2010. Photo Galerie Malingue.

373 Raoul Dufy in his Forcalquier studio in 1952.

374 *The Grand Concert*. 1948. Oil on canvas, 65 × 81 cm (25⅝ × 31⅞ in.). Nice, Musée des Beaux-Arts. L IV, 1425. Photo M. de Lorenzo.

375 *Black Freighter*. 1952. Oil on canvas, 80 × 50 cm (31½ × 19⅝ in.). Lyons, Musée des Beaux-Arts. L II, 733. Photo B. Lontin.

376 Raoul Dufy in his Perpignan studio in 1946.

377 *Le Rond-point de la Vierge*, illustration for *Les Bucoliques*. 1946. Watercolour. Private Collection. Photo Flammarion.

378 *Musicians in the Countryside*. 1948–49. Oil on cardboard, 23 × 46.5 cm (9 × 18¼ in.). Perpignan, Musée Hyacinthe-Rigaud. L IV, 1476. Photo Flammarion.

379 Illustration for *Les Nourritures terrestres*. 1950. Watercolour. Private Collection.

380 *The Arenas at Toledo*. 1949. Watercolour, 65 × 50 cm (25⅝ × 19⅝ in.). Private Collection. GL II, 1716. Photo Flammarion.

381 *Bullfight*. Around 1944. Oil on canvas, 81.6 × 100.3 cm (32⅛ × 39½ in.). New York, Metropolitan Museum of Art, gift of Raymonde Paul, in memory of her brother C. Michael Paul. L supp., 2027. Photo Museum.

382 *Mexican Musicians*. 1951. Oil on canvas, 81 × 100 cm (31⅞ × 39⅜ in.). Nice, Musée des Beaux-Arts. L IV, 1488. Photo M. de Lorenzo.

383 *Imaginary View of Venice*. Around 1950. Watercolour, 76 × 20 cm (29⅞ × 7⅞ in.). Private Collection. Photo Flammarion.

384 Raoul Dufy on his terrace at Forcalquier, shortly before his death.

BIBLIOGRAPHY

LIST OF BOOKS ILLUSTRATED BY RAOUL DUFY

(N.R.F. Nouvelle Revue Française)

1910
1 drawing in *La Grande Revue*.
1911
30 wood engravings, 1 vignette, 3 headings, 3 ornamental bands and tailpieces for Apollinaire, *Le Bestiaire ou Cortège d'Orphée*, Delplanche, large 4to. Printed in an edition of 120 (republished in 1919 by La Sirène in an edition of 1,050 with plates reduced in size).
1913
Typographical woodcut decorations for Reval, *Le Royaume du printemps*, Mirasol, 8vo.
1916
Woodcut cover from a drawing by the author for Fleuret, *Falourdin*, Delphi, at the Pythian tripod, the 3rd year of the delirium of Lamachus, 6to.
Woodcut for Verhaeren, *Poèmes légendaires de France et de Brabant*, Société littéraire de France, 6to. 61 de luxe copies + normal print.
1917
12 woodcut illustrations within the text and 1 inset plate for *L'Almanach des lettres et des arts*, p.p. A. Mary and R. Dufy, Martine, 16mo.
Les Élégies martiales, Camille Bloch. 180 copies 16mo and 71 8vo.
1918
Portrait and 20 woodcut headings for Gourmont, *M. Croquant*, Georges Crès, 16mo, edition of 160.
1919
2 woodcuts for the Comtesse de Noailles, *Destinée*, Feuillets d'Art, large 4to, edition of 1,200.
Woodcut for *L'Almanach de cocagne pour l'an 1920*, La Sirène, 16mo.
1 drawing in *Aujourd'hui*, Bernouard, 4to.
1920
4 woodcuts including 1 inset plate for *L'Almanach de cocagne pour l'an 1921*, La Sirène, 16mo.
Wood-engraved headings for Duhamel, *Élégies*, Camille Bloch, 4to.
Frontispiece for Fleuret, *La Comtesse de Ponthieu*, La Sirène, small 16mo.
18 coloured drawings for Gourmont, *Des Pensées inédites*, La Sirène, 16mo.
25 drawings, stencil-coloured by Richard, for Mallarmé, *Madrigaux*, La Sirène, 4to. 110 copies.
5 drawings for Willard, *Tour d'horizon*, Au Sans Pareil, 16mo. 353 copies.
1921
Wood engraving for *L'Almanach de cocagne pour l'an 1922*, La Sirène, 16mo.
Lithograph portrait for Claudel, *Ode jubilaire pour le six-centième anniversaire de la mort de Dante*, N.R.F., 12mo. 525 copies.
1922
Portrait engraved with burin by Gorvel for Boylesve, *Ah! Plaisez-moi . . .*, N.R.F., collection 'Une Oeuvre, un portrait', 16mo. 1,050 copies.
1923
Cover and 30 woodcuts coloured by J. Rosoy and L. Petitbarat for Fleuret, *Friperies*, N.R.F., 16mo. 270 copies.
1924
1 colour plate for Hervieu, *L'Âme du cirque*, Librairie de France, large 4to. 386 copies.
1925
97 drawings including 20 inset plates for Coquiot, *La Terre frottée d'ail*, Delpeuch, 4to. 116 copies ex + normal print 16mo, including only 77 drawings.
Portrait for Coulon, *L'Enseignement de Rémy de Gourmont*, Éd. du Siècle, 12mo. 750 copies.
Portrait for Tailhade, *Poésies posthumes*, Messein, 12mo. 1,000 copies.
1926
36 lithographs for Apollinaire, *Le Poète assassiné*, Au Sans Pareil, 4to. 470 copies.
3 drawings for Coquiot, *En Suivant la Seine*, Delpeuch, 8vo. 235 copies.
1927
Portrait engraved by G. Aubert for Fleuret, *Falourdin*, N.R.F., collection 'Une Oeuvre, un portrait', 16mo. 809 copies.
1928
Wood-engraved portrait for Allard, *Les Élégies martiales, 1915–1918*, N.R.F., collection 'Une Oeuvre, un portrait', 16mo.
Frontispiece for Gide, *Les Nourritures terrestres*, N.R.F., collection 'À la Gerbe', 8vo. 125 copies.
Portrait engraved by Gorvel for Gourmont, *Esthétique de la langue française*, Les Arts et le Livre, collection 'L'Intelligence', 8vo. 1,120 copies.
Frontispiece etching for Mallarmé, *Poésies*, N.R.F., collection 'À la Gerbe', 8vo. 125 copies.
1 engraving for Courthion, *Raoul Dufy*, Chroniques du Jour, 4to. 375 copies of which only 50 on Arches paper contain the engraving.
1929
Portrait for Cocteau, Mac Ramo, George, *Maria Lani*, Éditions des Quatre-Chemins, 4to.
1930–1932
Watercolour sketches for *Normandie*, commissioned by Vollard for a text by President Édouard Herriot, *La Forêt normande*, left unfinished after the death of Vollard in 1939.
1930
1 lithograph for Tharaud, 'Georgina', in *D'Ariane à Zoé*, Librairie de France, 4to. 220 copies. Frontispiece and 5 etchings for Berr de Turique, *Raoul Dufy*, Floury, 4to. (Only the first 200 copies on Japan paper contain the 5 etchings.)
94 etchings for Montfort, *La Belle Enfant, ou l'Amour à quarante ans*, Vollard, 4to. 340 copies.
1931
1 vignette, plates, 1 heading and one ornamental band engraved in wood for Apollinaire, *Le Bestiaire ou Cortège d'Orphée. Supplément: les deux poèmes refusés*, produced at the expense of an admirer, 4to. 29 copies, + 1 containing the scored plates.
Frontispiece etching, ornamental band, heading, 2 plates, and tailpiece, colour lithographs for Fleuret, *Éloge de Raoul Dufy*, for the friends of Dr Lucien Graux, undated, folio.
1931–1936
Colour lithographs for Daudet, *Aventures prodigieuses de Tartarin de Tarascon*, Scripta et Picta, 4to. 130 copies.
1932
6 drawings for Courthion, *Suite montagnarde*, Éd. Lumière. 210 copies.
Three portraits for Montfort, *Choix de proses*, Les Marges.
1936
Frontispiece for Berthault, *Vaisseaux solaires*, preface by Montherlant, Correa, 16mo.
19 watercolours and black-and-white cover for Dérys, *Mon Docteur le vin*, Ets Nicolas, small 4to.
1937
1 etching for Gérard d'Hauville, *Mes Champs-Élysées*, in *Paris 1937*, Daragnès.
1930
20 etchings for Brillat-Savarin, *Aphorismes et Variétés*, Les Bibliophiles du Palais, 4to. 200 copies.

1944
Portrait for Salacrou, *Les Fiancés du Havre*, N.R.F., 16mo.
1948–1949
1 lithograph and 7 drawings for Massat, *La Source des jours*, Bordas.
2 watercolours for 'La Tentative amoureuse', in *Oeuvres illustrées d'André Gide*, N.R.F.
1950
12 watercolours for Gide, *Les Nourritures terrestres et Les Nouvelles Nourritures*, 'Le Rayon d'or', N.R.F.
1951
6 etchings and 1 lithograph for Courthion, *Raoul Dufy*, Cailler. (Only the first 225 copies contain the 7 illustrations.)
10 watercolours for Colette, *Pour un Herbier*, Mermod.
1945–1951
Pencil drawings for Virgil, *Bucoliques*, unfinished project for Scripta et Picta.
1953
16 original lithographs and 45 illustrations for Fargue, *Illuminations nouvelles*, Textes-Prétextes.

MAIN EXHIBITION CATALOGUES

1927
Galerie Le Portique, Paris.
1941
Galerie Louis-Carré, Paris.
1947
Galerie Louis-Carré, Paris.
1949
Galerie Louis-Carré, New York.
1952
Raoul Dufy, Musée d'Art et d'Histoire, Geneva.
1953
Raoul Dufy, Musée National d'Art Moderne, Paris.
1955
Musée Toulouse-Lautrec, Albi.
1957
Rétrospective Dufy, Salon des Indépendants, Paris.
Raoul Dufy, Galerie Beyeler, Basle.
1962
Legs de Mme Dufy au Musée du Havre, Maison de la Culture du Havre.
1963
Donation Dufy, Musée du Louvre, Galerie Mollien, Paris.
Homage à Raoul Dufy, Galerie des Ponhettes, Nice.
1967
Raoul Dufy, National Museum of Western Art, Tokyo.
1968
Raoul Dufy, National Museum of Modern Art, Kyoto.
1972
Raoul Dufy, Galerie Dina-Vierny, Paris.
1973
Raoul Dufy, créateur d'étoffes, Mulhouse.
1976
Raoul Dufy, Wildenstein Gallery, Tokyo.
1977
Raoul Dufy dans les collections de la ville de Paris, Musée d'Art Moderne de la Ville de Paris.
Raoul Dufy, créateur d'étoffes, 1910–1930, Musée d'Art Moderne de la Ville de Paris.
Raoul Dufy in Nice, Galerie des Ponchettes, Collections du Musée des Beaux-Arts, Nice.
Raoul Dufy au Musée National d'Art Moderne, Paris.
1979
Impression-créations de Raoul Dufy et Paul Poiret, Musée des Beaux-Arts André Malraux, Le Havre.
1981
Raoul Dufy, 1877–1953, Theo Waddington, London.
Raoul Dufy, aquarelles, Galerie Louis-Carré et Cie, Paris.
1983
Raoul Dufy, Galerie Salis, Salzburg.

Raoul Dufy, Art Point Gallery, Tokyo.
1983–1984
Raoul Dufy, Hayward Gallery, London.
1984
Raoul Dufy, Galerie Marwan Hoss, Paris.
Raoul Dufy, Holly Solomon Gallery, New York.
1985
Raoul Dufy, oeuvres de 1904–1953, 30th Salon de Montrouge.
Raoul Dufy et la Mode, I.I.C. Galerie Marcel-Bernheim, Paris.
1986
Raoul Dufy, Trianon de Bagatelle, Paris.
1987
Raoul Dufy Textile Design, Art Point Gallery, Tokyo.
Raoul Dufy, Association Campredon, Art et Culture, L'Isle-sur-la-Sorgue (Vaucluse).
Raoul Dufy, Galerie Malingue, Paris.
Raoul Dufy, Tamenaga Gallery, Tokyo.
Les Oeuvres fauves de Raoul Dufy, Musée de l'Annonciade, Saint-Tropez.
1988
Raoul Dufy, touring exhibition, Shibo–Osaka–Shizuoko–Miyazaki–Fukuoka.
1989
Raoul Dufy et la musique, Musée des Beaux-Arts de Tours.

MAIN MONOGRAPHS

1929
Pierre Courthion, *Raoul Dufy*, Paris, Chroniques du Jour.
1930
Marcelle Berr de Turique, *Raoul Dufy*, Paris, Floury.
1931
Fernand Fleuret, *Éloge de Raoul Dufy*, Paris, Manuel Bruker.
1932
Jean Ajalbert, *Les Peintres de la Manufacture Nationale de Tapisseries de Beauvais: Raoul Dufy*, Paris, Eugène Rey.
1944
Louis Carré, *Dessins et croquis extraits des cartons et carnets de Raoul Dufy*, Paris, Louis Carré.
1946
Jean Cassou, *Raoul Dufy, poète et artisan*, Geneva, Skira.
1951
Pierre Courthion, *Raoul Dufy*, Geneva, Cailler.
1953
Bernard Dorival, *La Belle Histoire de la Fée Électricité de Raoul Dufy*, Paris, La Palme.
Alfred Werner, *Raoul Dufy*, New York, Abrams.
1954
Jacques Lassaigne, *Dufy*, Geneva, Skira.
1957
Raymond Cogniat, *Dufy décorateur*, Geneva, Cailler.
1962
Raymond Cogniat, *Raoul Dufy*, Paris, Flammarion.
1965
Marcelle Oury, *Lettres à mon peintre*, Paris, Perrin.
1970
Alfred Werner, *Raoul Dufy*, Paris, Nouvelles Éditions Françaises and New York, Abrams.
1979
Guido Perroco, *Dufy*, Milan, Fabbri (1966) and Paris, Hachette.
1985
Alfred Werner, *Dufy*, Paris, Cercle d'Art and New York, Abrams.

ARTICLES – SPECIAL ISSUES

Henri Clouzot, 'Les "Tissus modernes" de Raoul Dufy', *Art et décoration*, December 1920, pp. 177–82.
Raoul Dufy, 'Les Tissus imprimés', *L'Amour de l'art*, No. 1, May 1920, pp. 18–19.

Jean Cassou, 'Dessins de Raoul Dufy', *Cahiers d'art*, No. 1, 1927, pp. 17–22.

Christian Zervos, 'Oeuvres récentes de Raoul Dufy', *Cahiers d'art*, Nos. 4–5, 1927.

Special issue of *Cahiers d'art*, 1928.

Special issue of *Sélection*, March 1928

Fernand Fleuret, 'Le Peintre de la joie, Raoul Dufy', *Formes*, No. 10, December 1930, pp. 5–6.

Arsène Alexandre, 'L'Exposition parisienne de Beauvais. Le mobilier de Raoul Dufy', *Le Renaissance de l'art français et des industries de luxe*, No. 3, 1938, p. 40–42.

Gertrude Stein, 'Raoul Dufy', *Les Arts plastiques*, 1949, p. 135–45.

Pierre Courthion, 'Raoul Dufy au Musée d'Art Moderne', *Arts*, 26 June 1953.

Bernard Dorival, 'Raoul Dufy et le portrait', *La Revue des Arts*, No. 3, September 1955, pp. 175–80.

Bernard Dorival, 'Le Thème des baigneuses chez Raoul Dufy', *La Revue des Arts*, No. 4, December 1955, pp. 238–42.

Bernard Dorival, 'Un Chef-d'oeuvre de Raoul Dufy entre au Musée d'Art Moderne', *La Revue des Arts*, No. 4, July-August 1957, pp. 170–74.

Bernard Dorival, 'Les *Affiches à Trouville* de Raoul Dufy', *La Revue des Arts*, No. 5, September–October 1957, pp. 225–28.

Georges Charensol, 'Raoul Dufy au Louvre', *Revue des deux mondes*, 15 March 1963, pp. 283–86.

Bernard Dorival 'Le Legs de Mme Raoul Dufy au Musée National d'Art Moderne', *La Revue du Louvre et des Musées de France*, Nos. 4–5, 1963, pp. 209–36.

Michel Hoog, 'Dessins, tapisseries et ceramiques legués par Mme Raoul Dufy au Musée National d'Art Moderne de Paris', *La Revue du Louvre et des Musées de France*, Nos. 4–5, 1963.

Gilberte Martin-Méry, 'Hommage à Raoul Dufy', *La Revue du Louvre et des Musées de France*, Nos. 4–5, 1970, pp. 305–08.

Axelle de Broglie, 'Dufy, pure soie', *Connaissance des arts*, No. 256, June 1973, p. 110–13.

Geneviève Breerette, 'Dufy créateur d'étoffes', *Le Monde*, 27 July 1973.

Anne-Marie Christin, 'Images d'un texte: Dufy illustrateur de Mallarmé', *Revue de l'art*, No. 44, 1979, pp. 68–74.

Jean-Marie Tuchscherer, 'Raoul Dufy et la mode', *Canal*, No. 24, January 1979, p. 22.

Antoinette Rézé-Huré, 'Raoul Dufy, le signe', *Cahiers du Musée National d'Art Moderne*, No. 5, 1980, pp. 410–22.

John McEwen, 'Raoul Revealed', *The Spectator*, 19 November 1983.

André Fermigier, 'Amours, Délices et Orgues. Dufy à Londres', *Le Monde*, 18 January 1984, pp. 1 and 16.

Peter de Francia, 'Dufy at the Hayward', *The Burlington Magazine*, Vol. LXXVI, No. 970, January 1984.

John McEwen, 'The Other Raoul Dufy', *Art in America*, March 1984, pp. 120–27.

John Russell, 'An Introduction to the Range of Raoul Dufy', *The New York Times*, 1 January 1984, pp. 23–24.

Jed Perl, 'Dufy among the Pattern Painters', *The New Criterion*, Vol. III, No. 6, February 1985, pp. 25–33.

CATALOGUES RAISONNÉS

1972–1977
Maurice Laffaille, *Raoul Dufy, catalogue raisonné de l'oeuvre peint*, Geneva, Motte.

1981–1982
Fanny Guillon-Laffaille, *Raoul Dufy, catalogue raisonné des aquarelles, gouaches et pastels*, Paris, Louis-Carré et Cie.

1985
Maurice Laffaille, Fanny Guillon-Laffaille, *Raoul Dufy, catalogue raisonné de l'oeuvre peint, supplément*, Paris, Louis-Carré et Cie.

ACKNOWLEDGMENTS

This work has been made possible by the untiring assistance of M Bernard Dorival and the interest that he took in my doctoral thesis, which gave me my passion for the work of Raoul Dufy.

I should like to remember the late André Robert, who gave me access to an enormous amount of documentation and archive material, most of it unpublished. I could not stress enough the debt that I feel towards him, his wife and his son, Jacques Robert, who has continued to show me the greatest kindness. It is thanks to them that I have been able to enjoy unforgettable moments in the intimacy of the studio in the Impasse de Guelma.

Perre Courthion's conversations with Raoul Dufy, and his great familiarity with Dufy's work were a basic source for this work. The memory of his kind consideration will stay with me.

My work also owes much to the memory of Henri Gaffié, who was kind enough to allow me access to his personal memories, information and unpublished documents.

My thanks are also due to Mme Perrine Poiret de Wilde. Her constant help and understanding gave me an emotional insight into the world of Paul Poiret.

I am particularly grateful to Sarah Wilson, whose advise was precious to me.

I should like to extend my warmest thanks to M Gerard Oury, who allowed me access to the invaluable archives of Marcelle Oury, and gave me permission to publish them.

I was able to consult Raoul Dufy's letters to Pierre Nicolau, Ludovic Massé and Dr Roudinesco thanks to the extreme kindness of Dr Bernard Nicolau, M Claude Massé and M Jean-March Roudinesco.

Mme Madeleine Milhaud allowed me access to a rich store of documentation. Her moving description of Darius Milhaud and his work was certainly one of the high points of my research.

I should also like to thank Mme Marie Bertin for her memories of *Le Boeuf sur le toit*.

My warmest thanks go to Mme Pierrette Angerra-Gargallo, who talked to me for a long time about Llorens Artigas and allowed me to publish the ceramics in her possession.

I was allowed to consult the archives of the Maison Bianchini-Férier. I am happy to thank Mme Anne Tourlonias and to extend my gratitude to M Raphaël Payen.

I was able to study Raoul Dufy's preparatory cartoons for the suite of furniture, *Paris*, thanks to M Jean Coural and Mme Gastinel, who allowed me access to the stores of the Mobilier National. Mme Hester Diamond's warm welcome gave me the opportunity to become thoroughly acquainted with Dufy's work in tapestry.

For their very great kindness I am eternally grateful to the curators of the museums containing works by Raoul Dufy. In particular I should like to thank M Jean Forneris, Mme Faro, his assistant, and Mme Marie-Claude Valaison for their kind assistance.

M Michel Hoog, to whom I am indebted for his fine teaching, helped me with his expert advice. I should like to extend my gratitude to him.

I thank Mme Antoinette Rézé-Huré for allowing me to consult her thesis.

The *catalogues raisonnés* of Raoul Dufy's work are an important reference without which I could not have completed my task. I should like to thank Mme Fanny Guillon-Laffaille, and fondly remember Maurice Laffaille.

I should also like to thank the numerous collectors who wished to remain anonymous and kindly helped me with the illustrations to this work.

For their active support I should like to thank everyone who helped me in my research, especially MM Fernand Madar, Laurent Madar, Antoine Halff and M and Mme Georges Belzeaux.

For their kind assistance I should like to thank the Galeries Louis-Carré, Bernheim-Dauberville, Artcurial, Schmit, Marwan-Hoss, and more particularly Mme Dina Vierny, M Landrot, M Daniel Malingue and Ms Holly Solomon for their generous contribution.

My thanks go out to M Jean François Barrielle for his enthusiastic encouragement. I am particularly grateful to his diligent and efficient colleagues at Flammarion, Delphine Le Cesne, Anne Sefrioui, France Le Queffelec, Jacques Nestgen, Michel Moulins and Jacques Maillot for his skills as a designer.

Finally, I dedicate this book to my husband. His intelligent advice and constant and affectionate support were a major inspiration in the writing of this book.

INDEX

Page numbers in italics refer to illustrations